THE MOST
RUSTED NAME
IN TRAVEL

Frommer's®

ATHENS & THE GREEK ISLANDS

3rd Edition

By Stephen Brewer

FrommerMedia LLC

Frommer's Athens & the Greek Islands, 3rd edition

Published by
Frommer Media LLC

ISBN 978-1-62887-549-2 (paper), 978-1-62887-550-8 (e-book)
Editorial Director: Pauline Frommer
Editor: Holly Hughes
Production Editor: Heather Wilcox
Cartographer: Roberta Stockwell
Photo Editor: Meghan Lamb
Cover Design: Dave Riedy

Front cover: Traditional Greek door on Mykonos Island.
Title page: Serifos, Cyclades islands.

For information on our other products or services, see www.frommers.com.

Frommer Media LLC also publishes its books in a variety of electronic formats. Some content that appears in print may not be available in electronic formats.

Manufactured in Malaysia

5 4 3 2 1

HOW TO CONTACT US

In researching this book, we discovered many wonderful places—hotels, restaurants, shops, and more. We're sure you'll find others. Please tell us about them, so we can share the information with your fellow travelers in upcoming editions. If you were disappointed with a recommendation, we'd love to know that, too. Please write to: Support@FrommerMedia.com

FROMMER'S STAR RATINGS SYSTEM

Every hotel, restaurant and attraction listed in this guide has been ranked for quality and value. Here's what the stars mean:

★ Recommended
★★ Highly Recommended
★★★ A must! Don't miss!

AN IMPORTANT NOTE

The world is a dynamic place. Hotels change ownership, restaurants hike their prices, museums alter their opening hours, and buses and trains change their routings. And all of this can occur in the several months after our authors have visited, inspected, and written about these hotels, restaurants, museums, and transportation services. Though we have made valiant efforts to keep all our information fresh and up-to-date, some few changes can inevitably occur in the periods before a revised edition of this guidebook is published. So please bear with us if a tiny number of the details in this book have changed. Please also note that we have no responsibility or liability for any inaccuracy or errors or omissions, or for inconvenience, loss, damage, or expenses suffered by anyone as a result of assertions in this guide.

CONTENTS

LIST OF MAPS

ABOUT THE AUTHOR

Stephen Brewer is a book and magazine writer who spent a summer discovering Crete 30 years ago and has been returning ever since. While he's partial to the village of Vamos and the Lasithi Plateau on Crete, he's never stepped foot on another Greek island he didn't like. He's also spent much time hiking around Olympia and Nafplion and exploring other parts of the Peloponnese as well as Athens. From home bases in New York and Italy, he also writes about England, Scotland, Germany, and Italy for *Frommer's Travel Guides*.

THE BEST OF ATHENS & THE GREEK ISLANDS

The Acropolis, the theater at Epidaurus, the palace at Knossos—Greece's ancient wonders are legendary, and all the more alluring when you throw in that blue sky and those warm blue seas, a natural beauty that at times can seem almost mystical. Plus, there's so much else: the beaches, some of the world's most luxurious places to stay, simple tavernas where a meal on the terrace can seem like the feast of a lifetime. Just the experience of sitting, watching, and taking it all in can be profound. To help you enjoy your time in Greece to the fullest, here's what we consider to be the best of the best.

THE best GREEK TRAVEL EXPERIENCES

- **Enjoy a taverna meal under the stars:** You can experience this pleasure anywhere in Greece, of course—maybe on an island with the sea in view, or in the countryside, with the scent of pine in the air, or even in busy, noisy Athens. The food is usually simple but fresh and delicious, the pace is almost always easygoing, and the spectacle of life buzzing around you is endlessly entertaining, like being in the theater. See "Where to Eat" sections throughout chapters 4 through 11.

- **Gasp at the Santorini caldera:** The cliffs glimmer in transcendent light, white villages look like a dusting of snow on the cliff tops, and boats sailing in and out of the harbor far below appear almost Homeric. Come sunset, one of Greece's most photogenic spectacles is a reliable show on this island where the sky is usually cloudless. See p. 215.

- **Gaze at the Acropolis, Athens:** You don't have to go out of your way to find a vantage point. The best approach is to let the sight catch you by surprise, as you look up from a narrow side street or traffic-choked square. One prime spot is the Grand Promenade; even Athenians get a thrill every time they follow this

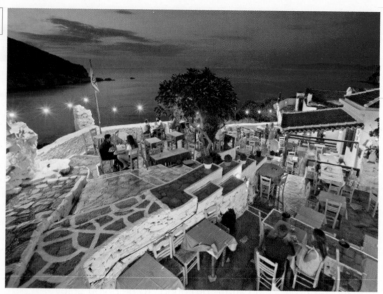

An alfresco dinner at even the simplest Greek taverna can be a transporting experience.

walkway around the base of the Acropolis Hill past some of the greatest monuments of antiquity. Think of the experience as time travel. See p. 92.

o **Get into the rhythms of Lalaria Beach, Skiathos:** Greece's beaches are among the most beautiful in the world, but nothing quite prepares you for the approach to this almost mystical cove in the Sporades archipelago. At first you won't quite know what that murmur is. Then you slowly become accustomed to the soft rumble of white marble stones rolling back and forth in the surf, amplified by sun-dappled sea cliffs. See p. 338.

o **Descend onto the Lasithi Plateau, Crete:** First the road climbs and climbs; then suddenly you reach the summit of the pass and at your feet spreads a high haven of orchards and fields, studded with windmills and protected by a tidy ring of mountains. Your explorations can include a cave that's one of the alleged birthplaces of Zeus—it's not hard to believe a god would choose to be born up here. See p. 298.

o **Catch your first glimpse of Skyros Town, Skyros:** This hilltop *hora* appears to defy gravity—at first sight the white houses clinging to a rocky mount high above the coastal plain look like a mirage. Make the ascent to the upper town, where a walk along the steep, narrow lanes only heightens the illusion. See p. 354.

o **Succumb to the simple charms of Mykonos:** For all its glitz and glamour, worldly Mykonos shows off its best side in Hora, where wooden balconies hang from square white houses, outdoor staircases are lined with pots of geraniums, and oleander and hibiscus scent the air. In the picturesque Little Venice quarter, the island's sea captains built their homes so close to the water's edge that waves wash against the lower floors. See p. 172.

best ENCOUNTERS WITH THE ANCIENT GREEKS

○ **Envision life as it once was in the Agora:** Athens has no shortage of ancient ruins, but those of the Agora, the marketplace and social center of the ancient city, might be the most evocative. Even though most of the shops and stoas have been reduced to rubble, just enough remains (including the best-preserved Greek temple in the world and an ancient clock tower and weather station) to give you an idea of what the place must have been like when Socrates sat with his students on shady porticos and vendors hawked spices and oils. See p. 103.

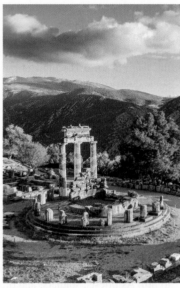

○ **Consult the oracle at Delphi:** No other ancient site is quite as mysterious and alluring as this sanctuary to Apollo, nestled amid olive groves high above the Gulf of Corinth on the flanks of Mount Parnassus. It's easy to see why the spot was so transporting for the ancients, who flocked here to seek the enigmatic counsel of Apollo. See p. 151.

○ **Encounter the gods on Delos:** One of the most sacred places for ancient Greeks still inspires, even in jumbled ruin. As you walk among

There's still a mystical air surrounding the ruined temples of Delphi, on the slopes of Mount Parnassus.

temples and skirt the shores of the sacred lake, you'll get a sense of what a trip to this island—the central point of the Cyclades—might have meant to a pilgrim of long ago. See p. 179.

○ **Look out to sea from the Temple of Poseidon:** You only have to make the pleasant trip from Athens down the Attic coast to Sounion to appreciate how ancient Greeks understood the concept that location is everything. It's easy to imagine how the sight of the majestic temple warmed the hearts of sailors returning to Athens after months at sea; you can even recreate the experience with a swim from the rocks below the site. See p. 118.

○ **Walk beneath the pines in Olympia:** The superheroes who bring most visitors to Olympia are not gods and artists but ancient athletes, who competed in the city's games, inaugurated in 776 B.C. Remnants of the stadium, gymnasium, training hall, and dormitories scattered around the site make such a vivid experience, you wouldn't be completely shocked to come upon a naked *pankration* competitor rubbing himself down with olive oil. See p. 147.

o **Gaze from the Acrocorinth:** Atop one of the world's most remarkable fortresses, high above the isthmus and the Corinth Plain, you seem to be sharing time and space with the Greek and Roman inhabitants of one of the most cosmopolitan cities in the ancient world. See p. 137.

o **Take a bow in the theater at Epidaurus:** Even the inevitable crop of stage-struck wannabes belting out show tunes doesn't detract from the thrill of standing on the spot where ancient actors performed the Greek classics when they were new. The 55 tiers of limestone seats remain much as they were, and acoustics are so sharp that a stage whisper can be heard at the top of the house. See p. 145.

o **Admire ancient marbles on Paros:** Parian marble has a way of catching your gaze and not letting go. After all, the most famous statue in the world, the *Venus de Milo,* is sculpted from the translucently white and luminescent stone quarried on this island in the Cyclades. On the back lanes of Parikia you may also be intrigued by a much less formal display: Bits and pieces of columns and pediments, debris from ancient temples, are wedged willy-nilly into the walls of the 13th-century Venetian *kastro,* a head-spinning glimpse into civilizations past. See p. 204.

GREECE'S best MUSEUM MOMENTS

o **Be mesmerized by ancient storytelling in the Acropolis Museum:** More than any other ancient pieces, the exquisitely carved Parthenon friezes capture fascinating snippets of divinity and humanity—in one, the goddess Athena Nike fastens her sandal (something you didn't think goddesses had to do). As priests, soldiers, and ordinary citizens parade across the marble strip, you almost want to jump in and join the procession. See p. 93.

Ancient Minoan culture seems to spring back to life in the vibrant frescoes of Iraklion's Archeological Museum on Crete.

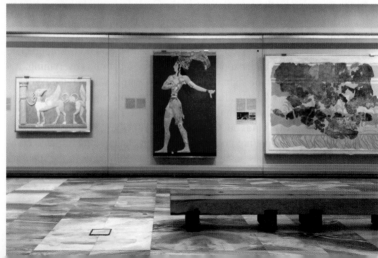

- **Lose track of time in Athens's National Archaeological Museum:** You don't have to be a classics scholar to appreciate the embarrassment of riches here. Just wander and stop in front of the pieces that catch your eye—all those figures frozen in marble for eternity; all that gold, jewelry, and pottery. Irresistible favorites are the colorful frescoes depicting residents of the Minoan settlement of Akrotiri on Santorini, going about their everyday lives more than 3,500 years ago. See p. 110.

- **Regard the Minoan frescoes in the Archaeological Museum in Iraklion:** The athletes, dancers, and other subjects seem to reach across the millennia and touch us—you can understand why a modern French archaeologist, looking at a 4,000-year-old scene of flounce-skirted court ladies, exclaimed, "Les Parisiennes!," giving the fresco its modern nickname. See p. 291.

- **Enjoy frieze frenzy at the Archaeological Museum on Paros:** The Parthenon scenes in Athens aren't Greece's only famous marble carvings. At the Archaeological Museum in Parikia, a fragment of the Parian Chronicle captures a march of Alexander the Great and other scenes from Greece's distant past. Another frieze nearby portrays the poet Archilochus, a 7th-century-B.C. master of the bon mot who famously sniped "'tis thy friends that make thee choke with rage." See p. 202.

- **Admire the figures in the Museum of Cycladic Art in Athens:** It's hard to distinguish these smooth, oblong, elongated figures from the modern pieces they've inspired by Henry Moore, Picasso, and Modigliani. More than 300 of these 3,500-year-old masterworks are housed in this Athens museum's light-filled modern galleries. Their timelessness is haunting. See p. 113.

- **Surround yourself with statues at the Achilleion on Corfu:** Few palaces are more beautifully situated, amid seaside gardens, and few are more ostentatious. Neoclassical, frescoed salons are filled with a forest of marble gods and goddesses, with Trojan War hero Achilles leading the pack. See p. 397.

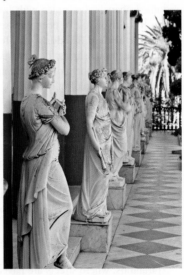

At Empress Elisabeth of Bavaria's Corfu getaway, Achilleion, the neoclassical statues abound.

GREECE'S best SMALL TOWNS

- **Meander into Anafiotika:** Charming, overused as the word is, really does apply to this village-unto-itself within the great city of Athens. The lower slopes of the Acropolis, just above the Plaka, were settled by craftsmen from the island of Anafi who came to Athens in the mid–19th century to

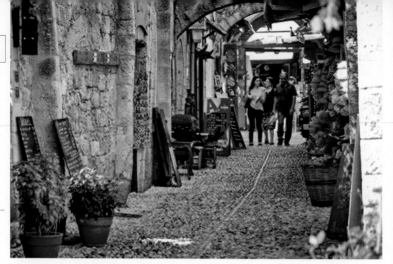

The medieval lanes of Rhodes's Old Town bring the age of Crusader knights to vivid life.

work on the new buildings of the revived capital; here they recreated their homeland with stepped streets and square white houses. Blue shutters, blue-domed chapels, balconies with bougainvillea spilling over the railings—you'll feel like you've been whisked off to a Cycladic island. See p. 102.

o **Wander around Rhodes's Old Town:** Ancient, crusaders knights, Italian nobles, Ottoman lords, Italian aristocrats—who hasn't left their mark on what's arguably the most continuously inhabited medieval town in Europe? Behind the circuit of massive town walls, a maze of lanes presents a delight at every turn—beautiful mosques, fountains burbling in quiet squares, bright pink flowers cascading over balconies. See p. 248.

o **Take in the Venetian Harbor in Chania:** Find a spot on the western side of the harbor in this Cretan port city—maybe the terrace of the Firkas, the waterside fortress the Venetians built—and take in the view. The shimmering sea, a lighthouse, and waterside palaces are rendered even more exotic by the presence of mosques and minarets the Turks left behind. See p. 322.

o **Explore the Tragaea villages, Naxos:** Mazes of white houses interspersed with little chapels appear on pine-clad hillsides, Venetian towers cling to rocky spires, and boulders are strewn across green valleys carpeted with olive groves and lemon orchards. The highest and most noble village is Apiranthos, where streets are paved in marble and the houses are made of rough, gray stone hewn from the mountain. See p. 196.

o **Settle in for a while in Vamos, Crete:** You'll get a taste of rural Greece at Vamos Traditional Village, an unusual inn that's a collection of houses spread around an old farming community amid orchards, fields, and vineyards east of Chania. Accommodations are more homey than fancy—being amid the rhythm of everyday Greek life is the real luxury. See p. 318.

o **Savor the spectacle of Hora, Folegandros:** This sparkling white traditional village is a throwback to the Middle Ages, with interlocking tree-shaded squares and white cubical houses that huddle inside a Venetian

castle and teeter on the edge of sea cliffs. Overlooking it all, atop a zigzag path, is the glistening white Church of Kimisis tis Theotokou (Mother of God). See p. 231.

o **Discover your favorite village on Tinos:** There are 60 of them by official count, nestled onto mountainsides around the island. All cluster around shady squares, and even the simplest village houses are often decorated with elaborately carved marble lintels and fanlights. In the surrounding countryside you'll also see the ornate *peristerionades* (dovecotes) for which the island is famous. See p. 186.

GREECE'S most FUN FAMILY OUTINGS

o **Browse the Central Market, Athens:** Big, noisy, smelly, and fragrant, this market's indoor and outdoor stalls bring together all the food of Greece, from exotic denizens of the deep to country cheeses and swinging meat carcasses. It's one of the city's top culinary experiences. Your kids might never settle again for that boring stuff you pack in their school lunches. See p. 108.

o **Sail through the National Marine Park of Alonnisos Northern Sporades:** Dolphins will escort your cruise through pristine waters off an archipelago that's home to creatures as diverse as the shy Mediterranean monk seal and the mythical Cyclops (the cave where the one-eyed monster was blinded by Odysseus, according to Homer, is in the park). A swim in a secluded cove tops off the experience. See p. 348.

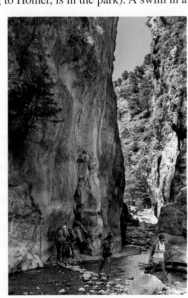

o **Squeeze into Spilia Skotini (Dark Cave), Skiathos:** Even in the company of a boatload of camera-clicking fellow explorers, you and your young companions may feel an almost Robinson Crusoe–like sense of discovery as you float into this spectacular sea grotto. The splash of waves, the shimmer of the sea, and the luster of the light transport everyone aboard into a watery fantasy world. See p. 338.

o **Hike the Samaria Gorge:** Yes, it will seem that you share the trail with just about every other traveler of all ages on the planet, but finding yourself in canyons only 3m (10 ft.) wide and 600m (1,969 ft.) deep is a profound experience nonetheless.

The longest gorge in Europe, Crete's Samaria Gorge is a daylong hike that kids will never forget.

It's all the more exhilarating when an eagle soars overhead and a kri-kri, the shy, endangered Cretan wild goat, makes a rare appearance. See p. 327.

o **See Athens from atop Mount Lycabettus:** Of the many heights in the capital, this craggy, pine-covered rise—Athens's highest hill—provides the best vantage point. You don't have to be a kid to think the ride up on the Teleferik (funicular) is a heck of a lot of fun, and the walk back down into Kolonaki is an adventure. You'll get a kick out of being so high above Athens, seeing the city spread out at your feet and the Aegean glistening in the distance. See p. 113.

GREECE'S best SEASIDE ESCAPES

o **Cruise along the southwestern coast of Crete:** Even on a public ferry, you'll feel like Odysseus or some other intrepid explorer as you chug past the mouths of mountain gorges, groves of cypress, hidden coves, and, every so often, a white-clad village tucked far away from the modern world. See p. 326.

o **Linger over lunch at Agios Sostis, Mykonos:** Paradise and Super Paradise are the island's famous beaches, but Agios Sostis's crescent of sand is much more paradisiacal—a rare tranquil find on famously boisterous Mykonos. The water is warm, the sands are soft, and a lunch of grilled fish or pork is served beneath a flowering vine at a simple beachside taverna. See p. 178.

o **Soak in a hot spring at Bros Therma, Kos:** For one of Greece's most relaxing beach experiences, head to Bros Therma on the Dodecanese island of Kos, where sulfurous water bubbles to the surface of a natural, boulder-enclosed pool on the beach. Soak up therapeutic benefits—treatment of rheumatism and arthritis, among other ailments—then plunge into the cooler sea. See p. 272.

o **Feel the golden sands between your toes on Koukounaries Beach, Skiathos:** The perfect crescent backed by pines is a Greek-isle fantasy. Your surfside stroll will not be a solitary experience, but a short walk through shady, sandy-floored groves will deliver you to a string of quieter sands on the Mandraki Peninsula of this popular Sporades island. See p. 338.

o **Take a stroll on the Nafplion Promenade:** It's hard to believe that this beautiful, busy Peloponnesian town—a fought-over prize for Turks and Venetians—is only a few steps behind you as you make your way along the Gulf of Argos, with blue water shimmering and gentle waves crashing onto the rocks below you. At the end of the walk you can dip into the sea beneath the Acronafplia Fortress at Arvanitia—one of the loveliest town beaches anywhere. See p. 143.

o **See the sea through the Portara, Naxos:** The great unfinished ancient temple doorway may lead to nowhere, but it beautifully frames the blue sea and the heights of Naxos Town's Venetian Kastro towering against the blue

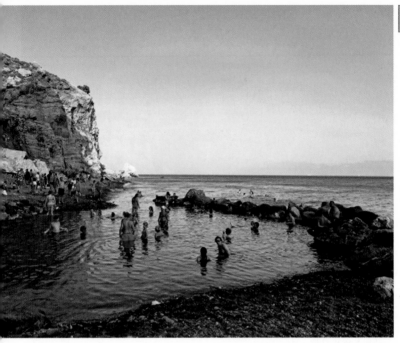

The relaxing waters of Bros Therma, on Kos, lies right next to the beach.

sky. According to legend, the massive marble portal was the entrance to the palace that the god Dionysus built for his lover, Ariadne. Taking a swim here is truly a divine experience. See p. 194.

o **Sail into Symi harbor:** A beautiful, broad, horseshoe-shaped expanse of blue sea is lined with pastel-colored houses and gracious neoclassical mansions from this Dodecanese island's shipbuilding and sponge-fishing heydays. The photogenic assemblage is particularly striking on this rough, rugged little island, which has so many chapels and monasteries that islanders claim you can worship in a different sanctuary every day of the year. See p. 258.

o **Get a good long look at Myrtos Beach:** Even from the hillside high above, this stretch of sand on the northwestern coat of Kefalonia is a stunner, backed by white cliffs and deep green forests and washed by turquoise waters. You won't be able to resist descending to sun and swim, and nearby Assos is beautiful in a quieter way, a gentle bay surrounded by pines beneath a ruined castle. See p. 407.

o **Swim through sea caves on Milos:** This island is full of exotic beach experiences. At Kleftiko, you can submerge yourself in a remarkable seascape of rock formations and sea caves; Sarakaniko is an otherworldly landscape of smooth white rocks surrounding an inlet, and at Papafraga you

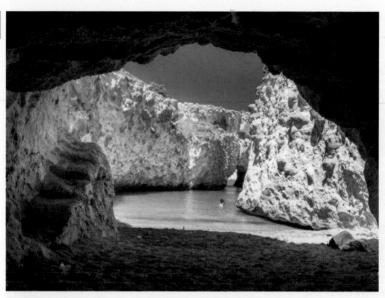

Take a dip in a roofless sea cave at Papafraga on the island of Milos in the Cyclades.

can swim through a long, fjordlike channel into a sea cave that opens to the sky. See p. 237.

most TRANSPORTING RELIGIOUS MOMENTS IN GREECE

o **Walk down to the sea at Moni Gouverneto, Crete:** Greece's largest island is generously graced with beautiful monasteries, but this one on the Akrotiri Peninsula adds a pilgrimage hike—a walk that begins in a tranquil courtyard and descends through a ravine etched with millennia-old hermitages to an isolated cove. See p. 323.

o **Climb Profitis Elias o Pilos, Sifnos:** It's quite a trek up the 850m-tall (2,789-ft.) mountain, the highest on this Cycladean island, to the isolated monastery at the summit. You'll understand the meaning of "Pilos," or "high one." A monk may be on hand to offer a glass of ice-cold water, and the views seem to extend across the entire Aegean Sea. See p. 212.

o **Tune into the spiritual aura of the Cave of the Apocalypse, Patmos:** In the cave hermitage of St. John the Divine, you'll be surrounded by many icons, the very stone that served as the saintly pillow, and a sense of holiness. You might even hear "a great voice, as of a trumpet" that rang through a cleft to deliver the Book of the Apocalypse, or Revelation. See p. 277.

o **Count church domes from the Kastro in Skopelos Town, Skopelos:** In this Sporades island capital—one of the most appealing towns in Greece—123 churches punctuate the lanes that climb the hillside. The sight

of so many blue domes will most likely inspire you to get to your feet and start exploring. See p. 343.

o **Chance upon Kapnikarea Church, Athens:** Right in the middle of busy, shop-lined Ermou Street, this little Byzantine gem sits on the site of an ancient temple to Athena and incorporates Roman columns from the Forum. Just setting eyes on the old stones and carvings whisks you away from the contemporary buzz to a different time and place. See p. 103.

o **Find all the doors to the Church of the Hundred Doors, Paros:** One of the oldest churches in the world is also, from the moment you step through the gates into the lemon-scented courtyard, one of the most other-worldly, steeped in legend. Founded in the 4th century, the landmark is filled with frescoes, icons, and even reminders of a famous murder. See p. 202.

o **Huff and puff your way up to the Meteora monasteries:** These six religious communities are awash in colorful frescoes, but the real visual treat is their gravity-defying settings, clinging to pinnacles high above the plain of Thessaly. To reach these fascinating monasteries, you'll climb what seem to be endless stairways—a vast improvement over the ladders and baskets the monks once had to use. See p. 155.

o **Witness the faithful on Tinos:** Almost any day of the year you can see people crawling from the port on hands and knees up Megalocharis, the long, steep main street, one side of which is carpeted to protect the knees of the faithful. At the top is the final approach up red-carpeted stairs to the Panagia Evangelistria, where an icon is said to heal the sick and ensure good health to all. See p. 185.

On the Dodecanese island of Patmos, you can meditate in the very cave where St. John the Divine received his vision of the Book of Revelation.

THE best LUXURY RETREATS IN GREECE

o **Aqua Blu, Kos:** A sensational pool terrace merges seamlessly with handsome lounges, while guest rooms are design statements combining contemporary chic with comfort, intimacy, and elegance. Guests are pampered with sea views, terraces, and such perks as fireplaces and private pools in some rooms and suites. See p. 265.

o **Atrium Hotel, Skiathos:** Beautiful accommodations ranging from doubles to lavish maisonettes tumble down a pine-clad hillside above one of the island's nicest beaches, commanding endless sea views from multiple terraces and outdoor spaces. Antiques and island-style furnishings are all carefully chosen by the architect-family that built and still runs this stunning retreat. See p. 333.

o **Cavo Tagoo, Mykonos:** Huge rooms and suites, set amid lovely gardens, are filled with high-tech gadgetry, gorgeous handcrafted furnishings, sunken tubs, and other soothing comforts. Most rooms have sea-facing terraces, many with private pools, built-in divans, and dining tables surrounded by exotic plantings. See p. 169.

o **Elounda Mare, Crete:** At this low-key, intimate, idyllic retreat—one of Europe's truly great getaways—swanky bungalows and other handsome guest quarters are tucked into verdant seaside gardens. All are furnished elegantly in traditional Cretan style, with expansive views over the Gulf of Elounda. A sandy beach and all sorts of shady seaside nooks are among many, many amenities. See p. 301.

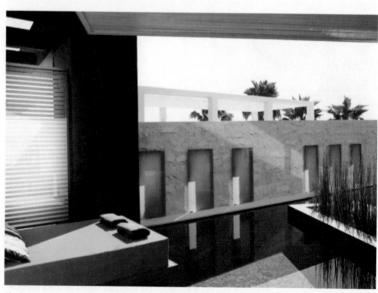

Sleek contemporary design creates an aura of serenity at the Aqua Blu resort on Kos.

- **Esperas, Santorini:** You'll feel like a cliff dweller at this welcoming enclave of traditional houses teetering on the edge of the caldera in Ia, an enchanted perch that seems like a world unto itself. Soak in stupendous views from the private terraces, beautiful pool and terrace, and tasteful accommodations. See p. 217.

- **Kapsaliana Village Hotel, Crete:** A rustic hamlet of honey-colored stone in hilly countryside above Rethymnon once belonged to the Arkadi monastery; it has now been shaped into a distinctive and relaxing country getaway. Village houses have been redone with designer flair, with contemporary furnishings offset by stone walls, arches, and wood beams. See p. 308.

- **Melenos Lindos Hotel, Lindos, Rhodes:** An authentically Lindian-style villa is a work of art, where hand-painted tiles, local antiques, handcrafted lamps, and weavings provide the backdrop for an almost otherworldly experience on a pine-scented hillside looking out to an idyllic cove. Huge beds make anyone feel like a reclining pasha. See p. 245.

- **Petra Hotel and Apartments, Patmos:** The Stergiou family has created a luxurious haven on a hillside above Grikos Bay, lavishing personal attention on guests in spacious, beautifully appointed rooms that exude island style. Most quarters have balconies or open to terraces furnished with pillowed divans for some Greek-island-style lounging. A pool glistens off to one side, and sandy Grikos beach is just at the bottom of the lane. See p. 274.

- **St. George Lycabettus Hotel, Athens:** Large, nicely decorated guest rooms (each floor has a different theme, from art nouveau to minimalism) and a beautiful rooftop pool do justice to a wonderful location—the slopes of Lycabettus hill just above the designer-boutique-lined streets of Kolonaki. The choicest quarters have views of the Acropolis. See p. 78.

- **Spirit of the Knights, Rhodes City:** In a beautifully restored Ottoman house in the quietest part of Old Rhodes Town, rooms are embellished with hand-painted ceilings, original beams, Ottoman stained glass, marble baths, and rich carpets and textiles, while a beautiful courtyard is cooled by a splashing fountain. See p. 243.

- **Villa Marandi, Naxos:** A stone-and-stucco villa set in seaside gardens fulfills just about anyone's fantasy of a Greek-island getaway. Beautifully designed rooms are large, stylish, and supremely comfortable; all have well-furnished terraces, most with sea views. A

Terraces open onto a private beach at Villa Marandi, on the island of Naxos in the Cyclades.

private strip of beach lies at the end of the garden path, and an expert staff serves cocktails and inspired Mediterranean-style meals on a beautiful poolside terrace. See p. 191.

THE best AFFORDABLE GREEK GETAWAYS

o **Carbonaki Hotel, Mykonos:** On Greece's most expensive island, there's no need to break the bank or sacrifice style and comfort. Just about all of these simply furnished but stylish rooms surround a beautiful, multilevel courtyard garden with a plunge pool, ensuring quiet (an especially welcome feature at night on this party-hearty island). See p. 170.

o **Fresh Hotel, Athens:** Soothing minimalist design, along with a rooftop pool, sun deck, and Zen-like spa, put a fresh face on the capital's gritty Omonia neighborhood. Among many modern amenities in the stylish, colorful rooms are window blinds that can be controlled from the beds—perfect for night owls not ready to face the morning sun. See p. 79.

o **Perivoli Country Hotel & Retreat, Nafplion:** A hillside planted with citrus and olive groves is a magical setting for this smart, comfortable little Peloponnese resort where handsome rooms all open to terraces and balconies facing a pool and, glistening in the distance, the Gulf of Argos. See p. 134.

o **Kalimera Archanes Village, Crete:** Tucked away in a lush walled garden among Archanes's lively lanes and squares of neoclassical houses, four meticulously restored 19th-century stone houses have been tastefully and traditionally furnished. See p. 299.

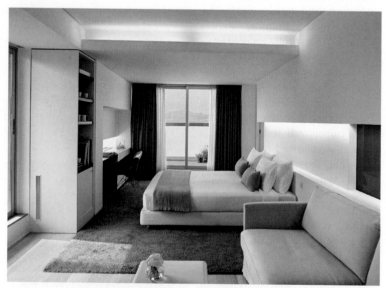

With their clean modern design, guest rooms at the Fresh Hotel make a welcome retreat after a day of sightseeing in Athens.

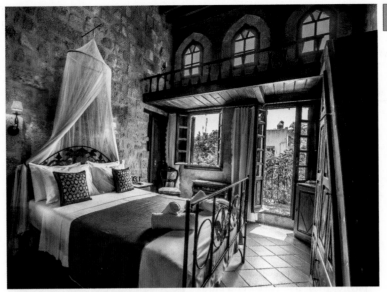

Antiques and architectural details set a medieval tone at the S. Nikolis Hotel in Rhodes Old Town.

o **Marco Polo Mansion, Rhodes Old Town:** In this restored 15th-century Ottoman mansion, each room is distinctive—one was a harem, another a hamam, another is lined with kilims—all decorated in deep hues that show off low-lying couches and stunning antiques. Excellent meals are served in the lush garden, one of the island's nicest dining experiences. See p. 246.

o **Museum Hotel George Molfetas, Kefalonia:** A historic home is a rarity in Kefalonia, making this one all the more distinctive. Attractive accommodations filled with heirlooms and hand-crafted pieces open to a courtyard, where excellent meals are served. See p. 403.

o **Perleas Mansion, Chios:** Your neighbors at this walled estate in the citrus-orchard filled Kambos district will be some of Greece's wealthiest shipping families. But the comfortable stone mansion and two surrounding cottages are soundly rooted in the simple pleasures of gracious country living, amid trees filled with birdsong. Rooms filled with antiques and art works only add to the charm. See p. 372.

o **S. Nikolis Historic Boutique Hotel, Rhodes Old Town:** You'd be hard-pressed to find a better place to soak in medieval ambiance than this charming and atmospheric cluster of houses from 1300. They're filled with antiques and modern amenities and decorated with personal flair, all surrounding a flower-filled courtyard. See p. 244.

o **Votsala Hotel, Lesbos:** Guests come back to the coast north of Mytilini time and again to enjoy a stay that that one-ups any typical resort experience. Seaside gardens, home-cooked meals beneath flowering trees, and breezy terraced rooms are matched by the almost legendary hospitality of hosts Yiannis, Daphne, and their family. See p. 361.

GREECE'S best PLACES TO EAT

o **Avli, Rethymnon, Crete:** This veritable temple to Cretan cuisine introduces diners to the freshest island ingredients. Fish and lamb appear in many different guises, as do mountain greens and other fresh vegetables, all served in a delightfully romantic garden, an arched dining room, and on a narrow lane out front. Stylish accommodations also available. See p. 310.

o **Benetos Restaurant, Patmos:** Benetos Matthaiou and his American wife, Susan, deliver one of this island's nicest dining experiences, on the terrace of a Tuscan-style villa at the edge of the sea. Fresh ingredients come from gardens on the property and nearby waters, showing up in dishes such as shrimp in phyllo, fresh fish baked in a citrus sauce, or a simple arugula salad with shaved Parmesan. See p. 275.

o **Kronio, Lasithi Plateau:** This cozy and welcoming establishment serves the finest food on Crete's Lasithi Plateau, from thick lamb stews to homemade bread and cheese-stuffed pies. Service is warm and welcoming. The proprietors' also have a countryside guesthouse, **Maison Kronio.** See p. 299.

The romantic courtyard garden of Avli, in Rethymnon, Crete.

o **Lithos, Naxos:** A stylishly contemporary dining room tucked beneath the walls of the Kastro is a quiet refuge of glistening white walls and floors accented with bright colors. These crisp surroundings are as fresh as the kitchen's simple yet satisfying creations, a pleasant change from standard taverna fare. See p. 192.

o **Metaxi Mas, Santorini:** An out-of-the-way countryside location doesn't seem to deter diners, who pack into this stone-walled dining room and terrace from noon until the wee

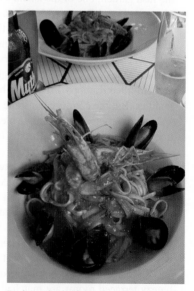

Fresh-caught shellfish make a difference in the seafood pasta at Lithos, on the island of Naxos.

hours. The draws on this sophisticated island? Simple time-honored dishes made with the freshest ingredients. See p. 221.

o **O! Hamos!, Milos:** If the Psatha family doesn't raise it, they don't serve it, so when you sit down to a meal in their homey courtyard expect the freshest salads and tastiest slow-cooked stews, accompanied by home-baked bread. See p. 235.

o **Taverna Sklithiri, Skiathos:** If you're not swept away by the setting—a flowery terrace on a golden beach with a turquoise sea almost lapping up against the tables—you really don't belong on a Greek island. Off the grill comes the freshest fish, along with all manner of other seafood, including plump mussels roasted in white wine. See p. 335.

o **The Well of the Turk, Chania, Crete:** To find your way to this all-but-hidden restaurant at the heart of the old Turkish quarter south of the Venetian Harbor, keep your eye on the minaret, and ask for directions along the way. An enticing selection of Greek and Middle Eastern appetizers, juicy lamb dishes, meatballs mixed with eggplant, and other specialties are served on the ground floor of a Turkish house and in a lovely courtyard. See p. 319.

o **To Maereio, Mykonos:** When winter sets in back home, you'll wistfully remember this delightful spot on a quiet lane set apart from the Mykonos bustle—simple and atmospheric, serving good traditional fare at reasonable prices. Country sausage, meatballs, zucchini fritters, and other delicious fare fill the tempting, ever-changing menu. See p. 172.

GREECE IN CONTEXT

While most Greeks are besotted with all that is new—a common greeting is *Ti nea?* ("What's new?")—most are also fiercely proud of those longtime attractions that enthrall visitors: Greece's mind-boggling physical beauty and its glorious past. Certainly, for most of us, to leave Greece without seeing Athens's Acropolis or Delphi, the most beautiful ancient site in all Greece, would be, as Aeschylus himself might have said, tragic. As for Greece's physical beauty, a trip into the Peloponnese or to Santorini or just about any other island will have you spouting clichés. Palamas, the poet who wrote the words to the Olympic Hymn, was reduced to saying of his homeland, "Here, sky is everywhere."

Of course, Palamas was right: The Greek sky, the Greek light, the Greek sea all deserve their fame. This is especially obvious on the islands. Greece has anywhere from 1,200 to about 6,000 islands (the count depends on what you count as an island, an islet, or a large rock). In any event, almost all of the approximately 200 inhabited islands are ready and waiting to welcome visitors. On the islands and on the mainland, throughout the countryside, picture-postcard scenes are around every corner. Shepherds still urge flocks of goats and sheep along mountain slopes, and fishermen still sit beside their caiques mending their nets.

If this sounds romantic and enticing, it is. But remember that the Greek love of the new includes a startling ability to adjust to the unexpected. Everything—absolutely everything—in Greece is subject to change. It's not by accident that the most Greek of all remarks is, *"Etsi einai e zoe,"* which literally means "That's life," but might better be translated as "Whatchya gonna do?" With luck, you'll learn the Greek shrug, and come to accept—even enjoy—the unpredictable as an essential part of life in Greece.

Recently, the unpredictable has become almost the only thing that is predictable in Greece. Massive debts and the government's unpopular attempts to restructure the economy, involving tax hikes and salary and pension reductions, have led to strikes and demonstrations. Covid and the loss of tourist revenue were other serious setbacks. Greece is moving forward, but serious questions remain as to how the country will solve its financial problems. Many

Greeks still suffer gravely, with high unemployment, especially among the young, and the crushing burden of harsh austerity measures, while an influx of immigrants puts new strains on the economy. You will probably notice that many Greeks voice concern about the future, yet in Athens, at least, new hotels, new restaurants, and such cultural arrivals as the new National Gallery, Goulandris Foundation, and Stavros Niarchos Foundation Cultural Center are reshaping the city in bright and promising ways. Meanwhile, Greeks remain warm and hospitable to visitors—and convinced they will weather current storms as they have weathered so many others since the dawn of history.

A LOOK AT THE PAST

Greece has a long history, indeed. Here is a brief introduction to some of the main periods in Greek history—though the nationalistic terms "Greece" and "Greek" are fairly modern concepts. Still, for millennia, the people who lived here regarded themselves as unified by a common language and many shared traditions and beliefs.

Ancient History

The history of Greece and its willful people is longer and more absorbing than a cursory look can convey. The earliest continuously occupied site was discovered at the Franchthi Cave in southeast Argolid, Peloponnese; evidence suggests the cavern was inhabited as early as 20,000 B.C.

The Ancient Greeks traveled and settled throughout the Mediterranean and along the Black Sea coast. Some of the oldest and most important civilizations in Europe were the **Cycladic** cultures (3200–2000 B.C.) that flourished on Santorini (also known as Thera) and nearby islands, and the **Minoan** people (3000–1400 B.C.) of Crete. While Cycladic architectural remains are sparse, at the National Archaeological Museum (p. 110) and the Museum of Cycladic Art in Athens and in other collections you can see elegant Cycladic figurines, fashioned from island marble, that are startlingly modern. Their culture was succeeded by the Minoans, the regional strongmen in seafaring and trade, who traded around the Mediterranean, selling timber, building ships, and possibly even sailing as far as England to obtain metal. Outstanding displays of Minoan culture can be viewed at the palace of Knossos (p. 293) near Iraklion, Crete, and the Iraklion Archaeological Museum

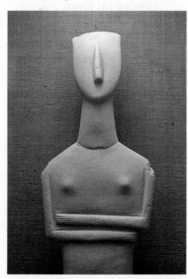

Ancient Cycladic figurines, like this one in the National Archaeological Museum (p. 110), look startlingly modern.

19

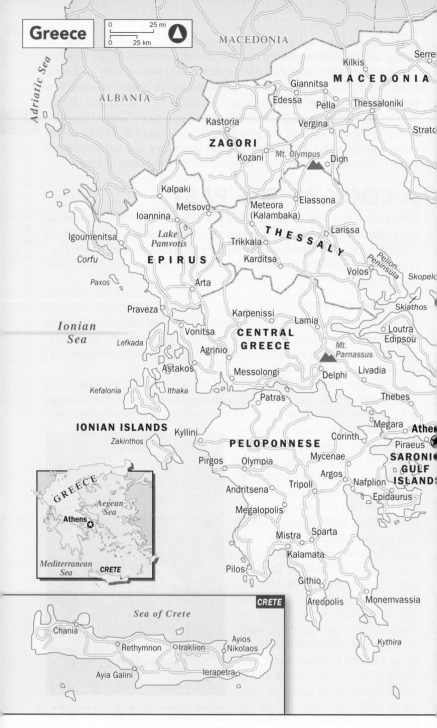

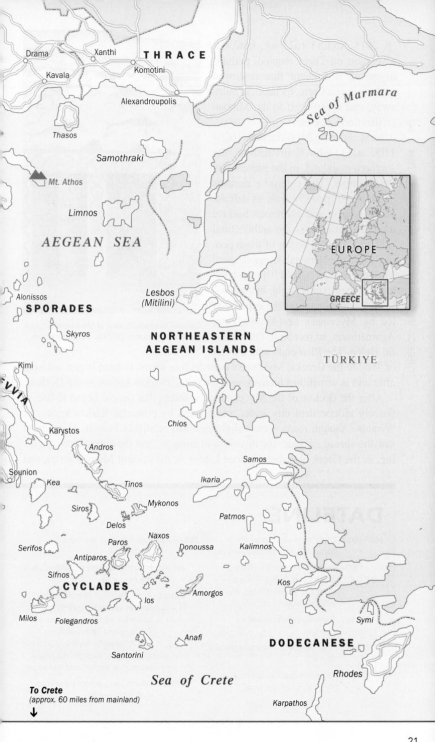

(p. 291). Around 1627 B.C, however, a volcano on Thera erupted, perhaps triggering a tsunami that destroyed settlements on Crete, 63 nautical miles away, and contributed to the Minoan civilization's decline.

Next came the **Mycenaeans** (1600–1100 B.C.), who flourished on the southern mainland, in the present-day Peloponnese. The extensive remains of Mycenae (p. 139), with its defense walls, palace, and enormous beehive tombs, demonstrates the architectural skill and political power of these people, while the National Archaeological Museum in Athens (p. 110) is a showcase for their famous gold. In the *Iliad*, Homer commemorates the expedition led by Mycenae's best-known king, Agamemnon, to recapture the beautiful Helen. The *Iliad* ends with the fall

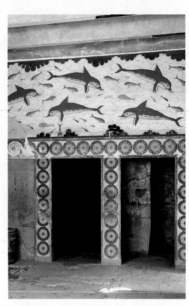

Colorful frescoes, typical of Mycenean art, can be seen at Knossos (p. 293), outside Iraklion, Crete.

of Troy to the Greeks; Mycenae's own decline seems to have begun not long after and is sometimes blamed on mysterious invaders known as the Dorians.

After the decline of the Mycenaeans, it seems that people began to live in fiercely independent city states, often ruled by powerful leaders known as "tyrants," though many were enlightened and relatively benign. This period saw the spread of trade, the invention of coinage, and the emergence of writing, as the Greek alphabet replaced Linear A, the ancient Minoan script, and

DATELINE

1627–00 B.C.	Eruption of volcano on Thera (Santorini); Akrotiri destroyed.
1300–1200 B.C.	Mycenaean palace built atop Acropolis in Athinai (Athens)—a cultural, administrative, and military center.
800 B.C.	Formation of the Greek alphabet.
776 B.C.	First Olympic Games take place in Olympia.
600 B.C.	Coins first used as currency (Aegina's silver drachma).
508–07 B.C.	First Athenian democracy established.
479 B.C.	Invading Persians raze Athens and the Acropolis.
480 B.C.	At the Battle of Thermopylae, Greeks led by Sparta's King Leonidas fall to the Persians. The Battle of Salamis follows, and Athenian forces finally drive out the Persians, though final peace will not be settled until 449 B.C.
478 B.C.	Athens League forms and rules over Greek cities.

Linear B, created by the Mycenaeans. Each city state had its own calendar, system of weights and measures, and important deities, yet later, during the Classical Era (see below), when the Persians from adjacent Asia Minor invaded Greece in 490 and 480 B.C., many of these Greek city-states—led by Athens and Sparta—stood together to turn back the Persians.

The Classical Era

Brief and glorious, the Classical era lasted from the 5th century B.C. to the rise of Philip of Macedon, in the mid-4th century B.C. This is when Pericles led Athens and when the Parthenon—and nearly every other ancient Greek monument, statue, and vase most of us are familiar with—was created. These ancient Greeks made advances in the arts, sciences, philosophy, and politics. Five of the seven Ancient Wonders were built during the Classical era: the statue of Zeus in Olympia (destroyed); the Colossus of Rhodes (destroyed); the Mausoleum at Halicarnassus, now Bodrum, Turkey (dismantled, with some bas reliefs in the U.K.); the Temple of Artemis at Ephesus (destroyed); and the Lighthouse in Alexandria (destroyed), at one time the tallest building in the world.

While the **Spartans** were known for their austere and militaristic form of governance, **Athens** took a different

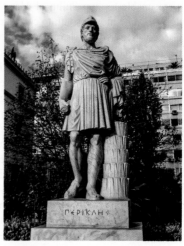

During the rule of Pericles (p. 96), most of Athens's greatest classical landmarks were built.

461 B.C. First Peloponnesian War between Athens and Sparta.	324 Emperor Constantine moves the Roman Empire's capital to the Greek city of Byzantium.
447–38 B.C. Parthenon built during Pericles's "Golden Age of Greece."	300s–400 Athens is a philosophical and educational mecca; Hadrian's Library rebuilt.
431 B.C. Second Peloponnesian War.	
336 B.C. Alexander the Great succeeds Philip II of Macedon and conquers Persia.	1054 The Great Schism divides the east (Orthodox) and west (Roman) churches.
58 B.C. Rome conquers Greece and adopts its gods, giving them new Latin names.	1100s–1400s Greece conquered by Franks, Catalans, Venetians, and Ottomans.
A.D. 50 Apostle Paul preaches in Athens.	1453 Constantinople is overrun by Turks.

continues

course with democracy. These city-states fought each other in the Peloponnesian War (431–404 B.C.), but soon thereafter united against the massive invading force of the Persians. First the Greeks won, at the **Battle of Marathon** (p. 116) in 490 B.C. Ten years later, at Thermopylae, the Persians won against a small army led by King Leonidas of Sparta. Finally, the Athenians defeated the Persians in 480 B.C. at the Battle of Salamis, led by Themistocles, who fought and won the battle decisively at sea.

The Hellenistic Era

Weakened by these wars, the cities were unable to stop Philip of Macedon when he moved south to conquer Greece. His son, Alexander, who became king of Macedon in 338 B.C. when he was only 23, soon marched from his base camp at Dion all the way to India, conquering everything in his path. Alexander died under mysterious circumstances (poison? too much wine?) on the way home in 334 B.C., leaving behind a vast empire that he had conquered but hadn't had time to organize and administer. Alexander's leading generals divided up his empire, declaring themselves not just rulers but, in many cases, divine rulers. Yet Alexander's conquests, which included much of Asia Minor

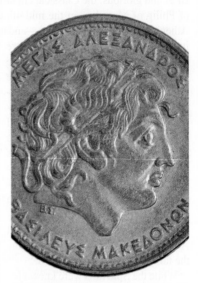

Alexander the Great, whose conquests spread Greek culture far and wide, is pictured here on an old 100-drachma coin.

1600s–1700s Ottoman rule.	King Otto in front of his palace on Syntagma (Constitution) Square.
1801–03 Lord Elgin ships Parthenon sculptures to England.	
1821 The War of Independence begins, lasting 9 years.	1896 First modern Olympic Games.
1827 In Battle of Navarino, Western powers crush Ottoman/Egyptian forces.	1912–13 Greece vastly expands its territory during the Balkan Wars.
1832–62 Greece becomes a monarchy under 17-year-old Prince Otto, son of Bavaria's King Ludwig.	1922–23 Greece receives 1.2 million refugees from Asia Minor (Turkey); Athens's population doubles between 1920 and 1928.
1834 Capital moved from Nafplion to Athens.	1940–45 Italy and Germany occupy Greece in World War II.
1843 Constitution demanded of	1946–49 Cold War hostilities fuel civil war.

and Egypt, had one lasting effect: They made the Greek language the administrative and spoken language of much of the world.

Within Greece itself, powerful new cities, such as Thessaloniki, were founded. Old cities, such as Athens, were revivified and ornamented with magnificent new civic buildings, such as the 2nd-century-B.C. **Stoa of Attalos** (p. 103), which contained shops and offices.

The Roman Conquest

From the 2nd century B.C. to the A.D. 3rd century, Greece—along with most of Europe, North Africa, and Asia Minor—was ruled by Rome. The Romans honored the Greeks for their literature and art—a tour of Greece and perhaps a year studying in Athens was common for many well-born Roman youths. The Greeks participated in what has become known as the Pax Romana, several centuries of general peace and calm under the Roman Empire.

The Byzantine Empire & Beyond

In A.D. 324, emperor Constantine the Great took control of the Roman Empire, moving the capital from Rome to the Greek city of **Byzantium** on the Bosporus. He renamed his capital Constantinople (Constantine's City) and, in a bold move, reversed the prosecutions of Diocletian, making Christianity the religion of his vast empire. The Byzantine empire lasted more than 1,000 years, until Constantinople fell on May 29, 1453, to the **Ottoman Turks.**

In the following centuries, Greece was ruled by a bewildering and often overlapping series of foreign powers: Venetians and Franks from the West and Turks from the East. Many Greeks left for Western Europe and brought ancient Greek texts with them, influencing the Renaissance. Those who remained became a subject people. The phrase "under the Turkish yolk for 400 years" became a common refrain.

1952 Greece joins NATO.	2002 Greece enters Eurozone.
1967 Martial law leads to a brutal 7-year dictatorship.	2004 Greece soccer team wins European Championship; Olympic Games held in Athens.
1981 Greece joins EEC (European Economic Community).	2009 Triggered by massive debts, Greece is thrown into a financial crisis.
1996 Greece and Turkey come to brink of war over islet of Imia.	2009–18 Greece's debt crisis worsens. Unemployment soars, and strikes, protests, and riots rock Athens and other cities. New loans are issued and bailout packages put in place.
1999 Joint rescue efforts after earthquakes in Turkey and Greece thaw relations with Turkey.	
2001 John Paul II becomes first pope to visit Greece since 1054.	

continues

Independence & a United Greece

Greece's **War of Independence** began in 1821, when the bishop at the Monastery of Agia Lavra, on the Peloponnese, raised the flag of revolt, calling for freedom or death. The ideals of Greece captured the imagination of the Romantics in Western Europe; Lord George Gordon Byron (see box on p. 107) and others traveled to Greece to take up the fight. In 1827, combined forces from Britain, France, and Russia crushed the Ottoman and Egyptian naval forces at the **Battle of Navarino** in the Peloponnese and granted Greece autonomy under an appointed monarchy. Otto, the 17-year-old son of King Ludwig of Bavaria, became united Greece's first king.

By the end of the 19th century, Greece's capital was in Athens, but most of today's country was still held by the Turks and Italians. The great Greek leader from Crete, Eleftherios Venizelos (after whom Athens International Airport is named) led Greece in the **Balkan Wars** of 1912–1913. When the wars were done, Greece had increased its territory by two-thirds, incorporating much of Epirus, Macedonia, and Thrace in the north and the large islands of Samos, Chios, and Crete.

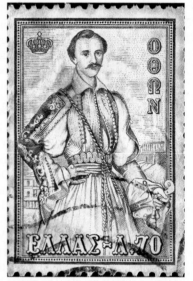

King Otto I, united Greece's first king, as pictured on a 1956 Greek stamp.

2016 Immigrants, many from Syria, arrive in vast numbers, especially on Greek islands bordering Turkey. Macedonia closes its borders, stranding thousands of immigrants in northern Greece, where camps are opened.

2018 So-called "bailouts" from the EU wind down, signaling a return to economic self-sufficiency.

2019 Tourism continues to increase, accounting for more than 25% of the Gross Domestic Product.

2020 Covid-19 pandemic brings international travel and the Greek tourism industry to a standstill.

2022 Tourism rebounds to 2019 highs, as Greece welcomes an estimated 33 million visitors. Meanwhile, the country copes with inflation, high unemployment, and other signs of a weak economy.

At the end of World War I, Greece invaded Turkey in an attempt to reclaim Constantinople and much of its former territory on the Aegean coast. Initially, the invasion went well, but the Turks, led by their future leader Mustafa Kemal (Atatürk), rallied and pushed the Greeks back to the sea. There, in 1922, in Smyrna (Izmir) and other seaside towns, the Greeks were slaughtered in what is still referred to in Greece as "The Catastrophe."

In the 1923 **Treaty of Lausanne,** the boundaries of Greece were fixed more or less as they are today, and Greece and Turkey agreed to an exchange of populations: Some 1.2 million ethnic Greeks who lived in Turkey were relocated to Greece, and about 500,000 Turks were sent from Greece to Turkey. Many spoke little or none of their ancestral language, and most were regarded with intense hostility in their new homelands.

Democracy, Prosperity & the Bailout

Whatever stability and prosperity Greece gained after the 1920s population exchange was seriously undercut by harsh German and Italian occupations during **World War II.** The famines of 1941 and 1942 were particularly severe; in Athens, carts went around the city each morning to collect the corpses of those who had died in the night. A bitter **civil war** (1944–49), between pro- and anti-communist forces, further weakened Greece. Recovery began slowly—assisted by U.S. support under the Marshall Plan—and did not take hold until well into the 1960s. In 1967, a right-wing junta of army officers, nicknamed **the Colonels,** seized power, ended the monarchy, and were themselves toppled when democracy was restored in 1974.

In 1981, Greece was accepted into the **European Economic Community** (EEC, also called the Common Market), the precursor of today's European Union. A period of initial prosperity, jump-started by EEC funding, was followed by steady inflation. The euphoria of 2004, when Greece won the European soccer championship and hosted the wildly successful **Athens Olympics,** soon fizzled. Greece, along with its EU neighbors, struggled to cope with such problems as immigration, rising prices, an increasingly fragile ecosystem, and the worldwide economic recession that began in 2008.

Greece has since seen its finances crumble in a very public and, to many Greeks, humiliating way, forcing the country to ask for help from the EU and subsequently the International Monetary Fund (IMF). Bailout packages required a slashing of government spending and extreme austerity measures. Many Greeks have had to accept these tough measures, which have caused job losses and wage and pension cuts. Unemployment is high and jobs are scarce; wages are shockingly low and the cost of living is high. Meanwhile, the migrant population has swelled, and younger people are seeking employment in other countries, much as older generations had to do after World War II. Many Greeks feel as if their country has been occupied yet again—as it was so many times in its turbulent history—this time by the EU and the IMF. Unable to devalue its currency, Greece has had to give up much of its sovereignty in order to accept bailouts, along with new, even stricter, austerity measures.

Yet there are reasons for optimism. Greece owns the largest maritime fleet in the world, and shipping and tourism account for the two biggest sectors of its economy, with tourism rebounding after the 2020–2021 Covid shutdowns. Greece has untapped oil reserves in its sea and gold in its land and could become a major player in renewable energy in the near future. Meanwhile, much as they did in antiquity, all roads in Greece lead to Athens. With its enviable location, large port, and state-of-the-art infrastructure, the capital may well be the key to leading the country back into the light.

THE ARTS IN GREECE

Architecture

Many of the buildings we know best—from football stadiums to shopping malls—have Greek origins. The simple Greek *megaron* gave birth to both the temple and the basilica, the two building forms that many civic and religious shrines still embody. The Greek temple, with its pedimental facade, lives on in government buildings, palaces, and ostentatious private homes throughout the world. Football and soccer are played in oval **stadiums,** the spectators now sitting on seats more comfortable than the stone slabs or dirt slopes they sat on in ancient Greek stadiums. Most **theaters** are now indoors, not out-doors, but the layout of stage, wings, and orchestra goes back to Greek the-aters. The prototypes of shopping malls, with their side-by-side multiplicity of shops, can be found in the agoras of almost every ancient Greek city. In fact, the mixture of shops and civic buildings, private homes, and public parks is one that most ancient Greeks knew very well.

In short, Greece was not just the "cradle of democracy," but the nursery of much of Western art and architecture. The portrait busts and statues of heroes that ornament almost every European city have their origins in ancient Greece. Both the elaborate vaulted funerary monuments and the simple stone grave markers of today can be found throughout ancient Greece.

Ancient Art

Ancient Greek art and sculpture have been major influences in the West and the East, shaping what is still considered the ideal. The gods took on perfect human form in marble **sculptures** created during the classical era, when Hel-lenic art reached its apex. Artists began carving and painting scenes on pedi-ments and friezes, and sculpture flourished around the Mediterranean.

Athletic performance was exalted then as now, and perfection of the human form in motion was achieved in sculpture with Myron's *Discus Thrower* (sur-viving in copies). The greatest sculptor of classical Greece is said to be Phi-dias, who designed the **Parthenon friezes** on the Acropolis (p. 92)—battles, legends, and processions, including serene-faced gods, representing order triumphing over chaos.

Rhodes, Corinth, and Athens each had their own styles of **pottery:** plants and animals, fantastical creatures, and humans, respectively. Black-figure pot-tery first appeared in the 7th century B.C. with humans as the subject, and

Athens produced most of it. With the 530-B.C. invention of the red-figure technique (black background, red clay), attributed to an Andokides workshop vase painter, artists were able to paint in finer detail. Athens became a center of ceramic exports by the 4th century B.C., but quality suffered with mass production, much as it has today.

Greece's artistic legacy didn't wither after the classical era. In medieval times, artists such as **Theophanes the Cretan** (died 1559) painted icons and frescoes; a number of good ones are in monasteries in Mount Athos and in Meteora (p. 155). **El Greco** (Kyriakos Theotokopoulos, 1541–1614), a student of Titian, was born in Crete, though he lived and died in Toledo, Spain. (See p. 291 for more on El Greco's Cretan legacy.)

Literature

The earliest known Greek writings are in Linear B, a Mycenaean script dating from 1500 to 1200 B.C. found on clay tablets. Some of the earliest literary works are 8th- or 9th-century-B.C. epic poems by **Homer:** the *Iliad,* on the Trojan War; and the *Odyssey,* on the journeys of Odysseus (Ulysses). Though both were passed along in oral form, both were recorded in ancient Greek, the oldest language in continuous use and the one on which the Latin alphabet is based. **Hesiod** (ca. 700 B.C.) wrote about his difficult rural life and a history of mankind, including the gods. Lyric poetry was sung in a chorus and accompanied by a lyre, also dating to about 700 B.C.

The ancient Greeks also invented drama, which told the stories of past heroes and legends in both tragedy and comedy. These performances were attended as religious festivals in honor of Dionysus. At the theater dedicated to him below the Acropolis (p. 92),

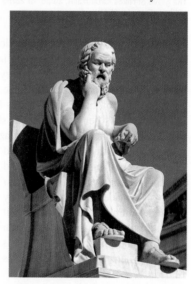

A statue of the great classical philosopher Socrates stands in front of the University of Athens.

awards for best plays were bestowed and displayed on Tripodon Street in Plaka. **Aristophanes** wrote bold comedies that sometimes poked fun at democracy.

Herodotus first wrote literary prose, while **Thucydides** meticulously researched his account of the Peloponnesian War, influencing the scholarship of later historians. In the 4th century B.C., **Socrates, Plato,** and **Aristotle** (a student at Plato's Academy) wrote treatises on logic, science, politics, ethics, government, and dramatic interpretation that have been the centerpieces of learning for millennia.

The grave of Nikos Kazantzakis, author of *Zorba the Greek* and *The Last Temptation of Christ*, in Iraklion, Crete (p. 296).

The 20th century brought international fame to two Greek masters. **Constantine Cafavy** (1863–1933), born in Alexandria, Egypt, of Greek parents, is an important figure in modern poetry. His most famous work is the beautiful "Ithaca": "When you depart for Ithaca, wish for the road to be long, full of adventure, full of knowledge." **Nikos Kazantzakis** (1883–1957) was born in Iraklion, Crete, when the island was still part of the Ottoman Empire. *Zorba the Greek* and other novels earned Kazantzakis nine Nobel Prize nominations and made him the most celebrated Greek writer of his time; *Zorba* and his novel *Last Temptation of Christ* were also made into internationally acclaimed films. Today you can visit Kazantzakis's grave in Iraklion (p. 296) and the beach at Stavros (p. 324) where *Zorba the Greek* was filmed.

Music

Greece has a long musical tradition, the word for "song" being related to ancient plays. The progression of Greek music took a different mono-phonic, rhythmic course than Western music, best represented in **Byzantine chant,** while folk and popular music has an Eastern character common to the Balkans and the former Ottoman Empire.

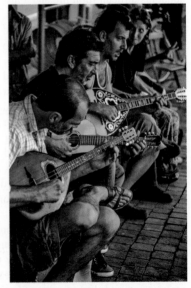

Street musicians in Athens play Greek folk music with bouzoukis and other traditional instruments.

Principal Olympian Gods & Goddesses

GREEK NAME	LATIN NAME	DESCRIPTION
Zeus	Jupiter	Son of Kronos and Rhea, high god, ruler of Olympus. Thunderous sky god, wielding bolts of lightning. Patron-enforcer of the rites of hospitality.
Hera	Juno	Daughter of Kronos and Rhea, queen of the sky. Sister and wife of Zeus. Patron of marriage.
Demeter	Ceres	Daughter of Kronos and Rhea, sister of Hera and Zeus. Giver of grain and fecundity. Goddess of the mysteries of Eleusis.
Poseidon	Neptune	Son of Kronos and Rhea, brother of Zeus and Hera. Ruler of the seas. Earth-shaking god of earthquakes.
Hestia	Vesta	Daughter of Kronos and Rhea, sister of Hera and Zeus. Guardian of the hearth fire and of the home.
Hephaestos	Vulcan	Son of Hera, lord of volcanoes and fire. Himself a smith, the patron of crafts employing fire (metalworking and pottery).
Ares	Mars	Son of Zeus and Hera. The most hated of the gods. God of war and strife.
Hermes	Mercury	Son of Zeus and an Arcadian mountain nymph. Messenger god, patron of commerce and eloquence. Guide of souls en route to the underworld.
Apollo	Phoebus	Son of Zeus and Leto. Patron of the light of day, and of the creative genius of poetry and music. The god of prophecy.
Artemis	Diana	Daughter of Zeus and Leto. Mistress of animals and of the hunt. Chaste guardian of young girls.
Athena	Minerva	Daughter of Zeus and Metis, born from the head of Zeus. Patroness of wisdom and of war. Patron of Athens.
Dionysos	Dionysus	Son of Zeus and Semele, born from the thigh of his father. God of revel, revelation, wine, and drama.
Aphrodite	Venus	Daughter of Zeus. Born from the bright sea foam off the coast of Cyprus. Patron of love.

Popular music exploded in the cities after 1923, with musicians arriving from Asia Minor following the population exchange. The hard-luck music of the refugees is called *rembetika* and has been likened to the blues, with a bouzouki player and usually a female vocalist in the ensemble, all seated in a row playing to small audiences.

Greek **folk music** is played during feasts on instruments such as the *bouzouki, oud, baglama, tambouras,* and *daouli.* Dancing is a big part of the event. There's even a type of rap *(mantinada)* on the islands of Crete and Amorgos in which performers make up the words as they sing. In towns, you might see and hear roaming street musicians playing popular tunes on the accordion, guitar, violin, and sometimes a clarinet.

THE GODS & GODDESSES

For the ancient Greeks, the world was full of divine forces, most of which were thought to be immortal. Death, sleep, love, fate, memory, laughter,

panic, rage, day, night, justice, victory—all of the timeless, elusive forces confronted by humans were named and numbered among the gods and goddesses with whom the Greeks shared their universe. To make these forces more familiar and approachable, the Greeks, especially the ancient poets, imagined their gods to be somehow like themselves. They were male and female, young and old, beautiful and deformed, gracious and withholding, lustful and virginal, sweet and fierce, and sometimes full of fun and mischief. The most powerful of the gods lived with Zeus on Mount Olympos and were known as the Olympians.

GREEK FOOD & DRINK

Greeks take what they eat, and how it is prepared, very seriously. Whereas many non-Greeks go to a restaurant in the hopes of getting something different from home cooking, in Greece it is always high praise to say that a restaurant's food is *spitiko* (homemade).

Greeks are more concerned with the quality and freshness of their food than they are with the place where it's served—a restaurant could literally be falling apart and no one would mind, as long as the meal is good. Fruits and vegetables taste strong and fresh (you will likely remember the taste of a tomato long after returning home), and portions are generous and meant to be shared. Other hallmarks of good Greek food are the generous use of pungent herbs for both flavoring food and making teas, and the generous use of olive oil.

What & When to Eat

For breakfast and as a snack, various savory pies are sold at countless holes-in-the-wall. *Tiropita* (cheese), *spanakopita* (spinach), and *bougasta* (cream/semolina) are the most common of these pies. *Koulouri* (round bread "sticks"), roasted chestnuts, and corn on the cob are sold on the street.

The midday meal is often the biggest of the day, eaten at home around 2 or 3pm after being cooked in the morning by Mama or Grandma. Students are dismissed from school around 1pm; shops and businesses close between 1:30 and 3pm. In summer, when the heat of the day is unbearable, the midday meal is followed by a siesta. Then, depending on the day, it's back to work, out for the evening stroll, and then out for dinner at 10pm. Kids and all. If you want to eat where the locals do, look for restaurants that are full at 10pm—the Greek dinner hour. Dining in Greece is not a staid affair, and it'll be boisterous.

Note that restaurants that cater to tourists are open all day or at least earlier than the usual 7pm. You'll find these in tourist centers such as Plaka in Athens, and at beach resorts.

Countless neighborhood *tavernas* (square tables, paper tablecloths, woven-seat chairs) serve simple Greek food in big portions with barrel wine. There are many other kinds of restaurants as well. *Psistaria* (grill restaurants) serve steaks and souvlaki (kebabs), and *mageiria,* or cookhouses, serve buffet-style stews with rice, pasta, meat sauce, and fish. Generally, the mageiria is the Greek equivalent of the fast-food joint, except the food is slow-cooked and

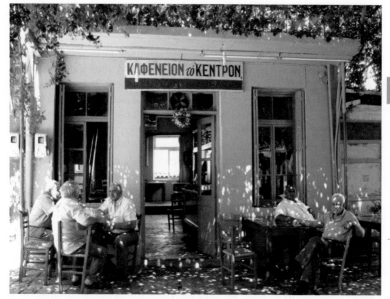

Almost every town and village in Greece has at least one *kafeneion* (coffeehouse).

kept warm; it's ready to serve when you walk in—the kind of place where you can sit down for lunch and eat by yourself. Almost every village has at least one **kafeneion** (coffeehouse), and usually two. Families, and women on their own, usually sit at tables outside. Indoors, the kafeneion is still an almost exclusively male establishment and often functions as a clubhouse. Men stop by, play a hand of cards or *tabli* (backgammon), and nurse a coffee or an ouzo for hours. *Ouzeries* specialize in small plates and appetizers, traditionally washed down with the anise-flavored liqueur ouzo. While an *ouzeri* is usually similar to a *kafeneion* (but with the emphasis more on ouzo), the food is often a bit heartier, often including grilled sausage or octopus. Greeks almost never drink without eating something, if only some chunks of feta cheese, a few olives, and perhaps some cucumber and tomato slices. This is an especially wise custom, especially when drinking fiery and potent ouzo, which turns a deceptively milky hue when diluted with water.

Menus in tourist-oriented restaurants are usually in Greek and English, but if not, just ask for help from your waiter, who is probably fluent in restaurant English. He may even take you into the kitchen to eye what's available. Often, the printed menu has little bearing on what is available; it never hurts to ask what's special that day. If you want tap water, not bottled, ask for it from the *vrisi* (tap). If you want the house wine, ask what their own wine is *(to diko sas krasi),* lest you be guided to much more expensive bottled wine.

Service is included in the bill, but it's customary to leave your waiter another 5% to 10% at a simple place, more at a fancier establishment. Greeks don't always tip in family-run places, but the wait staff, counting on seasonal

earnings, often expect a tip from foreign tourists. As anywhere, feel no obligation to tip when service is poor, but service in Greece is usually so friendly and personal that you'll want to leave something.

That said, restaurant service can be very informal, to the point of negligence. While you will often be served fairly quickly, your waitperson may well disappear after that. It may seem rude, but it's more often simply a reluctance to rush diners. Greek restaurants aren't focused on "turning" tables several times a night—you are welcome to linger as long as you wish. Even so, don't be afraid to get your server's attention to get coffee or dessert, or to ask for the bill—many restaurants won't present the bill until you ask for it.

If you go out with Greek friends, prepare to go late and stay late and to put up a losing fight for the bill. Greeks frown on bill splitting; usually, one person is host, and that is that. And, if you are invited to a Greek home for a meal, assume that everything will run hours late and that you will be offered an unimaginable amount of food. This is especially true on holidays—it's for a good reason that the week after Easter, most newspapers carry supplements on "How to Lose the Weight You Gained at Easter."

The Basics

Greeks consume more **olive oil** than any other nation (some 30 liters, or 8 gallons, per person per year) and they want that oil to be not just Greek, but from specific regions, preferably from specific groves. The olives of the Peloponnese are especially admired, with Kalamata olives prized both for oil and eating. **Cheese** is the other staple of the Greek diet. Although a slab of feta, usually sprinkled with oregano, tops most Greek salads, there's a wide variety of cheeses. Most Greek cheeses, like feta, are made from sheep or goat's milk. Creamy *mizithra* is more delicate than feta, best when eaten fresh and soft, but useful when cured and grated on pasta. *Kefalotyri* and *graviera* are popular favorites, slightly bland, but with enough tang to be interesting. A favorite cheese preparation is *saganaki,* in which graviera or another type of cheese is pan-fried then drizzled with lemon.

Fresh Greek fruit and vegetables in season are top notch and still make up a major part of the Greek diet. Casseroles are staples in home kitchens and tavernas, especially *moussaka,* ground beef and eggplant topped with bechamel, and *pastitsio,* pasta backed with beef, bechamel, and cheese. Recipes are handed down from generation to generation, and everyone's *yiayia* (grandma) makes the best. A standard Greek snack consist of olives, a chunk of bread, and a slab of cheese.

Meze

Greeks eat a lot of starters, called *mezedes* or *meze,* before the main course or on their own as a light meal. These are mostly meatless, include dips and salads, and are meant to be shared with the table. Most meals begin with a salad, usually Greek *horiatiki,* consisting of fresh tomatoes, cucumbers, olives, and onions, topped with a big slab of feta—note that lettuce is never an ingredient of a true Greek salad. Of the dips, *tzatziki* with yogurt, garlic,

and cucumber is a standard, as are fava, a purée of yellow split peas, and *taramosalata,* a puree of fish roe and onions. A selection of *krokates* (croquettes) or fritters is usually on the menu, made with zucchini or tomato, lightly fried and served with a dip. *Melitzanosalata* (eggplant salad) is another delicious vegetarian starter. Most menus include a few seafood mezes, such as marinated or grilled *ochtapodi* (octopus) or, depending on where you are, fresh-from-the-sea anchovies or sardines, usually lightly fried and eaten whole, bones and heads and all.

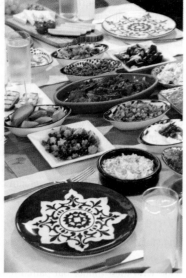
A bountiful spread of *mezedes* is the first course of a traditional Greek meal.

Meat & Fish

Greeks say "Get to the roast" when they mean "Get to the point." Meat is popular even in this nation surrounded by the sea, whether it's a *brizola* (plain cut steak) or chop, *stifado* (rabbit stew), or *lemonato* (lemon-flavored roast).

Kebabs—better known here as **souvlaki** (small spit) or **gyro** (meat shaved off a vertical rotisserie)—are Greece's go-to fast food, often served in a pita with tomatoes, onions and French fries for a quick and inexpensive meal. You'll find kebab shops wherever you travel in Greece.

Moschari yiouvetsi is chunks of beef baked with orzo pasta, onion, tomato, and wine in individual clay pots. Another baked dish is *arni kleftiko:* lamb usually cooked with cheese and herbs in a packet of wax paper. More lamb dishes are *arni psito* or *arni tou fournou,* roasted with garlic and herbs. *Katsika* (goat) is cooked in a similar way. You can also get beef *stifado,* a stew made with copious amounts of wine, rosemary, tomato, and baby onions. *Brizola hirini* (pork) comes in huge slabs, nothing like small North American chops. *Avgolemono* (egg-and-lemon sauce) also goes with pork and lamb.

Ground beef is the main ingredient for *keftedes,* a meat patty that can stand alone, "beefed up" with egg, grated onion, breadcrumbs, and spices, then coated in flour before being fried. Mixed with rice and dropped in water with an avgolemono sauce, it becomes *giouvarlakia. Biftekia* is a meat patty, not beef steak. You can also find *gemista* (ground beef mixed with rice and stuffed in large tomatoes or green peppers), *kolokithakia gemista* (stuffed zucchini/courgettes), and *papoutsakia* (meaning "little shoes," stuffed eggplant/aubergines).

As for the bounty of the sea: A *psarotaverna* is a restaurant that serves mainly fish. The fresh catch will often be displayed on ice, or the waiter will bring around a fish to show it off and display its freshness, then fillet it at the table. A good restaurant will explain exactly how your choice will be prepared—most

fish are best when grilled and sprinkled with mountain herbs. Fish is usually sold by the kilo, not the serving, so be sure to clarify the cost before ordering.

Dessert

Many Greek restaurants do not serve dessert, and Greeks often troop off after a meal to a pastry shop (the tongue-twisting *zacharopolasteion*). Recently, tavernas have started to serve a free sweet, ranging from apple slices with honey and cinnamon to ice-cream confections topped with sparklers. Delicious yogurt *(yiaourti)* is served from a traditional clay container and drizzled with honey *(meli)*. *Mustalevra,* grape must and flour, is dark, wobbly, and sweet. Baklava is flaky, thin phyllo pastry layered with walnuts and pistachios and soaked in honey syrup; variations include a candied fruit or chocolate center. *Dandourma* is an ice-cream concoction mixed with milk and cherry syrup, and *kaimaki* is a uniquely flavored ice cream (literally frozen cream).

Wine

The story of Greek wine extends back some 6,500 years. It even has a hero, Dionysus, the god of wine. In antiquity, it's believed that Greeks didn't drink wine with their dinner but paired it with fruit, nuts, and desserts. In modern times, harsh-tasting *retsina,* a strong wine infused with pine sap, was often the only choice in Greek restaurants. While one sip was often enough to put off some foreigners, retsina actually accompanies some Greek foods quite nicely. However, other excellent Greek wines are becoming widely available, from regions all over the country. Assyrtikos, most famously those from Santorini (p. 226), are flinty whites, while Agiorgitiko reds from the Nemea vineyards in the Peloponnese (p. 138) are full-bodied and highly palatable. Part of the pleasure of traveling is tasting the wines of the different regions and islands at their source, such as the sweet muscats of Samos (p. 383) and the fruity red blends on Crete (see Chapter 8). Rosés, produced mainly in the mountainous regions, can be excellent and they go well with a mix of dishes, including meze.

Don't shun the local *hima*—barrel wine sold at the corner store in 1.5-liter water bottles. Some wines can be excellent one year and less good the next, so ask at the neighborhood cava (wine shop/off-license/liquor store) for a recommendation. In tavernas, barrel wine *(krasi)* is ordered by the kilo (not liter) and brought to the table in distinctive tin jugs; most of the time, it's pretty good. In rural areas and on the islands, wine is produced (and if not bottled, then barreled) on the family plot, alongside cans of olive oil and jars of honey. It may not be great, but families have perfected their techniques over the years, and some have turned into well-respected wine estates.

Ouzo

Although many Greeks, especially Athenians, now prefer whiskey and other spirits, the national distilled drink is still this clear, licorice-flavored liqueur that turns cloudy when you add water, though you can also drink it neat. Ouzo is made from fermented grape skins, mixed with star anise and other herbs, boiled

in a still, and stored for a few months before being diluted to 80 proof/40% alcohol. Drink too much and you'll get a killer headache; one or two glasses is enough. It's usually consumed with appetizers and seafood (hence, *ouzeries*), on islands and by the seaside. It was traditionally the drink of fishermen and at *kafenia* (coffee shops), where you still find older men sitting around drinking ouzo as they talk and play cards or backgammon.

Crete's version, **raki** (lion's milk), also Turkey's national drink, isn't flavored with anise and is more like Italian grappa. It's called *tsipouro* in other regions of the country. You can get smooth *rako-melo* (raki and honey, a surefire cure for a cold or sore throat) on some of the islands.

Licorice-flavored ouzo, Greek's national distilled drink, turns a cloudy white when mixed with water. Drink too much and you'll get a killer headache.

Beer

Yes, Greece does have a beer culture, maybe not as exuberant as that of Germany, Belgium, or England, but national brands **Mythos, Alfa,** and **Fix** are widely available. Microbreweries are appearing everywhere, and you're likely to come across local beers in your travels. Look for **Volkan** on Santorini, **Nissos** on Tinos, **Solo** and **Brink's** on Crete, **Magnus** on Rhodes, and **Skopelos** and **Chios** at their namesake sources. **Corfu Beer** is the largest brewery on Corfu. **Zeos** and **Sparta** are brewed in the Peloponnese.

WHEN TO GO

Just about everyone agrees that the best time to visit is Greece is spring and early summer (mid-Apr to mid-June) or autumn (Sept to mid-Oct). At these times you'll avoid the summer high season, with its high heat, high prices, and big crowds. These drawbacks loom especially large if you plan a high-season visit to the more popular islands, Mykonos and Santorini first and foremost among them. In the spring, you'll see more wildflowers than you could have imagined—and swim in a sea that's a bit cool but more pleasant than you'd hoped for. In the autumn, you will enjoy golden days with still-warm waters.

Of course, there are a few considerations to keep in mind outside of high season. Off-season there are fewer boats and flights to the islands, and several island shops, hotels, and restaurants do not open until June and then close in October. During the off-season life comes to a standstill on many islands, or at least turns its back to tourism, and wintertime rains can dampen any romantic notions of lonely wandering in empty landscapes.

During **Easter week,** nearly every hotel room outside of Athens is booked well in advance by city Greeks who head to the country to celebrate Greece's most important holiday. Many sites and museums are closed Good Friday, Easter Saturday, and Easter Sunday, while many shops close on Good Friday and Easter Saturday. (See "Holidays," below).

Weather

Winters can be chilly, with bursts of warm weather giving way to cold spells (sometimes it even snows in Athens). Many buildings are not insulated, and the centrally controlled heating is often intermittent, making the cold season seem very long indeed. Summers are just plain hot (and usually dry), sometimes reaching 110°F (43°C) in the midday sun, hence the siesta between 3 and 6pm. The seasonal north (Etesian) winds blow mid-July to mid-August, but it can get very windy anytime, stopping ferry transport. Our temperature chart for Athens reflects some reliable statistics (note that this is the *average* daily temperature, not the daytime high), but don't be surprised if you find deviations from it when you visit Greece. Our figures for Crete are based on Iraklion's temperature/precipitation.

Average Monthly Temperatures & Precipitation

		JAN	FEB	MAR	APR	MAY	JUNE	JULY	AUG	SEPT	OCT	NOV	DEC
ATHENS	TEMP °F	50	50	54	59	67	75	81	81	75	67	59	53
	TEMP °C	10	10	12	15	19	23	27	27	23	19	15	11
	PRECIP. (in.)	1.9	1.6	1.6	.9	.7	.3	.2	.3	.4	2.1	2.2	2.4
CRETE	TEMP °F	54	55	57	61	68	73	79	77	73	68	63	57
	TEMP °C	12	13	14	16	20	23	26	25	23	20	17	14
	PRECIP. (in.)	3.5	2.7	2.3	1.1	.6	.1	.1	0	.7	2.6	2.3	3.1

Holidays

In addition to the following holidays, every day in Greece is sacred to one or more saints. That means that every day, at least one saint (and everyone named for that saint) is celebrated. Many towns and villages also celebrate the feast days of their patron saints. Tiny chapels that are used only once a year are opened for a church service followed by all-day wining and dining. If you're lucky, you'll stumble on one of these celebrations. Official holidays in Greece are New Year's Day, January 1; Epiphany, January 6; Independence Day, March 25; Orthodox Good Friday; Orthodox Easter Monday; Labor Day, May 1; Orthodox Whit Monday (descent of the Holy Spirit, 50 days after Easter); Assumption, August 15; Ochi Day, October 28 (celebrates Hellenic counterattack again Italian forces in 1940); Christmas Day, December 25; Boxing Day, December 26.

Calendar of Events

Feast of St. Basil *(Ayios Vassilios).* St. Basil is the Greek equivalent of Santa Claus. The holiday is marked by the exchange of gifts and a special cake, *vassilopita,* made with a coin in it; the person who gets the piece with the coin will have good luck. January 1.

Epiphany (Baptism of Christ). Baptismal fonts and water are blessed. A priest may

ORTHODOX EASTER & holy week

The Greek calendar revolves around religious holidays. The biggest is **Orthodox Easter** (*Pascha*)—usually a week later than Western Easter, and the only holiday calculated according to the Julian calendar. Most of the native population—97% of whom are Greek Orthodox—observe the traditions. Most people who did not fast for the 40 days of Lent begin fasting during Holy Week, which starts on the Monday before Easter. On **Holy Tuesday,** devotees whitewash their houses and walkways. On **Wednesday,** they bring holy oil home from church and use it, along with sprigs of basil, to bless the households. On **Holy Thursday,** they receive Communion, and priests in special dress read biblical accounts of the Last Supper during an all-night vigil. At home, followers boil eggs and dye them red to symbolize the blood of Christ and rebirth. Many also bake Easter bread (*tsoureki*) and biscuits (*koulourakia*). Church bells solemnly toll on **Good Friday,** and at around 8pm, a candlelit procession through the parish accompanies a decorated funeral bier (*epitaphios*) of Christ. On **Saturday,** most people go to their neighborhood church just before midnight with candles (*lambades*); the children carry lavishly decorated ones, often received as gifts from their godparents. The lights of the church are dimmed at midnight, symbolizing Christ's death. The priest then brings out a holy flame, brought from Jerusalem, and passes it to church members, who light one another's candles while saying "*Christos anesti*" ("Christ is risen"). Youths light fireworks, and congregants return home with their lit candles and bless their homes by "drawing" a cross on the doorframe with the candle's smoke. On **Easter Sunday,** they break the Lenten fast by cracking the eggs and eating *mageritsa* soup, made with dill, rice, *avgolemono* (egg-lemon) sauce, and the innards of the lamb roasting for dinner. Easter Sunday brings feasting, drinking, and dancing, as the smell of lamb permeates the air from roof-terrace spit-roasts. At church, passages on the Resurrection are read in many languages, symbolizing world unity. **Easter Monday** is a national holiday.

throw a cross into the harbor and young men will try to recover it; the finder wins a special blessing. Children, who have been kept good during Christmas with threats of the *kalikantzari* (goblins), are allowed to help chase them away. January 6.

FEBRUARY

Carnival (*Karnavali*). Be ready for parades, marching bands, costumes, drinking, dancing, and general loosening of inhibitions, depending on the locale. On the island of Skyros, the pagan "goat dance" is performed, reminding us of the primitive Dionysiac nature of the festivities. Crete has its own colorful versions, whereas in Athens, people bop each other on their heads with plastic hammers. Celebrations last for 3 weeks up to the beginning of Lent.

MARCH

Independence Day & Feast of the Annunciation. These two holidays are celebrated simultaneously with military parades, especially in Athens. The religious celebration is particularly important on the island of Hydra and in churches or monasteries named Evangelismos (Bringer of Good News) or Evangelistria (the feminine form of the name). March 25.

APRIL

Feast of St. George (*Ayios Yioryios*). The feast day of the patron saint of shepherds is an important rural celebration with dancing and feasting. Arachova, near Delphi, is famous for its festivities. The island of Skyros also gives its patron saint a big party. April 23, or if the 23rd falls before Easter, the Mon after Easter.

MAY

May Day. On this generally urban holiday, still celebrated by Greek communists and socialists, families have picnics in the country and pick wildflowers, which are woven into wreaths and hung from balconies and over doorways. May 1.

Feast of St. Constantine (*Agios Konstandinos*). The first Orthodox emperor, Constantine, and his mother, **St. Helen (*Agia Eleni*),** are honored. It's a big party night for everyone named Costa and Eleni. (Name days, rather than birthdays, are celebrated in Greece.)

JUNE

Athens Epidaurus Festival. Featured are superb productions of ancient drama, opera, orchestra performances, ballet, modern dance, and popular entertainers. The festival takes place in the handsome Odeum of Herodes Atticus, on the southwest side of the Acropolis, and at the 4th-century B.C. theater of Epidaurus in the city of the same name. aefestival.gr. June to early October.

Miaoulia. This celebration on Hydra honors Hydriot Admiral Miaoulis, who set much of the Turkish fleet on fire by ramming it with explosives-filled fireboats. www.hydra. gr. Late June.

International Classical Musical Festival. Concerts are staged throughout Nafplion, in the Peloponnese. www.nafplionfestival.gr/ en. Late June/early July.

Midsummer Eve. Dried wreaths of flowers picked on May Day are burned to drive away witches, in a version of pagan ceremonies now associated with the birth of John the Baptist. June 23 to June 24.

Navy Week. Celebrations takes place throughout Greece. In Volos, the voyage of the Argonauts is reenacted. On Hydra, the exploits of Adm. Andreas Miaoulis, naval hero of the War of Independence, are celebrated. End of June/early July.

JULY

Bourtzi Festival. In the harbor of Skiathos town, the Bourtzi cultural center presents ancient drama, modern dance, folk music and folk dance, concerts, and art exhibits. Mid- to late July.

Feast of Ayia Marina. The feast of the protector of crops is widely celebrated in rural areas. July 17.

Feast of the Prophet Elijah (*Profitis Elias*). The prophet's feast day is celebrated in the hilltop shrines formerly sacred to the sun god Helios. July 20.

Psimeni Raki Festival. The Cycladic island of Amorgos is famous for making this drink that infuses *tsipouro* with honey and herbs, and tastings inspire a night of revelry. amorgos.gr. July 28.

Syros International Film Festival. Outdoor spaces around the island become open-air cinemas where Greek and international works are screened. syrosfilmfestival.org. End of July.

AUGUST

Feast of the Transfiguration (*Metamorphosis*). This feast day is observed in numerous churches and monasteries of that name. August 6.

Aeschylia Festival of Ancient Drama. Classical dramas are staged at the archaeological site of Eleusis, home of the ancient Mysteries and birthplace of Aeschylus, west of Athens. August to mid-September.

Renaissance Festival. Rethymnon, Crete, stages medieval plays and musical performances. www.rfr.gr. Late August to early September.

SEPTEMBER

Dionysia Wine Festival. This is not a major event, but it's fun if you happen to find yourself on the island of Naxos. First weekend in September.

Santorini International Music Festival. Musicians present concerts around the island, from classical to flamenco. First 3 weeks of September.

Anniversary of the Battle of the Straits of Spetses. The island celebrates with a reenactment in the harbor, fireworks, and an all-night bash. Weekend closest to September 8.

Aegina Fistiki Festival. The island of Aegina celebrates its famous nut, the pistachio, with visual arts tours, contests, and concerts. www.aeginagreece.com. Mid-September.

AnimaSyros. Animators from around the world converge on Syros for workshops, exhibitions, and screenings. animasyros.gr. Late September.

Ochi Day. General Metaxa's negative reply (*ochi* is Greek for "no") to Mussolini's demands in 1940 is the occasion for a feast-day party with patriotic outpourings, including parades, folk music and folk dancing. October 28.

Feast of the Archangels Gabriel and Michael (Gavriel and Mihail). Ceremonies are held in the many churches named for the two archangels. November 8.

Feast of St. Nikolaos (Ayios Nikolaos). This St. Nick is the patron saint of sailors. Numerous processions head down to the sea and to the many chapels dedicated to him. December 6.

Christmas. The day after Christmas honors the Gathering Around the Holy Family *(Synaksis tis Panayias)*. December 25 and 26.

New Year's Eve. Children sing Christmas carols *(kalanda)* outdoors while their elders play cards, talk, smoke, eat, and imbibe. December 31.

SUGGESTED GREECE ITINERARIES

3

Whether you are looking for the perfect beach, setting your sights on classical wonders, or following in the footsteps of pilgrims to holy places, you'll be amazed by the wealth of sights and experiences awaiting you in Greece. To help you get the most out of your travels, here are some suggestions for planning your trip. Keep in mind that traveling in Greece can be unpredictable at times, and high winds, strikes, and inconvenient schedule changes can thwart the best-laid plans. So, be flexible, and also be prepared for many good meals and warm welcomes along the way. These routes are geared to summer travel, when it's much easier to move from island to island than it is off season. And now, as you set off for Greece, *Kalo taxidi!* (Have a good trip!)

THE BEST OF ANCIENT GREECE

Athens whisks travelers across the centuries to the glories of ancient Greece, and that magic will keep working as you explore a wealth of classical sites across the mainland and on the islands.

Days 1–2: Athens ★★★

Set an unhurried pace this first day. Summer hours keep most monuments and museum open late, plus sights in the sprawling capital are fairly concentrated. If you plan to see a number of Athens's classical sites, you can score significant savings by purchasing the **Acropolis combination ticket** for 30€ (see p. 89), which includes admission to the Acropolis, Theater of Dionysus, Temple of Olympian Zeus, the Ancient Agora, the Roman Forum, the Library of Hadrian, and Kerameikos Cemetery. You can buy the ticket at any of the sites.

The **Acropolis** (p. 92) is probably within walking distance of your hotel, maybe even within sight of it. The ascent through the **Beule Gate** and up a well-worn path is stirring,

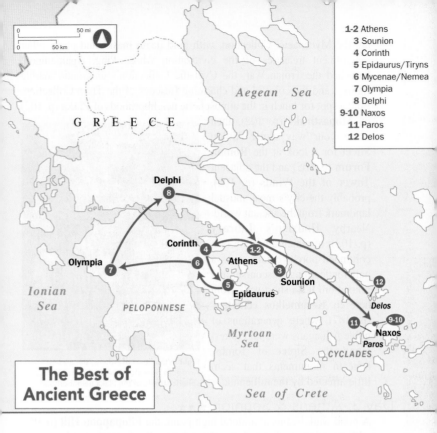

1-2 Athens
3 Sounion
4 Corinth
5 Epidaurus/Tiryns
6 Mycenae/Nemea
7 Olympia
8 Delphi
9-10 Naxos
11 Paros
12 Delos

Aegean Sea

GREECE

Delphi
8

Corinth
4
1-2
Olympia
7
6
Athens
3
Sounion
5
Epidaurus

Ionian
Sea

PELOPONNESE

12

Delos

11
9-10
Naxos
Paros

Myrtoan
Sea

CYCLADES

The Best of Ancient Greece

Sea of Crete

and the ruins of the perfectly proportioned Parthenon and surrounding temples summon up the glory of classical Greece. Next stop is the **Acropolis Museum** (p. 93), where sculptures and statuary that once adorned the Acropolis temples include a section of the magnificent Parthenon Frieze. Then stroll along the **Grand Promenade** (p. 96), a cobblestone-and-marble, pedestrian-only boulevard that skirts the Acropolis Hill. You'll get a glimpse of the **Theater of Dionysus** (p. 99), where the dramas of Aeschylus, Sophocles, and Euripides once delighted audiences. Plunge back into the present day by following **Adrianou (Hadrian) Street** through the colorful **Plaka** neighborhood (p. 102). End your day by strolling around the evocative remains of the **Ancient Agora** (p. 103), once the business and political hub of ancient Athens, with the beautifully preserved **Temple of Hephaestus** rising above the ruins. Then it's time for dinner, maybe at one of the many outdoor tavernas in the nearby **Psyrri** district.

Begin your second day in Athens with a mid-morning visit to the **National Archaeological Museum** (p. 110), with the world's finest collection of Greek antiquities. (Depending on where you're staying, you may want to walk at least part of the way there, best up Athinas St. for a stop at the lively, colorful **Central Market,** p. 108.) Essential galleries

are the Mycenaean Collection, with gold death masks and many other magnificent treasures of the civilization whose king, Agamemnon, launched the Trojan War; the Cycladic Collection's enigmatic marble figures; and the colorful and charming frescoes of the Thira Collection. Find a spot for lunch in the atmospheric neighborhoods of **Plaka** (p. 102)

Right in the heart of Athens, the ancient Acropolis rises into view above the atmospheric streets of the Plaka neighborhood.

or **Monastiraki** (p. 102), then make your way along Aiolou Street for a look at the **Roman Forum** (p. 105) and the adjacent **Tower of the Winds** (p. 106), probably the city's most unusual landmark from the ancient world. Nearby **Hadrian's Library** (p. 103), of which a portion of a columned porch remains, was a hall for learning, discourse, and relaxation. It's a short walk from here to **Kerameikos cemetery** (p. 107), where generations of noble Athenians were laid to rest along the Street of Tombs, beneath monuments that seem little affected by the millennia.

Day 3: Athens & Sounion ★★★

A good walk begins at a literal high point, the **Filopappou Hill** (p. 95), with stunning eye-level views of the Acropolis. From there it's an easy stroll down pedestrian-only **Dionysiou Areopagitou** to the beautifully preserved **Hadrian's Arch** (p. 96), erected in honor of the emperor in A.D. 131. Just beyond is another monument Hadrian bestowed upon Athens, the **Temple of Olympian Zeus** (p. 98), the largest ancient temple in Greece, with 15 of its 104 columns still in place. From there a street skirts the **Zappeion Garden** to the formidable **Panathenian Stadium** (p. 98), reconstructed from the ruins of an arena built around 330 B.C. to host the first modern Olympic Games in 1896. End your day with a sunset trip out to the magnificent **Temple of Poseidon at Sounion** (p. 118), commanding a bluff at the southernmost tip of Attica. Ancient sailors rejoiced at first sight of the landmark, a sign they were nearing home, and sentinels kept watch here for approaching warships during the Peloponnesian Wars. Many tour companies in Athens offer sunset bus trips to Sounion, a much quicker way to get there than public transportation.

Days 4–6: Nafplion ★★★ & the Ancient Sites

The easiest way to explore the ancient sites of the Northern Peloponnese is by car, and if you pick one up at the Athens airport you'll have easy access to the toll road heading east across the **Isthmus of Corinth**

(p. 136), the narrow neck of land that connects the Peloponnese to the rest of mainland Greece. As you cross the **Corinth Canal** (p. 136), built in the 1890s, reflect upon how ships formerly had to sail an extra 400km (240 miles) around the Peloponnese to reach Athens. From the canal it's another 13km (8 miles) east to **Ancient Corinth** (p. 138), the ruins of a powerful Greek and Roman city that once rivaled Athens in wealth. Long before you reach the site, the **Acrocorinth** (p. 137), one of the world's most remarkable fortresses, looms into view high atop a barren mountain. End the visit with a drive up to the Acrocorinth, with its three rings of massive fortifications and mountaintop views that sweep across the sea to the east and west.

It's another 55km (33 miles) to **Nafplion** (p. 141), where you'll settle in for the next 3 nights. Nafplion's intriguing Old Town is crowded onto a narrow peninsula that juts into the Bay of Argos, surrounding marble-paved **Syntagma Square.** High above the city (reached via 999 steps cut into the cliff face) are the fortifications of the **Acronafplia,** the southeastern heights which have defended the city for some 5,000 years. The massive walls of the Venetian **Palamidi Fortress** also ramble across a bluff above the sea and the city. Back at sea level, a pine-scented promenade leads to **Arvanitia,** the town beach.

Day 5: Epidarus ★★★ & Tiryns ★

It's a half-hour drive, about 27km (16 miles), east from Nafplion to **Epidarus** (p. 144), site of one of the best-preserved classical Greek theaters in the world. The acoustics are so perfect that a whisper onstage can be heard at the top of the 55 tiers, as someone among your fellow visitors will no doubt demonstrate. The adjoining **Sanctuary of Asklepius at Epidaurus** was one of the most famous healing centers in the Greek world, dedicated to Asklepius, son of Apollo and god of medicine. One of the sanctuary's preferred treatments involved serpents flicking their tongues over an afflicted body part.

In the afternoon, make the short drive (5km/3 miles) from Nafplion out to **Ancient Tiryns** (p. 144), surrounded by a wall of massive stones—some weighing as much as 15 tons—that exude such force that the writer Henry Miller observed that the ruined city "smells of cruelty, barbarism, suspicion, isolation."

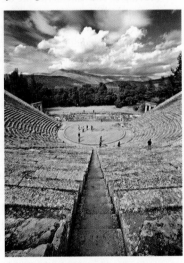

Fifty-five rows back, you can still hear every word spoken on stage at the theater of Epidaurus.

Day 6: Ancient Mycenae ★★★ & Nemea ★★

It's a pretty drive of 23km (14 miles) north from Nafplion through farm-lands and vineyards to **Ancient Mycenae** (p. 139). Still-massive fortifi-cations, the magnificent **Lion Gate,** and sprawling ruins tucked beneath massive cliffs suggest the might of what was once the greatest city in the western world, dominating much of the southern Mediterranean from around 1500 B.C. to 1100 B.C. This is where King Agamemnon launched the Trojan War, and craftsmen created the gold masks and other treasures on display at the National Archeological Museum in Athens (p. 110).

Ancient Nemea (p. 138), another 23km (14 miles) north, is gently folded into the foothills of the Arcadian Mountains and surrounded by the famed Nemean vineyards. The once powerful city was known throughout the ancient world for the Nemean Games, held every 2 years. The 4th-century-B.C. stadium is still largely intact, and a vaulted tunnel that leads from a dressing room to the field is one of the great marvels of ancient engineering. The drive back to Nafplion takes under an hour.

Day 7: Olympia ★★★

Pack up the car and set off for **Olympia** (p. 147), site of the original Olympic Games. The drive is less than 3 hours, so you should have plenty of time to visit the ruins and museums in the afternoon (the site and museum are open to 8pm for much of the summer, and to 7:30 and 7 in early and late Sept). Remains of the stadium, gymnasium, training hall, and dormitories richly evoke the city's famous ancient games, inau-gurated in 776 B.C. Olympia was also a sacred place, a sanctuary founded around the 10th century B.C. to honor Zeus and his wife, Hera, and ruins of temples and sanctuaries are dotted around the mountainside site. These ancient landmarks come to life through virtual reality glasses available from the in-town office of **Olympia Back in Time.** In the archaeological museum the standout is the gleaming white marble *Hermes Carrying the Infant Dionysus,* possibly by Praxitelis, the greatest of all ancient sculp-tors. The small **Hotel Pelops** (p. 135) is a delightful place to stay right in town; guests can use the pool at the **Europa Best Western** (p. 135), so you might be able to get in a swim after visiting the ruins and enjoy a drink or dinner in the Europa's garden taverna.

Day 8: Delphi & the Sanctuary of Apollo ★★★

It's about 3 hours from Olympia to your next stop, Galaxidi. Follow the highway north and east past Patras to Rio, where a dramatic bridge crosses the Gulf of Corinth; the crossing is followed by more scenic coastline as you head east along the Gulf of Corinth. Your stop for the night is the handsome old port town of **Galaxidi** (p. 150), on the gulf shores below Delphi. Settle into the **Hotel Ganimede** (p. 151), occupy-ing an old sea-captain's mansion with a garden. You can walk from there to the town beaches and your choice of waterside tavernas.

Get an early start in the morning and head 35km (22 miles) northeast up the mountainside to Delphi. No other ancient site is quite as mysterious and alluring as the **Sanctuary of Apollo** (p. 181)—you may well feel a tingle in your spine as you climb the Sacred Way to the Temple of Apollo, where priestesses once received cryptic messages from the god.

Allow about 2½ hours for the drive from Delphi to the Athens airport, where you can leave your rental car. It's a half-hour bus ride or 20-minute taxi trip from the airport the port at Rafina, where you can catch the late afternoon boat to Naxos. If you left Delphi about noon, you should have plenty of time; if not, spend the night in or around Rafina and take one of several morning boats to Naxos.

Days 9–10: Naxos ★★

Settle into **Naxos Town** (p. 193). The **Chateau Zevgoli,** just below the Venetian Kastro, is one of most atmospheric hotels in the Greek isles, while the **Studios Kalergis** puts you right on the sands at Agios Yeorgios beach at the edge of town. You can get by without a car on Naxos, because an excellent bus network connects Naxos Town with many villages and beaches. The bus company also runs a daily summertime tour that's a good introduction to the island. A couple of days gives you time to explore and enjoy the appealing mountain valleys, long stretches of sand, and some impressive vestiges of antiquity. The most noticeable is the **Portara,** an unfinished marble doorway on the islet of Palatia at the northern end of Naxos Town harbor, providing a dramatic backdrop for an approach to the island by sea. According to myth, the god Dionysus built this for Ariadne, the jilted daughter of King Minos of Crete, but it was probably part of a temple begun and abandoned in the 6th century B.C. Another 6th-century B.C. remnant is a *kouros,* a huge marble statue of a beautiful youth, lying in the garden of an estate in **Melanes** outside Naxos Town; you'll come upon another kouros on a hillside above the little port **Apollonas** on the north coast. To the south, near **Sangri,** some columns and walls of a **Temple of Demeter,** goddess of grain, still stand amid fertile fields. A long string of sandy beaches lines the southwest coast.

Day 11: Paros ★★

The short, 45-minute crossing from Naxos to **Paros** (p. 197) introduces you to a wonderful piece of ancient art. **The Parian Chronicle,** intricately carved in marble that slaves quarried on the island, depicts the march of Alexander the Great and other ancient events. The frieze is in the archaeological museum in **Parikia,** the island's main port, next to the extraordinary **Panagia Ekatontopylani** (Church of the Hundred Doors), founded in the 4th century, rebuilt in the 6th century, and one of the oldest churches in the world. Inside the vast interior is a forest of columns of the famous Parian marble, the same marble that was fashioned into the *Venus de Milo.* You will encounter an enchanting jumble of bits and bobs in the

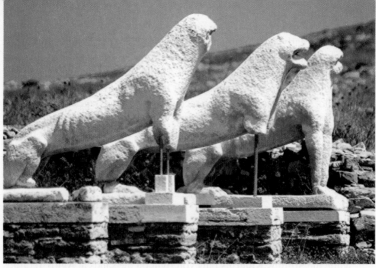

On the sacred isle of Delos, three stone lions seem ready to spring to life.

Kastro, the seaside fortress the Venetians cobbled together in the early 13th century using marble fragments of ancient temples. Boats run back and forth between the two islands throughout the day, so before returning to Naxos you should have time to make a cross-island trip by bus out to the charming port town of **Naoussa.**

Day 12: Delos ★★★

You have a couple of ways to visit **Delos** (p. 179) from Naxos. Tour companies run day trips that depart in the morning for a visit to the ancient site, usually with a stop for some time on Mykonos. If those schedules aren't convenient, you can take the boat to Mykonos (less than an hour away on fast boats) and ferry over to Delos from there. In ancient times this little outcropping was the most famous island in Greece—birthplace of Apollo, a sacred religious sanctuary, a flourishing trade center, and headquarters of the Delian League, the confederation of Greek city-states. As you step ashore and see such famed antiquities as the **Terrace of the Lions,** it soon becomes clear what a monumental role Delos played in the life of ancient Greece. You will probably arrive back in Naxos in time for an early evening boat to Athens.

HOLY PLACES

From the otherworldly landscapes of the Meteora to a humble cave on Patmos, here is an introduction to some of Greece's most holy places. Chances are that you'll set off on this itinerary from Athens, and no matter how long you stay in the city, it's only fitting to launch a tour of pilgrimage sites with a trip to the **Acropolis** (p. 92), sacred to the ancients, focus of festivals and processions, and still stirring pride in all Greek hearts. Beneath the hilltop ruins in the **Acropolis Museum** (p. 93), the Parthenon frieze that once ornamented the

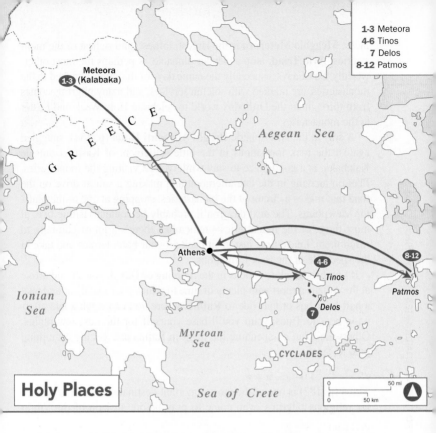

Holy Places

temple is a remarkably animated marble tableau of maidens, priests, soldiers, worshippers, and oxen making their way to the Acropolis to honor the goddess Athena.

Days 1–3: The Meteora ★★★

At the edge of the Plain of Thessaly, the enormous, rounded rock spires of the **Meteora** (p. 153) rise to just a little under 300m (1,000 ft.) and are all the more spectacular because many are topped by gravity-defying monasteries. Tour agencies in Athens offer 1- and 2-day trips to the Meteora, and it's fairly easy to get there independently by train or bus, but it's much more convenient to rent a car. The drive from Athens to **Kalabaka,** the town at the base of the peaks, takes about 4 hours, most of it on the E75 toll road.

Monks began building the monasteries on these peaks in the 9th century, and by the end of the 14th century, the pinnacles were topped with 24 monasteries, providing protection from Turkish persecution, proximity to the heavens, and isolation in which to commune with God. Six are still inhabited, each by just a few nuns and monks, who welcome visitors who make the climb, often via hundreds of steps carved into the rock

49

faces. **Meggoio Meteroro** is the largest, loftiest, and richest of the monasteries; **Ayia Triad,** atop a slender pinnacle, is perhaps the most otherworldly. Feast days, especially the name days of the saints attached to the monasteries, are marked with solemn services, and many pilgrims comes from throughout the Orthodox world to celebrate Holy Week and Easter at the monasteries.

A stay at the atmospheric **Pyrgos Adrachti Hotel** (p. 154), snuggled against the rock formations in the little settlement of Kastraki outside Kalabaka, is a good place to stay while you're visiting the monasteries. Plan on arriving in the late afternoon and making a sunset drive on the road that makes a circuit of the monasteries, stopping at one of the blufftop viewpoints. The next day you'll probably be content visiting two, at most three, of the monasteries—remember, there's a lot of climbing to reach them. Leave time just to sit back on your hotel terrace and take in the spectacle of the rock formations.

If you head back to Athens in the morning of **Day 3,** you should arrive at the Athens airport with plenty of time to return your rental car and take a half-hour bus or taxi ride to **Rafina,** where you can catch a late afternoon boat to Tinos, were you'll base yourself for the next few nights. Otherwise, plan on spending the night in Rafina and getting a morning boat to Tinos.

Days 4–6: Tinos ★★★

Tinos (p. 182) is one of the most important destinations in all of Greece for religious pilgrims, who come to pray before an icon of the Virgin

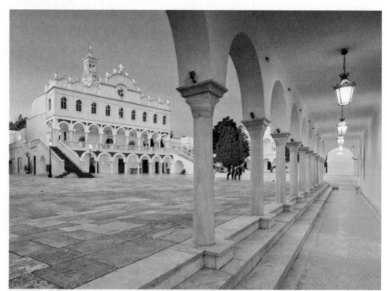

The Panagia Evangelistria church on the Cycladic island of Tinos is considered the "Lourdes of Greece" for the miraculous powers of its icon of the Virgin Mary.

Mary. They arrive in droves on August 15, the Feast of the Dormition of the Virgin Mary, when it takes a miracle to land a hotel reservation and the quiet island is overrun. At just about any other time, however, a stop here gives you a chance not just to experience this major pilgrimage site but also to enjoy one of the most beautiful and appealing islands in the Cyclades. See p. 183 for some suggested island hotels. On **Day 4,** set off to see the icon at the **Panagia Evangelistria** (Our Lady of Good Tidings), commanding a hillside overlooking Tinos Town. Many pilgrims crawl on their hands and knees up **Megalocharis,** the long, steep main street, one side of which is carpeted to protect the knees of the faithful. An alternate route is on colorful pedestrian-only **Evangelistria,** lined with stalls selling holy water, incense, candles, and mass-produced icons, also leads up to the church. Inside the church, hundreds of gold and silver hanging lamps illuminate the icon of the Virgin, said to work miraculous cures and bring good health. According to the story, in 1882 a local nun named Pelagia repeatedly dreamt that the Virgin appeared to her and told her where to find the icon, which was soon unearthed right here. Tinians built this beautiful landmark to house the icon with marble from the island and nearby Paros.

On **Day 5,** take a 1-day overview tour of Tinos, offered by the island's bus company, which stops at several villages and the 10th-century **Convent of Kechrovouniou** (also known as the Monastery of Kurias Angellon/Our Lady of the Angels). This villagelike compound was the home of Pelagia, the nun whose vision revealed the location of the island's famed icon. On **Day 6,** rent a car to explore more of the island's beautiful white villages. The largest, **Pyrgos,** is famous for its marble, shown off in the **Museum of Marble Crafts. Panormos,** on a bay on the coast below, is fringed with sandy beaches, so you can spend some time enjoying the sun and sea.

Day 7: Day Trip to Delos ★★★

Tour agencies in Tinos offer summertime day trips to Delos, or you can take the boat to Mykonos and a ferry to Delos from there. No one stays on **Delos** (p. 179), just as no one was allowed to be born, to die, or to be buried one of ancient Greece's most sacred religious sanctuaries. In myth, Delos is the birthplace of Apollo, and the island grew to be the center of an Apollo cult. Pilgrims once made their way from the harbor to the **Sanctuary of Apollo** along the Sacred Way, it's awe-inspiring to follow in their footsteps past the ruins of columned porticos and the snarling stone beasts on the **Terrace of the Lions.**

Day 8: Tinos to Patmos

There's no direct ferry from Tinos to your next stop, Patmos, where you'll spend the last few nights of your journey. Any trip will include a change in Piraeus or on Syros or another island; the easiest way (most direct with shorter transfer times) is usually to take a mid-afternoon ferry

to Piraeus and switch there for an overnight boat to Patmos, with arrival the next morning.

Days 9–12: Patmos

St. John the Divine (aka the Theologian) arrived on **Patmos** (p. 273) in A.D. 95 and spent several years dwelling in a cave and composing the Book of Revelation. From that time on, the island has been regarded as hallowed ground and a place of pilgrimage. The spiritual highpoint of your visit might be sitting on a stool in the **Cave of the Apocalypse,** near the stone that served as John's pillow. The fortresses-like **Monastery of St. John the Theologian,** established a millennia ago, dominates the heights of Hora and was a great center of learning through many turbulent centuries. One of the many footpaths that crisscross Patmos connects the monastery with the Cave of the Apocalypse on the hillside below, and the downhill walk, with sea views and fresh island air fragrant with herbs, is as easy as it is transporting.

While John is still a powerful presence on the island and continues to attract the faithful by the boatload, Patmos is also a cosmopolitan retreat popular with well-to-do Athenians and foreigners. A stay at the **Petra Hotel,** above **Grikos Bay,** adds a great deal of luxury and island style to a visit, any there are many nice guest houses in Skala and outlying villages. A good bus network serves many towns and beaches, and sooner or later you should find your way to **Psili Ammos,** a beautiful and isolated stretch of sand shaded by cedar trees, reached by a 30-minute hike from the little settlement of Diakofti, or by one of the boats that make beach runs from Skala. Ferries make the overnight trip back to Piraeus, but they don't operate every night, so check schedules carefully. An alternative is to take a boat to nearby Kos and fly to Athens from there.

SUN & SCENERY

Then there is the other side to Greece—the side that appeals to beach lovers who want to spend their time in the sun amid some of Greece's most stunning scenery. On this tour, we'll visit a range of stunning beaches on three very different Greek islands.

Days 1–3: Hydra

A dearth of beaches doesn't detract from the appeal of **Hydra** (p. 162) as an island getaway, only about 1½ hours from Athens. Handsome stone *archontika* (mansions) of honey-colored stone overlook the harbor and are set against rugged landscapes, giving Hydra its distinctive, almost otherworldly character. One of these old houses, on a shady back lane, is now the **Hotel Phedra,** with beautifully furnished rooms and pretty terraces. Another delightful feature of Hydra is that it is car-free, making walking a delight—especially along the waterside paths that lead to at

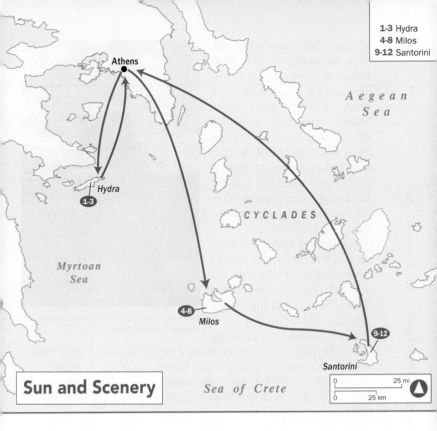

1-3 Hydra
4-8 Milos
9-12 Santorini

Spilla and **Kaminia** beaches for swimming in the warm, clean Aegean waters. On one of your days on the island, venture a little farther afield by taking a water taxi from the harbor to the pine-lined coves of **Molos, Palamida,** and **Bisti,** which are a little sandier (rugged Hydra is not the place for soft white sand). Or take an excursion boat from the harbor to **Ayios Nikolaos,** a pebble beach on the south coast with sun beds and refreshment concessions.

Days 4–8: Milos

Take a late-morning boat back to Piraeus, where you can catch an afternoon boat that will get you to **Milos** (p. 232) in the evening. Convenient places to base yourself are Adamas, the main port, and Plaka, the old town above, both with excellent restaurants and bus connections to other villages and beaches; another option is Pollonia, a fishing port with nice beaches on the northeast coast that has become a pleasantly low-key resort. For a list of appealing hotels, see p. 233. Over the next 3 days, treat yourself to a sampling of the island's beaches, many accessible by bus: **Sarakaniko** is an otherworldly landscape of smooth white rocks surrounding an inlet and little coves, and **Papafraga** is another volcanic landscape where you can swim through a long, fjordlike channel into a

53

sea cave that opens to the sea. Most remarkable of all is **Kleftiko,** a seascape of rock formations and sea caves on the south coast. Kleftiko and nearby beaches are easily accessible only by excursion boat, so to get there, sign onto one of the day-long cruises that make stops at scenic spots along the way for swimming. Tour operators in Adamas and elsewhere advertise them.

Take a little time away from the beach to explore the island's other sights, too. **Plaka** is a beautiful old village of white, cubical houses on a hillside above Adamas, and is topped by a Venetian **Kastro.** Just down the

White volcanic rock takes on weird shapes at Kleftiko beach on Milos.

hill, in **Trypiti,** are two of the island's ancient sites—a Roman theater and Greece's only Christian artifacts. **Klima,** on the seaside below, is an atmospheric place for a dip, as the water's edge is lined with colorful houses typical of the island, with moorage for a boat below and modest living quarters above.

Days 9–12: Santorini

A mid-morning boat from Milos on **Day 9** gets you to **Santorini** (p. 213) in the early afternoon. Try to be on deck as the boat enters the deep harbor with its high lava-streaked cliffs, created by a volcanic eruption around 1500 B.C.—it's one of Greece's most unforgettable travel experiences. You'll soon discover that stunning scenery is just part of the appeal of Santorini—the island's remarkable coastlines are also etched with beautiful beaches, where crystal clear water washes onto volcanic sands.

A caldera-side hotel makes the most of this stunning scenery; an especially pleasant perch in Ia is **Esperas,** while **Astra Suites** is a luxurious and distinctive inn in Imervogli. At some point the next morning, tear yourself away from the view-filled terraces that are hallmarks of caldera-view hotels to walk at least a portion of the 10km (6-mile) path that follows the top of the cliff between **Fira** and **Ia.** You'll enjoy a bird's-eye view over the outrageously blue waters and clusters of white houses perched on top of the cliffs like a dusting of snow. Watching the sunset from Ia is a celebratory event accompanied with a glass of wine, then head down to **Ammoudi,** the little fishing port below Ia, for a seafood dinner at **Katina's** or another waterside taverna.

On another day, catch a bus from Ia, Fira, or any stop along the caldera to go to the southern end of the island and **Ancient Akrotiri,** Greece's version of Pompeii—a well-preserved Minoan-era town that was buried in that same 1500 B.C. eruption that shaped modern Santorini. Adjoining the site is **Paralia Kokkini** (Red Beach), carpeted in red volcanic pebbles. If you want to get away from the crowds, board a water taxi at Red Beach for the short trip along the southern coast to **White Beach,** dramatically enclosed within an amphitheater of white cliffs. Across the island, the black-sand **Kamari beach** is on one side of

The red sands of Kokkini Beach on Santorini.

a headland and **Perissa beach** is on the other; both are on bus lines from Fira. Looming above them is **Ancient Thera,** the ruins of the island's Greek and Roman city, high atop a promontory. You'll have a choice of several boats for the 5- to 7-hour return trip to Athens, as well as several daily flights (less than an hour).

GREECE FOR FAMILIES

Yes, we know what kids want—a swimming pool! But you've come all the way to Greece, so here we show off the best of Athens and the islands while trying to balance the needs of young travelers, too. If you've got older kids who want to learn about ancient history, consider adding a day trip from Athens to any of the sites in the **Best of Ancient Greece** itinerary (p. 42).

Days 1–2: Athens ★★★

Start your first day in Greece with the landmark you can't go home without seeing: the **Acropolis** (p. 92). It's a long climb through the **Beule Gate** up a well-worn path to the top, where you should find a spot to sit and just gaze at the ruins of the perfectly proportioned Parthenon and surrounding temples. Help the kids put it all together with a visit to the **Acropolis Museum** (p. 93), at the base of the hill, where the original sculptures and statuary from the site are on display. If their legs are up to it, you can then stroll along the **Grand Promenade** (p. 96), a cobblestone-and-marble, pedestrian-only boulevard that skirts the Acropolis Hill, and end your sightseeing by strolling around the evocative ruins of

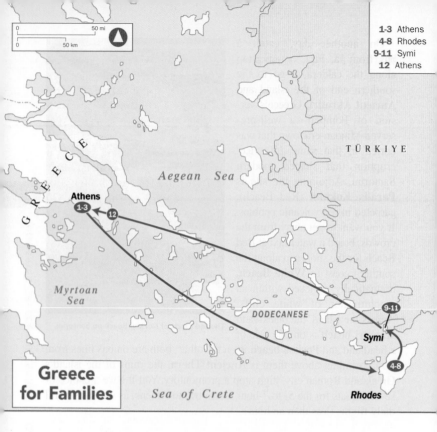

1-3 Athens
4-8 Rhodes
9-11 Symi
12 Athens

**Greece
for Families**

the **Ancient Agora** (p. 103), where Socrates once conducted open-air seminars and St. Paul sought converts for the new religion of Christianity. After that, it's time for a bite, maybe at **Kostas** or another souvlaki place in the **Plaka** or **Monastiraki** (p. 87).

Begin **Day 2** with a visit to Athens's **National Archaeological Museum** (p. 110), with the world's finest collection of Greek antiquities. Youngsters will be intrigued by the gold death masks in the Mycenaean Collection, with its Trojan War connections; the Thira Collection's vividly colorful frescoes from Santorini are almost like an ancient comic strip. Then walk south down through Omonia Square to the lively **Central Market** (p. 108). The sheeps' heads and live chickens are perfect gross-out sights, and there are lots of tasty snacks and pastries to be picked up. Make your way down Aiolou Street for a look at the **Roman Forum** (p. 105) and the adjacent **Tower of the Winds** (p. 106), an early version of a clock tower, only with sundials instead of clock faces. Then hop on the Metro at Monastiraki for a ride to the Evangelismos station, from where it's a short walk to the funicular that climbs **Lycabettus Hill** (p. 113), a theme-park worthy ride. At the top you'll all be mesmerized by the views of the Acropolis and across the city to the sea.

Day 3: Athens to Rhodes

This evening, you'll board a boat to Rhodes, so you have a good part of the day for some more Athens sightseeing before heading down to Piraeus. The kids can watch the **Changing of the Guard** (p. 100), every hour on the hour at the Parliament Building on Syntagma Square, then they can let off some steam with a walk through the **National Gardens** (p. 100). On the south side of the gardens are three more gee-whiz monuments from Ancient Athens: **Hadrian's Arch** (p. 96), erected in honor of the Roman emperor in A.D. 131; the **Temple of Olympian Zeus** (p. 98), the largest ancient temple in Greece; and the **Panathenian Stadium** (p. 98), reconstructed from the ruins of an arena built around 330 B.C. to host the first modern Olympic Games in 1896. From Piraeus it's a cruise of at least 14 hrs. to Rhodes, but the family can relax on board and sleep well in a cabin. (If a night at sea doesn't appeal, you can fly to Rhodes instead.) The last boat to Rhodes usually leaves around 6pm, with an arrival at around 11am the next day.

Days 4–5: Rhodes City ★★★

However you get to Rhodes, make **Old Town** (p. 248) your base. If the children are tired of togas and dusty columns, this medieval enclave is the perfect antidote—one of Europe's great historic quarters, full of story-book atmosphere. Many hotels have pleasant gardens, and the **Athineon Hotel** just outside the old city walls has family-oriented suites and a nice swimming pool. Two landmarks will fire up youngsters' imaginations. The **City Walls,** 4km (2½ miles) in length and 12m thick (40 ft.) in places, are complete with fortified gates and bastions. You can walk around the walls in their entirety, either in the dry moat between the inner and outer walls, or along the ramparts on top. The **Street of the Knights** is one of the best-preserved and most evocative medieval relics in the world, a 600m-long (1,968 ft.) stretch of cobbles where crusader knights of various nations maintained their towered, crenellated inns. For a quick dip, join the locals at **Elli beach,** where the waves wash onto a long stretch of sand and you can rent a sunbed and have a snack at one of the many concessions. A

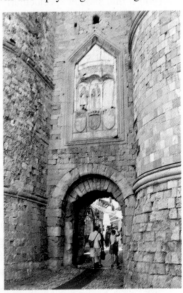

Exploring the castellated precincts of Rhodes Old Town is like entering an episode of *Game of Thrones.*

bonus here is the old-fashioned **Rhodes Aquarium** (p. 254), home to exotic-looking sea creatures.

Day 6: Day Trip to Lindos ★★

Frequent buses make the trip to **Lindos** (p. 252), the most picturesque town on the island outside of Rhodes Old Town, a collection of white-stucco houses tucked between the sea and the towering **Ancient Acropolis** (p. 252). Kids will probably want to board a donkey (also known as a "Lindian taxi") for a slow plod all the way to the top. There, atop a flight of stone steps, are a medieval castle and an ancient Greek terrace littered with the remains of a great assembly hall with a grand columned portico. Down below is a beach that is just too tempting to resist.

Day 7: Exploring the Rest of Rhodes ★★

On **Day 7,** rent a car and pack a picnic lunch for a day of exploring the green and mountainous **West Coast** (p. 256). First stop is **Pelaloudes,** the **Valley of the Butterflies,** one of the world's few natural habitats for resin-seeking Jersey Tiger moths *(panaxia quadripunctaria)*. This is a touristy attraction but the parklike setting is quite picturesque, with many ponds, bamboo bridges, and rock displays. From here a scenic 40km (25-mile) drive along the coast brings you to the ruined, late-15th-century knights' **castle of Kastellos** (Kritinia Castle), high above the sea; kids can jump around the ruined ramparts and enjoy the views before sitting down for that picnic lunch. Another 30km (18 miles) down the coast, you'll find another spectacularly sited crusader castle, **Monolithos,** atop a rocky outcropping. End your day with a late-afternoon swim at the nice beach at **Fourni,** 5km (3 miles) southeast. It's 78km (47 miles) back to Rhodes Town; the drive will take about 1 hour and 45 minutes.

On **Day 8** it's time for some more modern family fun. Head out to kids-oriented **Faliraki** (p. 256), 9km (6 miles) south of Rhodes Town on the east coast. Aside from the beach, the big attraction out here is the **Water Park,** with slides, a wave pool and lazy river, and other watery fun. Ticket price includes free bus transfer from Rhodes Town. **Skypark** is a kid-friendly entertainment arcade with bowling, trampolines, mini-cars, skating, and other amusements, while **Aquaworld Aquarium** shows off fish from Greek waters.

Days 9–11: Symi ★★★

Take a morning ferry to **Symi** (p. 258), where the boat sails into beautiful, mansion-lined **Yialos harbor.** One of the pleasures of this rugged little island is the slow pace. Challenge the kids to climb the 375 or so wide stone steps, known as the Kali Strata (the Good Steps), to picturesque **Horio** (p. 258), the old island capital. There's good swimming and snorkeling from the shoreline around Yialos; in fact, a stay at the in-town **Hotel Nireus** comes with the chance to swim right from the waterfront terrace. On **Day 10** take a boat taxi from Yialos to enjoy one of the island's beautiful beaches, such as **Nanou Bay, Marathounda,** or **St. George's Bay.**

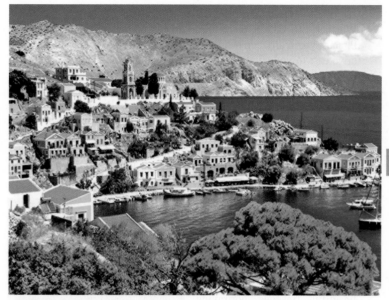
Colorful houses ring the beautiful harbor of Yialos on the island of Symi.

On **Day 11,** you'll visit Symi's top tourist sight, the **Taxiarchis Mihailis Panormitis Monastery** (p. 262). This unexpectedly grand whitewashed monastery, dedicated to the patron saint of seafaring Greeks, is tucked away on Symi's hilly, green southwestern corner. You can browse around the heavily frescoed church and chapels that open off a courtyard, and don't miss the wooden ship models in the attached museum. The most exciting way to reach the monastery is by boat; there is also twice-a-day bus service from Yialos and Horio. However you get there, count on a refreshing swim in Panormitis Bay.

Day 12: Back to Athens

Now it's time to head back to Athens. No better way to end a vacation in Greece than with a sea voyage, and, depending on timing, you can catch the couple-times-a-week boat from Symi to Piraeus or return to Rhodes and take one of the ferries that run more frequently from there. Then, of course, there's plan B—a quick flight from Rhodes to Athens.

CRETE IN 10 DAYS

Greece's largest island has it all—stunning landscapes, tall mountains, deep gorges, powdery beaches, remnants of the ancient Minoan civilization, and exciting and exotic cities. There's a lot to cover, but in 10 days you'll get a good sampling of these many pleasures.

Days 1–2: Agios Nikolaos ★ & Elounda ★

Whether you take a plane from Athens or the overnight boat from Piraeus, you'll arrive in nearby Heraklion, where you should rent a car to drive east to your first touring base, the animated and appealing resort town of **Agios Nikolaos** (p. 300), about an hour's drive east of Iraklion. Promenades surround Lake Voulismeni, connected to the sea by a narrow channel, and the beautiful beaches of the **Elounda Peninsula** (p. 304) are nearby. A popular local excursion is by boat to **Spinalonga** (p. 306), a haunting island in the Gulf of Mirabello that's been a fortress, a place of refuge, and until fairly recent years, a leper colony. You have a big choice of hotels in Agios Nikolaos as well around Elounda, and some of the most luxurious resorts in Greece line the shores of Mirabello Bay.

Day 3: Iraklion ★★

Drive back to **Iraklion** (p. 285) in the morning, where you'll check into your hotel for the next 2 days. Head first for the **Archae-ological Museum** to look at its beautiful frescoes portraying Minoan life, along with other exuberant artifacts of the sophis-ticated Minoan culture. Seeing these riches will help you better appreciate your next stop, the grandeur of outlying **Knossos,** the palace that about 3 millennia ago was the center of Minoan culture. In the late afternoon, return to the old center of Irak-lion, where a cooling breeze often picks up and you can join Irakliots for a stroll around the

The Minoan palace complex of Knossos is the top attraction of Iraklion, Crete's capital.

old city. A mandatory stop before returning to Agios Nikolas is one of the cafes at **Ta Liontaria** (The Lions) square, overlooking the fountain adorned with four leonine symbols of the Venetian Republic.

Day 4: The Lasithi Plateau ★★★

Make the short but scenic drive up to the **Lasithi Plateau** (p. 298), a glori-ous slice of rural Crete where a tidy patchwork of orchards and fields spreads out to the encircling hills. Enjoy a long lunch up here at the **Kronio** restaurant (p. 299), then visit the **Psychro Cave,** one of several caverns around Greece said to have been the birthplace of Zeus. Return to Iraklion.

Day 5: Crete's South Coast & Rethymnon ★★

Set off by making the 2-hour drive down to **Matala** (p. 297), a pleasant beach resort on the south coast famous for its cliffs riddled with caves

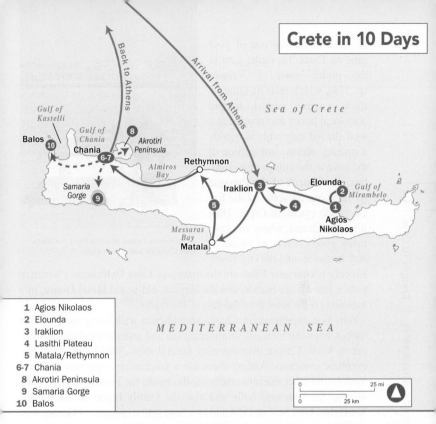

Crete in 10 Days

Gulf of Kastelli

Gulf of Chania

Balos

10

Chania

6-7

8 Akrotiri Peninsula

Almiros Bay

Rethymnon

Samaria Gorge

9

Messaras Bay

Matala

Sea of Crete

Elounda

2

Iraklion

3

Gulf of Mirambelo

4

1

Agios Nikolaos

Back to Athens

Arrival from Athens

MEDITERRANEAN SEA

1 Agios Nikolaos
2 Elounda
3 Iraklion
4 Lasithi Plateau
5 Matala/Rethymnon
6-7 Chania
8 Akrotiri Peninsula
9 Samaria Gorge
10 Balos

0 25 mi

0 25 km

that have housed everyone from Roman soldiers to 1960s hippies. The real draw here are the beaches—the best are **Kommos,** a long stretch of sand just north of Matala, and isolated **Red Beach,** reached by a 20-minute hike over a headland on the south side of town. After a swim, head north and west again, winding through the scenic **Amari Valley** (p. 313), a panorama of vineyard- and orchard-covered mountain slopes beneath the snow-capped peak of Mount Ida. On a high plateau just north of the valley, the ornate **Arkadi Monastery** (p. 313) is a patriotic landmark for Greece, the scene of a bloody fight against the Turks in the 1860s. Then make the half-hour drive back to the north coast and **Rethymnon** (p. 307), an exotic maze of Venetian and Turkish houses and mosques, crowded onto a sea-girt peninsula with and a massive seaside fortress. Treat yourself to dinner in the romantic garden of **Avli** (p. 310), famous for its innovative preparations of Cretan cuisine. This is also a luxurious place to stay, and one of many character-filled hotels occupying historic mansions and palaces in the Old Town.

Days 6–7: Chania ★★★

It's a short drive from Rethymnon to **Chania** (p. 315), 72km (45 miles) to the west, one of the most beautiful cities in Greece and a good place

to settle in for the rest of your time on Crete. En route, stop in the pretty town of **Vrisses** (p. 324), which rests its fame on thick, creamy yogurt, topped with local honey and savored at a well-shaded cafe table alongside a rushing stream. Just outside of the town in the village of Alikambos, the **Church of the Panagia** (p. 325) houses some of the finest fresco cycles in Crete. Then it's on to Chania, where you have many good choices of places to stay in and around the Old Town.

A marvelous sweep of waterfront mansions lines Chania's Venetian harbor.

Especially character-filled are the luxurious **Casa Delfino,** in a Venetian palace just off the harbor, and the elegant, old-world **Hotel Doma,** in a mansion on the seaside to the east of the center.

Your first experience in Chania should be a walk along the Venetian harbor, enjoying views of shimmering sea and waterside palaces. As you get to know Chania over the next several days, you'll discover some excellent museums. Among them are a fascinating collection of ship's models and other maritime memorabilia inside the **Firkas,** the waterside fortress the Venetians built, and also the **family home of Eleftherios Venizelos,** born here in 1864 and two-time prime minister of Greece who was instrumental in gaining independence for Crete.

Day 8: Day Trip to the Akrotiri Peninsula ★★★

A short drive east from Chania takes you onto the **Akrotiri Peninsula** (p. 323), jutting into the Cretan Sea. The lands at the northern tip of the peninsula are the holdings of three adjacent monasteries. **Agia Triada** is a beautiful and exotic complex of Byzantine and Venetian design, and at the 11th-century **Monastery of Katholiko,** A steep path leads past hermitages where St. John the Hermit and his followers lived in caves and ends at a little cove. While you're out here, you can relax at **Stavros** with a swim at the beach where the film *Zorba the Greek* ends with a dance on the sands.

Day 9: Samaria Gorge ★★★

The **Samaria Gorge** (p. 327) is one of the most traveled places in Crete, but crowds of eager hikers don't detract from the spectacle of its narrow passageways and sheer steep walls. Copses of pine and cedar and a profusion of springtime wildflowers carpet the canyon floor, where a river courses through a rocky bed. The hike ends with a well-deserved swim in the Libyan Sea. The easiest way to visit the gorge is on an organized tour; many tour operators in Chania offer them.

Day 10: Balos ★★★

An idyllic place to spend your last day on Crete is **Balos** (p. 325), a dazzling beach at the end of a remote peninsula west of Chania. The rough track out is suitable only for four-wheel-drive vehicles, so drive to Kissamos, 37km (21 miles) west of Chania, and board one of the many excursion boats that head out to the beach from there. Bring sunscreen and a wide-brimmed hat, since there's not much shade, and leave plenty of time to get back to the port in Chania for the 9pm sailing of the boat to Piraeus.

ATHENS

This is Athens: Exciting, exasperating, worldly, and oh so hot. Home to gods, goddesses, and some of history's greatest philosophers and storytellers, Athens is an ancient city with a modern edge. Glorious classical monuments are a backdrop for the city's greatest resource, 4 million Athenians, who—in the face of economic turmoil, social disruptions, the ups and downs of tourism, and all sorts of other perils—are cosmopolitan, fun-loving, forward-thinking, and for the most part welcoming hosts.

4

As you explore Athens—seeing the Acropolis, wandering the Agora, visiting ancient temples and Byzantine churches—take a *siga, siga* (slowly, slowly) approach. Walk streets lined with neo-classical mansions; take in the scents; linger in courtyard gardens and on rooftop terraces. For cool respite head to the National Gardens, and for gorgeous sunsets perch on the peak of Lycabettus hill. Check out stalls laden with fresh fruit, nuts, and mounds of Aegean seafood in the 19th-century glass-and-steel Central Market. Discover the urban chic of Gazi, Psyrri, and other once-neglected downtown neighborhoods. You'll find that Athens is beautiful and gritty, ancient and up-to-the-moment, sultry and restless, frustrating yet seductive, and most of all—like the sight of the Acropolis looming above it all—rather unforgettable.

ESSENTIALS

Arriving

BY PLANE The **Athens International Airport Eleftherios Venizelos** (www.aia.gr; ⓒ **210/353-0000**), 27km (17 miles) northeast of Athens, is usually called "Venizelos," or "Spata" after the nearest town. Venizelos is a large, modern facility, with plenty to keep you busy, including a small museum with rotating art exhibits and ruins found during the airport's construction. The **Greek National Tourism Organization** has an information desk in the arrivals hall. The baggage storage (left luggage) facility at one end of the main terminal arrivals area is open 24 hours a day and charges 8€ per medium-sized piece for 6 hours and 13€ for 24 hours.

The **Metro** (www.amel.gr) is the most convenient and fastest way to travel between the airport and downtown. A sleek Metro station is connected to the terminal via moving walkways, with trains departing every half-hour from 6:30am to 11:30pm (trains

from the city to the airport run 5:50am–10:50pm). The trip takes roughly 40 minutes. A one-way fare is 9€; a 48-hour round-trip fare is 16€.

Buses (www.oasa.gr) depart 24 hours a day from outside the arrivals hall of the main terminal building (doors 4 and 5). One-way fare from the airport to Syntagma Square (X95) or to the port of Piraeus (X96) is 6€. The X95 runs every 10 minutes from 7am to 10pm (10pm–7am, it's every 30 min.). The X96 runs every 20 minutes from 7am to 10pm (10pm–7am, it's every 40 min.). You can buy a ticket from a booth beside the bus stop or on the bus; you must validate your ticket by punching it in the machine within the bus. If you're going from the airport to the port of Rafina (departure point for many boats to the Cyclades), you can take a **KTEL bus;** they run every 40 minutes between 4:45am and 10:20pm, leaving from a stop outside the terminal opposite the Sofitel Hotel. You may buy the 3€ ticket from the booth near the stop or on the bus.

The **Proastiakos-Suburban Railway** is a handy option for travelers heading elsewhere in Greece. It runs directly to Athens's Larissa Station, departing from the same platforms as the Metro every 15 minutes between 6:10am and 9:45pm; the trip takes 38 minutes and the fare is 10€. One train per hour continues to Corinth and onto Kiato in the Peloponnese. Other routes connect the airport to Larissa station and on to the port of Piraeus, with service between 6am and 11pm; the trip takes a little over an hour, less on some runs, and costs 10€. For more information, go to www.trainose.gr, or ask the airport tourist office staff for help in pinning down the site's somewhat confusing schedules. For more public transport information, see p. 70.

Taxis from the airport to downtown Athens charge a flat rate that includes tolls and luggage. Once you are in the taxi, make sure the meter is set on the

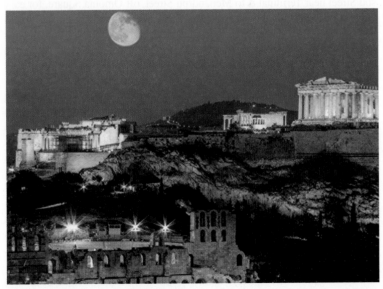

The ancient Acropolis, Athens's most famous sight, presides over the city from its sacred hilltop, testament to the enduring spirit of Greek culture.

correct tariff (tariff 1 is charged 5am–midnight; tariff 2 midnight–5am). Fare to the center is 38€, late-night 54€. Depending on traffic, the drive can take under 30 minutes or well over an hour—something to remember when you return to the airport. **Rental cars,** including those from big names like Hertz, Avis, and Alamo, are available at the airport.

BY CAR　If you arrive by car via **Corinth** (to the southwest), the signs into Athens will direct you fairly clearly to Omonia Square, which you will enter from the west along Ayiou Konstantinou. In Omonia, signs *should* direct you toward Syntagma Square and other points in central Athens (signs in Omonia disappear mysteriously). If you arrive via **Thessaloniki** (to the north), signs pointing you into central Athens are few and far between. It's not a good idea to attempt this for the first time after dark. Your best bet is to look for the Acropolis and head toward it until you see signs for Omonia or Syntagma squares. Best advice: Avoid driving in Athens at all—turn in your rental car at the airport (off the peripheral road and clearly marked as you approach the city from any direction).

BY BUS　There are two main stations for **KTEL** (www.ktel.org), the national bus company, located about 3km (2 miles) from one another in the northwestern part of the city. **Terminal A,** also known as Kifissou for its location at 100 Kifissou (© 210/512-9233), handles buses to and from the Peloponnese and parts of Northern Greece; this terminal is often referred to as Kifissou, or Kifissou Terminal A. **Terminal B** (260 Liossion St.; © 210/831-7096) handles buses to and from Central Greece (including Delphi, Thebes, Evvia, and Meteora) and some destinations north and east of Athens; this terminal is often referred to as Liossion or Liossion Terminal B. Public bus no. 051 (1.20€) runs from Kifissou Street near Terminal A to Menandrou Street, off Omonia Square, for easy connection to the Omonia Metro station. Bus 420 runs from Kifissou to Piraeus harbor (the stop near the port is at Akti Kondili and Thermopilon), though it's quicker and easier to take a taxi or bus 051 to Omonia and get on a Metro train to Piraeus. Express bus 93 links Kifissou with the airport (6€, buy your ticket from a stand inside the station). To travel from Liossion to central Athens or Piraeus, take any bus from the Praktoria stop across from the station entrance to the Attiki Metro stop. Or you can take a taxi from either station to Syntagma Square; the fare should cost 8€ to 18€, and if traffic is light, the ride is less than 20 minutes, but it can take an hour. *Note:* Taxi drivers who pick up passengers at the bus stations can be unscrupulous about overcharging, so don't get into a cab without settling on an estimated fare and make sure the meter is turned on.

A third bus station, the **Mavromateon terminal** (www.ktelattikis.gr; © 210/880-8080; Metro: Victoria Square) is at the entrance to Areos Park at Patission and Alexandras, just north of Omonia Square near the Archaeological Museum. Also known as the Areos Park Terminal, the station handles buses for most destinations in Attica, including Sounion. The closest Metro station, Victoria Square, is 2 blocks away.

The multiple terminals can be confusing, but the station staff, along with hotel concierges, can usually tell you which bus leaves from where and how

to get to the right terminal. On a positive note, bus travel will be made easier in the mid-2020s, when a new central bus depot, with Metro connections, is slated to open in outlying Eleonas.

BY TRAIN Trains arrive at **Larissa station** (Stathmos Larissis; ℭ **210/529-8837**), also known as Athens Railway Station. From the Larissa Metro station you can easily reach Omonia, Syntagma, and other central points on line 2 (Larissa). A taxi to the center of town should cost about 10€.

BY BOAT Most boats arrive at and depart from **Piraeus,** Athens's main seaport, 11km (7 miles) southwest of the city center. Free shuttle buses will take you from your boat to a stop near the Piraeus Metro station. It's a 20-minute ride (fare 1.20€) to Monastiraki, Omonia, and Thissio Metro stations. The far slower bus 040 (fare 1.20€) runs from Piraeus to central Athens (with a stop at Filellinon, off Syntagma Sq.) every 15 minutes between 5am and 1am (hourly 1am–5am). To get to Athens International Airport from Piraeus, you can take the X96 bus (6€) or the Metro (10€; change at Monastiraki station). You may prefer to take a taxi to avoid the trip from your boat to the bus stop or subway terminal, but be prepared for serious bargaining: The fare on the meter from Piraeus to Syntagma should be 15€ to 20€, but many drivers offer a flat fare, which can be as much as 30€.

If you arrive at Piraeus by hydrofoil, you'll probably dock at **Zea Marina** harbor, about a dozen blocks south across the peninsula from the main harbor. Getting a taxi from Zea Marina into Athens can involve a wait of an hour or more—and cab drivers usually drive hard bargains. To avoid the wait, walk up the hill from the hydrofoil station to catch bus 905 (fare 1.20€), which connects Zea to the Piraeus Metro station, where you can continue into Athens. You can buy a ticket from the stand near the bus stop. If you arrive late at night, however, you may be out of luck, as the ticket stand may be closed.

About 35km/21 miles east of central Athens, the port of **Rafina** is the arrival/departure point for many boats to and from the Cyclades. If you disembark here, walk to the bus stop up the hill from the pier to catch a bus to the airport, where you can get a bus or Metro train to the city center (see above). Buses run about every 1½ to every 2 hours throughout the day and the fare is 3€, pay on the bus. Go to www.ktelattikis.gr for timetables.

Visitor Information

The central office of the **Greek National Tourism Organization** (abbreviated GNTO in English-speaking countries, EOT in Greece) is opposite the Acropolis Museum at Dionissiou Aeropagitou 18–20 (ℭ **210/331-0392**; Metro: Akropoli; Mon–Fri 9am–7pm, Sat–Sun 10am–4pm). Another GNTO information desk (ℭ **210/345-0445**) is in the airport arrivals hall. Available 24 hours a day, the **tourist police** (ℭ **210/171**) speak English as well as other languages and will help you with problems or emergencies. An excellent online resource, *Matt Barrett's Athens Survival Guide* (www.athensguide.com), offers a personalized insider's take on the city plus lots of practical information.

Trendy nightspots have revitalized the once-derelict Psyrri neighborhood.

City Layout

Think of central Athens as an almost perfect equilateral triangle, with its points at Syntagma (Constitution) Square, Omonia (Harmony) Square, and Monastiraki (Little Monastery) Square, near the Acropolis. The area bounded by Syntagma, Omonia, and Monastiraki squares is defined as the commercial center, from which cars are mostly banned. To get your bearings, look up to the **Acropolis,** west of Syntagma Square, and to **Mount Likavitos** (Lycabettus), to the northeast. From most parts of the city, you can see both.

At one time **Omonia Square**—Athens's commercial hub—was considered the city center, but nowadays, most Greeks think of **Syntagma Square,** site of the House of Parliament, as ground zero. The two squares are connected by parallel streets, Stadiou and Panepistimiou. West of Syntagma Square, Ermou and Mitropoleos lead to **Monastiraki Square.** From Monastiraki Square, Athinas leads north back to Omonia past the Central Market. The old warehouse district of **Psyrri,** now a hip enclave, is between Athinas and Ermou.

If you stand in Monastiraki Square and look south, you'll see the Acropolis. At its foot are the **Ancient Agora** (p. 103) and the **Plaka,** Athens's oldest neighborhood. The Plaka's twisting labyrinth of streets can challenge even the best navigators, but the district is small enough that you can't go far astray, and it's a pleasant place in which to wander aimlessly. Many Athenians speak some English, and almost all are helpful to direction-seeking strangers.

Neighborhoods in Brief

Athens is a collection of many different neighborhoods, each with its own distinctive flair. Take time simply to stroll around the central city from one neighborhood into another. Part of the walk should be along the **Grand Promenade,** the walkway that stretches from Hadrian's Arch past the Acropolis to the Ancient Agora, then past Thissio and on to the Kerameikos cemetery.

Around the Acropolis At the base of the Acropolis and the pine-clad slopes of Lofos Filopappou (Filopappos Hill) and Lofos Mousson (Hill of the Muses) are elegant residential enclaves. The **Grand Promenade** leads to the Acropolis Museum, the Theater of Dionysus, and other sights.

Syntagma Square The heart of Athens is the focal point of the city's political and civic life, from protest rallies to New Year's celebrations. The handsome neoclassical building at the head of the square is the **Greek Parliament building,** formerly the Royal Palace, where you'll see the Changing of the Guard several times a day. Adjacent to Parliament are the **National** (p. 100) and **Zappeion** (p. 101) **Gardens.**

Plaka Spreading below the Acropolis, Plaka is the most touristic neighborhood in the city; it can be impossibly crowded but also atmospheric and romantic. Its narrow medieval streets—many named after Greek heroes from antiquity or the Greek War of Independence—twist past ancient sites, Byzantine churches, offbeat museums, and 19th-century homes. Restaurants and cafes line many lanes. **Anafiotika** (p. 102), a Cycladic-style town at the base of the Acropolis, is a tiny village within Plaka.

Monastiraki This neighborhood on the fringe of the **Agora** (p. 103) and the **Roman Forum** (p. 105) is best known for its flea markets. They're open every day but are usually best—and most crowded—on Sunday. Many tavernas, cafes, and shops line the streets. The most appealing street is **Adrianou,** lined with restaurants and cafes on one side and the Agora on the other.

Psyrri Between Athinas and Ermou streets, this working-class district was once derelict and forgotten; now its converted warehouses and neoclassical houses hold trendy bars, restaurants, clubs, cafes, tavernas, galleries, and *mezedopoleia* (establishments offering "small plates"), sitting side by side with some still-remaining workshops. This area bustles from late afternoon until early morning. Some outer pockets remain a bit gritty.

Gazi West of Psyrri, this former industrial wasteland is now a bohemian enclave. Locals socialize, drinks in hand, in **Gazi Square,** surrounded by some of the city's coolest bars and eateries; a cavernous foundry that once spewed black gas fumes (the name *Gazi* means "gas") is now an arts complex, **Technopolis** (p. 126). Between Psyrri and Gazi is **Kerameikos** (p. 107), the little-visited ancient cemetery with many stunningly beautiful classical sculptures.

Omonia and Exarchia Time was, Omonia was a grand *plateia* (square), surrounded by neoclassical buildings. Today it's gritty and encircled by an endless swirl of traffic, but several new hotels have added some luster. The **National Archaeological Museum** (p. 110) lies north of Omonia Square; the student neighborhood of **Exarchia** sprawls east from there, full of buzzing squares and pedestrian streets.

Kolonaki and Lycabettus Tucked beneath the slopes of Lycabettus hill, elegant Kolonaki has long been a favorite address for well-to-do Athenians, its streets packed with designer houses, art galleries, and gathering spots. Imposing **Leof Vasiliss Sofias,** nicknamed the Museum Mile, is lined with neoclassical mansions, many of which now house museums (among them the **Benaki;** p. 106). A funicular ride leaves all the urban chic behind for the top of **Lycabettus Hill** (p. 113) and the spectacle of Athens laid out under your feet like a sparkling map.

Koukaki Wedged between the busy thoroughfare Syngrou and the **Filopappou Hill** (p. 95), this residential enclave is far enough off the beaten track to provide a glimpse of real Athenian life, but it's still close to many classical sites: The **Acropolis Museum** and **Acropolis** (p. 92) are just to the north, while steep lanes lead up into hills studded with ancient ruins. At the convenient Syngrou-Fix Metro station, you can catch a free shuttle to the **Stavros Niarchos Foundation Cultural Center** (p. 125).

Getting Around

BY PUBLIC TRANSPORTATION

The best online source for information, with a trip planner that allows you to map a route, is **Transport for Athens** (www.oasa.gr). **Fares** are 1.20€ for a single ride, which covers all travel for a 90-minute period, even if you switch from a bus to a Metro train or vice versa. A day ticket costs 4.10€, a 5-day ticket 8.20€, both excluding travel to the airport; a 20€ tourist ticket covers 3 days of unlimited travel plus transport to and from the airport. **Be certain to keep your ticket handy:** Uniformed and plainclothes inspectors periodically check tickets and can levy a fine of up to 60€ on the spot to riders who cannot produce tickets.

The **Metro** runs from 5:30am to midnight Sunday through Thursday; on Friday and Saturday, trains run until 2am. All stations are wheelchair accessible. Stop at the Syntagma station or go to the GNTO (p. 67) for a system map. Even if you don't use the Metro to get around Athens, you may want to take it from Omonia, Monastiraki, or Thissio to Piraeus to catch a boat to the islands. (Don't miss the spectacular view of the Acropolis as the subway goes above ground by the Agora.) Three stations—Syntagma Square, Monastiraki, and Acropolis—handsomely display finds from the subway excavations. The system is continually being expanded, so expect occasional construction delays.

You can also get almost anywhere you want in central Athens or the suburbs by **bus** or **trolley,** which run 24 hours a day. Check out the **Athens Urban Transport Organization** (www.oasa.gr; ✆ **185**) for directions, timetables, route details, and maps, or get advice from hotel concierges or tourist offices. You may not pay fares on the bus or trolley, so be sure to buy a ticket before boarding. Tickets are sold from machines at Metro and tram stations, or from ticket booths located next to a few bus stops around the city (newsstands and shops don't sell tickets). Ticket machines have an English-language interface and accept credit and debit cards. A convenient bus route for cruise ship passengers is the number X80 bus, which from May through October connects the terminals in Piraeus with Syntagma Square, the Acropolis, and the Stavros Niarchos Foundation.

BY TAXI

Taxis are inexpensive, and most drivers are honest. Even so, make sure that driver is using the meter and determine what the rate will be from point A to point B; unscrupulous drivers picking up passengers at bus and train stations may try to charge a high flat rate. When you get into a taxi anytime up until midnight, check to make sure the **meter** is turned on and set to 1 (the daytime rate) rather than 2 (the late-night rate, which is almost double the price). The meter should be set on 2 only between midnight and 5am *or* if you take a taxi outside the city limits; if you plan to do this, negotiate a flat rate in advance. The "1" meter rate is .74€ per kilometer within city limits (it's 1.30€ per

kilometer at night and outside city limits); the meter starts at 1.29€ and minimum fare is 3.47€. There's a surcharge of 1.18€ for service to or from a port or rail or bus station, 4.72€ to or from the airport. Luggage costs .43€ per bag over 10 kg (22 lb.). *Note:* These prices change all the time and will almost certainly be higher by the time you visit Greece.

Don't be surprised if the driver picks up other passengers en route; he will work out everyone's share of the fare (make sure he does!). If you plan to travel around Athens by taxi, carry a business card from your hotel, so you can show it to the taxi driver on your return trip.

You can flag down a taxi (not always easily done) or find one at taxi ranks around the city center; a taxi is free when the red-and-white sign is up. Most hotels, even modest ones, will arrange a taxi for you, usually with a reliable driver they regularly work with. The convenient Beat app lets you request a cab (and even specify an English-speaking driver). You can also use your Uber app to summon a taxi. With both you can pay with cash or a credit card uploaded to the app.

Taxis accept credit cards, though some drivers will claim their credit-card machine isn't working and they can only take cash (they may even offer to take you to an ATM); insist on using your card, and if necessary, ask to be taken to a hotel where a doorman can intervene on your behalf.

BY CAR

In Athens, a car is far more trouble than convenience. The traffic is heavy, finding a parking place is extremely difficult, and much of the central city is closed to cars. You can easily get to most places instead on foot or by the city's extensive public transport system; taxis are plentiful and fairly inexpensive, too. If you do plan on renting a car, maybe to visit Delphi or go into the Peloponnese, you'll find many rental agencies south of Syntagma Square and in Athens International Airport. Airport rentals are especially handy because you can immediately get onto the highway network that will whisk you away from the city. See p. 66 for more on renting a car in Athens. Should you find yourself with a car to stash in Athens, centrally located garages include **Parking Menandrou** (Menandrou 22, near Omonia Sq.; ✆ **210/524-1027**) and **Parking Syntagmas** (Filellinon 12, near Syntagma Sq.; ✆ **210/324-4090**). At these and other central garages expect to pay 2€ an hour and about 20€ for 24 hours.

ON FOOT

Since most of what you'll want to see and do in Athens is in the city center, it's easy to do most of your sightseeing on foot. The city has created pedestrian zones around Omonia, Syntagma, and Monastiraki squares, in the Plaka, in Kolonaki, and elsewhere. **Dionissiou Areopagitou,** at the southern foot of the Acropolis, is also pedestrianized, with links to the Grand Promenade past the Ancient Agora, Thissio, and Kerameikos. Stay alert, however: Athens's multitude of motorcyclists seldom respect the rules, and a red light or stop sign is no guarantee that vehicles will stop for pedestrians.

[FastFACTS] ATHENS

ATMs Automated teller machines are common at banks throughout Athens. Use these instead of machines in shops, restaurants, or currency exchanges, where rates are usually higher and you'll have less recourse if something goes wrong. The **National Bank of Greece** operates a 24-hour ATM in Syntagma Square on Leoforos Vasilisis Amalias.

Banks Banks are generally open Mon–Thurs 8am–2pm and Fri 8am–2:30pm. All banks are closed on Greek holidays. (See p. 38.)

Business Hours Even Greeks get confused by their complicated, changeable business hours. In winter, shops are generally open Mon and Wed 9am–5pm; Tues and Thurs–Fri 9am–2pm and 5:30–9pm; and Sat 8:30am–3:30pm. In summer, hours are generally Mon, Wed, and Sat 8am–3pm; Tues and Thurs–Fri 8am–2pm and 5:30–10pm. There are many, many exceptions: Most stores in central Athens are open all day, and many in the Plaka and other tourist areas stay open until late in the evening. Department stores and supermarkets generally operate Mon–Fri 8am–8pm and Sat 8am–6pm.

Dentists & Doctors Embassies may provide lists of dentists and doctors, as do some hotels. For an English-speaking doctor or dentist, get a referral from

SOS Doctor (www.sosiatroi. gr; ✆ **201/821-2222**).

Embassies & Consulates See p. 420 in Chapter 12.

Emergencies In an emergency, dial ✆ **100** for the **police** and ✆ **171** for the **tourist police.** Dial ✆ **199** to report a **fire** and ✆ **166** for an **ambulance** and the **hospital.** Athens has a **24-hour** line for foreigners, the **Visitor Emergency Assistance** at ✆ **112** in English and French.

Hospitals **KAT,** the emergency hospital in Kifissia (www.kat-hosp.gr; ✆ **213/208-6000**), and **Asklepion Voulas,** the emergency hospital in Voula (www.asklepieio.gr; ✆ **213/216-3000**), are open 24 hours a day. **Evangelismos,** a centrally located hospital below the Kolonaki district at Vas. Sophias 9 (✆ **213/204-1000**), usually has English-speaking staff on duty.

Laundromats **Easywash** (easywashathens.gr) operates self-service laundries around town, with coin-operated machines open 7am–midnight, including in the Plaka at Aggelou Vlachou 8 (Metro: Syntagma) and in Koukaki at Dimitrakopoulou 69 (Metro: Syngrou-Fix).

Lost & Found The police's **Lost and Found,** Leoforos Alexandras 173 (✆ **100**), is generally open Mon–Sat 9am–3pm. For losses on the Metro, an office in Syntagma

station (www.stasy.gr; ✆ **210/327-9630**) is open Mon–Fri 7am–7pm. Lost passports and other documents may be returned by the police to the appropriate embassy, so check there as well. It's an excellent idea to travel with photocopies of your passport, prescriptions, and tickets.

Luggage Storage There are storage facilities at Athens International Airport (see p. 64); the Metro stations in Piraeus and Monastiraki have storage lockers but they often aren't operating for security reasons. **Bagbnb** (bagbnb.com) offers facilities throughout the central city, including Syntagma and Monastiraki, where you can store a bag for about 10€ a day. If you plan to stay again at your hotel after a side trip, ask if the hotel will store your excess luggage while you travel.

Pharmacies *Pharmakia,* identified by green crosses, are scattered throughout Athens. Hours are usually Mon–Fri 8am–9pm, often with an afternoon closing from 2–5:30pm. When closed, pharmacies post the location of others that are open or will open in an emergency. Newspapers such as the *Athens News* also list pharmacies that are open outside regular hours.

Police In an **emergency,** dial ✆ **100.** For help dealing with a troublesome taxi driver, hotel staff, restaurant staff, or shop owner, call the **tourist police** at ✆ **171.**

Post Offices The main post offices in central Athens are at Koumoundourou 29, off Omonia Square (Mon–Sat 8am–5pm), and in Syntagma Square at the corner of 60 Mitropoleos (Mon–Fri 7:30am–2:45pm).

Restrooms There are public restrooms in the underground stations beneath Omonia, Syntagma, and Kolonaki squares, but you'll probably prefer a hotel or restaurant restroom. Toilet paper is often not available, so carry tissue with you. Do not flush paper down the commode; use the receptacle provided.

Safety Athens is among the safest capitals in Europe, with few reports of violent crimes. **Pickpocketing,** however, is not uncommon, especially in the Plaka, Monastiraki and Omonia Square, around the Acropolis and other tourist sights, on the Metro and buses, and in Piraeus. Place your valuables in your front pockets, in an inside zipped pocket, or in a money belt, and keep a grip on your camera, phone, or tablet. Avoid the side streets of Omonia and Piraeus at night. Carry only a credit or debit card and leave your passport, valuables, and extra cards in a security box in your hotel room or ask to use the hotel safe. If you feel you need your passport with you, carry a photocopy, not the original. See also p. 424.

Taxes A VAT (value-added tax) of between 6% and 24% is added onto everything you buy. Be wary: Some shops list prices that do not include VAT and add the extra percentage after you've handed over a credit card. In theory, if you are not a citizen of an EU country, you can get a refund at the airport on major purchases. See p. 425 for tips on how to get a refund.

Telephones Public phones are scarce, and most accept only phone cards, available at the airport, newsstands, and **Telecommunications Organization of Greece (OTE)** offices. Cards come in several denominations, starting at 3€. Most OTE offices and **Germanos** stores (including the one in the airport) now sell cellphones and phone cards at reasonable prices. For more on phones, see p. 425.

Tipping Athenian restaurants include a service charge in the bill, but a few extra euros are appreciated. To tip taxi drivers, round up the fare (for example, for a fare of 8.80€, pay the driver 10€). In hotels, tip anyone who carries your bag (1€ or 2€) and count on that much per day for the person who cleans your room.

Wi-Fi Most hotels and many bars and cafes offer free Wi-Fi. There are Wi-Fi hot spots in Syntagma Square, Kotzia Square, Flisvos marina, and other public spaces; the airport also has free Wi-Fi.

WHERE TO STAY IN ATHENS

Concepts of low and high seasons are a bit murky in Athens. Summer is low season for business-oriented hotels, with deals available for leisure travelers, but it's high season for tourist-oriented hotels, where prices might plunge in the winter. To find the best prices, check hotel websites. When in doubt, ask, and bargain—if rooms are available, savvy hoteliers will gladly negotiate. Many hotels, especially in the budget category, prefer payment in cash and will often give you a discount for it. Few hotels offer parking; in the listings below, we note those that do (see p. 71 for centrally located parking facilities). Note also that Athens hotels do not always include breakfast in their rates; in the listings below, we note places where breakfast is included.

Expensive

Electra Palace ★ One of the largest hotels in the Plaka delivers old-fashioned luxury in a vast lobby and somewhat staid guest rooms, done up with stylish faux antiques, pastel color schemes, and marble bathrooms. The best

73

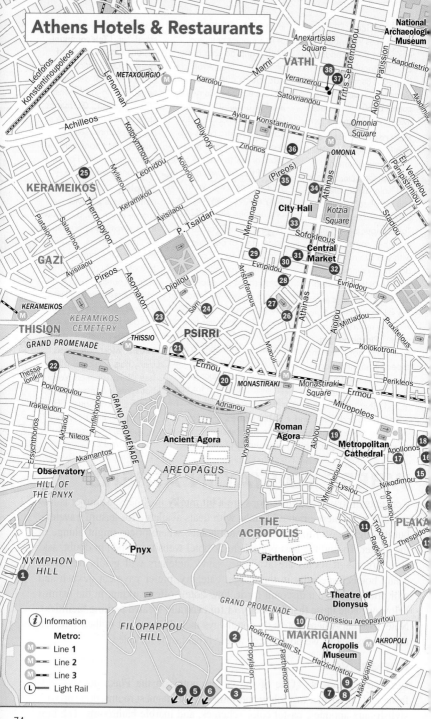

Athens Hotels & Restaurants

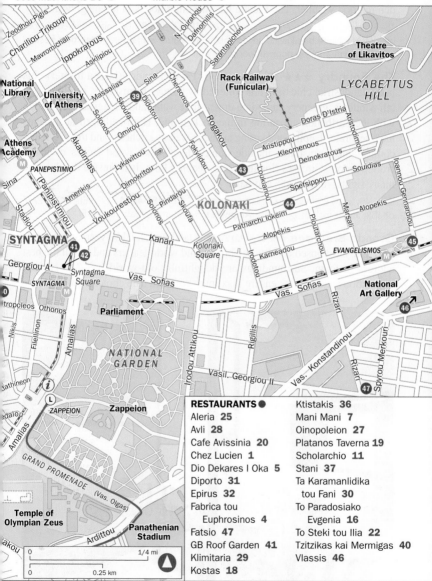

reason to stay here is the beautiful rooftop pool, where you feel you can almost touch the Acropolis while doing laps. Some upper-floor rooms are smaller than those below, but they have the same knockout views and are less prone to Plaka traffic noise. (Ask for one of these when you make your reservation—your request will be honored "subject to availability.") Second choice is a room with a balcony facing the palm-filled garden, an oasis in the central city. Service is polished, though a bit rote, and a buffet breakfast is served in the garden in good weather. The Electra has two other hotels in the neighborhood.

18–20 Nikodimou. www.electrahotels.gr. ℰ 210/337-0000. 106 units. 165€–390€ double. Rates include breakfast. Parking 15€ a day. Metro: Syntagma. **Amenities:** Restaurant; bar; gym; rooftop pool; indoor pool; spa; free Wi-Fi.

The Foundry ★★★ Set in a 1930s Psyrri foundry (later a theater), this hotel's industrial chic design is softened by vintage furnishings, bright colors, tall windows, greenery cascading down stone walls, and a magical roof garden with the Parthenon appearing in the background. High-ceilinged apartments have separate sleeping and sitting areas, as well as kitchens, and their stylishly comfortable furnishings include quirky details like wood stoves or handcrafted wood staircases floating up to sleeping lofts. Just outside the door are many sights, restaurants, and bars.

Sarri 40. www.thefoundrysuitesathens.com. ℰ **211/182-4604.** 12 units. 150€–225€ double. Rates include breakfast. **Amenities:** Roof terrace; bar; free Wi-Fi.

Grande Bretagne ★★★ An Athens landmark for 160 years, the Grande Bretagne has housed royalty, celebrities, and world leaders and is still the best address in town. Surroundings are delightfully old-world, yet 21st-century innovations and gizmos ensure maximum comfort. The choicest rooms, done

Guest rooms at The Foundry, a 1930s metal-working factory, have industrial chic flair.

The Grande Bretagne hotel has attracted A-listers for more than a century and a half with its old-world style of luxury.

up in traditional luxury, have balconies overlooking Syntagma Square, the Parliament, and the Acropolis. An attentive staff looks after every detail, and the rooftop pool and adjoining GB Rooftop bar/restaurant enjoy magical views of the city with the Parthenon floating atop it.

Syntagma Sq. www.marriott.com. © **210/333-0000.** 328 units. 350€–550€ double. Some rates include breakfast. Parking 15€ a day. Metro: Syntagma. **Amenities:** 2 restaurants; 2 bars; free airport pickup; concierge; health club and spa; 2 pools (indoor and outdoor); room service; free Wi-Fi.

The Modernist ★★ The former Canadian Embassy has been redone with a pared-down aesthetic and a black-and-gray palette, warmed up with genuine hospitality and extreme comfort in the public areas and sleek, stylish guest rooms. A breakfast buffet and all-day snacks are available in a welcoming communal room off the lobby, while the rooftop bar matches great views with signature cocktails. The slightly out-of-center location is a 10-minute walk from Kolonaki Square and 20 minutes from Syntagma, the Metro is just outside the door, and the National Gallery is across a busy boulevard.

Ioannou Gennadiou 4 at M. Kotopouli. www.themodernisthotels.com. © **216/000-2130.** 38 units. 185€–250€ double. Rates include breakfast. Metro: Evangelismos. **Amenities:** Bar/restaurant; gym; free Wi-Fi.

Monsieur Didot ★★ A neoclassical townhouse on a shady street at the edge of Kolonaki retains woodwork and other original details of this recently converted private home. Each of the large, high-ceiling rooms is different, one with its own terrace, another with a separate entrance; all are tastefully furnished with custom-made traditional and contemporary pieces, original art, and well-stocked bookcases (room names, in fact, are literary references: The Sonnet, The Ode, etc.). Though communal space is minimal, the two manager/owner sisters and their small, hospitable staff are on hand to make sure

guests have a pleasant stay. The upscale shops of Kolonaki are in one direction, edgy Exarchia in the other.

Sina 48. monsieurdidot.com. ✆ **210/363-7625.** 6 units. 160€–200€ double. Rates include breakfast. Metro: Panepistimiou. **Amenities:** Roof terrace; library; free Wi-Fi.

St. George Lycabettus Hotel ★★ Large, nicely decorated guest rooms (they're done in different motifs, from art nouveau to contemporary) and a beautiful rooftop pool do justice to a wonderful location—the pine-scented slopes of Lycabettus Hill, just above the boutique-lined streets of Kolonaki. The Lycabettus cable car is just outside the door and Syntagma Square is an easy walk away. Most rooms look toward the summit; some have Acropolis views, and others overlook a small park or the hotel's interior. Non-guests can use the pool for 45€.

2 Kleomenous. www.sglycabettus.gr. ✆ **210/729-0711.** 154 units. 190€–250€ double. Parking 14€ a day. Metro: Syntagma or Evangelismos. **Amenities:** 2 restaurants; 2 bars; concierge; pool; room service; art gallery; cinema; free Wi-Fi.

Moderate

Acropolis View Hotel ★★ The leafy, quiet neighborhood around this pleasant little inn on the south side of the Filopappou Hill is an easy walk from Plaka, and the Grand Promenade is just outside the front door, putting the ancient sights just steps away. Its airy, spotless rooms are freshly done in earth tones. Some face the Acropolis, as does the roof terrace; others overlook the Filopappou, a slightly less dramatic but pleasing prospect.

Rovertou Galli and Webster 10. www.acropolisviewhotel.gr. ✆ **210/921-7303.** 32 units. 55€–130€ double. Rates include buffet breakfast. Metro: Akropoli. **Amenities:** Breakfast room; bar; roof garden; free Wi-Fi.

Attalos Hotel ★★★ A roof garden with a well-stocked bar and knockout Acropolis views is one of the many appeals of this longtime favorite, a comfortable and friendly base within walking distance of Monastiraki, the Plaka, the Central Market, and ancient sights. Guest rooms are extremely well kept, and soundproofed windows and walls (a rarity in this hotel category) ensure a good night's sleep. Some choice balcony rooms even offer views of the Acropolis or the Lycabettus hill. This is known as maybe the best good-value lodging in central Athens (especially for the so-called economy rooms), so it's wise to book well in advance.

Athinas 24. www.attaloshotel.com. ✆ **210/ 321-2801.** 78 units. 65€–150€ double. Breakfast 9€ (included in some rates). **Amenities:** Roof garden; bar; free Wi-Fi.

The Attalos Hotel offers a great value in Central Athens with its comfortable, if simple, guest rooms and Acropolis-view roof garden.

Coco-Mat Athens BC ★★★ Poised at ground zero for Athens sightseeing, this outpost of contemporary luxury is across the street from the Acropolis Museum and a near neighbor to the Plaka, Temple of Olympian Zeus, and the Koukoki restaurants. Locale is not all this place has to offer, though—beautifully designed spaces incorporate the glassed-over remains of a Roman villa, and a rooftop pool and bar top off guest rooms done in natural fabrics and muted tones, the best with close-up Acropolis views. Beds are supremely comfortable, as they should be, since this chain is part of the empire that created the Coco-Mat mattresses you'll encounter all over Greece.

Falirou 5. www.athensbc.com. ℗ **210/723-0000.** 115 units. 110€–180€ double. Rates include buffet breakfast. Metro: Akropoli. **Amenities:** Restaurant; 2 bars; indoor and outdoor pools; spa; gym; bikes for rent; free Wi-Fi.

Fresh Hotel ★★ Soothing minimalist design accented with bright colors, along with a rooftop pool and view-filled cocktail terrace, put a fresh face on this hotel between the Central Market and Omonia. Laid-back ambiance, a helpful young staff, and appealing in-house bar/restaurants serving light Mediterranean fare, all provide a soothing break from the city bustle. Stylish, artful rooms include such modern amenities as window blinds that can be controlled from the beds. When you're ready to hit the streets, hip Psyrri is nearby, and Plaka and the Acropolis are within walking distance.

Sofokleous 26. www.freshhotel.gr. ℗ **210/524-8511.** 133 units. 90€–170€ double. Rates include buffet breakfast. Parking 12€ a day. Metro: Omonia or Monastiraki. **Amenities:** Restaurant/bar; pool; gym; free Wi-Fi.

Herodion ★★ Handsome contemporary furnishings and colorful artwork lend an air of luxury to this family-run Plaka inn, a favorite of return travelers. The Tsimidopoulos family's hospitality is a top attraction, along with the popular Point rooftop bar and restaurant and adjoining hot-tub-equipped terrace, with full-on views of the Acropolis and Acropolis Museum. Many of the attractive rooms have the same views, some from balconies.

Rovertou Galli 4. www.herodion.gr. ℗ **210/923-6832.** 90 units. 150€–275€ double. Rates included breakfast. **Amenities:** 2 bars; 2 restaurants; roof terrace; free Wi-Fi.

O & B ★★ Psyrri's clubs, as well as many of the central city's ancient and modern sites, are just outside the door, making this relaxed, intimate hotel a hit with travelers wishing to get the most out of Athens life. Lots of style, highly personalized service, high-tech amenities, and beautifully designed earth-toned rooms all add up to a chic but friendly urban experience. Some quarters overlook the surrounding streets, many with balconies. The choicest accommodation is the junior suite with Acropolis views from its terrace. The hotel's lounge/bar and restaurant are popular local haunts.

Leokoriou 7. www.oandbhotel.com. ℗ **210/331-2950.** 11 units. 130€–170€ double. Rates include buffet breakfast. Metro: Thissio or Monastiraki. **Amenities:** Restaurant; lounge bar; free Wi-Fi.

Pallas Athena Hotel ★ Ten international artists were picked to outfit this hotel's 57 "graffiti" rooms with themes ranging from Japanese and

Byzantine art to comic book art. Decorated with birds, trees, flowers, clouds, or superheroes, they lean towards the psychedelic, but some more Zen-like surroundings, bathed in neutral tones, are also available. Despite the pervasive gimmickry (the check-in desk is fashioned from two converted Mini Coopers), all the accommodations are solidly comfortable and service is friendly and down-to-earth. The streets beyond the front door definitely have some urban grit, but many city stops—including the Central Market and Monastiraki—are close at hand.

Athinas 65 and Lycourgou. www.grecotelpallasathena.com. ☎ **210/325-0900.** 79 units. 125€–190€ double. Rates include buffet breakfast. Metro: Omonia or Monastiraki. **Amenities:** Restaurant/bar; gym; free Wi-Fi.

Periscope ★ The strong minimalist design here—all grays and whites, industrial-style bathrooms with powerful showers, and "periscope-like" aerial shots of the city throughout—doesn't sacrifice comfort, and it fits right into the stylish Kolonaki neighborhood. Some of the city's best shopping and cafe life is just outside the door, and the Benaki and Cycladic Art museums are near neighbors. The lobby and rooftop bars are scenes in themselves.

22 Haritos. www.yeshotels.gr. ☎ **210/623-6320.** 22 units. 120€–225€ double. Most rates include buffet breakfast. Metro: Evangelismos. **Amenities:** Cafe/bar; restaurant, gym; free Wi-Fi.

Inexpensive

Acropolis House Hotel ★ One of a cluster of basic but clean lodgings in a quiet corner of the Plaka, the Acropolis House occupies a 150-year-old villa and a slightly newer attached wing. Original features include murals revealed during renovations and a breezy terrace. Be sure to ask for one of the older rooms when booking—those in the newer wing are bland and many of their bathrooms, though private, are across the hall. Rooms 401 and 402 have good Acropolis views.

Kodrou 6–8. ☎ **210/322-2344.** 19 units. 55€–115€ double. 10€ surcharge for A/C. Rates include continental breakfast. Metro: Syntagma. **Amenities:** Free Wi-Fi.

Adonis Hotel ★ Room decor at this basic, value-for-money fixture in the Plaka is spruce and nicely done in neutral tones. Attractive but functional furnishings don't go much beyond a bed and a chair, while bathrooms are well equipped but small. Compensating for a lack of luxury are a prime location (on a pleasant back street just a 10-min. walk from Syntagma Sq.) and outdoor spaces: All rooms have balconies, from which a slight neck crane affords an Acropolis view, and an airy roof terrace houses a pleasant bar.

3 Kodrou and Voulis. www.hotel-adonis.gr. ☎ **210/324-9737.** 26 units. 75€–100€ double. Rates include continental breakfast. Metro: Syntagma. **Amenities:** Cafe/bar; rooftop garden; free Wi-Fi.

Art Gallery Hotel ★ A 1950s house beneath Filopappou Hill was once the residence of a visiting artist, who left many of her works behind. Even the vintage cage elevator evokes more gracious times. Many guests settle in for

months at a time, and the hardwood floors and polished old furniture have a homey, lived-in sheen. Note that some bathrooms, while private, are across the hall from rooms. A buffet breakfast (8€) and evening cocktails are served in a top-floor lounge and roof garden with views of the Acropolis.

5 Erechthiou. www.artgalleryhotel.gr. ℂ **210/923-8376.** 22 units. 50€–80€ double. Metro: Syngrou-Fix. **Amenities:** Roof terrace; free Wi-Fi.

Athens Studios ★★ These spacious apartments, with decent kitchens, basic yet spiffy contemporary furnishings, and private balconies overlooking the pleasant neighborhood, are a big hit with families, who also appreciate the self-service laundry, in-house cafe, and two bars, one on the rooftop. Twin beds and separate sitting areas make the units well suited to unattached traveling companions and small groups. Travelers on a tight budget can check into one of the multi-bed dorms. The Acropolis and Acropolis Museum are just a few steps away, and among many perks—including the friendly, laidback atmosphere—are walking tours of the surrounding sights.

Veikou 3a. www.athensstudios.gr. ℂ **210/923-5811.** 26 units, 60 dorm beds. 80€–120€ private double, from 20€ bunk in dorm. Rates include breakfast. Metro: Akropoli. **Amenities:** Cafe; 2 bars; laundry; baggage storage; free Wi-Fi.

Central Athens Hotel ★ A prime Plaka location, just 2 blocks off Syntagma Square, comes with a big perk—a roof garden with views of the Acropolis that you can enjoy while soaking in a communal Jacuzzi. Rooms are no-nonsense contemporary, geared to practical comfort rather than luxury; the choicest enjoy Acropolis views from small balconies. Some rooms can be connected for families or guests traveling in groups. Given the proximity of the Syntagma Metro, airport bus connections, and city sights, this is a good choice if you're only in town for a night or two on your way to the islands.

Apollonos 21. www.centralhotel.gr. ℂ **210/323-4357.** 84 units. 90€–140€ double. Most rates include breakfast. **Amenities:** Restaurant/bar; free Wi-Fi.

Dave Red ★★★ Call the decor barebones or minimalist chic, but the small rooms at this smartly refurbished property are comfortable and extremely functional, with excellent showers and clever open storage; many even have narrow balconies. With pleasant communal spaces—a roof terrace and lounge—it all adds up to extremely good value. The surrounding streets are gritty, but a well-lit pedestrian arcade leads from the front door to bustling Omonia square, and a friendly ground-level bar (plus a police station across the street) instills a sense of safety to nighttime comings and goings.

Veranzerou 25 at M. Kotopouli. brownhotels.com/athens/davered. ℂ **214/402-7660.** 70 units. 65€–85€ double. Breakfast 10€. Metro: Omonia. **Amenities:** Bar/restaurant; free Wi-Fi.

Dorian Inn ★ The big draw here is the large rooftop pool, a perk that few other central hotels in this price range offer. This chance to cool off after a day of sightseeing, along with relaxing on a breezy roof lounge with city views in every direction, offsets a decidedly gritty west-of-Omonia location. The staff is extremely professional and friendly, spacious rooms are comfortable in a

chain-hotel sort of way, and the Metro, Psyrri nightlife, and the National Archaeological Museum are all nearby.

15–19 Tsaldari. www.dorianinnhotel.com. ⓒ **210/532-9782.** 145 units. 85€–135€ double. Rates include buffet breakfast. **Amenities:** Bar; 2 restaurants; pool; free Wi-Fi.

Jason Inn Hotel ★ At this basic but cheerful and well-run place you are at the edge of the city's trendy enclaves of Psyrri, Gazi, and Thissio, and just steps from Monastiraki's busy cafes. The Kerameikos cemetery, with some of the city's most intriguing ruins, is just across the street. Rooms, some set up for families of four, are furnished with IKEA-style modern flair; most have balconies, and all have use of a rooftop terrace. If the inn is full, the staff may be able to find you a room in one of their other hotels in the vicinity.

Agion Assomaton 12. jason-inn.hotelsathens.org. ⓒ **210/325-1106.** 57 units. 70€–110€ double. Rates include buffet breakfast. Metro: Thissio. **Amenities:** Breakfast room; bar; roof garden; free Wi-Fi.

Marble House ★★ This longtime fixture in Koukaki, a residential quarter just south of the Acropolis, is at the end of a dead-end lane, where you can enjoy the quiet setting from a marble-sheathed front verandah or from little balconies off many rooms. Comfortable sponge-painted guest rooms, furnished with iron bedsteads and antiques, include refrigerators (handy for stocking up at nearby grocery stores) and ceiling fans (you can also pay an extra 5€ for air-conditioning). A few units have kitchens, as does a ground-floor apartment next door. The surrounding area has many popular restaurants

Set in a quiet residential area, Marble House offers comfortable guest rooms, some with balconies, though not all with private bathrooms.

and bars and the Acropolis Museum is nearby. *Note:* The hotel accepts credit cards to hold reservations but often asks for payment in cash upon arrival.

Anastasiou Zinni 35. www.marblehouse.gr. ℂ **210/923-4058.** 16 units. 30€–50€ double w/private bathroom, 25€–45€ double w/shared bathroom, apartment 55€–80€. Breakfast 5€. Metro: Syngrou-Fix. **Amenities:** Free Wi-Fi.

Student and Traveller's Inn ★ When location matters and budget is an issue, look no farther than this well-run and attractive hostel on a pretty pedestrian street at the edge of the Plaka. Accommodations are in multi-bunk dorms or, for those with a bit more cash, in small private rooms, some with private bathrooms and balconies. A few larger units are set up for families.

Kydathinaion 16. www.studenttravellersinn.com. ℂ **210/324-4808.** 40€–60€ double w/ private bathroom, 35€–45€ double w/shared bathroom, 18€ bunk in dorm. Metro: Syntagma. **Amenities:** Courtyard; free Wi-Fi.

WHERE TO EAT IN ATHENS

Dining in Athens in a real pleasure, with excellent cooking taking center stage everywhere from traditional tavernas to the latest hotspots. Settings are wonderful, too, as many restaurants occupy old houses and shady courtyards. Probably the only restaurants to avoid are those with waiters stationed outside to lure diners: That's almost always a giveaway that the place caters to tourists—the meal may not be terrible, but it's likely to be mediocre, and you won't get the full Athenian dining experience. A meal in Athens, particularly dinner, is to be relished, never rushed and preferably enjoyed alfresco.

Expensive

Aleria ★★★ MODERN GREEK A restored and stunningly decorated neoclassical mansion with a romantic courtyard is the setting for one of the city's most memorable dining experiences, where chef Gikas Xenakis offers tasting menus—one a feast of meat and seafood, the other vegetarian, both paired with Greek wines. Pastitsio and other innovations on Greek classics are also available a la carte.

Meg. Alexandrou 57. www.aleria.gr. ℂ **210/522-2633.** Main courses 20€–30€, set menus 55€–75€. Mon–Sat 7pm–12:30am. Metro: Metaxourgeio.

GB Roof Garden ★★ MEDITER-RANEAN Politicians, royalty, and Hollywood stars have all enjoyed a meal and knockout Acropolis views

The romantic courtyard of Aleria, one of Athens's most memorable places to dine.

here, atop the city's poshest hotel, the Grande Bretagne (p. 76). The outlook and swank don't overshadow an excellent menu that combines Greek and Italian flavors, with non-fussy pastas alongside fish and steaks done on the grill or in a wood-burning oven. It's also a top spot for a sunset cocktail. Whatever brings you here, dress in smart casual attire.

Grande Bretagne Hotel, Syntagma Sq. www.gbroofgarden.gr. ℭ **210/333-0000.** Main courses 30€–50€. Daily 6:30–11am and 1pm–2am. Metro: Syntagma.

Moderate

Café Avissinia ★★ GREEK Take refuge from the surrounding flea market in this atmospheric, old-fashioned lair, a long-standing city institution. Homey seafood dishes (including plump mussels roasted in wine and washed down with ouzo) star on the menu, alongside stews and other traditional fare. The house wine is delicious, and live music wafts through the old rooms on Saturday and Sunday afternoons.

Kinetou 7 at Abyssinia Sq. cafeavissinia. net. ℭ **210/321-7047.** Main courses 10€– 15€. Tues–Sat 11am–2am, Sun 11am–7pm; closed mid-July to Aug. Metro: Monastiraki.

Chez Lucien ★ FRENCH You might have to wait to get a place at one of the shared tables in this small knick-knack-filled room, a throwback to 1960s bohemian Paris, but it's

Near the Abyssinia Square flea market, Café Avissinia has been serving homey traditional Greek food for years.

worth the trip to the slightly out-of-the-way Petralona neighborhood. The French bistro fare here, offered on drinks-included set menus, is delicious and much less expensive than you'll find at other Athens outposts of French cooking.

Troon 32. ℭ **210/346-4236.** Main courses 18€–25€. Tues–Fri 6pm–midnight, Sat 1pm–midnight, Sun 1:30–11pm. Metro: Petralona. Bus: 227.

Fabrica tou Euphrosinos ★★ GREEK Honoring Euphrosinos, the patron saint of cooks, this kitchen aspires to a monastery style of cooking, using only seasonal produce, artisanal cheeses, and fresh-baked breads and pastries. The results are delicious, served in a multilevel space fitted out eclectically with contemporary art and retro furnishings. The tempting menu is drawn from around Greece, with slow-cooked rooster, lamb stews, and vegetable-rich salads, all accompanied by an extraordinary wine list.

Anastasiou Zinni 34. www.fabricaefrosinou.gr. ℭ **210/924-6354.** Main courses 9€–15€. Tues–Fri 5–11pm, Fri–Sat 1pm–midnight, Sun 1–11pm. Metro: Sygrou-Fix.

Klimitaria ★★★ GREEK Stone walls laced with climbing plants and huge wine barrels add plenty of atmosphere to a Pysrri institution that, in various guises, has been feeding the neighborhood for more than a century (and claims to stand above a sanctuary to Apollo). Several times a week the excellent moussaka, pasticcio, slow-cooked lamb, and other homey classics, with daily specials on display near the kitchen, are accompanied by *rembetika* music, which draws a crowd—Pericles, one of the owners, is a musician of some note. Reservations are a good idea at any time.

Theatrou Sq. 2. www.klimataria.com.gr/start. © **210/321-6629.** Main courses 8€–18€. Daily noon–2am. Metro: Omonia or Panepistimiou.

Oinopoleion ★★ GREEK The name means "wine shop," and aptly so: The Markou family began selling wines from their suburban vineyards on these premises in 1928, soon adding a small *mageireio* (cookhouse) for craftsmen from surrounding workshops. They've since evolved the business into a friendly neighborhood taverna, focusing on dolmades, moussaka, grilled meats, and other classics, still accompanied by their own wines. It's all served in an old-fashioned room up front and a delightful garden in back.

Aischylou 12. oinopoleio.gr. © **213/008-1461.** Main courses 7€–16€. Wed 4:30–11:45pm, Thurs–Fri 4–11:45pm, Sat–Sun 12:15–11:45pm. Metro: Monastiraki.

Mani Mani ★★★ GREEK In these attractive upper-floor dining rooms around the corner from the Acropolis Museum, the focus is on the flavorful cuisine of the namesake region, the barren, rugged tip of the Peloponnese (captured in stunning photographs and murals on the white walls). Mountain herbs infuse rooster *bardouniotikos* stuffed with *siglino* (cured pork), or *hilopite,* noodles topped with chicken, fennel, and sun-dried tomatoes, while shrimp with orzo and other seafood dishes pay tribute to the sunbaked, sea-girt region. A well-heeled crowd pours in to enjoy this country fare, so reserve a table if you want to join them.

Falirou 10. manimani.com.gr. © **210/921-8180.** Main courses 10€–20€. Daily 2–11pm. Metro: Akropoli or Syngrou-Fix.

To Steki tou Ilia ★ GREEK/GRILL HOUSE This grill house set along a pedestrian street encourages a leisurely meal—part of the name, "ilias," means "hangout," and that's what many regulars come to do. The house specialty is an irresistible *paidakia*—chargrilled lamb chops served the old-fashioned way, with grilled bread sprinkled with olive oil and oregano. There's a second location at 5 Eptachalkou St., Thissio (© **210/345-8052**).

Thessalonikis 7. © **210/342-2407.** Main courses 8€–18€. Mon–Sat 1pm–1am; Sun 1–5:30pm. Metro: Thissio.

Vlassis ★★ GREEK For a home-cooked meal, do what the Athenians do and head to this neoclassical mansion in a quiet neighborhood near the American embassy. Greeks call this kind of food *paradisiako* (traditional); dozens of salads, spreads, and small meat and seafood dishes are brought to your

table in the art-lined dining room or flowery terrace and you pick what you want. Be forewarned—you'll be tempted to take more than you can eat!

Meandrou 15. vlassisrestaurant.gr. ℂ **210/646-3060.** Main courses 7€–15€. Mon–Sat 1pm–midnight, Sun 1–5pm. Metro: Megaro Mousikis.

Inexpensive

Avli ★★★ GREEK Once you've found this welcoming courtyard (*avli*) tucked away in Psyrri beyond a small graffiti-ridden door, the worn furnishings and funky decor make it clear the emphasis is on good food and good times. You wont find a long menu here—instead the tiny kitchen sends out mezes, or small plates, of cabbage rolls, country sausages, and what many regulars consider to be the best *keftedes* (meatballs) in town.

Agiou Dimitrou 12. ℂ **210/321-7624.** Small plates from 6€. Wed–Fri and Sun 1pm–2am, Sat 1–3pm. Metro: Panepistimiou.

Dio Dekares I Oka ★★★ GREEK At this Koukaki neighborhood favorite, red-checked tablecloths and soft lighting create an atmosphere as welcoming as the friendly service and lovingly prepared meals. Daily specials, displayed next to the kitchen, always include fresh fish and grilled meats, accompanied by a *magirefta* or two (one-pot meals) and lots of appetizers and salads. Even a straightforward moussaka or simple baked eggplant with feta are reminders of just how flavorful well-prepared Greek home cooking can be.

Anastasiou Zinni 29-3. dyodekaresioka.gr. ℂ **210/922-0583.** Main courses 8€–13€. Daily 12:30–11:30pm. Metro: Syngrou-Fix.

Friendly service and a crowd of regulars nake Dio Dekares I Oka a neighborhood favorite, off the tourist trail.

Fast-Food Classics

Whether it's a gyro or slice of baklava you're craving, it's easy to find authentically Greek fast food in Athens, and these places especially merit going out of your way to enjoy. **Kostas,** Pentelis 5 (Metro: Syntagma), has been dispensing *souvlaki* from a street-side window in the Plaka for about 70 years. The formula never varies: just-baked pita, marinated and grilled pork, dairy-fresh yogurt, home-grown tomatoes, onions, and parsley, salt, and pepper. The current Kosta, grandson of the founder, serves Monday to Saturday from 9am to 4pm, but he often runs out by 2 or 3pm. A stop for *loukamades* is old-fashioned **Ktistakis,** Socrates 59 (✆ **210/524-0891;** Metro: Omonia). Bentwood chairs and marble floors evoke the early 20th

century, when the family began making these treats, best described as deep-fried doughnut holes—though that doesn't do justice to the carefully crafted dough balls filled with honey and sprinkled with cinnamon. They serve Monday to Friday 9am to 8pm, Saturday 10am to 8pm, and Sunday 11am to 8pm. A holdover from the days when milk bars were commonplace in Athens, unfussy **Stani,** Marika Kotopouli 10 (✆ **210/523-3637;** Metro: Omonia), is still *the* place for sheep's-milk yogurt, drizzled with country honey and topped with walnuts. Delicious pastries and fried eggs are also offered for an all-day breakfast or snack, Monday–Saturday 6:15am–11pm and Sunday 7:30am–11pm.

Diporto ★ GREEK No sign, no menu, no English—descend the steps to this basement lair to experience a throwback to old-time working-class Athens, where you're likely to share a rustic table with a longtime regular. The kitchen serves five or six daily dishes, often a chickpea stew or platter of fried fish. Wine is dispensed from barrels along one wall—go for the old-fashioned retsina, a perfect accompaniment to the home-style cooking. Diporto (the name refers to the two doors at the top of the stairs) often closes in summer, when even Athenians can't take the heat in the cramped space.

Sokratous 9. ✆ **210/321-1463.** Main courses about 8€. Mon–Sat 8am–7pm. Metro: Omonia or Monastiraki.

Epirus ★★ GREEK Butchers, fishermen, surly loners, chic shoppers, and bar-hoppers rub elbows at one of the city's favorite stops for old-fashioned home cooking. The big draw is the tripe soup, a surefire cure for a hangover and a fortifying start to the day for the market workers who pour in at dawn. Many other soups, stews, and traditional favorites like moussaka are usually on the huge old stove—including the ever-popular *magiritsa* soup, with lamb offal, or rich fish and chicken soups. Diners enjoy views of the kitchen in one direction and the market stalls in the other.

Filopimenos 4 (inside the Central Market). ✆ **210/324-0773.** Main courses 6€–10€. Mon–Sat 6am–8pm. Metro: Omonia, Panepistimiou, or Monastiraki.

Fatsio ★★★ GREEK The name may evoke an Italian trattoria, but this 70-year-old landmark is pure Athenian, named for founder Georgios Fatsio.

Like the comfy decor, home-style dishes are decidedly old-school, slightly infused with the flavors of Greek Istanbul. Artichokes in lemon sauce, meatballs, baked fish, savory meat patties, and other standards are served from hot plates, and casserole dishes set outside the kitchen are popular with a crowd of regulars. Attentive service enhances the charming experience.

Efroniou 5. www.fatsio.gr. ℰ **210/721-7421.** Main courses 7€–12€. Daily 11am–6pm. Metro: Evangelismos.

Platanos Taverna ★ GREEK A beloved institution to many, established in 1932, stands out amid its tourist-trap neighbors. Succulent roast lamb with artichokes brings regulars back time after time to dine in a pretty courtyard beneath a plane tree (*platanos*). The wine list includes a wide choice of bottled wines from all around Greece, although the house wine is tasty.

Dioyenous 4. ℰ **210/322-0666.** Main courses 10€–11€. Mon–Sat noon–midnight, Sun noon–5pm. Metro: Monastiraki or Syntagma.

Scholarchio ★★ This popular old *ouzeri*, its white walls lined with paintings by customer artists, is geared to pleasing a crowd—and has specials for groups of four or more. Choose from a tray of 18 delicious appetizers: tzatziki, moussaka, taramosalata, fried eggplant, sausages (served flaming), and the rest of the roster of Greek classics. An appreciative and often boisterous following comes regularly to partake.

Tripodon 14. www.scholarhio.gr. ℰ **210/324-7605.** Meze 3€–8€. Daily 11:30am–12:30am. Metro: Syntagma or Monastiraki.

Ta Karamanlidika tou Fani ★★ GREEK A modern-day *mezetzidikot* (combo taverna-deli-meze house) takes you on a gastronomic tour of Greece, with a regional array of cheeses, cured meats (*pastirma*), savory pies, and cold mezes, followed by platters of grilled country sausages and other heartier fare, along with delicious baklava and other sweets. The old-fashioned high-ceilinged neoclassical room does justice to the honest cuisine, and cases and shelves around the tables display cured meats, olive oil, honey, and other products for sale from selected small-scale producers.

Sokrates 1. karamanlidika.gr. ℰ **210/325-4184.** Small plates from 7€. Mon–Sat 8am–11pm. Metro: Monastiraki or Omonia.

To Paradosiako Evgenia ★★ With the busy Plaka as a backdrop, a snack or meal at this coffeehouse/taverna comes with delicious food and friendly service, either at sidewalk tables or in two small flower-filled rooms. Grilled sardines, fried *gavros* (anchovies), and country sausages appear alongside dips and other mezes, including what might be the best fava bean spread in the city, accompanied by crusty bread. Oven-cooked standards, all made fresh daily, include a memorably creamy moussaka.

Voulis 44. ℰ **210/321-4121.** Meze 4€–7€, main courses 8€–10€. Mon–Fri 8am–noon and 4–11pm, weekends 8am–midnight. Metro: Syntagma.

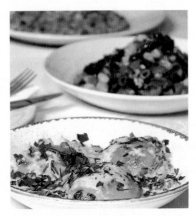

Tzitzikas kai Mermigas ★

MODERN GREEK Kebabs, meat and vegetable pies, onions stuffed with bacon, and other traditional dishes are served on tables topped with butcher paper in a whimsically retro room that evokes an old-fashioned grocery store. The food and decor is a big hit with Athenians: You'll find several other branches around town.

Mitropoleos 12–14. www.tzitzikas mermigas.gr. ⓒ **210/324-7607.** Meze 4€–8€. Tues–Thurs 6:30pm–12:30am, Fri 6:30pm–1am, Sat 1pm–1am, Sun 1–11:30pm. Metro: Syntagma.

Evoking an old-fashioned grocery store, Tsitsikas kai Mermigas delivers traditional Greek street food and meze for a quick, satisfying meal.

EXPLORING ATHENS

One important thing to know about Athens: Much of what you want to see is clustered on and around the Acropolis Hill, so you can visit a lot of sights fairly easily on foot. Many visitors give the capital 2 days, tops, before shipping out for the islands. That's enough time to see the **Acropolis** (p. 92) and the two treasure troves of ancient art, the **Acropolis Museum** (p. 93) and the **National Archeological Museum** (p. 110), and also wander through the Plaka and Monastiraki neighborhoods, with their rich street life and scattering of antiquities. You'll no doubt end up wanting more, though, and this lively, cosmopolitan, just plain fun city has plenty else to offer.

The Acropolis & Nearby Sights

The beloved 2,400-year-old landmark of Greece's Golden Age stands high above the city (Acropolis means "High City"), an enduring symbol of perfection that instills pride in even the most hard-nosed Athenians, and awe in their visitors. Wars, plunder, pollution, and neglect have taken their toll on the Parthenon, the harmonious temple to Athena, and the smaller monuments that

Save with the Acropolis Ticket Package

If you plan to see a number of Athens's classical sites, you can score significant savings by purchasing the **Acropolis combination ticket** for 30€. Valid for 5 days, this package includes admission to the Acropolis, Theater of Dionysus, Temple of Olympian Zeus, the Ancient Agora, the Roman Forum, the Library of Hadrian, and Kerameikos Cemetery. You can buy the ticket at any of the sites. Individual entry fees could add up to 54€, so the pass represents a substantial savings, at least in summer (admission prices to many sites drop by half in the winter, while the ticket package costs the same).

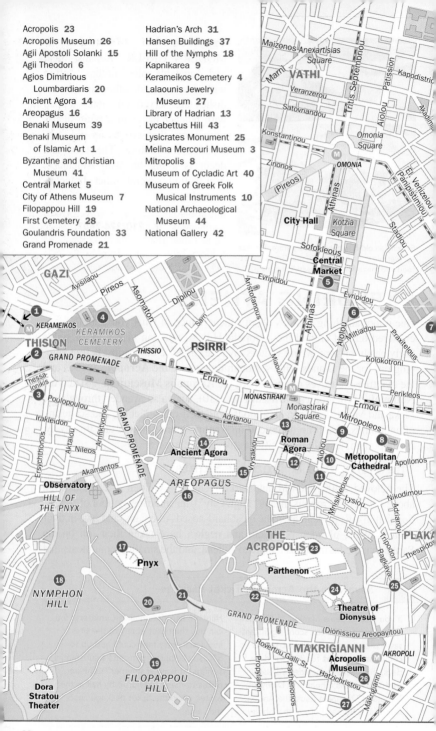

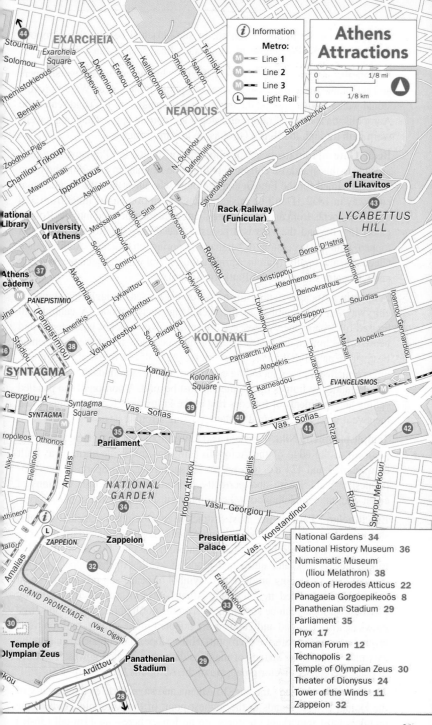

Athens Attractions

EXARCHEIA

Stournari
Solomou
Themistokleous
Benaki
Zoodhou Pigis
Chariliou Trikoupi
Mavromichali

National Library

University of Athens

Athens academy

SYNTAGMA

Georgiou A'

SYNTAGMA

ropoleos Othonos

sthineon

ZAPPEION

jalou

Temple of Olympian Zeus

Exarcheia Square

Devenion
Arachevis
Eresou
Methonis
Kallidromiou
Smolenski
Isavron
Tsimiski

NEAPOLIS

N. Ouranou
Dafnomilis

Sarantapichou

Ippokratous
Asklipiou
Didotou
Sina
Skoufa
Chersonos
Massalias
Solonos
Omirou
Akadimias
Lykavittou
Dimokritou
Solonos
Pindarou
Skoufa
Fokylidou
Rogakou

Amerikis
Stadiou
Voukourestiou

Kanari

Kolonaki Square

Vas. Sofias

Syntagma Square

Parliament

NATIONAL GARDEN

Zappeion

Amalias
Filellinon
Nikis

Nikis

Amalias

GRAND PROMENADE
(Vas. Olgas)

Ardittou

kou

Theatre of Likavitos

LYCABETTUS HILL

Rack Railway (Funicular)

Doras D'Istria
Aristippou
Kleomenous
Deinokratous
Loukianou
Spefsippou
Aristodimou
Souidias
Ioannou Gennardiou
Alopekis
Marsali

KOLONAKI

Patriarchi Iokeim
Alopekis
Ploutarchou
Iliodotou

Karneadou

EVANGELISMOS

Vas. Sofias

Rizari

Rizari
Spyrou Merkouri

Irodou Attikou
Vasil. Georgiou II

Vas. Konstandinou

Eratesthenou

Presidential Palace

Panathenian Stadium

PANEPISTIMIO
(Panipistimiou)

Vas. Sofias

ZAPPEION

National Gardens 34
National History Museum 36
Numismatic Museum
 (Iliou Melathron) 38
Odeon of Herodes Atticus 22
Panagaeia Gorgoepikeoös 8
Panathenian Stadium 29
Parliament 35
Pnyx 17
Roman Forum 12
Technopolis 2
Temple of Olympian Zeus 30
Theater of Dionysus 24
Tower of the Winds 11
Zappeion 32

surround it on the hilltop. Even so, in sun-bleached beauty, the Acropolis continues to show the heights to which a civilized society can aspire.

Acropolis ★★★ ANCIENT SITE/RUIN In ancient times, worshippers and celebrants made the ascent to the Acropolis on the Sacred Way, a processional walkway that crossed the city from Kerameikos (p. 107) and scaled the Acropolis via a series of ramps and steps. The current approach, along a well-worn path through the **Beule Gate,** is no less inspiring.

Beule Gate From the ticket pavilion just off the Grand Promenade, a path ascends to this grandiose entryway built by the Romans in A.D. 280, and more recently named for the French archaeologist who unearthed the monumental entryway in 1852. (Don't be misled by the inscription on the lintel from 320 B.C.—fragments from an earlier monument were incorporated into the Roman gate.) Just beyond the gate is a pedestal that during the Roman years was topped with a succession of statuary honoring charioteers, Anthony and Cleopatra, and finally, Marcus Agrippa, the general who defeated the Anthony and Cleopatra's forces at the Battle of Actium.

Propylaia Ancient visitors to the Acropolis passed through this symbolic entryway, an antechamber to the sacred precincts beyond. A central hall housed five gates; one was reserved for priests, worshippers, charioteers, and beasts who climbed the Acropolis in a long procession during the Panathenaic Festival (depicted in the Parthenon Frieze; see p. 95). A forest of elegant columns remains in place, including a double row that surrounds the inner porch and dramatically frames the Parthenon, just beyond. A portion of the paneled ceiling and fragments of frescoes hint at the Propylaia's former grandeur and the awe it must have inspired in those passing through.

Temple of Athena Nike Tucked next to the Propylaia, on a vertigo-inducing platform at the edge of the Acropolis Hill, this miniscule shrine was built between 427 and 424 B.C. as a prayer for success against Sparta in the Peloponnesian War. Square and perfectly proportioned, with four columns at either end, the temple honors Athena in her guise as the goddess of victory.

Erechtheion Perhaps the most distinctive of all Greece's ancient temples stands on the spot where Poseidon and Athena allegedly squared off in a contest to see who would be honored as patron of the city. Poseidon struck his trident into a rock and unleashed a spring, while Athena topped him by miraculously producing an olive tree, symbol of peace and prosperity (much valued but short-lived in 5th-c.-B.C. Athens). Marks, supposedly made by Poseidon's trident, can be seen in a rock on the north porch, and an olive tree grows nearby. The god and goddess are honored in the temple, built on three levels to accommodate the Acropolis Hill's slope. It's supported in part by caryatids, columnlike statues of maidens draped in pleated gowns. The ones in place are copies; five originals are in the Acropolis Museum (p. 93).

The Parthenon The sanctuary to Athena and storehouse of the treasury of the Delian League stands at the highest point of the Acropolis. Two of the temple's most remarkable features are no longer here—an 11m-tall (36-ft.)

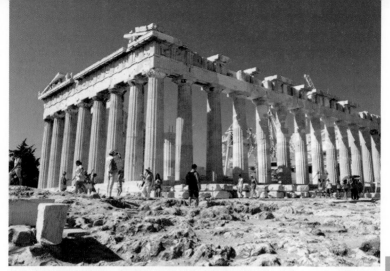

The main event in Athens, sightseeing-wise: The Parthenon, a spectacular temple to Athena that takes pride of place on the Acropolis hilltop.

gold-plated statue of Athena by the great sculptor Phidias, and the 160m (530-ft.) Parthenon Frieze. Segments of the frieze are in the Acropolis Museum (see below), while others were carted off to London by Lord Elgin between 1801 and 1805 (see p. 95 for more on Greece's battle to reclaim these treasures). Much the worse for wear—battered by looting, weather, pollution, and an explosion ignited by Venetian artillery in 1687—the majestic temple is still the symbol of artistic perfection. With a sharp eye you might detect an optical illusion; since straight lines appear curved, Parthenon architects slightly curved the temple's 50 columns so they appear perfectly straight.

Dionysiou Areopagitou. odysseus.culture.gr. ✆ **210/923-8747.** Admission 20€ (10€ Nov–Mar); included in Acropolis combination ticket (p. 89). Apr–Oct daily 8am–8pm; Nov–Mar daily 8am–5pm (last entries ½ hr. before closing). Elevator for visitors with disabilities.

Acropolis Museum ★★★ MUSEUM The sculptures and statuary that once adorned the temples of the Acropolis—a breathtaking presence through the tall windows—are shown to beautiful advantage here, among acres of glass and marble. Caryatids (female sculptures used as architectural supports), statues of Korai (maidens) dedicated to Athena, figures of Kouri (young men), and elaborate friezes—4,000 works altogether—are displayed in the light-filled galleries. What's not here are many segments of the Parthenon Frieze, carted off to England from 1801 to 1804. Greece wants these treasures back, and stunning quarters on the museum's top floor await their return.

A walk through the galleries, with their airy views of the Parthenon, mimics an ascent up the Acropolis Hill. On the ground floor, the **Acropolis Slopes** gallery houses votives, offerings, and other finds from sanctuaries at the base of the Acropolis, where cults to Athena and other gods and goddesses worshipped; an overlook provides a look at ruins *in situ* beneath the museum. The

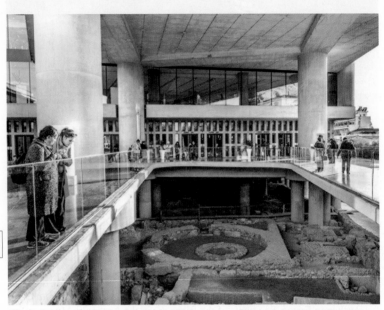

Museumgoers can study the statues and sculptures of the Acropolis close up in the galleries of the Acropolis Museum, while copies of the originals brave the elements on the hill above.

marble floor slopes to the next level, where works are arranged in the order in which ancients walking through the Acropolis would have seen them. A head of Hermes by Alkamenes, in the **Propylaia** collections, once greeted visitors going through the ceremonial entranceway; in the **Temple of Athena Nike** exhibit, a relief captures the goddess in a refreshingly humanlike pose, unfastening her sandal; and in the **Erechtheion** section, five famous caryatids, female figures used as columns on the temple's south porch, are grouped on a balcony. In the top floor **Parthenon Galleries,** friezes and metopes are arranged as they originally appeared on the temple, which can be viewed through floor-to-ceiling windows. Wrapping around the walls is a 160m-long (530 ft.) section of one of the world's greatest ancient treasures: the Frieze of the Great Panathenaia (also known as the Parthenon Frieze), a tableau of a procession in honor of Athena (see "The Frieze Fracas," p. 95).

Dionysiou Areopagitou 15. www.theacropolismuseum.gr. ✆ **210/900-0900.** Admission Apr–Oct 10€, 5€ students and kids under 18; Nov–Mar 5€, 3€ students and kids under 18. Apr–Oct Mon 8am–4pm, Tues–Thurs and Sat–Sun 8am–8pm, Fri 8am–10pm. Nov–Mar Mon–Thurs 9am–5pm, Fri 9am–10pm, Sat–Sun 9am–8pm (last entries ½ hr. before closing). Online booking highly recommended in summer.

Agios Dimitrios Loumbardiaris ★ CHURCH Legend surrounds this little 14th-century church nestled in a copse on Pnyx Hill. In 1645, so the story goes, the Ottoman commander of the Acropolis garrison planned to fire upon Christians gathering for services in honor of St. Dimitrios. The night before

THE frieze FRACAS

Fifty panels of the Parthenon Frieze—the remarkably animated marble frieze of maidens, priests, soldiers, worshippers, and oxen making their way to the Acropolis to honor the goddess Athena—are in the British Museum in London. Lord Elgin, one-time British ambassador to the Ottoman Empire, began removing segments of the frieze in 1801, supposedly with the permission of Turkish officials, and shipped them home. Greece is demanding the return of the treasures, carrying on a campaign that actress and minister of culture Melina Mercouri launched in the 1980s. Britain's long-standing argument that Greece can't properly care for the treasures is belied by the stunning new galleries that now stand completed, awaiting their return.

the attack, lightning hit the gunpowder magazine, igniting an explosion that killed the commander but spared his Christian daughter. The humble stone and wood church is decorated with some delightfully primitive frescoes.

Apostolou Pavlou, on the path opposite (south of) the Acropolis entrance. Free admission. Hours vary. Metro: Akropoli. Bus: 230.

Areopagus ★★ HISTORIC SITE A bald granite outcropping next to the Acropolis, reached by treacherous steps carved out of the rock, is one of the most ancient and storied places in Athens. According to legend, the gods tried Ares here for killing Halirrhothius, son of Poseidon. (Ares was acquitted on the grounds that he was protecting his daughter from Halirrhothius's unwanted advances.) The summit was also the meeting place of the Council of the Areopagus, an assembly of citizens who judged murder trials, and for Socrates and his students, who came here to discourse. St. Paul delivered his famous Sermon to an Unknown God from atop the Areopagus, trying to convert Athenians to Christianity. You may well encounter pilgrims from around the world who climb the hill to pay homage to Paul.

Continuation of Theorias opposite the Acropolis entrance. Metro: Akropoli. Bus: 230.

Filopappou Hill ★★ VIEWPOINT This summit, also known as Lofos Mousson (Hill of the Muses), lies just west of the Acropolis, affording stunning eye-level views of the Parthenon—views that have mesmerized gazers since the days of Pericles, when the general assembly (Ecckesia) met on the nearby Hill of the Pnyx (p. 98).

Follow Dimitriou Aiginitou off the Grand Promenade.

First Cemetery ★ CEMETERY Since the 19th century, prominent Athenians have been laid to rest in this parklike expanse of greenery that climbs the cypress- and pine-clad slopes of Ardittos Hill behind the Temple of Olympian Zeus. Among those buried here are Heinrich Schliemann, the archaeologist who uncovered Troy and Mycenae, and Melina Mercouri, the actress, politician, and activist who launched the battle for the return of the Parthenon

Frieze (p. 95). Other lesser-known people rest beneath spectacular monuments, many carved by stonemasons from the island of Tinos. The cemetery's most beloved monument is *Sleeping Lady* (1877), crafted by Tiniot Yannoulis Halepas for the tomb of Sophia Afentaki, the 18-year-old daughter of a wealthy Athenian. Walking along the shaded lanes is a popular outing; many Athenians come here to picnic near their loved ones' graves.

Anapafseos and Trivonianou. ✆ **210/923-6720.** Apr–Oct 8am–8pm; Nov–Mar 8am–5:30pm. Bus: A3, A4, 057, 103, 108, 111, 155, 206, 208, 237, 856, or 227.

Grand Promenade ★★★ LANDMARK A walkway of marble and cobblestone skirts the base of the Acropolis Hill, linking some of the world's most famous ancient sites, all the way from the Temple of Olympian Zeus and Hadrian's Arch to the Ancient Agora, providing a stroll through the millennia accompanied by the scent of pine. This walkway, officially known as Dionysiou Areopagitou through ancient Athens, continues along a branch from Plateia Thissio through Kerameikos Cemetery (p. 107) out to Gazi and along Andrianou through Monastiraki into Plaka. Walking along this pedestrians-only boulevard surrounded by the great monuments of ancient Greece is one of the capital's greatest pleasures.

Hadrian's Arch ★★ ANCIENT SITE This beautifully preserved, albeit soot-darkened, triumphal arch was erected in honor of the emperor in A.D. 131. The marble monument divided the old Greek city from the new Roman city that Hadrian—an ardent Hellenophile—endowed with many temples and monuments, naming the district Hadrianopolis after himself. Hadrian considered Athens the cultural capital of the Roman Empire, and he struck his claim to the city by having the arch's east side inscribed with "This is the city of

THE VISION OF pericles

Ever since the Acropolis was first inhabited, at least 5,000 years ago, the flat-topped, 156m-high (520-ft.) rocky outcrop provided Athenians protection and views of enemies approaching, either by sea or across the plains. Such measures proved powerless, however, against the Persians, who razed Athens and the Acropolis in 479 B.C.

Athenians and Spartans banded together to rout the Persians in 449 B.C., and a year later, the great general and statesman Pericles set about rebuilding the Acropolis. Plundering the state coffers, he hired the sculptor Phidias and the architects Iktinos and Kallikrates. Using the era's finest artisans, the purest marble, and a workforce of thousands, he completed the Parthenon within 10 years and most of the other temples and monuments within another decade or two.

The perfectly proportioned Parthenon and its neighbors on the Acropolis were showpieces for the superiority of Athens and the achievements of the Golden Age—the philosophy of Socrates, the plays of Aeschylus and Sophocles, the artistry of Praxiteles and other sculptors, and the birth of democratic ideals. Pericles bankrupted Athens by building the Acropolis; by 404 B.C. the city had fallen to the Spartans. But the harmony and proportion Pericles achieved on the Acropolis has survived the ages.

Hadrian and not of Theseus" and the west side with "This is Athens, once the city of Theseus." The gate is remarkably well preserved, though ignobly besieged by a swirl of passing traffic.

Amalias and Dionysiou Areopagitou.

Hill of the Nymphs ★ NATURAL LANDMARK The northernmost of the hills surrounding the Acropolis is topped by the **National Observatory,** built in 1842 to designs by Theophilos Hansen, the Danish architect of the Academy at the University of Athens (p. 109) and other public buildings around the capital. The observatory, with a French-built telescope from 1902, is open for tours, with some evening telescopic star-gazing. Just below is the multi-domed **Agia Marina** church, a 20th-century replacement of an earlier church honoring Saint Marina, the patron saint of childbirth. Her presence here continues the hill's long association with nymphs who were believed to protect pregnant women and sick children. Ancient Athenians would leave the garments of sick children beneath the trees in the hopes that nymphs would work a cure. In places the rugged hillsides are etched with caves, including one known as the Prison of Socrates, said to be where the philosopher was forced to drink hemlock after being found guilty of corrupting Athenian youth; the story is unproven (and highly unlikely) but adds a bit of romance to the bucolic surroundings. You may even see a herd of white ponies, grazing in their off hours when they aren't busy pulling buggies on the tourist route.

Dionysiou Areopagitou/Apostolou Pavlou. National Observatory Visitor Center: www. noa.gr. ✆ **210/349-0000.** Admission 5€ adults, 2.50€ students. Mon–Fri 9am–1:30pm and select evenings at 9pm (check website).

Lalaounis Jewelry Museum ★ MUSEUM Greece's millennia-long knack for crafting fine jewelry comes to the fore in the workmanship and style of internationally renowned designer Ilias Lalaounis (b. 1920). His magnificent gold and silver interpretations of Greek designs, inspired by cultures from the Minoans to the Ottomans, are displayed in the former Lalaounis workshops, alongside jewels and bling from around the world. The designer's dazzling pieces are on offer in the museum shop, but don't look for prices any lower than they are at other tony Lalaounis shops around the world.

Karyatidon 4 and Kallisperi 12. www.lalaounis-jewelrymuseum.gr. ✆ **210/922-1044.** Admission 5€. Mon–Sat 9am–3pm. Metro: Akropoli. Bus: 230.

Odeon of Herodes Atticus ★ ANCIENT SITE Wealthy statesman, scholar, and philanthropist Herodes Atticus funded works throughout Greece, including the baths at Thermopylae and a theater in Corinth. In A.D. 160 he presented to Athens this theater, tucked into the slopes of the Acropolis, in memory of his wife, Regilla. Since a 1955 restoration, audiences fill the 34 rows of seats for drama, music, and dance performances in the summertime Hellenic Festival. You may enter the theater only during performances, but walk around the pine-scented grounds and you can see portions of the arched exterior and get a sense of the theater's elegant proportions.

Grand Promenade, Thrassilou and Dionysiou Areopagitou.

CITY OF enlightenment

For almost 1,500 years—from around 900 B.C. to A.D. 500—Athens was one of the most important cities in the ancient world, a center of trade and for many centuries renowned for promoting art and philosophy. Much of the ancient city you see today was built or transformed by the Romans, who gave Athens free status and financed many public works. Athens enjoyed the favor of Hadrian and other Roman emperors until the 6th century, when Justinian, a Christian, declared the famous schools of philosophy to be pagan institutions and closed them.

Panathenian Stadium ★ ANCIENT SITE Built around 330 B.C. to host the Panathenian games, this arena has been well used over the millennia. Greco-Roman aristocrat Herodes Atticus (see above) had the stadium reconstructed in A.D. 143–144, and the so-called Kalimarmaro ("Beautiful Marble") underwent another redo by architect Ernst Ziller and Anastasios Metaxa to host the first modern Olympic Games in 1896. The Panathenian is still used for events; during the 2004 Olympics it hosted archery competitions and was the finish line for the marathon.

Vas. Konstantinou and Irodou Attikou. Metro: Akropoli.

Pnyx ★★ HISTORIC SITE The ancient Assembly met on the Pnyx during the 5th and 4th centuries B.C., which more or less makes the hilltop the birthplace of democracy. Any citizen of Athens was welcome to come here to debate and vote on matters of importance to the city. (Granted, women were not allowed to be citizens, and most residents of the city were slaves.) Pericles stood on this spot to argue for funds to build the Parthenon—which, once built, became such a distraction that in 404 B.C. the semicircle of benches was turned around so that the Parthenon was behind the Assembly members' backs. Take a seat and gaze across to the Acropolis to see just how engaging the spectacle of the monument still is.

Dionysiou Areopagitou and Apostolou Pavlou. Metro: Akropoli.

Temple of Olympian Zeus ★★ ANCIENT SITE The greatest monument that Roman emperor Hadrian bestowed upon his beloved Athens is this massive temple, the largest in Greece, completed in A.D. 131. The ruler Peisistratos had begun it in the mid-500s B.C., but work stopped for lack of funds; Aristotle later cited the temple as an example of the excesses with which tyrants enslaved the populace. By Hadrian's time the unfinished temple, with its vast foundations and huge columns, had lain abandoned for centuries. Hadrian may have been inspired to complete it after seeing two of its columns in Rome, installed in 81 B.C. by the general Sulla in the Temple of Jupiter on the Capitoline Hill. Hadrian's temple lacks the grace of the Parthenon but is undeniably impressive: 104 Corinthian columns, more than 1.5m (5 ft.) in diameter, stood 16m (52 ft.) tall. The 15 that remain in place are dramatically floodlit at night. At one time, a giant replica of Phidias's statue of Zeus (one

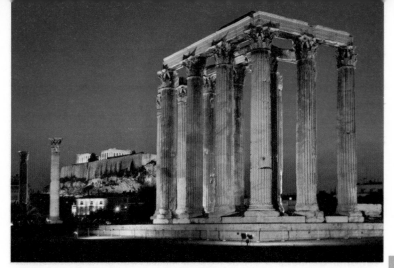

The massive Temple of Olympian Zeus was completed by the Roman emperor Hadrian, determined to leave his own mark on the great city of the Greeks.

of the Seven Wonders of the Ancient World) stood in an inner chamber, with a similarly grandiose statue of Hadrian himself next to it.

Vas. Olgas St. and Amalias Ave. odysseus.culture.gr. ℂ **210/922-6330.** Admission 3€; included in Acropolis combination ticket (p. 89). Daily 8am–5pm. Metro: Syntagma or Akropoli.

Theater of Dionysus ★★ ANCIENT SITE A theater has been tucked into the slope of the Acropolis Hill since the 6th century B.C., when Athenians began celebrating a Dionysus Festival to honor the god of wine and ecstasy with days of dancing, feasting, and drinking. Celebrations became more refined during the 5th-century B.C. Golden Age, when theatergoers came from all over Greece to see the dramas of Aeschylus, Sophocles, and Euripides. The ruins you see today are of a vast marble theater begun in 342 B.C. that sat 17,000 spectators on 64 tiers of marble benches; 20 rows remain, as does a claw-footed throne, carved with satyrs, reserved for the priest of Dionysus.

Grand Promenade, Thrassilou and Dionysiou Areopagitou sts. ℂ **210/322-4625.** Admission 2€; included in Acropolis combination ticket (p. 89). Apr–Oct Mon–Thurs 8am–8pm, Fri–Sun 8am–10pm; Nov–Mar 8am–3pm. Metro: Akropoli or Thissio.

Around Syntagma Square

This lively expanse of paving stones is figuratively and literally the center of Athens. It's overlooked by the formidable Parliament building, once the palace of Otto of Bavaria, the first monarch of a newly independent Greece, under whose less-than-stellar leadership the first constitution was adapted in 1843. Ever since, the square has been a hallowed ground of Greek nationalism, a stage for protests, celebrations, and—as you'll observe—the comings and goings of everyday life in the capital. Tree-lined **Vasillis Sofias,** the city's Museum Row—home to the Museum of Cycladic Art (p. 113), the Benaki Museum (p. 106), and several other collections—leads off the Square to the

east. **Plaka** and **Anafliotika,** two of the city's oldest neighborhoods, are just to the south; **Omonia,** the commercial center, is to the north; and the old working-class neighborhoods of **Monastiraki** and **Gazi** are to the west. Before you hurry off to explore, stop to take a peek at the ruins of Roman baths unearthed during construction of the Metro (more artifacts are displayed inside the modernistic station)—a wonderful example of the juxtaposition of ancient and modern that you'll often encounter in Athens.

Outside Greece's Parliament on Syntagma Square, soldiers of the elite Presidential Guard parade in in colorful 19th-century costumes.

National Gardens ★ PARK Queen Amalia, wife of King Otto, almost started another revolution back in the mid–19th century when she banned the Greek public from using the 16 hectares (40 acres) behind her palace, now the Parliament. Its lawns, paths, ponds, and gardens full of exotic plants from around the world have been open to all since 1923. With shady arbors and dense copses that burst with the song of parrots and other birds, they're a welcome refuge from the swirl of traffic just outside the gates.

Daily 7am–10pm. Free admission.

National History Museum ★ MUSEUM Palaia Vouli, or Old Parliament (it housed the Greek Parliament from 1875–1935), is a suitable home for collections that focus largely on "modern" Greek history, from the Ottomans' arrival in the 15th century to World War II. The Greek War of Independence is idealistically captured with such mementoes as the sword and helmet Lord Byron (p. 107) donned when he came to Greece to aid the cause. Less glorious chapters of the nation's past are depicted in galleries surrounding the former assembly chamber, from the harsh yoke of Ottoman rule to the Battle of Crete.

Stadiou at Kolokotroni. www.nhmuseum.gr. ℂ **210/323-7617.** Admission 3€ (free admission Sun and some holidays). July–Aug Tues–Sun 9am–4pm; Sept–June Tues–Fri 9am–4pm, Sat–Sun 10am–4pm. Metro: Syntagma.

Stepping Lively

In front of Parliament at Syntagma Square, two *Evzones*—soldiers of the Presidential Guard—keep watch at the Tomb of the Unknown Soldier (Amalias Ave. and Vas. Georgiou St.). It's easy to spot them, dressed as they are in the frilly white skirts and pom-pommed red shoes of their ancestors who fought to gain Greece's freedom during the War of Independence (1821–28). Every hour on the hour, the guards do some pretty fancy footwork in front of the tomb. A much more elaborate duty-rotation ceremony **(Changing of the Guard)** occurs on Sunday at 11am, usually to the accompaniment of a band.

Numismatic Museum (Iliou Melathron) ★★ HISTORIC HOME
Heinrich Schliemann, the German archaeologist who unearthed the ancient ruins of Troy and Mycenae, commissioned German architect Ernst Ziller to design his Athens residence, which he named Iliou Melathron (Palace of Troy). Ziller emblazoned the gates with swastikas (a popular design in ancient Greece) and decorated the vast interior with marble, columns, and ancient-looking frescoes—just the right setting for the learned Schliemann to entertain dinner guests by reciting the *Iliad* from memory. The splendid rooms are enhanced by the holdings of the Numismatic Museum, one of the world's finest collections of ancient and historic coins—600,000 in all, dating from 700 B.C., including many from Troy and Mycenae. Many coins are arranged by the themes depicted on them—loiter over the cases to compare charming representations of gods and goddesses, Roman generals and Byzantine emperors, and mythical beasts and sea creatures.

Panepistimiou 12. www.nummus.gr. ✆ **210/364-3774.** Admission 6€. Wed–Sun 8:30am–3:30pm. Metro: Syntagma.

Parliament ★ HISTORIC BUILDING The fortresslike palace that Munich architect Friedrich von Gaertner built for King Otto in 1848 probably did not endear the unpopular monarch to his Greek subjects. It's a formidable presence on Syntagma Square, perhaps befitting its present role as home to the Greek Parliament. Among the few signs of life are two photogenic soldiers in traditional *foustanellas* (ceremonial skirtlike garments) guarding the Tomb of the Unknown Soldier (see box, p. 100). The most impressive thing about this building is the way its stone changes color throughout the day, from off-white to gold to a light blush mauve before it is lit dramatically at night.

Closed to general public.

Zappeion ★ HISTORIC BUILDING Amid the nationalistic fervor of the newly formed Greek nation, millionaire Evangelias Zappas sought to build a hall to host world-fair-style exhibitions as well as ceremonies for the revived Olympic Games. Theophilos Hansen, who'd shown a neoclassical bent in his designs for the Greek Academy (p. 109) and National Library (p. 109), designed the huge semicircular hall, inaugurated in 1888 and named after Zappas. Hansen adorned the long facade with a portico and an elegant row of columns, but his pièce de résistance lies within—a vast circular atrium surrounded by a two-story arcade supported by columns and caryatids. The Zappeion was the venue for fencing competitions during the first modern Olympic Games in 1896; more recently in 1981 it hosted ceremonies signing Greece into the European Union. The surrounding **Zappeion Gardens,** crisscrossed by broad promenades, adjoin the National Gardens.

Enter from the National Gardens or from Amalias, Vas. Olgas, or Vas. Konstantinou sts. zappeion.gr. Free admission. Daily 9am–5pm (hours may vary, depending on events). Metro: Syntagma.

The Plaka & Monastiraki

These sprawling districts north and east of the Acropolis are remnants of 19th-century Athens, with Byzantine churches and fragments of the ancient city scattered along narrow lanes. Alleys, simple bougainvillea-clad houses, and a round-the-clock holiday atmosphere give these neighborhoods the cheerful ambiance of a Greek island. Vendors hawk souvenirs (especially along Adrianou and Pandrossou Sts. in the Plaka and around Monastiraki Sq.); chicly clad young Athenians sit in cafes alongside their worry-bead-wielding elders; and waiters try to lure passersby into restaurants serving undistinguished cuisine. It's easy to feel you've stumbled into a tourist trap as you amble through the Plaka and into Monastiraki, but this colorful heart of old Athens is also quintessentially and alluringly Greek.

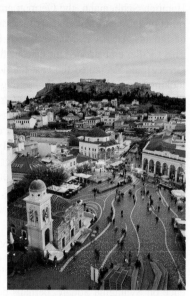

With its mosaic pavements and tile-roofed mosque, Monstiraki Square still has the aura of the Turkish bazaar that once thrived here.

Agii Apostoli Solanki ★ CHURCH One of Athens's oldest churches was built in the Agora around A.D. 1020 to honor St. Paul, who preached Christianity in the surrounding stoas and atop nearby Areopagus Hill. The Ottomans and overly zealous 19th-century renovators all but obliterated the church's charm, but it was tenderly restored to its original form in the 1950s. A few fine early Byzantine frescoes remain in place, alongside some 17th-century wall paintings moved here from a now-demolished church.

Dionysiou Areopagitou, in the Ancient Agora. Free admission. Hours vary.

Home Away from Home

In the quiet enclave of **Anafiotika,** whitewashed stepped streets and bougainvillea-clad houses climb the rocky slopes of the Acropolis. A world removed from modern Athens, Anafiotiika was settled by masons and other craftsmen who migrated from Anafi and other Cycladic islands in the mid-1800s to find work building the new capital. They built these simple houses in the style of their homeland and renovated the enchanting 17th-century church of **Agios Girogios tou Vrachou** (St. George of the Cliff), perched on the flanks of the Acropolis Hill. In the garden is a memorial to Konstantinos Koukidos, an Acropolis guard who wrapped himself in a Greek flag and threw himself off the top of the bluff when the Germans invaded in 1941.

Ancient Agora ★★★ ANCIENT SITE The center of commercial, administrative, and social life in ancient Athens for almost 1,000 years, starting in the 6th century B.C., the Agora is today a jumble of broken columns and crumbling foundations strewn among olive, pink oleander, cypress, and palm trees. Long ago, the city elite gathered to watch ceremonial processions pass through the Agora on the Sacred Way; so important was the Agora in ancient Greece that it was ground zero, the point from which all distances throughout the Greek world were measured. With a little imagination, life at the center of ancient Athens can come alive as you explore its monuments.

The sole remaining ancient structure is the beautifully preserved **Temple of Hephaestus,** from the 5th century B.C. Devoted to Athena and Hephaestus, god of blacksmiths, it was once surrounded by metalworking shops; a beautiful frieze atop the 34 columns depicts Hercules and Theseus, ancient Greece's superheroes who slew monsters and performed other amazing feats. The government's ruling body met and lived in the circular **Tholos;** the council met in the nearby **Bouleuterion** and state archives were kept in the **Metroon.** The **Stoa of Attalos** was once the city's major shopping venue, with marble-paved colonnades that were popular gathering places; St. Paul preached Christianity here and Socrates sat on a bench expounding his philosophical principles. (The stoas—porticos—of the Agora lent their name to stoicism.) Reconstructed in the 1950s, the two-story stoa holds a museum displaying pottery, oil flasks, bronze disks used to cast votes, and many other finds evoking commercial and political life in ancient Athens. Just behind is the beautiful church of **Agii Apostoli Solanki** (p. 102). **Adrianou,** the neighborhood's most pleasant street, follows the north side of the Agora toward Kerameikos cemetery. Many of its 19th-century houses have been converted to cafes; sit at an outdoor table and soak in the views over the ruins to the Acropolis.

Main entrance on Adrianou (near Agiou Filippou). odysseus.culture.gr. ℂ **210/321-0185.** Admission 10€ (Nov–Mar 5€); included in Acropolis combination ticket (p. 89). Apr–Sept daily 8am–8pm; Oct 8am–6pm; Nov–Mar 8am–4pm. Metro: Monastiraki or Thissio.

Kapnikarea ★ CHURCH One of the greatest pleasures of strolling through crowded Monastiraki is coming upon this 11th-century gem, planted right in the middle of busy, shop-lined Ermou Street. Built on the site of an ancient temple to Athena, the tile-domed stone church incorporates Roman columns from the Forum; it escaped demolition twice as Athens began to boom in the middle of the 19th century. Standing proud, slightly sunken beneath the level of the modern street, the landmark is an endearing testament to the city's long past.

Ermou and Kapnikarea. Free admission. Hours vary. Metro: Monastiraki.

Library of Hadrian ★★ ANCIENT SITE Roman emperor Hadrian built this lavish hall, of which a portion of a columned porch remains, for learning, discourse, and relaxation. At the center of the complex was a large inner court, surrounded by 100 columns supporting a portico overlooking the courtyard's garden and pool. Opening off the court were lecture halls, rooms for reading

and conversation, and a library where papyri were stored in stone cabinets (a few of which survive). Hadrian intended the library to be his contribution to the intellectual life of Athens; he and other Romans considered the city to be the Empire's center of learning and enlightenment, and many noble Roman families sent their sons to Athens to be educated. You can also view inside the ruin from the south end of Aiolou street.

Areos. odysseus.culture.gr. ☏ **210/923-9023.** Admission 4€ (Nov–Mar 2€); included in Acropolis combination ticket (p. 89). Apr–Oct daily 8am–8pm; Nov–Mar daily 8am–3pm. Metro: Monastiraki.

Lysicrates Monument ★★ ANCIENT SITE Many so-called choragic monuments like this once lined ancient Tripodon Street (Street of the Tripods), which still runs through the Plaka. Choragics were producers who trained and costumed choruses and dancers for festivals; winners displayed their trophies (three-footed vessels known as tripods) atop lavish monuments. This is the only surviving example, erected by Lysicrates to show off the trophy he was awarded in the Dionysian festival of 334 B.C.

Lysikratous and Herefondos. Metro: Syntagma.

Mitropolis ★ CHURCH The city's cathedral—home church to the archbishop of Athens and the chosen place of worship for the Athenian elite—was completed in 1862 amid the new capital's building boom. Its massive walls incorporate marble from dozens of earlier churches around the city that were demolished to make room for roads and buildings. Next door is the medieval church Panagia Gorgoepikoös, or Little Mitropolis (see below).

Mitropoleos. Free admission. Hours vary. Metro: Monastiraki.

Monastiraki Square (Plateia Monastiraki) ★★ LANDMARK This lively square, paved in colorful mosaics, takes its name from a medieval monastery and poorhouse, of which only the church of **Panayia Pantanassa** remains. The square's most prominent feature is the tiled-domed 18th-century **Tzistarakis Mosque,** a remnant from the days of Ottoman rule. It became infamous when a Turkish administrator destroyed a column from the Temple of Olympian Zeus to extract lime for the mosque's construction; a plague that soon ravaged the city was blamed upon that desecration. Inside, several halls display beautiful Turkish ceramics. A Turkish bazaar grew up around the Tzistarakis Mosque, and narrow lanes leading off the square still have a souk-like feel, lined with stalls and tiny shops. That aura is especially evident on Sunday mornings, when a flea market snakes along Ifestou and nearby Kyntou and Adrianou streets. A 21st-century innovation in the square is a glass enclosure revealing the Iridanos River, which once flowed freely around the base of the Acropolis and was considered sacred by ancient Athenians.

Ermou and Athinas. Metro: Monastiraki.

Museum of Greek Folk Musical Instruments ★ MUSEUM With roots in the ancient world and the Byzantine and Ottoman empires, Greek

music is far more than the *Never on Sunday* theme played endlessly in tourist taverns. The lyres and other gorgeously crafted instruments on display here make a delightful introduction to Greek musicology, enhanced by recorded music and occasional live performances in the courtyard (home to a family of tortoises).

Diogenis 1–3. *©* **210/325-0198.** Admission 3€. Wed–Mon 8:30am–3:30pm. Metro: Monastiraki or Thissio.

Panagia Gorgoepikoös (Little Mitropolis) ★★ CHURCH Though overshadowed by the unremarkable 19th-century Mitropolis (Metropolitan

Cathedral) next door, this little church dedicated to the Virgin Mary Gorgo-epikoös ("she who hears quickly") is much closer to the hearts of Athenians. The late-12th-century builders chose the site of an ancient temple to Eileithyia (goddess of childbirth and midwifery) and made use of its old stones and cornices. More than 90 stone reliefs decorate the church, revealing layers of the past—some are ancient, depicting the Panathenaic games, others are Roman, and many are early Byzantine designs of plants and animals, brought here from other shrines around the city.

The tiny Byzantine Panagia Gorgoepikoös is a charming chapel filled with stone reliefs from many different eras.

Mitropoleos and Agias Filotheis at Mitropoleos Sq. Free admission. Hours vary. Metro: Monastiraki.

Roman Forum ★ ANCIENT SITE The well-preserved Gate of Athena Archetegis is inscribed with a notice that these now-ruined monuments—a rectangular marketplace that was the city's commercial center during Roman rule—were erected with funds from Caesar and Augustus. Hadrian, who rebuilt so much of Athens in the 2nd century, is represented in the forum by a simple inscription regulating the sale of oil at the bazaar that operated near the entrance. In the 16th century, when Athens fell to the Ottomans, Mehmed II the Conqueror was allegedly so taken with the city's classical beauty that he prohibited destruction of the ancient monuments on pain of death. Besides converting the Pantheon to a mosque, he also built the Fethyie (Victory) mosque on the north side of this forum to celebrate his conquest. The most sought-out remnant, however, is a Roman latrine, maybe only second to the Acropolis as the most popular spot in Athens for photos.

Aiolou and Pelopida. *©* **210/324-5220** or 210/321-0185. Admission 8€ (Nov–Mar 4€; included in Acropolis combination ticket (p. 89). May–Oct daily 8am–8pm; Nov–Apr 8:30am–3pm. Metro: Monastiraki.

4

ATHENS

Exploring Athens

Tower of the Winds ★★★ ANCIENT SITE One of the most intriguing buildings of the ancient world stands on high ground next to the Roman Forum. Built by Syrian astronomer Andronikos Kyristes around 50 B.C., with a weather vane and eight sundials visible from afar, the structure was one of the first known versions of a clock tower. Each of its eight sides is inscribed with friezes of Boreas and other personifications of the winds; inside, a water clock employed gears and sophisticated mechanisms to regulate the flow of water from a stream on the Acropolis Hill into a basin, allowing timekeepers to make measurements. A walk along **Aiolou Street** (named for Aeolus, god of wind) offers a nice view of the tower. Turn off Aiolou into Pandrossou, a pedestrian alley that once was the Turkish bazaar—one of the city's few vestiges of the 400 years of Ottoman rule. A bazaar-like aura still prevails; the narrow lane is chockablock with souvenir and jewelry shops.

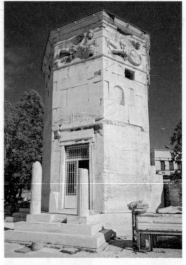

With its weather vanes and sundials, the eight-sided Tower of the Winds is a fascinating relic of ancient astronomy.

Near corner of Pelopida and Aiolou. Metro: Monastiraki.

Psyrri & Gazi

Monastiraki runs into Psyrri, a busy working-class neighborhood where leather crafters, tinsmiths, and basket weavers work out of small shops. By day, cafes and shops make it clear that the neighborhood is gentrifying, as does the proliferation of colorful murals and graffiti; street art is especially exuberant on **Louka Nika,** a little alley that's become an artistic showcase. When the sun sets, the neighborhood transforms into one of Athens's prime stages for night life, as nocturnal-by-nature Athenians crowd the tavernas, bars, and clubs until dawn. To the west is Gazi, where old brick smokestacks that once infamously spewed fumes and smoke now glow with colored lights, providing a beacon above the increasingly gentrified streets.

Benaki Museum of Islamic Art ★★ MUSEUM A 19th-century neo-classical house and outbuildings display Islamic ceramics, carpets, woodcarvings, and other objects, including an exquisitely carved wood-and-ivory chessboard. Especially evocative are two reconstructed living rooms from the Ottoman times and a 17th-century reception room from a Cairo mansion. In the cellar are the remains of a portion of the walls of the ancient city, while the excellent rooftop cafe affords views of Kerameikos and the Acropolis.

Agion Asomaton 22 and Dipylou. www.benaki.gr. ✆ **210/367-1000.** Admission 9€. Thurs–Sun 10am–6pm. Metro: Monastiraki.

Kerameikos Cemetery ★★★ ANCIENT SITE Potters settled Kerameikos (from which the word *ceramics* is derived) as early as 1200 B.C., and by the 7th century B.C. the district had become the main burying ground of Athens. Generations of noble Athenians were laid to rest along the Street of Tombs, beneath monuments that seem little affected by the millennia—including a splendid marble bull atop the tomb of Dionysos of Kollytos and a marble relief of Dexileos, showing the young soldier on horseback preparing to spear an opponent (similar to his own death at the hands of the Corinthians in 394 B.C.). Not as well preserved are two gates in the ruins of the city walls: the Dipylion Gate, the main entrance to the city, and the Sacred Gate, reserved for participants in sacred processions. Celebrants of the Eleusinian mysteries followed the Iera Odos (Sacred Way) through this Sacred Gate to Demeter's temple in ancient Eleusis (now modern Elefsina, 22km/14 miles west); sections of the road remain, as do segments of the Long Walls that Themistocles erected in 478 B.C. Pottery, funerary sculptures, and other finds from Kerameikos are displayed in the Oberlaender Museum, next to the entrance. Kerameikos is one of the lesser-visited ancient sites in Athens, so you can wander through these peaceful and storied surroundings at leisure.

Ermou 148. ✆ **210/346-3552.** Admission 8€ (Nov–Mar 4€); included in Acropolis combination ticket (p. 89). May–Oct daily 8am–8pm; Nov–Apr 8:30am–3pm. Metro: Thissio.

Melina Mercouri Museum and Cultural Centre ★ MUSEUM Take a romp through 19th-century Athens along a typical street of the then-newly transformed capital, painstakingly re-created in a former hat factory. Shop windows display clothing and dry goods, a door opens into a neoclassical house, and a *kafeneion* (coffeehouse) is so authentic you can almost hear the clatter of worry beads. Ground-floor spaces show off *karagiozis* (shadow puppets). The center evokes the memory of Melina Mercouri (1920–94), the

LORD byron's ATHENS

Back in 1809, when Psyrri was known as a haven for underworld thugs and a hotbed for revolutionaries, British poet Lord Byron, an ardent Hellenophile, boarded at 11 Agias Theklas St. (now a warehouse). His landlord's 12-year-old daughter, Teresa Makris, inspired his poem "Maid of Athens." Returning to Greece in the 1820s, Byron wrote part of "Childe Harold" while staying in the 17th-century Capuchin monastery, now destroyed, that once surrounded the **Lysicrates Monument** (p. 104). At the **Temple of Poseidon** (p. 118), he carved his name on one

of the columns; visiting **Marathon** (p. 116), he wrote: "The mountains look on Marathon, And Marathon looks on the sea, And musing there an hour alone, I dreamed that Greece might still be free."

Mementoes of Byron's involvement in the Greek independence movement can be found at the **National History Museum** (p. 100) and the **Benaki Museum** (p. 106). Alas, before he could fight to free Greece, Byron succumbed to fever in the boggy, cholera-infested town of Mesolongi, where he died on April 19, 1824.

actress and former minister of culture who launched the battle for the return of the Parthenon Marbles (see box, p. 95). The center is in Thissio, an old neighborhood just west of the Acropolis and south of Kerameikos.

Iraklidon 66a. ℂ **210/345-2150.** Free admission. Tues–Fri 10am–7pm, Sat–Sun 10am–3pm. Metro: Thissio.

Technopolis ★★ MUSEUM Gazi translates as "gas lands," a reference to the unwelcome effect this former foundry once had on its surroundings. In the late 1990s the city of Athens converted the complex to a culture center (Technopolis means "Arts City"), and brick-and-stone-walled exhibition spaces now surround a courtyard that's often used for concerts. Furnaces and other industrial equipment remain in place, interspersed with art exhibits and performance spaces. One hall houses the **Maria Callas Museum,** allowing a voyeuristic peek at some of the diva's personal effects and clothing. The main exhibition spaces at Technopolis are usually open until 9pm, after which you can catch a late dinner at one of the many restaurants and cafes that have sprung up in Gazi and adjoining Psyrri.

Pireos 100. athens-technopolis.gr. ℂ **2130/109-300.** Metro: Kerameikos.

Omonia & Exarchia

Much of life in Athens transpires on and around busy, gritty Omonia Square, north of the Plaka. There's plenty to see—the central market, university, and National Archaeological Museum are all within easy reach—and you'll find no lack of color. You can follow a pedestrian walkway, Aiolou, north from Monastiraki to Omonia, through Kotzia Square, but walk at least part of the way along Athinas Street, a busy avenue where shops cater to everyday needs, selling everything from tools and twine to votive candles and live chickens.

Agii Theodori ★ CHURCH Marble tablets over the door date this squat church to the middle of the 11th century. With its sturdy stone walls and eight-sided, tile-roofed dome, the church has withstood bombardment during the War of Independence and other ravages, to stand as a sentinel from another

Not Your Ordinary Grocery Store

The sheep heads, live chickens, and calf carcasses probably won't tempt you, and even much of the snack food offered (such as steaming bowls of tripe soup) can seem a bit, uh, exotic. But few places in Athens are livelier and more colorful than the **Central Market** ★★ on Athinias Street. The scent of wild herbs wafting through the vast halls is transporting, as heaping piles of comestibles provide a culinary tour of Greece: You probably never knew there were so many kinds of olives or varieties of creatures in the sea. Cheese, bread, sliced meats, and other picnic fare are sold at the north end of the market. The market opens at 6am Monday through Saturday and should be in full swing by the time you arrive at a more reasonable hour.

age above the bustle of the busy streets below. Inside are many 19th-century frescoes and some charming terra-cotta reliefs of plants and animals.

Evripidou and Aristidou, at Klafthmonos Sq. Free admission. Hours vary. Metro: Panepistimiou.

City of Athens Museum ★ MUSEUM Newlyweds King Otto and Queen Amalia set up temporary housekeeping in this modest 1830s house while their royal palace (now Parliament) was being built. The reception rooms, study, and library are fitted out to look as if the royal couple—still teenagers when they came to Athens to assume leadership of the new nation— might pop in at any moment. Most intriguingly, a plaster model to the scale of 1:1,000 shows what the city looked like in 1872, when it was home to just 25,000 souls. If you stop for a coffee or light meal in the museum's Black Duck Garden Bistrot, you'll be in good historic company—Amalia, who laid out the National Gardens as her private park, supervised the landscaping here, in this pleasant bower where she and Otto retreated from their official duties.

7 Paparigopoulou. www.athenscitymuseum.gr. **©** **210/323-1397.** Admission 5€. Mon– Fri 9am–4pm; Sat–Sun 10am–3pm. Bistrot: May to mid-Oct daily 9am–2am; mid-Oct to Apr daily 9am–5:30pm. Metro: Panepistimiou.

Exarchia Square ★ SQUARE The heart of the university district of Athens is covered in graffiti and surrounded by boho shops and laidback, shabby-chic cafes. You can join the artists, intellectuals, and hordes of youth for a vicarious look at Athenian student and intellectual life. A student uprising in Exarchia on November 17, 1973, left 34 dead but eventually brought down Greece's oppressive military dictatorship.

Stournari and Themistokleous. Metro: Omonia.

The Hansen Buildings ★★ HISTORIC BUILDINGS In the 1840s, Danish architects Theophilus and Christian Hansen came to Athens to fulfill Bavarian King Otto's plan to rebuild the capital in neoclassical style. They focused their energies on three adjoining buildings, now surrounded by the University of Athens. Theophilus undertook the **Academy of Athens,** where two 23m-tall (75 ft.) columns topped with statues of Athena and Apollo flank a portico richly embellished with statuary—note the elaborate pediment frieze depicting the birth of Athena. In the main hall, beneath frescoes of the myth of Prometheus, is a statue of Simon Sinas, Greek consul to Vienna, who bankrolled the project. The public may enter to look at the main hall and library of the Academy, which promotes sciences, humanities, and fine arts. Theophilus's brother Christian Hansen, King Otto's court architect, began work in 1839 on the **university's main building.** Well versed in classical sensibility (he also spent his time in Athens reconstructing the Acropolis's Temple of Nike), he showed more restraint than his brother, adorning the university hall's refined facade with a graceful tall portico. For the **National Library,** the third in the Hansen brothers' trilogy, Theophilus indulged his bent for extravagance with a sweeping pair of curving marble staircases. It's well

worth ascending them to see the exhibits—the library displays some of Greece's most rare manuscripts, including fragments of 6th-century gospels and the earliest known written versions of Homeric epics.

Academy of Athens: Panepistimiou 28, www.academyofathens.gr, ⓒ **210/366-4700,** free admission, limited hours, usually weekdays. University of Athens: Panepistimiou 30, en.uoa.gr, ⓒ **210/727-7000,** interior closed to general public. National Library: Omonia 32, www.nlg.gr, ⓒ **210/338-2541,** free admission, Mon–Fri 9am–4pm. Metro: Panepistimiou.

National Archaeological Museum ★★★ MUSEUM The splendor of ancient Greece comes to the fore in the world's finest collection of Greek antiquities. Galleries behind the neoclassical facade are filled with sensuous marble statues that once adorned temples throughout Greece, and other treasures span Greek history from the age of Homer to the days of the Roman Empire.

Three collections steal the spotlight. The **Mycenaean Collection** evokes the short-lived civilization that dominated the southern Mediterranean from around 1500 to 1100 B.C.; its king, Agamemnon, launched the Trojan War and inspired the legends of Homer. In their royal tombs, the Mycenaens left behind gold death masks and many other magnificent treasures, unearthed by Heinrich Schliemann in the 1870s. The so-called Mask of Agamemnon, once thought to be that of the king, has since been proven to predate him (some call the intriguing mask the "Mona Lisa of Prehistory"). In the **Cycladic Collection** you'll find enigmatic marble figures typical of this early civilization, some 5,000 years ago, as well as some three-dimensional pieces, including an utterly charming harp player and a life-size female figure that is the largest

The National Archeological Museum is like a treasure chest, the world's finest collection of Greek antiquities.

A CITY transformed

Cycladic piece yet to be unearthed. The **Thira Collection** showcases colorful frescoes from the Minoan settlement of Akrotiri on Santorini (also known as Thira), buried in a volcanic eruption around 1600 B.C. Hauntingly beautiful images of monkeys (indicating trade with North Africa), ships sailing past leaping dolphins, and young women gathering saffron reveal much about everyday life in such a distant past.

Some of the ancient world's most moving images are captured in the museum's **funerary monuments,** including one from the Grave of Aristonautes in Kerameikos (p. 107), in which a boy tries to refrain a frisky horse. While most of ancient Greece's bronze statues were melted down for weaponry over the centuries, three extraordinary **bronzes** were retrieved from shipwrecks: a galloping steed with a horseman astride its back; Marathon Boy, depicting a youth, perhaps a young Hermes; and a majestic figure from around 400 B.C. that may be Poseidon or Zeus—his hands are clasped to hold a missing piece that may have been a thunderbolt or a trident.

Patission 44 and Oktovriou 28. www.namuseum.gr. © **210/821-7717.** Admission 12€ (Nov–Mar 6€). Mid-Apr to Oct Tues 1–8pm, Wed–Mon 8am–8pm; Nov–Mar Tues 1–8pm, Wed–Mon 8:30am–3:30pm. Metro: Victoria. Trolley: 2, 3, 4, 5, 6, 7, 8, 9, 11, 13, or 15.

Omonia Square ★ SQUARE This traffic-heavy city hub lacks the grace of Syntagma Square: Surrounded by banal office blocks, it's often torn up for improvements and frequented by some decidedly shady denizens. But the scrappiness of the space is in keeping with the square's history: When created in 1833 as part of the new capital's renewal, it was intended to honor King Otto, but after the unpopular monarch's ouster it became a hotbed of popular unrest, and was renamed Omonia, which means "Unity."

Athinas and Konstantinou. Metro: Omonia.

Kolonaki & Lycabettus

Well-coiffed, -shod, and -clothed Athenians tend to gravitate to the Kolonaki neighborhood, just north and east of Syntagma Square. You may want to follow in their footsteps—not just to sip coffee in their favorite lairs, but to spend an afternoon in some of the city's finest museums and chic boutiques. Top off the experience with an ascent to the top of Lycabettus hill for a spectacular view of the sun setting over the city.

Benaki Museum ★★★ MUSEUM Antonis Benakis (1873–1954) spent his vast fortune satisfying his taste for anything having to do with Greek heritage, spanning the millennia from prehistory to the 20th century. More than 20,000 objects are showcased in the Benaki family's 19th-century mansion and a modern wing. Among the treasures: Mycenaean and Roman jewelry, 5,000-year-old gold and silver bowls that transition from the Stone Age to the Bronze Age, pistols Lord Byron brandished when he came to Greece in 1824 to join the fight for independence, and paintings by El Greco (who left his native Crete for Spain). Reception rooms plush with paneling and Persian carpets were re-assembled from an Ottoman mansion in Macedonia. A rooftop cafe overlooking the National Gardens (p. 100) is a refined place to recharge; the gift shop is stocked with beautiful reproductions.

Koumbari 1. www.benaki.gr. ✆ **210/367-1000.** Admission 12€ (Thurs free admission to permanent collection 6pm–midnight). Mon, Wed, and Fri–Sat 10am–6pm, Thurs 10am–midnight, Sun 10am–4pm (last entry 1 hr. before closing). Metro: Syntagma or Evangelismos.

Set in a 19th-century mansion in the upscale Kolonaki neighborhood, the Benaki Museum has a wide-ranging trove of Greek art and cultural artifacts.

Byzantine and Christian Museum ★★ MUSEUM From their palaces in Constantinople, Byzantine emperors and the hierarchy of the Orthodox church ruled much of the Balkans and Asia Minor, from the 6th century well into the 15th century. Few collections anywhere match this trove of icons, manuscripts, frescoes, mosaics, and sculptures from that period. One of the most enchanting pieces is an ivory depicting a lyre-playing Orpheus surrounded by animals—an allegorical reference to Christ and his followers, typical of the transition from paganism to Christianity. Mosaic floors from a 5th-century basilica and a Roman villa show similar refinement.

Vasilissis Sofias 22. www.byzantinemuseum.gr. ⓒ **213/213-9517.** Admission Apr–Oct 8€, Nov–Mar 4€, free for visitors under 18. Mon and Wed–Sun 8am–8pm, Tues 1–8pm. Metro: Evangelismos.

Goulandris Foundation ★★ MUSEUM Impressionists and the European and American artists who followed them are the focus of this private collection, one of the world's most extensive, valued at an estimated $3 billion. Van Goghs and Cezannes fill galleries in a neoclassical mansion with a well-designed extension, alongside works by Jackson Pollack and many others, including contemporary Greek artists. Ship owner Basil Goulandris and his wife, Elise Karadontis, spent much of the second half of the 20th century jet-setting and collecting; their foundation also created the Museum of Contemporary Art on the island of Andros, where Basil and his twin brother, Nicholas (founder of the Museum of Cycladic Art, below) were born.

Eratosthenous 13. goulandris.gr. ⓒ **210/725-2895.** Wed–Mon 10am–6pm (Fri until 8pm). Admission 10€, 7€ seniors. Metro: Evangelismos.

Lycabettus Hill ★★ VIEWPOINT One of the most popular rides in town is aboard the Teleferik that climbs to the pine-clad summit of Athens's highest hill, topped with the gleaming white **church of Ayios Giorgios.** An early evening ascent via the funicular from Kolonaki usually ensures a breeze and a spectacular sunset. Legend has it that Athena intended to use Lycabettus to make her temple on the Acropolis even loftier; distracted while winging her way over the city, she dropped it, doing us all a favor. You can walk down (or up, for that matter) on one of the many well-marked paths.

Funicular leaves every 20 min. in summer from Ploutarchou St. 6€ round-trip. Metro: Syntagma or Evangelismos.

Museum of Cycladic Art ★★★ MUSEUM From 3200 to 2000 B.C., one of Greece's early civilizations produced enigmatic, almost abstract marble figures that today seem strikingly modern. Greece's wealthiest shipping dynasty, the Goulandris family, amassed more than 300 of these figures, now housed in light-filled modern galleries. Such modern masters as Picasso and Modigliani were hugely inspired by these figures; most are female, suggesting they were sculpted in honor of a goddess, though a few warriors and other males slip into the mix. Additional exhibits display vases, lamps, tools, and other artifacts for an enlightening look at everyday life in ancient Greece.

At the Museum of Cycladic Art, sculptures on the lid of an ancient urn offer a glimpse into this enigmatic early Greek civilization.

Temporary exhibitions occupy an adjoining 19th-century neoclassical mansion by Ernst Ziller, who designed many municipal buildings in Athens.

Neophytou Douka 4. cycladic.gr. ℂ **210/722-8321.** Admission 10€, 7€ seniors. Mon–Sat 10am–5pm (Thurs until 8pm), Sun 11am–5pm. Metro: Syntagma or Evangelismos.

National Gallery ★★ MUSEUM The city's treasure trove of Greek art (Athens's equivalent to the Tate Britain) moved into stunning new quarters in 2021, bringing the national collection out of mothballs after almost a decade. Colorful, mural-like *People's Market,* by 20th-century master Panagiotis Testis, greets visitors to halls hung with works from the 14th century to recent decades—Doménikos Theotokópoulos, better known as El Greco, is duly honored, and so are some non-Greeks from Rembrandt to Matisse.

Vasileos Konstantinou 50. www.nationalgallery.gr. ℂ **214/408-6201.** Admission 10€. Wed–Mon 10am–6pm (last admission 5pm). Metro: Evangelismos.

Toys & Threads

The Benaki holdings (p. 106) include other intriguing collections around the city, such as **Mentis (Nema) Passementerie,** on the southern fringe of Gazi at Polyfenous 3 (ℂ **210/347-8292**; Metro: Kerameikos). This former textile factory turned out tassels for the Evzone Guards as well as braids, fringes, and curtain tiebacks for late 19th-century and early 20th-century bourgeoisie. Machinery is still in working order, as operators will demonstrate. The factory's open Tuesday–Saturday 10am–3pm, closed in August; admission is free. Wooden horses, porcelain dolls, puppets, and hundreds of other beautiful handcrafted toys from throughout the Mediterranean fill a 19th-century villa that's now the **Toy Museum,** Poseidonos 14 and Tritonos 1 in Faliro (ℂ **212/687-5280**; tram: Trokantero). Admission is 9€, free for those under age 22; the museum is open Thursday to Sunday 10am–6pm, closed in August.

Plateia Kolonaki ★ SQUARE In the leafy Kolonaki neighborhood, it's easy to think that well-heeled residents do nothing but shop, then sit at the cafes around Kolonaki Square. In the center of the square, an ancient column gives the surroundings their name—"kolonaki" means "little column." Take a seat at a cafe and enjoy a frappe (a tasty concoction of Nescafé and frothy milk) while watching the endless parade of beautifully coiffed elderly women, well-fed businessmen, wafer-thin models, and young men on the prowl.

Off Kanari and Koumbari. Metro: Syntagma or Evangelismos.

Outside the Center

Monasteries, temples, and other age-old landmarks surround Athens in the hilly landscapes of Attica. Never too far from the sea, these sights are rich in myth and the labyrinthine history of Greece.

Daphni Monastery ★★★ RELIGIOUS SITE One of Greece's finest Byzantine monuments was founded in the 6th century on the site of a temple to Apollo (you can still see one of the temple columns in a wall). Daphni takes its name from the laurels associated with Apollo, whose amorous pursuit of the nymph Daphne ended in her being transformed into a laurel tree. A prime position on the busy route to Corinth left the monastery vulnerable to sackings by medieval crusaders and some rough handling during the War of Independence. Yet its spectacular 11th-century mosaics remain intact, depicting saints, prophets, angels, and, from the center of the tall dome, Christos Pantokrator (Christ in Majesty). Daphni can be an ordeal to reach by public

West of Athens, the Daphni Monastery has some spectacular 11th-century mosaics from its Byzantine past.

transport; the easiest way is to take the Metro to the Agia Marina station and bus 801, 811, 865, 836, 866, 876, or A16 from there to the Psyciatreio stop (that's the Psychiatric Hospital of Attiki, just east of the monastery). Allow plenty of time and check that the monastery is open before setting out. If you're driving to the Peloponnese, Daphni is an easy stop as you head west toward the Corinth Canal. With a little navigating, you could also work in a visit to the Sanctuary of Eleusis (p. 117).

Lera Odos, Attica, 9km (5½ miles) W of Athens. odysseus.culture.gr. © **210/581-1558.** Free admission. Wed–Sat 8:30am–3:30pm.

Marathon ★ ANCIENT SITE The race name we use so widely today harks back to 490 B.C., when a young man, Pheidippides, ran the 42km (26 miles) from this little town at the edge of the marshy coast to Athens, burst into the Agora, cried "We've won," then dropped dead from exhaustion. He was announcing the seemingly miraculous victory of the Athenians, outnumbered three to one, over the Persian army. It was said that the mythical hero Theseus appeared to fight alongside the Athenians, and that the god Pan put in an appearance too. All told, the Persians lost 6,400 warriors and the Athenians just 192. Humiliated, the powerful Persian navy returned to Asia Minor without attacking Athens. The site of the Athenian victory is hallowed ground in Greece, although there's not much to see here. The Marathon Tomb, where Athenian heroes were buried, rises from the battlefield; a fragment of the column the Athenians erected to celebrate independence is in an archaeological museum about 1.6km (1 mile) from the tomb. Runners might want to step into the separate **Marathon Race Museum,** at Marathonos 25 (marathonrun museum.com; © **229/406-7617**), to see exhibits tracing the history of the marathon as an Olympic competition; also on view is a well-done video chronicling the ancient battle and historic run. That museum is open Tuesday to Friday 9am to 3pm and Saturday and Sunday 10am to 2pm; admission is 2€ adults, 1€ for ages 12 and under.

Marathonas, 42km (26 miles) NE of Athens. odysseus.culture.gr. © **0294/55-155.** Admission 6€ for battlefield and archaeological museum. Mon–Wed 8:30am–3:30pm. Buses depart from Pedion tou Areos Park station every 30–60 min; fare 5€; trip time 2 hr.

Monastery of Kaisariani ★ RELIGIOUS SITE One of the most tranquil spots close to Athens is this simple monastery at the foot of Mount Hymettus, once carpeted with pine groves (sadly, decimated in recent fires). The 11th-century complex has ancient roots—it was built on the foundations of a Christian church that in turn replaced a temple to Aphrodite. The surroundings are still surprisingly bucolic, given the proximity of the city's sprawl. A spring rising on the grounds fed the River Illisos, which in antiquity supplied the capital with water; the mountainside was famous for the honey gathered from great swarms of bees. Philosophers brought their students to Kaisariani to escape the heat of the city, as many Athenians still do. You may see brides drinking from the spring water gurgling forth near the entrance to the monastery—it's said to help induce pregnancy. To get here by public

transport, take bus 608 from stops along Leof. Vasilissis Sofias in Kolonaki, the monastery is a 3km (1½ miles) walk from the end of the line.

Off Academias St., Kaisariani, about 10km (6 miles) E of central Athens. odysseus. culture.gr. ℂ **210/723-6619.** Admission 2€. Wed–Mon 8:30am–4pm.

Sanctuary of Artemis at Vravrona (Brauron) ★★ ANCIENT SITE

You'll encounter many sanctuaries in Greece where ancient cults worshipped specific deities. This one is especially quirky and charming. As legend has it, a young man killed a bear that had attacked his sister, and an epidemic soon broke out. A ceremony of young girls dancing in bear masks was mounted, and the epidemic subsided. The bear-dance became a regular event, and a temple to Artemis, goddess of wild animals and the hunt, was built. (None other than Iphigenia, King Agamemnon's daughter, was once a priestess here.) All that remains of the temple are some foundations and a cave said to be the Tomb of Iphigenia. On the grounds you'll also see a bridge that once crossed a long-ago diverted stream, its ancient stones rutted by wagon wheels. A restored stoa is lined with bedrooms, complete with small beds and tables, where the young celebrants were housed. Masks, marble heads of the girls, and other artifacts are in the small museum at the entrance. To reach the sanctuary by public transport, take the subway to Nomismatokopeio then bus 304 or 316 from there to Vravrona; trip time is about 1 hour and 45 minutes. It's a 20-minute walk or short taxi ride from the stop to the sanctuary.

Vravrona, 38km (22 miles) E of Athens. odysseus.culture.gr. ℂ **22920/27020.** Admission 6€. Daily 8:30am–3:30pm. Site closed periodically for restoration, so check ahead.

Sanctuary of Eleusis ★★ ANCIENT SITE

It's hard to imagine that present-day Eleusis, a forest of belching refineries and warehouses, was once the bucolic realm of Demeter, goddess of the harvest. As the story goes, Hades, god of the underworld, kidnapped Demeter's daughter, Persephone. Demeter came to Eleusis in search of her daughter, and, with the intervention of Zeus (Persephone's father), struck a deal with Hades that Persephone could return to earth for half the year. In gratitude, Demeter gave Triptolemos, son of the king of Eleusis, seeds and a chariot in which he could fly around the earth to disperse them. This story inspired the Eleusian Mysteries, rites that celebrated the cycle of life and death. Celebrants annually made their way here along the Sacred Way from Kerameikos Cemetery (p. 107) to engage in rituals that only the initiated could witness, under pain of death. You can follow the Sacred Way into the Temple of Demeter, where a row of seats surrounds the hall where the rites took place. Much of what remains at the site is Roman, including an arch honoring Hadrian (it inspired the Arc de Triomphe in Paris). The sanctuary is a bit neglected, and an adjacent museum is closed for renovations. To reach the site by public transport, take the A16 or B16 bus from Plateia Eleftherias, just north of Monastiraki. The sanctuary is a convenient stop if you're driving from Athens to the Peloponnese; you could also combine this with a visit to the Daphni Monastery (p. 115).

Off I. Agathou, Elefsina, 23km (14 miles) W of Athens. ℂ **210/554-6019.** Admission 6€. Daily 8am–8pm (shorter hours in winter).

Stavros Niarchos Foundation ★★★ ARTS COMPLEX You will feel uplifted even before hearing a note from the Greek National Opera or seeing a rare manuscript in the airy Greek National Library, both based in this stunning complex designed by Italian architect Renzo Piano. In addition to the concert hall, noted for its acoustics, and the library, the center is a manicured landscape of parkland graced with groves of young olive trees, with expansive views of Athens and the nearby sea. You can enjoy a picnic beside a canal and dancing fountains, or take a free 90-minute English-language guided tour, conducted most days at 10am and 4:30pm (register online). From central Athens, the easiest way to reach the center, at the northern edge of the coastal Faliro neighborhood, is on a free shuttle bus from Syntagma Square, with a stop at the Syngrou-Fix Metro station; it runs hourly much of the day, every half hour Friday evenings and weekends. From May through October the number 80 bus runs between the Acropolis Museum and Piraeus with a stop at the Niarchos Foundation; you could also take the coastal tram to the Tzitzifies stop. The nearby waterfront is being transformed as a new office, residential, and entertainment quarter.

Syggrou 364. www.snfcc.org. ℂ **216/809-1000.** Free admission. Most facilities daily 6am–midnight; visitor center daily 8:30am–10pm.

Temple of Poseidon at Sounion ★★★ ANCIENT SITE Commanding a 29m (95-ft.) bluff at the southernmost tip of Attica, this temple to the god of the sea, commissioned in 444 B.C. by the statesman Pericles (who also built the Parthenon), still has fifteen of its original 34 columns. The rugged coast below the temple has changed little since ancient times, making it easy to imagine the joy sailors felt to see this landmark, a sign they were nearing home. Gazing out over the sea from the temple, you can understand its role as a lookout post where sentinels watched for approaching warships during the Peloponnesian Wars. Many visitors come to enjoy the sunset from the temple; for an especially memorable view at any time, enjoy a swim in the sea just below the ruin. *Note:* The easiest way to visit Sounion is on organized sunset tours offered by such agencies as CHAT and Key (see p. 120). Otherwise, take the bus from Areos Park station, with departures every half hour for the 2-hour trip (plus 1km cab ride or walk to temple).

Cape Sounion, 70km (43 miles) E of Athens. ℂ **22920/39-363.** Admission 10€. Daily 9:30am–sunset.

ORGANIZED TOURS

Athens is an easy city to navigate and explore on foot. Most of what you will want to see is concentrated beneath the Acropolis around Syntagma, Monastiraki, and Omonia Squares. Guided tours quickly show off the highlights and can help make sense of Greek history's layers of facts and myths. A superb introduction to the city, the **Athens Free Walking Tour** (www.athensfree walkingtour.com) has knowledgeable locals leading a 2½- to 3-hour walk from the Panathenaiko Stadium through Plaka into Montastiraki, showing off the Roman Agora, Anafiotika, Parliament, Syntagma Square, and many other

HIT THE beach

When summertime temperatures hit 46°C (115°F) in the shade, you may be pleased to find it's easy to get to a beach near Athens. A nice string of sand follows the coastline south of the city, known as the Apollo Coast. You'll pay anywhere from 4€ to 7€ to get onto these beaches (reduced prices for children); once you're there you can rent sunbeds, umbrellas, and all sorts of other amenities. Avoid traffic-choked Poseidon Avenue along the coast by taking Athens's **coastal tram** (www.tramsa.gr), Line 3 (Blue), which runs from Syntagma Square along a scenic coastal route to Voula. From there you can reach other seaside points on the 122 and other buses. The tram runs 5:30am–1am, later on Friday and Saturday (last departure from Syntagma 2:15am). You can use a travel card or get tickets (1.20€) from machines at the stops. Another option is to take the Metro to the Ellinikon stop and the 122 bus from there along the coast.

In Glyfada, 17km (10 miles) south of Athens, **Asteras Glyfadas** ★, 58 Poseidonos Ave. (www.asterascomplex.com; ℂ **210/894-4548;** tram: Metaxa St.), offers a Miami Beach vibe: white recliners, white umbrellas, white sand (imported), and a string of bars that will deliver drinks to your lounge chair. The water can be a bit shallow and murky, but most patrons are too caught up in the scene to care.

Another 3km (2 miles) down the coast in Voula, **Voula A** ★, 4 Alkyonidon St. (ℂ **210/895-9632;** tram: Asklipiou Voulas St.), draws regular crowds of 20-somethings and teenagers who don't seem to mind that the beach is pebbly and, unless you snag a sun bed, unshaded. Besides sand and surf, it has a swimming pool, a snack bar, water slides, watersports gear (skis, tubes, and boards), parachuting, pedal boats, racquetball, beach volleyball, minisoccer, some bars, and a minimarket. A beachfront cafe and other facilities stay open at night after the beach closes. Nearby **Thalassea** ★, also known as Voula B (www.thalassea.gr; ℂ **210/895-9632**), is a bit less of a scene than its neighbor, with calm, clean waters protected by breakwaters. Just south of Voula, a 2km (1-mile) seaside path connects **Mikro Kavouri** and **Makro Kavouri** beaches, an unusually scenic stretch dotted with palm groves and enticing coves.

One of Athens's favorite beach getaways, **Vouliagmeni** ★★, Poseidonos Avenue (ℂ **210/967-3184**), some 25km (16 miles) south of Athens, has trees, shade, and sand and sea so sparkling that the beach has earned the European blue flag for cleanliness. Surrounded by cave-riddled cliffs and greenery, **Lake Vouliagmeni**, just south of town, maintains a constant 24°C (75°F) temperature year-round; a concession on the shore (www.limnivouliagmenis.com; ℂ **210/896-2237**) lets you enjoy its allegedly curative waters, complete with "doctor" fish that provide some gentle skin-nibbling.

Across the peninsula from Vouliagmeni lies popular **Yabanaki Varkiza** ★★, on Sounion Avenue in Yabanaki (ℂ **210/897-2414**), some 30km (19 miles) southeast of Athens. It's hardly a quiet getaway, with rows of sun beds and blaring beach bars, but the ride here on the 122 bus is a treat, winding along the Attica peninsula's spectacular cliffs. If you're traveling by car or taxi, it's easy to continue from Vouliagmeni or Yabanaki to Cape Sounion (see p. 118), along a rocky coastline etched with coves that are great for snorkeling and swimming.

landmarks, accompanied by insightful, intelligent commentary. While you do not enter sites along the way, you will be well prepared to return and tour on your own. Tours run daily, departing at 10am or 6:30pm; book a place on the

website, where you will find departure times and other details. True to the name, tours are free, though it's customary to give your guide a well-deserved tip.

Athens by Bike, near the Acropolis Museum at Athanasiou 16 (www.athens bybike.gr; ✆ **216/900-3321**), provides a good introduction to the central city on two wheels. A daily 3½-hour e-bike tour begins at 9:30am for 45€; other tours are also available. **Athens Highlights Mythology Tours** from Alternative Athens, Karaiskaki 28 (www.alternativeathens.com; ✆ **210/126-544**), delve into the mythology with which the city is so deeply intertwined, with stops at such storied places as the Parthenon, Theater of Dionysus, Temple of Athena Nike, Temple of Olympian Zeus, and the Agora. Daily tours last about 4 hours and cost from 65€, entrance fees to sites included. The **Athens Food Adventure,** from the Greece Tour Hub (www.greecetourhub; ✆ **210/321-0031**) is a good introduction to Greek cuisine (and Greek life, Athenian architecture, and other topics as well), with a foray into the Central Market and surrounding streets. Tours last about 3½ hours and cost 38€, with many tastings along the way. Greece Tour Hub also leads excellent Athens walking tours, with prices from 43€, along with excursions to Delphi and the Meteora.

Two commercial agencies with good itineraries and well-informed guides are **CHAT Tours,** 4 Stadiou (www.chatours.gr; ✆ **210/323-0827**), and **Key Tours,** 4 Kalliroïs (www.keytours.gr; ✆ **210/923-3166**). Both offer half- and full-day bus tours of the city, as well as excursions farther afield to Corinth, Delphi, and other sights (see p. 130, in chapter 5), and afternoon tours to the Temple of Poseidon at Sounion (p. 118).

The old standby **CitySightseeing** (www.city-sightseeing.com) is a good way to get the lay of the land and see the major sites in one go. Open-top double-decker buses begin and end a 90-minute circuit at Syntagma Square with stops at sites that include the Acropolis, the Benaki Museum, the Central Market, Kerameikos, Kotzia Square, Monastiraki, the National Archeological Museum, Omonia Square, Panathenaiko Stadium, Plaka, Psyrri, the Temple of Zeus, Thission, and the university. Prerecorded commentaries are available in English, Greek, Spanish, French, German, Italian, Russian, and Japanese. Tickets are valid for 24 hours (for instance, from 4pm of the day of first use to 4pm the following day); buses depart every half-hour from 8:30am to 9pm. Tickets cost 20€ for adults, 8€ for ages 6 to 14. To get the most value from the 24-hour ticket, make a full circuit late in the afternoon on the first day, then use the bus to visit sites of the most interest to you the next day.

ATHENS SHOPPING

Many of the best shops catering to Athenians and their visitors lie within a fairly small area in the triangle bounded by Omonia, Syntagma, and Monastiraki squares. The Plaka can seem like one giant souvenir stand, but some excellent shops are tucked along its narrow lanes. Pedestrianized Ermou Street, running west from Syntagma Square past the Plaka and Monastiraki,

is the city's main shopping strip. The Kolonaki neighborhood, on the slopes of Mount Likavitos, provides great window shopping—much of what you see in the boutiques is imported and expensive. Voukourestiou, Tsakalof, Skoufa, and Anagnostopoulou streets are other shopping avenues.

Collectibles

Antiqua ★ One of Athens's oldest and finest antiques dealers sells 19th-century watercolors, icons, coins, and other easy-to-carry high-end souvenirs. Irodotou 7. www.antiqua.gr. ✆ **210/323-2220.** Metro: Evangelismos.

Astrolavos Art Galleries ★★ This highly touted gallery plays a big part in the Greek art scene, showing well-known and up-and-coming artists. Xanthippou 11. www.astrolavos.gr. ✆ **210/729-4342.** Metro: Syntagma.

Diskadiko ★★ You'll find new and used LPs in all genres in this passionately assembled collection on a tiny lane. Owner Iosef Aggelidis is happy to fill you in on the Greek music scene. Agias Eleousis. todiskadiko.com. ✆ **210/698-3804.** Metro: Monastiraki.

Ikastikos Kiklos Sianti ★ One of Athens's largest and sleekest gallery showcases contemporary Greek artists. Vas. Alexandrou 2. ikastikos-kiklos.com. ✆ **210/724-5432.** Metro: Evangelismos.

Old Prints ★ The extensive stock of old maps, books, and drawings here includes some beautiful prints of flowers and birds. Kolokotroni 15. antiquebooksandprints.com. ✆ **210/323-0923.** Metro: Syntagma.

For high-end window-shopping, head for the upscale boutiques and galleries of Kolonaki.

Roussos Antiques ★ Porcelain dolls in traditional costumes, made at a workshop in western Athens, are a highlight here, alongside handcrafted Greek trinkets and jewelry and other European and Middle Eastern pieces. Stadiou 3. www.roussosantiques.gr. ✆ **210/322-2815.** Metro: Syntagma.

Spiridonas Tsavalos ★ A large showroom and workshop on the premises can supply an icon of any saint you'd like. Xydia 3. ekklisiastika-eidi.com. ✆ **210/924-5054.** Metro: Syngrou-Fix.

Zoumboulakis ★ Athens's oldest gallery has introduced the work of many Greek artists over the years. The Syntagma store specializes in silkscreens, poster art, and ceramics; a branch at 20 Kolonaki Sq. shows contemporary work. Kriezoutou 6. www.zoumboulakis.gr. ✆ **210/363-4454.** Metro: Syntagma.

Books & Magazines

Kiosk ★ Athens's best-stocked foreign-press **periptero** (kiosk) never closes, which is fortunate for news and magazine junkies. 18 Omonia Sq. at Athinas St. *℗* **210/322-2402.** Metro: Omonia.

Stoa tou Vivliou ★ An entire shopping arcade devoted to books includes rare volumes, current editions (some in English), and rare bindings. A bibliophile's delight. Pesmzoglou 5. *℗* **210/325-3989.** Metro: Omonia.

Department Stores

Attica ★ Up-and-coming Greek designers are showcased through eight floors of fashionable clothing in the landmark City Link building. The store has branches around the city. Panepistimiou 9. www.atticadps.gr. *℗* **211/180-2600.** Metro: Syntagma.

Hondos Center ★ The flagship store of this toiletries chain has all the grooming items you'll ever need, along with clothing for men and women, kitchenware, linen luggage, and many other accessories. Check out the lavish perfume counters or stop on the top floor to enjoy city views over coffee. 4 Omonia Sq. www.hondos.gr. *℗* **213/039-4000.** Metro: Omonia.

Fashion & Beauty

Aptiva ★★ The spotlight is on bees in this multi-floor Kolonaki shop where cosmetics and soaps are crafted from royal jelly, honey, and pollen. In the top-floor spa, clients enjoy honey-based treatments in hive-inspired cubicles. Solonos 6. www.apivita.com. *℗* **210/364-0560.** Metro: Syntagma or Evangelisimos.

Dimos Jewelry ★★ Byzantine designs, reproductions of ancient pieces, and other classics are the mainstays of this Plaka shop founded by Sotiris Dimos in 1968, now in the hands of son and master designer Stavors. Mpenizelou Palaiologou 3. www.dimosjewellery.gr. *℗* **210/321-4302.** Metro: Syntagma.

Stavros Melissinos ★★★ Sophia Loren, Jackie O., and Anthony Quinn are among the celebs who've sported these handmade leather sandals, first created in 1954 by "poet shoemaker" Stavros Melissinos. Son Pantellis now runs the enterprise. Tzireon 16. melissinos-sandals-poet.com. *℗* **210/321-9247.** Metro: Akropoli.

Food & Wine

Ariana ★★ Lanes around the Central Market are lined with shops that specialize in one foodstuff; here the specialty is olives, with barrels brimming with varieties from around Greece, raised in their own groves below Delphi, along with fine olive oils. Olives can be vacuum-packed. Theatrou 3. www.eliesariana.gr. ☏ **210/321-1839.** Metro: Monastiraki or Omonia.

Aristokratikon ★ Athens's premier purveyor of chocolate has been turning out decadently rich creations since 1928. Voulis 7. www.aristokratikon.com. ☏ **210/322-0546.** Metro: Syntagma.

Bahar ★★ Spices and dried herbs from Greek mountainsides are accompanied by herbal oils and other elixirs; the bags of herbs and mountain teas are ideal for easy-to-carry gifts. Evripidou 31. www.bahar.gr. ☏ **210/321-7225.** Metro: Omonia or Monastiraki.

Karavan ★ The dessert-deprived can sate their cravings at this cafe and shop with bite-sized, honey-soaked baklava and *kadaifi* (Greek pastry with nuts and syrup). Voukourestiou 11. ☏ **210/364-1540.** Metro: Syntagma.

Loumidis ★ This old-fashioned coffee roaster has been around since 1920. You can choose from a huge variety of Greek and Turkish coffees and the *briki* (traditional little coffee pots) in which to brew them. Aiolou 106 at Panepistimiou St. ☏ **210/321-6965.** Metro: Omonia.

Miran ★★★ Run by the same family since 1922, this shop near the Central Market sells *pastourma* (cured air-dried beef), *sujuk* (spicy sausage), and other meats that residents of Asia Minor introduced to Athens during the population exchanges. Euripodou 25. www.miran.gr. ☏ **210/321-7187.** Metro: Omonia.

Venti ★★★ Cakes, cookies, pastries, breads, and other wares at this Athens institution, with shops around town, are so tempting and attractively displayed you can't leave empty handed. At the large and stylish Omonia store you can sit down and enjoy your treat with a cup of coffee. Pl. Omonia 7. ☏ **210/289-6400.** Metro: Omonia.

Gifts

Amorgos ★★ Wooden utensils, embroidered linens, shadow puppets—anything Greek-made seems to find a place on the crowded shelves in this standout amid the Plaka tourist shops. Kodrou 3. ☏ **210/324-3836.** Metro: Syntagma.

Center of Hellenic Tradition ★ Genuine folk arts and crafts from around Greece, including pottery, decorative roof tiles, and old-fashioned painted-wood shop signs, are on offer, as is delicious light fare in the shop's cafe. Pandrossou 36. ☏ **301/321-3842.** Metro: Monastiraki.

Ekavi ★ *Tavli* (backgammon) sets—the game of choice for Greece's cafe crowd—and chess sets with pieces resembling Olympic athletes or Greek gods

are handmade by the Manopoulos workshops in wood, metal, or stone and sold at this authorized dealer. Voulis 21. www.manopoulos.com. ✆ **210/942-1791.** Metro: Syntagma.

Kombologadiko ★ Fashioned from bone, stone, wood, or antique amber, *komboloi* ("worry" beads) sold here can be used as a stress reliever or worn as jewelry. Amerikis 9. ✆ **212/700-0500.** Metro: Panepistimiou.

Konstantopoulou ★ On Lekka Street's long row of silver shops, Konstantopoulou has the best selection of table settings, candlesticks, cutlery, and the like. Lekka 23–25. www.silverware.gr. ✆ **210/322-7997.** Metro: Syntagma.

Mala (Komboloi Club) ★ Beautiful amber worry beads are the house specialty, though *komboloi* fashioned from many other materials are also available; prices run from 15€ to 9,000€. Praxitelous 1. www.komboloiclub.com. ✆ **210/331-0145.** Metro: Panepistimiou.

NIGHTLIFE & ENTERTAINMENT
The Performing Arts

Athens's biggest performing arts event, the **Athens Epidaurus Festival,** stages drama, opera, symphonies, ballet, and modern dance, with dazzling performances by an international roster of stars. The **Odeon of Herodes Atticus** (p. 97) is one of many venues hosting evening performances in June and July; the sight of the Acropolis looming overhead is no small part of the spectacle. The remarkably well-preserved **Theater of Ancient Epidaurus** and the adjacent **Little Theater of Ancient Epidaurus,** about 2 hours southwest of Athens, stage many of the festival's productions of classical drama, on Friday and Saturday evenings from early July through mid-August; packages include transport by bus. The festival box office is at Panepistimiou 39 (aefestival.gr; ✆ **210/928-2900;** Metro: Syntagma).

Athenaeum International Cultural Centre ★ Dedicated to Greek-American opera legend Maria Callas, the center sponsors many classical concerts, including a winter and spring series at its neoclassical headquarters. The Maria Callas Grand Prix competition for operatic vocalists and pianists brings international talent to the city in March. One of the city's top events, an annual concert on or around September 16 (the anniversary of Callas's death) is staged at the Odeon of Herodus Atticus. Adrianou 3. www.athenaeum.com.gr. ✆ **210/321-1987.** Metro: Thissio or Monastiraki.

Dora Stratou ★★ This beloved institution has been performing traditional Greek folk dances at a beautiful garden theater on Filopappou Hill since 1953. Evening performances run daily from June through September. Scholiou 8. www.grdance.org. ✆ **210/324-4395.** Metro: Akropoli or Petralona. Bus 230. Trolley 15.

Gagarin 205 ★ This cavernous modern hall hosts rock concerts, with a lineup of Greek and international stars playing to crowds of 1,300 or more.

Free shuttle buses make it easy to get out to opera, ballet, and other performances at the stunning modern Stavros Niarchos Foundation.

Check the website for schedule. In summer, the action moves to venues on the coast. Liosion 205. www.gagarin205.gr. ℂ **211/411-2500.** Metro: Attikis.

Megaron ★ Exceptionally fine acoustics make this sleek modern venue a standout on the classical musical circuit. Recitals, symphonic performances, and other programs by an international roster of musical talent run from September to June. Vas. Sofias and Kokkali. www.megaron.gr. ℂ **210/7228-2714.** Metro: Megaron Mousikis.

Olympia Municpal Music Theatre Maria Callas ★ This grand old hall in Omonia, former home of the Greek National Opera (now at the Stavros Niarchos Center; see below), hosts concerts and theater performances at affordable prices, often for free. Letters, photographs, handbags, and other personal effects of the theater's namesake, the great opera star Maria Callas, are displayed in the foyer. Akadimias 59–61. ℂ **210/371–1200.** Metro: Panepistimiou.

Onassis Cultural Center ★ Theater works, concerts, film screenings, art exhibitions, and other productions are showcased in the imposing Onassis Stegi, a hall that is a stage set in itself, encased in a glass shell open to the busy avenue out front. Leof. Andrea Siggrou 107. www.onassis.org. ℂ **211/198-1784.** Metro: Sigrou Fix.

Stavros Niarchos Foundation Cultural Center ★★★ The Greek National Opera performs in stunning Stavros Niarchos Hall, as does the Greek National Opera Ballet. The Alternative Stage hosts children's opera and new works. See p. 118 for more about the center, including transport options. Syggrou 364. www.nationalopera.gr. ℂ **213/088-5700.**

Technopolis ★★ What was once a fume-spewing factory is now a trendy art center and a dramatic backdrop for cutting-edge concerts and dance. In late May and early June, the center stages the Athens Technopolis Jazz Festival. 100 Piraeos St. athens-technopolis.gr. ✆ **213/010-9300.** Metro: Kerameikos.

Cleverly converted from old gas works in the Gazi neighborhood, Technopolis (see above) is now a cultural magnet with art exhibits and cutting-edge concerts.

Nightlife

It's pretty easy to find a club or bar in Athens. When in doubt, head to **Psyrri,** once a nighttime nest of hooligans but now *the* place to partake of nightlife. **Gazi** is the city's up-and-coming gay district, with bars and clubs catering to men and women, straight and gay. Clubs and bars in **Exarchia** are popular with students from nearby Athens University. The streets and squares of the **Plaka, Monastiraki,** and **Thissio** are chockablock with outdoor cafes and bars; Kolokotroni Street, running from Plaka into Monastiraki, is lined with late-night spots, many around Agias Irinis Square. Sophisticated **Kolonaki** is also a popular neighborhood for cocktails and late-night drinks.

Most nightspots don't heat up until midnight; many don't even open until 11pm and stay open until 5 or 6am. Also note that several big dance clubs in Athens close for the summer and move to the sea coast.

A summertime staple is **outdoor cinema.** Two favorites are **Cine Thission,** beneath the Hill of the Nymphs at Apostolou Pavlou 7 (www.cine-thissio.gr; ✆ **210/343-0864;** Metro: Thissio), and **Cine Paris,** in the Plaka at Kydathineon 22 (www.cineparis.gr; ✆ **210/322-2071;** Metro: Akropoli; check website for reopening dates after renovations). Both are usually open nightly, May–September, and often screen English-language films with Greek subtitles. Films usually begin at 9pm. Whatever's on screen, the sight of the beautifully lit Acropolis floating above the city usually steals the show.

BARS & LOUNGES

Baba au Rum ★★★ Rum-based concoctions are the specialty in these quirky, cozy surroundings, but other exotic drinks are available, too, as well as a surprisingly large range of nonalcoholic house-made sodas. Klitiou 6. babaaurum.com. ✆ **211/710-9140.** Metro: Syntagma or Monastiraki.

Balthazar ★★★ A beautiful courtyard garden and the elegant interiors of a neoclassical mansion attract a well-heeled crowd who enjoy lounge music and a light menu. Tsocha 27. www.balthazar.gr. ✆ **210/644-1215.** Metro: Ambelokipi.

Baraonda ★ At the edge of Kolonaki near the international hotels, this small garden is a popular spot in summer, catering to business travelers and cosmopolitan Athenians with polished food and cocktails. In winter, it moves inside to red velvet curtains, stone walls, and chandeliers. Live music most nights. Tsocha 43. www.baraonda.gr. ✆ **210/644-4308.** Metro: Ambelokipi.

Cinque Wine Bar ★★★ Two intimate spaces, one in Psyrri and the other in Monastiraki, introduce you to dozens of wines from throughout Greece, accompanied by cheeses and other light fare. Psyrri: Agatharchou 15, Metro: Thisssio. Monastiraki: Voreou 10, Metro: Monastiraki. www.cinque.gr. ✆ **215/501-7853.**

The Clumsies ★★ Several levels of smartly designed indoor-outdoor spaces in a 1919 neoclassical building provide a relaxed setting for cocktails by night, a cafe menu by day. Praxitelous 30. theclumsies.gr. Metro: Panepistimiou.

Juan Rodriquez Bar ★★ An atmospherically retro lair full of mahogany fittings, globe lamps, vintage furnishings, and ferns serves excellent cocktails and often accompanies them with music. Pallados 3. ✆ **210/322-4496.** Metro: Monastaraki.

Podilato ★★ Laid-back, stylish, and perpetually crowded, the "Bicycle" in Exarchia caters largely to students who drink and talk until dawn against a backdrop of DJ music. Themistokleous 48. ✆ **210/330-3430.** Metro: Omonia.

360 Cocktail Bar ★ The name, of course, refers to the Acropolis views, and they're smashing. It's an all-day stop, from morning coffee to cocktails. Ifaistou 2. www.three-sixty.gr. ✆ **210/321-0006.** Metro: Monastiraki.

HOTEL LOUNGES

A for Athens ★ With its highly visible sign, this all-day rooftop venue has become a navigation point in the central city; the real draw is the 360-degree views from just about any seat, accompanied by well-crafted cocktails. A for Athens Hotel, Miaouli 2–4. aforathens.com. ✆ **210/324-4244.** Metro: Monastiraki.

Air Lounge ★★★ This is the place to get away from it all, in an outdoor garden that surrounds a pool and overlooks the Acropolis—hands-down one of the most relaxing spots in the busy center of town. Fresh Hotel, Sofokleous 26. www.freshhotel.gr. ✆ **210/524-8511.** Metro: Omonia.

Alexander's ★★ An 18th-century tapestry of Alexander the Great hangs over the bar, keeping an eye on what many seasoned travelers claim is the best hotel lounge in the world. It has a clubby, old-boy ambiance, but the "old boy" next to you might be a prince or an oil baron. Try the signature drink, the Mandarin Napoleon Select, a delicious concoction laced with the oils of Sicilian tangerines. Hotel Grande Bretagne, Syntagma Sq. www.gbroofgarden.gr. ✆ **210/333-0000.** Metro: Syntagma.

Zillers Roof Garden ★★★ A terrace atop a 19th-century neoclassical mansion-turned-hotel is an ideal getaway, with stunning Acropolis views—a

hard-to-beat backdrop for grownup drinks and a refined Mediterranean menu. Mitropoleos 54. thezillersathenshotel.com. ℂ **210/322-2277.** Metro: Monastiraki.

MUSIC BARS & DANCE CLUBS

Bios ★ This Psyrri hotspot does multi-duty as a club, screening room, art gallery, and cafe, often adding excellent music in a basement nightclub and hip roof garden. Pireos 84. www.bios.gr. ℂ **210/342-5335.** Metro: Kerameikos.

Booze Cooperative ★★★ Three floors of an old factory offer a little bit of everything—coffeehouse, bar, dance club, art gallery, screening room, meeting place. Music is often live, at other times provided by popular DJs. Should you still wish to smoke while clubbing, this is the place for it—Booze is registered as a political headquarters, exempting it from the city's smoking ban. Kolokotroni 57. www.boozecooperativa.com. ℂ **211/405-3733.** Metro: Monastiraki.

Cantina Social ★★ A Psyrri neighborhood favorite never seems to slow down, from morning coffee to a swinging late-night scene, with diverse music accompanied by projected art in the courtyard. Leokoriou 6–8. ℂ **210/325-1668.** Metro: Kerameikos.

Half Note ★★ The city's most popular venue for jazz, tucked away in a quiet corner behind the Temple of Olympian Zeus, has hosted the greats for the past 30 years. Trivonianou 17. www.halfnote.gr. ℂ **210/921-3310.** Bus: A3, B3, 057.

Six D.O.G.S. ★★ Four adjoining bars in Monastiraki join forces to create one of the city's hippest venues, combining a laid-back library, sleek cocktail lounge, and garden with a huge dance hall/performance space known for its remarkable acoustics. Avramiotou 6–8. sixdogs.gr. ℂ **210/321-0510.** Metro: Monastiraki.

Stamatopoulos ★ A cool garden and nostalgic wall murals set the mood for a night of traditional *rebetika* and *bouzoukia* music, accompanied by good taverna fare and decent house wine. Lissiou 26. www.stamatopoulostavern.gr. ℂ **210/322-8722.** Metro: Syntagma.

GAY & LESBIAN BARS & CLUBS

Big Bar ★ That's "big" as in bear, though the less hirsute are also welcome in these laid-back, sociable surroundings. Falaisias 12. ℂ **694/628-2845.** Metro: Kerameikos.

Myrovolos ★ This gay-friendly cafe and bar is especially popular with women and stays open late. Giatrakou 12. ℂ **210/522-8806.** Metro: Kerameikos.

Noiz Club ★ Big and noisy, this Gazi club offers two dance floors and two DJs. It's especially popular with gay women but welcomes all. It's crowded until 4am or 6am on weekends. Leof. Konstantinoupoleos 78. ℂ **210/346-7850.** Metro: Kerameikos.

Rooster Cafe ★ A laidback hangout on Psyrri's lively central square is open all day, from 9am to late, serving coffee, snacks, meals, and cocktails, Platea Agias Irinis 4 ℂ **210/322-4410.** Metro: Omonia or Monastiraki.

Sodade 2 ★★ A mainstay in gay-friendly Gazi, Sodade 2 is popular with men and women, whatever their tastes might be. It gets packed on weekend nights. Triptolemou 10. ℂ **210/346-8657.** Metro: Kerameikos.

CASINOS

Club Hotel Casino Loutraki ★ In the seaside resort town of Loutraki, 80km (50 miles) south of Athens, this complex has 80 gaming tables, 1,000 slot machines, a luxury hotel, a restaurant, and a spa with curative hot springs. Casino Express buses (ℂ **210/523-4188** or 210/523-4144) run frequently to and from Athens. 48 Poseidonos Ave. www.clubhotelloutraki.gr. ℂ **27440/65-501.**

Regency Casino Mont Parnes ★ A cable car takes you up Mount Parnitha, 18km (11 miles) north of central Athens, to this laid-back casino complex with 50 table games and more than 500 slot machines. You can't get away with shorts, though no one will insist on a jacket and tie, either. Entrance fee is 6€. Aharnon. www.regency.gr. ℂ **210/242-1234.**

AROUND ATHENS

F ire up the imagination for some time travel. Just a few hours outside of Athens lie some of the most legendary sites of Greek history and myth. More than just piles of old stones, they're the haunts of superheroes, villains, willful gods, and naughty goddesses, all brought to life by Homer and ancient playwrights. King Agamemnon launched the Trojan War from his palace at stony Mycenae; centuries later, Saint Paul preached at Corinth, one of the largest, most cosmopolitan cities in the ancient world. The rich and powerful of the Mediterranean world consulted the oracle at Delphi, perhaps the most beautiful and mysterious of all ancient sites, while athletes traveled from as far away as the Black Sea to compete in the games at Olympia. Visiting these ancient sites brings the thrill of stepping back through the millennia and reliving the great epics of western civilization.

To the northwest on the plains of Thessaly, the magical Meteora monasteries cling to pinnacles, seeming to float between heaven and earth. Southwest of Athens in the Saronic Gulf are a clutch of island getaways, all an easy sail away from the capital.

STRATEGIES FOR SEEING THE ANCIENT SITES

Athens-based companies such as **CHAT Tours,** Xenofontos 9 (www.chatours.gr; ✆ 210/323-0827), and **Key Tours,** 4 Kalliroïs (www.keytours.gr; ✆ 210/923-3166), offer tours to Delphi and ancient sites in the Peloponnese. Typical day excursions might cover just Delphi or a pair of Peloponnesian sights; 2- to 3-day tours tend to make a full loop, going to Corinth, Epidaurus, and Mycenae, then swinging through Olympia before heading up to Delphi and back to Athens. Other 2-day excursions take in Delphi and the Meteora. Whatever option you choose, try to avoid seeing too much in too short a time—beware of those ambitious, exhausting tours that pack Corinth, Mycenae, Epidaurus, and Nafplion into 1 day. Costs range from about 80€ for a 1-day tour to about 300€

for multi-day tours, including lodging and transportation and often admission fees (or at least discounts on admission).

Independent travelers to the Peloponnese may want to consider spending a night or two in Nafplion as a base for visiting the surrounding sites, and/or an overnight in Olympia, with a stop in Delphi on the way back to Athens.

THE PELOPONNESE

Greece's southern peninsula, divided from the mainland by the Corinth Canal, is virtually a grab bag of famous ancient sites: the awesome palace of king Agamemnon at Mycenae; the mysterious thick-walled Mycenaean fortress at Tiryns; magnificent classical temples at Corinth, Nemea, and Olympia; and the monumental theaters at Argos and Epidaurus, still used for performances today. These are all in the north of the region, within easy reach of Athens. Also in the northern Peloponnese, **Nafplion** is one of the most beautiful towns in Greece, with its beaches and neoclassical mansions facing the Gulf of Argos; it's a favorite weekend getaway for Athenians. It's your top choice for an overnight when you're visiting the ancient sites, although Olympia, farther west than the other sites and a 2-hour drive from Nafplion, warrants an overnight, too, and has a lively, friendly vibe and some nice places to stay and eat.

Where to Stay & Eat Near the Peloponnese Sites

NAFPLION

Antica Gelateria di Roma ★★★ SWEETS/COFFEE A little bit of Italy comes to Nafplion in this delightful shop. It serves delicious espresso, but that takes second place to what many regulars consider the best ice cream in Greece. Athenian weekenders in Nafplion usually stop here to try yet another flavor.

Pharmakopoulou 3 and Komninou. © **27520/23520.** Sweets and sandwiches 4€–12€. Daily 8am–12:30am

Aolus ★★★ GREEK Some of Nafplion's most authentic Greek cooking is served at this charming taverna on a side street near the harbor, with a cozy, low-ceilinged room and tables out front. Many different salads, made with seasonal greens and produce, add to a mix of stuffed tomatoes and peppers, veal slow-cooked with cheese and peppers, moussaka, and other delicious Greek standards. A piece of orange pie caps off on a memorable meal.

Vasilissis Olgas 30. © **275/202-6828.** Main courses 8€–13€. Daily noon–1am.

Family Hotel Latini ★★ This stylish redo of a former sea captain's mansion has a prime location near the port, only steps from Nafplion's Syntagma Square. Most rooms are large, bright, and surprisingly quiet; many have balconies and sea views. The top-floor suite is especially accommodating. Downstairs, a welcoming bar-breakfast room opens to a sidewalk terrace.

Othonos 47. www.latinihotel.gr. © **27520/96470.** 10 units. 60€–75€ double. Rates include breakfast. **Amenities:** Bar/cafe; free Wi-Fi.

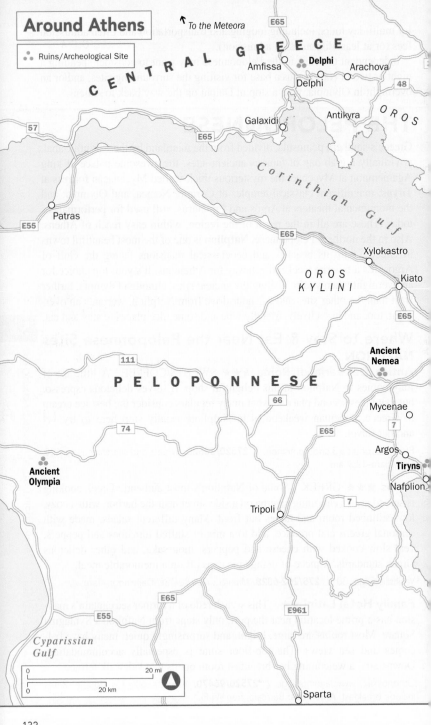

Around Athens

.: Ruins/Archeological Site

↑ To the Meteora

CENTRAL GREECE

E65

Amfissa •: **Delphi**

Delphi Arachova

Antikyra

48

OROS

Galaxidi

57

Corinthian Gulf

E65

Patras

E55

E65

Xylokastro

Kiato

OROS KYLINI

E65

111

Ancient Nemea •:

PELOPONNESE

66

Mycenae

E65 7

Argos

Tiryns

Nafplion

74

•: **Ancient Olympia**

Tripoli

7

E65

E961

E65

E55

Cyparissian Gulf

0 20 mi

0 20 km

Sparta

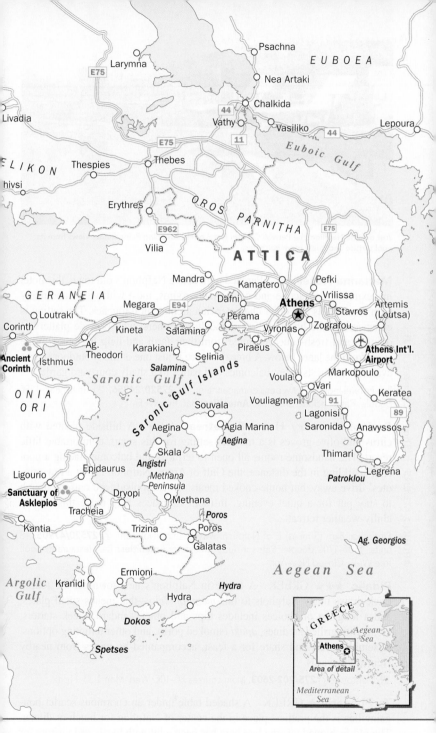

Just outside Napflion, the Perivoli Country Hotel offers sweeping Peloponnese views from its pool terrace and guest room balconies.

Marianna Hotel ★★ Perched high above Nafplion's old town, this hotel has extremely attractive and comfortable rooms, most with views and many with stone walls and other character-rich architectural touches. The setting is enhanced by the hospitality of the Zoltos brothers, who provide platters of oranges and fresh-squeezed juice from their farm and help lug bags up the steps from the lanes below. A breezy terrace is just one of many outdoor spaces available to guests, from balconies and patios to a shady courtyard garden.

Ilia Potamianou 9. www.pensionmarianna.gr. ℗ **27520/24256.** 20 units. 85€–125€ double. Rates include breakfast. **Amenities:** Bar; free Wi-Fi.

Perivoli Country Hotel & Retreat ★★★ A hillside planted with citrus and olive groves is a magical setting for this smart, comfortable little resort. The handsome rooms all open to terraces and balconies facing a pool and, sparkling in the distance, the Gulf of Argos. Nafplion is just a few min- utes' drive away, but home-cooked meals served poolside are reason enough to stay put for a quiet evening. In-room fireplaces help make this a cozy chilly-weather retreat.

Pirgiotika. 8km (5 miles) E of Nafplion. www.hotelperivoli.com. ℗ **27520/47905.** 18 units. 110€–170€ double. Rates include breakfast. **Amenities:** Bar; restaurant; pool; free Wi-Fi. Closed Nov–Apr.

Pidalio ★★★ GREEK A locale in Nafplion's new town off the tourist track draws many Nafpliots to this *mezedopoleio*—that means small plates, and a long list of choices includes dips and other standard Greek starters, along with grilled sardines, *apaki* (smoked pork), and other tempting options. Assemble a few and share for a feast, accompanied by wines from nearby Nemea vineyards.

25 Maritou 5. ℗ **275/202-2603.** Main courses 6€–10€. Wed–Mon 1:30–11pm.

Ta Phanaria ★ GREEK A shaded table under an enormous scarlet bou- gainvillea is the prettiest place in the center of Nafplion for lunch or dinner. The old-fashioned taverna fare here has been a hit with locals and visitors for

years. Aside from such standbys as moussaka, many vegetable dishes, stews, and grilled chops fill out the big menu.

Staikopoulo 13. www.fanaria.gr. *C* **27520/27141.** Main courses 7€–15€. Daily noon–midnight.

Taverna Old Mansion (Paleo Archontiko) ★★ GREEK You'll long remember a meal here as a quintessential Greek experience, offering good traditional Greek *spitiko* (home) cooking—stews, chops, and usually several vegetarian choices—on a narrow lane in Nafplion's Old Town. Every once in a while, musicians stroll in to complete the picture-perfect scene.

Siokou 7. *C* **698/186-8914.** Main courses 8€–15€. Daily noon–midnight (dinner only in some winter periods).

OLYMPIA

Modern Olympia is a one-street town; the few things you do not find on Praxitelous Kondili will be just off it.

Europa Best Western ★★ The most luxurious accommodations in Olympia are the large and well-appointed rooms at this airy hilltop retreat. Many have sunken sitting areas that open to balconies, providing lots of space for relaxation. Amenities include a pleasant garden surrounding a large pool, and the hotel's outdoor taverna can't be beat for a meal on a summer evening.

Oikismou Drouba, above modern town. www.hoteleuropa.gr. *C* **26240/22650.** 80 units. 90€–110€ double. Rates include breakfast. **Amenities:** 2 restaurants; bar; pool; free Wi-Fi.

Hotel Pelops ★★★ These spruce and appealing rooms on a quiet back street are an easy walk away Olympia's ruins and museums. Small terraces overlook the surrounding hills, and the Spiliopoulou family is on hand with gracious hospitality. Guests can use the beautiful swimming pool of the Europa Best Western (see above), just up the hill.

Varela 2. www.hotelpelops.gr. *C* **26240/22543.** 26 units. 45€–55€ double. Rates include breakfast. **Amenities:** Bar; lounge; free Wi-Fi.

Pheidas Grill House ★★ GREEK Olympians send their visitors to this busy terrace and informal taverna on the north end of the main street for what they consider to be the best kebabs and gyros in town. Heaping platters come with fluffy fried potatoes and can be accompanied by dips, starters, and salads. The country sausages and pizzas are excellent, too.

Praxitelous Kondily 60. *C* 26240/23880. Main courses 4€–7€. Mon–Sat 11am–10pm.

Taverna Bacchus ★★ This appealing countryside taverna with a large terrace has good-sized guest rooms upstairs, with nice touches like wood ceilings, tile floors, and beautiful views over rolling hills; some studios with kitchenettes are in an adjoining cottage. A swimming pool sparkling in the garden is welcome after a day exploring the nearby ruins. Home-cooked meals are served in the dining room clustered around a huge hearth and a wide terrace overlooking the surrounding olive groves.

Ancient Pisa, 3km (2 miles) E of Olympia. www.bacchustavern.gr. *C* **26240/22298.** 11 units. 70€–95€ double. Rates include breakfast. **Amenities:** Restaurant; bar; pool; free Wi-Fi.

Isthmus of Corinth ★

80km (50 miles) W of Athens

The name Peloponnese means "Pelops Island," but for centuries this peninsula west of Athens was not really an island, but connected to the mainland by this narrow neck of land, only 6.3km (4 miles) wide. Ships approaching Athens were forced to sail an extra 400km (240 miles) around the Peloponnese. Numerous schemes for shortcuts were attempted over the millennia: The ancient Greeks built a stone road, the Diolkos, to cart goods and small ships between the Gulf of Corinth and the Saronic Gulf (portions still run along the modern canal); after several attempts to dig a canal, the Romans settled for rolling ships across the isthmus on logs, similar to the way the Egyptians transported granite blocks to build the Great Pyramids. In A.D. 67, Emperor Nero set 6,000 slaves to work with spades, but that endeavor proved costly and impractical. It was not until the Suez Canal was completed in the 1870s that interest turned again to digging a water route across the isthmus. A Greek team completed the job in 1893, making the Peloponnese an island at last.

Most highway traffic zooms across the Isthmus, but you can pull off into the Canal Tourist Area where a well-marked viewpoint affords a view of the ribbonlike waterway, the ship traffic, and, most impressively, the 86m-high (282-ft.) walls of rock through which the canal was cut. An added attraction is the daredevil antics of bungee jumpers, for whom the chasm is a big draw. The lookout is also popular with thieves who prey on gawking tourists, so be sure to lock your car doors and watch for pickpockets.

Corinth ★★★

89km (55 miles) W of Athens

Now lying in vast ruins and surrounded by fertile plains, Corinth—one of the most important cities in the world for well over a thousand years—still evokes wealth and power. A prime location on the narrow Isthmus of Corinth gave the huge city, with a population of 100,000 by 400 B.C., not one but two ports, gateways to the Middle East as well as Italy. Goods from all over the known world once flowed into Corinth. A player in the Trojan and Persian Wars, the city was a major sea power with a huge fleet, and its colony at Siracusa on the island of Sicily became another of the world's great Greek cities. Corinth's citizens were known for their love of luxury, reflected in the so-called Corinthian Order of architecture, in which columns are topped with elaborate capitals decorated with acanthus leaves and scrolls. They were also known for their free-wheeling lifestyle, exemplified by the Temple of Aphrodite's 1,000 sacred prostitutes—morals that vexed St. Paul when he came here to preach Christianity in the 1st century A.D. What you see today is actually the remains of two cities, for the Romans destroyed much of Corinth when they overran Greece in the 2nd century B.C. Julius Caesar ordered the city's reconstruction in A.D. 52, and much of today's site dates to that era.

Like many Peloponnese sites, Ancient Corinth preserves layers of history: Many of its remains are Roman, but several columns still stand from the earlier Greek city's Temple of Apollo.

ESSENTIALS

Train travel from Athens to Corinth is efficient and fairly frequent via the **Proastiako** suburban railway system from Athen's Larissa Station (p. 413). The trip takes 1 hour and 10 minutes. For up-to-date schedules and fares (about 12€ from Athens to Corinth) visit www.trainose.gr, or (since the website can be bewildering) inquire at the tourist office in Athens or at Larissa Station. If you're driving, you can shoot over to Corinth in an hour or so on the **E94 toll road.** KTEL **buses** leave from Athens's **Terminal A,** 100 Kifissou (✆ **210/512-9233**), about every hour; the trip takes 1½ to 2 hours, depending on traffic and the number of stops. For schedules, check www.ktelargolida.gr. The fare is about 11€. If you arrive by train or bus, you'll have to a catch a taxi or local bus from the station to the ancient site.

EXPLORING ANCIENT CORINTH

Acrocorinth ★★★ RUINS Standing sentinel some 540m (1,700 ft.) above the coastal plain, the acropolis of ancient Corinth has been a lookout post, place of refuge, and shrine since the 5th century B.C. Byzantines, Franks, Venetians, and Turks all added to the ancient walls, creating three rings of massive fortifications, pierced by gates, that ramble across the craggy mountaintop. The ruins of the Temple of Aphrodite stand atop the highest reaches of the peak. In ancient times the reward for the climb was the company of one of the temple's 1,000 prostitutes; trekkers who make the 1-hour uphill climb now settle for views that sweep across the sea to the east and west, including both ends of the canal, and a broad swath of southern Greece. The less adventurous can make the ascent by car or in one of the taxis that wait at the bottom of the peak.

Old Corinth. odysseus.culture.gr. ✆ **27410/31266.** Admission 2€. Daily 8:30am–4pm.

Ancient Corinth ★★ ANCIENT SITE The most imposing remnant of the Greek city is the ruins of the **Temple of Apollo,** on a low hillock from which 7 of the temple's original 38 Doric columns still rise. Most of the rest of the city that remains was built by the Romans, whose shops line the **forum** ruins. On the Bema, a raised platform for public speaking in the forum, St. Paul appeared before the Roman prosecutor Gallio in A.D. 52 to plead his innocence against accusations that he was persuading the populace to worship God in unlawful ways. The Romans refurbished the **Greek Theater,** adding rows of seats and engineering the arena so it could be flooded for naval battles. Two fountains of the ancient city also remain. Glauke, daughter of the king of Corinth, allegedly threw herself into the **Glauke Fountain** when Medea, the scorned wife of Jason (who had sailed the Mediterranean with his Argonauts in search of the Golden Fleece), presented her with a wedding dress that burst into flames. The **Fountain of Peirene,** rebuilt by the Romans with arches and arcades, surrounds a spring that allegedly began to bubble forth when Peirene, a Greek woman, wept at the death of her son until she dissolved into a stream of water.

Old Corinth. odysseus.culture.gr. ✆ **27410/31207.** Admission 8€, includes Archaeological Museum. Daily mid-Apr to Aug 8am–8pm; Sept 1–15 8am–7:30pm; Sept 16–30 8am–7pm; Oct 1–15 8am–6:30pm; Oct 16–31 8am–6pm; Nov to mid-Apr 8am–3pm.

The Archaeological Museum ★ MUSEUM Display cases groan under the weight of the famous Corinthian pottery, decorated with red-and-black figures of birds, animals, gods, and humans, often in procession. Among the city's chief exports was black figure pottery, the most common style of ancient Greek vases, in which figures turn black after firing; the wares of Corinthian potters could be found throughout the ancient world. From the Roman city come several mosaics, including a delightful one in which Pan pipes away to a clutch of cows. Behind closed doors, the museum keeps an extensive collection of graphic representations of afflicted body parts from the Shrine of Asclepius (god of medicine); if you express a scholarly interest, a guard may unlock the room for you.

Old Corinth. odysseus.culture.gr. ✆ **27410/31207.** Admission 8€; includes Ancient Corinth. Same hours as Ancient Corinth (above).

Ancient Nemea ★★

25km (15 miles) SW of Corinth; 115km (72 miles) SW of Athens

Gently folded into the foothills of the Arcadian Mountains and surrounded by the famed Nemean vineyards, this once-great city was known throughout the ancient world for the Nemean Games, held every 2 years. Like those at Delphi, Olympia, and Corinth, the games drew athletes from all over the Greek world.

ESSENTIALS

From Athens, take the highway to Corinth and then continue southwest toward Tripolis to the Nemea turnoff. About five buses a day travel here from Athens, usually via Corinth, from Athens's **Terminal A,** 100 Kifissou (✆ **210/ 512-9233**). Allow about 3 hours for the trip. Ask to be let off at the ancient site of Nemea (Ta Archaia), on the outskirts of the hamlet of Archaia Nemea, not

THE nemean games: **BORN IN LEGEND**

Popular legend has it that the Nemean Games were founded to honor Hercules, who slew a ferocious lion lurking in a den outside Nemea—the first of 12 labors he was assigned by King Eurystheus in penance for killing his own children. According to another myth, the games were founded to honor Opheltes, son of the Nemean king. The oracle at Delphi predicted the baby prince would remain healthy if he stayed off the ground until he could walk. One day his nursemaid set him down in a bed of parsley while she showed soldiers the way to a spring; in her absence, a serpent strangled the boy. This story explains why judges at the games wore black for mourning, and the victor was crowned with a wreath of parsley.

in the village of Nea Nemea. For schedules, check www.ktelargolida.gr; a one-way fare is about 14€.

EXPLORING ANCIENT NEMEA

Coins from every Greek city have been unearthed among the ruins here, proof that the Games attracted competitors from far and wide. Those coins, along with athletic gear and other artifacts, are displayed in a small **museum** at the site. The 4th-century-B.C. **stadium** is still largely intact—in fact, races are still sometimes held on its running track. The vaulted **tunnel** that leads from a dressing room to the track, a marvel of ancient engineering, sheds new light on the development of the arch, once seen as a Roman innovation: Its presence here in a pre-Roman structure suggests that troops traveling with Alexander the Great during his India campaign in 326 B.C. may have introduced the architectural concept to the Mediterranean world. Nemea was also famous for its **Temple to Zeus,** several columns of which remain, although the ruins were mined extensively for a Christian basilica nearby.

Outside modern Nemea. odysseus.culture.gr. ℂ **27460/22739.** Admission 6€. Daily mid-Apr to Aug 8am–8pm; Sept 1–15 8am–7:30pm; Sept 16–30 8am–7pm; Oct 1–15 8am–6:30pm; Oct 16–31 8am–6pm; Nov to mid-Apr 8am–3pm.

Mycenae ★★★

50km (31 miles) S of Corinth; 120km (75 miles) SW of Athens

Just looking at this ruined city, with its still-massive fortifications, it's easy to imagine what Homer meant when he said that "Mycenae was once rich in gold." Sprawling ruins, tucked beneath massive cliffs, suggest the might of what was once the greatest city in the western world. Though its heyday was short-lived, Mycenaean civilization dominated much of the southern Mediterranean from around 1500 B.C. to 1100 B.C. Its power base was built on a bluff above the fertile Agrolid Plain, surrounded by deep ravines between two barren craggy peaks. It's a somber setting, befitting the tragic story told by Homer and later embellished by playwrights Aeschylus, Sophocles, and Euripides—in effect, the world's first great soap opera. It all comes to life in Mycenae: King Agamemnon launched the Trojan War after beautiful Helen,

his brother Menelaus's wife, was abducted by the Trojan prince Paris. When Agamemnon returned from Troy, he was slain by his wife, Clytemnestra, and her lover Aegisthus; Agamemnon's son and daughter, Orestes and Electra, killed Aegisthus in revenge.

The wealthy Mycenaeans also left behind many magnificent treasures, which German archaeologist Heinrich Schliemann unearthed in the 1870s; most are now on display at the National Archeological Museum in Athens (p. 110), but a few remain here in the site's small museum.

ESSENTIALS

If you're driving, you'll probably stop at Corinth first then continue to Mycenae on the toll road, **E64,** to the Nemea exit, and follow signs to Mycenae from there. KTEL **buses** from Athens's **Terminal A,** 100 Kifissou (© **210/ 512-9233**), stop about a mile from the site, at Fithia; the bus trip from Athens requires a change in Corinth.

EXPLORING ANCIENT MYCENAE

Mycenae is so steeped in legend that it's difficult to separate fact from fiction. Even archaeologist Heinrich Schliemann was convinced that a golden death mask he found in a tomb was that of Agamemnon, though the mask predates the king by centuries. Some artifacts are in a small museum near the entrance, but most of the treasures, including the famous mask, are in the National Archaeological Museum in Athens (p. 110).

You enter the city through a fortified entrance, the **Lion Gate ★★★**, which is topped by a relief of two lions, now headless, who face each other with their paws resting on a pedestal. You can still see the holes for pivots that once supported a massive bronze-sheathed wooden door. An adjacent **round tower** provided a vantage point from which guards could unleash arrows on invaders.

Uphill, the **Main Palace ★** may have been the palace of King Agamemnon, the Mycenaean king who fought in the Trojan War. Traces of a central hearth and supporting columns are still visible in the throne room. Schliemann, who romantically and at times carelessly intertwined myth and historical fact, conjectured that a bathtub in an apartment adjoining the ceremonial hall was the very one in which the king was slain by his adulterous wife, Clytemnestra. Other ruins show the city's preparedness for a long siege: The **granary** could store massive quantities of wheat and a vast subterranean **cistern ★★** held an enormous

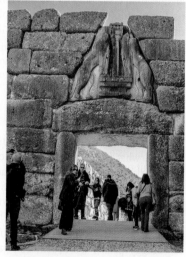

Passing through the fortified Lion Gate, visitors to the ruins of Mycenae can sense the prestige and power of Agamemnon and other kings of this once-great empire.

reservoir of water, delivered by a secret channel; climb down the wooden staircase to appreciate its immensity. In the haunting **Grave circles,** Schliemann found a trove of face masks, cups, and jewelry, all fashioned from gold—14 kilos (31 lb.) worth—now displayed at Athens's National Archaeological Museum.

On another hill, the largest and grandest Mycenaean tomb, **the Treasury of Atreus ★★**, consists of a narrow passageway fashioned out of massive blocks, leading to a high domed subterranean chamber. Evidence shows the tomb was too early to be the burial place of King Atreus, Agamemnon's father, but it was so richly decorated, it must have been built for royalty.

Off Nafplion–Argos and Corinth–Argos rds. odysseus.culture.gr. © **27510/76585.** Admission Apr–Oct 12€, Nov–Mar 6€. Daily mid-Apr to Aug 8am–8pm; Sept 1–15 8am–7:30pm; Sept 16–30 8am–7pm; Oct 1–15 8am–6:30pm; Oct 16–31 8am–6pm; Nov to mid-Apr 8am–3pm.

Nafplion ★★★

145km (90 miles) SW of Athens

If not the most beautiful city in Greece, Nafplion is certainly a top contender—and this storied port on the Gulf of Argos is more than just pretty. For centuries, Byzantines, Franks, Venetians, and Turks fought over the city, and their once-mighty forts and castles are now spectacular viewpoints. For a few years after Greece achieved independence in 1828, Nafplion was even the nation's first capital. Elegant Venetian houses, neoclassical mansions, churches, and mosques line the streets that surround the marble expanses of Syntagma Square, where Nafpliots sit at cafe tables to sip coffee, chat, and watch the parades of passers-by. You may well want to combine a visit to Nafplion with a visit to Epidaurus, with its well-preserved ancient theater, only half an hour away.

ESSENTIALS

By car, you can get here from Athens in less than 2 hours on the **E94/E65** toll roads. KTEL **buses** leave hourly from Athens's **Terminal A,** 100 Kifissou (© **210/512-9233**); the trip takes 2 to 3 hours, depending on traffic and the number of stops. For schedules, go to www.ktelargolida.gr; one-way fare is 14€.

EXPLORING NAFPLION

Wedged onto a narrow promontory between the sea and the heights dominated by the Acronafplia and Palamidi fortresses, old Nafplion is a delightful place. Tall townhouses line narrow lanes that lead off lovely **Plateia Syntagma** (Constitution Square), and two broad seaside promenades, the **Bouboulinas** and **Akti Miaouli,** are lined with cafes and patisseries. Palaces, churches, and mosques are remnants of the Venetians and Turks who occupied the city for centuries; other monuments are from Nafplion's brief tenure as the capital of Greece, from 1829 until 1834, when King Otto moved the capital to Athens.

Acronafplia ★★ RUINS Fortifications have stood on the heights above Nafplion for some 5,000 years. Until the Venetians arrived in the 13th century, the entire town lived within the walls, out of harm's way from pirates. Scattered

The handsome Peloponnese city of Nafplion was briefly the first capital of unified Greece, as commemorated by this statue of King Otto I in Trion Navarchon Square.

among the pine-scented hilltops are the ruins of several castles and forts, a testament to the Byzantine, Frankish, and Venetian powers who fought for control of Nafplion and the rest of the Peloponnese. A well-fortified Venetian castle, the **Castello del Torrione,** is the best preserved of the fortifications.

Daily dawn–dusk. Free admission.

Archaeological Museum ★★ MUSEUM

A thick-walled Venetian store-house houses assorted artifacts from the many ancient sites that surround Nafplion. The Mycenaeans steal the show with their splendid craftsmanship, unearthed at Mycenae, Tiryns, Dendra, and other settlements. These include a bronze suit of armor so heavy that scholars have concluded the wearer could only have fought while riding in a chariot. There are also death masks and offerings from the extensive network of tombs at Mycenae.

Plateia Syntagma. odysseus.culture.gr, ℂ **27520/27502.** Admission Apr–Oct 6€, Nov–Mar 3€. Wed–Mon 8:30am–3:30pm.

Bourtzi ★ FORT

This picturesque 15th-century island fortress in the harbor has witnessed pirate attacks, served as headquarters for the town executioners, and was once equipped with a massive chain that the Turks could draw across the harbor to block entry. From anywhere in town the crenellations and sturdy hexagonal watchtower look like a mirage shimmering across the water. Boats chug out to the Bourtzi from Akti Maouli, the town quay.

Harbor. Free admission. Daily dawn–dusk. Boat is usually about 5€.

Palamidi ★★ FORT

The mightiest of the three fortresses that defend Nafplion is Venetian, completed in 1714 and surrounded by massive walls and eight bastions. The Venetians were so confident upon completing the Palamidi, they left only 80 soldiers in Nafplion; the Turks easily seized the fortress just a year later. Centuries later, Greek rebels took the fortress from the Turks during the War of Independence in 1821. Prisoners confined in the

Palamidi dungeons over the years were forced to cut the 999 steps that climb the cliff face from the town below.

Above Old Town. www.visitnafplio.com. ✆ **27520/28-036**. Admission Apr–Oct 8€, Nov–Mar 4€. Daily Apr–Oct 8am–7:30pm; Nov–Mar 8am–3pm.

Peloponnesian Folklore Foundation Museum ★★★ MUSEUM In this handsome neoclassical house, the emphasis is on beautiful textiles, along with looms and other equipment used to make clothing—harking back to the days when almost all everyday items were made at home. Peloponnesian families donated many dowry items and embroidery, though the holdings come from all over Greece, including such rarities as *sperveri*, tents that surround bridal beds in the Dodecanese. Overstuffed drawing rooms from the homes of well-to-do 19th-century Nafpliots provide a glimpse into the comfortable lives of the bourgeoisie.

Vasileos Alexandrou 1. www.pli.gr. ✆ **27520/28947**. Admission 5€. Mon–Sat 9am–2:30pm; Sun 9am–3pm.

Promenade ★★★ WALKWAY All that remains of the walls that were constructed in 1502 to encircle the city is one bastion, the so-called Five Brothers. Built to defend the harbor, it was named for its five Venetian cannons, all bearing the lion of St. Mark, Venice's patron saint. A beautiful seaside promenade extends beyond the Five Brothers, skirting the southeastern tip of the peninsula, following a ledge between the Acronafplia above and the rocky shore below. Arvanitia beach, at the end of the promenade, is popular with residents who gather here to chat and swim from the pebbly shoreline.

Tou Sotiros (Church of the Transfiguration) CHURCH The oldest church in Nafplion was a convent for Franciscan nuns during the 13th-century Frankish occupation; later it was refurbished as a mosque by the Turks. A distinctly Christian presence has prevailed since 1839, when Otto, the Bavarian king who ruled over a united Greece, presented the church to Greek Catholics and the so-called Philhellenes, foreigners who fought alongside Greeks for independence from the Turks. The names of the Philhellenes, among them British poet and adventurer Lord Byron, are inscribed on the columns.

Old Town. Free admission. Daily 8am–7pm.

OUTSIDE NAFPLION

Argos ★ TOWN/RUINS What's now an agreeable farm town was once one of the most powerful cities of the ancient Peloponnese. Ancient Argos saw its heyday in the 7th century B.C., under the leader Phaedon, until it was eventually eclipsed by Sparta. Scant remains scattered around the modern town include a **theater** that, with room for 20,000 spectators in 89 rows of seats, was one of the largest in the ancient world; summertime performances are still held here (daily 8:30am–3pm; admission 2€). The Romans re-engineered the arena to use it for mock naval battles and channeled the water into the adjacent baths. High atop the town are two citadels, famous in antiquity. The **Aspis** was the city's first acropolis, abandoned when the higher **Larissa** was fortified in

the 5th century B.C., with an inner and outer system of walls and towers, the ruins of which are still visible. You can drive to both on rough roads, or make the ascent on a rugged, steep path from the ancient theater; allow at least 3 hours for the round trip and bring water. The piles of sunbaked old stones at the top really aren't the draw: Your reward for the climb is spectacular views of fertile plains and the sparking blue waters of the Gulf of Argos. The site is always open and admission is free.

Tiryns ★★ RUIN A jumble of massive stones—known as Cyclopean (since only the mythical Cyclops could have moved them)—some weighing as much as 15 tons, were once part of the walls surrounding this fortress-town that may have been the seaport for ancient Mycenae. Homer praised the city as "mighty-walled Tiryns," and the sheer power the place exudes gave rise to the ancient belief that it was the birthplace of Hercules. A modern traveler, the writer Henry Miller, observed that the ruined city "smells of cruelty, barbarism, suspicion, isolation." Not all about Tiryns was barbaric, however: A palace within the walls was once decorated with splendid frescoes of women riding chariots and other scenes, now in the National Archaeological Museum in Athens (p. 110). In a series of storage galleries and chambers on the east side of the citadel, the walls of one long passageway with a corbeled arch have been rubbed smooth by generations of sheep sheltered here after Tiryns was abandoned—a graphic example of how the mighty can fall.

5km (3 miles) N of Nafplion, off Nafplion–Argos Rd. (Take Nafplion–Argos bus and ask to be let off at Tiryns.) odysseus.culture.gr. © **27520/22657.** Admission Apr–Oct 4€, Nov–Mar 2€. Daily 8:30am–3:30pm.

Epidaurus ★★★

32km (20 miles) E of Nafplion; 63km (39 miles) S of Corinth

Just as the stadium at Olympia (p. 147) brings out the sprinter in many visitors, the theater at Epidaurus tempts many to step stage center to recite poetry or burst into song. One of the best-preserved classical Greek theaters in the world is a magnificent arrangement of 14,000 limestone seats set into a hillside. Pausanias, the 2nd-century-A.D. Greek traveler and chronicler, commented, "Who can begin to rival . . . the beauty and composition?" Or, he might have added, the acoustics? They are so perfect that a whisper onstage can be heard at the last row of seats, as demonstrated at productions of the summertime Hellenic Festival. To the ancients, Epidaurus was best known for the Sanctuary of Asklepios, a healing center that featured such remedies as dream interpretation and the flickering caress of serpent tongues.

ESSENTIALS

If you're coming from Athens or Corinth, turn left for Epidaurus immediately after the Corinth Canal and follow the coast road to Ancient Epidaurus (or Epidaurus Theater), not to Nea Epidaurus or Palea Epidaurus. From Nafplion, follow the signs for Epidaurus and keep an eye out for signs for the Theater (the theater and sanctuary are poorly signposted, but there are some road signs saying ANCIENT THEATER). Three buses a day run from Athens's **Terminal A,**

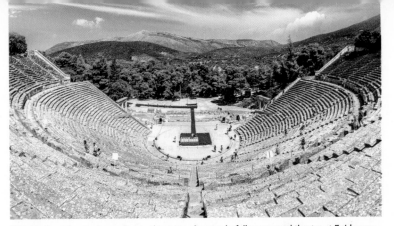

With 55 tiers of seats descending to the stage, the wonderfully preserved theater at Epidaurus once again hosts live performances every summer.

100 Kifissou (℡ **210/512-9233**), to Nea Epidaurus, about 20km (12 miles) north of the site; you can continue from there by taxi. The trip takes about 1½ hours and the fare is 11€; for schedules, go to www.ktelargolida.gr. Buses run from Athens and from Nafplion on days of performances at the Theater of Epidaurus; check with the theater box office (see p. 146).

EXPLORING EPIDAURUS

The Sanctuary and Museum ★★ RUINS The Sanctuary of Asklepius at Epidaurus was one of the most famous healing centers in the Greek world. Asklepius, son of Apollo and god of medicine, was worshipped in the beautiful **temple** at Epidaurus (undergoing restoration, as is much of the sanctuary) by cure seekers who were housed in an enormous guesthouse, the **Katego-geion.** They were treated in the **Abaton,** where Asklepius came to them in drug-induced dreams and dispensed advice on cures. The round **Tholos** appears to have housed healing serpents, which could allegedly cure ailments with a flicker of the tongue over an afflicted body part; it's believed the snakes lived in the labyrinth-like inner foundations. The **Excavation Museum** helps put some flesh on the bones of the confusing remains with an extensive collection of architectural fragments from the site, including delicate acanthus flowers from the mysterious tholos. Assorted terra-cotta body parts were votive offerings that show precisely which part of the anatomy needed to be cured; a display of surgical implements will make you grateful that you didn't have to go under the knife in ancient times—although hundreds of inscriptions record the gratitude of satisfied patients.

Admission included in theater (see below).

The Theater ★★★ ANCIENT SITE The magnificent open-air theater at Epidaurus is one of the best preserved from the ancient world. Buried for close to 1,500 years, the stage and 55 tiers of seats—divided into a lower section of 34 rows and an upper section with 21 rows—remain much as they were. Acoustics are so sharp that a stage whisper can be heard at the top of the house. Researchers have demonstrated that the theater's superb acoustics are

Classical performances at the ancient theater are usually given Friday and Saturday and sometimes Sunday at around 9pm June through September. Many productions are staged by the **National Theater of Greece,** some by foreign companies. Ticket prices range from 20€ to 60€. For the latest ticket prices and other information, contact the **Athens**

Epidaurus Festival, at the Epidaurus theater or in Athens at 39 Panepestimiou (aefestival.gr; ✆ **210/928-2900**). Most of Nafplion's travel agencies sell tickets on the day of a performance. The ancient tragedies are usually performed, either in classical or modern Greek; programs usually have a full translation or synopsis of the play.

due to its limestone seats, which deaden the low-frequency murmurs of the audience while magnifying the higher-frequency voices of the actors. odysseus.culture.gr. ✆ **27530/22009.** Admission Apr–Oct 12€, Nov–Mar 6€; includes theater, sanctuary, and museum. Daily Apr 8am–7pm; May–Aug 8am–8pm; Sept 1–15 8am–7:30pm; Sept 16–30 8am–7pm; Oct 1–15 8am–6:30pm; Oct 16–31 8am–6pm; Nov–Mar 8am–5pm.

Olympia ★★★

311km (193 miles) W of Athens

One of the most storied archaeological sites in the world, the stadium, gymnasium, training hall, and dormitories at the foot of the Kronion Hill evoke Olympia's famous ancient games, inaugurated in 776 B.C. It's easy to see why the ancients, with their knack for finding the most beautiful settings for their creations, favored this spot, with forested hillsides, pine-scented mountain air, and the Alpheios and Kladeos rivers rushing past the remains of temples and public buildings. Before Olympia became a sports venue, the site was a sacred place, a sanctuary founded around the 10th century B.C. to honor Zeus and his wife Hera. Like ancient worshippers and spectators, you'll probably find that visiting the mountainside site is a bit of a spine-tingling thrill.

ESSENTIALS

Olympia is about a 3½-hour drive from Athens, and a little over 2 hours from Nafplion. There is a daily **bus** to Krestena (about 16km/10 miles south) from Athens's **Terminal A,** 100 Kifissou (www.ktelileias.gr; ✆ **210/512-9233**); from there you can continue by taxi, about 15€.

EXPLORING ANCIENT OLYMPIA

The superheroes who bring most visitors to Olympia are not gods and artists but ancient athletes. Competitors from throughout Greece were granted safe passage to the games under the Ekecheiria, a truce that promoted the notion of a united Greece. In their footsteps came spectators, touts, vendors, poetry reciters, entertainers, and prostitutes. The aim of the 5-day festivities was for city-states to commingle peaceably; in part, however, they were also a wine-fueled bacchanal. An excellent enhancement to a visit to the site is a pair of virtual reality glasses and an audio guide from **Olympia Back in Time;** at

A ceremonial torch is lit at the ruins of ancient Olympia, home of the first Olympic Games, to be transferred by relay to the host city of the modern Games.

various points amid the ruins you are cued to put on the glasses to see excellent re-creations of some key sites, complete with characters. Glasses and audio earphones rent for 20€ a set for 3 hours from the in-town office across from the main church, about a 10-minute walk from the site. For more information go to www.olympiabackintime.com; © **697/657-7473.**

Ancient Olympia ★★ ANCIENT SITE Fifth-century Roman Emperor Theodosius II, ruling that the Olympic games were pagan rituals, cleared much of ancient Olympia, and earthquakes and mudslides over the centuries finished the job. Enough rubble remains, however, to lend a sense of the layout and magnificence of the ancient city. The entrance is just west of the modern village, across the Kladeos River. The first ruins are those of the **gymnasium,** with a field surrounded by porticoes where athletes could train in bad weather, and the **Palaestra,** a training ground for wrestlers and runners. Just beyond is the **Workshop of Phidias,** where the great sculptor crafted his gold-sheathed statue of a seated Zeus, 13m (43 ft.) tall, that became one of the Seven Wonders of the Ancient World; archaeologists found the sculptor's tools here, along with a cup inscribed with "I belong to Phidias." The **Leonidaion** was a luxurious hostel for visiting dignitaries, next to the **Theokoleon,** chambers of the priests who oversaw the Altis, the sacred precinct of Zeus. Within the Altis complex stood the **Temple of Hera** and the **Temple of Zeus,** once surrounded by 36 columns, one of which was re-erected

All in a Day's Work

Legend tells us that Hercules, assigned 12 heroic labors for slaying his children, rerouted the Alpheios River to clean out the foul stables of King Augeas. Then he relaxed by mapping out the Olympia stadium with his toe and running its length—192m (630 ft.)—without taking a breath, just to work off steam. In so doing, he established the city and the games.

in honor of the 2004 Athens Olympic Games. The Temple of Zeus was the site of Phidias's famous Zeus statue (it was carted off to Constantinople in the 5th c., where it was destroyed in a fire). The Temple of Hera had its own great artwork, *Hermes Carrying the Infant Dionysus,* the only work by the great sculptor Praxiteles to survive the centuries (it's now in Olympia's Archaeological Museum; see below). The **Metroon** is shrine to Rhea, mother of the gods, and the **Pelopeion** honors Pelops, king of the Peloponnese; his altar was drenched nightly with the blood of a black ram. When Philip of Macedonia overran Greece in 338 B.C., he erected his own shrine, the **Philippeion.** A perpetual flame burned in the **Prytaneion,** a banqueting hall where victorious athletes were feted. The most powerful city-states stored their equipment and valuables in the **treasury,** and next to it is the **Nymphaeum,** a grandiose, column-flanked fountain house from which water was channeled throughout the city. To the east of the Altis are the **stadium** and **hippodrome.**

The Archaeological Museum ★★★ MUSEUM This collection makes clear Olympia's astonishing wealth and importance in antiquity: Every victorious city and almost every victorious athlete dedicated a bronze or marble statue to Olympia, making the city something of an outdoor museum. Among the collection's highlights is a monumental sculpture from the **west pediment of the Temple of Zeus** showing the battle of the Lapiths (Greeks who lived in Thessaly) and centaurs—symbolizing the triumph of civilization (the Lapiths) over barbarism (those brutish centaurs)—as the magisterial figure of Apollo, the god of reason, looks on. On the **east pediment,** Zeus oversees the chariot race between Oinomaos, king of Pisa, and Pelops, the legendary hero who sought the hand of Oinomaos's daughter. Crafty Pelops loosened his oppo-

nent's chariot pins, thereby winning the race, the girl, and the honor of having the entire Peloponnese named after him. At either end of the room, sculptured **metopes** show scenes from the Labors of Hercules, including the one he performed at Olympia: cleansing the stables of King Augeus by diverting the Alpheios River.

The museum's standout, ***Hermes Carrying the Infant Dionysus,*** has a room to itself. The glistening white marble (the torso is said to have been worn smooth by the admiring hands of temple assistants) depicts the divine messenger Hermes about to deliver the newborn Dionysos to the mountains, where he was raised by nymphs. As legend has it, Zeus conceived Dionysus with his mortal lover Semele

Charioteer helmets are among the evocative relics displayed at Olympia's Archaeological Museum, one of several excellent on-site museums.

THE THRILL OF VICTORY, THE agony OF DEFEAT

For the ancients, the Olympic Games were the greatest show on earth, staged every 4 years in honor of Zeus, king of the gods. For nearly 12 centuries, they drew athletes from as far as the shores of the Black Sea. Behind them followed prostitutes, pushy vendors, orators, and tens of thousands of spectators, including die-hard fans such as Plato and the ruler Dionysus of Syracuse. Roman Emperor Nero demanded that the Games take place a year early, in A.D. 67, when his schedule would allow him to travel from Rome to compete. After bribing officials to disqualify competitors, he won six events—including a race he didn't finish after falling from his chariot.

Conditions were primitive, but most attendees were happy to sleep under the stars to watch the world's greatest athletes perform—and to curry favor with Zeus and the other gods, who were worshipped during the proceedings. In the early years, the only event was a foot race on a strip of grass the length of the stadium, a unit of measure known as a stade (185m/610 ft.). By 500 B.C., wrestling, boxing, discus throwing, and more than 50 events took place over the course of 5 days. The most popular event was the *pankration*, a combined wrestling-boxing-kicking match with only two rules: no biting or eye gouging. Strangulation was perfectly acceptable. The game ended when one athlete quit, passed out, or died. Polydamas, a pankration champ, was as famous for his exploits off the field as on—he slew a lion with his bare hands, stopped a speeding chariot in its tracks, and single-handedly defeated a trio of Persia's mightiest warriors.

Regardless of social status, any free, Greek-speaking male without a criminal record could enter the games. Competitors rubbed themselves with olive oil and sand (an ancient sunscreen) and ate ground lizard skin (their version of steroids). Victors won money, tax emptions, free meals for life, laurel wreaths, the favor of the gods, and the services of Hetaeras, high-class escort girls. Only virgins and certain priestesses could attend the men's games. Trespassers, if caught, were tossed from a cliff.

One brave female, Kallipateira, dressed as a trainer to watch her son compete but accidentally revealed her sex while climbing over a wall. Her life was spared, but from then on trainers, like athletes, were not allowed to wear clothes—though boxers were allowed to wear metal knuckle bands to add sting to their punches.

but was forced to hide the infant from his ever-jealous wife, Hera. The plump baby thrived and grew up to become the god of wine, revelry, and theater. The work is typical of Praxiteles, the 4th-century-B.C. sculptor whose graceful, intimate creations in marble often depicted the gods as humanlike. Transporting as the work is, scholars have long debated the possibility that it's a copy by a contemporary or even a Roman master.

Other Museums Historical exhibits scattered around Ancient Olympia explore the games and the site. The **Museum of the History of the Olympic Games in Antiquity** ★★ engagingly covers the ancient contests, finger-breaking and eye-gouging and all, with text panels, illustrations, and some gee-whiz artifacts, such as ancient chariot wheels. The **Museum of the History of the Excavations in Olympia** ★, in the former home of German archaeologists, documents the excavations of Olympia with photos, journals,

and letters, beginning in 1766, when British antiquarian Richard Chandler discovered the ruins.

Olympia. odysseus.culture.gr. ℂ **26240/22517.** Admission Apr–Oct 12€, Nov–Mar 6€; includes site and museums. Daily Apr–Aug 8am–8pm; Sept 1–15 8am–7:30pm; Sept 16–30 8am–7pm; Oct 1–15 8am–6:30pm; Oct 16–31 8am–6pm; Nov–Mar 8am–5pm.

DELPHI ★★★

178km (110 miles) NW of Athens

No other ancient site is quite as mysterious and alluring as this sanctuary to Apollo, nestled high above the Gulf of Corinth on the flanks of Mount Parnassus. It's easy to see why the spot was so transporting for the ancients. Look up and you see the cliffs and crags of Parnassus; look down, and Greece's most beautiful plain of olive trees stretches toward the Gulf of Corinth. Since Delphi is just about 180km (112 miles) from central Athens, you can easily visit the site in a day. The ruins look their best in spring, when they are surrounded by wildflowers and the mountain above is still covered in snow, but they're spectacular any time.

Essentials

There are usually four KTEL **buses** daily to Delphi (three on weekends) from Athens's Liosson Terminal B bus station at 260 Liossion (www.ktel-fokidas. gr; ℂ **210/831-7153** or 210/831-7096). One-way fare is 15€.

To drive to Delphi **from Athens,** take the National Road toward Corinth, then the Thebes turnoff; allow at least 2 hours. If you're approaching Delphi **from the Peloponnese,** cross the Rio-Antirio Bridge into Central Greece and follow the coastal road as it climbs upwards from Itea to Delphi (65km/40 miles). The road is spectacular, but with many curves and almost as many tour buses. The museum and ancient site (signposted) are about 1km (½ mile) east of town, on the Arachova Road. Parking is along the road outside the site.

Delphi's online tourist site is at **www.visitdelphi.gr**.

Where to Stay & Eat in Delphi & Galaxidi

A seaside alternative for a night or two in Delphi is beautiful Galaxidi, filled with sea-captains' mansions and fringed with beaches, 35km (22 miles) southwest of Delphi. The Athens–Delphi bus usually continues on to Galaxidi, and you can use the same bus route to get back up to explore the ancient site.

Epikouros Restaurant ★★★ GREEK Views and home cooking are a winning combination in this rather sophisticated dining room and glassed-in terrace. An extensive menu features local mountain cheeses and homegrown vegetables, along with lamb with fresh tomato sauce, *keftedes* (grilled meatballs), *sousoutakia* (rice-and-meat balls, stewed in tomato sauce), and other old-fashioned classics. You'll feel you're enjoying an authentic Greek experience even when the tour groups pack in.

Vasileos Pavlou and Frederikis, Delphi. www.epikouros.net. ℂ **22650/83250.** Main courses 9€–18€. Daily noon–11pm.

Hotel Ganimede ★★★ A character-filled old mansion accommodates guests in distinctive rooms and suites, no two alike—some with antiques, polished wood floors, and paneled ceilings, others contemporary-style studios with kitchens. Guest rooms surround a flower-filled courtyard set up for lounging and casual meals, including an excellent buffet breakfast featuring local cheeses, honeys, and jams.

Gourgouri 20, Galaxidi. ganimede.gr. *✆* **22650/41328.** 7 units. 55€–95€ double. Rates include breakfast. **Amenities:** Bar; outdoor lounge; free Wi-Fi.

Hotel Varonos ★★ At one of the nicest and best-value lodgings in town, comfortable guest rooms, painted in soothing pastels, overlook the plains below town, many with small balconies. A fire burns in the lobby hearth during winter months. The Varonos family could not be more helpful, and their shop next door is filled with local honey, herbs, preserves, and other goodies.

Vasileos Pavlou 25, Delphi. www.hotel-delphi.gr. *✆* **22650/82345.** 12 units. 50€–70€ double. Rates include breakfast. **Amenities:** Lounge; free Wi-Fi.

O Bebelis ★★★ GREEK A century-old cookhouse that once catered to mariners is still the best place in Galaxidi to eat. Chef Nikos excels at innovative dishes that are a nice break from standard taverna fare. Stuffed onions and baked eggplants with feta are delicious preludes to pork baked with plums or fresh grilled fish, followed up with crème brulee, all elegantly served in a character-filled, double-height paneled room.

Nikolaou Mama. *✆* **22650/41677.** Main courses 8€–16€. Daily 1–3pm and 7–11pm.

Taverna Vakchos ★★ GREEK The family who cook and prepare the excellent meals here pride themselves on serving only the freshest vegetables and just-picked mountain herbs. You can put together a delicious meatless feast from daily offerings of greens or *briam,* a juicy vegetable stew; simple grilled and oven-roasted meat dishes are also on offer. Vakchos is Greek for Bacchus, the wine god, who makes an appearance in excellent local wines and in a mural. Rooms open to a large terrace overlooking Delphi and the plains below town.

Apollonos 31, Delphi. www.vakhos.com. *✆* **22650/83186.** Main courses 7€–10€. Daily 11:30am–4pm and 6–11pm.

Exploring Ancient Delphi

Ancient Delphi ★★ ANCIENT SITE Slightly below the ancient site, the terraced **Sanctuary of Athena** was the first stop for many pilgrims climbing up the slope from the sea. They would pause to pay homage at such shrines as the exquisitely beautiful **Tholos** (Round) temple, dedicated to an unknown goddess. A shrine has stood on this spot since 1500 B.C., when the Mycenaeans established a sanctuary to the earth goddess Gaia. The formal entrance to the site was the monumental walkway known as the **Sacred Way ★**, once lined with magnificent temples that city-states erected as votive dedications to Apollo (with a bit of one-upmanship to see who could outdo one another). These were some of the greatest works of antiquity, filled with treasures. Today only their foundations survive, except for the **Athenian Treasury,** restored in

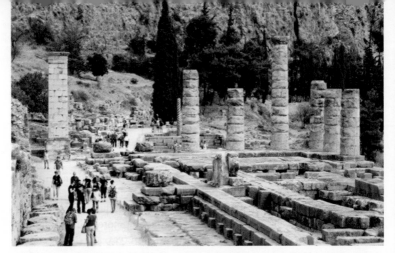

The Temple of Apollo was the central attraction in ancient Delphi, where mysterious priestesses uttered cryptic prophecies that could change the fate of nations.

the 1930s. The 4th-century-B.C. **theater** ★★ and nearby **stadium** ★★ hosted the musicians, performers, and athletes who came to Delphi for the Pythian Games, held every 4 years in honor of Apollo. Both the theater and the stadium afford magnificent views over the sanctuary and surrounding mountains.

The main attraction, however, was (and still is) the **Temple of Apollo** ★★★. Six limestone columns and rocky foundations, set against craggy cliffs, are all that remain. Begun in the 7th century B.C. the temple, according to legend, was designed by Trophonios and Agamedes, gods who labored as earthly architects. Over the centuries, the temple was financed by Greece's most important families and foreign powers. Funding the temple was not only a mark of status but also a sound investment in the future, because here one might receive life-altering words of wisdom. Allegedly, questions inscribed on stone tablets were presented to a Pythian priestess, who'd undergone a cleansing and purification ritual. Speaking for Apollo, she would utter garbled verse to priests, who interpreted them and passed along enigmatic statements (setting a precedent adapted by today's politicians). Among the supplicants were rulers and generals who came from throughout the Mediterranean world seeking advice. Perhaps the most famous piece of advice was given to King Croesus of Lydia, who asked if he should attack the Persians. If he did so, he was told, he would destroy a great empire. He did attack, and he did destroy a kingdom—his own.

odysseus.culture.gr. ⓒ **22650/82312.** Admission Apr–Oct 12€, Nov–Mar 6€; includes site and museum. Daily Apr–Aug 8am–8pm; Sept 1–15 8am–7:30pm; Sept 16–30 8am–7pm; Oct 1–15 8am–6:30pm; Oct 16–31 8am–6pm; Nov–Mar 8am–5pm.

Archaeological Museum ★★★ MUSEUM These spacious, well-lit galleries show off treasures from the Delphi temples and shrines. Seeing these magnificent works helps bring the importance of the sanctuary to light; time permitting, walk around the site, then tour the museum, then do another round of the site, using your imagination to put these treasures in place. A bronze statue of a charioteer, one of the great works to come down from ancient

Greece, honors a victory during Delphi's Pythian games. (He is believed to have stood next to the Temple of Apollo.) Some of the most fascinating finds are friezes depicting the feats of the gods, the superheroes of the ancient world. A 4th-century-B.C. marble egg (omphalos), a reproduction of an even older version, honors Delphi's position as the mythical center of the ancient world. Legend has it that Zeus released two eagles from Mount Olympus to fly around the world in opposite directions; where they met would be the center of the world and that, of course, was Delphi.

Admission included in Delphi site; see above.

THE METEORA

Kalabaka: 356km (220 miles) NW of Athens

The plain of Thessaly can seem endless on a hot summer day, until suddenly you see a cluster of gnarled black humps and peaks near the town of Kalabaka. These hoodoo-shaped formations, rising to just a little under 300m (1,000 ft.), are often compared to the mountains of the moon, and they are all the more spectacular because many are topped by gravity-defying monasteries. Monks began building the monasteries on these peaks in the 9th century, for protection, proximity to the heavens, and isolation in which to commune with God. By the end of the 14th century, the pinnacles were topped with 24 religious communities. Significantly fewer than half are still inhabited, and those by just a few nuns and monks; six of them welcome visitors. Visiting requires a climb up steep, vertiginous stairways, often via hundreds of steps carved into the rock faces. All the huffing and puffing, however, might be an improvement over the original means of ascent: in nets hoisted on ropes that, as one 19th-century British visitor was shocked to learn, were only replaced when one broke, often with a monk suspended in midair.

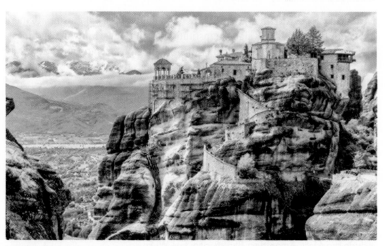

Clinging to the tops of rocky spires above the plain of Thessaly, the monasteries of the Meteora almost seem to defy gravity.

Essentials

Whether arriving by car, bus, or train, you'll probably approach the monasteries from the gateway town of Kalabaka. By **car,** the trip takes about 4 hours on the E75 and other good roads. **Buses** from Athens's Liossion Terminal B Station (260 Liossion St.; ✆ **210/831-7096**) go to Trikala, about a 5-hour trip, where you can switch to a bus to Kalabaka, another 45 minutes. **Trains** make the trip from Athens's main Larissa Station (Stathmos Larissis; www.trainose. gr; ✆ **210/529-8837**) to Kalabaka in about 4 hours. **Meteora Thrones Travel Center** (meteora.com; ✆ **24320/78455**) organizes a day trip from Athens by train, with a departure from Athens at 7:15am and return at 9:30pm. A minibus meets the train in Kalabaka for a tour of the monasteries. Fee is about 95€, fares and monastery admissions included. **Key Tours** (www.keytours.gr; ✆ **210/923-3166**) is one of many companies that offer 2-day trips to Delphi and the Meteora, with transport, guided tours, and overnight accommodation, from about 150€. Another good source for information and tours in the area is **Meteora Travel** (www.visitmeteora.travel; ✆ **24320/23820**).

Where to Stay & Eat in the Meteora

Kastraki, a little town adjoining Kalabaka, is more low-key than its larger counterpart and a little less geared to tourism.

Dellas Boutique Hotel ★★ Everything seems outsize at this stylish perch at the edge of Kalambaki—the large rooms, elegantly done in dark woods, the oversize terraces, and the Meteora rock formations, so close that you can almost reach out and touch them. The staff does double duty as travel guides, on hand with monastery hours, the best viewpoints, and tips on where to eat.

Kalabaka-Kastraki road. ✆ **243/207-8260.** 22 units. 70€–95€ double. Breakfast 10€. **Amenities:** Bar; terrace; free Wi-Fi.

Meteora Restaurant ★★ GREEK To enjoy the local cuisine it's hard to beat this century-old Kalabaka institution. Lamb stewed in wine and meatballs in a tomato sauce are typical of this rural region, accompanied by plenty of fresh garden-grown vegetables, and no one does these standards better than this family-run kitchen.

Trikalon 2, Kalabaka. ✆ **24320/22316.** Main courses 6€–12€. Daily noon–10pm.

Pyrgos Adrachti Hotel ★★★ You'd have to sleep in a monastery to feel more attuned to the spirit of the Meteora than you will at this stylishly simple and appealing guest house practically snuggled against the rocks. A cozy fireplace in the lobby and polished wood and rich fabrics in the guest rooms make you feel right at home, as does a welcoming staff. Plant yourself in front of one of the large windows or on one of the balconies and terraces and take in the spectacle outside.

Kastraki. www.hotel-adrachti.gr. ✆ **24320/22275.** 10 units. 55€–65€ double. Rates include breakfast. **Amenities:** Bar; garden; free Wi-Fi.

Taverna Bakaliarakia ★★ GREEK At this friendly, family-run operation in the center of Kastraki, steaks, chops, souvlaki, kebabs, and sausages from the grill are a specialty, but plenty of vegetarian dishes are available, too, including excellent zucchini fritters. Weather permitting, the place to sit is on the terrace out back, with an eerie rock formations looming right over the tables.

Kastraki main street. ⓒ **243/202-3170.** Main courses 7€–11€. Daily 12:30–11:30pm.

Exploring the Meteora

The circuit of the six Meteora monasteries is only about 25km (15 miles), though after climbing up and down steep steps and paths you'll probably decide to limit your visits to two or three. After a day of touring, you'll understand why it was once believed that St. Athanasios (founder of Megolo Meteoro, the first great monastery here) was carried up to his lonely aerie by an eagle. An almost mandatory activity for anyone spending the night in the Meteora is a sunset visit to one of the well-marked viewpoints off the road that makes the circuit of the monasteries.

Ayia Barbara Roussanou ★ MONASTERY Time was, you could only reach this 13th-century convent via ladders and ropes, which made it a safe refuge for rebels hiding from the Turks. Today, 16 resident nuns and their visitors need only cross a bridge from a nearby hillside to access what is essentially a flat-topped rock, large enough to accommodate nice gardens. If the nuns offer you sweets while you sit there, be sure to leave a contribution in the church collection box.

ⓒ **24320/22649.** Admission 3€. Thurs–Tues 9am–4pm.

Ayia Triada ★★ MONASTERY It's not easy to say which of the monasteries has the most spectacular position, but this perch on a slender pinnacle, reached only by laboring up 140 steps, is near the top of the list. It really does seem to belong to another world. The few monks who live here are usually glad to show visitors around the refectory, courtyard, and chapel hewn into the rock, as well as knockout views of the other monasteries. In World War II Germans looted most of its riches, including the bell, but a remaining fresco shows St. Sisois looking upon Alexander the Great's skeleton, a reminder that earthly power is fleeting. If this monastery looks familiar, perhaps you saw it in the final scene of the James Bond film *For Your Eyes Only*. You can walk the 3km (2 miles) here from Kalabaka on a well-marked footpath.

ⓒ **24320/22220.** Admission 3€. Fri–Wed 9am–4pm.

Ayios Nikolaos Anapaphas ★ MONASTERY A relatively gentle path leads up to this 14th-century hideaway that seems jammed onto a tiny outcropping atop a pinnacle. Fine frescoes by the 16th-century Cretan painter Theophanes the Monk include a delightful depiction of the Garden of Eden, with elephants, fantastic beasts, and all manner of fruits and flowers; scenes from of the life of St. Ephraim the Syrian portray the pillar atop which he lived for many years in the Syrian desert. Tour buses often bypass this stop,

meaning you may well enjoy the sense of isolation that drew monks here in the first place.

☏ **24320/22375.** Admission 3€. Sat–Thurs 9am–5pm.

Ayios Stefanos ★ MONASTERY Founded in the 12th century and now a nunnery, this airy complex is easily accessible via a bridge from the main road from nearby Kalabaka. Many priceless frescoes were defaced and others were destroyed during World War II and the civil war that followed, but the monastery's most famous relic was saved: the head of St. Charalambos, whose powers include warding off illness. The 30 or so nuns who live here sell embroidery, paint icons, work in the community, and restore sections of the monastery as they can afford to do so. Donations are always welcome.

☏ **24320/22279.** Admission 3€. Tues–Sun 9am–1:30pm and 3:30–5:30pm.

Megolo Meteoro ★★★ MONASTERY Founded in the 14th century by St. Athanasios from the famous monastic island of Mt. Athos, the largest, loftiest, and richest of the Meteora monasteries was greatly enlarged in the 16th century. Frescoes in the Church of the Transfiguration depict gruesome scenes of the martyrdom of the saints and a bloodcurdling Last Judgment and Punishment of the Damned. A shady courtyard is a pleasant place to catch your breath after a 400-step ascent, and a barrel-lined wine cellar suggests that monastic life was not all prayer and meditation—though a spooky collection of skulls in the sacristy might dampen earthly levity.

☏ **24320/22278.** Admission 3€. Wed–Mon 9am–3pm.

Varlaam ★★ MONASTERY Across a narrow bridge over a ravine and up 192 steps, this lonely 14th-century hermitage was expanded in the 16th century by two brothers from Ioannina, who considered Ioannina's monastery and lakeside scenery too sybaritic for the monastic life. The Meteora's harsh landscape was more to their liking, though it took them more 20 years to haul enough materials up the cliffs to build the fresco-adorned church. (According to legend, they had to drive away the monster who lived in a cave on the summit before they could begin work.) Monks sitting in the peaceful garden are often willing to chat with visitors.

A climb of 192 steps will take you to the Varlaam monastery, with its many frescoes and painted icons.

☏ **24320/22272.** Admission 3€. Sat–Thurs 9am–4pm.

ISLAND ESCAPES NEAR ATHENS

When the heat in Athens gets to be too much, do as the Athenians do—get on a boat and head to a nearby island in the Saronic Gulf. Aegina, Poros, Hydra, and Spetses dot the waters between Athens and the Peloponnesian peninsula. To reach them, you need only take the Metro to Piraeus and board a hydrofoil; the farthest of the four main islands, Spetses, is less than 2 hours away.

Each island has a distinct character. **Aegina** retains the old-world atmosphere of a fishing port and also has one of Greece's best-preserved temples, dedicated to the mysterious Aphaia. **Poros** promises miraculous cures at its Monastery of Zoodochos Pigi, as well as a long stretch of lemon-grove-backed sand (technically not on the island, but along its mainland holdings). **Hydra,** with its rugged landscapes and handsome stone mansions, wins the prize for beauty and a sense of getting away from it all—even a dearth of beaches doesn't detract from the island's charm. **Spetses** combines worldly elegance with palm-shaded neoclassical mansions and plenty of sand.

Essentials

Car ferries and excursion boats for the Saronic Gulf Islands usually leave from **Piraeus's main harbor;** high-speed boats leave both from the main harbor and from **Marina Zea** harbor. Cars are not allowed on Hydra and, with few exceptions, on Spetses.

Hellenic Seaways (www.hellenicseaways.gr; ℓ **210/419-9200**) offers fairly frequent service to Aegina, Poros, Hydra, and Spetses. **Saronikos Ferries** (www.saronicferries.gr; ℓ **210/417-1190**) takes passengers and cars to Aegina and Poros. **Euroseas Ferries** (www.ferries.gr/euroseas; ℓ **210/411-3108**) offers speedy catamaran service from Piraeus to Hydra and Spetses. You can get an overview of schedules at www.ferryhopper.com and www.gtp.gr.

Many Athenians choose to drive most of the way to Spetses, through Corinth and Porto Heli to Kosta, separated from Spetses by a channel a third of a mile wide; ferries and water taxis cross over to Spetses regularly from there, and a large car park in Kosta charges 5€ a day. You can also drive to Poros, through Corinth to Galatas, from which car ferries make a 5-minute crossing to the island about every half hour.

Many Athens travel agencies offer three-island tours (usually Poros, Hydra, and Aegina), though you'll find it hard to savor the character of each place with such exhausting island hopping. Given the ease of reaching the islands on your own, you're better off choosing one and enjoying a relaxing day there.

Where to Stay & Eat in the Saronic Gulf Islands

Proximity and boat service makes it easy to visit the Saronic islands on a day trip from Athens, but if you're not in a rush to get back, an overnight or two allows you to enjoy the islands at their social best in the evenings.

Bratsera ★★ A former sponge factory makes good use of its provenance, with a dazzling, jacaranda-shaded pool (the only hotel pool in Hydra) fashioned out of the former sponge-washing vat. The vast drying hall is now a

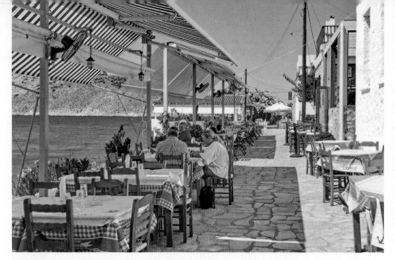
Seafood tavernas line the waterfront in Aegina's harbor.

stunning lounge/lobby, and stone walls and wood planking enliven rooms and suites, many opening to shared or private outdoor spaces. Amenities include the service of a porter to cart your luggage to and from the port.

Hydra Town. bratserahotel.com ℭ **229/805-3971.** 25 units. 190€–220€ double. **Amenities:** Bar; restaurant; fitness room; pool; free Wi-Fi.

Economou Mansion ★★ A 19th-century sea captain's mansion might make you decide to stay out in Spetses for a while. The shady garden is enlivened with sea-motif mosaics and a pool, while in the cozy and elegant seaview guest rooms, handsome tile floors are covered with old carpets and big iron bedsteads are dressed with fine linens.

Kounoupitsa, Spetses Town. www.economouspetses.gr. ℭ **22980/73400.** 8 units. 80€–150€ double (discounts for long stays). Rates include breakfast. **Amenities:** Pool; free Wi-Fi.

Hotel Miranda ★★ Oriental rugs, antique cabinets, wooden chests, marble tables, nautical prints, and contemporary paintings do justice to a beautifully restored 1820 captain's mansion on Hydra. There's even a small art gallery downstairs; upstairs are bedrooms and suites of varying shapes and sizes, many with such enhancements as frescoed ceilings and large balconies overlooking the town and port.

Miaouli, Hydra Town. www.mirandahotel.gr. ℭ **22980/52230.** 14 units. 100€–225€ double. Rates include breakfast. **Amenities:** Free Wi-Fi. Closed Nov–Feb.

Maridaki ★ GREEK One of a string of old-fashioned tavernas and ouzeri along the waterfront in Aegina's port, Maridaki has a ringside seat on the sparkling water and all the comings and goings on land. Join the locals with a plate of grilled octopus (dried on a line right out front) and a glass of ouzo. The mezedes are also excellent, as are souvlaki, moussaka, and other taverna fare.

Port, Aegina Town. ℭ **22970/25869.** Main courses 8€–20€; some fresh seafood priced by the kilo. Daily 7:30am–midnight.

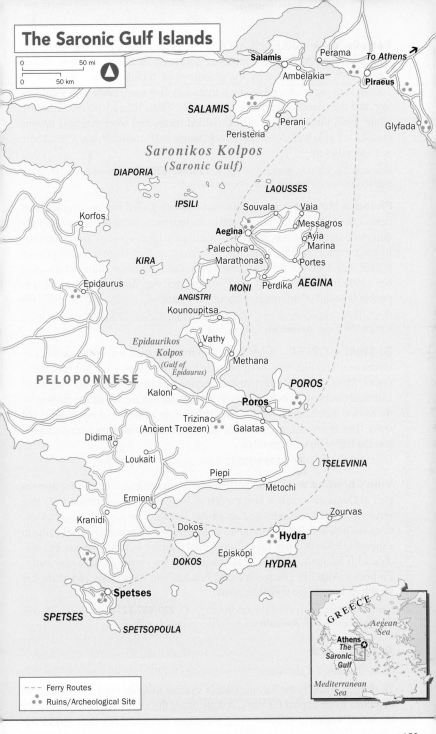

The Saronic Gulf Islands

0 ——————— 50 mi
0 ——————— 50 km

Salamis
Perama
To Athens ➚
Ambelakia
Piraeus

SALAMIS
Perani
Peristeria
Glyfada

Saronikos Kolpos
(Saronic Gulf)

DIAPORIA
LAOUSSES

IPSILI
Souvala
Vaia
Messagros

Korfos
Aegina
Ayia
Marina
Palechora
Portes

KIRA
Marathonas
Perdika
AEGINA

Epidaurus
MONI
ANGISTRI
Kounoupitsa

Vathy

Epidaurikos
Kolpos
(Gulf of
Epidaurus)
Methana

PELOPONNESE
POROS
Kaloni

Poros
Trizina
(Ancient Troezen)
Galatas

Didima
Loukaiti
△ **TSELEVINIA**
Piepi
Metochi
Ermioni
Zourvas
Kranidi
Dokos
Hydra
Episkopi
DOKOS
HYDRA

Spetses
SPETSES
SPETSOPOULA

- - - Ferry Routes
• • Ruins/Archeological Site

GREECE
Aegean
Sea
Athens
The
Saronic
Gulf
Mediterranean
Sea

Patralis ★★★ GREEK/SEAFOOD A breezy seaside dining room and terrace on the Spetses coast road just northwest of Dapia has been serving since 1935; it's now run by the grandsons of founder Panos. Seafood, of course, is the specialty, including a legendary fish soup, pasta with local lobster, and the island's own fish *a la spetsiola,* fillets baked with breadcrumbs, white wine, tomatoes, and olives. Grilled meats and other standard taverna classics are also well done, and a welcoming staff ensures that any meal here is a special event.

Kounoupitsa, Spetses. www.patralis.gr. © **229/807-5380.** Main courses 9€–18€; some seafood priced by the kilo. Daily noon–midnight.

Phaedra Hotel ★★★ A house set within a walled garden on quiet lanes behind the port is an idyllic and attractive hideaway, its large rooms tastefully done with iron bedsteads and polished antiques. One two-story family unit has its own terrace, another room has a balcony, and all share a nicely planted terrace with views of the enclosing mountains. Proprietor Hilda, who named her hotel after the Hydra-set 1962 Melina Mercouri film, is a warm and hospitable host full of information about her island.

Hydra Town. phaedrahotel.com. © **229/805-3330.** 6 units. 100€–190€ double. Rates include breakfast. **Amenities:** Garden; free Wi-Fi.

To Steki ★ GREEK A few blocks up from the quay end of the harbor, this Hydra mainstay has long been popular for its excellent food and reasonable prices. Murals portray a picturesque version of island life that has long since vanished (and was probably never so idyllic), though the island life passing by the terrace is certainly colorful. The kitchen does a fine job of maintaining old ways: The moussaka, oven-roasted lamb, and stuffed tomatoes are delicious, and the fish soup is memorable.

Miaouli, Hydra Town. © **22980/53517.** Main courses 7€–18€. Daily noon–midnight.

Villa Christina ★★ A homey guesthouse in a mansion behind the Spetses port at Dapia surrounds a lush garden of bougainvillea and lemon trees that serves as a breakfast room and an all-day lounge. The pleasant accommodations are non-luxe but comfortable, well-kept, and an extremely good value in expensive Spetses. They range from small doubles to family rooms and studios with kitchens; some have balconies and sea views, all have new baths. Proprietor Angeliki can recommend beaches and restaurants and share her wealth of knowledge about the island.

Dapia, Spetses. www.villachristinahotel.com. © **229/807-2218.** 16 units. 70€–95€ double. Breakfast 5€. **Amenities:** Snack bar; garden; free Wi-Fi.

Aegina ★★

30 km (19 miles) SW of Piraeus

The largest island in the Saronic Gulf is so close to Athens that many islanders commute to the capital for work. A walk along the waterfront of Aegina Town shows off Aegina at its best, giving a glimpse into island life that, despite the

presence of Athenian teenagers staring into their iPhones, seems unchanged over the decades. Fishing boats bob at the docks; a covered fish market, the Psaragora, does a brisk business in the morning; and fishermen hang out on the terraces of *ouzeris*. A walk inland along winding stone streets to the corner of Thomaidou and Pileos shows off **Markelos Tower,** a Venetian-era fortified house that in 1827 hosted meetings of the first government in Greece; the pink-and-white landmark now occasionally hosts art exhibits.

Aegina was at one time a rival to Athens, and the island's most splendid ancient monument—one of the best-preserved, though unsung, antiquities in Greece—attests to its one-time wealth and power. The majestic **Temple of Aphaia ★★**, set above the sea in a pine grove 12km (7 miles) east of Aegina Town (odysseus.culture.gr; ℂ **22970/32398**) commands a promontory facing Athens and the Attic coast. It's so close to the mainland that both the Parthenon and Temple of Poseidon at Sounion can be seen on a clear day (with binoculars); to the ancients, these three sanctuaries constituted a Sacred Triangle. Built in the late 6th or early 5th century B.C., on the site of earlier shrines, Aegina's temple was dedicated to Aphaia, a goddess with the enviable ability to vanish into thin air to avoid unwanted amorous advances (see box, below). Although 25 columns of the temple remain standing, the finest feature is missing: a magnificent pediment frieze depicting scenes from the Trojan War, now in the Glyptothek in Munich. Admission is 6€; the temple is open May–Oct daily 8am to 8pm, Nov–Apr 10:30am–5:30pm (closed Wed Feb–Mar).

The crumbling remains of the island's longtime capital, **Palechora ★**, sprawls across a hillside 5km (3 miles) east of Aegina Town. The ghost town was abandoned in the early 19th century, when an end to piracy made it safe to settle along the coast again, but more than 30 Byzantine churches remain, a dozen or so of them still in use. Many of these are decorated with faded frescoes, with the best covering the walls of the church of **Ayioi Anargyroi.**

One of the island's nicest seaside perches is **Perdika,** a leisure and fishing port 9km (5½ miles) south of Aegina Town, easily reached via the island bus (see below). Aside from a lively waterfront, with a long line of fish tavernas, the town has a sandy beach, Klima, that may be the island's nicest. For an

APHAIA, THE vanishing GODDESS

While the **Temple of Aphaia** (see above) is Aegina's most evocative ruin, no one really knows who Aphaia was. It seems that she was a very ancient, even prehistoric, goddess who eventually became associated with both Artemis and Athena. According to some legends, Aphaia lived on Crete, where King Minos—usually preoccupied with his labyrinth and Minotaur—fell in love with her. When she fled, Minos pursued her, until she finally threw herself into the sea off Aegina to escape him. She became entwined in fishing nets and was hauled aboard a boat. A sailor then fell hopelessly in love with the beautiful creature. So she jumped overboard again, swam ashore on Aegina, and, as her smitten admirer watched from his boat, vanished right before his eyes (*afandos* means "disappear").

extra-special getaway, and a refreshing swim, take a boat from the pier in Perdika to **Moni,** a pine-clad island nature preserve; boats come and go about every hour and charge 5€ round-trip.

Good bus service around Aegina leaves from Plateia Ethneyersias, near the ferry dock in Aegina Town. Buses leave hourly in summer for the Temple of Aphaia (3€; purchase tickets before boarding). Every Saturday and Wednesday in summer, **Panoramic Bus Tour (ⓒ 22970/22254)** offers a 3½-hour bus tour of the island (6€; leaves Aegina Town 10:35am), taking in the Temple of Aphaia, several beaches and villages, and the **Hellenic Wildlife Hospital** (ⓒ **22970/28267)** at Pachia Rachi, where monkeys, wild boar, crocodiles, owls, and other exotic creatures are rehabilitated and housed before being returned to the wild.

Hydra ★★★

79km (46 miles) SW of Piraeus

This rugged little island has been admired and appreciated for centuries. Seafaring merchant families built proud mansions of honey-colored stone on Hydra in the late 18th and early 19th centuries, artists and writers began arriving in the 1960s, and in their wake came the rich and famous. They keep a low profile, however, and with the absence of cars (transport is by foot or mule), Hydra seems wonderfully removed from the modern world.

The captains' lasting legacy, their handsome stone *archontika* (mansions) overlooking the harbor, still give Hydra town its distinctive character. The curved, picturesque harbor and the splendid houses overlooking the blue water (most houses on the waterfront are now occupied by bars and expensive shops) are especially striking because they're set against barren gray and brown mountainsides. The only places on Hydra that are habitable, in fact, are Hydra Town and some clusters of pretty seaside houses at neighboring Kamini and Vuchos, making the island seem even more like a privileged getaway.

In earlier days, Hydra was a prosperous port that sent ships as far away as America; that history comes to the fore at the harborside **Historical Archives**

Water taxis from Hydra Town's charming harbor shuttle visitors to beaches around the island.

and Museum ★ (www.iamy.gr; ⓒ 22980/52355), which displays old paintings, carved and painted ship figureheads, and costumes. Admission is 4€; the museum is open daily (May–Sept 9am–4pm and 7:30–9:30pm; Oct–Apr 9am–4pm). The hilltop **Lazaros Koundouriotis Historical Mansion ★**, built by an early 19th-century Albanian family who contributed generously to the cause of independence, is now a house museum displaying period furnishings and costumes. It's usually open from March through October, daily except Monday, 10am to 2:30pm and 5:30pm to 8:30pm; admission is 4€. If you wander the side streets on this side of the harbor, you will see more handsome houses, many of which are being restored.

Six monasteries are tucked away in the island's remote, barren hinterlands, and hiking to them across the herb-scented countryside is a popular outing. (This is certainly not an excursion for a hot summer's day.) Most popular is the pilgrimage up to the **Monastery of the Prophet Elijah ★**, on the flanks of Mount Eros, at 500m (1,650 ft.) the island's highest peak—a fairly challenging 2-hour trek along a well-marked route from Hydra Town. Many visitors make the trip by donkey, with rates starting at a highly negotiable 60€. Once there, the monks will offer you a glass of cold water in their shady courtyard and probably try to sell you some needlework made by the nuns at **Ayia Efpraxia ★**, on the hillside just beneath the monastery. The nuns there occasionally allow visitors in to see their charming chapel as well.

A pleasant waterside walk west from Hydra Town brings you to especially nice spots for a swim in warm Aegean waters at **Spilla** and **Kaminia.** Still farther west are the pine-lined coves of **Molos, Palamida,** and **Bisti** (all three as sandy as it gets on Hydra), best reached by water taxi from the main harbor (about 10€). Excursion boats from the harbor also set sail for **Ayios Nikolaos,** a pebble beach on the south coast with sun beds and refreshment concessions (the cost is about 8€ per person round-trip).

Poros ★

51km (32 miles) SW of Piraeus

Poros is separated from the mainland by a channel only 370m (1,214 ft.) wide—Poros means "straits"—and paradoxically, the best beach experience on Poros is actually back on the mainland. A 5-minute ferry ride will take you across the strait to Galatas, which is part of the island's holdings; a 10-minute taxi ride from the ferry brings you to **Aliki,** a stretch of sand on a spit wedged between the bay and a lake. In spring and early summer, the shoreline is scented by surrounding lemon groves.

The scant remains of the **Temple of Poseidon ★** (5km/3 miles south of Poros Town) are associated with Demosthenes, the great 4th-century-B.C. Athenian orator who took refuge here when Macedonia attacked Athens. When discovered, he asked to write one last letter—and bit the nib off his pen to release concealed poison. The orator's remains allegedly lie beneath a monument at the **Monastery of Zoodochos Pigi** (3km/2 miles from Poros Town; ⓒ 22980/22926), with its heavily frescoed church. The monastery also

has a famous orphanage that once housed as many as 180 boys and girls whose parents had lost their lives in the Greek War of Independence. A spring is believed to have curative powers—discovered when a 17th-century archbishop, hovering near death, took a sip and sprang back to life. Similar miracles have been reported ever since, and you can fill a bottle or two at the spring to test its life-giving powers for yourself. The monastery is open daily 8am to 1:30pm and 4:30 to 8:30pm (closes 5:30pm Oct–Apr). Buses from Poros Town will take you to either the temple or the monastery.

Spetses ★★★

98km (58 miles) SW of Piraeus

The greenest of the Saronic Gulf islands was known even in antiquity as Pityoussa (Pine-Tree Island). Many of Spetses's pine trees became the masts and hulls of vessels, and in time, the island was almost as deforested as its rocky neighbor Hydra. In the early 20th century, local philanthropist Sotiris Anargyros bought up more than half the island, then replanted barren slopes with pine trees. He also built an ostentatious mansion, the first of many on this island now noted for its handsome *archontika,* or fine houses. Today, pine groves and architecture are the island's greatest treasures; though fires have decimated the pines in recent years, they are resurging. Many of the mansions have lush gardens and pebble mosaic courtyards that can be viewed only in a quick peek when gates are left ajar.

Spetses Town (aka **Kastelli**) meanders along the attractive seafront of the northeastern coast in a lazy fashion, from the main square, the **Dapia** (which is also the name of the harbor where the ferries and hydrofoils arrive) to the **Old Port,** a distance of a little over a mile. This stretch is, for the most part, the only settlement on the island, most of which is carpeted in pine forests that

Like its neighbor Hydra, Spetses is car-free, but horse-and-carriage tours let you explore the mansion-lined back lanes of Spetses Town.

SHE swore LIKE A SAILOR!

A monumental bronze statue on the Spetses Town waterfront honors one of the greatest heroes of the War of Independence, **Laskarina Bouboulina.** The daughter of a naval captain from Hydra, she was the widow of two more sea captains, who left her with nine children and a large fortune. Bouboulina financed the warship *Agamemnon* and served as its captain in successful naval attacks on the Turks at Nafplion, Monemvassia, and Pylos. She was said to be able to drink any man under the table; strait-laced citizens sniped that she was so ugly and ill-tempered the only way she could keep a lover was with a gun. Bouboulina remained on shore long enough to settle into the **Laskarina Bouboulina House (**© **22980/72077)** just off the port in Spetses Town; she

was shot in a family feud years after retiring from sea. The house keeps flexible hours (posted outside) but is usually open daily from 10:30am to 6pm from Easter until October. An English-speaking guide often gives a half-hour tour. Admission is 5€. In the **Spetses Mexis Museum (**© **22980/72994)**, in the stone Mexis mansion (signposted on the waterfront), you can see Bouboulina's bones, along with archaeological finds and mementos of the War of Independence. The museum is open daily except Tuesday, from 8:30am to 3:30pm (closes 3pm Oct–Apr); admission is 3€. In the nearby boatyards you can often see caiques being made with tools little different from those used when Bouboulina's mighty *Agamemnon* was built here.

drop down to beaches. A handsome black-and-white pebble mosaic on Dapia commemorates the moment during the War of Independence when the first flag, with the motto "Freedom or Death," was raised. Greek forces routed the Turks in the Straits of Spetses on September 8, 1822.

Spetses has limited bus services to the beaches in summer, and, given the flat terrain, bikes are an excellent way to get around, especially on an electric bike; rentals from the many travel agencies near the harbor run about 12€ per day, 18€ for an e-bike. For better or worse (worse for pedestrians) islanders prefer motorbikes, also widely available for rent, from 30€ a day. The traditional mode of transport on the island is horse-drawn carriages, a good way to tour the mansion-lined back lanes. Fares for these are highly negotiable.

The easiest way to get to the various **beaches** around the island is by water taxi. **Ayia Marina,** about a 30-minute walk southeast of Spetses Town, is the best beach close to town and terribly popular; it's the place to see and be seen for a chic Athenian crowd, and some beachgoers arrive in high style via horse and buggy. On the forested west coast, 6km (4 miles) west of Spetses Town, **Ayii Anargiri** has one of the best sandy beaches anywhere in the Saronic Gulf, a perfect C-shaped cove lined with trees, but almost more bars and tavernas than greenery. Also on the west coast, about 10km (6 miles) west of Spetses Town, the beach at **Ayia Paraskevi** is an idyllic stretch of sand bordered by pine trees. It figures in *The Magus,* the novel that English author John Fowles wrote after a stint teaching at the island's exclusive prep school in the early 1950s, though it's no longer the isolated strand it once was. West over some rocks is the island's official nudist beach.

THE CYCLADES

The Cyclades are named from the ancient Greek word for circle because they encircle one of ancient Greece's most sacred religious sanctuaries: Delos, birthplace of the god Apollo. Santorini's volcanic caldera, the volcanic seascapes of Milos, the dramatic cliffs of Folegandros—memorable sights keep coming as you travel through this rugged, often barren archipelago of 24 inhabited islands and hundreds of islets floating southeast of the mainland. Dazzling white villages topped with brilliant blue domes, some of the best beaches in Greece, delicious meals on the shady terraces of village tavernas—these deservedly popular islands work their charms in many ways.

MYKONOS ★★

153km (95 miles) SE of Piraeus

Dry and barren Mykonos is no natural beauty, but even so, this low-lying hunk of rock is one of the most popular of all the Greek isles. Ever since Jackie O. and other celebs started stepping ashore from their yachts in the 1960s, Mykonos has been a place to see and be seen. You may love the party scene or want to flee on the next boat, but stick around long enough and you'll discover the island's more down-to-earth allure, too.

Essentials

ARRIVING Mykonos International Airport, about 3km (2 miles) south of Hora, is well connected to Athens by several **flights** daily, most operated by Olympic Airways (www.olympic-airways.gr; �? **210/966-6666**) and Aegean Airlines (en.aegeanair.com; �? **210/ 998-8300**). In summer, the airport is also served by many flights to and from London, Frankfurt, Rome, and other European cities. A bus (mykonosbus.com; ℗ **22890/26797**) runs hourly from the airport into Fabrika square at the edge of Hora; pay the 2€ fare to the driver. A taxi from the airport to Hora costs 10€–15€.

Frequent **ferry service** runs to and from the mainland port of Piraeus, and high-speed catamarans go to and from Rafina and Lavrio, both outside Athens. In season there are daily ferry connections between Mykonos and other Cyclades, including Andros, Ios, Naxos, Paros, Santorini, Siros, and Tinos; usually daily service to

The Cyclades

- - - - - Ferry Route

*Aegean
Sea*

Karystos

To Skiros

To Rafina

Gavrio
Batsi
ANDROS

To Rafina

Ioulis
KEA

Gyaros

Pirgos
TINOS
Tinos

To Rafina

Kithnos
(Hora)
KITHNOS

Ermoupolis
SIROS
Megas
Yialos

Mykonos
(Hora)
MYKONOS
Platis Yialos

DELOS

To Piraeus

Serfopoula

SERIFOS
Serifos
Livadi

Naoussa
Parikia **PAROS**
Aliki

Naxos
Town
Apollonas

Koronos
NAXOS

Donoussa

Koufonissi

Keros

To Piraeus

Kamares
Artemonas
Kastro
Apollonia
SIFNOS
Platis Yialos

Antiparos

Iraklia

Katapola
AMORGOS

To Astipalea

Kimolos

Plaka
Adamas
MILOS

Sikinos

Hora
FOLEGANDROS

Yialos
Ios (Hora)
IOS

To Piraeus

Ia
Fira
Kamari
Emborio Perissa
**SANTORINI
(THIRA)**

Anafi

Sea of Crete

To Crete

0 50 mi
0 50 km

GREECE
*Aegean
Sea*
Athens ✪
**THE
CYCLADES**
*Mediterranean
Sea*

167

Iraklion and Rethymnon, Crete; and twice a week boats to Kos, Rhodes, Samos, Skiathos, Skyros, and Thessaloniki.

The island has two ports: The old port, just at the edge of Hora, generally handles high-speed catamarans, while the new port, 2km (1 mile) north of Hora in Tourlos, accommodates ferries. Be sure to check which port you'll be arriving in and from which you'll be departing. Keep in mind that due to winds, boats often run late. The websites www.gtp.gr and www.ferryhopper. com are useful resources for checking out the many ferries that serve Mykonos, but your best bet for up-to-date schedules is to check at individual agencies. Reputable agencies on the main square in Hora include **Delia Travel** (www.mykonos-delia.gr; ✆ 22890/22322) and **Sea & Sky Travel** (www.sea sky.gr; ✆ 22890/22853).

VISITOR INFORMATION Windmills Travel ★ (www.windmillstravel. com; ✆ 215/215-9400) has an office at Fabrica square where you can get general information, book accommodations, arrange excursions, and rent a car or moped.

GETTING AROUND You can reach many places on the island by boat or bus. **Caiques** to Super Paradise, Agrari, and Elia beaches depart from Platis Yialos beach, on the island's south side, every morning, weather permitting; there is also service from Ornos beach in high season (July–Aug) only. Caique service is highly seasonal, with almost continuous service in high season and no caiques October through May. Mykonos has an excellent **bus** system, with frequent service operated by KTEL Mykonos (mykonosbus.com; ✆ 22890/ 26797) to towns and beaches around the island. Depending on your destination, a ticket costs about 1€ to 4€. There are two bus stations in Hora, one near the Archaeological Museum and one on the other side of town (both are well marked). With a little planning, you should be able to get just about anywhere you want to go by bus, but you may want to rent a **car, moped,** or **all-terrain vehicle** for a day to explore some farther-flung beaches, especially those on the north coast. Expect to pay at least 50€ per day for a small car with manual transmission, 30€ for a bike (prices rise to even more in July–Aug). Among many rental agencies on the island, **Amenos** (www.mykonosrentcar.com; ✆ 22890/24607) has offices in Hora near the School of Fine Arts and in Plata Gialos. Rentals include free parking in a lot at the edge of Hora—a huge plus, since parking in town is tight. If you stash your car in a no-parking area, the police will remove your license plates and you—not the rental office—will have to find the police station and pay a steep fine to get them back.

Where to Stay on Mykonos

Prices for accommodations can be sky-high in July and August, and even at that, hotel rooms can be scarce. Book well in advance, or consider a shoulder season visit—rates in May or late September might be at least 50%, even 75% less.

EXPENSIVE

Belvedere ★ At this chic and cool retreat in the palm-shaded Fine Arts District of Hora, rooms look out toward the distant sea, lush gardens, and a

shimmering pool. A study in white-on-white simplicity, these quarters are so stylish, with handcrafted island furnishings fashioned from rich woods, that you might not notice their small size. One of the in-house restaurants is the very hip open-air sushi emporium **Matsuhisa Mykonos** (an offshoot of the Matsuhisa-Nobu family in London, Los Angeles, Miami, New York, and elsewhere around the world). A spa and pool bar are among the other amenities.

Off Odos Ormou Agi-Agou Ioanni (aka Ring Rd.), School of Fine Arts District, Hora. www.belvederehotel.com. (✆ **22890/25122.** 48 units. 270€–700€ double. Rates include breakfast. **Amenities:** 2 restaurants; 3 bars/lounges; fitness center; Jacuzzi; pool; sauna; spa; free Wi-Fi. Closed Nov–Mar.

Cavo Tagoo ★★

At this sophisticated getaway above the marina just north of Hora, a sumptuous outdoor lounge surrounds the infinity pool, while an indoor pool is the centerpiece of an attractive spa. Huge rooms and suites, set amid beautiful gardens, are done with golden stone accents amid expanses of soothing white with splashes of blues and greens; they're filled with high-tech gadgetry, handcrafted furnishings, and luxurious baths with sunken tubs and walk-in showers. Most rooms and suites have divan-equipped sea-facing terraces, many with private pools. It's a 10-minute walk into Hora along a busy road without a sidewalk or shoulder—it's best to let the hotel car whisk you back and forth.

On an island known for its upscale resorts, Cavo Tagoo keeps the bar high.

Tagoo, coast road to Tourlos. www.cavotagoo.gr. (✆ **22890/23692.** 70 units. 600€–1,200€ double. Rates include breakfast. **Amenities:** Restaurant; bar; 2 pools; spa; in-room pools; Jacuzzis; free Wi-Fi. Closed Nov–Apr.

Mykonos Grand ★★

This sprawling resort on the island's west end above Agios Yiannis beach (where the film *Shirley Valentine* was set) breaks the generic Greek holiday complex mold with exceptional service (a level you'd normally get only in much more intimate surroundings) and endless pampering amenities. Many of the sea-facing rooms have deep whirlpool tubs and steam rooms; stylish decor makes the most of some fairly small spaces. A beautiful pool sparkles above the private sandy beach, and a spa, tennis courts, and in-house bars and restaurants make staying put a pleasant alternative to coping with high-season crowds.

Agios Yiannis. www.mykonosgrand.gr. (✆ **22890/25555.** 100 units. 400€–700€ double. Rates include breakfast. **Amenities:** 2 restaurants; 3 bars; pool; beach; spa; free Wi-Fi. Closed mid-Oct to Apr.

MODERATE

Apanema ★★★ Large, airy rooms above the marina just north of Hora are simply but tastefully done, comfortable and casually elegant with woven rugs on cool tile floors, splashes of bright colors, handcrafted pottery, and handsome wood pieces. Balconies open to a sea-facing terrace and pool, with a small indoor-outdoor restaurant and bar tucked next to one end.

Tagoo, coast road to Tourlos. www.apanemaresort.com. © **22890/28590.** 17 units. 220€–450€ double. Rates include breakfast. **Amenities:** Restaurant; bar; pool; free Wi-Fi. Closed mid-Oct to Apr.

Petasos Beach ★★ Many of these bright, sharply appointed accommodations are fairly standard size, but that hardly seems to matter when their glass doors and balconies open onto a huge swimming pool, lavish sun terraces, and the sparkling Aegean. The beach at Platis Yialos is more crowded than a rush-hour bus, but the Petasos has its own seaside aerie, a rocky peninsula from which a ladder descends into the heavenly waters. Dining is on a ledge above the sea. Hora and the south coast beaches are within easy reach by bus, caique, or taxi.

Platis Yialos. www.petasos.gr. © **22890/23437.** 133 units. 250€–550€ double. Rates include breakfast. **Amenities:** 2 restaurants; bar; beach; fitness center; pool; sauna and steam room; spa; free Wi-Fi. Closed mid-Oct to Apr.

INEXPENSIVE

Carbonaki Hotel ★★ One of the island's oldest hotels, tucked away on the back lanes of Hora, is family-run with a well-deserved reputation for hospitality. Just about all of the simply furnished but stylish rooms surround a beautiful, multilevel courtyard garden with a plunge pool, ensuring quiet (especially welcome at night, when late-night diners make their way home along the little lane out front). Downstairs is an attractive bar and lounge; breakfast (extra) and drinks are served here and in the garden. The hotel can only be reached on foot, but it's a short walk from the bus station and a parking lot, near a taxi stop along Hora's ring road.

23 Panachrantou St., Hora. carbonaki.gr. © **22890/24124.** 21 units. 80€–210€ double. Breakfast 12€. **Amenities:** Garden; pool; free Wi-Fi. Closed mid-Oct to Apr.

Fresh Boutique Hotel ★★ Minimalist design, soothing lighting, and earth tones bring a sense of calm to the heart of Hora in these small but attractive and well-equipped rooms surrounded by shops, restaurants, and bars. Double-glazed windows and an interior garden, onto which many rooms open, help ensure a good night's sleep.

Kalogera 31, Hora. www.hotelfreshmykonos.com. © **22890/24670.** 10 units. 80€–170€ double. Rates include breakfast. **Amenities:** Restaurant; garden; free Wi-Fi.

Pietra e Mare ★★★ A hillside above Kalo Livadi Beach is one of the island's quieter settings, ideal if you want to forgo nightlife for relaxing surroundings and easy access to a beautiful stretch of sand. Bright-white and stone walls accent the Cycladic styling of this handsome complex, full of shady nooks and crannies with a pool as a focal point. The large, bright rooms are stylishly

simple and open to pretty shared terraces. Hora is about 12km (7 miles) away, but you may want to stay around for dinner in the excellent restaurant.

Kalo Livadi Beach. ℂ **22890/71152.** 31 units. 100–300 double. **Amenities:** Restaurant; bar, pool; free Wi-Fi.

Where to Eat on Mykonos

In Mykonos, you can eat like a king—at least like a shipping magnate or film star—or a mere commoner, in unabashedly glitzy hotspots or delightfully simple tavernas. Not all Mykonos dining prices are daunting: Many grill houses in Hora serve up gyros for about 5€, including **Sakis,** near the Alpha Bank at Kalegora 7 (www.sakisgrill.com; ℂ **22890/24848**). Another fast-food stop in Hora is **Pepper,** Kouzi Georgouli 18 (www.pepper-mykonos.com; ℂ **22890/27019**), for burgers and souvlaki. For a hands-on experience with island cuisine, **Mykonos Cooking Classes** (www.getyourguide.com) take guests into a home kitchen to show off traditional methods of making such classics as stuffed peppers; sessions cost about 65€ for a 6-hour program, transport, food, and drink included.

Fish Taverna Kounelas ★★ SEAFOOD This plain upstairs room with a cramped garden below is a Hora institution, living up to its reputation with simple preparations of the freshest fish and seafood available and some excellent seafood pastas. Prices are fair and vary with weight; you may have to negotiate with the rushed and sometimes surly staff to make sure they don't foist a lavish seafood feast on you. You're welcome to go to the kitchen and pick out the fish, shrimps, or other seafood you want.

Savoronou 1, near Old Harbor and town hall, Hora. ℂ **22890/22890.** Entrees 8€–20€. Daily 6pm–2am.

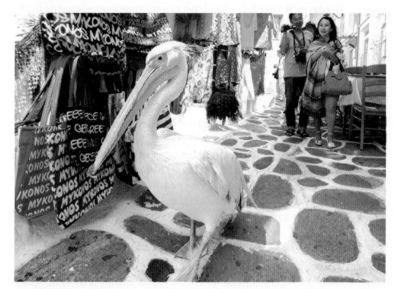

The descendants of Mykonos's mascot, Petros the Pelican, still strut around the streets of Mykonos Town (also called Hora).

Funky Kitchen ★★ GREEK/SEAFOOD The name doesn't do justice to this restaurant's creative menu or its casually relaxed surroundings, with white tables on white-edged flagstones on the little lane out front and a bright, blond room inside. Dishes are creative and flavorful—tuna is seared and accompanied with a tangy *babaganoush,* pork medallions are topped with dollops of rich creamy yogurt, pork tenderloin is pillowed on a bed of rich couscous. The house dessert, chocolate nirvana, is so rich you won't mind sharing with the table. Reservations are essential in season.

Bassoula Igantiou, off Plateia Lakka. Hora. www.funkykitchen.gr. ✆ **22890/27272.** Entrees 12€–25€. Daily 6pm–1am.

Kiki's Tavern ★★ GREEK One of the island's great pleasures is a swim at beautiful Agios Sostis on the north shore followed by a lazy lunch beneath the flowering vine that shades Kiki's seaside terrace. Fish and meat are grilled outdoors, and you'll step into the kitchen to choose one of the just-made fresh salads. The place has no electricity and shuts up at sundown.

Agios Sostis. No phone. Entrees 6€–8€. Daily noon–7pm. Closed Nov–Mar.

La Maison de Katrin ★ GREEK/FRENCH One of the island's most iconic restaurants was serving fusion cuisine long before that became a trend—wonderful seafood soufflés, French leg of lamb infused with island spices, and an apple tart with light Greek pastry. The candlelit room in the heart of old Hora is pretty and so blessedly quiet you won't mind not being outdoors, but if you need to be, ask to sit at one of the tables out front.

Ayios Gerasimos and Nikou, near Old Harbor, Hora. katrinmykonos.com. ✆ **22890/ 22890.** Entrees 20€–35€. Daily 6pm–1:30am.

Niko's Taverna ★ GREEK These tables sprawling across a square in the heart of Hora are never empty, and the basic tavern fare—moussaka, cabbage stuffed with feta, and other standards—is reliably good. Avoid lunch and early evening, when the cruise-ship crowd packs in; wait to dine late and you can linger beneath the trees and stars.

Agios Moni Sq. near Parapotianis, Hora. www.nikos-taverna.com. ✆ **2289/024320.** Entrees 6€–10€. Daily noon–1am.

To Maereio ★★★ GREEK The twin brothers who run this simple and atmospheric place come from a line of chefs and they treat their customers to the family's recipes for country meatballs, zucchini fritters, chicken with lemon, and other delicious dishes, offered on a small menu and in daily specials. This is the favorite of many Mykonites, so come early or late to avoid the crush and ask for a table on the little street out front.

16 Kalogera, Hora. ✆ **22890/28825.** Entrees 9€–14€. Dinner 7pm–1am.

Exploring Mykonos Town (Hora) ★★★

No matter how crowded the narrow streets may be, like legions of other international travelers you will soon succumb to the Cycladic charms of Mykonos Town (better known as Hora). Wooden balconies hang from white cubical houses,

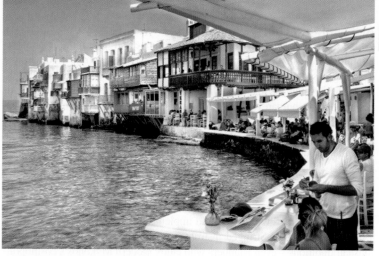

In Little Venice in Mykonos Town, the sea captains' mansions lining the water's edge are now occupied by chic bars and restaurants.

outdoor staircases are lined with pots of geraniums, and oleander and hibiscus scent the air. The experience is made all the more pleasant by the absence of motorized traffic, mostly prohibited beyond **Plateia Mando Mavrogenous.** This busy square is named for the island heroine who pushed back a fleet of invading Turks in the War of Independence in 1822. Despite her fame, the beautiful and aristocratic Mando Mavrogenous died forgotten and in poverty on Paros, but she is now honored with a marble bust here, gazing out over the harbor. The mazelike arrangement of the surrounding lanes was laid out to baffle invading pirates, and they can still have the same effect on those looking for a specific address. Even locals often navigate by benchmarks—"the little lane after the big tree," whatever, so when in doubt simply ask for the nearest landmark.

Matoyanni Street, lined with expensive boutiques, leads south from the square into the Old Quarter. The glittering wealth on this street, with its distinctive white-outlined paving stones, belies the fact that until tourism transformed the island in the 1960s, bleak sun-parched Mykonos was the poorest island in the Cyclades.

On **Dinameon Street,** you'll find one of the island's favorite landmarks, the Tria Pagadia (Three Wells). Legend has it that a virgin who drinks from all three wells will soon find a husband. The water is no longer potable—but then, virgins are few and far between on worldly Mykonos these days.

Perhaps the most famous icons of Mykonos are the windmills that line **Alefkandra Ridge** on a point of land just south along the waterfront from the Old Quarter. Alefkandra means "whitening"—women used to wash their laundry in the surf and string it out on the ridge to take advantage of the same breezes that once propelled the giant blades. Other windmills line a barren ridge above Hora to the east. Until a few decades ago 16 of these conical, thatch-roofed mills were still in operation around Mykonos to grind grain.

Archaeological Museum ★ MUSEUM Filling a couple of stark rooms off the harbor are funerary sculptures and vases excavated from the purification pit on the island of Rhenea. The artifacts were originally buried with the dead on the sacred island of Delos; in the 5th century B.C., the oracle at Delphi advised the Athenians to cleanse Delos to reverse their defeats in the Peloponnesian War, so human remains and funereal offerings were removed to the necropolis on Rhenea. From Mykonos comes a large *pythos* (vase) from the 7th century B.C., painted with vivid depictions of Greek soldiers emerging from the wooden horse to bring about the fall of Troy.

Agios Stefanos. odysseus.culture.gr. ⓒ **22890/22325.** Admission 4€. Wed–Mon 9am–4pm.

Folklore Museum ★ MUSEUM An evocative throwback to times past, this museum is filled with household implements, costumes, and a re-created 19th-century kitchen. Stringed instruments reflect the island's long-standing musical traditions—even islanders who enjoy modern Mykonos's cosmopolitan nightlife probably also know the ages-old laments sung at feasts at the island's more than 400 churches. The museum is also the final resting place of Petros, a pelican who took shelter on Mykonos during a storm in the 1950s and soon became the island's mascot. Since the island began to prosper from the arrival of well-heeled visitors not long afterward, Petros may well have brought good luck with him. Petros met his own bad fortune under the wheels of a car in 1985 and was stuffed for posterity. Several other pelicans have since taken up residence in and around Mykonos Town.

Near Church of the Paraportiani. www.mykonosfolkloremuseum.gr. ⓒ **6946/775528.** Free admission. Mon–Sat 9am–2pm.

Little Venice ★★★ NEIGHBORHOOD The esplanade that follows the harbor is especially pleasant in evening, when Mykonites and their visitors stroll and sit at cafe tables to catch a sea breeze, and eventually the seaside walk leads west into the area now known as Little Venice. Many of the island's sea captains built homes at water's edge here, on the west side of Hora; the

Windows onto Mykonos's Seafaring Past

For centuries before the jet set arrived, the island residents of Mykonos made a humble living from the sea. In fact, the Mykonites were also once corrupt corsairs, and by the 17th century the harbor at Mykonos had become an infamous pirates' nest. Only in the 19th century, when the piracy business went out of fashion in the Aegean, did the island's traders and merchants become respectable.

In the heart of the Old Quarter, you can pore over the navigational bric-a-brac displayed at the **Aegean Maritime Museum** at 10 Dinameon St. (aegean-maritime-museum.gr; ⓒ **21081/25547;** admission 4€). The little museum is open April to October, daily 10:30am to 1pm and 6:30 to 9pm. Next door you'll find **Lena's House,** the overstuffed home of a 19th-century sea captain (ⓒ **22890/22591;** free admission). The house is open daily from April to October, 6:30pm to 9:30pm (from 7pm Sun).

TEST THE winds

Prevailing winds on Mykonos (and throughout the Cyclades) blow from the north, which is why the island's southern beaches are usually calmer. Periodically, however, a hot southern wind occurs during the summer, kicking up Sahara-like sandstorms on the south coast beaches. On such days, in-the-know sun worshippers head instead to the northern beaches—and you should do likewise. In Mykonos town, particularly hot temperatures and calm in the harbor are a pretty good sign that the southern wind is coming.

As for the north coast, on many days during July and August into September, the strong *meltemi* winds blowing from the north tend to whip up awesome and unrelenting waves—which is when the water there is filled with surfers.

houses are so close to the sea that waves wash against the lower floors—inspiring comparison to houses along the canals of Venice. Of course, those Italian waterways are more placid than the Aegean, and a drink on the seaside balconies of bars in the captains' former dwellings often comes with a shower of sea spray. At the north end, the waterside **Church of the Paraportiani** (Our Lady of the Postern Gate) is actually four little churches pieced together into a squat, rambling, lopsided assemblage that's homely and utterly charming. In the absence of straight lines, the whitewashed walls look lumpy and rumpled, like a poorly iced cake, and they fascinatingly reflect the shadowy shades of the sea that crashes against the foundations.

Exploring Ano Mera ★

The only sizable settlement on Mykonos besides Hora is set amid stark, rolling hills in the center of the island, 8km (5 miles) east of Hora. To one side of the shady plateia is the **Monastery of Moni Panagias Tourlianis ★**, where intricate folk carvings cover the marble bell tower. Inside are elaborate baroque altar screens and incense holders fashioned in the shape of dragons. Even a water spout in the courtyard is decorated with the carved figure of a woman wearing a crown, accordingly known as the Queen. The monastery contains an icon of the Virgin that has been working miracles since it was found in the countryside several centuries ago; every August 15, the feast of the Virgin, the icon is carried in a procession across the island to the Church of **Agia Kyriaki** in Hora (ℭ **0289/71249**). Admission to the monastery is free, but it's open randomly; you can always see the exterior carvings, however.

Mykonos Beaches

Beaches on Mykonos are not the best in Greece, but they are among the most popular. The beaches on the island's **south shore** have the best sand, views, and wind protection, but from June into September you'll have to navigate through a forest of beach umbrellas to find your square meter of sand. A few (**Paradise, Super Paradise**) are known as party beaches, and guarantee throbbing music and loud revelry until late at night—actually, until dawn. Others (**Platis Yialos** and **Ornos**) are quieter and more popular with families.

With all the south coast beaches, keep in mind that most people begin to arrive in the early afternoon; you can avoid the worst of the crowds by going in the morning. The **north coast beaches,** such as Agios Sostis and Panormos, are much less developed but just as beautiful, though windy in July and August.

Beaches Near Hora For those who can't wait to hit the beach, the closest to Mykonos Town is **Megali Ammos (Big Sand)** ★, about a 10-minute walk south—it's very crowded and not particularly scenic. To the north, the beach nearest town is 2km (1 mile) away at **Tourlos;** however, because this is now where many ships dock at the new harbor, it's not very scenic either. **Ornos** ★, popular with families, is about 2.5km (1½ miles) south of town and has a fine-sand beach in a sheltered bay, with hotels backing the shore. Buses to Ornos run hourly from the South Station between 8am and 11pm.

 Platis Yialos ★, with back-to-back hotels and tavernas along its long sandy beach, is extremely easy to get to from Mykonos Town by car or bus. It has pristine aqua-blue waters and a variety of watersports, but it is usually so packed with beach chairs that you can't even see the sand, and its tawdry boardwalk is lined with mostly mediocre eateries. From here, however, you can catch a caique to the more distant beaches of Paradise, Super Paradise, Agrari, and Elia (see below), as well as a small boat to Delos. The bus to and from North Station in Hora runs every 15 minutes from 8am to 8pm, then every 30 minutes until midnight. *Tip:* The first stop on the bus from town to Platis Yialos, **Psarou** ★★, is a higher-brow version of its neighbor, with white sand and greenery overlooked by the terraces of tavernas and hotels.

South Coast Beaches Buses from Hora's North Station serve the south coast beaches, with service every half hour throughout the day. Caiques to Super Paradise, Agrari, and Elia depart from Platis Yialos (see above) every morning, weather permitting; there is also service from Ornos in high season (July–Aug). Note that there are no caiques October through May. **Paradise** ★ is the island's most famous beach, with golden sands washed by breathtakingly beautiful water,

Caiques and buses make it easy to reach the sheltered beaches on Mykonos's south coast, but you may have to share them with party crowds.

but no one comes here for the sea. Lined with bars, tavernas, and clubs, Paradise is the premier party beach of the island. (One beach party on Paradise that revelers won't want to miss is the **Full Moon Party,** a once-a-month bacchanal that would make Dionysus blush. The only other party that compares to it is the **Closing Party** every Sept, which has become an island institution.) The more adventurous arrive at Paradise by moped on roads that are incredibly narrow and steep. Seeing how very few leave this beach sober, it is in your best interest (even if you have rented a moped) to get back to town by bus or taxi.

Super Paradise (Plindri) ★, in a rocky cove just around the headland from Paradise, is somewhat less developed than its neighbor, but no less crowded. The left side of the beach is a nonstop party in summer, with loud music and dancing, while the right side is mostly nude and gay. The waters here are beautiful but very deep, so it isn't the best swimming option for families with small children. You can get to the beach by bus or by caique; if you go by car or moped, be very careful on the extremely steep and narrow access road. Farther east across the little peninsula is **Agrari ★★,** a cove sheltered by lush foliage, with a good little taverna and a beach that welcomes bathers in all modes of dress and undress.

One of the longest beaches on the island, **Elia ★★** is a sand-and-pebble beach surrounded by a circle of steep hills. Despite its popularity, there is no loud bar/club here, so the atmosphere is more sedate than the Paradise beaches. It's a 45-minute caique ride from Platis Yialos and on the bus route from Mykonos Town. The next major beach is **Kalo Livadi (Good Pasture) ★.** Located in a farming valley, this long, beautiful beach is about as quiet as a beach on Mykonos's southern coast gets. There's a taverna adjacent to the beach and a few villas and hotels on the hills.

The last resort area on the southern coast accessible by bus from the north station is **Kalafatis ★.** This fishing village was once the port of the ancient citadel of Mykonos, which dominated the little peninsula to the west. A line of trees separates the beach from the rows of buildings that have grown up along the road. The waters are pristine, there's a good beach restaurant and bar, and hotels along the sands offer water-skiing, surfing, and windsurfing lessons. Boats are available to take you to **Dragonisi,** an islet with caves ideal for swimming and exploring. (You might also catch a glimpse of rare monk seals—these caves are reportedly a breeding ground for them.) Adjacent to Kalafatis in a tiny cove is **Ayia Anna ★,** a short stretch of sand with a score of umbrellas. Several kilometers farther east, accessible by a good road from Kalafatis, **Lia ★** has fine sand, clear water, bamboo windbreaks, and a small, low-priced taverna.

Make a Splash

Offshore breezes, underwater scenery, and crystal-clear waters make Mykonos one of the Aegean's favorite playgrounds for watersports enthusiasts. For diving and snorkeling excursions and instruction, try the **Mykonos Diving Center** on Paradise Beach (www.dive.gr; © **22890/ 24808**) or **W-Diving** on Kalafati Beach (www.mykonos-diving.com). For windsurfing board rental and instruction, try the **Wind Surf Center** on Kalafati Beach (www.pezi-huber.com; © **22890/72345**).

North Coast Beaches The island's north coast beaches are unspoiled, often windswept, and much less crowded than those in the south. Huge Panormos Bay has three main beaches. The one closest to Hora, **Ftelia ★★**, is a long fine-sand beach, easily one of the best on the island. Farther up the bay's west coast are two well-sheltered beaches, **Panormos ★★★**, where a long stretch of fine sand is backed by low dunes, and 1km (3/4 mile) farther north, **Agios Sostis ★★**, a lovely small crescent below a tiny village. There isn't any parking at Agios Sostis; leave your vehicle along the main road and walk down past the church and Kiki's taverna, a perfect spot for lunch. Buses run from Mykonos Town to Panormos four times a day in high season. Farther east, **Fokos ★★**, north of Ano Mera, is a superb swath of sand set amid raw, wild scenery.

Mykonos Shopping

Fashion designers such as Christian Dior and Givenchy were chief among the international travelers who began to visit Mykonos in the 1950s. They discovered the island's distinctive textiles, often woven by hand in a striped pattern, and incorporated the designs into their creations. Young Mykonites then began designing their own fashions, which were soon taken up by Jacqueline Onassis and other well-heeled visitors. The tradition continues. **Parthenis** showcases designs based on the work of the late Dimitris Parthenis, an innovative island designer, and his daughter, Orsalia, in a shop near Little Venice on Plateia Alefkandra (orsalia-parthenis.gr; ℰ **22890/23080**). **Themis Z** shows off easy, chic clothing and home decor designs by Mykonos local Themis Zouganeli, on Plateia Goumeniou (themisz.com; ℰ **22890/23210**).

Efthimiou, on Zouganeli, sells almond sweets, a traditional Mykonos favorite, and wine made on the island (ℰ **22890/22281**). **Gioras Wood Medieval Mykonian Bakery** (ℰ **22890/27784**) is a magical spot, down some steps off Efthimiou Street, where cheese pies, breads, and baklava and other delectable pastries emerge out of a centuries-old wood oven.

Mykonos After Dark

Night owls have no lack of venues for nocturnal escapades. Little Venice is the island's most popular spot at sunset, with several especially pleasant waterside bars. **Galleraki** (galleraki.gr; ℰ **22890/27188**), **Kastro's** (www.kastros mykonos.com; ℰ **22890/23072**), and **Katerina's** (katerinaslittlevenicemykonos. com; ℰ **22890/23084**) serve up views from their balconies, along with refined music, sophisticated clientele, and decent cocktails (to be sipped slowly, at 12€ or more a drink). Bars in the center of Hora are popular for after-dinner drinks and people-watching, pleasures that go on well into the wee hours. **Aroma,** on Matoyanni (aromamykonos.com; ℰ **22890/27148**), and **Lola,** Zanni Pitaraki 4 (ℰ **22890/78391**), are perennially popular. Gay bars **Babylon** (ℰ **22890/25152**) and **JackieO'** (www.jackieomykonos.com; ℰ **697/301-0981**) are next-door neighbors on the waterfront in the old port; JackieO' also has an outlet on Super Paradise Beach.

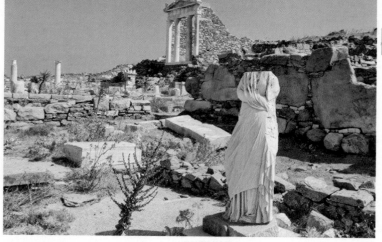

The legendary birthplace of the god Apollo, the island shrine of Delos is a worthwhile day trip, with frequent excursion boats visiting from Mykonos, Naxos, and Paros.

The late-night scene is liveliest at Paradise Beach, where **Cavo Paradise** (cavoparadiso.gr; ℂ **694/850-4989**) and the **Paradise Club** (www.paradise clubmykonos.com; ℂ **694/946-8227**) get going at about 2am and charge hefty covers (at least 25€) for the privilege of dancing till dawn. A sobering morning swim is included. The Mykonos scene changes each season, however, so check out what's new and hot once you get to the island.

A Side Trip to Delos ★★★

No one stays on Delos, but day-trippers arrive by the boatload from Mykonos and the other Cyclades, flocking to this uninhabited isle to see one of the most important—and haunting—archaeological sites in the Aegean.

As the legendary birthplace of Apollo, Delos was one of ancient Greece's most sacred religious sanctuaries. Even in antiquity, Delos was set apart from the rhythms of everyday life: No one was allowed to be born, to die, or to be buried there (the remains of locals were placed in a purification pit on Rhenea, just to the west. Delos even had a robust second act, developing under the Romans into a flourishing center of trade, with a huge slave market, on the shipping routes between the Aegean and the Middle East. Delos was gradually abandoned, however, after most of the population was massacred in a wave of attacks beginning in 88 B.C. Except for occasional visits by Venetians and crusaders, the temples, mosaics, and shrines were left to the elements—as you'll see them today.

GETTING THERE From Mykonos, organized guided and unguided excursions leave starting around 8am about four times a day Tuesday through Sunday at the west end of the old harbor. Every travel agency in town advertises Delos excursions (some with guides). Individual caique owners also have signs stating their prices and schedules. The trip takes about 30 minutes and costs 22€ round-trip; as long as you return with the boat that brought you, you

Delos

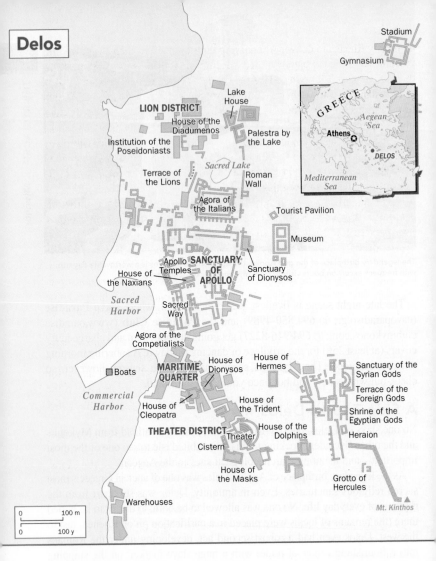

Stadium

Gymnasium

LION DISTRICT

Lake House

House of the Diadumenos

Palestra by the Lake

Institution of the Poseidoniasts

Sacred Lake

Terrace of the Lions

Roman Wall

Agora of the Italians

Tourist Pavilion

Museum

Apollo Temples

SANCTUARY OF APOLLO

Sanctuary of Dionysos

House of the Naxians

Sacred Harbor

Sacred Way

Agora of the Competialists

Boats

MARITIME QUARTER

House of Dionysos

House of Hermes

House of the Syrian Gods

Terrace of the Foreign Gods

Shrine of the Egyptian Gods

Commercial Harbor

House of Cleopatra

House of the Trident

THEATER DISTRICT

Theater

House of the Dolphins

Heraion

Cistern

House of the Masks

Grotto of Hercules

Warehouses

Mt. Kinthos

GREECE

Aegean Sea

Athens

DELOS

Mediterranean Sea

0 100 m
0 100 y

can (space available) decide which return trip you want to take. The last boat for Mykonos usually leaves by 5pm. The site is closed on Mondays, and boats usually do not make the crossing in rough weather. You can also visit Delos on organized tours from Naxos and Paros, usually leaving once a day in the morning and returning late afternoon, with a stop in Mykonos.

EXPLORING THE ISLAND

In myth, Delos is the birthplace of Apollo, god of music and light, begotten of Zeus and his lover Leto. When Zeus fell in love with Leto and she became pregnant, Zeus's furious wife, Hera, ordered the Python, the earth dragon, to pursue Leto. Poseidon took pity on Leto and provided her a safe haven by anchoring Delos to the sea floor with four diamond columns. She first stopped

on nearby Rhenea to deliver Artemis, Apollo's twin sister; then she gave birth to Apollo on Delos, grasping a sacred palm tree on the slopes of Mount Kynthos, the highest hill on the island, as Zeus watched from the summit.

The island grew to be the center of an Apollo cult, hosting the annual Delian festival in his honor. Its power as a trade center grew, and for a few decades in the 5th century B.C., Delos was important enough to be the headquarters of the Delian League, a confederation of Greek city-states, and the site of its treasury. By 100 B.C., under Roman occupation, Delos had a cosmopolitan population of 25,000, drawn from throughout the Mediterranean world; its market sold 10,000 slaves a day.

Next to the harbor, you can see what's left of the **Agora of the Competialists,** a Roman-era domain of members of trade guilds known as Competialists. Just to the east of it is the **Delian Agora,** site of the slave market.

Pilgrims once made their way from the harbor to the **Sanctuary of Apollo** along the Sacred Way, past two long, columned porticoes. After the 2nd century B.C., they would enter the sanctuary through the **Propytheria,** a triple-arched marble gateway that opened to a precinct of temples and shrines. Some of the oldest remains on Delos are here, including a shrine thought to be Mycenaean, from as early as 1300 B.C. Three great temples to Apollo were erected in the 6th and 5th centuries B.C. One of them, the **Porinos Naos,** housed the treasury of the Delian League from 477 to 454 B.C.

Just beyond the eastern perimeters of Apollo's precinct are the ruins of the long **Sanctuary of the Bulls,** so called for a pair of carved bull heads over the entryway. Two former headquarters of state are next to the sanctuary, the **Bouleterion** (Council House) and the **Prytaneion** (Senate).

A slight depression in the earth is all that remains of the Sacred Lake, now dry. On its shores stood the enormous **Agora of the Italians,** once bordered by 112 columns, and a 50m-long (164 ft.) promenade, the **Terrace of the Lions,** where 5 replicas of the original 12 or even 16 marble lions still stand, as if ready to pounce (the originals of these five lions are in the site museum). Presented by the people of Naxos around 600 B.C., the snarling lions were probably intended to guard the sanctuaries and also inspire righteous fear in worshippers.

North of the lake is the **House on the Lake,** a once-elegant residence; the **Granite Palaestra,** a gymnasium and bath complex; and beyond that, the **stadium,** where the Delian Games were first staged in the 5th century B.C. A nearby **synagogue** was built around 80 B.C. to serve Syrian and Lebanese Jews who came to Delos during the island's heyday as a trading center.

East of the harbor, in what was once the residential district of the island, you can see a **theater** carved into a hillside that could seat 5,000 spectators. Elaborate villas built by wealthy merchants and bankers in this area include the **House of the Dolphins, House of the Masks** (perhaps a boardinghouse for actors), and the lavish **House of Dionysus.** Behind this rises Mount Kynthos, which you can ascend on a stepped path for a stunning view of the sea and ancient city.

A snack bar sells beverages and light meals.

Site and museum: odysseus.culture.gr. ✆ **22890/22259.** Admission 12€ (reduced on some organized tours). Tues–Sun 8:30am–3:30pm. Closed Nov–Mar.

TINOS ★★★

161km (87 nautical miles) SE of Piraeus

Among Greeks, Tinos is best known as a pilgrimage site, where the devout ascend a red-carpeted stairway on their knees to reach the Panagia Evangelistria church.

Each year, thousands of the faithful come to Tinos to pray before the icon of the Virgin Mary in the church of the Panagia Evangelistria (Our Lady of Good Tidings), and thousands of others come to baptize their babies at Greece's holiest shrine. Sometimes called the "Lourdes of Greece," it's the most important destination in all of Greece for religious pilgrims.

That, however, is just one side of one of the least touristic and beautiful islands of the Cyclades. The villages of Tinos are some of the most appealing in the archipelago, nestled into mountain slopes and connected by a network of walking paths that make the island a hiker's paradise. Beaches are often secluded and little visited. Across the countryside you'll see ornately crafted *peristerionades* (dovecotes), for which the island is famous, and even the simplest village houses are often decorated with elaborately carved marble lintels, door jambs, and fan windows. Greek pilgrims usually spend a day or two here, but you will probably find that's not nearly enough time on the island.

Essentials

ARRIVING Frequent **ferry service** runs to and from Piraeus and Rafina on the mainland. The trip takes about 4 hours by regular ferry, as little as 2 hours by fast boat. Ferries make the half-hour run almost hourly to and from nearby Mykonos, which has the closest airport (see p. 166).

GETTING AROUND Tinos has a fairly good **bus** network (www.kteltinou.gr; ✆ **22830/22-440**), with buses operating out of a station on the harbor near the ferry dock. Buses serve many of the villages and beaches, but operate to and from each at best three or four times a day, so you'll be hard-pressed to visit more than a few places in a day. You may want to rent a car for at least a day to do a circuit of the villages; among many agencies is **Jason,** on the waterfront in Tinos Town (www.jason-rentacar.gr; ✆ **22830/22583**). Rates begin at about 50€

When to Visit Tinos

Don't even think about arriving on Tinos without a reservation around **August 15** (Feast of the Assumption of the Virgin), when thousands of pilgrims travel here to worship. **March 25** (Feast of the Annunciation) is the second-most important feast day here, but it draws fewer pilgrims because it is harder to travel by sea in March. Pilgrims also come here on **July 23** (the anniversary of St. Pelagia's vision of the icon) and on **January 30** (the anniversary of the finding of the icon).

a day in season. The bus company offers a tour of the island through **Poseidon Travel** (www.poseidontravel-tinos.com; ✆ **22830/22440**). Buses depart from the Tinos town station daily from late June to late September at 11am and return to Tinos town around 5pm, after traveling through the interior to stops at Kechrovouniou monastery, Volax or another village, Panormos for lunch and a swim, and Pirgos. You won't see much in depth, but at 15€ this is a cost-effective way to get a sense of the island's interior for some further exploration.

Where to Stay on Tinos

Agnantio ★★★ These fresh accommodations on a quiet corner off the waterfront are filled with sea views and sunlight, facing the water from breezy balconies and terraces. Furnishings are crisp and contemporary, with such extra touches as excellent lighting, plenty of outlets, nicely equipped bathrooms with large glass-doored showers, and extremely comfortable beds (all a rarity in many Greek guesthouses). Proprietors Nikos and Doria serve a generous breakfast with home-baked cakes, pastries, and egg dishes, as well as offering pickup service from the port and assistance with car rentals and other matters.

Agailis 3, Tinos Town. agnantio-tinos.gr. ✆ **22830/25505.** 8 units. 60€–80€ double. Rates include breakfast. **Amenities:** Cafe; free Wi-Fi.

Hotel Porto Raphael ★★★ This friendly and stylish hotel run by brothers Isidoros and Juliano is ideal for a beach getaway. Set in semitropical gardens surrounding a pool, it's just above the sheltered sands at Agios Ioannis and a short walk from the long beach at Agios Sostis. Tinos Town and many of the island villages are a short drive away, and a bus links Agios Ioannis with Tinos Town. Studios and one- and two-bedroom apartments have well-equipped kitchens and are bright and cheerful, with built-in divans and other attractive island-style furnishings, and they all open to sea-facing terraces. The brothers serve breakfast, lunch, and dinner in their taverna downstairs.

Agios Ioannis Porto. www.portoraphael.gr. ✆ **22830/23913.** 25 units. 70€–130€ double. Rates include breakfast. **Amenities:** Restaurant, bar, pool; free Wi-Fi. Closed Nov–Apr.

Vicenzo Family Rooms ★★ Accommodations at this practically legendary Tinos town hotel spread across a couple of buildings. Options include suites (one with a glass-fronted Jacuzzi) and large family apartments, but even the doubles seem deluxe, with slate floors, wood beams, and comfortable hand-crafted furnishings. Hospitality is topped off with services usually found in much larger hotels, such as evening turn-down, babysitting, and laundry. A stay comes with an invitation to visit the family's farm, which supplies the produce that appears in light meals served in the attractive garden.

15th 25 March St., Tinos Town. www.vincenzo.gr. ✆ **22830/25888.** 30 units. 80€–120€ double. Rates include breakfast. **Amenities:** Cafe; bar; garden; hot tub; play area; free Wi-Fi.

Where to Eat on Tinos

The island is known for delicious pork sausages, *loukanika,* seasoned with garlic and fennel, and *louza,* pork filets that are marinated in wine and herbs

and then dried. You'll see them on some taverna menus. Wild artichokes are an island specialty, served with the leaves boiled and drizzled with olive oil and lemon, or baked into pies. A favorite pastry is *tsimbita,* little pastries of pleated phyllo filled with cheese and flavored with cinnamon and orange. They are among the many sweets at **Halaris,** a century-old baker near the ferry dock at Evangelistrias 3 (© **22830/23350**) in Tinos Town, with other locations around the island.

Katoi Tavern ★★ GREEK The picturesque square of Smardakito village does double duty as a dining room, with tables set beneath the trees next to a fountain. Grilled meats are the specialty, with the star being *kokoretsi,* the restaurant's own version of pork with cheese and peppers. Casseroles, including roasted eggplant, are excellent. Your meal will probably end with a complimentary raki, for which the village is known.

Smardakito. © **22830/51706.** Main courses 7€–14€. Daily 7pm–midnight.

Malamatenia ★ GREEK Behind the newer buildings along the port, Tinos takes on the look of a Cycladic village, and this old taverna is as atmospheric the traditional houses that surround it. Tables spill out of a handsome old dining room onto a little lane and tree-shaded courtyard next to a church, and waiters who have served the same customers for decades deliver dishes as pleasantly old-fashioned as the setting, among them *kleftiko* (lamb roasted with potatoes), moussaka, and country omelets with the island sausage.

Tinos Town, behind waterfront. © **22830/24240.** Main courses 7€–18€. Daily 12:30–11pm. Closed mid-Oct to Apr.

Marathia ★★ SEAFOOD This thatch-covered terrace beneath tamarisk trees on Agios Focus beach is the island's prime stop for fresh fish, simply grilled with mountain herbs or served in pastas, and accompanied by fresh salads, Tinian cheeses, and such local specials as artichoke pie in season. Pork slow-cooked with honey and fennel and a few other meat dishes are well done, too. The beach bar serves breakfast, snacks throughout the day, and cocktails well into the evening.

Agios Fokas Beach. www.marathiatinos.gr. © **22830/23249.** Main courses 9€–18€. Daily 8:30am–11:30pm.

Mikro Karavi ★★★ GREEK What was once an outdoor cinema is now the setting for what many visitors find to be their best meal on the island, served in a pretty garden and a wine cellar fashioned out of an old *hamam.* Brother-and-sister team Antonis and Stamatoula focus on Tinian island flavors with such dishes as marinated anchovy-and-eggplant salad and ravioli stuffed with rabbit, followed by honey cheese pie or one of the house's other specialty desserts. It's all topped off with a glass of complimentary geranium liqueur.

Trion Ierarchon, Tinos Town. www.mikrokaravi.com. © **22830/22818.** Main courses 10€–18€. Daily noon–11:40pm.

Exploring Tinos Town ★★

Tinos's harbor front is fairly undistinguished, but the waterside is lively (closed to traffic on summer evenings) and lined with welcoming cafes. Just

beyond, meandering lanes open into quiet squares. The island's most notable sight is **Panagia Evangelistria,** on a hill overlooking town and visible from well out to sea, especially when illuminated at night. Almost any day of the year you can see people crawling from the port on hands and knees up **Megalocharis,** the long, steep main street, one side of which is carpeted to protect the knees of the faithful. At the top is the final approach to the cathedral, up a flight of red-carpeted steps from a courtyard of black-and-white pebble mosaics. Adjacent pedestrian-only **Evangelistria** is a market street, lined with shops selling jewelry and souvenirs; near the top, it shifts to stalls brimming with vials of holy water, incense, candles, mass-produced icons, and T-shirts and magnets.

Church of Panagia Evangelistria ★★ MUSEUM According to local lore, in 1882 a nun named Pelagia repeatedly dreamt that the Virgin appeared to her and told her where to find a miraculous icon. Pelagia told the bishop of Tinos about her dreams, and he instigated a search for the icon. Before long, the remains, first of a Byzantine church and then of the icon itself, were unearthed, and the Tinians built the massive church of the Panagia, sheathed in gleaming marble from Paros and Tinos, in just 2 years. The present-day popularity of the shrine also grows from the fact that the icon was unearthed in the earliest days of the Greek state, which led to Our Lady of Tinos becoming the patron saint of the Greek nation. Hundreds of gold and silver hanging lamps illuminate the icon of the Virgin, to the left of the entrance and almost entirely hidden by votive offerings of gold, silver, diamonds, and precious gems dedicated by the faithful. Others leave more modest offerings of ex-votos in the shape of arms, hearts, legs, and other afflicted parts that shine in the glow of hundreds of candles. Renderings in etched silver depict some of the miracles the icon has worked, among them a depiction of a ship with a fish hanging beneath it. According to tradition, the ship was foundering in a fierce storm and taking on water through a breach in its hull. When the captain and crew called out to the Virgin for help, the storm abated and the ship reached harbor, where it was discovered that an enormous fish was plugging the hole in the hull. Beneath the church is the crypt, with the chapel where the icon was found surrounded by smaller chapels. The crypt is often crowded with Greek parents waiting to have their (usually howling) toddlers baptized. Others come to fill vials with holy water from the spring.

Hora. www.panagiatinou.gr. © **22830 22256.** Free admission. Daily 7:30am–8pm.

Rules of Etiquette

Remember that Tinos is a *place of pilgrimage.* It is considered disrespectful to wear shorts, short skirts, halters, or sleeveless shirts in the precincts of the Evangelistria (or any other church, for that matter). Photographing the pilgrims, especially those approaching the shrine on hands and knees, is not appropriate. On the other hand, it's just fine to photograph the joyful baptismal parties approaching or leaving the church. Don't explore the church during a service.

Exploring the Rest of Tinos ★★★

Two mountains rise above the island's hilly interior. **Mount Tsiknias,** the highest summit on the island, rises to 670m (2,198 ft.), lofty heights that were once believed to be the domain of Borealis, god of the north wind. Tinos has always been known, and feared, for its winds, and ancient mariners used to make offerings to Borealis as they passed the island. Winds can still be the bane of beachgoers.

The other peak, **Exobourgo** (565m/1,854 ft.), is a rocky spire that looks bizarrely like a twisted fist and is crowned by the remains of a Venetian kastro (castle). Sheer rock walls surround the fortress on three sides; the only path to the summit starts behind a Catholic church at the base of the rock, on the road between Mesi and Koumaros about 15km (9 miles) outside of Hora. As you make the fairly easy ascent, you'll pass several lines of fortification and ruins of mansions, barracks, and churches that litter the hillside pastures. The Turks defeated the Venetians here in 1714 and drove them from the island.

Beneath these two summits lie 60 or so small villages of white cubical houses, some of the most beautiful and unspoiled villages in the Cyclades. The hamlets of **Dio Horia, Arnados,** and **Triandaros** are on slopes topped by the 10th-century **Convent of Kechrovouniou** ★ (also known as the Monastery of Kurias Angellon/Our Lady of the Angels), 9km (6 miles) north of Hora. This large compound, really a fortified village, was the home of St. Pelagia, the nun whose vision revealed the location of the island's famed icon. Arnados is especially intriguing, with a number of *stegasti*, tunnel-like streets formed by the overhanging second-floor rooms of village houses. Dio Hora is a cluster of white houses surrounding a village fountain shaded by plane trees.

In **Loutra,** 10km (6 miles) north of Tinos Town, the many *stegasti* surround an imposing 17th-century Jesuit monastery that houses a small museum of village life, showing off wine presses and farm implements. If the door is locked, ring the cow bell at the entrance. From the 1860s to the 1950s, girls from all over Greece came to Loutra to attend the Roman Catholic Ursuline School; a tour shows off the students' lives and studies in this remote spot that to many must have seemed like the ends of the earth. The museum and school are open usually open mid-June to mid-September from about 10:30am to 3:30pm (no phone). Admission is free.

Volax, 4km (2½ miles) northeast of Loutra, is in a valley studded with

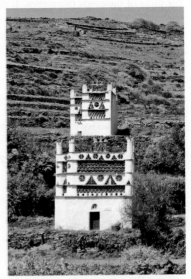

Since medieval times, Tinos has been known for its elaborately decorated dovecotes (*peristerionades*), which you'll still see all over the island.

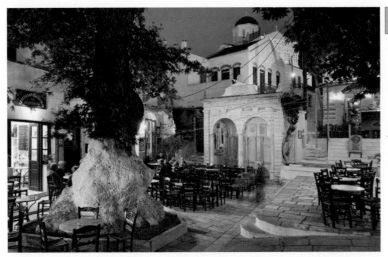

The central plaza of Pirgos, a charming village known for its marble sculpting traditions.

rotund granite boulders, some several stories high. On the theory of "if you have lemons, make lemonade," the villagers constructed a substantial stone amphitheater amid these bizarre formations, for summertime theatrical productions. Volax is also known for its local basket weavers, who sell their durable and attractive wares from home workshops. They soak their reeds in basins at the spring down a short flight of steps at the bottom of the village.

One of the smallest and most charming Tinian villages, **Aetofolia** (7.5km/4½ miles northwest of Loutra) was once a pottery center, as you will learn at the **Museum of Traditional Pottery** (admission 2€; no phone or website; Apr–Sept 11am–2pm and 5–8pm). Ceramics made on Tinos and the neighboring Cyclades are shown off to their best advantage in a delightful, traditional 19th-century island house.

Panormos, on the northwest coast 25km (15 miles) from Tinos Town, is a small fishing port surrounded by beach-fringed coves, a pleasant place for a swim and seaside meal.

Pirgos ★★★ TOWN　What is arguably Tinos's most beautiful village surrounds an enchanting, cafe-filled plateia shaded by enormous plane trees and centered around a marble fountain. Renowned for its school of fine arts, Pirgos is a center for marble sculpting, and many of the finest sculptors of Greece have trained here. One of the town's most famous residents was Yiannoulis Halepas, a member of a prominent family of marble workers, who became Greece's foremost sculptor of the late 19th and early 20th century (his tomb sculpture *Sleeping Lady* is a standout of the First Cemetery in Athens; see p. 95). His beautiful home near the entrance to the village is now the **Museum of Yiannoulis Halepas ★★**, filled with his tools, sculptures, and personal belongings. More work by local artists is on display in the **Museum of Tinian Artists ★★** next door. Both are open Tuesday through Sunday from 11am to

For the Birds

Tinos is famous for its dovecotes, stout stone towers elaborately ornamented with slabs of the local shale, with ornamental perches and passageways for the doves. It is said that the island has some 2,000 of them. The first dovecotes here were built by the medieval Venetians, who brought with them the dovecote's distinctive miniature tower architecture. They used the doves' droppings as fertilizer, and the birds soon became an important part of the local diet. Locals still sometimes cook them, often in tomato sauce, as a winter dish. Some of the most elaborate dovecotes can be found in the towns of **Tarambados** and **Smardakito**, adjacent villages about 9km (5½ miles) north of Tinos Town.

8pm; admission is 3€. **The Museum of Marble Crafts ★★**, on a hill behind the village past the cemetery, recreates a Tinian marble quarry and displays fanlight windows, doorway ornaments, and grave monuments done by Tinian artists, along with the tools they use to make them. The museum is open Wednesday to Monday 10am to 6pm in summer, 10am to 5pm off-season and admission is 3€. Pyrgos is 23km (14 miles) northwest of Tinos Town and buses run between the two towns four times a day.

Tinos Beaches

If you're staying in Tinos town, the easiest place to take a dip is the beach at **Agios Fokas,** a long sandy stretch just east of town. **Kionia,** about 3km (2 miles) west of Hora, is the closest the island comes to having a beach resort, with a long stretch of sand backed by modest hotels and restaurants; some little coves at the west end are more isolated. (The island's only excavated antiquities are just across the road from the beach, where the modest remains of a Temple of Poseidon poke through the undergrowth. The site is open Wed–Mon 8:30am–3pm and admission is 3€.) The long sandy beach at **Agios Sostas** is adjacent to the sheltered cove at **Agios Ioannis,** on the southeastern corner of the island, just 5km (3 miles) outside Hora. Single track roads lead down to **Livada,** about 18km (11 miles) northeast of Hora, and several other relatively isolated beaches on the north coast. Note that north winds can deter the most determined beachgoer and make swimming a challenge. The beach at Livada is surrounded by beautiful rock formations, and the surf crashing over them puts on a good show. The most pleasant place for a swim on the north coast is **Panormos,** about 25km (15 miles) northwest of Hora. The little seaside village and a string of beaches on the same bay, including **Rochari,** are backed by shade trees.

NAXOS ★★

175km (109 miles) SE of Piraeus

One of the first tourists to visit Naxos was the god Dionysus, who descended to the island to woo the mortal princess Ariadne, recently jilted by her lover Theseus. The god allegedly blessed Naxos with fertility, which explains why the largest and greenest island in the Cyclades has fertile valleys overlooked

by proud farming villages, abundant fields (potatoes are a famous staple), and meadows and pastures where cows and sheep graze. Rising high above these landscapes is the highest mountain in the Cyclades, Mount Zas, associated in antiquity with Zeus, who felt at home on lofty eminences.

Long stretches of sand ring Naxos's shores, and some of the best beaches in the Cyclades line the southwest coast. Inland are temples, Venetian towers, and Byzantine churches. Despite such a wealth of natural beauty and monuments, Naxos is also one of the less visited of the major Cyclades. While its justifiably popular beaches are a magnet for throngs of sun-loving northern Europeans, the villages and countryside can often seem appealingly isolated.

Essentials

ARRIVING Naxos is well connected by **boat** service to and from Piraeus and Rafina on the mainland, with as many as 10 arrivals and departures throughout the day on high-speed and regular ferries. There's fairly frequent service as well to and from Paros, Santorini, Mykonos, Siros, and the other Cyclades. In summer, four or more boats a day make the 45-minute crossing between Naxos and Paros, making it especially easy to combine visits to those two islands. The websites www.gtp.gr and www.ferryhopper.com are useful resources for ferry schedules, but keep in mind that due to winds, boats in the Cyclades often run late. The Naxos Apollon airport, 5km (3 miles) south of Naxos Town, handles two to four **flights** a day to and from Athens, depending on the season, operated by **Aegean Airlines** (en.aegeanair.com), **Olympic Air** (www.olympicair.com), and **Sky Express** (www.skyexpress.gr). The airport can handle only small planes and seats sell out quickly, so in high season especially, book early if you plan to fly.

VISITOR INFORMATION Naxos does not have a municipal tourist office, but you'll find some info online at naxos-island.com. You can get maps and information at **Zas Travel** (www.zastravel.com; ✆ **22850/23-330**), on the Paralia opposite the ferry pier, or any of the other agents along the waterfront. Many agencies offer day tours to Mykonos and Delos.

GETTING AROUND The **bus** station is on the harbor. Schedules are posted and agents can answer questions; daily schedules and other info are available at www.naxos-tours.gr. In summer, there's service every 30 minutes to the south coast beaches at Agios Prokopios, Agia Anna, and Plaka; buses also run several times a day to and from inland villages. Buy tickets in the station, from a machine outside the office, or at shops around the island. In summer, the island bus company operates guided tours to inland villages and other points of interest, about 25€; get brochures and info at the bus station. In summer, there's fierce competition for seats on the beach routes, so get to the station well ahead of time. Given the ease of getting around the island by bus, a car is not really necessary, though you may want to rent one for a day of exploring the inland villages on your own. **New Car,** in Naxos Town on Ioannou Paparigopoulou (new-car.gr; ✆ **22850/23595**), is one of many agencies in Naxos Town; rentals run about 50€ a day in season.

Where to Stay on Naxos

Apollon Hotel ★★ The owners of the Chateau Zevgoli (see below) also run this more modern hotel next to the sea in the Fontana neighborhood in the lower town. They've imported much of the Chateau's charm into the flowery terrace out front and in antiques-filled lounges. Guest quarters are less character-filled but comfortably standard, with traditional furnishings, large bathrooms, and balconies that face the attractive neighborhood and look out to sea. This is a good choice for travelers who want to stay in Naxos Town but aren't up to lugging luggage uphill, or who want to park a car outside their hotel.

Fontana, Naxos Town. www.naxostownhotels.com. ✆ **22850/26801.** 13 units. 40€–90€ double. Breakfast 10€. **Amenities:** Bar/cafe; terrace; free Wi-Fi.

Chateau Zevgoli ★★★ A medieval mansion tucked next to the walls of the Kastro, high above the harbor, the Chateau Zevgoli has so much charm and character that you will not mind the trek through the narrow lanes to the front patio—taxis can't get anywhere close. Inside the three-story landmark, a welcoming wood-beamed lounge with a fireplace is filled with family heirlooms of owner Despini Kitini. Marble-floored, tastefully done guest rooms surround a plant-filled courtyard. Several have sea-view balconies, and all exude a vaguely exotic old-world flair, with dark furnishings and a few antiques here and there. A breezy roof terrace overlooks the harbor and Portara. Two charming apartments have been fashioned out of a 13th-century Venetian house opening to a lofty, sea-view terrace even higher up, in the Kastro.

Bourgo, just below Kastro. www.naxostownhotels.com. ✆ **22850/22993.** 10 units. 55€–90€ double. Breakfast 10€. **Amenities:** Bar; free Wi-Fi.

Panorama Hotel ★ A perch at the edge of the Kastro places these inviting, breezy rooms within the neighborhood's exotic warren of narrow lanes—blessedly free from traffic noise—yet they're a relatively easy uphill climb from parking and taxi drop-offs. A large roof terrace overlooks the town and harbor, as do some of the white-washed rooms, enhanced with iron bedsteads and other traditional touches.

Apollonos and Dionysou, Naxos Town. www.panoramanaxos.gr. ✆ **22850/22330.** 13 units. 35€–75€ double (4-night min. stay mid-July to Aug). Rates include breakfast. **Amenities:** Roof garden; fridges; free parking nearby; free Wi-Fi. Closed Nov–Apr.

Santana Beach ★★ These chic rooms in Agia Anna are the island's ultimate beach getaway. Sea views take center stage in the good-sized and attractively minimalist rooms and apartments, done in neutral colors with contemporary furnishings; the soft sands lie just beyond their cushion-filled terraces. Bathrooms are commodious, with separate sink areas and huge showers. Downstairs is a cafe on a large welcoming veranda, steps from the beach.

Agia Anna. Santanabeach.gr. ✆ **228/504-2841.** 5 units. 150€–300€ double. **Amenities:** Restaurant/bar; beach; free Wi-Fi.

Studios Kalergis ★★ Across from the sands of Agios Yeoryios (St. George) beach, at the southern edge of Naxos Town, this hotel is about a

10-minute walk from the center, in a pleasant neighborhood of white houses and small hotels. Bright, attractive studios with well-equipped kitchenettes are stylishly decorated with painted wood ceilings and handsome traditional pieces. Upper-floor units open off a big terrace and have breezy sea-view balconies; those on the lower floor share many shady nooks amid the garden's greenery, with the beach just on the other side of a low wall. An adjacent beachside cafe serves an excellent breakfast (not included in room rates), as well as snacks and drinks into the early evening.

Agios Yeoryios, Naxos Town. studios-kalergis.com. ⓒ **22850/22425.** 18 units. 100€–170€ double. **Amenities:** Cafe; beach; free Wi-Fi. Closed Nov–Apr.

Villa Marandi ★★ This stone-and-stucco villa set in seaside gardens surrounding a large pool is a pitch-perfect Greek island retreat. Beautifully designed and maintained rooms are large, stylish, and supremely comfortable, with crisp fabrics and casually elegant custom pieces. All have large, well-furnished terraces, most with sea views. A private strip of beach is at the end of the garden path, while the island's spectacular west coast beaches, Naxos Town, and other island sights are all an easy drive away. An expert and hospitable staff serves cocktails and inspired Mediterranean-style meals in the beautiful garden next to the pool.

At elegant Villa Marandi, some guest rooms open right onto a private beach.

Stelida, 5km (3 miles) W of Naxos Town. www.villa-marandi-naxos.com. ⓒ**2285/024652.** 16 units. 180€–240€ double. Rates include breakfast. **Amenities:** Restaurant; bar; pool; beach; free Wi-Fi. Closed Nov–Apr.

Where to Eat on Naxos

The island's rich landscapes produce most of what you'll eat here, with a cuisine that's land-based rather than from the sea—meat and cheese from the cows and sheep that graze in seaside pastures; potatoes and other vegetables from village gardens and fields; wild herbs that grow on rocky mountainsides and infuse honey. Even some of the most sophisticated restaurants in Naxos Town serve such old-fashioned island staples as wild rabbit stews or rooster simmered with red wine and tomatoes. Shelves are laden with local cheese, honey, and olives at **Kiriakos Tziblakis** (ⓒ **022850/22230**), a fragrant, old-fashioned food emporium on Papavasiliou, Naxos Town's main inland shopping street, just off the waterfront. Accompany your choices with a selection of island wines from **Promponas** on the waterfront Paralia (ⓒ **22850/22258**); ask for a free tasting of *kitro,* a lemon liqueur for which many Naxian households have a secret recipe. The liqueur also moistens *melachrino,* a cake made with local walnuts that you'll find at most bakeries around the island.

Akrogiali ★★ GREEK You'll feel the sand beneath your feet at the best and most appealing of a string of tavernas lining the beach in popular seaside Agia Anna. The sea practically laps against the tables that, come evening, replace the daytime sunbeds, so it's not surprising that grilled or fried fish is on the menu, along with casseroles, roasted lamb and pork, and other taverna classics.

Beachfront, Agia Anna. ℂ **22850/42726.** Entrees 8€–15€. Daily 9am–midnight. Closed mid-Oct to Apr.

Dukako ★★★ GREEK/NAXIAN The flower-filled courtyard of a former monastery in the lower section of the Bourgo, in Naxos Town, sets the scene for one of the island's most magical dining experiences, bringing many visitors back night after night for meals that begin with salads straight from the restaurant's farm and move on to such Naxian specialties as *kalogeras,* a casserole of beef, eggplant, and cheese. The standout is the house's own version of pork or chicken souvlaki, served on a spit as a meal for two. Service is several cuts above what you usually encounter on the island.

Naxos Town. www.facebook.com/doukatonaxos. ℂ **22850/27013.** Main courses 9€–22€. Daily 6pm–1am. Closed Nov–Apr.

Lithos ★★★ MODERN GREEK This stylishly contemporary dining room, with glistening white walls and floors accented with bright colors, is tucked beneath the walls of the Kastro. In good weather, the friendly sister and brother team also serve at tables strung along the steep lane out front, offering a small menu that's a refreshing change from standard taverna fare: *Kritharoto* is a creamy risotto with sausage and feta, carmelized pork belly is succulent and delicious, and seafood linguine is laden with clams and fresh fish.

Just beneath Trani Porta. Naxos Town. ℂ **2285/026602.** Entrees 8€–14€. Daily noon–2am.

Metaxy Mas ★★ GREEK It seems that all of Naxos pours into this landmark at the foot of the Kastro, and whether you're seated in the stone-and-wood dining room, on the terrace, or at one of the tables that spill out onto the lane, you'll enjoy delicious takes on Greek and island classics. Garden-fresh salads and a long list of *mezes*—including island cheeses and feta sautéed with tomatoes and peppers—are followed by moussaka, slow roasted lamb, and some inventive seafood pastas, accompanied by carafes of the house wine.

Bourgo, Naxos Town. ℂ **22850/26425.** Entrees 7€–15€. Daily 12:30pm–2am.

Taverna Platanos ★★ GREEK The main marble street of Aprianthos, the prettiest of the Tragaea Valley villages (p. 196), is lined with traditional tavernas that for many islanders are the focus of a trip into the mountains. One of the most popular stops is a little square where tables are set beneath the shade trees and on a terrace hanging high over the valley below. Some of the hearty mountain fare includes rooster baked with red wine and spaghetti with goat meat; slightly lighter choices include grilled country sausages and *bifteki,* a beef patty stuffed with Naxian graviera cheese and served with roasted potatoes fresh from village gardens.

Main street, Aprianthos. ℂ **22850/61192.** Entrees 5€–10€. Daily noon–midnight.

Exploring Naxos Town

From the harbor, it's an easy climb along little lanes through Bourgo, the lower town, and from there a heftier trek up to the hilltop Kastro, the walled fortress of the Venetians who ruled Naxos from 1207 until it fell to the Turks in 1566. The name Kastro also applies to the neighborhood of handsome Venetian-style mansions that huddle beneath and within the fortress walls.

Bourgo ★ NEIGHBORHOOD A long line of cafes line pedestrian-only Parali, entry to the busy streets of the Bourgo, the lower section of the Old Town. During Venetian rule, the overlords lived above in the Kastro, while the Bourgo was home to the Greek citizens of Naxos. But even long before that, Mycenaeans, classical Greeks, Romans, and early Christians inhabited this stretch of shoreline. This long past comes to light in the extensive excavations in front of the Mitripolis (cathedral), on Cathedral Square just inland from the waterfront, where bits and pieces of ancient chapels, temples, and an agora are well marked. The excavations are an open site, where you can wander for free. Inside the cathedral, coats of arms of Venetian families litter the marble floor, and Byzantine icons showing Western subjects reflect the island's mix of Eastern and Western traditions. The church is open Tuesday to Sunday, 8am to 2:30pm; admission is free.

Kastro ★★★ NEIGHBORHOOD Many of the narrow streets winding uphill from the Bourgo lead into the Kastro, the Venetian fortress, and the neighborhood of tall houses, chapels, and convents within its walls. Of the 12 towers that once rose above the fortification, only the Tower of Crispi remains. The most impressive way to make the transition from the bustle of the Bourgo into the medieval world of the Kastro is though **Trani Porta** (Strong Gate), via

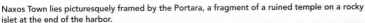

Naxos Town lies picturesquely framed by the Portara, a fragment of a ruined temple on a rocky islet at the end of the harbor.

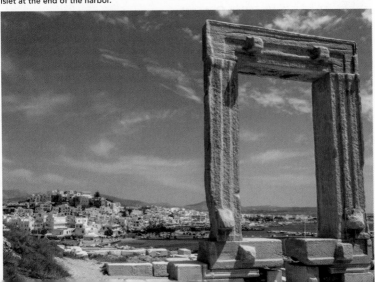

193

Apollon Street at the northern end of the port. An incision on the right column of the arch marks the length of a Venetian yard, used to measure the cloth merchants brought to Naxos for aristocratic households. The coats of arms of noble medieval Venetian families appear above many doorways, and flowering vines trail over walls surrounding well-kept gardens. Many residences are still occupied by members of the families who built them; the home of the Dellarocca-Barozzi clan is open to the public as the **Domus Della Rocca-Barozzi Venetian Museum** (✆ 22850/22387), next to the Trani Porta. Salons are filled with furnishings the family has collected during their 300 years of residency, and the garden is the setting for summertime concerts. Admission is 5€; the house is open June to August, daily 10am to 3pm and 7 to 10pm.

Portara ★★★ ANCIENT SITE A great unfinished doorway stands on the islet of Palatia at the western end of Naxos Town harbor, providing a dramatic backdrop for an approach to the island by sea. According to myth, the god Dionysus built this for Ariadne, daughter of King Minos of Crete. Ariadne helped the hero Theseus escape the maze of the Minotaur at Knossos (p. 293), but Theseus abandoned her on Naxos. Dionysus took pity on the lovesick princess and swept down in a chariot borne by leopards to marry her; the Portara was the gateway to their bridal palace. (This story inspired both Titian's beautiful painting *Bacchus and Ariadne* and the opera *Ariadne auf Naxos* by Richard Strauss.) The more prosaic story is that this was part of a temple to Apollo begun by the ruler Lygdamis in 530 B.C., which was abandoned after he was overthrown in 506 B.C. A thousand years later the Venetians carted off much of the temple's marble to build their hilltop Kastro, but this doorframe and lintel, constructed from slabs weighing 20 tons each, were too heavy to move. Along the shore just north of the Portara are some of Greece's oldest antiquities—the submerged remains of houses and steps

Naxos: A Venetian Outpost

Naxos was both Venetian and Turkish for many centuries. In 1210, Venetian duke Marco Sanudo began ruling the Cyclades on behalf of Constantinople; Venetian rule under lax Turkish oversight lasted into the 18th century. The fact that a French School was founded here by Roman Catholic Jesuits in 1627 is testimony to how permissive the Turkish administrators were. Nikos Kazantzakis, the famous Cretan author of *Zorba the Greek* and other modern classics, attended that school in 1896. The island made a lasting impression on the young Kazantzakis, who always remembered it as a land of "great sweetness and tran-

quility." However, he left abruptly when his father appeared at the door with a torch, demanding, "My boy, you papist dogs, or else it's fire and the ax!" The school's former building is now the **Archaeological Museum** (odysseus. culture.gr; ✆ 22850/22725; admission 2€). A highlight is the museum's sensuous, elongated white marble Cycladic statuettes, which date to 3000 B.C. yet strikingly resemble the work of 20th-century Italian sculptor Amedeo Modigliani. From mid-April through October, the galleries are open 9am to 2pm, Thursday through Monday, with varying hours the rest of the year.

constructed by Cycladic peoples who lived on the island as long as 5,000 years ago. You can take a look at the underwater antiquities while swimming off the rocks below the temple door.

Around Naxos

Away from the spectacular yet crowded beach strip on Naxos's southwestern coast are lush valleys, craggy hillsides, and old villages that surround shady squares. Among these rural landscapes you'll find a scattering of antiquities and Byzantine chapels and monasteries.

Agios Mammas ★ CHURCH　One of the oldest churches on Naxos was built under the Byzantines in the 9th century as the island's cathedral, seat of the Greek Orthodox archbishops of the Cyclades. Though abandoned through much of the Middle Ages, the stone church is still a commanding presence on the herb-scented hillside. If you're lucky, the church may be open, but even if it isn't, you can admire its rough-hewn exterior. Views extend far across the countryside where sheep and goats graze—an apt tribute to St. Mammas, the patron saint of shepherds.

3km (2 miles) S of Pirgos Bellonia on a lane off road to Sangri, 8km (5 miles) S of Naxos Town.

Apollonas ★ VILLAGE　This once-quiet fishing village on the northern tip of the island is a popular, though undistinguished, summer resort. Besides the good sandy beach, many travelers are attracted here to see a huge *kouros* statue, 10m (33 ft.) tall, on a hillside just outside of town. It's still attached to the slab from which it was being carved when it was abandoned in the 7th century B.C.—most likely because the huge statue cracked when shifted.

37km (22 miles) NE of Naxos Town.

Melanes ★★ ANCIENT SITE　Melanes (also known as Flerio) lies in one of the many verdant valleys that carpet the interior of Naxos. In the shady garden of a Venetian estate, nestled in a gorge at the end of the valley, lies a *kouros,* a huge marble statue of a beautiful youth reclining on a pillow. Some 6m (20 ft.) long, the statue was carved in the 6th century B.C., probably intended for the Sanctuary of Apollo on Delos (p. 181). You can admire the boy's repose as you sip a beverage at a cafe run by the garden's owner.

About 7km (4 miles) E of Naxos Town on road to Kinidharos. Free admission. Open site.

Pirgos Bellonia (Pirgos Tower) ★ HISTORIC SITE　Venetian over-lords built tall fortified towers across Naxos, not only to provide refuge from pirate attacks, but also to keep an eye on their estate workers from the upper stories. When danger was imminent, tower dwellers lit fires on the flat roofs to warn their neighbors. These stone castles may seem like a romantic, fairy-tale presence in the countryside today, but back in the day they could be most unwelcome when residents drew up drawbridges and poured boiling oil through the loopholes. An especially elaborate example, the Bellonia tower was once the home of the Venetian archbishop of Naxos—look for an emblem of the Lion of St. Mark, symbol of the Venetian Republic, embedded above

the doorway. The tower is a private residence today, though it is sometimes possible to slip into the adjoining twin chapels, one for Roman Catholics and one for Orthodox Catholics.

5km (3 miles) S of Naxos Town, near village of Galando.

Sangri ★★ TOWN Old tower houses and cypress trees rise from the end of a valley to mark the entrance to Sangri, a cluster of three small villages that tumble into one another on a hillside. **Mount Profitis Elias,** topped with a chapel and a ruined Byzantine fortress, overlooks the villages. At the foot of the mountain is a beautiful fortified monastery, **Timios Stavros** (the True Cross), now abandoned. In the 18th and early 19th century, before Naxos became part of a united Greece, monks here secretly taught Greek language and culture, which had been neglected under the centuries of Venetian and Turkish rule. Sangri's most notable monument is the ruined **Temple of Demeter,** about 5km (3 miles) outside the village on a well-marked road (admission 2€). Archaeologists have only recently re-erected its columns and pediments, which had lain scattered about the site for centuries.

13km (8 miles) SE of Naxos Town.

Exploring the Tragaea Villages ★★

Spreading across the center of Naxos, the beautiful Tragaea Valley epitomizes the green landscapes that make Naxos different from the other Cyclades. Olive groves and lemon orchards climb the slopes of mountainsides, and chapels, monasteries, and small villages overlook countryside that has changed very little from the days of the Byzantines.

Begin in **Moni ★★**, some 18km (12 miles) east of Naxos Town. This little mountain village is known throughout Greece for the **Church of Panagia Drosiani** (Our Lady of Refreshment), with its dome and walls of rough-hewn rock. Legend has it that during a drought in the 8th century, Naxians brought icons of the Virgin from churches across the island to the sea to pray for rain: Only the icon from this church yielded results. Some of the oldest frescoes on the walls of the three simple chapels date to the 7th century and are rich with imagery not always seen in Orthodox art. Hours vary, but the church is generally open daily, 8am to 1pm and 4 to 6pm; admission is free but donations are welcome.

Far from being a simple rustic outpost, the Tragaean valley village of Chalki has some elegant Venetian-era houses along its narrow lanes.

Chalki ★, 5km (3 miles) southwest of Moni, surrounds a beautiful plaza, shaded by plane trees. In the 1,500-year-old tile-roofed **Church of Panagia Protothrone** (Our Lady Before the Throne), layers of frescoes date to the 6th century, with the oldest depicting the Apostles. The 17th-century **Pirgis Frankopolous,** a Venetian tower house, is sometimes open to the public; from its upper floors you can see a broad swath of the Tragaea Valley.

The white houses of **Filoti ★**, 3km (2 miles) southeast of Chalki, sparkle on the flanks of Mount Zas—which, at a little more than 1,000m (3,281 ft.), is the tallest peak in the Cyclades. The towers of the **Church of Kimisis tis Theotokou** (Assumption of the Mother of God) stand above the rooftops, a beacon to revelers who come from all over Naxos in mid-August for the island's biggest *paneyeri* (feast), in honor of the Virgin. Hours vary, but the church is generally open daily, 8am to 1pm and 4 to 6pm; admission is free but donations are welcome. From the village, a trail climbs the face of the mountain to the **Arghia Cave,** one of several caverns in Greece said to be the birthplace of Zeus. The cave is spectacular, entered through a wide natural arch that leads into a main chamber spanning more than 4,000 sq. m (43,056 sq. ft.) without support. Tools found in the cave suggest human habitation more than 5,000 years ago.

A tour ends high above Filoti in **Apiranthos ★★**, 7.5km (4½ miles) to the northeast, where the streets are paved in marble and the houses are made of rough, gray stone hewn from the mountain. The village is barely distinguishable from the hillside out of which it is carved.

Naxos Beaches

The capes and promontories of the southwest coast shelter Naxos's finest beaches, some of the best in the Cyclades. The sandy strands closest to Naxos Town, especially Agios Yeoryios and Agios Prokopios, are fine but crowded. **Agios Yeoryios ★**, right at the edge of town, can't be topped for convenience if you're staying in town; its shallow waters are ideal for young swimmers. Busy **Agios Prokopios ★** is about 8km (5 miles) south of Naxos Town, the first of a long stretch of golden sand along the southwest coast and one of several beaches on this stretch, including **Agia Anna,** served by bus. If you have a car, it's well worth continuing just a little farther south to its less-crowded neighbors **Plaka ★★**, backed by sand dunes and bamboo groves, and **Kastaraki ★★**, etched with rock formations. Both stretch for miles, leaving plenty of room for everyone. **Pyrgaki ★★★**, the southernmost beach on this part of the coast (though still only 21km/13 miles from Naxos Town), seems a world removed, with empty white sands and crystalline waters edged with fragrant cedar forests. Summertime bus service from Naxos Town serves most of these beaches, running about every half-hour.

PAROS ★★

160km (100 miles) SE of Piraeus

Marble dug out of Paros quarries was the pride of the ancient world, fashioned most famously into the *Venus de Milo*. Today Paros is a favorite of travelers

who relish a mix of antiquities, sand, sun, and quiet coves—minus the crowds and hype of Mykonos and Santorini. The narrow lanes of Parikia, or Paros Town, are cooled by marble fountains and wind their way to a ruined medieval castle built with chunks pillaged from ancient temples. One of the world's oldest churches, Panagia Ekatontopylani, is a Byzantine masterpiece with a lemon-scented courtyard and a purported 100 doors. Shorelines open to gentle bays, sandy beaches, and little ports like chic Naoussa, where tiny lanes dead-end at the sparkling blue water. In the mountainous hinterlands, Lefkes and other medieval villages are tucked onto terraced hillsides crisscrossed with marble Byzantine paths. In the unlikely event Paros fails to deliver enough of an island getaway, little Antiparos is just a short ferry ride away.

Essentials

ARRIVING Paros is served by as many 10 **boats** a day from the mainland ports of Piraeus and Rafina in season, and in summer, four or more boats a day make the 45-minute crossing between Naxos and Paros, making it easy to visit one island from the other. Frequent ferry and hydrofoil service links the island with its Cycladic neighbors Ios, Mykonos, Santorini, and Tinos, and several times a week, boats arrive and depart from and to Folegandros, Sifnos, and Siros. For up-to-date schedules, go to www.gtp.gr or www.ferryhopper. com. The Paros National Airport (10km/6 miles south of Parikia; ✆ **2284 090502**) handles several **flights** a day to and from Athens on Olympic Air (www.olympicair.com) and Aegean (en.aegeanair.com), but since the runway is short, there are no flights with larger aircraft from abroad. A bus usually meets flights for transfer to Parika, and a taxi costs about 20€.

VISITOR INFORMATION A tourist information office inside the wind-mill on the Parikia waterfront is open daily in summer; the municipal website, paros.gr, is also a good source. **Santorineos Travel** (www.traveltoparos.gr;

The fishing port of Naoussa, on the north end of Paros, has developed into a chic alternative to Paros Town for dining and nightlife.

① **22840/24-245**) and **Polos Tours** (polostoursparos.com; *①* **22840/2233**) are among the travel agencies on the harbor that sell boat tickets, offer excursions, and handle car and scooter rentals. Many agencies offer daylong tours to Mykonos and Delos.

GETTING AROUND A good **bus** network (ktelparou.gr) will take you where you need to go on Paros, so a car is not really necessary. The main bus station (*①* **22840/21-395**) in Parikia is on the waterfront, to the left as you face the windmill. There is often hourly service between Parikia and Naoussa, from 8am to midnight in high season. Other buses run frequently, from 8am to 9pm, in two general directions from Parikia: south to Aliki or Pounda, and southeast to the beaches at Piso Livadi, Chrissi Akti, and Drios, passing the Marathi Quarries and the town of Lefkes. Schedules are usually available at the Parikia bus office. Buy tickets at the offices in Parika and Naoussa or at shops around the island.

Where to Stay on Paros

Hotel Dina ★★★ If you're not looking for luxury, you may find these simple rooms that open to balconies and terraces to be your Parian paradise. You reach the nicely old-fashioned hotel—an island institution, having housed guests for the past 45 years—through a narrow, plant-filled courtyard at the quiet end of Parikia's Market Street. The choicest of the tidy, plain, but comfortable rooms is number 8, at the back, with a balcony that faces a little chapel, so close you can almost reach out and touch the blue dome. Dina Patellis is a gracious and helpful hostess and she and her associates will tell you what you need to know about seeing the island. Dina's late husband wrote the excellent *Guide Through Ekatontapiliani*, about the town's remarkable church, available in local bookshops.

Market St., Parikia. www.hoteldina.com. *①* **22840/21-325.** 8 units. 50€–85€ double. **Amenities:** Garden; free Wi-Fi. Closed Nov–Apr.

Parilio Hotel ★★ Casual, indoor-outdoor living is made easy at this stylish little resort above the beach at Kolympithres, where the light-filled suites open to large terraces equipped with sun beds and, on most, dining areas. Natural woods, terracotta and marble floors, and a soothing neutral palette augments the pared-down Cycladic-style complex that surrounds a huge cross-shaped swimming pool, with rock formations rising from the waters. An open-air dining room serves Mediterranean meals in relaxed surroundings.

Kolympithres. pariliohotelparos.com. *①* **22840/51000.** 33 units. 250€–650€ double. **Amenities:** Restaurant; bar; pool; spa; free Wi-Fi. Closed mid-Oct to Apr.

Svoronos ★★★ The Svoronos family has been running this delightful bungalow colony since the 1960s, welcoming guests in studio and one-bedroom apartments set in large, pretty gardens on a back lane just outside Naoussa. The white-washed Cycladic surroundings are complimented by handsome traditional furnishings and beamed ceilings, and sun-bed equipped terraces

overlook lawns and flower beds. The lively port is a 10-minute walk away and some of the island's best beaches are within easy reach.

Naoussa. svoronosparos.com. © **22840/51409.** 16 units. 65€–95€ double. Rates include breakfast. **Amenities:** Bar/cafe; gardens; play area; free Wi-Fi. Close mid-Oct to Apr.

Yria Hotel Resort ★ Like many resorts around Greece, this handsome assemblage on the coast just south of Parikia imitates a Cycladic village, with whitewashed bungalows tucked into well-tended gardens with the blue sea glistening in the near distance. Rooms and suites are done in pleasant-if-unexciting decor (lots of soft pastels with bright blue-and-white motifs) and have well-furnished terraces overlooking the grounds and a huge swimming pool. A sandy beach is about 150m (500 ft.) down the lane.

3km (2 miles) S of the port, in Parasporos. www.yriahotel.gr. © **22840/24-154.** 60 units. 210€–650€ double. Rates include breakfast. **Amenities:** Restaurant; bar; concierge; fitness center; pool; tennis; spa; free Wi-Fi. Closed mid-Nov to Apr.

Where to Eat on Paros

Islanders have some favorite seafood preparations that are served in many restaurants. One is octopus, usually grilled and served with a squeeze of lemon or on a bed of fava, and another is *gouna:* Roasted mackerel that's split open, filled with herbs, and quickly grilled. Mizithra is the island's soft goat cheese that sometimes stands in for feta in Greek salads. A 50-year-old presence in Parikia, **Aliprantis Bakery** (aliprantisbakery.gr; © **22840/236063**) serves delicious pastries, sweets, and sandwiches, while **Kargas** (© **22840/53505**) might be the most popular spot in Naoussa; this cheap-meal option serves generous gyros, kebabs, and souvlaki late into the night. A complimentary glass of *souma,* the island's version of raki, follows many meals.

Bountaraki ★★★ GREEK At this no-fills local favorite on the seaside at the edge of Parikia, a server will rattle off daily specials that often include delicious *imam biyaldi* (eggplant with onions and spices), and octopus in fava and a few other seafood dishes. Dining is in a couple of homey, kilim-littered rooms or on a sea-facing terrace out front. They don't take reservations in summer, so plan on dining early or late to avoid the crush.

Seafront, Parikia. bountaraki8.webnode.gr. © **22840/22297.** Main courses 8€–14€. Daily noon–11:30pm.

Distrato ★★ GREEK/INTERNATIONAL It's hard to resist taking a seat beneath the spreading branches of an enormous ficus tree on the street that runs from the cathedral to Market Street. You can start the day here with a coffee and croissant and end it with wine and one of the tasty pasta dishes. The kitchen also serves an assortment of crepes, sandwiches, and salads. A shop stocks nicely packaged organic Greek produce. If there are no tables at Distrato, try **Symposio,** a few steps away, with tasty snacks and breakfast, minus the shady tree but with a vine-covered terrace.

Paralia, Parikia. © **22840/22-311.** Snacks and entrees 8€–15€. Daily 9am–12:30pm.

Taverna Glafkos ★★ SEAFOOD An entryway off a quiet back lane leads to tables right on the waters washing onto Agios Dimitrios Beach, so close you'll get splashed when the winds pick up. The nearby fishing docks supply the ingredients for a short menu of mussels, fried calamari, seafood pastas, and grilled fish.

Naoussa. www.facebook.com/GlafkosRestaurant. ⓒ **22840/52100.** Main courses 9€–18€. Daily 1pm–midnight. Closed Nov–Apr.

Trata Taverna ★★ GREEK/SEAFOOD This waterfront seafood house looks like one of the neighboring boat sheds along the waterfront and the name means "trawler," so little surprise the fish and seafood are the specialties, plucked off the boats by owners Nikoletta and Leftiris and reputed to be the freshest and best on the island. Everything that isn't caught offshore is raised on or around the island, including shellfish from coastal beds and the vegetables that appear in *kolokithokeftedes,* zucchini patties with dill, and a chickpea stew. A glass of *souma,* homemade from grapes, tops off a meal.

Parikia waterfront, near the harbor. ⓒ **22840/24651.** Entrees 8€–20€. Daily noon–1am.

Exploring Parikia ★★

Old Parikia, just behind the busy harbor, is a pretty cluster of whitewashed Cycladic houses on lanes of white-etched paving stones that open into shady squares. A stepped street passes a marble fountain, built under French-Ottoman rule in the late 18th century and inscribed with a verse that ends, "Come, good folk, every one, take drink but be sparing of me." The street leads on into the Kastro, the seaside fortress Venetians cobbled together in the early 13th century using marble fragments of ancient temples. Pediments and chunks of columns are pieced randomly into the walls, presenting a jumbled glimpse of the classical-era days when Paros grew wealthy from marble quarried on the

One of the oldest churches in the world, Paros's Church of the Hundred Doors is full of icons, frescoes, and columns of the famous Parian marble.

island by tens of thousands of slaves. The fortress provided the Venetians little protection against pirates; however, they were eventually chased off the island by Barbarossa, the most famous medieval brigand of them all.

Archaeological Museum of Paros ★★★ MUSEUM

A rich depiction of Greece's distant and often mythic past, the **Parian Chronicle**—intricately carved in marble quarried on the island—commands pride of place in these galleries. The fragment here tells only the tail end of the story, from 356 to 299 B.C., highlighting in complex imagery the march of Alexander the Great and the birth of the poet Sosiphanes. (To follow the entire chronicle, you need to travel to England, where the other slab, covering 1581–356 B.C., has been on display at the Ashmolean Museum in Oxford since 1667.) Among other intriguing remnants scattered about the museum is a marble frieze of the 7th-century-B.C. poet Archilochus, who was born on Paros and died on the island in a battle against the Naxians. He is shown reclining on a couch, as if he is about to utter one of his famously ironic verses laden with such timeless insights as "for 'tis thy friends that make thee choke with rage."

Near waterfront, behind church. odysseus.culture.gr. ℂ **22840/21231.** Admission 2€. Wed–Mon 8:30am–3:30pm.

Panagia Ekatontopylani (Church of the Hundred Doors) ★★★

CHURCH One of the oldest churches in the world is also, from the moment you step through the gates into the lemon-scented courtyard, one of the most transporting. The surroundings are steeped in legend. Helen, mother of Constantine, the first Christian emperor of the Roman Empire, took shelter on Paros during a storm on her way to the Holy Land in 326 A.D. Here, it is said, she had a vision of finding the True Cross (the one on which Christ was crucified) during her voyage, and she vowed to build a church on Paros if she did. Her dream came to pass, and Constantine completed the basilica upon his mother's death. Emperor Justinian rebuilt the church in the mid-6th century, sending Isidoros, the architect of the Hagia Sofia in Constantinople, to Paros to build the dome. Isidoros handed the commission over to his apprentice Ignatius, then was so filled with envy when he saw the splendid structure that he pushed the apprentice off the church roof. Ignatius grabbed Isidoros as he fell; the two men plummeted to their deaths. A sculpture on the gate near the Chapel of St. Theodosia supposedly shows Isidoros rubbing his beard, a sign of apology, and Ignatius rubbing his head, perhaps plotting revenge. (More likely, the figures are satyrs who once adorned a temple of Dionysus that stood on the spot.) Only 99 of the eponymous 100 doors have been found; the last will not be located, legend has it, until Constantinople is Greek once again. A thick wall, embedded with monks' cells, surrounds a shady entrance court. Within the cross-shaped church, frescoes, icons, and a sea of columns of Parian marble are bathed in soft light. The church is one of Greece's most important shrines to the Virgin Mary and is much visited on her feast days, when pilgrims arrive from throughout Greece.

Near waterfront. ℂ **22840/21243.** Free admission. Daily 8am–8pm.

Around Paros

Byzantine Road ★ HISTORIC SITE A section of this stone-and-marble roadway, paved in the Middle Ages and once the main route across the island, descends from the mountain village of Lefkes through olive groves and grazing land to Prodomos on the coastal plain below. The well-marked walk from Lefkes is easy—only about 4km (2½ miles), mostly downhill, from the bottom of the village. Prodomos is a fascinating little place, where whitewashed houses, squat little chapels, and gardens with bougainvillea spilling over the walls are confusingly arranged in a bull's-eye pattern radiating from a central *plateia*—a maze intended to thwart invaders and still ensured to do so today. Check schedules for buses from Prodomos back to Lefkes or Parikia, or you could be stranded for hours.

Christos sto Daos ★ CONVENT The convent of Christ of the Wood, reached by a path on a hillside just above the Valley of Petaloudes (p. 204), is the final resting place of St. Arsenios, a 19th-century schoolteacher and abbot noted for his ability to conjure up rain in times of drought. In a famous exchange, he told a group of farmers who sought out his divine services, "If you truly have faith, why have none of you brought umbrellas?" The nuns sometimes allow visitors, but women only, to come into their walled compound to view the tomb. All visitors can take in the serenity of the isolated setting and the sweeping views of the sea and surrounding farmlands.

5km (3 miles) S of Parikia off airport road. Free admission, donations welcomed.

Lefkes ★★ VILLAGE The medieval capital of Paros sits high atop an interior mountain, out of harm's way from the pirates who once raided the coast. Brigands who made their way this far inland were further thwarted by the town's mazelike arrangement of narrow lanes, cascading down the mountainside from the beautiful main square. Rising high above the cluster of white houses are the impressive twin towers of the **Church of Agia Triada,** an enormous 19th-century marble edifice (daily 8am–6pm). Windmills on an adjoining ridge are still used to grind grain, grown in a tidy patchwork of terraced fields interspersed with olive groves.

Mountaintop Lefkes, Paros's medieval capital, is crowned by the towers of the Church of Agis Triada.

5km (3 miles) S of Marathi, 10km (6 miles) SE of Parikia.

Museum of Cycladic Folklore ★ MUSEUM The Cyclades are magically re-created in a lovely garden, where you'll see carefully crafted models 203

Translucently white and luminescent, the highly prized white marble of Paros was dug out from three shafts in Marathi. Some of the greatest works of antiquity were crafted from Parian marble, among them *Hermes Carrying the Infant Dionysus* by Praxiteles, now in the Archaeological Museum in Ancient Olympia; the *Venus de Milo*, the most prized ancient treasure of the Louvre in Paris; and temples on the sacred island of Delos.

Thousands of slaves worked the dank Marathi quarries, just outside Parikia, night and day, wearing oil lanterns strapped to their heads that gave the marble the name *lynchnites*, "won by lamplight." French engineers came to Marathi in 1844 to mine marble for Napoleon's tomb at Les Invalides in Paris, the last people to work the quarry. The quarries are presently closed to visitors.

of the dovecotes of Tinos, the lighthouse of Andros, the Kastro in Parikia, and other monuments of the Cyclades. All are the creation of Benetos Skiadas, who is often on hand to show off the model ships he builds and will make models to order upon request.

Aliki Rd., near airport, about 8km (5 miles) S of Parikia. www.benetos-skiadas-folkartist-paros-gr.com. © **698/168-0068.** Admission 5€. Apr–Oct daily 10am–5pm.

Naoussa ★★ TOWN Many players in the Mediterranean have anchored in this ancient port on a broad gulf: Persian and Greek warships, Venetian galleons, Russian frigates taking on supplies during the Turko-Russian War of 1768–1774, and the French pirate Hugue Crevelliers. Reminders of this storied past—a Venetian watchtower, the submerged ruins of the seaside *kastro* fortress, and a medieval gateway—today lend a colorful backdrop for fishing boats bobbing in the harbor and an animated resort life that transforms the quiet village during the summer. Even when the town is busiest, you can still get lost in tiny lanes winding inland from the harbor or come to a dead-end next to the sparkling blue water. Perch on the shady terraces of seaside *ouzeries* and explore the shady, whitewashed lanes of the old town. The **Church of Agios Nikolaos Mostratou** reflects Naoussa's maritime traditions with models and plaques of ships that mariners have left as offerings of thanks for salvation from drowning; it's open daily 8am to 6pm and admission is free. Some of the best sands on the island flank Naoussa: Santa Maria and Langeri to the east, Kolimbithres to the west.

10km (6 miles) E of Parikia.

Valley of Petaloudes (Valley of the Butterflies) ★★ NATURE SITE On the grounds of a Venetian estate spread across a small vale, you'll discover a surprisingly verdant landscape watered by several springs, one of the greenest patches on this dry island. The valley is especially enticing in the spring and early summer, when flowers bloom against a backdrop of cypress trees, and the air hums with the flapping wings of swarms of butterflies—actually, a species of tiger moth with spectacular brown and coral red wings.

THE PAROS ANTIDOTE: antiparos

This islet off the southwestern coast of Paros was once a place to get away from it all, and still is. These days, though, villas along its cove-laced coastline have become the not-so-secret hideaway of some famous film stars, while rates at some nice yet charmless hotels have soared up to accommodate the less privileged. Still, the open countryside is beguiling, beaches at Glyfa and Soros are sandy, the water is sparkling, and life is relaxed in whitewashed Antiparos Town and other settlements. All this makes the crossing to Antiparos a pleasant and worthwhile detour. Boats run hourly throughout the day from Parikia (3€ each way, about 20 min.), and a car ferry shuttles all day from Pounda (3.50€ each way for car and driver). A bus makes the rounds of villages and sights on Antiparos. The island's big attraction is the **Cave of Antiparos** ★★ (off coast road, 10km/6 miles south of Antiparos Town; admission 5€; Apr–Oct 10am–3:30pm). Legions of travelers have climbed into the grotto, including 19th-century British poet Lord Byron (see box, p. 107). The most noted visitation was on Christmas Eve 1673, when a French nobleman arranged a candlelight mass for 500 celebrants in a 40m-tall (131 ft.) cavern known as the Cathedral. An inscription on the base of a stalagmite, known as the Altar, commemorates the event. Near the entrance to the cave, the monastery of **Agios Ioannis Spiliotis** (St. John of the Cave) was built around a grotto etched out of the hillside. Here, a miracle occurred when St. John turned the doors to stone to protect residents who had taken refuge inside from marauding pirates.

The best time to experience the spectacle is in the early evening, when moths by the thousands awaken from their daytime slumber and flutter upward toward the cool air. When the creatures are not alight, feel free to scold visitors who clap and shout to alarm the butterflies and make them fly, often causing the fragile insects to collapse.

5km (3 miles) S of Parikia off airport road. www.butterfliesparos.com. ✆ **22840/91211.** Admission 5€, free for children 12 and under. Mid-May to mid-Sept daily 8am–7pm.

Paros Beaches

Some of the island's most popular beaches are on either side of the gulf of Naoussa. **Santa Maria** ★★★, popular with windsurfers, is the most beautiful beach on the island, with especially clear water and shallow dunes of fine sand along the irregular coastline. **Santa Maria Watersports** (✆ **694/572-2404**) provides windsurfing gear and a brief lesson for about 20€ per hour. **Kolimbithres** ★★ is interspersed with huge boulders that divide the gold-sand beach into several tiny coves. Both can be reached by boat or bus from Naoussa.

The southeastern shore of the island is also lined with fine beaches, including the long strip of golden sands at **Chrissi Akti (Golden Beach)** ★★, 20km (12 miles) southeast of Parikia, where the World Cup windsurfing championships take place every August (offshore winds make this one of Europe's best windsurfing spots). **Piso Livadi,** just north of Chrissi Akti and 17km (10 miles) southeast of Parikia, is a pleasant seaside village surrounded by pine

forests and fronted with a sand beach that's popular with families. Chrissi Akti and Piso Livadi are well served by buses from Parikia.

Paros After Dark

Nightlife on Paros is no match for that on Mykonos or Santorini. Nevertheless, islanders and their visitors enjoy sitting outdoors to enjoy an evening. Just behind the windmill in Parikia, the local landmark **Port Café ★** (© 22840/27354), a basic *kafenion* lit by bare incandescent bulbs, is filled day and night with tourists waiting for a ferry, bus, taxi, or fellow traveler. **Pirate Bar ★** (© 6979/194074), on the market street within the old quarter behind the harbor, often has classical music and good jazz. **Alexandros Cafe ★** (www.alexandros restaurant.com; © 6930/671269), in a restored windmill by the harbor, is a perfect spot to enjoy the sunset and watch the passing evening scene.

In Naoussa, **Agosta ★** (© 694/571-1207) is a popular harborside spot for an after-dinner drink, while **Kafeneio Palio Agora** (© 22840/51847), tucked into the old lanes behind the waterfront, is a wonderfully old-fashioned place to snack and drink.

SIFNOS ★★★

185km (111 miles) S of Piraeus

Sifnos is the favorite getaway of too many people to be a well-kept secret, but it's still one of the most beautiful islands in the Cyclades. The mountains that frame Sifnos's deep harbor, Kamares, are barren, but as the road climbs from the port, you will see old fortified monasteries, elegantly ornamented dovecotes above cool hollows that remain astonishingly green well into summer, and sparkling white villages strung out along the crests of the interior hills. Long stretches of amber sand and quiet coves rim the coast, and slate and marble paths, *monopati,* cross the island, making Sifnos a walker's delight. Sifnos does not have much in the way of nightlife or must-see sights, but that's part of the appeal. In August much of well-to-do Athens seems to be transplanted to the island, so you might want to choose another time to visit and enjoy the island's quiet charms.

Essentials

ARRIVING Weather permitting, there are at least four **boats** daily from Piraeus, including car ferries and fast boats, some of which take cars. They arrive at Kamares, the island's port. From Kamares the road climbs through a narrow gorge, past olive groves, and emerges at **Apollonia,** the island's main settlement, about 5km (3 miles) southeast. Ferries travel on ever-changing schedules to other islands, including Serifos, Kimolos, Milos, Tinos, Paros, and Kithnos. Go to www.ferryhopper.com or www.gtp.gr for the latest schedules, but remember, boats in the Cyclades run notoriously late; any ticket agency on the island will give you estimated arrivals and departures.

VISITOR INFORMATION The best place on the island for information and help getting a hotel room, boat tickets, car, motorbike, or hiking excursion is **Aegean Thesaurus Travel and Tourism ★★**, with offices on the port

(www.thesaurus.gr; ✆ **22840/32-152**) and on the main square in Apollonia (✆ **22840/33-152**). Just off the main square in Apollonia, **Xidis Travel** (www.xidis.com.gr; ✆ **22840/32-373**) is another good travel agent.

GETTING AROUND Apollonia's central square, Plateia Iroon (which locals simply call the Plateia or Stavri), is the main **bus** stop for the island. Buses run regularly to and from the port at Kamares, north to Artemonas and Cheronisso, east to Kastro, and south to Faros, Platis Yialos, and Vathi. Apollonia's main square is also the island's primary **taxi** stand. There are about 10 taxis on the island, each privately owned; you can get their mobile phone numbers from travel agents and some cafes. Most hotels, restaurants, and shops will call a taxi for you.

Reliable agencies for **cars, motorbikes,** or **ATVs** (all-terrain vehicles) are **Aegean Thesaurus** (www.thesaurus.gr; ✆ **22840/33151**), in Apollonia, and **Proto Moto Car** (www.protomotocar.gr; ✆ **22840/33793**), with a quayside office in Kamares and offices in Apollonia and Plati Yialos. In high season, you should reserve ahead. The daily rate for an economy car with full insurance is from 50€; a moped or ATV rents from 25€.

Where to Stay on Sifnos

Akti Hotel Platys Yialos ★★ This modernist 1960s landmark—opened as part of the long-defunct government-operated Xenia chain—overlooks the cove in Plati Yialos, set apart from the busy strip of the island's only beach town. The sand beach slopes gently into the sea, ideal for children, and ground-floor guest rooms, with patios facing the garden and water, are especially well suited to families. Rooms on upper floors command sweeping sea views from their balconies. Bright, attractive room decor features white furnishings against white walls, with the occasional touch of local stone and color. A flagstone sun deck extends from the beach to a dive platform at the end of the cove.

Platis Yialos. www.platys-gialos.gr. ✆ **22840/71324.** 24 units. 100€–220€ double (4- to 7-night min. stay July–Aug, 2-night min. stay other times). Rates include breakfast. **Amenities:** Restaurant; bar; pool; watersports; free Wi-Fi. Closed Oct–Mar.

THE golden YEARS

Sifnians were among the wealthiest of the ancient Greeks, thanks to the silver and gold they mined. They flaunted their riches and made especially lavish offerings to Apollo on the sacred island of Delos (p. 179). One year the greedy Sifnians decided to substitute gilded lead for their offering of gold. As the story goes, Apollo detected the ruse and wreaked his revenge by conjuring an earthquake that caused the mines to flood. The mines on Sifnos did stop yielding riches, but on account of natural causes: Many of the mines were dug beneath sea level and eventually filled with water; others were simply depleted of their precious minerals over time.

Instead of a busy port town, Sifnos's capital, Apollonia, is a charming cluster of five whitewashed villages set on inland hills.

Elies Resorts ★ Sifnos has always been sophisticated, but quietly so, and this luxury retreat on a hillside above Vathy brings glossy glamour to the island. Whether this is a welcome change depends on your taste and budget (many islanders resent the intrusion). Lavish rooms and villas are full of contemporary style and comforts, many with private pools; indoor/outdoor restaurants are excellent; and a large swimming pool sparkles above a sandy beach. The beautiful seaside village of Vathy is just beyond the gates.

Vathy. www.eliesresorts.com. ⓒ **22840/34000.** 32 units. 285€–490€ double. **Amenities:** Restaurant; bar; pool; beach; spa; tennis courts; free Wi-Fi. Closed Oct–Apr.

Hotel Anthousa ★★ These rooms above the very popular Gerontopoulos Cafe are right in the center of town. They face a flowery garden or look out to the surrounding hills, but even so, all of Sifnos seems to congregate outside the windows, so don't expect quiet. Rooms have balconies and are simple yet appealing, with crisp blue fabrics and homey furnishings. The location makes a handy base for exploring the rest of the island by bus, and the open-air cafe downstairs is a great place to linger.

Apollonia. hotelanthousa-sifnos.gr. ⓒ **22840/31431.** 15 units. 40€–80€ double. **Amenities:** Cafe; garden; fridges; free Wi-Fi. Closed Oct–Apr.

Petali Village Hotel ★★★ This comfortable perch is high above Apollonia, requiring a walk uphill from the square but ensuring views across the villages and the rolling interior hills to the sea. The extremely comfortable rooms and suites are oversized and attractive and face well-kept gardens from large terraces. All the village sights and services are within walking distance, and the pool and the summertime-only restaurant are most welcome after a day of sightseeing.

Apollonia. sifnoshotelpetali.com. ⓒ **22840/33024.** 25 units. 125€–220€ (4-night min. stay July–Aug). Rates include breakfast. **Amenities:** Restaurant; bar; pool; free Wi-Fi.

Verina Astra ★★★ These rooms and suites face the sea from thyme-scented hills outside Artemonas and are soothingly done with contemporary furnishings set against stone floors, rough-hewn walls and other simple, traditional flourishes. They all open to large, comfortably furnished private outdoor spaces. An infinity pool that seems to splash right into the Aegean is the centerpiece of a low-key communal terrace where casual meals are served.

Poulati. verinahotelsifnos.com. ℂ **6976/867641.** 14 units. 250€–450€ double. **Amenities:** Restaurant/bar; pool; free Wi-Fi. Closed Nov–Apr.

Where to Eat on Sifnos

Sifnos is famous for its olive oil and sophisticated cooking; in fact, "Tselementes," a Greek slang term for cookbook, is a tribute to the famous 20th-century Sifnian chef and cookbook writer, Nikos Tselementes. The secret, it's said, is slow-roasting in ceramic pots made of Sifnian clay; many restaurants serve a dish prepared this way, called *mastelo*—goat or lamb soaked in wine and sprinkled with dill, set on grapevine shoots in a pot, and placed in an oven to slow steam for hours. As you travel around Sifnos, you'll notice a lot of bakeries (a bakery is called a *furno* in Greece) and sweet shops. Among the island's most popular bakeries are **Katerina Theodorou,** on the main street in Aretmonas, and **Gerontopoulos Pastry Shop** in the Hotel Anthousa in Apollonia.

 Narlis Farm (www.sifnos-farm-narlis.com; ℂ **697/977-8283**), in Apollonia, hosts half-day cooking courses (around 100€), during which visitors gather ingredients from the farm, make traditional Sifnian recipes, and enjoy a meal.

Chrysopigi ★★ GREEK/SEAFOOD You can see the seaside monastery of the same name from the shady terrace of this very relaxed taverna on Apokofto beach. Caper salad and other Sifnos specialties are made daily, and fresh fish from the fleet at Faros, just around the headland, is grilled to perfection.

Apokofto. ℂ **22840/71295.** Entrees 5€–15€. Daily 10am–11pm. Closed Oct–Apr.

Kafenes ★★★ GREEK It's worth the trip down to the port just to enjoy a meal at this friendly, arbor-covered taverna terrace and a cozy adjoining room. Many of the tavernas in town are good and do a brisk business with diners coming and going from the port, but Adoni and his family are island-famous for the salads, fresh vegetables, homemade sausages, and fruit-infused liqueurs they produce on their farm, as well as their preparations of wild goat and other Sifnian dishes.

Hotel Boulis, Kamares. ℂ **22840/32122.** Entrees 6€–12€. Daily 11am–midnight.

A BAKER'S dozen

A Sifnian baker named Venios once had 13 children—a baker's dozen—and almost all the children and their children's children and successive generations of the Venios family became bakers. Several bakeries in Sifnos to this day are owned by one or another member of the Venios family. Many families, and even some restaurants, send their *revithia* (chickpeas) in a Sifnian clay pot, a *skepastaria*, to a Venios bakery to be slow-cooked overnight for a traditional Sunday dinner.

To Liotrivi ★ GREEK One of the oldest and best-known restaurants on Sifnos has introduced legions of travelers to caper salad, chickpea croquettes, and other island specialties. Service is not always first-rate, but a meal on the square out front or in a cozy dining room is still a nice experience.
Artemonas ℅ **22840/31921.** Entrees 8€–15€. Daily noon–11pm.

Exploring the Apollonia Villages ★★

The island's capital, Apollonia, is really a cluster of five villages that tumble across the inland hills in haphazard fashion, a jumble of whitewashed houses and blue-domed churches interspersed with vineyards, orchards, and gardens. Flagstone footpaths delicately outlined in whitewash wind through the villages and converge on **Plateia Iroon** (Hero's Square). A bus from the port in Kamares makes the trip up to the square hourly from about 6am to midnight every day in summer. To one side of the square, the **Popular and Folk Art Museum** (℅ **22840/33730**) is a showplace for island embroidery and weaving, along with the earthenware pots and jars that Sifnians once loaded onto ships in exchange for staples. The museum is generally open April through October, daily 10am to 1pm and 6 to 10pm; admission 2€). A short walk west up a path brings you to the **Panagia Quranophora** (Church of Our Lady of the Heavenly Light), where a relief of St. George crowns the doorway. A marble column and a few other fragments of a temple to Apollo are scattered about the shady courtyard.

Artemonas ★ VILLAGE The path from Plateia Iroon rises through the quiet village of Ano Petali, drops down to a stone bridge across the Marinou River, then climbs into the most beautiful of the Apollonia villages. The remains of a temple to Artemis—Apollo's sister, goddess of virginity and the hunt—are said to be buried beneath the **Kochi,** one of several churches that rise above the village rooftops. **Panagia tou Barou** (Church of Our Lady of the Baron) is named for one of the Italian nobles who ruled Sifnos from the 15th through early 17th centuries. The baron allegedly fell in love with a nun in a nearby monastery and, to sate his unrequited ardor, seduced several local women; his offspring soon populated the quarter, known ever since as the Barou in his honor. A bust of a more respectable resident, Nicholas Chrysogetos, stands near the village square. The surroundings have changed little since this hero of the 1821 War of Independence taught in Artemonas before becoming Greece's first minister of education. This is a nice spot in which to linger and sip a coffee before resuming your wanderings along any of the lanes that lead off the square.

Exambala ★ VILLAGE The name of the southernmost of the Apollonia villages translates as "trouble in the night"—a reference to the days under Turkish rule when the village was famous for spirited, independence-oriented rhetoric and song that often got out of hand as the nights wore on. On a hillside just outside the village the large, whitewashed monastery of **Kyria Vryssiani** (Sacred Spring) stands among olive groves. The cool spring that still bubbles forth in the courtyard is said to supply the freshest water on the island.

Around Sifnos

The island is not known for its beaches, though **Chrysopigi** (see below) and **Vathy** (p. 212) are idyllic places to get into the water. **Kamares,** the port, has a nice sandy beach. **Plati Yialos,** on the island's south coast, is the only bonafide beach resort on Sifnos. This one-street town is pleasant enough but pretty much devoid of character and exists only for tourism during the summer season.

Agios Andreas ★★ CHURCH/ANCIENT SITE One reason to make a vigorous 20-minute hike up to this hilltop church is to enjoy the almost 360-degree view of Sifnos and neighboring islands. (A road also climbs to the summit.) Another reason is to explore the excavations of an **ancient acropolis,** and its excellent small site museum. People have lived on this spot from perhaps the 13th century B.C. until at least the 4th century B.C. Massive walls that once stood some 6m (20 ft.) high (shorter versions still stand here) encircled the settlement, with its sanctuary of Artemis and small houses. From the site, you can see the remains of some of Sifnos's more than 80 stone towers, used for defense and for communication: Bonfires could flash messages quickly across the island from tower to tower. All this and more is explained in the excellent museum, where everything is labeled both in Greek and English.

2km (1 mile) S of Apollonia. Free admission. Wed–Mon 8am–3pm.

Chrysopigi ★★★ MONASTERY The Monastery of Panagia Chrysopigi (the Golden Wellspring) has been close to the heart of Sifnians since it was founded atop a rocky islet in 1650 to house an icon of the Virgin Mary that fishermen found washed up on the rocks. The image soon miraculously intervened to save the island from the plague—and came to the rescue again in 1928, when locusts descended upon the island. Yet another miracle occurred when two women fled to the monastery to escape pursuing pirates. They

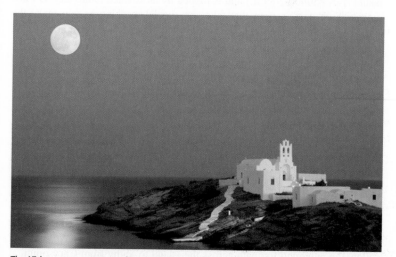

The 17th-century monastery of Paagia Chrysopigi is believed over the years to have saved Sifnos islanders from plagues and pirates.

prayed to the Virgin, who interceded by creating a deep chasm in the rocks to separate Chrysopigi from the mainland (a bridge now crosses the rift above the churning sea). Fishermen bring their sons to the monastery to be baptized in a font on a rocky point at the very edge of the surf, hoping to ensure that the boys will forever be safe from the perils of the seafaring life. You can contemplate the beautiful, still-active monastery with its simple church from a sandy beach, Apokofto, nestled beside an adjacent cove. A stone path leads around a headland to **Faros,** a small fishing village that takes its name from the lighthouse that guides the fleet past the rocky shoreline.

8km (5 miles) SE of Apollonia. Church open occasionally, hours vary; courtyard always open.

Kastro ★★ TOWN While the villages of Apollonia are light and airy, Kastro is somberly medieval, a fortress hugging a rocky promontory above the surf. The capital of Sifnos under Venetian rule, the fortress/town was virtually unassail-able, made so by a row of connected houses that form a solid defensive wall around the inner town. Tunnel-like passages lead into a maze of little lanes and tiny squares lined with tall Venetian-era houses—and littered here and there with sarcophagi left behind by the Romans who occupied Sifnos long before the Venetians came. The two-room **Archaeological Museum** (free admission) dis-plays bits of pottery and friezes from the ancient city that occupied these heights 3,000 years ago. The museum is open Wednesday through Monday, 8:30am to 4pm. The **Church of the Eftamartyres** (Seven Martyrs) sits atop a sea-girt promontory far beneath a clifftop promenade that skirts the town's outer flanks. The scene of the white chapel practically floating on the waves is remarkably picturesque, especially when wind-whipped waves buffet the sturdy white walls.

4km (2½ miles) E of Apollonia. Frequent bus service from Apollonia.

Profitis Elias o Pilos ★★ MONASTERY The highest mountain on the island rises 850m (2,789 ft.) and is topped by an isolated monastery. O Pilos means "high one," a term that takes on special meaning as you make the 1-hour-long climb on a steep, well-worn path, the only means of access, and regard the panoramic views across what seems like most of the Aegean Sea. A monk is often on hand to show you around the thick-walled courtyard and chapel and offer a glass of cool water. The monastery celebrates the feast of Elias around July 20, when hundreds of celebrants make a nighttime pilgrim-age up to the monastery carrying torches.

Trail begins 2km (1 mile) W of Apollonia in Katavati, a hamlet just south of Exambala.

Vathy ★★ TOWN Until a new road was laid about 25 years ago, the only way to reach Vathy was on foot, donkey, or boat. Even with this road link to the rest of the island, Vathy remains a serene getaway, a small collection of houses along a beach of fine sand, backed by a verdant valley. This setting is made all the more beautiful by the presence of the **Monastery of the Taxiarchis Evan-gelistrias** (Archangel of the Annunciation), so close to the seaside that the whitewashed walls and a bell tower seem to rise out of the water. *Note:* If you follow the *monopati* footpath across the island to Vathy from Chrysopigi, at the top of the peninsula above the Bay of Platos Yialos you'll notice the **Aspro**

Pirgos, or White Tower, a lookout post built round 500 B.C., when the mines of Sifnos still yielded gold and the island was an important Aegean outpost.

12km (7 miles) W of Chrysopigi by road, 5km (3 miles) by path.

Sifnos Shopping

Famed in antiquity first for its precious metals, Sifnos was famous well into the 20th century for ceramics. Among the island's main exports were bowls, plates, and jugs for everyday use, and the island still produces some wonderful brown glaze pottery with minimalist white decorative swirls. As you crisscross the island, you'll see signs advertising pottery workshops. Giannis and Simos Apostolidis carry on a century-old family ceramics tradition and show off their wares in their **En Sifno** workshop, just outside Kamares in Leivadas (apostolidis-ceramics.gr; ✆ 22840/33721). **Sifnos Stoneware** in Artemonas (www.sifnos stoneware.com; ✆ 22840/33090) displays pottery and dinnerware that Antonis Kalogirou, carrying on a family tradition, fashions from the deep gray or red clay mined in the inland hill region. In Apollonia, Kastro, and Artemonas a number of other shops sell pottery, but it's mostly from neighboring Paros (p. 197)—Parian pottery is distinguished by its bright colors, shiny glazes, and scenes of fruit, flowers, and island life. For distinctive jewelry, Spyros Koralis's **Ble** (✆ 22840/33055), in Apollonia, does innovative work in silver and gold.

SANTORINI ★★★

230km (143 miles) S of Piraeus

Sailing into Santorini is one of the great Greek travel experiences. From the deck of the ferry, you will be looking up the 300m-high (1,000 ft.) cliffs that form the western flanks of the main island. The bay, some 10km (6 miles) long and as deep as 400m (1,312 ft.) in places, is actually the flooded caldera of a volcano, whose eruptions caused the center of a once-large island to collapse. Gaze back west to the islets on the west side of the bay, Therasia and Aspronissi, and you'll see that they were originally fragments of the rim. From the sea, the towns and villages that line the caldera look almost like apparitions. At first the clusters appear to be natural formations of white stone, until blue domes come into focus and you notice white cubical houses practically teetering on the sides of the cliffs.

Little wonder that Santorini is the most visited of the Greek isles. You won't encounter too many vestiges of authentic Greece here or explore wild terrain, but you will soak in the beauty of one of the world's most spectacular natural settings. When you tear yourself away from the views of the volcanic caldera, you can bask on black sand beaches and encounter the remains of prehistoric civilizations at Akrotiri and Ancient Thera.

Essentials

ARRIVING **Aegean Airlines** (en.aegeanair.com), **Olympic Air** (www. olympicair.com), and **Sky Express** (www.skyexpress.gr) fly several times a day between Athens and the Santorini airport, **Monolithos** (✆ 22860/31-525),

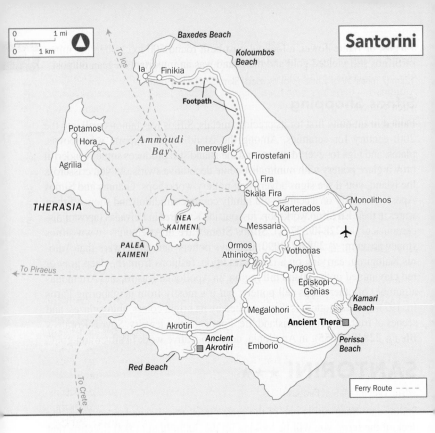

Santorini

6km (3½ miles) east of Fira. The small airport also handles flights to and from other European cities operated by **easyJet** (www.easyjet.com) and many other airlines, including summertime charters. There are frequent connections with Mykonos and Rhodes, and service several times a week in summer to and from Iraklion, Crete. A bus to Fira (4€) meets most flights; the bus stop is beside the airport entrance and tickets are sold on board. A taxi to Fira costs about 13€.

Frequent **ferry** and high-speed **catamaran** service runs to and from Piraeus on the mainland. The trip takes 9 to 10 hours by car ferry on the Piraeus-Paros-Naxos-Ios-Santorini route, or 4 hours by catamaran, if you go via Piraeus-Paros-Santorini. Boats are notoriously late, especially the catamarans; any travel agent or the **Santorini Port Authority** (© **22860/22-239**) will be able to give you updates. In summer, ferries connect several times a day with Ios, Naxos, Paros, and Mykonos, with almost daily service to and from such smaller Cyclades islands as Folegandros, Sifnos, and Sikinos. Service to Iraklion or Rethymnon on Crete runs once or twice daily, and service to Thessaloniki (a trip that takes 17–24 hr.) runs four to five times per week. Go to www.ferryhopper.com or www.gtp.gr to keep up with ever-changing schedules.

Almost all ferries dock at **Athinios,** where buses meet each boat for the trip to Fira (one-way to Fira costs 3€; buy tickets on board); taxis are also available from Athinios, charging about 15€. Santorini Port Super Shuttle

(www.santoriniport.co; ✆ **6940/792211**) has an office at the port and offers shared transport around the island, as low as 12€ to Ia and other far-flung spots. The service is especially handy late at night when buses are not running. Athinios is charmless, lined with a few lackluster and overpriced tavernas; when you come here to catch a ferry, it's a good idea to bring a snack, water, and a good book.

The exposed port at **Skala,** directly below Fira, is unsafe for the larger ferries but is often used by small cruise ships, yachts, and excursion vessels. If your boat docks here, head to town either by cable car (6€, luggage 3€ each piece) or you can do the 45-minute uphill walk. Avoid making the trip on the back of one of the often-mistreated donkeys.

VISITOR INFORMATION Bellonias Tours (www.bellonias.com; ✆ **22860/ 32026**), **Kamari Tours** (✆ **22860/31-390**), and **Pelican Travel** (www.pelican. gr; ✆ **22860/22220**) are well established on the island, offering bus tours, boat excursions around the caldera, and more. You'll find some helpful information on the island at the municipality of Fira website, www.santorini.gr.

GETTING AROUND The **central bus station** is just south of the main square in Fira. Most routes are served every hour or half-hour from 7am to 11pm in high season. A conductor on board will collect fares, which range from 2€ to 5€. Destinations include Akrotiri, Athinios (the ferry pier), Ia, Kamari, Monolithos (the airport), Perissa, Perivolas Beach, Vlihada, and Vourvoulos.

A **car** is not really necessary, except for maybe a 1-day excursion to visit Pyrgos, wineries, Akrotiri, Ancient Thera, or to make a sweep of the island's famous volcanic beaches. Many travel agents on the island rent cars, charging about 60€ a day in high season for a small car with unlimited mileage. Parking is tight around Fira; it's best to use the free, well-marked municipal lot at the southern edge of town. If you park in a no-parking area, the police will

A caldera IS BORN

A caldera forms when molten rock, known as magma, is ejected from a volcanic crater during an eruption. Without the support of underlying magma, the land surrounding the crater collapses. A volcanic eruption several hundred thousand years ago created the caldera in Santorini, when the center of a circular island collapsed and the sea rushed in to fill the caldera. Volcanic debris from other eruptions has refilled the caldera many times over the millennia, only to collapse again. By the time of the last eruption, around 1600 B.C., the Santorini caldera was almost entirely ringed with land, except for one narrow channel.

One of the largest eruptions on record, the 1600 B.C. explosion blew open additional channels, creating the present-day appearance of the caldera.

Which leads to the million-dollar question: Is Santorini Atlantis? Plato tells us that Atlantis "disappeared into the sea depths" some 9,000 years before his time—but that's only one zero off from 900 years (a mistake passed down through the ages, perhaps?). Plato wrote in the 5th century B.C., so the missing-zero theory places the destruction of Atlantis tantalizingly close to the time of Santorini's last eruption.

remove your license plates, and you, not the car-rental office, will have to pay a steep fine to get them back.

If you decide to rent a **moped** or **ATV,** keep in mind that many roads on the island are narrow and winding. Between local drivers who take the roads at high speed, and visiting drivers who aren't sure where they're going, the island's high accident rate should be no surprise. If you're determined to use these modes of transportation, expect to pay about 25€ per day, less in the off-season. Greek law now requires wearing a helmet.

The **taxi** station is just south of the main square. In high season, book ahead by phone (© **22860/22-555** or 22860/23-951) if you want a taxi for an excursion; be sure that you agree on the price before you set out. For most point-to-point trips (Fira to Ia, for example), the prices are fixed. If you call for a taxi outside Fira, you'll be charged a pickup fee of at least 2€; you're also required to pay the driver's fare from Fira to your pickup point. Bus service shuts down at midnight, so book a taxi in advance if you'll need it late at night.

Where to Stay on Santorini

Many hotels along the caldera are accessible only via very long flights of steep steps. Staff members are usually on hand to carry your bags, but if you're not up to some fairly rigorous climbs, these places are not for you—and many are not suitable for young children. Ask about accessibility when booking and, if that's an issue, seek out lodgings on level ground. You'll save a hundred or more euros a night if you choose to stay somewhere other than along the caldera rim in Fira and the towns north from there to Ia. Wherever you stay, reserve as far in advance as possible if you're planning a visit in July or August, when rooms book up quickly. Many hotels require a minimum stay or 2 or 3 nights at that time.

A view from the rim of Santorini's spectacular caldera is not to be missed, though you'll pay dearly to get that view from your hotel room.

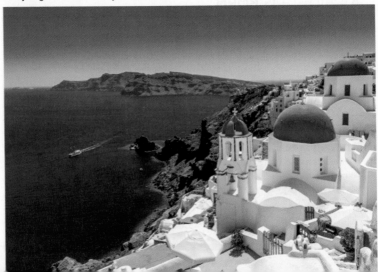

EXPENSIVE

Astra Suites ★★★ Dramatic eagle's-eye views over the caldera and the Skaros promontory set the scene for stylishly appointed suites and apartments that surround a lovely pool and cling to the side of the caldera, looking like a tiny, whitewashed village. This amazing setting is the backdrop for extremely comfortable accommodations, with vaulted ceilings, beautiful tile work, and handsome wood and fabrics. Everything is just right, and the management and staff—a large part of what makes Astra so special—go out of their way to ensure that, providing service that focuses on every detail.

Imerovigli. www.astrasuites.com. ℂ **22860/23-641.** 27 suites. 400€–650€ double. Rates include breakfast. **Amenities:** Bar; restaurant; pool; spa services; free Wi-Fi.

Esperas ★★★ You'll feel like a cliff dweller at this welcoming enclave of traditional houses teetering on the rim of the caldera at the edge of Ia. Shops and restaurants are just steps (in the literal sense) away, and a path leads to stairs descending to Ammoudi's beach. Even so, this enchanted perch seems a world unto itself, set apart from the busy Ia scene. Views are stupendous from the private terraces (many with hot tubs) or the beautiful pool and terrace, and the tasteful accommodations, filled with traditional island furnishings, invite seclusion (a rare commodity on the crowded caldera these days). The in-house restaurant shows off local produce in delicious salads, wonderful seafood dishes, and a slow-cooked lamb shank.

Ia. www.esperas.com. ℂ **22860/71088.** 17 units. 320€–550€ double. Rates include breakfast. **Amenities:** Restaurant; bar; pool; free Wi-Fi. Closed Nov–Mar.

Ikies ★★ On an island famous for dramatic settings, this aerie tucked away on the side of the caldera ranks high. All units are different, though each is a greatly enhanced cliff house with a kitchenette, living area, and bedroom or two. Many are on two levels, and each opens to its own terrace with a private hot tub and eye-filling views. Stonework, domed ceilings, bright-blue shutters, and other architectural details provide plenty of exotic island ambiance, while furnishings are a design-magazine-worthy mash-up of contemporary and traditional styling. Attentive, low-key service accentuates the feeling that you are in a world of your own with the sparkling Aegean at your feet.

Ia. www.ikies.com. ℂ **22860/71311.** 11 units. 50€–750€ double. Rates include breakfast. **Amenities:** Room service; pool; free Wi-Fi. Closed Nov–Mar.

MODERATE

Aressana Spa Hotel ★★ Travelers put off by the steps of caldera-view hotels will find a welcome refuge in this stunning retreat set around a dramatic swimming pool and lush gardens in the middle of Fira. The surroundings can be aggressively hip, but the stylish rooms are large and offer every comfort; most rooms have balconies or terraces, often facing the pool and quiet gardens, and many have the high barrel-vaulted ceilings typical of this island.

Fira. www.aressana.gr. ℂ **22860/23-900.** 50 units. 250€–400€ double. Rates include breakfast. **Amenities:** Cafe; bar; pool; room service; free Wi-Fi. Closed mid-Nov to Feb.

Aura Marina ★★ A hillside above the village of Akrotiri at the south end of Santorini is the quiet setting for airy, handsomely furnished apartments, many multilevel, that look over the sea and the caldera. All of the beautifully designed units have sitting rooms, kitchenettes, and bedrooms/sleeping lofts, and all open to large terraces with private plunge pools. You'll need a car to reach this pleasantly remote place, but you'll be near the island's best beaches as well as the archeological sites.

Near Akrotiri. www.aura-marina.com. ✆ **2286/083101.** 9 units. 190€–400€ double. 3-night min. stay many periods. **Amenities:** Private pools; free Wi-Fi. Closed Nov–Mar.

Hotel Keti ★★ You don't have to take out a second mortgage to afford a caldera view at this delightful and reasonably priced inn clinging to the cliff face below the center of Fira, full of the island's famously eye-catching scenery. Rooms are pleasantly vaulted, whitewashed, and traditionally furnished. All open onto a shared terrace overlooking the caldera, while bathrooms, at the back of the rooms, are carved into the cliff face. The fanciest accommodation in the house is a suite with an outdoor Jacuzzi. You'll do some climbing to get in and out of this hideaway, but your efforts are well rewarded.

Fira. www.hotelketi.gr. ✆ **22860/22324.** 7 units. 200€–250€ double. Rates include breakfast. 3-night min. stay July–Aug. **Amenities:** Bar; free Wi-Fi. Closed Nov to mid-Mar.

Zannos Melathron ★★ Pyrgos, an atmospheric medieval citadel in the island's center that was once its capital, is the setting for this distinctive and luxurious hideaway, part of the Relais & Chateaux group. Two exotic 18th- and 19th-century neoclassical mansions are set in lush gardens behind high walls. Restrained old-world ambience fills the frescoed lounges and guest rooms, all facing patios and a pool and done in elegantly traditional island style. Wine and food are first-rate, views are extensive (it's one of the island's highest points), and the welcoming lanes of Pyrgos are just outside the door.

Pyrgos. www.zannos.gr. ✆ **22860/28220.** 12 units. 225€–330€ double. Rates include breakfast. **Amenities:** Restaurant; bar; airport pickup; concierge; Jacuzzi; pool; room service; free Wi-Fi.

INEXPENSIVE

Anatoli Hotel ★★ The remains of an old winery have been transformed into this handsome cluster of whitewashed stone houses on the east side of Fira—a world removed from the noise and bustle but still with spectacular water views, not of the caldera but over the east coast beaches far below. No-frills, traditionally styled rooms open off hillside terraces and gardens and come in many sizes and configurations, some set up with kitchens for families. Most have vaulted ceilings and other quirks; many look over the pool and sea from balconies. The center of Fira is a 5-minute walk away.

Fira. www.anatolihotel.gr. ✆ **22860/22759.** 21 units. 70€–140€ double. Rates include breakfast. **Amenities:** Restaurant; bar; spa; pool.

Chez Sophie ★★★ Popular Kamari beach is just down the road from one of the island's best-value choices, a pleasant ocher-colored little inn where the

owner and her family seem determined to make guests feel like they've found a home in Santorini. Rooms vary in size and furnishings but all are comfortably non-fussy, with balconies and well-done bathrooms; some have sea views and they all surround a pretty terrace and pool. Buses make the short trip to Fira about every half hour from a nearby stop and Ancient Thera is just up the road.

Kamari. www.chezsophie.gr. © **22860/32912.** 12 units. 70€–160€ double. 3-night min, stay July–Aug. Rates include breakfast. **Amenities:** Bar; pool; free Wi-Fi.

Paradise Hotel ★ If you're willing to forego the caldera views, you'll be lucky to find yourself in this delightful spot near the island's ancient sites and lava beaches. Pleasantly plain, tile-floored rooms surround a flowery garden and enormous pool, living up to the standards of a Best Western affiliation. Though the nearby sea is just out of sight, the scene of village life unfolding all around you is a spectacle in itself.

Akrotiri. www.hotelparadise.gr. © **22860/81277.** 40 units. 80€–160€ double. Rates include breakfast. **Amenities:** Pool; free Wi-Fi. Closed Nov–Mar.

Smaragdi ★★★ "Smaragdi" is a gemstone and an apt name for these attractive and extremely good-value accommodations set back from black-sand Perissas Beach. Rooms range from economy units to luxurious suites, but even the basic choices are good size and don't skimp on style or comfort. All have generous outdoor spaces (shared, in the economy category) and are clustered around a flower-filled pool terrace. Service is notably attentive, with an amiable staff providing bus schedules, dispensing sightseeing tips, and helping guests find nearby markets and laundries. Easy-going beach bars and tavernas are just down the lane, as is a bus stop for connections to Fira.

Perivolos, Perissas Beach. maragdihotel.gr. © **22860/8270160.** 46 units. 70€–170€ double. Rates include breakfast. **Amenities:** Bar; snack bar; pool. Closed Oct to mid-Apr.

CYCLADIC architecture

On Santorini and other Cycladic Islands, houses were crowded together, one on top of another with common walls, to make optimal use of the land, provide protection, and save money and labor when materials often had to be transported on the backs of donkeys. Many houses on Santorini were built into the cliff face for extra economy (some of the most luxurious hotels on the island now occupy such cave dwellings). Walls were thick for warmth in the winter and for coolness in the summer, and windows were small. Often the only windows were in the front of the house, on either side of a windowed door, above which a clerestory window was placed to emit light and let hot air trapped near the ceiling escape—still a feature in many Santorini hotel rooms. Local materials on Santorini were red and black volcanic stone and "Theran earth," a volcanic ash that served as mortar. Roofs were vaulted, an efficient way to bridge interior spaces without using support beams and to allow rain to run off into cisterns, where it was stored for drinking and irrigation. Even many flat-roofed houses are vaulted, with parapets built atop the vaults to serve as terraces or passageways to more houses.

Villa Maria ★★ You get a different look at the caldera from the southern end of the island, and at these bright-white houses perched on the edge of a cliff outside Akrotiri, those views come at a fraction of the price you'd pay in Fira or Ia. Pleasantly simple rooms and apartments, awash in shades of white and pale blue, are filled with light and sea views. All have sea-view balconies, and a large sun terrace surrounds a pool.

Akrotiri, about ½ mile outside town. www.villamariasantorini.com. ℃ **22860/82334.** 8 units. 90€–115€ double. Rates include breakfast. **Amenities:** Pool; kitchens; free Wi-Fi. Closed mid-Oct to Apr.

Where to Eat on Santorini

A good meal in Santorini introduces you to island-grown ingredients that include capers; tomatoes, either sun-dried or made into tomato fritters; fava beans, actually yellow split peas, usually pureed and drizzled with olive oil; and white eggplants, often made into *melitzanosalata,* a delicious dip. Several of these fresh ingredients show up in Santorini Salad, a taverna staple. Meals on the island can be expensive, but some inexpensive and authentic fast-food fallbacks are **Pito Gyros Traditional Grill House** in Ia (pitogyros.com; ℃ **22860/71119**) and **Greek Souvlaki Karvounaki** in Fira on 25 Maritou (℃ **22860/25095**).

EXPENSIVE

Restaurant-Bar 1800 ★ GREEK/CONTINENTAL A 200-plus-year-old sea captain's house in the center of Ia is one of Santorini's favorite dining spots, and little wonder. Fresh fish beautifully sauced with capers, tender lamb chops with green applesauce, and other inspired cuisine does justice to the exquisite decor—and, for that matter, to the views from the roof terrace. After you eat, you can decide whether the owner (an architect and chef) deserves more praise for his skill with the decor or with the cuisine.

Main St., Ia. www.oia-1800.com. ℃ **22860/71485.** Entrees 18€–35€. Daily noon–midnight.

MODERATE

Candouni ★★ GREEK It's hard to pass by this 19th-century sea captain's house, with its enticing candlelit garden and charming old rooms filled with antiques and mementos of old Santorini. The Korkiantis family has put together a similarly homey menu of seafood pastas and slow-cooked lamb, and they take care of their guests with warmth. Musicians play some evenings.

Ia. www.candouni.com. ℃ **22860/71616.** Entrees 10€–25€. Daily noon–midnight.

Katina's ★★ SEAFOOD Fish tavernas line the quay at Ammoudi, the fishing port below Ia. All are good, and given the islanders' discerning taste when it comes to seafood, none would stay in business long if they failed the freshness test. Family-run Katina's is one of the oldest and most revered places on the waterfront, yet it never lets down its high standards. At all these tavernas, the fresh fish, calamari, or octopus you choose from the iced display cases will be grilled and served with fresh salads and vegetables. Lapping waves and bobbing fishing boats provide a suitable backdrop. What more

could one ask for? Maybe a taxi back up the hill when it's time to leave. Just ask your waiter and one will appear.

Ammoudi, at bottom of steps from Ia. © **22860/71280.** Entrees 10€–25€ or more; fish sold by weight. Daily noon–midnight.

Metaxi Mas ★★★ GREEK/CRETAN An out-of-the-way location in the countryside outside Pyrgos doesn't seem to deter eager diners, who pack into the stone-walled dining room and terrace from noon until the wee hours. The name means "between us," but no one's chosen to keep this buzzing place a secret. The chief draws are simple time-honored dishes made with the freshest ingredients: delicious salads, perfectly grilled fish, heavenly shrimp *saganaki*, simply roasted eggplant, tomato fritter. Service, unfortunately but understandably, can seem a bit rushed.

Pyrgos, Exo Gonia. www.santorini-metaximas.gr. © **22860/31323.** Entrees 7€–12€. Daily 2:30–11pm.

To Psaraki ★★★ GREEK/SEAFOOD The name means "little fish," fitting for this garden and balcony hanging over the harbor of Vilchada on the southern end of the island. The freshly caught fish and seafood here comes from select local suppliers, prepared with the tomatoes, white eggplants, and capers for which the island is famous. Grilled fish is the specialty, and the *tarama* (fish eggs) baked with eggplant, tomato, and feta seems to combine all the flavors of the island.

Vilchada, 10km (6 miles) S of Fira. topsaraki.gr. © **22860/82783.** Entrees 10€–25€. Daily 1–11pm. Closed mid-Oct to Apr.

INEXPENSIVE

Roka ★★ GREEK A neoclassical house with a colorful garden on the back streets of Ia is a welcome retreat from the busy scene on the caldera rim. The traditional taverna fare sticks close to the basics, making the most of island ingredients. Vegetable pies, peppers stuffed with rice and pine nuts, and grilled meat and fish are unfailingly delicious.

Ia. www.roka.gr. © **22860/71896.** Entrees 8€–15€. Daily 12:30–11pm.

Taverna Eleni's 1955-ex-Nikolas ★ GREEK An authentic Greek taverna seems almost out of place in Fira these days—but that, of course, is the appeal of this simple, whitewashed room that has been serving old favorites, from a good moussaka to lamb in lemon sauce, for more than 50 years. Eleni, who's worked here for decades and taken over from founder Nikolas, is usually on hand to make sure her guests are happy—and they are, especially in light of the down-to-earth prices. Arrive early or late, as the place is always busy.

Just up from the main square, Fira. © **22860/36422.** Entrees 7€–10€. Daily 3–11pm.

Zafora ★ GREEK From a seat on the terrace, you can take in the action of this pleasant village (near the ancient site of the same name) while sampling tomato fritters, pasta with seafood, stuffed peppers, and other local favorites. This is a good lunch stop if you're exploring the southern end of the island.

Akrotiri. © **22860/83025.** Entrees 7€–12€. Daily 11am–11pm.

Exploring the Ancient Sites

Archaeologists have unearthed two notable ancient sites on Santorini: Ancient Thera, from around the 9th century B.C., and Akrotiri, settled by Minoans from Crete around 3000 B.C. Many of the treasures from these ancient settlements are now in the National Archeological Museum in Athens and elsewhere.

> ### Ancient Sites Ticket Package
>
> For 15€, you can purchase a ticket package that includes all of Santorini's archeological sites and museums: Ancient Akrotiri, Ancient Thera, the Museum of Prehistoric Thera, and the Collection of Icons and Ecclesiastical Artifacts at Pyrgos. The ticket is good for 4 days.

You'll still find plenty of delicately painted cups, jugs, *pithoi,* and other artifacts from both sites, along with some wonderful fresco fragments, in Fira's **Museum of Prehistoric Thera,** near the bus station. It's open daily except Tuesday, 8:30am to 3:30pm (until 3pm Nov to mid-Apr). Admission is 6€ or part of combined ticket (see box at left).

Ancient Akrotiri ★★★ ANCIENT SITE One of the best-preserved ancient settlements in the Aegean, the so-called Minoan Pompeii was settled by Minoans who sailed over from Crete as early as 3000 B.C. By 2000 B.C., Akrotiri was a flourishing urban center that grew olives and grain, created fanciful art, wove beautiful textiles, sent trade ships to ports as far away as Egypt, and took peace so much for granted that residents saw no need to build defensive walls.

Buried deep in ash during the eruption of 1600 B.C., Akrotiri was not uncovered for another 3,300 years, by workers mining ash and pumice in 1860. No human remains and valuables were ever found, suggesting that the inhabitants had enough warning to flee the city. What they could not take with them were

The Minoan city of Akrotiri was buried by the eruption in 1600 B.C. and not uncovered again until 1860.

the magnificent paintings that once covered the walls of their public buildings and homes; these are now in the National Archaeological Museum in Athens (p. 110). Their images, of monkeys (indicating trade with North Africa), ships sailing past leaping dolphins, cows, and young women gathering saffron reveal much about this early society that disliked war and admired beauty. On site you can still see some 40 remarkably well-preserved stores, warehouses, and houses lining Akrotiri's main street, as well as many giant *pithoi* (earthenware jars) and their contents of oil, fish, and onions. More than two-thirds of the town still remains covered and may one day reveal more treasures and secrets of the past. One of the island's famously colored beaches, Paralia Kokkini (Red Beach), is next to Akrotiri; at most times it's pleasantly uncrowded.

6km (4 miles) W of Pyrgos. odysseus.culture.gr. ✆ **22860/81366.** Admission 12€ or part of combined ticket (see p. 222). Mid-Apr to Oct Mon and Wed–Thurs 8:30am–3:30pm, Tues and Fri–Sun 8am–8pm; Nov to mid-Apr daily 8:30am–3pm.

Ancient Thera ★★ ANCIENT SITE This ruined city high atop a rocky headland reaffirms the notion that the ancients never underestimated the value of a good location. The town was first settled in the 9th century B.C., and since then Egyptian sanctuaries, Greek temples, Roman baths, and Byzantine walls have risen atop its seaside cliffs. The ruins are a jumble left behind by these different cultures, but the views are so dizzying you probably won't mind a little confusion. Most striking is the **Stoa Basilike** (Royal Porch), a colonnade 40m (131 ft.) long and 10m (33 ft.) wide, built in part by Egyptian troops of Ptolemy, garrisoned on Santorini in the 3rd century B.C. The large **Terrace of the Festivals** in front of the **Temple to Apollo Karneios** was the stage for the Karneia, a Greek festival in which Ephebes—adolescent males undergoing strict military training—danced naked; the display was more than a little erotic, and it's been suggested that the spectacle inspired a large phallus carved onto a nearby wall with the inscription "to my friends." The youth trained in the **Gymnasium of the Ephebes** and bathed afterward in facilities that the Romans fashioned into elaborate baths. Below the promontory is Kamari, the most famous beach on Santorini, a dramatic swath of silky black sand.

6km (4 miles) E of Akrotiri, 10km (6 miles) SE of Fira. odysseus.culture.gr. ✆ **22860/31366.** Admission 6€ or part of combined ticket (see p. 222). Mid-Apr to Oct Thurs–Tues 8:30am–3:30pm; Nov to mid-Apr Tues–Sun 8am–3pm.

Exploring Fira ★

The island capital, **Fira** (also spelled Thira or Thera), surrendered its soul to tourism several decades ago, but the cliffside setting remains as intoxicating as ever. From **Ypapantis,** the walkway that follows the rim of the caldera, the view is never less than staggering. The blue sea sparkles some 300m (984 ft.) below, cliffs take on multicolored hues in the sun, and white houses appear to tumble from the cliff tops. This extraordinary vista is especially dramatic from the stepped path that winds down the cliff face to the little harbor of **Fira Skala.** You can also board a cable car (www.scc.gr) for the descent and ascent. Tour guides will try to cajole you into mounting a donkey for the ride down

Opt for a cable car ride to climb up to Fira from the port, rather than making the ascent on one of the overworked tourist donkeys.

and up the cliff-face, but leave the swaybacked beasts in peace; the cable car makes the trip in 2 minutes, runs every 15 minutes from 7:30am to 9pm, and costs 6€ each way (3€ for children).

A good refuge from the crowds along shop-lined Erythron Stavron street is the nearby **Megaro Gyzi Cultural Centre ★★**, next to the Cathedral of St. John at Martiou 405 (gyzimegaron.gr; ℂ **22860/22244**). Fascinating photographs show Santorini as it looked before and just after the most recent seismic catastrophy, the earthquake of 1956, which leveled much of the island. The handsome 17th-century mansion that houses the museum is one of the few historic homes in Fira that withstood the quake. Admission is 3€; the museum is open Monday through Saturday 10am to 4pm. The center is closed from November through April.

A quiet outpost just north of Fira, **Firostefani ★** is a good place to appreciate the island's beautiful architecture (see box, p. 219). Fira, Firostefani, and many other villages on Santorini were built atop cliffs to protect them from pirates who once marauded around the Aegean. As you walk down any of the lanes descending from the cliff top, note how the white cubical houses huddle together on narrow lanes, one on top of another, many dug into the side of the cliff, a concept born out of necessity and creating an impossibly picturesque townscape.

Exploring North Around the Caldera

Tucked into the highest point on the caldera rim 2½ km (1½ miles) north from Fira, the little village of **Imerovigli ★★** delivers more of the visual treats so common on Santorini—views of the caldera and Skaros, a rocky promontory below. Skaros was once crowned with an ancient city and later the fortified town of Rocca, the seat of Venetian nobility and Turkish administrators. After descending the stepped, quiet streets of Imerovigli, then a precipitous drop down a cliff path, you'll reach the rocky heights that connect Skaros to the rest of Santorini. Then it's uphill for 2km (1 mile) or so, along a cliff face of volcanic rock, to the ruins of the fortifications, toppled by earthquakes over the years, and a small chapel. Your rewards for the excursion are phenomenal views over the bay and up the walls of the caldera to the villages glistening on the cliff tops.

Another 9km (6 miles) north, Santorini's most picturesque village, **Ia ★★★**, clings to the northwestern tip of the caldera. Once populous and prosperous,

WALKING THE caldera path

Walking even a portion of the 10km (6-mile) cliff-top path from Fira to Ia is one of the best experiences you will have on Santorini. Looking over the bay and the crescent of cliffs is like staring into the Grand Canyon—an ever-changing scene in which the rock seems to switch color before your eyes and what looks like a patch of snow takes shape as a cluster of houses.

Santorini is actually the eastern rim of a volcano and the largest fragment of an island that was blown apart by a series of massive eruptions (the 1600 B.C. blast was one of the largest volcanic eruptions ever recorded). Looking across the bay, you can see other remnants of the rim, the isles of Therasia and Aspronisi (White Island); in the center are two isles of blackened earth, Nea and Palea Kaimeni (New and Old Burnt Isles), the cones of volcanoes. This geology reveals itself slowly, and its unique beauty seems to intensify with every step you take along the caldera path. Allow at least 2 hours for the walk from Fira to Ia; it's a good idea to start in the morning, before the heat of the day.

it was home to many of the island's wealthy maritime families in the 19th century, when Santorini had one of the largest merchant fleets in the Aegean. By 1850, more than 200 Santorini vessels were shipping the island's wine to Russia, transporting Russian wheat to ports of call around Europe, and sailing to Athens laden with prized Santorini volcanic pumice, in demand for the building craze then transforming the new nation's capital. Ia was all but leveled in the earthquake of 1956, when most residents fled, leaving behind a ghost town of half-ruined houses. Today, however, Nikolaou Nomikou, the main pedestrian way, is lively once again—perhaps too lively at times—and

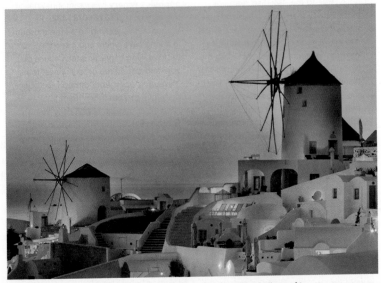

A picturesque set of windmills overlooks the caldera in the clifftop village of Ia.

the blue Aegean sparkles enticingly below cave houses reclaimed as comfortable hotels. Many visitors flock to Ia to watch the sunset from the ruined walls of the Kastro, at the western edge of town—a spectacular sight, but no more so here than anywhere else on the caldera.

A small fishing fleet bobs in the sea far below Ia in the little port of Ammoudi, reached by a flight of 300 stone stairs that wind down the cliff. The quay is lined with a row of tavernas that serve fresh fish right off the boats, and a small pebble beach serves well for a quick swim.

Exploring Pyrgos & the Vineyards

Pyrgos ★★, some 6km (4 miles) inland from Fira, was the longtime capital of the island under the Venetians and Turks. Deliberately located away from any harm that could arrive by sea, Pyrgos makes a striking appearance as you approach from the flat, arid coastal plain: A cone of tiered houses rises on the flanks of a hill beneath a Venetian citadel. Built back-to-back and on top of each other, the compact white houses provided a phalanx against invasion, and the lanes that tunnel beneath them could be blockaded to keep out intruders. The once mighty castle atop this medieval maze was impenetrable, but not immune to earthquakes, one of which toppled its walls half a century ago. The overgrown ruins afford views across the island. Pyrgos is easy to reach by bus.

The monastery of **Profitis Elias** ★★ crowns a nearby peak, the tallest on Santorini at almost 1,000m (3,281 ft.). Islanders make their way to these

A taste **OF SANTORINI WINES**

The eruption of 1600 B.C. covered Santorini with ashy volcanic soil that is extremely hospitable to the Assyrtiko grape, a hardy variety that yields the island's distinctly dry whites and *vin santo*, a sweet dessert wine. Some 36 other varieties grow on Santorini as well, including the white Athyri and Aidani and the red Mantilaria and Mavrotagano. Growers twist the vines into low-lying basket shapes that hug the ground for protection against the wind, and nighttime mists off the sea provide just enough moisture. Several wineries offer tastings and tours; most of the larger operations cater to busloads of passengers from cruise ships, so don't expect a winery visit to be low-key. Wineries that offer tastings include **Boutari,** in Megalochori (✆ 22860/81011); **Antoniou,** in Megalochori (✆ 22860/23557); and **Santo,** in Pyrgos (✆ 22860/22596). The enormous tasting rooms and terraces at Antoniou and Santo overlook the caldera, adding drama to your tippling. **Koutsoyannopoulos winery** (www.santoriniwine museum.com; ✆ **22860/31322**), in Vothonas, has assembled a little museum in a long cave where you'll see the backbreaking harvesting techniques of yore and taste three or four wines; the museum is open April through October daily 9am to 7pm (from 10am Sun) and November through March daily 9am to 5pm (from 10am Sun); admission is 10€, tasting included. For an introduction to Santorini wines, visit **www.santorini.org/ wineries**. On minibus excursions with **Santorini Wine Tours** ★★★, professional sommelier Vaios Panagiotoulas takes guests to several distinctive wineries, with tastings and descriptions of the ins and outs of Santorini grape-growing and winemaking; for information, go to www.santoriniwinetour.com (✆ **22860/28358**).

breezy heights not just for the views but to pay tribute to the community that kept Greek traditions alive at a secret school during Turkish rule in the 18th and 19th centuries. A shady series of rooms off the courtyard houses some of the rare books and icons the monks safeguarded. Admission to the monastery is free, though hours vary with the comings and goings of the caretakers.

The enterprising monks also produced excellent wine on their steep hillsides, shipping the output all over Europe on their own merchant ship, which flew the monastery banner. Vineyards still grow around Pyrgos and nearby **Megalochori ★**, about a 5-minute drive southwest from Pyrgos (and 7km/4 miles south of Fira). Megalochori is the quietest village on the island and also one of the prettiest, nestled well off the caldera rim. Many of the white houses crowded around the town square at one time housed caves where residents processed and stored their wines. Their vintages, and those of Santorini's other *canavas* (wineries), rank among the top Greek wines (see box, p. 226.) Several small shops offer tastings, usually for a small fee, or you can sample local wines in one of the tavernas on the main square, overlooked by blue domes and white clock towers.

Excursion from Santorini

A fleet of excursion boats leave from Armeni, below Ia, and cross to **Nea Kaimeni** (New Burnt Isle), one of the cones of the volcano that still smolders in the caldera, often stopping for a swim in the hot springs that bubble up off **Palea Kaimeni** (Old Burnt Isle). Boats then continue to the quiet island of **Therasia,** a fragment of the rim across the caldera from Santorini, for lunch. Excursions usually cost about 20€ and can be arranged with any of the legion of tour operators on the island.

Beaches on Santorini

Santorini's beaches may not be the best in the Cyclades, but a cluster at the south end of the island, away from the high rim of the caldera, have the distinction of being carpeted with black and red volcanic sand. On the southeast coast, **Kamari ★★** and **Perissa ★★**, both with black sand, are crowded and backed by hotels and tavernas. **Perivolos** is an extension of Perissa. Hikers can enjoy both Kamari and Perissa with a trek up and over the Mésa Vounó headland that divides the two. The ruins of Ancient Thera (p. 223) top the heights, some 400m (1,320 ft.) above sea level. Head uphill on well-marked paths from either beach, following signs to Ancient Thera, passing

A small museum at the Koutsoyannopoulos winery (see box, p. 226) explores traditional techniques used years ago by Santorini's winemakers.

227

the Panaghia church above Perissa and the Zoodochos Pigi above Kamari; the hike is about 3km (2 miles) but allow a couple of hours for the steep ascent and descent and don't attempt it in the heat of the day. **Volcano Diving Center** (www.scubagreece.com; *©* **22860/33177**) at Kamari offers guided snorkel swims for around 25€ and scuba lessons for around 60€. The **Santorini Dive Center,** at Perissa, also has scuba and snorkel facilities and instruction (www.divecenter.gr; *©* **22860/83190**).

Southwest, at the end of the road to Ancient Akrotiri, Red Beach (Paralia Kokkini) is usually a bit less crowded than other beaches on the island.

Santorini Shopping

Santorini is an island of jewelers. The most renowned shop, with lovely reproductions of ancient baubles, is **Kostas Antoniou** (antoniousantorini.com; *©* **22860/22-633**), on Ayiou Ioannou, north of the cable car station in Fira. The **Bead Shop** (*©* **22860/25-176**), by the Museum of Prehistoric Thera, sells beads, of course, most carved from island lava.

Replica Hellenic Art and Culture (*©* **22860/71916**), on the main street in Ia, sells contemporary statuary and pottery as well as museum replicas. Down the street, the English-language bookshop **Atlantis** (www.atlantisbooks.org; *©* **22860/72346**) is a haven for visitors hungry for a good read.

Santorini Nightlife

Santorini's sunsets are legendary, and many visitors traipse to Ia to watch the end-of-day spectacle from there; other viewers enjoy the fiery scene as a backdrop for a cocktail on the terrace of **Franco's** (francosbar.gr; *©* **22860/24428**) or **Palaia Kameni** (www.paliakameni.com; *©* **22860/22430**), caldera-side bars in Fira.

Quieter venues in Fira include the relaxed pool bar at the **Aressana Hotel** (www.aressana.gr; *©* **22860/23900**) and the **Cori Rigas Art Café** (coririgas artcafe.com; *©* **22860/25251**), just off the caldera path below the Museum of Prehistoric Thera. **Kira Thira,** just south of the Archaeological Museum on Ipapantis (*©* **690/909-7271**) is a serious adult jazz bar with live music some nights and muted, conversation-inducing selections on others.

In Ia, **Restaurant-Bar 1800** (www.oia-1800.com; *©* **22860/71485**) and **Hassapiko** (www.hassapiko.gr; *©* **22860/71244**), in a former butcher shop, keep the evening going with a lively bar scene well into the night.

As the evening wears on, the string of ever-changing discos on the seaside in **Kamari,** on the island's southeast coast, heat up. **Open Air Cinema Kamari** (santorinicinema.com; *©* **22860/33452**) just off the beach, has summertime nightly showings, accompanied by cocktails, at 9:30pm.

FOLEGANDROS ★★★

64km (38½ miles) NW of Santorini

Little Folegandros, a volcanic outcropping only 33km (12 sq. miles) in total area, is home to fewer than 800 permanent residents, but it has everything

travelers would want to discover on their perfect Cycladic island: dramatic scenery, some very nice beaches, and what might be the most beautiful town in all the Greek islands. The island has few sights, little in the way of luxury, and none of the glamour of Santorini or Mykonos—all of which adds to its appeal as an island getaway that, while not undiscovered, is still unspoiled.

Essentials

ARRIVING Boat service to and from the island changes frequently and is often sporadic. Check schedules carefully when making hotel reservations or you may find yourself with a room and no way to get to it. In summer, a boat or two usually arrive daily from Piraeus; service is severely curtailed in winter. Summer service also usually includes at least two boats a day to and from Santorini, and it's also usually possible to make connections to and from other Cycladic islands through the island of Syros. For up-to-date schedules, go to www.gtp.gr or www.ferryhopper.com. Travel agencies on the island list daily schedules. Boats arrive in Karavostasis, 3km (2 miles) below Hora, the main town, and well connected by bus. Most hotels offer port pickup and drop-off.

VISITOR INFORMATION Hotels and cafes on the island usually post bus and boat schedules and notices of local events. A good source on the island for accommodation, boat tickets, car and motorbike rentals, and excursions is **Folegandros Travel** (folegandros-travel.gr; ✆ **22860/41273**), with offices in the port of Karavostasis and in Hora. You can find a lot of information online at folegandrosinfo.gr.

GETTING AROUND The island's main paved road runs from Karavostasis at one end of the island through Hora and Ano Meria to Agios Georgios at the other end. Bus transport is excellent, with service operating out of a station at the edge of Hora. Drivers sell tickets. Stops along these routes allow you to get just about anywhere on the island, though you may need a hike to reach some of the remote beaches. Boat service from Karavostasis also serves many beaches. **Diaplous Travel** (www.diaploustravel.gr; ✆ **22860/41158**) in Hora operates daily boat tours that circle the island with stops at five beaches, about 25€. A car is not really necessary on the island, unless you want to have one for a day to explore Agios Georgios beach and some other far-flung spots, most reached on unpaved roads.

Where to Stay & Eat on Folegandros

The island specialty is *matsata:* fresh, eggless pasta with tomato sauce and rabbit, lamb, or goat (also sometimes with chicken and pork, as a concession to international visitors). The restaurants that crowd the Hora squares are all quite good, though many have departed from traditional island cuisine to cater to visitors with Mediterranean menus. One place in Hora that sticks to Greek tradition is the very popular **Souvlaki Club** (✆ **22860/41002**), with gyros and fast-food grill favorites. Many islanders take advantage of the summer influx of travelers and rent rooms in their houses—check listings at www.folegandros.gr.

Aegeo Hotel ★★★ This handsome cluster of white houses with blue trim is on a hillside just outside Hora, with a nice outlook over the town to the

The hilltop main town of tiny Folegandros still feels much like a mountain village, with social life centered around three tree-shaded main squares.

church of Kimisis tis Theotokou. Small and attractively furnished rooms, and a few larger suites, all have terraces and share a shady, nicely outfitted courtyard and a welcoming lobby lounge.

Hora. www.aegeohotel.com. ✆ **22860/41468.** 11 units. 55€–105€ double. Breakfast 8€–12€. **Amenities:** Bar; lounge; terrace; free Wi-Fi. Closed Oct–Apr.

Irini's ★★★ GREEK This little grocery store with 10 tables crowded next to the shelves is widely acclaimed, but fame doesn't affect the homey atmosphere or the quality of the dishes that emerge from the tiny kitchen. *Matsata* is the house dish, here often topped with meatballs, but moussaka and other classics are usually on offer, too, accompanied by tomato fritters, huge salads, and other dishes made with fresh-from-the-garden produce.

Ano Meria. ✆ **22860/41436.** Entrees 8€–10€. Daily noon–midnight (shorter hours in winter).

Polikandia Hotel ★★ Nicely located amid village life right at the edge of Hora's old center, one of the island's smarter lodgings is a cluster of whitewashed houses surrounding a pool and flower-filled terraces. Fairly basic but homey rooms have wood and stone accents in keeping with traditional island architecture, along with balconies and terraces.

Hora. www.polikandia-folegandros.gr. ✆ **22860/41322.** 25 units. 110€–195€ double. Breakfast 10€. **Amenities:** Cafe; bar; room service; pool; roof terrace; port pickup and drop-off; free Wi-Fi. Closed Oct–Apr.

To Spitiko ★★ GREEK This is the place to try the island *matsata,* not only because the local favorite is especially good here, but also because it's served beneath a canopy of trees on a breezy lane just off the sea cliff edge of town. An especially stiff breeze will send diners into a plain dining room next to the kitchen, which also makes such island vegetarian classics as chickpea stew and caper salad. (The restaurant's name, shared with many other restaurants in Greece, means "homemade.") The adjacent **Artos kai Gefsi** bakery is a good stop for dessert or stocking up for breakfast.

Hora. ✆ **22860/41235.** Entrees 7€–14€. Daily noon–midnight (shorter hours in winter).

Exploring Folegandros

From **Karovostasis,** an undistin-
guished string of houses clustered
above the harbor, the road climbs 3km
(2 miles) up to **Hora ★★★,** the
island's capital and only sizeable set-
tlement. Like many Cycladic towns, it
was built on inland heights to elude
pirates, but unlike similarly beautiful
towns on Santorini and Mykonos,
Hora remains practically untouched,
still a sparkling white traditional settle-
ment. Streets made of green and blue
paving slates outlined in brilliant white
lead in and out of three interlocked
squares, lively gathering spots filled

The Church of Kimisis tis Theotokou lies even
further uphill from Hora, reachable only by a
switchbacking path.

with little chapels, shops, and cafe tables beneath the spreading branches of
century-old lime trees. Exterior staircases of white flat-roofed houses lead to
balconies bedecked with geraniums and bougainvillea. Many of these houses
huddle against and inside the walls of the **Kastro,** the castle the Venetians built
when they took control of the island in the 13th century; others teeter on the
edge of cliffs some 250m (820 ft.) above the sea, rivaling the cliff-top spec-
tacles of Santorini. The **Church of Kimisis tis Theotokou** (Mother of God)
commands a barren hilltop high above the town, reached by a switchback,
zigzag path. If you find the climb strenuous, you'll be put to shame when you
come upon a bridal party making the way up in full regalia, high heels and all.

Outside of town, hills are laced with stone walls enclosing terraced fields that
allow farmers to grow barley on steep slopes. These steep barren hills explain
the origin of the island's name, from an archaic word for "rock-strewn."
They're crisscrossed by an elaborate network of foot and donkey paths, some
paved with ancient marble blocks, others hacked from the natural bedrock.

West from Hora, along the spine of the mountainous interior, is **Ano Meria,**
a hamlet of scattered farms that's the island's second-largest village. One of the
farmsteads is now the small **Ecological and Folklore Museum,** where an old
house, outbuildings, and a vineyard and orchard show off household items,
tools, and a lifestyle that's been handed down for generations—all the more
fascinating because, old-fashioned costumes aside, the collection reflects life as
it still is today in the surrounding village. The museum (no phone; free admis-
sion, but donation appreciated) is usually open 5 to 8pm weeknights in July and
August; the bus from Hora drops you a pleasant stroll away. Hours change fre-
quently, so check with your hotel or any travel agency when you get to the island.

Folegandros Beaches

Far below the cliffs that encircle most of the island are rocky coves sheltering
pebble beaches. Some are accessible by bus from Hora, others require a boat

ride or a combination bus ride and hike. On either side of the port of Karavostasi are **Vardia** and **Livadi,** both reached by short walks. Livadi is backed by a campground and has toilet facilities and a food concession. A more pristine beach is **Katergo,** at the island's southern tip, reached by hourly boat service from Karavostasi harbor (5€ round-trip, including a side trip into a large sea cave en route). Buses from Hora run almost hourly to the pleasant but sometimes crowded beach at **Agali;** from there a path follows the coast west to a quiet cove at **Galifos,** then to **Agios Nikolaos.** Beachgoers also arrive at Agios Nikolaos by boat, often to have lunch at one of two tavernas: **Papalagi,** with its hilltop terrace, and **Agios Nikolaos Taverna,** serving grilled fish on a shady terrace right on the sand.

Ano Meria is the starting point for walks along old donkey paths to several beaches. One leads southwest down the hills toward **Agios Nikolaos**—from where you can make the easy walk back to **Agali** and from there get the bus to Hora. Another path from Ano Meria leads north across the island to **Agios Georgios,** with nice pools wedged into the rock formations at one end and some welcome patches of shade; the walk is an invigorating 45-minute scramble each way down and up the hillsides on rough stones, so bring water and wear sturdy shoes.

MILOS ★★

180km (108 miles) SE of Piraeus

Small and rugged, the westernmost island of the Cyclades is best known for what's no longer here—the most famous statue to come down to us from ancient Greece, the Venus de Milo, now in the Louvre. What is left, much to the delight of travelers, are some of Greece's most spectacular beaches, many carved out of volcanic rock formations, along with a clutch of appealing villages and some impressive ancient ruins. Aside from these attractions, the island is also famous for mineral extraction, as it has been since antiquity; large tracts are off-limits and given over to open-pit and strip mine operations.

Essentials

ARRIVING Anek **ferries** connect Milos with Piraeus and Heraklion Crete, and the island is also well connected to many of the other Cyclades, including Folegrandros, Santorini, Serifos, and Sifnos. Boats arrive in Adamas (officially Adamantas), the island's capital. For lines and schedules, go to www.ferryhopper.com or www.gtp.gr. The small island airport is served by two **flights** a day to and from Athens operated by Olympic Airlines. Fairly frequent bus service connects the airport with Adamas.

VISITOR INFORMATION A small **tourist office** (© **22870/22182**) across from the port is open daily in summer, from 8am to 3pm and 6 to 10pm, and in winter Monday through Friday, 9am to 5pm. The office can supply a map, as can any of the travel agencies along the waterfront. For information on the island, including accommodation, car rental, and other practical matters, go to www.milosgreece.gr. Many agencies offer all-day boat tours, with prices ranging from 45€ (on a 60-passenger boat) to 120€ (for a small-group cruise),

often including snacks, lunch, and drinks. Many of these trips skirt the south coast, with several stops at remote beaches along the way.

GETTING AROUND **Buses** operate out of a station near the waterfront with hourly service throughout the day between Adamas and Plaka and Tripti; they run slightly less frequently between Adamas and Pollonia and some of the beaches; go to milosbuses.com for timetables. Fare is 1.80€ per trip, payable on the bus. Many agencies along the waterfront rent cars from about 50€ a day and scooters from about 30€. Arm yourself with a detailed map, since many roads on the island are small dirt tracks; check with the rental agency about any limitations on where you're allowed to drive—you won't be covered for damages if you venture down some roads. You can get by without a car fairly easily by coordinating sightseeing and beachgoing with bus schedules.

Where to Stay on Milos

Melian Hotel ★★★ Waves lap against the terrace of this villalike hotel in the Pelekouda district at the edge of Pollonia. The large rooms and suites are distinctively decorated with hand-crafted pieces and well-curated art; amenities include outdoor hot tubs in some suites. All have sitting areas and large terraces furnished with rattan couches and easy chairs, and are equipped with luxurious bathrooms with large, walk-in showers. The beach is just a few steps away.

Pollonia. www.melian.gr. © **22870/41150.** 15 units. 190€–400€ double. **Amenities:** Cafe; bar; hot tub; spa; free Wi-Fi. Closed Oct–Apr.

Olea Milos Bay ★ Set amid soothing Mediterranean plantings, these pleasant rooms and suites have rough-hewn white walls, tile floors, and plain built-in Cycladic-style furnishings that give off a relaxed island vibe, all the more so with the blue sea glimmering beyond the balconies and terraces. Papikinou Beach is just across the road, and the center of Adamas is an easy walk away, less than a mile along the waterfront.

Adamas. www.oleahotel.gr. © **22870/31003.** 13 units. 210€–290€ double. **Amenities:** Bar/cafe; free Wi-Fi.

With its traditional Cycladic architecture, the village of Plaka overlooks the Gulf of Milos, just above the port town of Adamas.

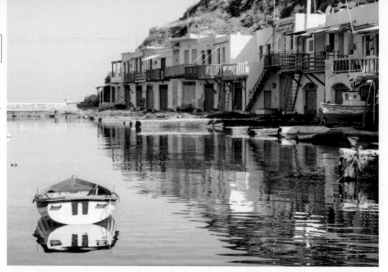

The charming village of Klima cups around a small cove on the gulf just northwest of Adamas.

Villa Notos ★★　These large, attractive, and extremely comfortable rooms and apartments at the edge of Adamas look over the water and Lagada beach. All have sitting areas and are equipped with small kitchens, and most open to large terraces. There's no restaurant and bar, and breakfast is not served, but the center of town is just a short walk away along the waterfront.

Adamas. www.villanotos.gr. ⓒ **6934/536002.** 6 units. 120€–250€. **Amenities:** Free Wi-Fi. Closed Nov–Apr.

Where to Eat on Milos

Diporto ★ GREEK　This old taverna with tables spilling into the lanes of Plaka sticks to the old-fashioned basics: snails in tomato sauce, a hearty goat stew, and other traditional island dishes. Begin any meal with a platter of the house appetizers—the zucchini balls with cheese and the fried cheese pies are not to be missed.

Plaka. ⓒ **22870/23259.** Main courses 8€–12€. Daily noon–11:30pm.

Elia Meat Point ★★ STEAKHOUSE/GREEK　Though Milos is a very long way from cattle country, the island's only steakhouse does an admirable job with steaks, chops, and ribs, and serves the best hamburger for miles around. Seafood is not an option here, though the sea laps right against the waterside terrace, but vegetarians can make a meal of dips, saganaki wrapped in phyllo, and salads, including an excellent horiatiki topped with Xinomitzihra, the island's creamy goat cheese. Service is friendly and efficient.

Adamas. ⓒ **695/195-7511.** Main courses 15€–25€. Daily 5:30pm–midnight.

Enalion ★★★ GREEK/SEAFOOD　At this attractive seaside terrace in Pollonia, garden-fresh vegetables grown on the family plot just outside of town are the star of the show. They find their way into a big array of salads and appetizers, accompanied by locally crafted cheeses, and accompany the

other specialty, fish and seafood plucked right from boats docked nearby, which is served grilled or cooked in savory fish stews.

Pollonia. enalion-milos.gr. ✆ **22870/41415.** Main courses 9€–20€. Daily 1–11:30pm. Closed mid-Oct to Apr.

O! Hamos! ★★★ GREEK The Psatha family has introduced farm-to-table dining to Milos. Everything they serve in their homey courtyard—meat, cheeses, vegetables—comes from their own farm, and even the herbs they use in their slow-cooked stews are grown in pots surrounding the tables. School exercise books that act as menus are filled with *katsikaki* (young goat) baked in parchment with molasses, *hanoumaki* (slow-roasted pork and eggplant), thick chickpea stews, and other signature dishes, served on handspun crockery and mopped up with home-baked bread. Expect a long wait in July and August.

Adamas (southeast waterfront). www.ohamos-milos.gr. ✆ **2287021672.** Main courses 9€–20€. Daily 1–11:45pm.

Exploring Adamas ★

Officially known as Adamantas (diamond in Greek), the island's main port and largest town sits on the northeast shore of the Gulf of Milos, a wide natural harbor that takes a big bite out of the center of the island. The gulf is actually the caldera of an ancient volcano, and sailing into Adamas you may well be reminded of the approach to Santorini, minus the dramatic cliffs. Life in Adamas centers on the waterfront promenade, lined with cafes and shops.

The Milos Mining Museum ★ MUSEUM As long as 13,000 years ago, miners on Milos were unearthing obsidian—hard, black volcanic glass—to be used as arrowheads and razor-sharp blades throughout the Mediterranean world. Milos also supplied ancient Greeks with a substance derived from silicates, similar to what is now known as fuller's earth, which was a household staple used for bleaching textiles, facial masks, and medicinal baths. Displays show off the many minerals still unearthed on the island and their uses, while some fascinating documentary footage records islanders talking about their work in the mines.

Adamas, south of harbor. www.milosminingm. ✆ **22870/22481.** Admission 5€. June–Aug Tues–Sun 10am–2pm and 6–9pm (until 10pm Aug); Apr–May and Oct Tues–Sun 10am–2pm.

Exploring the Plaka Peninsula ★★★

The attractive white cubical houses of **Plaka** cling to a hillside above Adamas and overlook the northern tip of the island. At the highest point, atop a conical hill, are the remains of a 13th-century *kastro* (castle), built by Frankish dukes from Naxos who established a stronghold here, with houses and churches crowded within its walls for protection. A walk up to the ruins affords wide-ranging views across the island and, on a clear day, all the way to Crete to the south and the Peloponnese to the west.

The road descends from Plaka to **Trypiti** (it's an easy downhill walk if it's not too hot), where a **Roman theater,** with 7 rows of marble seats, is carved into a hillside (always open, no fee); nearby are the scant remains of the

ancient city. Also carved into a hillside, and connected to the theater by a dirt road and steps, are Greece's only **Christian catacombs** (Wed–Mon 9am–6:45pm; admission 4€), a vast network of underground passages that burrow some 185m (607 ft.) into the soft earth. Some 2,000 early Christians were entombed in the tunnels in the 3rd and 4th centuries A.D. Visitors walk through the damp claustrophobia-inducing tunnels past hundreds of burial vaults into a large cavern once used for clandestine worship.

Klima, the port of ancient Milos, is a short drive or a 3km (2-mile) downhill stroll from the catacombs. Almost nothing remains of the distant past, but the little collection of seaside houses is charming. Klima and other towns at this end of the island—**Mandarakia, Firopotamos, Areti,** and **Fourkouvoni**—are built around protective coves in a style unique to Milos. Whitewashed houses are dug out of the hillsides, with waterside boathouses on the ground floors and living quarters above; doors, shutters, and balconies are painted in bright shades of red, blue, and green that add even more luster to the bright seas that wash against them. Bus service does not extend to Klima, so if you do not have a car you'll have to walk back up to Trypiti.

Archaeological Museum of Plaka ★★ MUSEUM In an old school building designed by Ernest Ziller, the 19th-century architect of some of Athens's grandest public buildings, this museum is filled with finds from Ancient Milos. Obsidian tools are displayed alongside terracotta vessels traders used to transport these and other mineral exports around the Aegean. Especially intriguing are the hollow animal figurines into which liquid offerings to the gods could be poured; they're from ancient Phylakopi, on the northeast coast (see below), as is a figurine of a woman known as the Lady of Phylakopi. A plaster cast pays homage to the Aphrodite statue now known as the Venus de Milo, which a farmer discovered near the theater in 1820. An officer from a French ship in port at the time bought the statue and, overcoming some resistance from Ottoman authorities, carried it off to Paris.

Plaka. odysseus.culture.gr. ✆ **22870/28026.** Admission 3€. Mon and Wed–Thurs 8:30am–3:30pm, Fri 2–10pm, Sat–Sun 9am–10pm (shorter hours in winter).

Pollonia & the Northeast Coast ★★

A dramatic volcanic seascape lies at the foot of the cliffs at **Papafraga,** 9km (5½ miles) northeast of Adamas, where winds have shaped the white volcanic rock along the shore into strange formations. It's said that pirates used to stash their bounty in the caves that notch the shoreline. You can cross the folds and crevices and descend to a deep fjord, where a little farther along you'll find the haunting remains of **Phylakopi,** a city founded about 3500 B.C.; it was last inhabited around 1600 B.C., when refugees fleeing Santorini's volcanic eruption may have sought shelter on Milos. The elements have worn away all but the faint remains of a large palace and a shrine. The site is open daily from 8am to 3pm (from 8:30am in winter); admission is 2€.

An appealing fishing village at the northeastern tip of the island, **Pollonia,** 11km (7 miles) from Adamas, has become a popular low-key resort, with

cafes and restaurants lining the harbor and a well-shaded beach. An ever-expanding row of attractive hotels face the seaside in the Pelekouda district west of town.

Those in search of more unspoiled surroundings can board a boat from Pollonia to **Kimolos,** a little island where donkeys roam the streets of scrappy little Hora, a jumble of white-washed Cycladic houses. Aliki and Klina are among the excellent beaches on Kimolos. Car ferries make the 30-minute crossing about four times a day.

The smooth white rocks of Sarakaniko, while not strictly speaking a beach, are a memorable spot for swimming and snorkeling.

The South & Far West ★★

Some of Milos's best sandy beaches are on the south coast (see below), many accessible only by dirt track. The farther west you go, the wilder the landscape becomes. The scrub-covered terrain rises along the flanks of **Mount Profitis Elias** and drops to the sea at **Triades** and other remote outposts. Much of the southwest is protected as a nature preserve, the domain of monk seals and other endangered species. Should you decide to trek across this lonely countryside, be on the lookout for one of them, the Milos viper.

Beaches on Milos

Sandy **Lagada** beach, at the northwest end of the harbor in Adamas, is fine for a quick dip, with plenty of shade, and **Papakinou,** on the other side of the harbor, is also sandy and shady. You'll want to venture farther out of town to some of the island's extraordinary stretches of sand. Many are accessible by bus from Adamas, though check schedules carefully so you don't miss the last trip back to town. In **Mantrakia** and **Firopotamas,** on the peninsula north of Adamas (no direct route or bus service), you can swim in beautiful water next to colorful houses that descend right into the water. There is frequent bus service to **Sarakaniko,** 5km (3 miles) north of Adamas, an otherworldly landscape of smooth white rocks surrounding an inlet and little coves; adding to the allure, and a bonus for snorkelers, is a partially submerged shipwrecked freighter just offshore. Buses also go to **Papafraga,** 9km (5½ miles) northeast of Adamas, another volcanic landscape where you can swim through a long, fjordlike channel into a sea cave that opens to the sea.

On the south coast, **Paleochori, Provitas** and **Tsigrado** are long, sandy beaches, each about 10km (6 miles) from Adamas and accessible by bus and paved road. Beaches beyond them can only be reached easily by excursion boat; the standout is **Kleftiko,** a remarkable seascape of rock formations and sea caves.

THE DODECANESE

7

H ugging the coast of Asia Minor, the Dodecanese islands lie at the crossroads of East and West. Over the ages, these outposts have been conquered and settled time and again—by Romans, medieval knights, Ottomans, Venetians, and early-20th-century Italians—who left behind them marvelous landmarks the ruins of the Askepleion on Kos, a stunning medieval quarter and Italianate art deco palaces in Rhodes, a Byzantine castle on Leros, the transporting Monastery of St. John and Cave of the Apocalypse on Patmos. These days it's the beaches—among the most spectacular in Greece—that draw hordes of invading sun worshippers.

Although the name means the Twelve Islands, the archipelago actually consists of 32 islands, each with its own character. Patmos and Symi are dry and arid in summer, while the interiors of Rhodes and Kos are fertile and forested. Patmos, Symi, and Leros are relatively quiet, relaxed getaways, while Rhodes and Kos are, for better or worse, among Europe's most popular island destinations. Getting around the islands is fairly easy—Rhodes and Kos each have airports, and boats dash from island to island.

RHODES (RODOS) ★★

250km (135 nautical miles) E of Piraeus

Selecting a divine patron was serious business for the ancients. Most Greek cities played it safe and chose a mainstream god or goddess, a ranking Olympian—someone such as Athena or Apollo or Artemis, or Zeus himself. It's revealing that the people of Rhodes wisely chose Helios, the sun, as their signature god.

Helios continues to bestow good fortune on the island. More than 2 millennia later, this island that receives on average more than 300 days of sunshine a year can still attribute its good fortune to sun-starved travelers from colder, darker, wetter lands around the globe, especially northern Europeans. Rhodes is also beautiful, though the modern era has not been gentle with much of the coastal strip. With a selective eye you can still see an island ringed with clean golden beaches, rising across fertile plains to a mountainous interior.

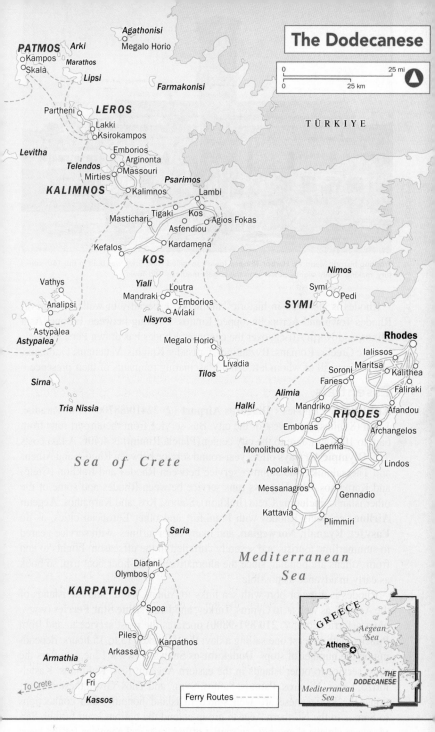

The Dodecanese

0 ——————————————— 25 mi
0 ——————————————— 25 km

PATMOS
Agathonisi
Arki
Megalo Horio
Kampos
Marathos
Skala
Lipsi

Partheni
LEROS
Lakki
Ksirokampos

Farmakonisi

TÜRKIYE

Levitha

Emborios
Telendos
Arginonta
Mirties
Massouri
KALIMNOS
Kalimnos
Psarimos

Lambi
Tigaki
Kos
Mastichari
Agios Fokas
Asfendiou
Kefalos
Kardamena
KOS

Vathys
Yiali
Loutra
Analipsi
Mandraki
Emborios
Astypalea
Avlaki
Astypalea
Nisyros

Nimos
Symi
Pedi
SYMI

Rhodes

Megalo Horio
Ialissos
Maritsa
Soroni
Kalithea
Livadia
Fanes
Faliraki
Tilos

Sirna

Alimia
Mandriko
Afandou
Halki
Embonas
RHODES
Archangelos
Monolithos
Laerma
Lindos
Apolakia
Messanagros
Gennadio
Kattavia
Plimmiri

Sea of Crete

Saria

Mediterranean Sea

Diafani
Olymbos
KARPATHOS
Spoa

Piles
Karpathos
Arkassa
Armathia

Fri
To Crete
Kassos

Ferry Routes - - - - -

GREECE
Aegean Sea
Athens ✪
THE DODECANESE
Mediterranean Sea

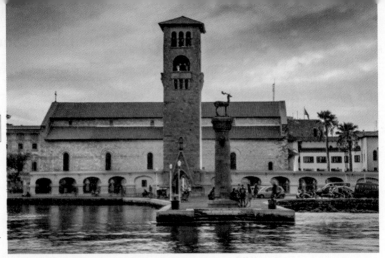

Fronting historic Mandraki Harbor, Rhodes Town's so-called New Town was built in the 16th century, making it only slightly newer than the largely medieval Old Town.

Rhodes is also rich in historic landmarks, especially in walled, medieval Rhodes Town and Acropolis-topped Lindos. Floating between Europe, Asia Minor, and North Africa, over the centuries Rhodes has drawn Persians, Hellenistic Greeks, Romans, Byzantines, Crusader Knights, Venetians, Ottomans, and Italians, all of whom left behind fascinating remnants of their presence.

Essentials

ARRIVING Rhodes's **Diagoras Airport** (✆ **22410/88700**) is in Paradisi, 13km (8 miles) southwest of the city. Bus service from the airport runs from 6am to 10:30pm; fare to the city center (Plateia Rimini) is 4.40€. A taxi costs 22€. **Olympic Airways** offers year-round service between Rhodes and Athens and Thessaloniki, and summer service between Rhodes and Iraklion (Crete) and Karpathos. **Sky Express** runs service between Rhodes and some of the other islands, including Crete (Iraklion), Samos, Kos, and Karpathos. **Aegean Airlines** connects Rhodes with Frankfurt and other European cities, as do **EasyJet, Ryanair, Norwegian,** and many other airlines, with service geared to summertime tourists and severely curtailed in the offseason. Flights to and from Athens are popular, since the alternative is a 13-hour boat trip, so book as early in advance as possible.

Rhodes is a major port with sea links to Athens, Crete, and the islands of the Aegean, as well as to Cyprus, Turkey, and Israel. **Blue Star Ferries** (www. bluestarferries.com; ✆ **210/891-9800**) operates the most service to and from Piraeus, with at least one sailing a day; the trip takes 13 to 15 hours, depending on the number of stops. **Dodekanisos Seaways** (www.12ne.gr) offers the most service to other islands in the eastern Aegean: Kos, Kalimnos, Kastellorizo, Leros, Nissiros, Patmos, Samos, Symi, and Tilos. Given these connections, the Dodecanese are well suited to island hopping, and connections to Samos in the Northern Aegean group extend the options even further. Services are always changing; ask tourist offices or travel agencies for the latest

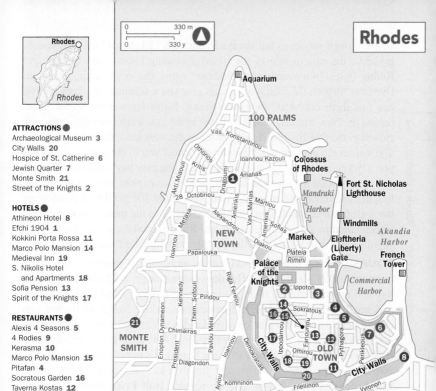

Rhodes

Scale: 0 — 330 m / 0 — 330 y

ATTRACTIONS
Archaeological Museum 3
City Walls 20
Hospice of St. Catherine 6
Jewish Quarter 7
Monte Smith 21
Street of the Knights 2

HOTELS
Athineon Hotel 8
Efchi 1904 1
Kokkini Porta Rossa 11
Marco Polo Mansion 14
Medieval Inn 19
S. Nikolis Hotel and Apartments 18
Sofia Pension 13
Spirit of the Knights 17

RESTAURANTS
Alexis 4 Seasons 5
4 Rodies 9
Kerasma 10
Marco Polo Mansion 15
Pitafan 4
Socratous Garden 16
Taverna Kostas 12

Map labels: Aquarium, 100 PALMS, Colossus of Rhodes, Fort St. Nicholas Lighthouse, Mandraki Harbor, Windmills, Akandia Harbor, NEW TOWN, Market, Eleftheria (Liberty) Gate, French Tower, Plateia Rimini, Palace of the Knights, Commercial Harbor, Ippoton, Sokratous, OLD TOWN, City Walls, MONTE SMITH, Vas. Konstantinou, Ioannou Kazouli, Amalias, 28 Octobriou, Alexandrou, Papalouka, Pindou, Chimairas, Diagondon, Komninon, Filellinon, Vyronon

information or check ferry schedules on-line at the Greek Travel Pages (www. gtp.gr) and Ferry Hopper (www.ferryhopper.com).

VISITOR INFORMATION During the summer high season only, you'll find a helpful **Rhodes Municipal Tourist Office** at Plateia Rimini, facing the port taxi stand (℡ **22410/35-945**), open daily usually 9am to 8pm. A branch at the foot of the Street of the Knights inside the Old Town is open year-round, Monday through Friday from about 7am to 3pm. Offices dispense maps and information on local excursions, buses, ferries, and accommodations. An excellent online resource, with bus schedules and other handy information, is the **Rhodes Travel Guide** (www.rhodestravelguide.gr).

GETTING AROUND Walking is the easiest way of getting around Rhodes Town, and in most of the Old Town it's the only way—you might have to ask your hotel to send someone to meet you at one of the gates and escort you down narrow lanes that are inaccessible to cars. The largest of many **taxi** stands is on the harbor front in Plateia Rimini. Set fares for one-way trips throughout the island are clearly posted. (A sample fare to Lindos is 80€ one-way; add at least another 20€ if the taxi waits for you.)

The island is fairly well served by **bus,** with routes connecting Rhodes Town with many beaches, mountain towns, and Lindos and the other main

sights, though service is not always frequent. **KTEL** buses (www.ktelrodou. gr) serve the eastern side of the island, including Faliraki and Lindos, and **Rodos** buses (www.sindikatodesroda.gr) serve the west, with service to Diagoras Airport; the tourist office can give you a schedule of routes, or you can find them online at www.ando.gr/eng. Buses leave from Averof Street behind the New Market; generally buses to the east leave from the south end, closest to the Old Town walls, and buses to the west leave from the other end. The staff at the manned ticket booths will direct you to the right spot and sell you a ticket; at other stops around the island you may buy a ticket on the bus.

You may want to rent a **car** for a day or two to explore some of the remote beaches and inland villages. Prices begin at about 40€ per day, depending on the season and demand. Keep in mind that some of the more remote roads on Rhodes require all-terrain vehicles, and Rhodian rental-car companies often stipulate that their vehicles be driven only on fully paved roads.

TOURS Several operators lead nature, archaeology, shopping, and beach tours around the island. **Triton Holidays** (tritondmc.gr; ✆ **22410/21690**) offers day and evening cruises, hiking jaunts, and full-day guided tours to Lindos and small villages, churches, and monasteries. Along Mandraki Harbor, you can find excursion boats that leave for Lindos at 9am and return around 6pm, with beach stops for swimming, costing about 40€; these are essentially party boats, so if your goal is simply to enjoy Lindos, it's better to make the trip by bus, taxi, or car. Other day trips take you over to Symi for about 30€ round-trip, with companies that include the reliable **Half Price Tours** (www.half pricetours.gr). The price includes free transfer from your hotel to the port, and tours add a stop on Symi at St. George Bay or at the monastery of Taxiarchis Mihailis Panormitis before docking in Yialos for about 3 hours, which gives you plenty of time to explore. Many companies also run day trips for around 35€ to nearby **Turkey,** but they usually only visit Marmaris, which has little to offer beyond a highly touristic bazaar. Half Price Tours offers more satisfy-ing Turkey trips (beginning at 40€), visiting Fethiye, with Lycian tombs dug into the hillside, and nearby Levissi, once home to 10,000 people but rendered a ghost town in 1923 with the Greek-Turkish population exchanges.

Where to Stay in Rhodes Town

The lanes of Old Town are lined with atmospheric places to stay. Many can be reached only on foot; hosts usually arrange to meet guests at the gates and escort them to the hotel. In summer, an electric cart shuttles hotel guests to and from the gates, which is especially handy if you're arriving and departing by ferry; ask your hotel about this complimentary service. While you'll forgo a beachfront, it's hard to imagine more evocative surroundings than this his-tory-soaked enclave. Many new hotels are clustered in New Town, but aside from easy access to the beaches, there's not much to draw you here.

EXPENSIVE
Kokkini Porta Rossa ★★ In this beautifully restored mansion just inside the St. John Gate (aka Porta Rossa), fireplaces, enclosed wooden balconies,

high wooden ceilings, and treasure-filled nooks and crannies are the legacy of a long succession of Turkish and Greek families, whose former quarters still exude the aura of a private home. Tasteful modern design enhances the rough stone walls and old wood and tile floors, while modern bathrooms are large and sumptuous. A beautiful garden lies just beyond gracious guest lounges, and service is attentive and polished.

Kokkini Porta. www.kokkiniporta.com. © **22410/75114.** 5 units. 375€–520€ double. Rates include breakfast. 2-night min. stay. **Amenities:** Bar; garden; room service; free Wi-Fi.

Spirit of the Knights ★★
Five luxurious suites and a cozily medieval chamber are tucked away in a beautifully restored Ottoman house in the quietest part of the Old Town. Hand-painted ceilings, original beams, Ottoman stained glass, marble baths, rich carpets and textiles, and other exquisite details embellish the meticulously maintained surroundings. A courtyard is cooled by a fountain where you're quite welcome to soak your cobble-weary feet. The family members who lovingly created this intimate retreat are devoted to making their guests feel welcome. Rates vary a lot with season and availability and can be a very good value.

14 Alexandridou. www.spiritoftheknights.com. © **22410/39765.** 6 units. 140€–240€ double. Rates include breakfast. **Amenities:** Bar; garden; Jacuzzi; room service; free Wi-Fi.

MODERATE

Athineon Hotel ★★ Resortlike amenities come with convenience at these modern suites surrounding a swimming pool just outside the Old Town gates. Spacious, plain-but-comfortable quarters all have kitchens, one or two bedrooms, and large balconies, some with sea views and others overlooking the circuit of greenery around the city walls. An open-air bar and lounges adjoin an appealing pool terrace. Space, good value longer-stay rates, excellent service, and the child-friendly pool are a big draw for families, and with the

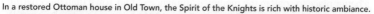

In a restored Ottoman house in Old Town, the Spirit of the Knights is rich with historic ambiance.

modern port just around the corner, this is also a good choice for island-hoppers who want to indulge in some modest luxury.

Vironos 17. athineon.rhodesislandhotels.com. ⓒ **22410/26112.** 70 units. 80€–200€ double. Rates include breakfast. Free parking. **Amenities:** Restaurant; bar; pool; sauna; gym; free Wi-Fi.

Efchi 1904 ★★ No need to sacrifice charm for a close-to-the-beach location in the New Town—these character-filled suites in a lovingly restored historic home on a little lane are the epitome of old-fashioned Greek hospitality. Oversized, wood-floored and beamed quarters are done in light colors and traditional Rhodian style, with built-in divans that provide extra sleeping space and waist-high curtained beds reached by a few steps. A sun-filled walled courtyard doubles as a lounge and breakfast room in good weather.

Marias Konstantaki 11. Rhodes Town. efchi1904.gr. ⓒ **6945/399911.** 5 units. 90€–165€ double. **Amenities:** Courtyard/lounge; free Wi-Fi.

Marco Polo Mansion ★★★ A 15th-century Ottoman mansion set in a lush garden is now a positively transcending hotel. Each room is distinctive—one was a harem, another a *hamam,* another is lined with kilims; smaller garden rooms are nestled amid fragrant greenery. All are decorated in deep hues that look like they've been squeezed from a tube, and furnished with low-lying couches and stunning antiques—little wonder style and fashion magazines love to photograph this exotically beautiful place overseen by hosts Spiros and Efi, who welcome their guests as family friends. Breakfast and dinner are served in the garden, where non-guests can share in one of the best dining experiences in the Dodecanese.

Aghiou Fanouriou 40–42. www.marcopolomansion.gr. ⓒ **22410/25562.** 17 units. 80€–140€ double. Rates include breakfast. **Amenities:** Restaurant; bar; garden; free Wi-Fi. Closed Nov–Apr.

S. Nikolis Historic Boutique Hotel ★★★ You'd be hard-pressed to find a better place to soak in the medieval ambiance of Old Town than this charming and atmospheric cluster of houses from 1300 that surround a flower-filled courtyard. Proprietors Sotiris Nikolis and his family have lovingly restored the original structures down to the last stone and beam, unearthing such treasures as a 2nd-century marble pediment lodged beneath the medieval foundations. They've filled rooms with antiques and personal flair, and embellished some with sleeping lofts, kitchenettes, balconies, and Jacuzzis. A roof terrace overlooks the Old Town, and a pleasant bar is tucked into the rear of the garden.

61 Ippodamou. www.s-nikolis.gr. ⓒ **22410/34561.** 16 units. 120€–160€ double. Rates include breakfast. **Amenities:** Restaurant (rooftop); bar; garden; free Wi-Fi. Closed sometimes for short periods Nov–Mar.

INEXPENSIVE

Medieval Inn ★★ No medieval gloom and doom in this whitewashed old house surrounding a shady courtyard, full of bright colors and enhanced with the warmth of hosts Manis and Lily. Rooms are small and fairly basic, and in some the bathrooms are private but not en suite. They're an excellent value

Rooms at the Medieval Inn are simple but cheerful.

given the comfort and ambiance, and they share the courtyard and sunny roof terrace. The sights of Old Town are just beyond the front gate.

8 Timachida St. www.medievalinn.com. ☏ **22410/22469.** 12 units. 50€–115€ double. Rates include breakfast. **Amenities:** Bar; garden; free Wi-Fi. Closed Nov–Mar.

Sofia Pension ★★ At this old-fashioned family home on a back lane in Old Town, a flowery garden, sunny roof terrace, and a warm welcome from the multigenerational hosts compensate for a lack of frills and any hint of designer luxury. The quirky guest quarters, some with mantels, brick walls, and other architectural elements, seem like rooms in a relative's home, with old bedsteads and mismatched bureaus and other family pieces. All have fridges and updated bathrooms, and an excellent breakfast is served in the garden.

Aristofanous 27. www.sofia-pension.gr. 9 units. ☏ **22410/36181.** 55€–80€ double. Breakfast 7€. **Amenities:** Refrigerators; garden; free Wi-Fi. Closed briefly in winter.

Where to Stay in Lindos

Melenos Lindos Hotel ★★★ This authentically Lindian-style villa is a work of art, where hand-painted tiles, local antiques, handcrafted lamps, and weavings provide the backdrop for an almost otherworldly experience on a pine-scented hillside at the edge of the Old Town. Huge beds are multilevel affairs that make anyone feel like a reclining pasha, while all rooms open to large, nicely furnished terraces embellished with statuary and architectural fragments, plus views out to the sea that washes against the shores of an adjacent cove. This distinctive retreat is the work of Michalis Melenos, who is on hand to ensure his guests are well-cared for. His hospitality also includes excellent Mediterranean-influenced dinners served on a roof terrace. He'll send a staff member to meet you at the entrance to town and escort you to his gate.

Lindos Town. www.melenoslindos.com. ☏ **22440/32222.** 12 units. 250€–350€ double. Rates include breakfast. **Amenities:** Restaurant; bar; room service; free Wi-Fi.

Where to Eat in Rhodes Town

Testimony to the island's Italian heritage, the popular **Gelato Artigianale Italiano,** Averof 6 (www.gelatoartigianaleitaliano.com; ℂ **22410/38108**), offers two dozen or so flavors; the shop is open daily from 11am to 1am.

EXPENSIVE

Alexis 4 Seasons ★★ GREEK/SEAFOOD The Karapanos family is a Rhodes legend, famed beyond the island for the seafood creations they've served at Alexis Taverna for more than 75 years. Now a younger generation continues the tradition, offering a slightly less formal, less expensive, but no less memorable experience in a multilevel rose-and-bougainvillea-scented garden, with a stone-walled parlor for colder weather. The emphasis here is still on seafood, from flavorful shrimp risotto to sea bass and other fish plucked from local seas and chargrilled to perfection. Salads and vegetables come from the restaurant's own garden. Any meal should end over an after-dinner drink on the roof terrace, with harbor lights and a canopy of stars adding to the enchantment.

33 Aristoltelous. www.alexis4seasons.com. ℂ **22410/70522.** Main courses 14€–22€. Mon–Sat 1–11:30pm, Sun 6–11:30pm. Closed late Oct to Mar.

MODERATE

4 Rodies ★★★ GREEK In a residential neighborhood just outside the city walls, a neoclassic house set in a pretty garden shaded by namesake *rodies* (pomegranate trees) specializes in *mezes,* small dishes that here are many notches above the standards you may have eaten in other tavernas. Broad beans paired with chorizo, warm feta dressed with honey and sesame, chicken legs stuffed with olives—you can select from a several innovative takes on Greek/Mediterranean staples, or let the chef select three, four, or five dishes to show off the kitchen's flair. A complimentary sweet and liqueur usually follow a meal.

Kanada 29. www.facebook.com/4rodies. ℂ **2241/130214.** Small plates from 5€. Wed–Sat 1:30pm–midnight, Sun 1pm–midnight.

Kerasma ★★ MODERN GREEK Reason enough to venture into the New Town is a meal at this popular spot on a street of good restaurants. Its innovative creations bring together the best flavors of Greek cuisine, served in stylishly contemporary surroundings. Octopus is served in a sauce of vinegar and honey, while salmon is marinated in raki, the potent liquor made in many households. Reservations are highly recommended.

George Leontos 4-6. ℂ **2241/302410.** Main courses 10€–25€. Thurs–Tues 1:30–11:30pm, Wed 5:30–11:30pm.

Marco Polo Mansion ★★★ GREEK Hosts Efi and Spiros encourage their guests, most of whom have dined here many, many times, to settle back and enjoy a meal beneath banana trees and hibiscus trellises in the garden of a 16th-century Ottoman official's home. To augment the excellent menu the kitchen comes up with a few special dishes each evening—grilled lamb,

roasted pork fillet, a bounty of seafood—made with the freshest ingredients and accompanied by excellent mezes and salads. Reservations are essential for much of the summer.

Aghiou Fanouriou 40–42. www.marcopolomansion.gr. ✆ **22410/25562.** Main courses 10€–18€. Daily 7:30–11:30pm. Closed Nov–Apr.

INEXPENSIVE

Pitafan ★ GREEK/FAST FOOD From the grill and spit at this busy corner with outdoor tables near the Jewish Quarter come delicious gyros and souvlaki, served with cold draft beer. These fast-food standards taste all the better when the surroundings are atmospheric Turkish houses with wooden balconies and a splashing seahorse fountain.

Ermou 60. ✆ **22410/73670.** About 5€. Daily 11am–10pm.

Socratous Garden ★★ GREEK/MEDITERRANEAN Step out of the fray of the touristic center of Old Town into this genuinely transporting hideaway shaded by luxuriant foliage and cooled by gurgling fountains. Don't expect fine dining, but snacks, light meals, coffee, cocktails, and some traditional Greek dishes are served from early morning into the late hours, making this is a good spot to take a breather while making the sightseeing rounds, or to enjoy a drink before or after dinner.

Sokratous 124. ✆ **22410/76955.** Main courses 7€–12€. Thurs–Tues 9am–11pm, Wed 24 hr.

Taverna Kostas ★★ GREEK This long-standing Old Town favorite stands the test of time, with grandfather Kostos in attendance over a friendly and attentive wait staff. In a handsome dining room and bright, lively conservatory they serve taverna favorites, with well-executed mezes and excellent grills, along with fresh seafood dishes.

Pithagora 62. ✆ **22410/26217.** Main courses 7€–16€. Daily noon–midnight.

Where to Eat Around the Island

Manos Mastrosavvas Traditional Café Restaurant ★★ GREEK The little town of Sianna, on the slopes of Mount Akramitis, is famous for honey fragrant with rosemary, thyme, and other wild mountain herbs and also for *souma,* a potent alcoholic beverage made from the grapes of highland wineries. For more than a century the Mastrosavvas family has been offering these local products on their breezy terraces and cozy dining rooms, alongside meals of farm sausages, homegrown vegetables, and their takes on moussaka and other Greek staples—including yogurt with honey that surpasses any version you've ever had before. You can also buy their products to take home with you.

Sianna Village. www.manos-siana.com. ✆ **22460/61209.** Main courses 7€–12€. Daily 9am–11pm.

Mavrikos ★ GREEK/FRENCH For 70 years, this favorite has been a draw for the rich and famous as well as legions of travelers famished after the climb to the Acropolis in Lindos. Brothers Michalis and Dimitri Mavrikos

carry on the family legacy on a rustic, sea-facing terrace off the main square, serving French and Greek dishes: oven-baked lamb, beef in a casserole with bergamot, tuna with fenugreek, and perfectly grilled beef filets or seasoned fresh red snapper. The brothers also run an ice-cream parlor, **Gelo Blu** (© **22440/31560**), serving homemade frozen concoctions and cakes. It's in the Old Town, near the church, and is open daily in season from 9am to 1am.

Lindos Town, main square. © **22440/31232.** Main courses 10€–30€. Daily 9am–11pm.

Stegna Kozas ★★ SEAFOOD Fish can practically jump right out of the sea onto the dining terrace, so it's little wonder that every dish served in this family-run institution on Archangelos beach is famously fresh. And not just the sea creatures—hand-kneaded bread baked in a wood oven, locally harvested sea salt, wild capers, and homegrown vegetables enhance such dishes as lobster spaghetti and shrimp from Symi. The wine list is extensive.

30km (19 miles) S of Rhodes Town and 18km (11 miles) N of Lindos. www.stegnakozas. gr. © **22440/22632.** Main courses 9€–22€. Daily noon–11pm.

Exploring Rhodes Town ★★★

Rhodes Town, a sprawling metropolis that's home to about two-thirds of the island's 120,000 inhabitants, is a town divided—between the walled Old Town, a remarkable evocation of the Middle Ages, and the New Town that spreads outside those massive walls.

Old Town is arguably the most impressive continuously inhabited medieval town in Europe, much of it protected as a UNESO World Heritage site. This is a remarkable and evocative place that warrants a stopover on any Greek itinerary. Of the 11 gates, the best way to enter is through **Eleftheria (Liberty) Gate** into **Plateia Symi.** Ruins of the **Temple of Venus,** which date from the 3rd century B.C., are somewhat diminished by the adjacent parking lot, but the few stones and columns still standing are reminders of the great Greek and Roman city that once stood here, with a population as large as that of the island today.

The **Street of the Knights** and **Palace of the Grand Masters** (p. 251) somberly evoke the island's medieval power elite, but the main streets of the Old Town resemble a raucous Turkish bazaar. Many of the Old Town's 6,000 current residents are of Turkish descent, from families that have been in Rhodes since the Ottomans took control of the island in the 16th century (in Greece they're known as "Greeks of the Muslim Faith"). Orffeos, Socratous, and Aristotelous streets are chockablock with outdoor stalls hawking leather goods and trinkets to a stream of tourists. Rising above the maze are mosques, the ruins of the 14th-century church of **Our Lady of the Bourgo,** the Turkish baths of **Yeni Hamam** on Arionos Square, the clock tower of **Fethi Pasha** (Orfeos 1; entrance to top 5€, May–Oct 9am–midnight), and the spikey minarets and fanciful Ottoman towers of the **Suleymaniye Mosque.** Just steps away from the fray are the quiet cobblestone lanes of the old Jewish and Turkish quarters around the **Kahal Shalom Synagogue,** where oleander cascades over garden walls and latticed porches hang over the streets. Old Town is a maze, and many lanes have no names; it's best just to wander. Whenever you

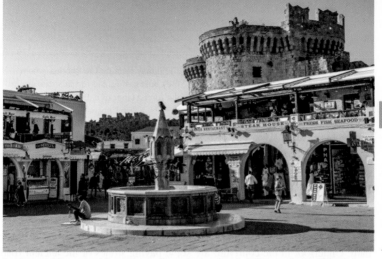

Ippokratous (Hippocrates) Square, a popular gathering place in Old Town, shows off the city's characteristic mix of medieval and Turkish cultures.

feel the need to find your bearings, look for Ippokratous Square, the center of the Old Town.

The so-called **New Town** is not new at all, settled in the 16th century alongside **Mandraki Harbor,** the port where ancient Rhodians and medieval knights moored their fleets. Historians have claimed that the Colossus—a statue 33m (108 ft.) tall and one of the Wonders of the Ancient World—straddled the entrance to the harbor. A colossal statue of Helos, the sun god, did rise above the ancient town, probably from what is now the Garden of the Palace of the Grand Masters, from 280 B.C. until it toppled in an earthquake in 226 B.C. Rising above the harbor now are statues of two deer, *elafonisi,* a tribute to the animals imported in antiquity to control a snake population so prolific that Rhodes was once known as "Snake Island" (it was later renamed "Island of the Sun").

The Italians put their stamp on the island's multicultural mix when they laid claim to Rhodes in 1912 after the defeat of the Ottomans. They erected a showplace along what they called Foro Italico, now the **Platea Eleftherias,** a palm-shaded avenue skirting the harbor, lined with the distinctive arcaded New Market and other Renaissance Revival (also known as Rationalist) landmarks, neoclassical with slight art deco overtones. Especially notable along this stretch are the Bank of Greece, the Municipal Theater, the arcaded Venetian-Gothic-style Prefecture (formerly the Palazzo del Governo), and the Post Office. The noted Italian colonial architect and diplomat Florestano di Fausto, who oversaw designs of this model city, also built the neo-Gothic Evangelismos Church, on the seaward side of the avenue, to assert a Roman Catholic presence over a population that was mostly Greek Orthodox and Muslim after centuries of Ottoman rule.

Archaeological Museum ★ MUSEUM The stone halls where the knights once fed the poor and tended to the infirm now display finds from around the island. The most acclaimed presence is *Aphrodite of Rhodes,* 249

The Knights of St. John

The great walls of Rhodes Town's Old Town and its impressive medieval landmarks are the work of the Knights of the Order of St. John (aka Hospitallers), a mixed lot of western European Catholic crusaders who functioned as occupation army and charity foundation wherever they settled. Forced by the Muslims to abandon the Holy Land in 1309, they retreated to Rhodes, where they built castles and fortifications using the forced labor of native Rhodians. The knights, a firm Christian presence in the increasingly Muslim southern Mediterranean, remained on Rhodes until 1522, when, after a 6-month siege, the Muslims forced them to retreat to Malta.

fashioned 2,000 years ago in creamy marble from the island of Paros; the plump beauty pushes her long tresses back as she prepares to step into her bath. Underfoot in the courtyard are some paving stones of the ancient road that led to the harbor, and some touching Roman-era tombstones (steles) line the walls, including one honoring Ploutos, aged 3, who died "loosening the support of a cart which had upon it a heavy load of stakes."

Museum Square. odysseus.culture.gr. © **22410/31048** or 25500. Admission 6€. Mid-May to Oct daily 8am–8pm; Nov to mid-May Tues–Sun 8am–3pm.

City Walls ★★★ LANDMARK Among the knights' most formidable achievements was the circuit of walls that still enclose the Old Town with 4km (2½ miles) of masonry, up to 40 feet thick in places. With fortified gates, bastions, and such innovations as curvatures to deflect cannon balls, the walls repelled attacks by Egyptians and Ottomans and were compromised only when an earthquake rocked the island in 1481. In 1523 the walls kept the besieging Ottoman Turks at bay; they lost 50,000 men in their efforts to take the island. (They eventually succeeded, but only after guaranteeing safe passage to the knights and Christian citizens who wished to leave.) You can walk around the walls in their entirety by following a path in the dry moat between the inner and outer walls, or by walking the ramparts that top part of the circuit, entered through the Palace of the Grand Masters.

Ramparts admission 3€. Early Apr to Oct Mon–Fri noon–3pm.

St. Anthony's gate, one of 11 different gates that lead through the massive medieval walls that encircle Old Town.

Hospice of St. Catherine ★ HISTORIC SITE At the eastern end of the main street of the Jewish Quarter (see below), this inn was built in the late 14th century by the Knights of St. John to house and entertain guests, much like the inns on the Street of the Knights (see below). One such guest, the traveler Niccole de Martoni, described the hospice in the 1390s as "beautiful and splendid, with many handsome rooms, containing many and good beds." The description still fits, though only one "good bed" remains amid the magnificent sea-pebble and mosaic floors, carved and intricately painted wooden ceilings, grand hall, lavish bedchamber, and engaging exhibits.

Plateia ton Martiron Evreon. Free admission. May–Sept daily 12:30–3:30pm.

Jewish Quarter ★ HISTORIC QUARTER The Old Town's Jewish community first settled here in the days of the ancient Greeks. Little survives today other than a few homes with Hebrew inscriptions, a Jewish cemetery, and the **Plateia ton Martiron Evreon** (Square of the Jewish Martyrs), embellished with a seahorse fountain and dedicated to the 1,604 Rhodian Jews who were rounded up here and sent to their deaths at Auschwitz. On Dosiadou, leading off Simiou just below the square, the Kahal Shalom Synagogue (www.jewishrhodes.org) holds services on Friday nights; the synagogue and a small museum are usually open Sunday through Friday from 2:30pm to 3:30pm; admission is free. A walking tour of the Jewish Quarter is sometimes available, depending on interest; the cost varies.

Monte Smith ★ NATURAL LANDMARK The ancient Greeks, ever mindful of a great location, chose this 100m (328-ft.) hill to build their **Acropolis** and a 3rd-century-B.C. **Temple of Apollo.** A few columns remain, along with the ruins of an Odeon and some other temples, next to a little theater that the Italians restored a century ago. The summit, named for a British admiral who fought Napoleon and American revolutionaries, is best known for its far-reaching views over the island and sea; the admiral built his observatory up here to keep an eye on Napoleon's fleet cruising the seas below.

3km (2 miles) W from center of Rhodes Town. Free admission to ruins, always open.

Street of the Knights ★★★ HISTORIC SITE One of the best-preserved and most evocative medieval relics in the world is this 600m-long (1,968 ft.) stretch of cobbles, following an ancient pathway that once led from the Acropolis of Rhodes to the port. By the early 16th century the street was the address of the inns of knights of various nations who belonged to the Order of St. John. The inns were eating clubs and temporary residences for visiting dignitaries, and their facades reflect the architectural styles of their respective countries. Most of the inns now house offices or private residences, but the most ornate of them all, the **Inn of France** (built in 1492) is open to the public Monday to Friday 8am to noon. The ground floor houses the Institut Français, but you can step in to see the garden. At the top of the street stands the massive **Palace of the Grand Masters** ★ (also known as Palace of

the Knights; odysseus.culture.gr; (?) **2413/65270**). Amid all its turrets and crenellations, it's easy to imagine knights in armor and maidens in cone-shaped hats passing through; however, it's actually a 1930s fantasy built to flatter Mussolini on a state visit. (The original palace was destroyed in 1856 when a nearby ammunition storehouse accidentally exploded.) The vast halls house mosaics stolen from Kos by the Italian military as well as a collection of antique furniture. Admission to the galleries is 6€ (Apr–Oct daily 8am–8pm; Nov–Mar Tues–Sun 8am–3pm).

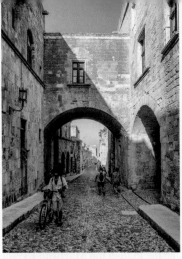
Crusader knights from various nations built their inns along the famous Street of the Knights.

A Side Trip to Lindos ★★

47km (28 miles) S of Rhodes Town

The most picturesque town on the island outside of Rhodes Old Town is a collection of white-stucco houses tucked between the sea and a towering **ancient acropolis.** Those glistening white ruins exert an almost irresistible pull—and you need only follow the signs (and the crowds) to reach them. Should a steep climb in the summer heat seem like too much, you'll pass a stand where, for 8€, you can climb aboard a donkey (also known as a "Lindian taxi") for a slow plod all the way to the top.

ARRIVING Be warned that Lindos is often deluged with tourists. Public buses leave for Lindos from Plateia Rimini in Rhodes Town frequently (fare 5.50€ each way); a taxi will cost 80€ one-way. In the busy square near the entrance to Lindos town, you'll find a **Tourist Information Kiosk** (?) **22440/ 31-900;** Apr–Oct daily 9am–10pm).

EXPLORING LINDOS

As you climb through town toward the acropolis, you'll notice that the lanes are strewn with embroidery and lace for sale, some of which may be the handiwork of local women (beware, though—much of what's sold in Lindos today is from Asia). Embroidery from Rhodes was highly coveted in the ancient world; it's claimed Alexander the Great wore a grand Rhodian robe into battle. In Renaissance Europe, French ladies used to yearn for a bit of Lindos lace.

Acropolis of Lindos ★★★ ANCIENT SITE Before you start the final ascent up a flight of stone steps to the acropolis, stop to inspect the relief carving of a Lindian ship, dating from the 2nd century B.C. The path then passes a medieval castle built by the Knights of St. John; the ruins of a Roman temple; and finally, an upper terrace planned by the ancient Greeks in the 4th century

The Acropolis of Lindos, built in the 4th century B.C., commands a beautiful hilltop site overlooking the Mediterranean Sea.

B.C. Upon this airy balcony stand the remains of a great assembly hall, a stoa, with a grand portico once supported by 42 columns. The glorious views from this perch now extend over medieval Lindos to the sea. To the south you can see the beach at St. Paul's Bay—legend claims the ever-wandering saint put ashore here. To the southwest rises Mount Krana, where caves are thought to have sheltered cults to Athena well into the Christian period. At the very top of the Acropolis, a small temple to Athena, fronted by four columns, is still a statement of elegant grace.

odysseus.culture.gr. © **22440/31258.** Admission 12€. Mid-Apr to Oct daily 8am–8pm; Nov–Mar Tues–Sun 8am–3pm.

Church of the Panagia ★ CHURCH More than 200 frescoes, covering every inch of the walls and arched ceilings here, are the work of an 18th-century master, Gregory of Symi. With a close look, you can pick out scenes of the Creation, the Nativity, and the Last Judgment. At your feet is an extraordinary floor made of sea pebbles.

Old Town, Lindos. Free admission. May–Oct daily 9am–2pm and 5–9pm.

Exploring the Rest of Rhodes

Ruins and beaches lure visitors out of Rhodes Town. The best beaches are along the island's east coast, while the heavily forested west coast is littered with crusader castles and ancient ruins.

Ancient Kamiros ★ ANCIENT RUINS Much of this once extensive hillside Greek city has yet to be unearthed (the Italians began excavations in 1928) but enough has been brought to light to suggest what life was like here more than 2,000 years ago. In a small valley are ruins of houses and shops along gridlike streets, as well as the foundations of a large temple. On a slope above are the remains of two aqueducts, assuring residents of a year-round supply of water. Bring a bathing suit, because across from the site is a good

WHERE TO SPEND TIME out of the sun

As befits an island with such a rich heritage, Rhodes is home to some quirky and fascinating museums. The **Rhodes Aquarium** (rhodes-aquarium.hcmr.gr; *② 22410/27308*), above Elli Beach in an art deco-style Italian marine research center from the 1930s, is home to many exotic Mediterranean species; its most popular denizens are spiky lionfish (admission 5.50€, 3.50€ ages 5–18, kids 4 and under free; daily 9am–8pm, until 4:30pm Nov–Mar). Rhodes is famous for honey, and the **Bee Museum** in Pastida, 11km (7 miles) SW of Rhodes Town (*② 22410/48200*) provides the buzz on everything about how these busy insects live, work, and are cultivated, while flowers and plants that depend on bee pollination thrive in an adjacent garden (admission 3€ adults, 1.50€ ages 13–18, kids 12 and under free; Mon–Sat 8:30am–5pm, also Sun June–Sept,

9am–1pm). In a little house set amid olive groves outside the town of the Archipoli, 35km (21 miles) SW of Rhodes Town, the **Toy Museum** (www.toy museum.gr; *② 69857/02210*) is filled with wind-up toys and battery-operated cars and trucks from the 1930s and 1960s; visitors can also feed coins into arcade games in the cellar (free admission; early Apr to Oct daily 11am–4pm). **The Museum of Mineralogy and Paleontology Stamatiadis** (www.geo museum.gr; *② 22410/90201*), just 8km (5 miles) SW of Rhodes Town at 33 Heraklidon in Lalysos, puts a new spin on Greek antiquities, with fossilized sea creatures from 230 million years ago and even a 5-million-year-old pineapple. There's lead and silver mined in Greece over the millennia, along with exquisite dark-green quartz and other rock stars (free admission; daily 9am–1pm and 6–8pm).

stretch of sandy beach, one of the best on the west coast of Rhodes, with a friendly beach taverna, the **Porto Antico** (portoantico.gr; *② 22410/40001*).

Kamiros, 34km (21 miles) SW of Rhodes Town, with regular bus service. *② 22410/40037.* Admission 6€. Apr–Oct daily 8am–8pm; Nov–Mar daily 8am–3pm.

Epta Piges (Seven Springs) ★ NATURAL LANDSCAPE The seven springs of the name surface in a wooded glen as bubbling streams that feed a small lake. Resident peacocks put on a show for an almost steady stream of visitors, and shaded walks and a swim in the cool water offer a refreshing break from more sun-parched parts of the island. A waterside tavern, established by a far-sighted farmer 70 years ago, does a brisk business throughout the day.

Archangelos, 30km (18 miles) SW of Rhodes Town. Open site, free admission.

Filerimos and Ancient Ialyssos ★★ ANCIENT RUIN One of the island's three founding city-states, Ialyssos was once home to the Phoenicians, whom the Dorians ousted in the 10th century B.C. An oracle had predicted that white ravens and fish swimming in wine would be the final signs before the Phoenicians were annihilated—so the cunning Dorians went to work whitewashing birds and throwing fish into wine jugs, and the Phoenicians left without raising their arms. When the Knights of St. John invaded the island, they, too, made their first base at Ialisos. Their small, whitewashed church, decorated with frescoes of Jesus and heroic knights, was built right into the hillside above the ruins of a 3rd-century B.C. Dorian temple to Athena

and Zeus Polios. Nearby the knights later established the Monastery of File-rimos to house an icon of the Virgin, believed to have been painted by St. Luke and brought to Rhodes from Jerusalem around the year 1000. The knights attributed the icon with the miraculous power of repelling the Turks during a 15th-century attack. Later, however, the icon did not prevent Suleiman the Magnificent from overrunning the island with his army of 100,000 men. Basing themselves in Ialisos, they destroyed the monastery. It was reconstructed, with beautiful cloisters, by the Italians in the 1920s, while the icon eventually found its way to Italy, then Russia (it's now in Montenegro).

14km (8½ miles) SW of Rhodes Town; 6km (3½ miles) inland from Trianda, on the island's NW coast. Admission 6€. Apr–Oct daily 8am–8pm; Tues–Sun 8:30am–3pm.

Petaloudes ★ NATURAL WONDER The Valley of the Butterflies is one of the world's few natural habitats for resin-seeking Jersey Tiger moths (*panaxia quadripunctaria*). The moths overtake this verdant valley in July and August to reproduce, drawn by the scent of storax plants and Europe's only natural forest of Oriental sweet gum trees. They feed at night, by day resting quietly on plants or leaves, so well-camouflaged that you may not notice at first that an entire branch is filled with the sleeping creatures. Resist the urge to clap and awaken them—that interrupts their natural cycles and depletes their energy supplies. The parklike setting, with its many ponds, bamboo bridges, and rock displays, along with the presence of these fragile creatures, creates a serene and soothing escape on this busy island.

25km (16 miles) S of Rhodes Town and inland. Admission 5€ mid-June to late Sept, 3€ other times. Daily 8:30am–6:30pm. Closed Nov–Apr.

Thermes Kallithea ★★ HISTORIC SITE Praised for their therapeutic qualities by Hippocrates, the curative springs at Thermi Kallithea attracted visitors through the Middle Ages. The place was then forgotten and abandoned until the 1920s, when the Italians restored it as a classic curative spa, erecting an exotic complex of buildings in what is best described as an Arabic/Art Deco style. After World War II Kallithea was once again abandoned until the late 1990s, when work began on a complete restoration of its beautiful structures. You can't soak these days, but a small bay alongside the complex is ideal for swimming and snorkeling, and you can stroll along garden paths and through the airy seaside pavilions, contemplating the history of such an unexpected place. Another, quieter beach is nestled amid the rocks just south of the entrance.

Off Kallithea Ave., 9km (6 miles) SE of Rhodes Town; 5km (3 miles) NE of Faliraki. www.kallitheasprings.gr. 📞 **22410/65691.** Admission 4€. May–Oct 8am–8pm; Nov–Apr 8am–5pm.

The Best Beaches on Rhodes

The east coast beaches south of Lindos, from Lardos Bay to Plimmiri (26km/16 miles in all), are the best on Rhodes, especially the long line of sand between Lahania and Plimmiri. Some stretches at **Lahania** ★★★ are relatively deserted and backed by dunes. **Plimmiri** ★★★ is especially picturesque, with

A DRIVING TOUR OF RHODES'S west coast

The west coast of Rhodes is particularly scenic, with deep green forests rising from the rugged coast toward mountain peaks. Above the coast 2.5km (1½ miles) southwest of Kamiros (p. 253) is the late 15th-century knights' castle of **Kastellos** (Kritinia Castle), a romantic ruin perched high above the sea that usually attracts a sunset-viewing crowd. It's a 50km (30-mile) trip out from Rhodes Town; visitors are free to wander around this open site.

From there a winding road leads inland 13km (8 miles) up the stony flanks of the island's highest mountain, **Attaviros** (1,196m/3,923 ft.) to **Embonas**, the wine capital of Rhodes. Winemaking on the island goes back to the Phoenicians, and the bucolic village is surrounded by vineyards. The esteemed **Emery Winery** (© **22410/29111**) and other shops sell such local varieties as Mandilaria and

Athiri, and tavernas welcome tour groups with meat-heavy barbecues accompanied by live music and folklore performances. A 15km (9-mile) drive southwest takes you to another picturesque village, **Siana**, nestled on the mountain's southern slopes. Stands along the road sell the village's famously fragrant honey and a sweet but potent wine that goes down all too easily—if you're doing the driving, sample the wares gingerly.

Drive southwest another 6.6km (4 miles) to **Monolithos,** a spectacularly sited crusader castle perched atop a rocky outcropping on a coastal mountain. A steep path leads up to the stony ruins, where the ramparts provide an eagle's-eye view of the coast. At the foot of the mountain (5km/3 miles southeast), you can end your drive by relaxing on a nice beach at **Fourni.**

soft sands skirting a bay that's ideal for swimming. At the southernmost tip of the island, off-the-beaten-track **Prasonisi (Green Island)** ★★, connected to the main island by a narrow sandy isthmus, has waves and world-class windsurfing on one side and calm waters on the other.

In Rhodes Town, the place for a dip is **Elli beach** ★, where the beach extends just beyond the walls of Old Town and along the New Town waterfront. The shoreline is pebbly, but that doesn't deter hordes of beachgoers, eager to get into the sea so close to town, and the water is crystal clear. Aside from many beach bars and sunbed concessions, an attraction is a diving platform about 600 feet offshore; the highest plunge is from about 25 feet, which makes jumpers feel like Olympians (and transforms many wannabes into scaredy-cats gingerly inching away from the edge). The beach rounds the point at the northernmost tip of the island, just below the Aquarium, and is "wild" here, that is, devoid of sunbeds, and the water is especially invigorating. To the south a well-maintained coast path leads to beautiful Kato Petres Beach, where boulders enclose a series of coves and a little chapel is tucked into a cliffside cave.

The island's most popular and developed beach resort is **Faliraki beach** ★★, 9km (6 miles) south of Rhodes Town on the east coast, with frequent bus service. The resort offers every vacation distraction imaginable, from bungee jumping to laser clay shooting. For families with kids in tow, there is a **water park** and a Disneyland-type amusement park, the **Magic Castle.** The southern end of the beach is less crowded and frequented by nude bathers.

Farther south are a number of sandy, sheltered beaches with relatively little development, including **Anthony Quinn Bay** ★★, 4km (2½ miles) south of Faliraki, named for the American actor who bought up a large part of this coastline when he filmed *The Guns of Navarone* on Rhodes in 1961. The clear emerald-green bay, surrounded by rock formations, is much visited, with bus service from Rhodes, and especially popular with snorkelers.

Rhodes Shopping

In Old Town, Sokratous was once the Turkish bazaar, and it still seems to be one, with many shops selling Turkish leather goods. (*Note:* Most of these shops close in late Nov and don't reopen until Mar.) Antiquity buffs should drop by the **Ministry of Culture Museum Reproduction Shop,** on Plateia Simi, which has an enticing selection of well-made reproductions of ancient sculptures, friezes, and tiles.

Rhodian wine has a fine reputation, and on weekdays you can visit **C.A.I.R.** winery, 20km (12 miles) outside of Rhodes Town, on the way to Lindos at 20 Chlom Leoforos, Rodu Lindou (www.cair.gr; © **22410/68770**). Another distinctive product of Rhodes is a rare **honey,** made by bees who feed exclusively on *thimati* (an herb like oregano); a prime place to buy this is the village of Siana (see p. 256), where it's sold out of private homes and at road-side stands. Rhodes is also famed for handmade **carpets** and **kilims,** a legacy of centuries of Ottoman occupation. Some 40 women around the island still make carpets in their homes; some monasteries are also involved. In the Old Town, Rhodian handmade carpets and kilims are sold at **Royal Carpet,** at 33 Apellou.

ESCAPE TO halki

When Rhodes seems a bit too cosmopolitan, make the short ferry crossing to little **Halki island,** off the west coast. Just 6 miles long and 2 miles wide, Halki has just one settlement, Nimporio, a colorful collection of houses and a few cafes strung alongside a harbor full of fishing boats, bobbing in the shadow of a church bell tower. In Nimporio you'll probably notice racks of homemade pasta drying in the sun; don't leave the island without trying this local specialty, *makarounes*, served with feta and caramelized onions (you'll find it most days at waterfront **Lefkosia;** © **0698/83202997**). The sandy beach at Pondamos is only a 10-minute stroll from town; for a little more seclusion, you can trek a mile or so to the beach at Kania. Ancient mule

paths lead to the island's few sights: The ruins of **Horio,** one-time capital, huddles beneath a castle built by the knights of St. John, and some little chapels and the monastery of **Agios Ionnis** sit in lonely splendor amid the arid landscape.

Local ferries to Halki operate several times a day in season from Kamiros Scala on the west coast of Rhodes; the 75-minute crossing costs about 15€ each way. (Buses from Rhodes Town to Kamiros Skala run two or three times a day; it's a half-hour taxi ride, costing about 35€.) **Dodekanisos Seaways** (www.12ne.gr) also runs a Halki–Rhodes Town route twice a week in summer, and ferries operated by **Anek** (www.anek.gr) sometimes call at Halki on trips between Piraeus and Rhodes.

Nightlife in Rhodes Town

Many cafes and bars stay open late, or even all night. In the Old Town, bars are clustered around Arionos Square; in the New Town, check out Orfanidou Street. The **Casino Rodos,** in the Grande Albergo Delle Rose Hotel on Papanikolaou Street (www.casinorodos.gr; © **22410/97500**), is a plush gaming space housed in an Arab-Byzantine fantasy palace built by the Italians in the early 20th century. Games include American roulette, blackjack, casino stud poker, and, of course, slot machines. The casino is open around the clock, and admission is free. Patrons must be 21 years old and sport respectable daywear until 7pm, smart casual attire after that time.

SYMI ★★

11km (7 miles) N of Rhodes

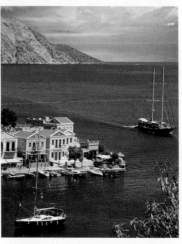

Barren, rugged Symi is often called "the jewel of the Dodecanese," and it's easy to see why as you sail into broad, horseshoe-shaped **Yialos harbor,** where pastel-colored, neoclassical-style houses are reminders of the island's shipbuilding and sponge-fishing heydays. Outside of this picturesque port, and the scenic old capital of **Horio** on a ridge above, the island is largely untamed, aside from a wealth of chapels and remote monasteries, including the famous one at **Panormitis**—so many, in fact, that islanders claim you can worship in a

With its tall, colorful houses and deep natural harbor, Symi's capital is a spectacular introduction to this inviting island.

different sanctuary every day of the year. A near-dearth of car traffic and a tiny road network means the only way to get around is by boat or on foot.

Many descendants of Symoites who emigrated when the sponge industry dwindled have returned, and the island's picture-perfect houses have become retreats for Athenians and other Europeans. Symi provides a welcome tonic from the crowds on Rhodes—it's a favorite spot for travelers who want to get away from it all without leaving all the sophisticated comforts behind.

Essentials

ARRIVING A car ferry runs daily in season to Symi from Athens's port, Piraeus. However, many (if not most) visitors to Symi arrive on an hourlong boat ride from Rhodes, usually those operated by **Dodekanisos Seaways** (www.12ne.gr). Symi is a popular spot for daytrip excursions from Mandraki Harbor in Rhodes (see p. 249).

VISITOR INFORMATION Symi does not have an official tourist office, but long-established **Kalodoukas Holidays** (www.kalodoukas.gr; © **22410/71077**)

can help with everything from booking accommodations to chartering a boat. Its office, at the base of the stairway to Horio, is open Monday through Saturday 9am to 1pm and 5 to 9pm. The agency offers many excursions during the summer. A good source of information on the island is www.allaboutsymi.com.

GETTING AROUND　Symi's main, and just about only, road leads to Pedi, a beach village one cove east of Yialos, and up to Horio, the old capital. In season, **buses** leave hourly from Yilaos for Pedi from 8am until 11pm, stopping at Horio en route (fare 1€). **Taxis** at the harborfront charge 10€ to Horio and 12€ to Pedi. **Scooters** are available for about 20€ a day, but due to the limited roads, you'll do better relying on public transportation and your own two feet. Many of the island's 4,000 daily visitors take **excursion boats** that stop at Panormitis Monastery or at Pedi beach. **Caiques** (converted fishing boats) shuttle people to various beaches, with prices ranging from 10€ to 20€, depending on distance.

Where to Stay on Symi

Hotel Aliki ★　A grand Italianate sea captain's mansion from 1895 whisks guests back to Symi's heyday, with high-ceilinged lounges and homey guest rooms where antiques sit on slightly creaky but highly polished floors. The waters of the port practically wash up against the front door, and many of the charming rooms and suites have sea views—as does a terrace above the roof-top garden. The Aliki is a popular overnight getaway from Rhodes; reservations are a must.

Akti Gennimata, Yialos. www.symi-hotel-aliki.gr. ✆ **22460/71665.** 15 units. 80€–150€ double. Rates include breakfast. **Amenities:** Bar; restaurant; Wi-Fi (free). Closed mid-Nov to Mar.

Hotel Kokona ★★　Behind a neoclassical façade this Venetian mansion in the center of Yialos has been redone from cellar to roof in a contemporary style with handsome, light furnishings and soothing neutral tones. Many modern comforts include sparkling, well-equipped baths with large, glassed-in showers, augmented with old-fashioned hospitality that extends to an excellent breakfast. Views (many from balconies) are over the town or a beautiful and quiet courtyard.

Symi. hotelkokona.gr. ✆ **22460/71451.** 12 units. 70€–90€ double. **Amenities:** Courtyard; Wi-Fi (free). Closed Nov to mid-Apr.

Hotel Nireus ★　A shaded cafe terrace, sunning dock, and swimming area provide a seaside getaway right in town, and the best of the blandly pleasant rooms have balconies that hang right over the water. The location, sea views, and hospitality make this is a long-standing favorite with return guests, so reserve well in advance.

Akti Gennimata, Yialos. www.nireus-hotel.gr. ✆ **22460/72-400.** 35 units. 90€–150€ double. Rates include breakfast. **Amenities:** Restaurant; bar; Wi-Fi (free). Closed Nov–Easter.

Hotel Nirides ★★　Commodious apartments, set amid pine trees on a rise overlooking Nimborios Bay, have kitchenettes and separate bedrooms and surround a pleasant terrace where drinks and informal meals are served; most

units have their own terrace or balcony. The one-taverna village of Nimborios, with a pristine beach, is just down the road, and it's a 20-minute walk along the coast to Yialos (with many swimming coves below); bikes are available and water taxis make the trip, though many taxi drivers refuse to make the drive on the rough road.

Nimborios Bay. www.niriideshotel.com. © **22460/71784.** 11 units. 75€–130€ double. Rates include breakfast. **Amenities:** Cafe/bar; bikes; Wi-Fi (free). Closed Nov–Mar.

The Old Markets ★★ Symi's 19th-century sponge-trading halls and a captain's mansion across the road provide some of the island's most comfortable and atmospheric lodgings. Stone walls, arches, mosaic floors, and handsome woodwork show off the landmark's provenance, while modern touches include sumptuous bathrooms and a small swimming pool. Drinks, and meals on request, are served on the waterside terrace overlooking the harbor.

Yialos harbor. www.theoldmarkets.com. © **22460/71440.** 10 units. 200€–275€ double. Rates include breakfast. **Amenities:** Restaurant; bar; pool; free Wi-Fi. Closed late Oct to Apr.

Where to Eat on Symi

The island serves a bounty of seafood, including the local specialty, Symiako Garidaki: baby shrimp simmered for just a few seconds in olive oil and garlic, eaten whole with skins on and a squeeze of lemon.

Giorgios and Maria Taverna ★ GREEK A simple whitewashed room opening to a vine-shaded terrace is the mainstay of social life in Horio. Meals are as traditional as the surroundings, often accompanied by impromptu music provided by one of the villagers.

Tasty little Symi shrimp, served fresh from the fishing boats, are a Symian specialty.

A big selection of *mezedes* can furnish a meal in themselves, though fresh fish and delicious kebabs come off the grill.

Horio. ℂ **22460/71984.** Main courses 8€–15€. Daily 12:15–3pm and 6–11:45pm (until 11:15pm Sun).

Tholos ★★ GREEK/SEAFOOD Stuffed vine leaves and simply grilled sea bream and other fresh seafood taste all the better in this perfect setting—on a promontory at the far end of the harbor, with the open sea spreading out to one side and the colorful town to the other. Waterside tables (some so close to water's edge that your shoes might get wet) are at a premium during the summer season, so reserve well in advance to ensure you get one.

Yialos harbor. ℂ **22460/72033.** Main courses 8€–15€. Daily noon–3:30pm and 6pm–12:30am (from 7pm Sun). Closed Nov–Apr.

Vasilis ★ GREEK/MEDITERRANEAN On this lively terrace just off the town square in Yialos fresh Symi shrimps are served in many different ways (best when broiled with tomatoes, feta, and herbs), and fresh fish is simply grilled or paired with other seafood in pastas. Vasilis disproves the rule that a kitchen can't master both seafood and meat; anything that comes off the grill here (including vegetables) is delicious.

Yialos. ℂ **22460/71753.** Main courses 9€–18€. Daily 10am–11pm. Closed Nov–Apr.

Exploring Symi

In Yialos, the ground floors of colorful waterside mansions are occupied by cafes, with shady terraces for lazy lingering watching boats bob in the harbor. Just behind the quay, 375 wide stone steps—known as the **Kali Strata** (the Good Steps)—ascend to whitewashed **Horio,** the old town and erstwhile island capital. By the late 19th century, Horio had been eclipsed by the port below, and day-to-day business on Horio's little lanes and shady squares still goes on as it has for centuries, providing a glimpse of island life that has long disappeared in other parts of Greece. One recent innovation is a paved road, along which cars, motorbikes, and a bus now make the climb from the harbor, though donkey is still the means of transport for carting goods around the village. In the haunting landscapes beyond Yialos and Horio, mountains drop down to lonely valleys and isolated coves that can be reached only by boat.

Climbing from the Yialos waterfront to the old town above, the Kali Strata starcase has 375 stone steps.

Archaeological and Folklore Museum ★ MUSEUM Two neoclassical houses on the narrow lanes

How the Locals Beat the Heat

Symi has no natural source of water and is dependent on a small desalination plant. Conservation is key. Symi is also one of the hottest places in Greece during the summer—come prepared with a hat, sunscreen, and a willingness to settle into a long siesta in the heat of the day. Symi's distinctive houses are designed to accommodate this heat and lack of water, built with high walls atop a cistern and roofed with ceramic tiles. Pipes from the roof channel water to the cistern during rainy periods; cool air from the pool is then channeled through vents between the floors that allow hot air to rise up and out of the roof.

of Horio are the repository for some fairly routine ancient sculpture that doesn't do justice to the island's ancient distinction. (Even Homer talks about Symi, home to beautiful King Nireus—the second-most handsome Greek man after Achilles—who sailed from Symi with three ships to join the Greeks in the Trojan War.) Most engaging are island weavings and other handicrafts, and a replica of an old Symiot house, its living and kitchen arrangements still typical of the surrounding dwellings. The English-speaking staff is usually eager to share the history of the island, which as recently as a century ago had up to 20,000 inhabitants, compared to about 2,500 today.

Horio. ⓒ **22460/71114.** Admission 2€. Wed–Mon 8:30am–4pm.

Taxiarchis Mihail Panormitis Monastery ★★★ MONASTERY
Tucked away on Symi's hilly, green southwestern corner is this unexpectedly grand white-washed compound dedicated to the patron saint of seafaring Greeks. The monastery, with a tall bell tower visible from miles away at sea, is still popular with Greeks as a place of pilgrimage and a refuge from modern life. A storied past of providing solace for sailors comes to light in the charming **museum,** where wooden ship models line the shelves next to centuries-old glass bottles stuffed with bank notes, all left to beseech the patron for deliverance from the perils of the sea. Legend has it that many of the bottles miraculously washed up on the beach at the foot of the monastery, just as the faithful intended. Opening off a courtyard paved in black-and-white pebbles, a heavily frescoed church and chapels are filled with icons, including one of Michael and the archangel Gabriel adorned in silver and jewels. Entrance

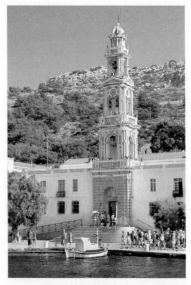

Excursion boats from Yialos visit the beautiful Taxiarchis Mihail monastery in Panormitis, devoted to the patron saint of sailors.

fees support the almshouse in the surrounding settlement, which provides shelter for the elderly. A tiny settlement of houses, a few shops, and a tavern just outside the monastery gates comes alive during the November 8 **Feast of Archangel Mihaili.** Panormitis is a popular summer destination; visitors arrive by excursion boat, twice-a-day buses from Yialos and Horio, or a fairly strenuous 6-hour hike across the countryside. If you walk, time your excursion to avoid the heat of the day and follow it up with a refreshing swim in Panormitis Bay.

Panormitis. panormitisymis.gr. ℗ **22460/71581.** Admission 2€. Monastery: daily 7am–8pm. Museum: Apr–Oct daily 8:30am–1pm and 3–4pm.

Symi Beaches

The closest beaches to Yialos are **Nos ★**, a 15m-long (50-ft.) rocky stretch north of the harbor, and **Nimborios ★**, a 20-minute walk farther out along the shoreline. A bus to **Pedi,** followed by a short walk, takes you to **St. Nikolaos beach ★**, with shade trees, or to **St. Marina ★**, a small beach with little shade. In season, boat taxis leave Yialos hourly for the beautiful isolated beaches at **Nanou Bay ★★**, **Marathounda ★★**, and **St. George's Bay ★★★**, a stop on some day excursions from Rhodes

Symi Shopping

Given Symi's long tradition of sponge diving, you probably won't want to leave without a natural sponge. Venerable waterfront shops **Dinos** (℗ **22460/71940**) and the **Aegean Sponge Centre** (℗ **22460/71620**) sell wares for daily use as well as some that are just too beautiful to use for anything other than to decorate the bathroom. Aegean also gives fascinating presentations on sponge diving.

KOS ★

98km (61 miles) NW of Rhodes; 370km (230 miles) E of Piraeus

In many ways, Kos is paradise. Miles and miles of golden sand ring the coastline.

Oleander and scented pines carpet landscapes that climb from a fertile agricultural plain into rugged mountains. A formidable 14th-century knight's castle overlooks the pretty waterfront capital, where ancient ruins seem to be laid out at your feet wherever you stroll. The most evocative ancient remnants are those outside town at the Asklepieion, the great healing center of antiquity that carried on the tradition of Hippocrates, who was born on Kos in the 5th century B.C. and taught here.

Eleftherias Square is the heart of Kos Town.

None of this history and beauty, of course, has gone unnoticed. While Kos is rich in sights, fine beaches, and sea-and-mountain scenery, the coastal plain has been zealously overbuilt as the island has wholeheartedly embraced package tourism, providing northern Europeans with all-inclusive weeks in the sun. You won't find much authentic Greek island life on Kos, until you go off the beaten path onto farm roads and into the mountains, but the islanders are warm and welcoming, and justifiably proud of the natural beauty that surrounds them.

Essentials

ARRIVING Hippocrates International Airport (www.kosairportguide.com; ⒸⒸ **22420/51229**) is served by **Aegean Airlines** (www.aegeanair.com), **Olympic Airways** (www.olympicairlines.com), and **Sky Express** (www.skyexpress.gr), with several flights a day to and from Athens in season, as well as seasonal service to and from Rhodes, Crete, and other islands. In summer Air Berlin, British Airways, EasyJet, Ryanair, and many other European carriers fly in and out of Kos from cities across the Continent. From outside the airport entrance, a public bus will take you the 26km (16 miles) to Kos Town for 3.20€, or you can take a taxi for about 25€; bus service also connects the airport with the resort towns of Kardamina, Kefalos, and Mastichari.

Ferries link Kos with Piraeus and Rhodes, as well Bodrum, Turkey, with most boats operated by **Blue Star Ferries** (bluestarferries.gr; ⒸⒸ **210/8919800**). Kos is also linked to other islands in the Dodecanese by high-speed boats, with fairly frequent service in the summer season; the major operator is **Dodekanisos Seaways** (www.12ne.gr).

VISITOR INFORMATION Kos harbor is strewn with travel agents, who can assist you with boat and plane tickets and provide information about sights and excursions. An excellent online reference is www.kosinfo.gr. The **tourist police** (ⒸⒸ **22420/22-444**), across from the castle, are available 24 hours to address any outstanding need or emergency, even trouble in finding a room.

GETTING AROUND **KTEL buses** (www.ktel-kos.gr) travel between Kos Town and Antimachia, Kardamina, Kefalos, Marmari, Mastichari, Pili, Tigaki, and Zia; fares range between 2.10€ one-way to Tigaki and 4.80€ to Kefalos. The island bus station is at 7 Kleopatras (ⒸⒸ **22420/22-292**). Open-air **tourist trains** loop around town, leaving from the harbor, for 10€; most everything on the routes can just as easily be seen on a leisurely walk, but it may be worth the fare to take the 15-minute trip out to the Asklepeion, saving you the walk in the heat. During the summer season, trains leave from the harbor Tuesday through Sunday, every 15 minutes between 9am and 6pm.

This is a congenial island for **cyclists.** Much of the coastal plain of Kos is quite flat, and aside from the main road from Kos town to Kefalos, roads are generally lightly traveled and well-suited to safe cycling. Bike paths wind through Kos Town and its surroundings. Rentals, including e-bikes, are available throughout Kos Town and can usually be arranged through hotels, which

also often offer bikes for free. Prices range from 10€ to 15€ per day. **Escape,** V. Georgiou 12 (© **22420/29620**), rents bicycles and scooters.

It's easy to rent a **car, motorbike, or all-terrain vehicle** through your hotel or any of several agencies around the harbor. Car rentals cost about 40€ a day in high season, and rentals for motorbikes and all-terrain vehicles range from 25€ to 40€. **Autoway** (www.autowaykos.gr; © **22420/25326**) is a reliable source for cars; the main office is at the airport but they will deliver a car anywhere on the island.

For a **taxi,** drop by or call the **harbor taxi stand** beneath the minaret and across from the castle (© **22420/23-333** or 22420/27-777). All Kos drivers are required to know English.

TOURS Dozens of tour boats moored along Kos Town's inner harbor offer sunset cruises and all manner of other day trips. Tours aboard the jaunty wooden boats *Christina* and *Katerina* are especially popular. Most rewarding are cruises visiting the three nearby islands Kalymnos, Pserimos, and Plati: Itineraries usually include stops for swimming on tiny Pserimos and Plati and some shore time in Pothia, the colorful capital of Kalymnos. From the deck you'll also catch a glimpse of the cliffs and gorges that make Kalymnos popular with rock climbers. Trips depart between 9am and 10am and return around 6pm; they usually include lunch so are a very good value at about 25€. Book by walking along the waterfront and talking to the eager crews; it's best to secure a space the evening before the trip.

Where to Stay on Kos

Kos is littered with hundreds of purpose-built resort hotels, offering varying degrees of comfort. Some are extremely luxurious and loaded with amenities; many cater to tourists on all-inclusive packages that include airfare, hotel accommodation, and meals, though most of these properties also welcome independent travelers if rooms are available. Rooms will appear on booking. com and other booking engines. Be aware, however, of what you're getting into before you commit to a stay. At many of these properties, you will be surrounded by often-boisterous partiers more interested in fun and sun than in sightseeing and local culture. These hotels are often set outside town centers, so you'll need a car or motorbike to get anywhere, and despite the word "beach" in their names, they're often far from the water, in a field along a back road—check location and transport options carefully. Since many were hastily built, attention to good design, including soundproofing, might be minimal.

EXPENSIVE

Aqua Blu ★★★ On Lambi Beach just outside Kos Town, the best hotel on Kos combines chic contemporary design with comfort, intimacy, and elegance. A sensational pool terrace merges seamlessly with handsome lounges, while guest rooms are design statements set up to pamper guests with sea views and terraces. You'll find fireplaces and private pools in some, and a wealth of built-ins and sleek bathrooms in all. Yet somehow the glossy

A restaurant at the chic Aqua Blu resort overlooks a stylish pool terrace and the glittering sea beyond.

surroundings don't dampen the staff's down-to-earth hospitality and close eye to detail. Amenities include a spa and a strip of private beach across the road.

Lambi Beach. www.aquabluhotel.gr. ⓒ **22420/22440.** 51 units. 150€–350€ double. **Amenities:** 2 restaurants; 2 bars; pool; spa; bikes; free Wi-Fi. Closed mid-Oct to late Apr.

Grecotel Kos Imperial Thalasso ★★ Kos has many all-inclusive resorts, geared mostly to visitors from Northern Europe. This sprawling, attractive resort on a garden-filled hillside above Psalidi Beach just east of Kos Town is the island's best-equipped hideaway, with a long list of amenities that includes dozens of swimming pools and artificial lagoons laced around the grounds; some of the waters are said to be therapeutic. Guest rooms are large and gracious, and most have indoor/outdoor living rooms that open to shady lawns. When swimming and lounging aren't enough, the beach is a launching pad for waterskiing, snorkeling, jet-skiing, and every other watersport imaginable.

Psalidi. www.kosimperial.com. ⓒ **22420/58000.** 330 units. 175€–350€ double. Rates include breakfast; rates with all meals also available. **Amenities:** 6 restaurants; 2 bars; room service; swimming pools; spa; beach; watersports; free Wi-Fi. Closed mid-Oct to late Apr.

MODERATE

Kos Aktis Art Hotel ★★★ A pool is one of very few amenities lacking at this chic harborside spot at the edge of Old Town, though that doesn't mean you'll be aquatically deprived. Sea views fill each of the chic, contemporary rooms that hang over the water with glass-fronted balconies; even the bathrooms seem to float in the blue Aegean, as sliding panels open to minimalist bedrooms enlivened with sea murals that mimic the blue waters beyond. If you can't resist diving in, a nice pebble beach fronts the property. The sleek restaurant downstairs is built around a reflecting pool and appropriately named H2O.

Vas. Georgiou 7. www.kosaktis.gr. ⓒ **22420/47200.** 42 units. 85€–250€ double. Rates include breakfast. **Amenities:** Restaurant; bar; beach; use of nearby spa and fitness center; free Wi-Fi.

INEXPENSIVE

Hotel Afendoulis ★★★　Nowhere in Kos do you receive so much for so little as you do in these sparkling, bright rooms nestled in a gracious residential neighborhood, a few hundred yards from the water and less than 10 minutes on foot from the center of Kos Town. Rooms are of the old-fashioned Greek pension variety, with simple, traditional furnishings and cramped bathrooms, but most have private balconies, many have views of the sea, and downstairs is a jasmine-scented garden shaded by arbors. If you are coming to Kos to bask in luxury, go elsewhere, but that would mean missing out on the hospitality of Alexis Zikas and his family, whose friendly attention turns a stay into a memorable experience. Beer, wine, and soft drinks are available at an honor bar in the welcoming lobby, and an excellent breakfast, including the family's homemade jams, is available for a small fee and not to be missed.

Evrepilou 1, Kos Town. www.afendoulishotel.com. ℂ **22420/25321.** 23 units. 30€–50€ double, breakfast extra. **Amenities:** Bar; laundry; free Wi-Fi. Closed mid-Oct to mid-Apr.

Sonia City Hotel ★　This former family home across from the Roman agora has been converted to a pension in crisp, contemporary style, and while the old house has lost a lot of its parquet-rich character, the clean-lined, neutral-toned furnishings are soothing and bathrooms are sparkling. Most of the airy, high-ceilinged rooms open to a veranda and share an attractive garden in the rear, and many look across the old town toward the port and Castle of the Knights.

Irodotou 9, Kos Town. www.hotelsonia.gr. ℂ **22420/28798.** 12 units. 70€–80€ double. Rates include breakfast. **Amenities:** Garden; refrigerators; free Wi-Fi. Closed mid-Oct to mid-Apr.

Where to Eat on Kos

EXPENSIVE

Petrino ★ GREEK　Summertime visitors to this 150-year-old, two-story stone *(petrino)* house sit outside on a three-level terrace filled with extravagant plantings and statuary, overlooking the ancient agora; in winter, the friendly service extended by three brothers and their well-trained staff moves inside to cozy parlors. Venture beyond the huge menu of mezes—stuffed peppers and figs, grilled octopus, shrimps in ouzo, *beki meze* (marinated pork), and other favorites—for delicious moussaka and other Greek taverna specialties, as well as what's said to be the island's best filet mignon. More than 50 carefully selected wines, all Greek, line the cellar.

Plateia Theologou 1 (abutting east end of agora). www.petrino-kos.gr. ℂ **22420/27251.** Main courses 10€–55€. Daily noon–midnight.

MODERATE

O Makis ★★★ SEAFOOD　Several seafood tavernas surround the port in Mastichari, but this shady terrace just off the seafront is the standout. Several generations have been selecting the fresh catch and seafood right off the boats for decades, and they serve the bounty simply grilled and in a few simple preparations, including a shrimp saganaki that's a house specialty (with fresh feta and tomatoes) accompanied by fresh vegetables from the garden. A platter

of fresh squid and octopus, washed down with local white wine from vineyards on the nearby hillsides, might be your most memorable meal on the island.

Just off the harbor, Mastichari. www.facebook.com/fishtavernomakis. ℂ **22420/59061.** Main courses 8€–25€. Daily 10am–midnight.

Taverna Ampavris ★★ GREEK One of the best tavernas on Kos is on the southern fringes of the bustling town center, in a 130-year-old house down a quiet lane. The rustic courtyard is the setting for meals based on local dishes from Kos and the surrounding islands. The *salamura,* from Kefalos, is mouth-watering pork stewed with onions and coriander; the *lahano dolmades* (stuffed cabbage with rice, minced meat, and herbs) is delicate, light, and not at all oily; and the *faskebab* (veal stew on rice) is tender and lean. Fresh-from-the garden vegetable dishes, such as broad string beans cooked and served cold in garlic and olive-oil dressing, are out of this world.

Ampavris. ℂ **22420/25696.** Main courses 8€–18€. Wed–Sun noon–12:30am, Sun and Tues noon–11:30pm. Closed Nov–Mar.

Taverna Mavromatis ★★ GREEK In the Mavromati brothers' 40-year-old vine- and geranium-covered beachside taverna on the beachfront east of the center of Kos Town, you may eat melt-in-your-mouth *saganaki* (grilled halloumi cheese), mint- and garlic-spiced *sousoutakia* (meatballs in red sauce), tender grilled lamb chops, moist beef souvlaki, or perfectly grilled fresh fish. It's a 20-minute walk or easy bike ride southeast of the ferry port, or you can get there on the local Psalidi Beach bus.

Vasileos Georgiou V, Psalidi beach. ℂ **22420/22433.** Main courses 6€–20€. Daily 9am–11pm.

Taverna Olympia Zia ★★ GREEK Sprawling terraces, roof gardens, and balconies at the edge of Zia are a decades-long island favorite, a top choice for family celebrations or just a leisurely meal in the mountain air. The scent of pine, cool breezes, and views across the coastal plain to the Aegean are backdrops for an extensive menu that ranges through excellent salads, mixed grills, and hearty stews, served with warmth from Michalis and son Nikos.

Zia. www.olympia-zia.gr. ℂ **22420/69254.** Main courses 7€–20€. Daily 10am–11pm.

INEXPENSIVE

Ampeli Wine Yard ★ GREEK Like many Kos seaside towns, Tigaki is hastily built and scrappy, though many of its hotels and tavernas front a beautiful sandy beach. East of town, orchards and fields take over, and tucked among them is this hideaway down a garden path in a vineyard. The arbors are the source of the house wine and vegetables are right out of the garden—you can taste the freshness in the moussaka, stews, and other dishes.

Tigaki, off the beach road east of town. www.ampelirestaurant.gr. ℂ **22420/69682.** Main courses 8€–15€. Daily noon–midnight.

Arap ★★★ GREEK/TURKISH Platanos, south of Kos Town on the road to the Asklepion, has many Greek-Turkish residents, and several tavernas here specialize in a delicious and spicy fusion cuisine. The Arap terrace is a good

place to get acquainted with the tradition, right down to the Greek-Turkish music on the sound system. *Dolmadakia* (stuffed vine leaves), *bourekakia* (little pies stuffed with meat and cheeses), grilled kebabs, and other small plates can be followed up with a long list of daily specials, often Pasha's spaghetti, a spicy concoction of minced meat, tomatoes, and herbs. This is a good lunch stop on a visit to the Asklepion. Cash only.

Platinos Square, Platinos. ⓒ **22420/28442.** Small plates 5€–8€. Daily 11am–midnight.

Pote Tin Kyriaki ★★★ GREEK The name means Never on Sunday, as in the Melina Mercouri classic film, and that's the only evening this busy neighborhood favorite doesn't do a brisk business. A mezes-only menu includes *marathópita* (fennel pie), fried mussels, stuffed zucchini flowers, and dozens of other small plates to be shared with the table. To find the little lane south of the center keep your eye on the nearby Eski Cami mosque tower.

Pisandrou 9. ⓒ **6930/352-099.** Small plates 4€–8€. Mon–Sat 8pm–5am.

Exploring Kos Town

Looming over the harbor, the **Castle of the Knights** was constructed by the Knights of St. John (p. 250) in the 15th century and fell to the Turks in 1522. What you see today, however, is merely a hollow shell—it's best just to stand back and admire from a distance this massive reminder of the vigilance that has been a part of life in Kos from prehistory to the present.

Kos town is strewn with archaeological sites, scattered amid the streets. Intermittently, steps lead into the excavations, where the curious can wander freely (and for free) amid scattered columns and building blocks. The ruins of the ancient Greek **agora** and some section of the **walls** of the classical city lie across a bridge from Platanou Square. To the southwest, in the so-called **West Excavations,** an ancient road leads past some 3rd-century-A.D. mosaics, including a depiction of Jupiter raping Europa, and columns marking the

hippocrates UNDER THE PLANE TREE

Hippocrates, the father of modern medicine, was born on Kos to a physician around 460 B.C. Inducted into the cult or teachings of the Asclepiads (physicians) at an early age, he also studied philosophy, rhetoric, and the sciences, and learned the theories of Pythagoras. He traveled to Asia Minor, Egypt, Libya, Thrace, and Macedonia in pursuit of knowledge, and became renowned when he is said to have delivered Athens from a cholera epidemic. An ardent teacher and practitioner, he attracted the ill and infirm to Kos from throughout the ancient world. Under the shade of a plane tree in **Platanou Square** he allegedly expounded upon the arts of empirical medicine and its attending moral responsibilities. (Among his prolific writings is the Hippocratic oath, still a code of conduct for doctors today.) Little matter that the tree that grows today is at best a few centuries old, and that Hippocrates—who allegedly lived to the ripe old age of 104—is recorded as teaching not here but at ancient Astypalatia on the far western end of the island. This legendary tree presents a romance-infused scene, as does the adjacent Ottoman-era **Loggia Mosque of Hassan Pasha.**

portico of a 2nd-century-B.C. gymnasium. The senate met in the nearby **Odeon,** a small 2nd-century-A.D. theater, with 18 remaining rows of seats. It was once thought that the **Nymphaion** was a sanctuary to the nymphs, though its elaborate arches enclose what now appears to have been a public lavatory.

Asklepeion ★★ ANCIENT SITE The mecca of modern Western medicine occupies an elevated site with grand views of Kos Town, the sea, and the Turkish coastline. This first medical school of the Western world—named for Asclepius, the Greek god of healing—was established here shortly after the death of Hippocrates (see box, p. 269); healing continued here until the end of the Roman Empire. Temples to Asclepius stand on the middle and topmost of the three terraces, while an allegedly curative spring still gushes forth on the lower terrace below. A grand central staircase ascends from the lower terrace, also the venue for the **Asklepieion Festivals,** where games, dancing, and sacrifices paid homage to the god. (Clearly, physicians were consulted and deities invoked in equal measure.) About half a mile down the road from the ruins, the **International Hippocratic Foundation** (www.ihfk.gr; 𝄐 **22420/22131**) has planted a medicinal herb garden containing 158 of the 254 healing species cited by Hippocrates; open the door into the front garden and follow the signs. It's usually open Monday through Friday from 10am to 1pm and admission is 3€.

Located 4km (2½ miles) SW of Kos Town. 𝄐 **22420/28763.** Admission 8€ adults, free for ages 16 and under. Apr–Oct daily 8am–8pm; Nov–Mar daily 8am–3pm. Tourist trains from Kos Town harbor run Tues–Sun 9am–6pm (every 15 min.); round-trip fare 10€.

Casa Romana ★ ANCIENT SITE The largest Roman villa in Greece, with 37 rooms surrounding three atria, was built and rebuilt over the centuries. What you see today is from the 3rd century A.D. Enough lavish mosaics, frescoes, marble paving, and fountains remain to suggest the high-flying lifestyle of the elite of the time in this city where the arts, science, and commerce flourished for centuries.

Leoforos Grigoriou. odysseus.culture.gr. 𝄐 **22420/23234.** Admission 6€. Apr–Oct Wed–Mon 8am–8pm; Nov–Apr Wed–Mon 8am–3pm.

Kos Archaeological Museum ★ MUSEUM The Italians established this collection of Greek and Roman sculptures and mosaics in the 1930s to display their finds from around the island. The 1935 fascist-era surroundings are as much an attraction as the ancient bits and pieces, the most intriguing of which are from the Asklepeion (see above). Among these is a 3rd-century Roman mosaic showing Hippocrates and Pan welcoming Asclepius, the god of healing, to Kos, the birthplace of Western medicine.

Plateia Eleftherias (across from municipal market). odysseus.culture.gr. 𝄐 **22420/24776.** Admission 6€ adults, 3€ students, ages 16 and under free. Mid-May to Oct Wed–Mon 8:30am–8pm; Nov to mid-May Wed–Mon 8:30am–3pm.

Exploring the Rest of Kos Island

Though you won't be aware of it from the poolsides of resort hotels, much of Kos is agricultural, with fields and orchards carpeting the fertile coastal

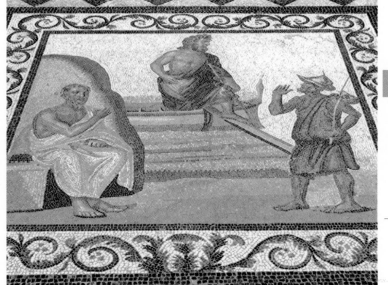

In the Kos Archaeological Museum, this Roman mosaic of Pan, Hippocrates, and Asclepius celebrates the island's role as a center of healing.

plains. The island is known for almonds and figs, and cows graze everywhere—it's not unusual to see a herd munching on grasses next to a modern hotel complex—while verdant, aromatic upland forests and mountains stretch almost the entire island's length. To enjoy this rural scenery, you'll need to get off the main road that bisects the island, connecting Kos Town with the airport and Kefalos in the southwest. Consider following the back roads through farms along the coast between Kos Town and Tigaki, or drop down through the mountains from Pili to Kardamaina on the southern coast.

The highest point on the island is **Mount Dikeos,** reaching nearly 900m (3,000 ft.). From **Zipari,** 9km (5 miles) southwest of Kos Town, the road climbs through stands of cypress and pines to several white-washed mountain villages on the forested flanks of Dikeos. The most appealing and animated, albeit buried in tourist shops, is **Zia ★★**, with farm stands selling honey and embroidery and wide-ranging views across the plains to the sea. Narrow mountain roads lead from Zia to the town of Pili, passing **Palio Pili (Old Pili) ★★**, a ruined mountainside settlement topped by a 9th- to 11th-century castle that grows so organically out of the rock, you might miss it. Wear sturdy shoes, since the walk up to the ruins is on rough stone paths, and if you want to continue up to the castle you'll have to scramble across rocks. If you don't have a car, you can take a bus from Kos to Zia, make the walk from Zia to Pili (about 5km/3 miles), then return from Pili to Kos Town by bus.

From Pili, the road twists and turns another 10km (6 miles) south to the **Castle of Antimachia ★★**, a well-preserved 14th-century fortress that was

another stronghold of the Knights of St. John (p. 250). Not much remains within the thick walls, but the sight of the formidable castle against a backdrop of stark mountains is compelling, and it offers transporting views across Kos to the sea and Turkey.

Kos Beaches

Most of Kos's 290km (180 miles) of coastline has been plotted and claimed, though with a little effort you may find a quiet spot. The beaches 3–5km (2–3 miles) east of Kos town are among the least congested, because they're pebbled rather than sandy.

The island's most acclaimed beaches are on the southwest coast, where long rows of sunbeds and concessions face calm seas at many spots between **Kardamena** ★ and **Kefalos** ★. Lots of watersports outfitters provide gear for those beachgoers who don't just want to lie in the sun; **Kardamena Watersports Center,** at the port in Kardamena (www.koswatersports.gr;

Deck chairs are lined up in the morning, waiting for sunseekers on long, sandy Tigaki Beach.

© **22420/91444**), is especially well equipped. Amid all the fray you can still find some quieter coves—below Agios Theologos, for example, the Vavithis family (including some repatriated from North America) operates **Sunset Wave Beach** ★★ concession and restaurant, a most enjoyable place to relax and enjoy a meal. Northeast of Kefalos, a swim at **Agios Stefanos** ★★ comes with water-level views of two early Christian basilicas, and **Poulemi** ★★★, 10km (6 miles) north of Kefalos, is backed by dunes and miraculously undeveloped—perhaps that's why it's also called Magic Beach.

On the north coast, a long strip of sandy beach begins at **Tigaki** ★★, 13km (8 miles) west of Kos Town. The 10km (6 miles) of sand extends into adjacent **Marmari** ★★, and behind them are dunes, scrubby pines, and, at the south end of Tigaki, extensive salt marshes that attract migrating flamingos and other birds. If you walk beyond the resorts and umbrellas, you'll find some relatively open patches. This north side of the island is popular for **windsurfing and kitesurfing;** operators along the beaches in Tigaki and Marmara rent everything you need.

One of the island's most relaxing beach experiences is at **Bros Therma** ★★, at the island's eastern tip, 12km (7½ miles) southeast of Kos Town and just west of **Agios Fokas.** Sulfurous water bubbles to the surface of a natural, boulder-enclosed pool on the beach. You can soak up therapeutic benefits—treatment of rheumatism and arthritis, among other ailments—then plunge into the cooler sea.

PATMOS ★★★

81km (50 miles) NW of Kos; 302km (187 miles) E of Piraeus

Tiny Patmos—only 12km (7 miles) north to south—is where St. John the Divine (aka the Theologian) spent several years in exile, dwelling in a cave and composing the Book of Revelation. From that time on, the island has been regarded as hallowed ground, and a place of pilgrimage. A magnificent monastery was established in 1088, and the island has more than 300 churches, one for every 10 residents.

Not that the people of Patmos necessarily spend their days in prayer, or expect you to. The rocky, rugged island is also a cosmopolitan retreat for Athenians and many European visitors, who enjoy soft sand beaches, pleasant seaside towns, and the island's relaxed yet sophisticated atmosphere. Most Patmians live in Skala, a pleasant port town halfway up the east coast.

Essentials

ARRIVING Patmos, the northernmost of the Dodecanese Islands, is well connected to other islands in the archipelago with boats operated by **Dodekanisos Seaways** (www.12ne.gr) and other smaller lines. Otherwise, however, it's hard to reach, with no airport and limited ferry service from Athens. The ferry line operated by **Blue Star Line** (www.bluestarferries.com) from Piraeus to Rhodes stops at Patmos, but not every day; on days when boats aren't running, you may be able to transfer through Kos (about a 2-hr. trip). **A.N.E. Kalymnou** lines (www.anekalymnou.gr) connects Patmos with Pythagorio, on Samos (see p. 379). The island has no airport; many visitors fly to Kos and take the boat to Patmos from there.

VISITOR INFORMATION Facing the main harbor square in Skala, the **tourism office** (✆ **22470/31-666;** June–Aug daily 9am–10pm) shares the Italianate "municipal palace" with the post office and the **tourist police** (✆ **22470/31-303**), who take over when the tourism office is closed. The **port police** (✆ **22470/31-231**), in the first building on your left on the ferry pier, are very helpful for boat schedules. Also on the harbor front, **Apollon Travel**

The imposing Monastery of St. John rises above the old town of Hora on Patmos.

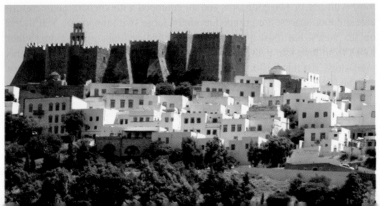

(www.travelling.gr; ☎ **22470/31-724**) can book excursion boats and arrange lodging in hotels, rental houses, and apartments throughout the island. If you book your ferry tickets online, this is where you'll pick them up. It's open year-round from 8am to noon and 4 to 6pm, with extended summer hours.

GETTING AROUND **Mopeds** are definitely the vehicle of choice on Patmos. At shops lining the harbor, 1-day rentals start at around 25€ and go up to 50€. Daily **car** rentals in high season start about 50€, but be aware that the island has few gas stations; watch your gas tank gauge. As the island is quite small, hiring a **taxi** is often a cheaper option; the island's main taxi stand is on the pier in Skala Harbor. **Bus service** runs between Skala, Hora, Grikos, and Kambos, with trips roughly every 2 hours (fare 1.80€; buy tickets on the bus). There's a current schedule online at patmosbus.gr, but to be sure, check with the tourist office or find postings at bus stops around the island.

Where to Stay on Patmos
MODERATE/INEXPENSIVE

Blue Bay ★ A cliffside perch at the southern edge of Skala puts you within easy walking distance of ferry and bus connections, while still being far enough removed to provide a sense of escape, enhanced by soothing views of the sea and port. Tile-floored, plainly furnished quarters are short in pizazz, but open to vista-filled verandas and share many flower-bedecked common spaces, including a breezy breakfast terrace and open-air bar.

Skala. www.bluebaypatmos.gr. ☎ **22470/31165.** 27 units. 60€–90€ double. Rates include breakfast. **Amenities:** Bar; refrigerators; free Wi-Fi. Closed Nov–Apr.

Captain's House ★★ Unfussy and welcoming, this in-town, good-value option with traditional island flair is just steps from shops, restaurants, and the ferry dock. Most of the simple but comfortable rooms face a garden and small swimming pool and others look out to sea, and a seaside terrace is a nice spot to enjoy a drink while watching the comings and goings in the harbor.

Skala. www.captains-house.gr. ☎ **22470/31793.** 17 units. 85€–120€ double. Rates include breakfast. **Amenities:** Bar/cafe; pool; garden; terrace; free Wi-Fi.

Patmos Garden ★★★ Get away from it all in this flowery garden at the far inland edge of Skala. Handsome, well-furnished tile-floored bungalows, most with one or two bedrooms and all equipped with kitchens and comfortable outdoor spaces, are grouped around a large swimming pool. You'll give up sea views, but most units have memorable outlooks up to Hora, which looks from here like a swash of white huddled beneath the fortresslike gray monastery. Town is a 10-minute walk away, as is the Cave of the Apocalypse, and the friendly proprietors offer transfer to and from the port. Do not confuse this place with the unaffiliated Patmos Garden Sea.

Skala. patmos.tripcombined.com. ☎ **22470/32895.** 15 units. 60€–140€ double. **Amenities:** Kitchens; bikes for rent; pool; free Wi-Fi. Pool closed mid-Oct to late Apr.

Petra Hotel and Apartments ★★★ The Stergiou family has created a luxurious haven on a hillside above Grikos Bay, lavishing personal attention

The Petra Hotel and Apartments offer stylish accommodations above Grikos Bay, near Hora on Patmos's southeast coast.

on their guests in spacious, beautifully appointed rooms and one- and two-bedroom suites that exude island style. Most quarters have balconies or open to terraces furnished with pillowed divans for some Greek-island-style lounging. The main veranda is another gracious living space, where snacks and casual meals are served. A pool sparkles off to one side, and sandy Grikos beach is just at the bottom of the lane. The Stergious are devoted to helping guests enjoy the best of the island and also offer a four-bedroom villa in Hora.

Grikos. www.petrahotel-patmos.com. ℰ **22470/34-020.** 13 units. 200€–350€ double. Rates include breakfast. **Amenities:** Restaurant; bar; room service; pool; free Wi-Fi. Closed Oct -May.

Porto Scoutari★★ Elina Scoutari has created her version of paradise on a hillside above the sea just outside Skala, where she attentively hosts guests in spacious, sparkling white, tile-floored accommodations embellished with nautical prints and antiques. Guest rooms, a beautifully furnished lounge filled with fine art and bibelots, and a casual dining area all face the large, deep swimming pool, surrounded by well-tended grounds. There's also a gym and small spa, as well as a wedding chapel, in keeping with the romantic aura of this choice spot.

Outside Skala center. www.portoscoutari.com. ℰ **22470/33123.** 30 units. 110€–190€ double. **Amenities:** Restaurant; bar; pool; spa; free Wi-Fi. Closed Nov -Apr.

Where to Eat on Patmos

On the main square in Skala, **Koumanis Bakery** (ℰ **22470/32894**) is the island's favorite stop for bread, cookies, and cakes, serving cheese pies that are ideal as a light lunch.

Benetos Restaurant ★★★ MEDITERRANEAN Benetos Matthaiou and his American wife, Susan, deliver one of the island's nicest dining experiences, on the terrace of a Tuscan-style villa at the edge of the sea, between

275

Skala and Grikos. Fresh ingredients come from gardens on the property and nearby waters, and show up in such dishes as shrimp in phyllo, fresh fish baked in a citrus sauce, or a simple arugula salad with shaved Parmesan. The couple spends winters in Miami, so a bit of international flair infuses the menu as well—ribeye, a rarity on a Greek island, is grilled to perfection. Carefully chosen wines accompany the meals, served at just a dozen or so tables; reservations are a must in summer season. Benetos also has a casual cafe in Hora (© **22470/34537**), serving drinks and light fare Tuesday through Sunday from 9am to 11pm, April through September.

Sapsila. benetosrestaurant.com. © **22470/33089.** Main courses 9€–26€. June–Sept Tues–Sun 7:30pm–midnight.

Taverna Livadi Geranou ★ GREEK/SEAFOOD Tables beneath shade trees on Livadi Geranou beach set the scene for an authentic island dining experience, in which saganaki and fresh spreads lead up to platters of fresh fish or grilled meats. A white chapel rising next to the blue scene completes the postcardlike setting. Livadi Geranou is on the northwest corner of the island, about 12km (6 miles) from Skala.

Llvadi Geranou, beyond Kambos Bay. No phone. Main courses 9€–18€, fish priced by the kilo. Daily 10am–11pm. Closed Oct–Apr.

To Chiliomodi ★★★ SEAFOOD The island's top spot for seafood is a fish shop that expands into a couple of plain taverna rooms, in good weather adding tables on a back lane and a breezy rooftop terrace. You'll be invited to step inside to see the cook/fisherman's morning catch, accompanied by a nice selection of mezes and salads brimming with bounty from the island gardens.

Behind the port, Skala. © **22470/34179.** Main courses 10€–18€. Daily 6am–1am, shorter hours in winter.

Tzivaeri ★★ GREEK One of Skala's most popular evening spots accommodates diners on a summertime sea-view balcony and in a cozy interior room. A large selection of small plates will delight vegetarians—dolmades, red peppers stuffed with feta, boiled greens, leek pie, fried eggplant, and huge salads—with moussaka, grilled lamb chops, and other taverna favorites also on tap. Live music (the name comes from a popular Greek folk song) is performed most summer evenings.

Skala. © **22470/31170.** Small plates from 5€. Wed–Mon 6pm–2am. Weekends only in winter.

Exploring Patmos

The island's two most extraordinary sights are perched on a hillside above Skala: the **Cave of the Apocalypse** and the **Monastery of St. John.** Surrounding the monastery, medieval **Hora** is a labyrinthine maze of whitewashed stone homes, shops, and churches.

Off season, opening days and times for the cave and the monastery are unpredictable (times listed below are for peak season, May–Aug), so if you

arrive then, consult the tourist office or a travel agency for the current open hours. Appropriate attire is required: Women must have covered shoulders and might be turned away in shorts that are considered too revealing.

In the very cave where St. John the Divine had his visions of the Book of Revelation, visitors can absorb its spiritual aura.

Cave of the Apocalypse ★★

RELIGIOUS SITE Through a cleft in an overhang in this small cave, St. John the Divine (see box, p. 278) is said to have received divine visions, hearing "a great voice, as of a trumpet." He dictated what he heard to his disciple Prochoros, who wrote the messages down using a slope of the cave wall as his desk. These words have come down to us as the Book of the Apocalypse, or Revelation, the last book of the New Testament of the Christian Bible. The cave is now encased within a sanctuary, which, in turn, is encircled by chapels and a 17th-century monastic school. You can take a seat on a stool in the cave and, surrounded by numerous icons and the very stone that served as John's pillow, drink in the site's spiritual aura. An excellent way to prepare for the experience is to bone up on the Book of Revelation.

On the road to Hora. ☎ **22470/31-234.** Admission 3€. Sun 8am–1pm and 4–6pm; Mon–Sat 8am–1:30pm, Tues 4–7pm, Sat 5–8pm, Sun 4–6pm.

Monastery of St. John the Theologian ★★ MONASTERY Towering over the southern part of the island, this formidable medieval monastery, bristling with towers and buttresses, looks far more like a fortress than a house of prayer. Its monks have lived within the thick walls for a millennium, surviving successive waves of pirates and occupiers—Normans, Franks, Knights of St. John, Venetians, Turks, Italians, all the way to the Germans during World War II. In 1088, with a hand-signed land grant from Byzantine emperor Alexis I Comnenus, Blessed Hostos Christodoulos arrived on Patmos to establish what would become an independent monastic state and a great center of learning through many dark centuries. The monastery soon had a fleet of trading ships and vast holdings as far away as Crete and Asia Minor. The skull of Christodoulos rests in a silver case in the main church, while the adjoining **Chapel of the Theotokos** is covered with 12th-century frescoes, some of the monastery's earliest artworks. The **treasury** displays only a few of the monastery's exquisite Byzantine icons, including one said to be by El Greco, alongside vestments and rare books. *Note:* One of the island's many footpaths

THE star saint OF PATMOS

St. John the Divine, also known as John the Apostle or John the Evangelist, is said to have been sent to Patmos in 95 A.D, when he was nearly 90, exiled for preaching Christianity. For 2 years he made his home in a small cave, now known as the **Cave of the Apocalypse** (p. 277). His life on the island was not entirely hermitlike—he sometimes walked around the countryside, preaching and talking with those he met. John, who lived to the ripe old age of 94—outliving his brother, the apostle James, by 50 years—is the only one of the 12 apostles who did not die a violent death. (Judas committed suicide, and the other 10 were martyred.) While some scholars question whether the John who lived on Patmos was indeed the same man as John the Apostle, John is still a powerful presence on the island and continues to attract the faithful by the boatload. Over the centuries, he and his mystical revelations have inspired masterpiece paintings by artists as diverse as Hieronymus Bosch, Titian, and Nicolas Poussin.

leads downhill from the monastery to the Cave of the Apocalypse (see above), an easy and rewarding walk with sea views and fresh herb-scented island air. The stones are rough, so wear thick-soled shoes.

Hora. ☎ **22470/31-234.** Free admission to monastery; 4€ to treasury. Daily 8am–1:30pm, Sat–Sun and Tues 4–7pm.

Patmos Beaches

In the north, the nicest beaches lie along the eastern coastline. **Meloï ★**, just 2km (1 mile) north of Skala, and **Kambos Bay ★**, about 6km (4 miles) north of Skala, offer a much-desired commodity—shade—along with umbrellas and other amenities. Livadi Geranou, about 6km (4 miles) farther west, is fringed with tamarisk trees and similarly shady. At **Livada ★**, 8km (5 miles) northeast of Skala, it's possible to swim or sometimes walk across to **Ayiou Yioryiou Isle;** be sure to bring shoes or sandals, or the rocks will do a number on your feet. The island's south end has two beaches: busy **Grikou Bay ★**, only 4km (2½ miles) south from Skala, and on the island's southwest end, **Psili Ammos ★★★**, an isolated fine-sand cove bordered by cliffs. It's possible to walk to Psili Ammos from the little settlement of Diakofti, about a 30-minute trek on goat paths (wear real shoes). Most people arrive by one of the caiques leaving Skala harbor in the morning and returning around 4 to 5pm. Round-trip fare is about 30€, one-way fare 20€.

Shopping on Patmos

Just behind the main square in Skala, **Parousia** (☎ **22470/32549**) is the best single stop for hand-painted icons and a wide range of books on Byzantine subjects. The proprietor, Mr. Alafakis, is quite learned in the history and craft of icon painting and can tell you a great deal about the icons in his shop and the diverse traditions they represent. Across from the port authority office, the fascinating shop **Selene** (☎ **22470/31742**) sells a highly selective array of

Greek handmade art and crafts, from ceramics to hand-painted Russian and Greek icons to marionettes, some as tall as 1m (3 ft.). The 1835 building is also a work of art, once a storage space for sails and later a boat-building workshop. Admire the shop's extraordinary floor made of handmade stamped and scored bricks, a traditional art on Patmos.

A Side Trip to Leros ★★

Little Leros might be the perfect getaway isle, with good beaches, colorful villages, delightful seaside cafes, even a medieval hilltop castle and some early 20th-century Italian architecture. You can walk just about anywhere, from one pretty village or sandy beach to the other. There's not much in the way of night life, fancy shopping, or luxurious resorts—but that's ideal if you're in search of quiet, relaxed, unspoiled island Greek life.

ARRIVING **Dodekanisos Seaways** (www.12ne.gr) and other smaller companies, including the *Patmos Star* (www.patmos-star.com), link Leros to Patmos and the other Dodecanese islands, with five or six departures and arrivals a day in summer. Boats arrive at Agia Marina on the east coast or Lakki on the west; Agia Marina is probably preferable, as it's closer to most of the hotels and places where you'll want to spend time. **Blue Star Ferries** (www.bluestarferries.com) make the run between Leros and Piraeus several times a week in summer, sailing in and out of Lakki.

Leros is also a popular daytrip destination for excursion boats from Patmos. Trips leave from Skala harbor around 10am and return around 6pm, often with a stop for a swim on Lipsi. Fares are about 25€; you can make arrangements simply by walking along the harbor front. These trips are pleasant but will give you only about 2 hours on Leros, not enough time to see much. You're better off making the trip on your own, booking tickets on a scheduled morning ferry and, if you only have a day to spend, returning that evening.

GETTING AROUND If you're a walker, it's a fairly easy stroll to just about anywhere you want to go on Leros—Agia Marina is only 4km (2½ miles) from Lakki. A bus makes the rounds of the villages, but operates only about 5 times a day in summer and less frequently off-season; check www. leros.gr for schedules. A taxi from Alinda or Agia Marina to Lakki costs about 8€. Several agencies rent cars and motorbikes, if you find you need motorized transport.

WHERE TO STAY & EAT ON LEROS

The island's top spot for pastry is **Sweet Leros 1897,** in Panteli (℃ **698/415-7024**), serving such favorites as *galaktoboureko* sweet custard in phylo, and *loukoumades* (fried doughnuts garnished with honey and sesame), along with coffees and homemade liqueurs. The shop is open daily 9am to 11:30pm.

El Greco ★★ SEAFOOD/GREEK A dining room that extends from a thatch-roofed terrace right onto Panteli Beach is the setting for a wide range of traditional Greek island classics done with many innovative twists—steamed

mussels in garlic sauce, grilled octopus, fresh sardines, sea bass carpaccio, all accompanied by delicious fresh salads and vegetables.

Panteli. © **22470/25066.** Main courses 8€–25€. Daily 9am–midnight.

La Casa di Colori ★★★ The restored 1907 mansion of the Tsaliki family, islanders who made their fortune in Egyptian cotton, is richly and eccentrically decorated, its design-worthy suites decorated with bright colors and flair. You'll find wood-plank floors, wooden chests, carved armoires, and antique ceiling fans in some, and a cool, tastefully simple island style in others. Furnishings include orthopedic mattresses and, in several suites, deep soaking tubs. Sea and castle views provide a lovely backdrop, and a rich breakfast with a daily-changing menu is served in the garden.

Agia Marina, Platanos. lacasadicolori.gr © **22470/23341.** 5 units. 80€–150€ double. Rates include breakfast. 4-night min. stay mid-July to mid-Sept. **Amenities:** Garden; free Wi-Fi. Closed Oct–May.

Mylos ★★ SEAFOOD/GREEK It's hard to resist the pull of this inviting, decades-old fish taverna, tucked onto a seaside ledge with terrace and glassed-in dining room beside a windmill at the far end of Agia Marina harbor. The tables almost seem to float on the sea, which spreads out in every direction below. Seafood choices include such especially fresh preparations as tuna tartare, octopus carpaccio, and rich pastas laden with shrimp and lobster.

Agia Marina. www.mylosexperience.gr © **22470/24894.** Main courses 9€–20€; some fish by the kilo. Daily 1–5pm and 7–11pm; shorter hours in winter.

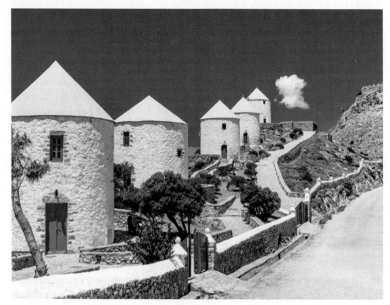

A row of quaint windmills near the Castle of Panagia have been converted to distinctive homes.

Utopia ★★ The name is a bit of oversell, but these basic-but-comfortable studios midway between Alinda and Agia Marina provide an inviting base for your time on the island. Traditionally appointed, stone-floored units have kitchens and dining areas, and some have separate bedrooms. All open to patios or balconies facing a flower-filled garden, and Krithoni Beach is just at the end of the lane.

Agia Marina. ⓒ **694/451-4883.** 16 units. 50€–55€ double. **Amenities:** Garden; kitchens; free Wi-Fi.

EXPLORING THE ISLAND

Though it's small and out-of-the-way, Leros was a military hotspot in 1943, when Germans took the island after heavy bombing and shelling; the action inspired the novel and film *The Guns of Navarone.*

The island's dominating show of might is the magnificent 11th-century **Castle of Panagia,** which crowns a stark hilltop on the northeast side of the island. On a ridge just below the high walls are a line of windmills, many quite picturesquely turned into residences. The northeast is where most visitors spend their time. **Alinda** is the closest Leros comes to having a resort, with a long line of sand backed by low-key hotels and beachfront tavernas, but the nearby villages are still atmospheric and authentically Greek. Appealing **Agia Marina,** about 1.5km (about a mile) east along the coast from Alinda, is the port of call for many boats that connect the Dodecanese islands, and its waterfront is lined with shady cafes. Just up the hillside, whitewashed houses merge into **Platanos,** the island capital, where some grand neoclassical edifices surround a lively square. From here the streets, many of them just flights of stairs, drop down to the appealing beach front at **Panteli.**

If you have more than a few hours on the island, you'll probably want to venture farther south and west to see sleepy **Lakki.** In the early 20th century, Italians used the deep natural harbor at Lakki as the base of their naval operations in the Eastern Mediterranean, and Benito Mussolini had broad avenues built, lined with rationalist (a pared-down version of art deco) villas and housing blocks that still lend Lakki an almost surreal, Fellini-esque aura. Examples include the sleek curved façade of the beautifully restored Cine Leros. Above the quiet coves on the bay southwest of Lakki, you can still see World War II military tunnels dug into the cliffs. One is now the **War Museum Tunnel,** filled with trucks, artillery, and other artifacts. A path from there leads uphill to the remains of an acoustic mirror—an early form of radar that reflected sound waves to detect approaching aircraft (curiously, it was believed that vision-impaired people were especially adept at reading these sound waves). The museum is open daily 9:30am to 1:30pm; admission is 3€. The seabed around Leros is still littered with World War II shipwrecks and crashed aircraft, which divers can explore with **Hydrovius Diving Center** (www. hydrovius.gr; ⓒ **22470/26025**) at Krithoni, between Agia Marina and Alinda.

CRETE

Nikos Kazantzakis, celebrated Cretan author of *Zorba the Greek,* wrote, "The mystery of Crete runs deep. Whoever sets foot on this island senses a mysterious force coursing warmly and beneficently through their veins, sensing their soul beginning to grow." You won't be on the island for too long before you know exactly what he means. You'll feel the island's pull in exotic cities set against bewitching landscapes backed by snow-capped mountains and in the haunting ruins of one of Europe's first civilizations. Resorts are cosmopolitan and mountain villages haven't changed in centuries. It's all here, and oh yes, the food is delicious and the beaches are spectacular.

You have much to see and a lot of ground to cover—the island is big, the largest in Greece—so think in halves. Spend part of your time in the east, maybe in and around sophisticated Agios Nikolas, and explore sights that, aside from the soft sands of the Elounda Peninusla, include the Minoan Palace of Knossos and the treasure-filled archaeological museum in Heraklion. Then head west to the romantic Venetian-Ottoman cities of Rethymnon and Chania to savor the beaches at Balos and Elafonisi and hike through the Samaria Gorge. You'll also want to cross forested mountain slopes and dip south from time to time to Myrtos, Sougia, and other remote spots on the unspoiled south coast. You'll soon understand what that dance at the end of *Zorba the Greek* is all about—there's a lot to celebrate on Crete.

ESSENTIALS

Arriving

BY PLANE **Aegean Airlines** (www.aegeanair.com; ✆ **801/112-0000**), **Olympic Airways** (www.olympicairlines.com; ✆ **210/926-9111**), and **Sky Express** (www.skyexpress.gr) operate daily flights between Athens and Crete's two main airports, in **Iraklion** and **Chania.** It's a 50-minute flight to either airport. Sky Express also offers at least one direct flight a week between Iraklion and Rhodes and limited summer service to and from Paros. Many carriers also operate mostly summer service between Iraklion and Chania, as well as connections to European hubs outside of Greece, making it

A popular way to travel to Crete involves overnight sailings from Piraeus on comfortable, well-equipped large boats.

possible to fly directly to Crete from London, Paris, Frankfurt, and other cities (for more information, see p. 240 and p. 408).

BY BOAT Boats from Piraeus regularly serve the island's main ports in Iraklion and Chania, with daily sailings on **ANEK Lines** (www.anek.gr) and **Minoan Lines** (www.minoan.gr). While the lines offer some daytime sailings in season, most travelers opt for 9- to 10-hour overnight journeys, on well-equipped ships with berths, lounges, and dining rooms that usually arrive around 6am. There's also a long, between 12 and 20 hours, crossing from Piraeus to Sitea once a week on **Aegeon Pelogos** (www.ferries.gr). In summer, ANEK ferries also run about twice a week between Irakilon and Rhodes (stopping en route at the islands of Karpathos, Kassos, and Khalki). **Minoan Lines, Hellenic Seaways** (hellenicseaways.gr), **Seajets** (www.seajets.gr), and other lines link Iraklion with many Cycladic islands (Ios, Milos, Mykonos, Naxos, Paros, and Santorini). In high season, occasional cruise ships from Italy, Cyprus, and Israel put into Iraklion. For ship schedules and other details, go to www.gtp.gr and www.greekferries.gr.

Getting Around Crete

Crete is a large island, and most visitors prefer to tour it by **car.** The five largest cities are all on the north coast—from west to east, Chania, Rethymnon, Iraklion, Agios Nikolaos, and Sitea—all within easy driving distance of each other. The **National Road,** three lanes wide in a few places, skirts the north coast, providing a fast way for cars and buses to travel from one end of the island to the other. It's 270km (162 miles), a 4-hour drive, between Chania in the west and Sitea in the east. It's 72km (43 miles), about 1 hour, between Chania and Rethymnon; another 78km (47 miles), 1 hour and 15 minutes, from Rethymon to Iraklion; 69km (41 miles), 1 hour, between Iraklion and Agios Nikolaos; and 70km (42 miles) between Agios Nikolaos and Sitea.

North-south distances range between 60km (37 miles) and 12km (7 miles), so sights on the south coast are rarely more than an hour's drive from the north. Rental agencies abound at both major airports and in the larger town centers. Rentals begin at about 45€ a day in summer for a small car with manual transmission. Insurance is usually included, usually with a 500€–900€ deductible.

Moped and **motorcycle rentals** are also popular, but be careful: Injuries are common among even experienced riders navigating chaotic urban traffic, and mountain roads can be dangerous, with few shoulders but lots of potholes and gravel. Helmets are required by law. Expect to pay about 30€ a day.

Buses on Crete are cheap, relatively frequent, and connect to all but the most isolated locales. The downside is that many bus schedules to remote destinations cater to locals, not tourists, with service only in the early morning and late evening. The long-distance bus system is operated by **KTEL,** which serves all of Greece. You can find schedules at **www.e-ktel.com**, **www.ktelherlas.gr**, and **www.cretetravel.com**, or ask a travel agency for bus information.

Visitor Information

Crete Travel (www.cretetravel.com; ☎ **28250/32-690**) is a valuable resource when planning a trip to the island, with a helpful website full of resources.

IRAKLION ★★

Situated in the middle of Crete's well-populated north coast, Crete's capital is not only the largest city on Crete, it's the fifth largest city in all of Greece. Yet many visitors spend only enough time here to visit the remarkable Minoan relics in the Archaeological Museum and the outlying palace of Knossos. Give the city more time and you'll discover a large historic quarter, bounded by massive walls and a harbor, that's filled with animated streets and squares and remnants of the city's Venetian and Turkish past.

ARRIVING Iraklion's **Kazantakis International Airport** (www.heraklion airport.net) is about 5km (3 miles) east of the city along the coast. (Plans are afoot to build a long-delayed new airport at Kasteli, 35km/21 miles southeast, perhaps, or perhaps not, opening in the mid-2020s.) **Aegean** and **Olympic Airlines** operate six or more daily flights to and from Athens, and **SkyExpress** offers daily flights as well, while many European airlines fly in and out during the busy summer season, connecting Iraklion with most major European cities. Major car-rental companies have desks at the airport. A **taxi** into Iraklion costs about 15€; public **bus** no. 1 also connects the airport with the city center (fare 2€); buy a ticket from the driver.

VISITOR INFORMATION A good source for maps and other material, including details on the many Minoan sites across the island, is the **municipal tourist office** (www.heraklion.gr) on Plateia Venizelou (also known as Lions Square, open Monday through Friday, 8:30am to 2:30pm. Among many reliable travel agencies is **Creta Travel Bureau,** 49B Dikeossinis (www.cretatrv. gr; ☎ **2810/300-610**).

GETTING AROUND Bus Station A (℃ **2810/245-019**), across from the entrance to the port, handles an extensive bus network that connects Iraklion with Agios Nikolaos (see p. 300) and the busy coastal resort towns to the east, as well as towns in the southeast; buses also head west from there to Rethymnon (see p. 307) and Chania (see p. 315), operating as often as every half hour during the day. **Bus Station B** (℃ **2810/255-965**), at Chania Gate on the southwest edge of the city, handles buses to and from the south, serving such places as Phaestos and Matala. Go to www.ktelherlas.gr for info on routes. Line 2 buses, connecting central Heraklion with **Knossos,** leave about every 20 minutes from Bus Station A and from Odos Evans in the city center, near the archaeological museum; fare is 1.40€ (pay the driver). Other Iraklion sites are within easy walking distance of one around the city center, much of which is closed to car traffic.

Where to Stay in Iraklion
MODERATE
Capsis Astoria ★★ A prime location across animated Plateia Eleftherias from the Archaeological Museum comes with a rooftop swimming pool and sun terrace, big perks for summertime guests who've spent the day visiting dusty archeological sites. Soothingly contemporary-style rooms are done with handsome wood veneers and colorful fabrics, and all have balconies. A welcoming bar/coffee shop off the lobby keeps long hours.

Plateia Eleftherias. www.capsishotels.gr. ℃ **2810/343080.** 130 units. 95€–130€ double. Rates include breakfast. **Amenities:** Restaurant; bar; pool; free Wi-Fi.

Hotel Galaxy ★★★ Once you get past the airport-modern aesthetic, you'll find extremely comfortable and well-equipped guest rooms furnished with sleek international flair. (They're popular with business folks who use the hotel's conference facilities.) Many rooms have sea-facing balconies, while others overlook a greenery-filled courtyard and huge swimming pool, the largest in Iraklion. The two restaurants include a pastry/coffee shop that's a popular gathering spot. The hotel is just outside the center, on the road to Knossos, but sights are an easy walk away.

Leoforos Dimokratias 75. www.galaxy-hotel.com. ℃ **2810/238812.** 127 units. 100€–150€ double. Rates include breakfast. **Amenities:** 2 restaurants; bar; pool; free Wi-Fi.

Lato Hotel ★★ Everything about this city-center refuge seems designed to soothe—from the pleasing contemporary decor to the Jacuzzi and steam room. A location above the Venetian harbor and fortress ensures sea views from many rooms (be sure to ask for one), most with balconies, as well as from the terrace of the excellent rooftop restaurant, open in summer (see Brilliant; p. 289).

Epimenidou 15. www.lato.gr. ℃ **28102/28103.** 58 units. 90€–125€ double. Rates include breakfast. **Amenities:** Restaurant; bar; free Wi-Fi.

Megaron Hotel ★★★ A long-abandoned office building/warehouse high above the harbor has been revamped as Iraklion's most stylish and luxurious

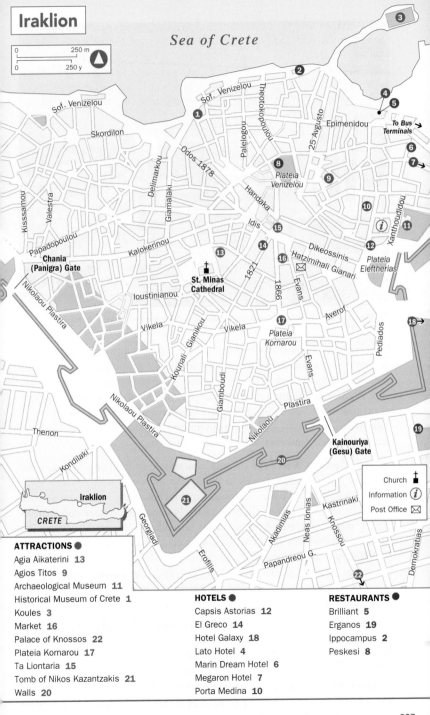

Iraklion

Sea of Crete

0 — 250 m
0 — 250 y

Sof. Venizelou
Sof. Venizelou
Skordilon
Theotokopoulou
Palelogou
Epimenidou
To Bus Terminals
Odos 1878
Delimarkou
Giamalaki
Kisssamou
Valestra
Papadopoulou
Handaka
Idis
25 Avgusto
Plateia Venizelou
Xanthoudidou
i
Dikeossinis
Plateia Eleftherias
Kalokerinou
Chania (Panigra) Gate
Hatzimihali Gianari
Nikolaou Plastira
Ioustinianou
St. Minas Cathedral
1821
1866
Evans
Vikela
Vikela
Plateia Kornarou
Averof
Kounali - Gianikou
Pediados
Giamboudi
Evans
Nikolaou Plastira
Plastira
Nikolaou
Thenon
Kainouriya (Gesu) Gate
Kondilaki
Georgiadi
Eroflis
Akadimias
Neas Ionias
Kastrinaki
Knossou
Papandreou G.
Demokratias

Iraklion
CRETE

Church †
Information *i*
Post Office ✉

ATTRACTIONS ●
Agia Aikaterini **13**
Agios Titos **9**
Archaeological Museum **11**
Historical Museum of Crete **1**
Koules **3**
Market **16**
Palace of Knossos **22**
Plateia Kornarou **17**
Ta Liontaria **15**
Tomb of Nikos Kazantzakis **21**
Walls **20**

HOTELS ●
Capsis Astorias **12**
El Greco **14**
Hotel Galaxy **18**
Lato Hotel **4**
Marin Dream Hotel **6**
Megaron Hotel **7**
Porta Medina **10**

RESTAURANTS ●
Brilliant **5**
Erganos **19**
Ippocampus **2**
Peskesi **8**

The Megaron Hotel's rooftop terrace overlooks Iraklion's harbor and Venetian fortress.

getaway, with stunning results that combine splash with warmth and comfort at a very good value. Public spaces surrounding an atrium include an intimate library; a dramatic rooftop terrace and swimming pool seem to hang over the city. High-ceilinged guest rooms are large, with lots of wood and a sleek mix of contemporary and traditional style. Many have sea-facing balconies.

Beaufort 8. www.gdmmegaron.gr. © **2810/305300.** 46 units. 90€–150€ double. Rates include breakfast. **Amenities:** Restaurant; bar; pool; free Wi-Fi.

Porta Medina ★★ The colorful atmosphere of Iraklion's Venetian and Ottoman historic center comes to the fore in this beautifully restored 19th-century house. Large rooms surround a garden courtyard, some with wooden balconies and tiled patios; all are attractively done with vintage and contemporary pieces, accented by stone walls and other architectural details. The glistening bathrooms have excellent showers. City sights and the port are within easy walking distance.

Evropis 28. porta-medina-boutique.cretetophotels.com. © **695/861-2891.** 5 units. 95€–130€ double. Rates include breakfast. **Amenities:** Garden; free Wi-fi.

INEXPENSIVE

El Greco ★ A basic, good-value choice comes with a plain breakfast and minimal bathrooms, but the location, just steps from Ta Liontaria, can't be beat, nor can the price. Rooms are a bit outdated but most are good-sized, and those overlooking the interior garden are blissfully quiet—a real blessing here in the center of town, where nightlife goes on until dawn.

Odos 1821 4. www.elgrecohotel.gr. © **2810/281071.** 90 units. 60€–65€ double. Rates include breakfast. **Amenities:** Garden; free Wi-fi.

Marin Dream Hotel ★★ A perch on a hillside between the center and the harbor puts these comfortable, contemporary-styled, good-sized rooms within easy reach of the port, bus station, Archaeological Museum, and other city sights, and the extremely helpful staff provides some genuine Cretan hospitality. Request one of the higher-floor rooms with a harbor-view balcony; the sunny rooftop cafe/breakfast room gets great harbor views as well.

Epimenidou 46 12. www.marinhotel.gr. ⓒ **2810/300019.** 50 units. 80€–125€ double. Rates include breakfast. **Amenities:** Cafe; bar; free Wi-Fi.

Where to Eat in Iraklion

Even in Iraklion's urbane restaurants, you're likely to find Cretan specialties such as *marathopita* (fennel pie) and *bougatsa* (sugar-sprinkled cheese turnover), along with plenty of fresh seafood, homemade cheeses and yogurt, and homegrown tomatoes, strawberries, and watermelons. The common Cretan cheese is *mizithra,* creamy and soft.

Brilliant ★★ GREEK The excellent Lato Hotel (p. 286) provides Iraklion's most chic dining experience, in a sleek room accented in shiny black and vibrant colors. The ingredients are basically Greek—and often local Cretan—but they appear in some unexpected combinations like tomato-brie puff pie and goat cheese with prosciutto. The menu changes frequently, with specials offered most nights; meals are accompanied by the best wines from the island. In summer, service moves upstairs to Herb's Garden, a dramatic rooftop overhanging the harbor.

Epimenidou 15. ⓒ **28103/34959.** Main courses 20€–25€. Daily 1pm–midnight.

Erganos ★★★ GREEK/CRETAN In a quiet corner of town about a 15-minute walk south of the center, the emphasis at this homey taverna off the tourist track is on Cretan village cooking. A huge following of city dwellers pack into the stone-walled rooms and airy terraces for slow-roasted lamb shank, homemade pastas, and farm-fresh vegetables grilled to perfection and topped with local olive oil. Pies stuffed with spicy cheeses, fava spreads, dolmades, and other appetizers are meals in themselves. The Kazantzakis grave (p. 296) is just across the street, in a park next to the city walls.

Geor. Georgiadou 5. www.facebook.com/taverna.erganos. ⓒ **2810/285629.** Main courses 8€–15€. Wed–Mon 1pm–1am.

Ippocampus ★★ SEAFOOD/MEZES You'll dine in true Greek fashion at this wildly popular *mezederia,* a standout in a strip of seafood restaurants facing the harbor. You can assemble a meal from a wide choice of small plates that might include zucchini fritters, delicately fried baby squid, and *tzatziki* and other spreads, then move on to servings of mussels in wine sauce and grilled fresh fish. A big crowd of regulars lines up to eat on the seafront terrace or clamorous room inside, so come early for dinner or late for lunch if you don't want to wait.

Leof. Sofokli Venizelou 3. ⓒ **28102/80240.** Small plates 5€–8€. Tues–Sun 12:30–11:30pm.

Peskesi ★★★ CRETAN Set in the stone-walled rooms of a neoclassical mansion (a lemon tree grows in one dining room), Peskesi has become a showcase for traditional Cretan gastronomy. Zucchini flowers stuffed with *mizithra,* the island's creamy soft cheese, and cheese-topped eggplants accompany herb-infused roasts of smoked pork and other dishes that will take you on a culinary tour of the island. Many of the ingredients of a meal here come from the restaurant's own farm. Reservations are recommended.

Kapetan Haralampi 6-8. peskesicrete.gr. ⓒ **2810/288887.** Main courses 9€–18€. Daily 1pm–2am.

CAFE SOCIETY

Dozens of cafes line the narrow streets of Iraklion's historic center between Plateia Eleftheria and Plateia Venizelou. Many are on Korai, a narrow passage just north of Dedalou, the main passageway through the center; the longer the evening wears on the louder you'll have to shout to be heard above pumping dance music and the cacophonous clatter of students from the Iraklion-based University of Crete. Some quieter places surround the Lions Fountain on Plateia Venizelou. Down toward the seafront, **Veneto,** Epimenidou 9 (ⓒ **2810/223686**), affords wonderful views of the harbor and the Venetian fortress through its tall windows and from the terrace.

Exploring Iraklion

Start your explorations at **Ta Liontaria** (Lions Square; p. 294), also known simply as "The Lions" or Fountain Square; officially it's Plateia Eleftheriou Venizelou. At the much-cherished cafe **Kir-Kor** (ⓒ **2810/242-705**), try a *bougatsa,* a flaky pastry filled with sweet cream custard or soft cheese, introduced by Armenian Greeks. It's a good spot for watching passersby hurry to and from the nearby market (p. 293) and Leoforos Kalokerinou, the main shopping street.

The namesake fountain in the center of Ta Liontaria (Lions Square) is a central meeting point in busy Iraklion, the capital and largest city of Crete.

el greco: **CRETE'S STAR ARTIST**

The most famous Cretan artist of all, **Domenikos Theotocopoulos** (1541–1614), best known as El Greco, allegedly studied at the **Agia Aikatarina** monastery school and soon became known for his skillful blending of Byzantine and Western traditions. He left the island forever in 1570 and perfected his distinctive expressionist style in Rome, Venice, and, finally, Toledo, Spain, where he died in 1614. Despite the painter's long exile from his native land, he was forever known as El Greco (the Greek), and he continued to sign his works with the Greek letters of his given name. His only two works in Crete hang in Iraklion's Historical Museum (p. 292).

Agia Aikaterina ★★ MUSEUM Northwest of Kornarou Square next to Agios Minas Cathedral, this small 15th-century church named for St. Katherine houses a museum of icons, most by Cretan artists. Under the Venetians, Crete became an important center of religious art, and many islanders—including Domenikos Theotocopoulos, the future El Greco (see box, above)—were sent to Venice to perfect their craft.

Karterou. iakm.gr. (℗ **2810/336316.** Admission 5€. Mon–Sat 9:30am–7:30pm, Sun 10:30am–7:30pm.

Agios Titos ★ CHURCH This beloved landmark just east of the Loggia honors Crete's favorite saint, Titus, who appears in scripture alongside Paul in Ephesus, Corinth, and Rome; in the 1st century A.D., Paul commissioned him to convert Crete to Christianity and ordained him Bishop of Gortyna, then the Roman capital (see p. 297). Founded in the 10th century, the church was destroyed in an earthquake in 1856 and rebuilt over the next few years as a mosque (Crete was then Turkish). The minaret was removed in the 1920s when the structure was rededicated as a church. A silver vault houses one of Crete's most sacred artifacts, the skull of Titus, who died in A.D. 107 at age 95.

Avgostos 25. Free admission. Daily 8am–7pm.

Archaeological Museum ★★★ MUSEUM The Minoans, whose civilization thrived on Crete some 4,000 years ago, come spectacularly to life in the world's most extensive collection of the artifacts they left behind. This is a mandatory first stop on a tour of Crete's many Minoan sites. Here you'll see large round **seal stones,** inscribed with an early form of Greek

The vast collection of Minoan artifacts at Iraklion's Archaeological Museum gives visitors a crash course in that ancient culture.

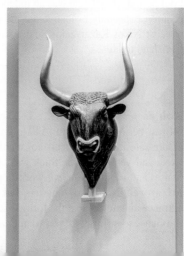

known as Linear B script, that have revealed a wealth of information about the Minoans. (One of the most elaborately inscribed stones—called the **Phaestos Disk,** for the palace near the southern coast where it was unearthed—remains a mystery: It's elaborately inscribed in Linear A, a script predating Linear B that has yet to be deciphered.) Beautiful **frescoes** portray proceedings at a Minoan court; *The Prince of the Lilies* depicts an athletic priest-king, wearing a crown with peacock feathers and a necklace decorated with lilies, leading an unseen animal to slaughter; other works show muscular men and trim women leaping over bulls—either a religious rite or an athletic contest. A whimsical fresco of court ladies in skirts, from the Palace of Knossos (p. 293), earned the nickname Les Parisiennes for its subjects' resemblance to ladies on the grand boulevards of the French capital. As early as 2000 B.C., Minoan craftsmen were producing **pottery** known as Kamares ware; other decorative pieces are made of stone, ivory, and a glass paste known as faience. Many pieces illustrate life in Minoan towns and palaces: One vase depicts a harvest ceremony, another a boxing match. A bare-breasted faience goddess holds writhing snakes, perhaps part of a religious ritual. *Rython,* vases for pouring libations, are carved in the shape of bulls' heads and other elaborate designs—yet more evidence that this ancient culture had a sophisticated flair for living.

Plateia Eleftherias. heraklionmuseum.gr. © **2810/279000.** Admission Apr–Oct 12€, Nov–Mar 6€; combined ticket for museum and Palace of Knossos 20€. Wed–Mon 8am– 8pm, Tues 10am–8pm.

Historical Museum of Crete ★★ MUSEUM Fascinating artifacts from Crete's long colorful past fill the rooms of this neoclassical mansion near the harbor. The *Baptism of Christ* and *View of Mount Sinai and the Monastery of St. Catherine* are the only works on the island by Crete-born artist Domenikos Theotocopoulo, known as El Greco (see box, p. 291). They take their place among ceramics, sculpture, icons, and artifacts from the island's Roman, Byzantine, Venetian, and Ottoman past. Several rooms document the bloody revolutions against Turkish rule in the 18th and 19th centuries and the very brief period when Crete was an independent state in the first years of the 20th century. Especially evocative are the re-creations of the library and study of novelist Nikos Kazantzakis, and a simple farmhouse interior, still typical of the island today.

Sofokli Venizelou. www.historical-museum.gr. © **28102/83219.** Admission 5€. Apr– Oct Mon and Wed–Fri 10am–5pm, Sat–Sun 11am–5pm; Nov–Mar Mon–Fri 9am– 3:30pm, Sat 10am–6pm.

Koules ★★ LANDMARK The Venetians put up this mighty, wave-lapped fortress between 1523 and 1540 to protect Iraklion from attack by sea, and to assure safe harbor for fleets constantly making the 3-week journey between Crete and Venice. Within thick walls topped by rambling ramparts are warehouses and vaulted *arsenali,* workshops where ships were repaired and outfitted, as well as officers' quarters and a prison. An inscription over the main entrance announces that the fortress stands on the remains of a fort erected by the Genoese in 1303; as you wander about, look for three plaques bearing the

symbol of the Venetian republic, a lion. Crete was a prize for Venice, awarded to the republic after Constantinople was sacked in 1204 and the holdings of the Byzantine Empire disbursed. Crete provided Venice with agricultural bounty, timber for shipbuilding, and a strong presence in the Mediterranean. Venice lost control of Crete to the Ottoman Turks in the middle of the 17th century. The view from the ramparts takes in a good swath of coast, the brooding mountains behind, and the inner and outer harbors, jammed today with pleasure craft, fishing boats, and ferries going to and from the mainland and islands.

Old Harbor. koules.efah.gr. ⓒ **2810/246211.** Admission 4€. Apr 16–Aug 31 Wed–Mon 8am–8pm; Sept 1–15 Wed–Mon 8am–7:30pm; Sept 16–30 Wed–Mon 8am–7pm; Oct 1–15 Wed–Mon 8am–6:30pm; Oct 16–31 Wed–Mon 8am–6pm; Nov–Mar Wed–Mon 8am–3:30pm; Apr 1–15 Wed–Mon 8:30am–4:30pm.

Market ★★ MARKET One long outdoor market stretches from Ta Liontaria to Plateia Kornarou. Stalls are piled high with fresh produce grown on the island, along with thick Cretan olive oil and *raki,* the fiery digestive liquor for which every Cretan household has a special recipe.

Palace of Knossos ★★★ ANCIENT SITE Cretan merchant and archaeologist Minos Kalokarinos discovered the remains of the largest Minoan palace complex atop Kephala Hill in 1878, and British archaeologist Sir Arthur Evans began excavating the site in earnest in 1899, soon after Crete was liberated from 3½ centuries of Turkish occupation. Employing an enormous workforce, Evans brought the complex to light in relatively short order. His work showed that the 1,300-room palace was originally built around 1900 B.C., rebuilt after an earthquake around 1700 B.C., and taken over by the Mycenaeans around 1400 B.C. The palace was the center of Minoan culture in every way—not just the court of royalty and an important religious and ceremonial center, but also an administrative headquarters and a huge warehouse where the Minoans stored everything: honey they cultivated; wheat, figs, and barley they grew; elephant tusks and saffron they imported from Africa and the Middle East. As you tour the palace, you'll see ample evidence of these various functions: tall clay jars in which wine, oil, and grain were stored; a splendid grand staircase that ascends from a ceremonial court up four flights through a light well; and the elaborate apartments of the queen, complete with

CRETE'S romeo & juliet

One of Iraklion's busy squares, **Plateia Kornarou** (p. 294) is named in honor of Vitsentzos Kornaros (1553–1617), a Cretan widely acclaimed as one of Greece's greatest poets. Even though you may not be familiar with his epic work, *Erotokritos*—a 10,000-verse romance of love, honor, friendship, and courage that is not dissimilar to *Romeo and Juliet*—you may well encounter segments of the poem in your Cretan travels: The verses are often set to folk music and sung at performances of traditional music. A statue in the square depicts the poem's eponymous hero, Erotokritos, who is on horseback bidding farewell to his beloved, Aretousa.

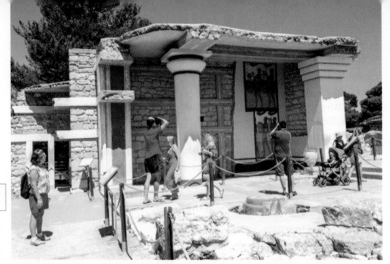

The palace complex of Knossos has been partially reconstructed and repainted—a sacrilege to archaeologists, but valuable to visitors seeking to imagine what life was like in Minoan times.

a bathtub and toilet that would have drained into the palace's complex sewage system. What's missing from Knossos (and other Minoan palaces and towns) are defensive walls. This culture seems to have been peace-loving and unconcerned about invasion—for better or for worse. While the decline of the Minoans remains a mystery, it has been attributed to attacks from outsiders as well as earthquakes and tsunamis after the eruption of the nearby Santorini volcano. Evidence suggests that Mycenaeans from mainland Greece took over the palace and other parts of Crete around 1400 B.C., but by 1200 B.C. they, too, had vanished. Evans rebuilt parts of the palace, reconstructing courtyards and rooms as they were under the Minoans and painting them vibrant colors—a sacrilege to purists that nonetheless richly re-creates Minoan life for today's visitors.

Knossos Rd., 5km (3 miles) S of Iraklion. odysseus.culture.gr. © **2810/231940.** Admission Apr–Oct 10€, Nov–Mar 5€; combined ticket for Knossos and Archaeological Museum 20€. Apr–Aug daily 8am–8pm; Sept 1–15 daily 8am–7:30pm; Sept 16–30 daily 8am–7pm; Oct 1–15 daily 8am–6:30pm; Oct 16–31 daily 8am–6pm; Nov–Mar daily 8:30am–5pm. Take bus 2 from Odos Evans in Iraklion city center or from Bus Station A; fare 1.70€, 2.50€ on the bus.

Plateia Kornarou ★ SQUARE This busy square south of Ta Liontaria is named for poet Vitsentzos Kornaros (see box, p. 293), although many locals refer to the square as Falte Tzami—a corruption of the Turkish Valide Camil, or Queen Mother—the name of a church-turned-mosque that once dominated the square and was demolished in the 1960s. This history is still reflected in the square's two fountains, one Turkish and one Venetian.

Ta Liontaria ★★ SQUARE The busy hub of Iraklion is officially listed as Plateia Eleftheriou Venizelou, for the Crete-born revolutionary and ever-popular prime minister (1910–20 and 1928–32), often considered the father of modern Greece. Any Irakliot, however, refers to the square as Ta Liontaria (the Lions), in honor of the famous Venetian-era **fountain,** adorned with four

leonine symbols of the Venetian Republic. The water that once streamed from their mouths filled a basin ornately carved with mythological figures. The plateia has been the center of island life since the 9th century, when the Arab rulers of the island staged a large slave market here. Today cafe tables fill the square, while the handsome 13th-century **Agios Marcos Church,** named for the patron saint of Venice, houses art exhibitions. The adjacent 17th-century **Loggia**—a replica of architect Andrea Palladio's elegant basilica in Vincenza—was once the seat of Venice's island government and is now Iraklion's city hall.

Walls ★★ LANDMARK The walls that still surround much of old Iraklion are a sturdy remnant of the past amid the untidy sprawl of the modern city. Venetians began building the walls soon after they arrived in the 13th century, eventually erecting a circuit 5km (3 miles) long and up to 40m (131 ft.) high atop a network of defensive ditches dug by the city's earlier Saracen and Byzantine inhabitants. In the middle of the 17th century the Venetian fortifications almost thwarted the vast Ottoman armies—in the longest siege in European history, Iraklion held out for 21 years after the Ottomans overran the rest of the island, finally surrendering in 1669. The Turks allegedly lost 100,000 men, the Venetians 30,000. When the Venetians finally agreed to lay down their arms, they were allowed to leave the city in ships laden with their belongings and important documents. Two elegant gates still punctuate the walls, the

AN ANCIENT tale of woe

Legend has it that the Cretan palace of Knossos was once home to **King Minos,** son of Zeus and Europa. Minos prayed to Poseidon to send him a white bull from the sea as a sign that he had the blessing of the gods to rule; he claimed he would sacrifice the bull in thanksgiving. The bull appeared, but Minos could not part with the beautiful creature; his wife, **Pasiphae,** too, was smitten, and she seduced the bull and gave birth to the **Minotaur.** Minos ordered the architect **Daedalus** to build a labyrinth to imprison this monstrous half-man, half-bull creature.

Meanwhile, after the Athenians killed Minos's son, Androgeos, Minos demanded the city send him seven boys and seven girls every 9 years to be sacrificed to the Minotaur. Minos's daughter Ariadne fell in love with one of these youths, **Theseus,** and she gave him a sword to slay the Minotaur and a ball of red fleece he could unravel to find his way out of the maze.

Minos, blaming Daedalus for Theseus's escape, imprisoned the architect in a tower. Daedalus crafted waxen wings for himself and his son, **Icarus,** so the pair could make a daring airborne escape. Icarus, however, failed to heed his father's advice and flew too close to the sun: His wings melted, and he fell into the azure waters off northern Crete, now known as the Icarian Sea, and drowned.

Nor does the unhappiness end there: Theseus and Ariadne fled Crete and the vengeful Minos, but Theseus abandoned Ariadne on the island of Naxos (p. 188) on their way to Athens. The spurned Ariadne put a curse on Theseus, and under her spell, he changed the sails of his ship to black. As he returned home to Athens, his father, Aegeus, saw the black-sailed ship approaching, assumed his son was dead, and fatally leapt from a cliff into the sea that to this day bears his name.

Chania Gate (also known as the Pantocrator Gate or Panigra Gate) in the west and the **Kainouryia Gate** (Gate of Gesu) in the southeast. At seven points, the walls thicken into arrowhead-shaped defenses known as bastions. The southernmost of these, **Martinengo Bastion,** is the final resting place of Nikos Kazantzakis (1883–1957), the Cretan author of *Zorba the Greek* and other modern classics who was born and died in Iraklion; he lies beneath a simple stone inscribed with his own words: "I expect nothing, I fear nothing, I am free." Irakliots come to pay tribute and take in airy views across the straggling outskirts to the mountainous interior of the island, dominated by the craggy peak of Mount Iouktas, attributed in legend to be the head of Zeus.

Open sunrise–sunset.

Around Iraklion

Acquaplus Waterpark ★ AMUSEMENT PARK You might not see why the slides, tunnels, and pools of this 23-hectare (57-acre) water park outside the hideously overbuilt resort town of Hersonissos are any more appealing than Crete's enticing seas, but your young traveling companions will. At times it seems every youngster in Greece has converged on this popular place. Take the national highway east to Hersonissos and follow signs. For buses from Iraklion Bus Station A, go to www.ktelherlas.gr; transfer at Hersonissos to local bus to water park.

About 25km (15 miles) E of Iraklion, outside Hersonissos. www.acquaplus.gr. 🕿 **28970/ 24950.** Admission 25€ adults, 17€ ages 5–12, kids 4 and under free. Transfer with pickup at hotels in and around Iraklion 7.50€ adults, 4.15€ ages 5–15, kids 4 and under free. May to mid-Oct 9am–sunset.

Cretaquarium ★★ AQUARIUM Jellyfish, sharks, and 2,500 other species of Mediterranean marine life swim through beautiful re-creations of Crete's offshore seascapes. Submersible periscopes and other high-tech gizmos provide fun ways to observe inside the 60 enormous tanks, designed by the Hellenic Center for Marine Research. For bus service from Iraklion's Bus Station A, go to www.ktelherlas.gr.

Outside Gournes, 16km (10 miles) E of Iraklion on national hwy. www.cretaquarium.gr. 🕿 **28103/37788.** Admission 10€ adults, 6€ ages 5–17 and adults over 65, 4 and under free. Apr–Oct 9:30am–7pm; Nov–Mar 9:30am–4pm.

Excursions from Iraklion

East of Iraklion, Crete's coastline is lined with resort towns, from overbuilt Hersonsissos and Malia all the way to prettier Agios Nikolaos (p. 300). Inland toward the southeast, the unique and beautiful **Lasithi Plateau** (p. 298) lies tucked into the mountains. On your way to the plateau, a nice stop is **Krasi,** a mountain village 45km (28 miles) southeast of Iraklion, that surrounds a square shaded by a plane tree said to be 2,400 years old—one of Europe's oldest trees, and also one of the largest, with a trunk diameter of 24m (79 ft.). A cooling mountain spring gurgles from two fountains opposite the tree.

South of Iraklion, a well-traveled road crosses the mountains then drops onto the **Messara Plain,** some of the most fertile agricultural land in Greece, a patchwork of olive groves, vineyards, vegetable fields, and greenhouses. (This part of the south is also easily accessible from Rethymnon, via the road south through the mountain village of Spili.) **Vori,** 63km (39 miles) southwest of Iraklion off the road to Mires, is a pleasant and unspoiled farming village that's home to the island's finest collection of folkcraft, the **Museum of Cretan Ethnology** (www.cretanethnologymuseum.gr; (✆ **28920/91110**). Handsome, well-designed displays provide an intriguing look at farm equipment, basketry, pottery, weavings, and furnishings. Admission is 3€ and the museum is open April through October daily, 11am to 5pm, and by appointment in winter.

On the south coast, besides the beach at **Matala** (see box, p. 297), there's a long stretch of sand backed by Minoan ruins and pine groves at **Kommos,** 3km (2 miles) north of Matala off the road to Phaestos, and **Red Beach,** reached by a 20-minute hike over a headland on the south side of Matala.

Gortyna ★★ ANCIENT SITE Layers of history overlap at this ancient site in the Messara Plain. What began as a small Minoan settlement flourished so well under the Greeks that by the 5th century B.C., citizens were governed by laws they literally set into stone—the Code of Gortyna, on display in a small building at the site. A small Greek theater and other structures remain, but most of what you see at Gortyna is Roman. After the Romans conquered Crete in 69 B.C., after years of bloody warfare, they made Gortyna the administrative center of Cyrenaica, a province that included Crete as well as parts of Northern Africa. Under their jurisdiction, roads, aqueducts, and other public works soon appeared throughout Crete. A Roman bath and theater stand amid the rubble of what was once a city of 10,000. When the Roman Empire divided into East and West regions in the 4th century, Crete came under the rule of Byzantium. The most intact remains, however, belong to the 6th century, when Christianity had gained a stronghold across the island under the Byzantine Empire. The ruins of a magnificent Byzantine basilica, destroyed during 9th-century Arab raids, stand on the site of a simple church erected in

A Beach Resort for the Ages

About 70km (43 miles) south of Iraklion, the pleasantly low-key beach resort of **Matala** may seem bland at first glance—but it has been popular with visitors for millennia. Legend has it that Zeus, taking the form of a white bull, wooed Europa on the beach at Matala. In classical Roman times, Brutus was said to be among the Romans who encamped in the caves that riddle a seaside bluff. These same caves housed hippies during the 1960s and now present a picturesque backdrop to a fine sandy beach. Matala is a nice place to relax, but the surrounding farm villages on the Messara Plain are more authentic—**Pitsidia, Kamilari,** and **Sivas** are geared to farming and laid-back tourism and offer nice tastes of rural Crete. They're especially popular with German visitors, who descend in droves from the north during the summer months to bask in the sun and easygoing lifestyle.

the 1st century by St. Titus, dispatched by Paul to convert the Cretans. Adding to the allure of this storied place is a 3km (2-mile) network of tunnels that runs beneath the ruins. It once supplied stone for the nearby Minoan palace at **Phaestos** (see below), and later served as an ammo dump for the Nazis; some scholars speculate this may have been the labyrinth King Minos built to hold the Minotaur (see box, p. 295).

Outside Agii Deka, on the Iraklion–Mires Rd., 47km (29 miles) SW of Iraklion. odysseus. culture.gr. *②* **28920/3114.** Admission 6€. Apr–Aug daily 8am–8pm; Sept 1–15 daily 8am–7:30pm; Sept 16–30 8am–7pm; Oct 1–15 8am–6:30pm; Oct 16–Mar 8am–6pm.

Lasithi Plateau ★★★ NATURAL WONDER Few experiences on Crete top the sensation of making the final steep, vertiginous ascent over the crest of the Dikti Mountains and getting your first glimpse of the Lasithi Plateau, a high haven hidden some 900m (almost 3,000 ft.) above sea level. At your feet, a tidy patchwork of orchards and fields dotted with windmills spreads out to the encircling hills. A road skirts the rim of the plateau, passing through small villages and the largest town, **Tzermiado.** Residents of the plateau are famous on Crete for their deft weaving and embroidery, executed in front of the fire on winter evenings (even summer nights can be chilly here); they sell these wares to busloads of visitors on day trips from the north coast. You can see some especially fine examples at the **Cretan Folk Museum** in Agios Giorgios; admission is 3€, and it's open April through October, Monday to Saturday 10am to 4:30pm. This plateau has been cultivated since the Minoans, and votive offerings suggest that ancient residents worshiped in the **Psychro Cave,** outside the village of the same name.

Orchards, farms, and windmills dot the beautiful Lasithi Plateau.

According to some legends, the cave was the birthplace of Zeus, hidden here out of reach of his father, Kronos, who had a penchant for devouring his offspring. Today touts and shills crowd the entrance, spoiling the sacred associations, but a descent on ladder-steep, rock-cut staircases into the grotto, with its many stalagmites and stalactites, is still thrilling. Admission to the cave (odysseus.culture.gr) is 6€; the cave is open June to September daily 8am to 8pm and October to May daily 8am to 3pm.

About 70km (43 miles) E of Iraklion. Take national highway E toward Hersonissos, then follow signs up to Lasithi Plateau.

Phaestos ★★★ ANCIENT SITE Italian archaeologists began unearthing the second-greatest Minoan palace about the same time Sir Arthur Evans was

excavating Knossos. Unlike Evans, though, the Italian team left the ruins much as they found them, and the overall results evoke Minoan life even more effectively than reconstructed Knossos. Lavish apartments, ceremonial areas, granaries, and warehouses suggest the importance of the palace complex, probably a key center of trade with Egypt and other parts of northern Africa, just across the Libyan Sea. The **Phaestos Disk**—found encased in a vault of mud brick at the palace during excavations—is one of the great mysteries of archaeology. (It's now on display at the Archaeological Museum in Iraklion; p. 291.) Elaborately inscribed on both sides in Linear A script, it is covered with concentric circles filled with four distinct symbols. Its purpose is unknown, but theories abound, ascribing the disk and its symbolism to everything from a prayer wheel to a board game.

Off Mires–Timpaki Rd., 63km (39 miles) SW of Iraklion. odysseus.culture.gr. ⓒ **28920/ 42315.** Admission 8€. Daily Apr–Aug 8:30am–8pm; Sept 1–15 daily 8am–7:30pm; Sept 16–30 8am–7pm; Oct 1–15 8am–6:30pm; Oct 16–Mar 8am–6pm.

WHERE TO STAY & EAT OUTSIDE IRAKLION

Kalimera Archanes Village ★★★ The village of Archanes, about 15km (9 miles) east of Iraklion, is surrounded by miles of vineyards; it's a good base for exploring Knossos and the other sights, as well as some of the island's leading wineries. Fresh whitewash and blooming flowerboxes give the village's lively lanes and squares of neoclassical houses a tidy appearance. Tucked away in a lush walled garden are four meticulously restored 19th-century stone houses, tastefully and traditionally furnished, with well-outfitted bathrooms and kitchens. Several are two-level; all open to terraces and are enhanced with fireplaces, beamed ceilings, and other architectural flourishes.

Theotokopoulou, Archanes. www.archanes-village.com. ⓒ **2810/752999.** 4 units. 90€–145€ double. Rates include breakfast. **Amenities:** Garden; free Wi-Fi.

Maison Kronio/Taverna Kronio ★★★ Proprietors Vassilis and Christine welcome guests in the best lodgings and finest restaurant on the

Lounging by the pool at Maison Kronio, travelers enjoy views of the Dikti mountains and the Lasithi Plateau.

Lasithi Plateau (p. 298). Spacious, well-equipped and nicely appointed apartments in the countryside outside Tzermiado sleep two to six people and surround a garden and pool, with the Dikti mountains framing the near horizon. The restaurant just down the road serves thick lamb stews, cheese-stuffed pies, and other homey and beautifully prepared Cretan fare. The friendly hosts are keen to advise their guests on how to explore the plateau.

Tzermiado, Lasithi Plateau. www.kronio.eu. ☏ **28440/22375**. 8 units. 50€ double. Rates include breakfast. Restaurant: main courses 5€–10€; daily noon–3pm and 7–11:30pm. Restaurant closed Nov–Mar.

Taverna and Studios Sigelakis ★★ GREEK In the heart of a little farm village near the south coast, an hour's drive from Iraklion, excellent meals, accompanied by friendly service and often a complimentary dessert and homemade *raki,* are served on a terrace or in a stone-walled dining room. Host Giorgios Sigelakis also offers attractively furnished and extremely comfortable studios down the road, with kitchens, living and sleeping areas, and terraces. Set amid well-tended gardens and olive groves, they're a little more sophisticated than you'd expect to find in such rural surroundings, conveniently near Phaestos (p. 298) and other sights in this part of southern Crete.

Sivas, 6km (4 miles) NE of Matala. www.sigelakis-studios.gr. ☏ **28920/42748**. 8 units. 50€ double. Restaurant: main courses 6€–10€; daily 7pm–midnight.

AGIOS NIKOLAOS ★

69km (43 miles) E of Iraklion

Attractive and animated, this busy resort town climbs steep hills above a natural curiosity, small but deep Lake Voulismeni. Just outside of town, the shores of the Elounda Peninsula are lined with some of Greece's most luxurious hotels.

ARRIVING Agios Nikolaos can be reached in about 1 hour by taxi or bus (1½ hr.) from the Iraklion airport. Bus service almost every half-hour of the day (in high season) links Agios Nikolaos to Iraklion; almost as many buses go to and from Sitia to the east, and buses serves other towns in eastern Crete as well. The terminal of the **KTEL** bus line (e-ktel.com; ☏ **28410/22-234**) is in the Lagos neighborhood, behind the city hospital.

VISITOR INFORMATION The enthusiastic staff at the **municipal information office,** in the heart of town at Koziri 1 (☏ **28410/22357**), can provide maps and brochures and help arrange accommodations and excursions. The office is open mid-April to October daily, 8am to 9:30pm. Among many travel agencies in town, **Nostos Cruises,** 30 R. Koundourou, along the right arm of the harbor (www.nostoscruises.com; ☏ **28410/26-383**) can arrange boat tours to the island of Spinalonga (p. 306), or you can book directly with tour boats in the harbor. Free parking is available along the sea, but observe parking signs carefully. A safer bet is to use a private parking lot (about 5€ per day); there's one at the corner of Kyprou and Koziri, just off the square at the top of Koundourou, the main street leading up from the harbor.

Where to Stay in & Around Agios Nikolaos

Agios Nikolaos is surrounded by some of the most luxurious resorts in the world.

EXPENSIVE

Elounda Beach ★★★ One of the first and most famous of the large Greek resorts has been an icon of the good life for generations of international travelers. After half a century, new ways to pamper guests keep emerging. Accommodations come in dozens of variations, from standard-but-luxurious doubles to garden villas with private pools to contemporary-chic bungalows with high-tech gadgetry that would make James Bond feel at home. Some of Crete's most memorable lodgings are the terraced units hanging over the water off to one side of the property. The many amenities include water sports, spa treatments, and a variety of dining experiences, even a fake Greek village, and service that is never less than top-notch.

3km (2 miles) S of Elounda village. www.eloundabeach.gr. ✆ **28410/63000.** 240 units. 270€–600€ double. Rates include breakfast. **Amenities:** 7 restaurants; 4 bars; 2 beaches; multiple pools; tennis courts; watersports; spa; free Wi-Fi. Closed Nov–Mar.

Elounda Mare ★★★ Most of the guests at this idyllic retreat, one of Europe's truly great getaways, come back year after year, and it is easy to see why. Bungalows, many with private pools, are tucked into verdant seaside gardens, and rooms and suites furnished elegantly in traditional Cretan style afford expansive views over the Gulf of Elounda. A sandy beach and all sorts of shady seaside nooks are among the many, many amenities. What most sets this luxurious lair apart is a sense of intimacy and a staff that make guests feel they're on a private seaside estate.

3km (2 miles) S of Elounda village. www.eloundamare.com. ✆ **28410/68200.** 90 units. 250€–500€ double. Rates include breakfast. **Amenities:** 8 restaurants; 3 bars; beach; pool; tennis courts; watersports; spa; free Wi-Fi. Closed Nov–Mar.

Many suites at the luxurious Elounda Mare resort have private pools overlooking the sea.

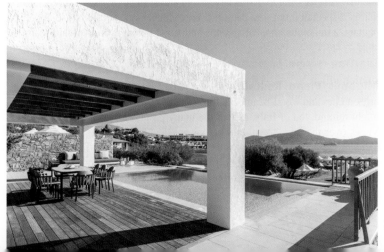

St. Nicolas Bay ★★★ Within walking distance of Agios Nikolaos, this wonderful resort is a world removed, hidden by gardens above a sandy beach. On hand are many of the same coveted amenities you'd find at the famous Elounda Peninsula resorts. Marble-floored rooms and suites, all with balconies or terraces, are awash in comfort, and low-key Cretan-style hospitality prevails. The final word in luxury here are the seafront bungalows with private pools, but you certainly won't feel deprived in any of these soothing accommodations.

Thessi Nissi. www.stnicolasbay.gr. ✆ **28410/25041.** 90 units. 275€–500€ double. Rates include breakfast. **Amenities:** 2 restaurants; 2 bars; beach; pool; watersports; spa; free Wi-Fi.

MODERATE/INEXPENSIVE

Akti Olous ★★ Near the sunken city of Olus, just outside Elounda village, a sandy beach and rooftop pool make this adults-only spot a good-value alternative to the luxury resorts nearby. All of the small but bright and well-furnished rooms are decorated in soothing aqua blues and greens; most overlook the sea and all open to balconies. A restaurant and bar are on a waterside terrace just above the beach, a perfect spot for a sunset cocktail.

Waterfront, Elounda. www.eloundaaktiolous.gr. ✆ **28410/41270.** 70 units. 85€–125€ double. Rates include breakfast. **Amenities:** Restaurant; bar; pool; beach; free Wi-Fi.

Hotel du Lac ★ Though the name conjures up a getaway in the Italian Lakes, the ambiance here is typically Cretan, and half of the clean, airy, no-frills accommodations hang right over Lake Voulismeni. All of the crisply contemporary units have balconies; some are double-size studio suites with kitchenettes. A dining room terrace is set right on the lakeshore.

Octobriou 28. www.dulachotel.gr. ✆ **28410/22711.** 18 units. 55€–65€ double. Rates include breakfast. **Amenities:** Restaurant; bar; free Wi-Fi.

Where to Eat in & Around Agios Nikolaos

Marilena ★★ GREEK/MIDDLE EASTERN The Elounda waterfront is a cluster of garish restaurants, none of which match the excellent cuisine and attentive service offered in this large room and even larger back garden. Grilled fish is a specialty, but you can dine very well on one of the house appetizer platters, a delicious array of spreads and small portions of meat and seafood.

Elounda Harbor. www.marilenarestaurant.gr. ✆ **28410/41322.** Main courses 6€–20€. Daily 11am–midnight. Closed Nov–Mar.

Migomis Piano Restaurant ★★ GREEK/MEDITERRANEAN The brick arches and wood-beamed ceilings in this cliff-edge, open-air dining room might remind you of Italy, as will the many pastas and grilled Tuscan steaks. Views over the lake, town, and harbor are decidedly Greek, however, as are many of the seafood creations and Cretan salads. The gentle tinkling of ivories in the background, along with polished service, put even more shine on a meal here. A cafe next door serves coffee and light meals throughout the day all year.

Plastira 20, Agios Nikolaos. migomis.gr. ✆ **28410/24353.** Main courses 10€–25€. Restaurant daily 1–11pm; cafe daily 8am–2am. Restaurant closed Nov–Mar.

The back garden of Marilena, a top restaurant choice on the Elounda waterfront.

Pelagos ★★ SEAFOOD Flavorful seafood pastas and what many locals consider the freshest fish in town are served in the handsome, simply furnished rooms and garden of this neoclassical mansion near the sea in the heart of town. A good selection of Cretan wines lends another flourish to reliably memorable meals here.

Stratigou Koraka 10 (1 block from waterfront), Agios Nikolaos. ✆ **28410/82019.** Main courses 6€–20€; some fish by the kilo. Daily noon–midnight. Closed Nov–Feb.

Taverna Stavrakakis ★★ GREEK When visiting Krista (p. 305), do yourself a favor and drive the few extra miles to this delightful little village taverna. Many of the ingredients that find their way into salads, *dolmades,* and other dishes are homegrown and served in friendly surroundings.

Exo Laconia, 8km (5 miles) W of Agios Nikolaos. ✆ **28410/22478.** Main courses 4€–8€. Daily 8am–11pm.

Exploring Agios Nikolaos

Wedged between the Gulf of Mirabella and the Sitia Mountains, Agios Nikolaos picturesquely climbs the hills that surround **Lake Voulismeni.** There's a cheerful holiday mood to the crowded waterfront and little lanes of this town, which is small enough that you can walk anywhere you want to go. In high season the streets around the port vibrate with visitors; the main street up from the harbor, **Koundourou,** is a good orientation point. You can swim right in town, from crowded but pleasant strips of sand at **Kitroplatia** and **Ammos.**

Byzantine Art on Crete

Byzantine art flourished on Crete in the 15th century, as artists fled to the island just before and after the fall of Constantinople in 1453. Crete became the center of the Byzantine art world, and hundreds of artists studied and worked in Iraklion (then known as Candia) and elsewhere around the island. As a Venetian possession, Crete met the Republic's need for a steady stream of Byzantine-influenced paintings and icons, but Cretan art was shipped throughout Greece and other parts of Europe as well. Cretan artists also painted frescoes on the walls of churches and monasteries across the island; it's estimated that more than 800 of these beautiful wall paintings remain in place. Some of the most elaborate and best-preserved are those in the **Panagia Kera** in Krista (p. 305). The art of icon painting is kept alive at **Petrakis Workshop for Icons** in Elounda (p. 304), which supplies churches throughout Europe and North America.

Folklore Museum ★ MUSEUM

Colorful everyday items and local crafts pieces, from carved walking sticks to musical instruments, are displayed here alongside Cretan textiles and embroidery. A re-creation of a typical village house, furnished with traditional wooden pieces and kitchen equipment, is especially appealing.

2 Kondalaki. ⓒ **28410/25093**. Admission 2€. Tues–Sun 2–6:30pm.

Lake Voulismeni ★ NATURAL SIGHT

Agios Nikolaos surrounds this tiny, deep lake, lying just inland next to the harbor and ringed with waterside cafes. Legend has it that the lake was a favorite bathing spot for the goddess Athena, and that the waters are bottomless (in fact, the depth has been definitively measured at 65m/213 ft.).

Waterside cafes line the shore of Lake Voulismeni, in the middle of Agios Nikolaos.

Agios Nikolaos Shopping

At **Atelier Ceramica,** Paleologou 28 (www.ateliernicgabriel.com; ⓒ **28410/24075**), you can visit the workshop of master ceramicist Nikolaos Gabriel, who creates authentic and vivid vases. He also carries a line of fine jewelry, made by others to his designs. **Pegasus,** 5 Sfakianakis, on the corner of Koundourou (ⓒ **28410/24-347**), offers a selection of jewelry, knives, icons, and trinkets—some old, some not. **Elixir,** Koundourou 15 (www.elixir.gr; ⓒ **28410/82593**), is piled high with Cretan olive oil, spices, wines, and other local products.

In Elounda, icon tradition is kept alive at the studio/store **Petrakis Workshop for Icons,** on the main square (www.greek-icons.com; ⓒ **28410/41669**). Georgia and Ioannis Petrakis work seriously to maintain this art form—Orthodox churches in North America as well as in Greece buy icons from them.

Day Trips from Agios Nikolaos

Agios Nikolaos is the jumping-off point for the Elounda Peninsula, with its beaches and resorts, and also, continuing along the coastal highway, to the far reaches of eastern Crete.

Elounda ★ TOWN A dramatic hillside road follows the Gulf of Mirabello along the flanks of the Elounda Peninsula to this once quiet fishing village, 11km (7 miles) north of Agios Nikolaos. Some of Greece's most sybaritic resorts now surround Elounda, providing the world-weary with many luxuries—none of which can top the views of the crystal-clear gulf waters and the landscape's stark beauty. Ancient Greeks established the city of Olus on these shores, although several of its structures, including a noted temple to the

mountain goddess Britomartis, were submerged more than 2,000 years ago. Scant remains are now visible beneath the waves off a causeway just east of the village; the waters above the ruins are popular with snorkelers.

Gournia ★★ ANCIENT SITE Often called the Minoan Pompeii, this small town's well-preserved ruins richly evoke everyday life 4,000 years ago. Harriet Boyd-Hawes, an American archaeologist, began to excavate the site in 1901, and her work unearthed olive presses, carpenter's tools, a coppersmith's forge, and other artifacts that yield clues to the enterprises that once kept its 4,000 inhabitants busy. Stepped streets climb hilly terrain and cross two major avenues, running at right angles to each other, that are lined by stone houses with workrooms or shops open to the street. Ladders inside lead to storage rooms below and living quarters above ground level. Gournia is near a narrow neck where Crete is only 12km (7 miles) wide, so the fishermen-trader inhabitants could either embark from the town's harbor or make their way to the south shore and set sail from there.

Just off the national highway. odysseus.culture.gr. © **28410/22462.** Admission 3€. Wed–Mon 8:30am–3:30pm.

Krista ★ TOWN Beautiful woven goods are strung in front of shops surrounding the lovely main square of this mountain village, 9km (6 miles) southwest of Agios Nikolaos. More artistry fills the small 14th-century **Panagia Kera** church, where some of Crete's most accomplished Byzantine frescoes cover the walls of the three naves: Scenes depict the life of Christ, the Second Coming, some fearsome views of damnation, and several lesser-known biblical tales, including the prayer of Saint Anna. Childless Anna, who prayed fervently, promising to bring a child up in God's ways, eventually gave birth to Mary, mother of Christ; accordingly, the colorful little church is popular with women seeking to bear children. The church is in countryside about 1km (less than a mile) north of the town center; it's open Wednesday through Monday 8:30am to 3:30pm; admission is 3€.

Myrtos ★★★ TOWN/BEACH This quiet, relaxed beach town, 50km (30 miles) southeast of Agios Nikolas, is on the undeveloped south coast, where small villages like this are surrounded by farms and wild, mountainous terrain. Myrtos retains much of its traditional appeal but has a scattering of modest hotels and restaurants above a long beach. A single-track road follows the coast 6km (4 miles) west to **Tertsa,** a smaller and similarly pleasant seaside getaway on another long swath of beach.

Palace of Malia ★ ANCIENT SITE Three kilometers (2 miles) east of the atrociously overdeveloped resort town of the same name, this ruined palace was once a beachhead of Minoan administration. The third-largest Minoan palace on Crete is not as overwhelming as Knossos or Phaestos, yet it richly evokes a Minoan settlement. As you walk through the ruins, you'll get a good sense of how the Minoans were both practical and highly ceremonial. Granaries and storerooms surround large courtyards that were probably

used for public gatherings and religious ceremonies; a limestone kernos, a large table etched with hollows in which seeds and other offerings were placed, stands near the central court, once lined with porticos; from there a large staircase ascends to terraces and more ceremonial spaces. Domestic apartments were located off the northern court. The sea laps against the northern side of the settlement, and the brooding Lasithi Mountains loom just a mile or so to the south—a natural setting that lends Malia a sense of timelessness despite the clutter of nearby resorts.

30km (19 miles) W of Agios Nikolaos. odysseus.culture.gr. ⓒ **2897/31597.** Admission 4€. Wed–Mon Apr–Oct 8am–8pm; Nov–Mar 8:30am–3:30pm.

Spinalonga ★★ HISTORIC SITE When the ancient Greeks inhabited nearby Olus, this island in the Gulf of Mirabello was still a peninsula, its seaward flanks fortified to protect the busy shipping channels. These bastions did not thwart Arabic pirates, however, who laid waste to the gulf shores around the 7th century. The region was not inhabited again until the 15th century, when the Venetians came to mine salt in the shallows of the gulf. They cut a channel to create an island, which they named Spina Longa (Long Thorn) and turned into a virtually impregnable fortress. Over the centuries, this barren outcropping became a refuge time and again. When the Turks overran Crete in the late 17th century, Spinalonga was one of the last spots to be conquered, remaining in Venetian hands until 1715; it became a place of refuge for Christians fearing persecution from the Ottoman occupiers. In turn, 200 years later it sheltered Turkish families after the Ottomans were overthrown in the war for Greek Independence in 1866. Another wave of outcasts arrived in 1903–1952, when Spinalonga became a leper colony. (The entrance lepers used is known as Dante's Gate, so fearsome was its reputation.) Once there, the ill received decent treatment, though they were condemned to isolation.

Today the island's spooky ruins and pebbly beaches are popular with daytrippers. Tour boats sail from Agios Nikolaos, Elounda, and Plaka (a fishing village just north of Elounda); the trip from Agios Nikolaos takes an hour and costs about 15€ a person, from Elounda or Plaka it's 15 minutes and 7€. Simply walk along the docks in any of these towns and you'll practically be pulled aboard one of the excursion boats. As boats approach the island, they cruise slowly past the tiny, uninhabited nearby islet of Agioi Pantes to catch a glimpse of the agrimi, also known as the kri-kri, an endangered species of long-horned wild goat endemic to Crete; this little island and the Samaria Gorge (p. 327) are among the last refuges for the shy animals. Try to go early in the morning, leaving no later than 10am, to avoid the midday sun and the crowds that converge on the otherwise deserted island. Back on shore, stop by a newsstand to pick up a copy of *The Island,* a popular novel by Victoria Hislop set in Plaka and Spinalonga.

Vai ★★ BEACH Despite the relative isolation at the far eastern edge of Crete, 100km (62 miles) southeast of Agios Nikolaos, this white-sand crescent backed by Europe's largest palm grove is one of Crete's most popular attractions. Vai attracts beachgoers by the busload, but a cove just over a small

At Crete's eastern end, beautiful Vai Beach attracts sunseekers.

headland to the south is slightly less crowded, and the beach and ruins of an ancient settlement at **Itanos,** 3km (2 miles) north, seem like a world removed. Itanos (odysseus.culture.gr; ✆ **28430/23917;** admission 3€; Wed–Mon Apr–Oct 8am–3pm, Nov–Mar 8:30am–3:30pm) was a thriving settlement for the Minoans and ancient Greeks and Romans, with a harbor for trade with Egypt and the Middle East; it was inhabited until the 15th century, when pirate raids forced inhabitants to move inland. Among the scant ruins of the mostly unexcavated site are the stony outlines of sanctuaries and temples. You can see vestiges of its harbor on the seabed while swimming or snorkeling from the beach.

RETHYMNON ★★

78km (50 miles) W of Iraklion, 72km (45 miles) E of Chania

Old Rethymnon, crowded onto a narrow peninsula jutting into the Sea of Crete, is an inviting warren of Venetian and Turkish houses, mosques, flowery squares, and a massive seaside fortress. The narrow lanes are made for wandering, and a long sandy beach runs right up to the town center. Magnificent mountain and valley scenery, monasteries, and other distinctly Cretan landmarks are also within easy reach of the city.

ARRIVING Rethymnon is about 1 hour from the Chania airport and 1½ hours from the Iraklion airport. Rethymnon is not directly served by ship from Piraeus, but in summer **Seajets** (www.seajets.gr) runs service a couple of times from the Cyclades (including Santorini, Naxos, Paros, and Mykonos) to Rethymnon. **Buses** to and from Iraklion and Chania run as often as every half-hour from early in the morning until midevening. In high season, buses depart Rethymnon as late as 10pm. The **KTEL** bus station (www.e-ktel.com; ✆ **28210/93052)** is at Akti Kefaloyianithon, on the seaside at the city's western edge.

VISITOR INFORMATION The **Tourism Office** (www.rethymno.gr; ℭ **28310/29148**) is on Venizelou, the main avenue that runs along the town beach. In high season, it's open Monday through Friday from 8am to 2:30pm; off-season, hours are unpredictable. There are many private travel agencies in town, including **Ellotia Tours** at 155 Arkadhiou (www.rethymnoatcrete.com). If you're arriving with a car, look for the well-marked public parking lot at Plateia Plastira, at the far western edge, just outside the old harbor. Free parking is also available along the seaside road that skirts the Fortezza.

Where to Stay in & Around Rethymnon
EXPENSIVE

Avli Lounge Apartments ★★ One of Crete's most renowned restaurants (p. 310) also pampers guests in so-called Lounge Apartments that surround the restaurant garden and occupy an old house across the street. Decor has design-magazine flair, combining Greek antiques, Asian pieces, and contemporary styling, all set against stone walls and wood beams; many rooms are enormous, though sizes vary, and come with such amenities as soaking tubs and a rooftop terrace and whirlpool.

22 Xanthoudidou. www.avli.gr. ℭ **28310/58250.** 12 units. 135€–220€ double. Rates include breakfast. **Amenities:** Restaurant; bar; roof terrace; Jacuzzi; free Wi-Fi.

Kapsaliana Village Hotel ★★★ Once part of the holdings of the Arkadi monastery (p. 313), this rustic hamlet of honey-colored stone has been tastefully transformed into a unique getaway, in hilly countryside about 18km (11 miles) above Rethymnon. Houses along the old lanes have been redone with contemporary furnishings in terraced guest rooms offset by stone walls,

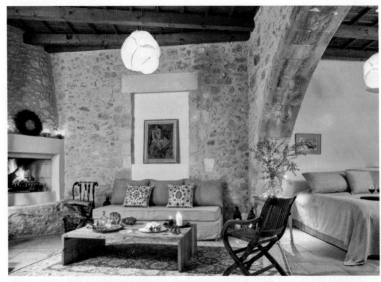

An entire stone-walled village was converted to create the upscale Kapsiliana Village Hotel, a half-hour's drive outside Rethymnon.

arches, and wood beams. Amid well-tended gardens you'll find lounges (one in a former olive mill), an outdoor dining terrace where Cretan specialties are served, and a sparkling pool. Beaches are a short drive away, as is Arkadi and the beautiful Amari Valley (p. 313).

Kapsaliana. www.kapsalianavillage.gr. © **28310/83400.** 22 units. 190€–240€ double. Rates include breakfast. **Amenities:** Restaurant; bar; pool; free Wi-Fi.

MODERATE

Palazzino di Corina ★★ Several of Rethymnon's old Venetian palaces have been converted to hotels, but few with as much panache as this one, set on a quiet back street near the harbor. Rooms, named after Greek gods or goddesses, have different shapes and sizes; all are smartly decorated with a mix of traditional pieces, along with jutting beams and stone walls. Some rooms require a climb up a steep staircase, while others open off a courtyard with a small pool, perfect for a refreshing plunge followed by a cocktail and a meal in the excellent in-house restaurant.

7–9 Dambergi. www.corina.gr. © **28310/21205.** 21 units. 85€–130€ double. Rates include breakfast. **Amenities:** Restaurant; bar; pool; free Wi-Fi.

Vetera Suites ★★ No end of care has gone into creating these distinguished lodgings in a centuries-old Venetian/Turkish house, where much of the old wood and stonework remains. Rooms are painstakingly furnished with antique pieces and tasteful reproductions, while modern conveniences, such as bathrooms and kitchenettes, are tucked into alcoves and sleeping lofts are nestled beneath high ceilings. Breakfast is delicious, but costs extra.

9 Kastrinogiannaki. © **28310/23844.** 4 units. 110€–180€ double. **Amenities:** Free Wi-Fi.

INEXPENSIVE

Fortezza Hotel ★ Many return visitors to Rethymnon swear by this comfortable, convenient choice in a quiet part of town, only a few blocks from the inner Old Quarter and a couple of blocks from the town beach and the Venetian Harbor. Rooms are fairly standard, but nicely furnished with good beds and handsome Cretan-style wood pieces; most have balconies. You'll get a better night's sleep if you ask for a room facing the courtyard and the large swimming pool—a rarity in the Old Quarter, where small courtyards usually accommodate only tiny plunge pools. Ample parking is nearby, making it easy to explore the surrounding coast and countryside.

10 Melisinou. www.fortezza.gr. © **28310/55551.** 52 units. 80€–115€ double. Rates include breakfast. **Amenities:** Restaurant; bar; pool; free Wi-Fi.

Hotel Leo ★★ A former home from 1450 is now a character-filled inn on a quiet side street. Stone walls, wood beams, fine fabrics, and a handsome blend of antiques and contemporary furnishings (including curtained beds) give off a romantic aura, making this an appealing option for honeymooners and couples. Amenities include beautifully equipped bathrooms and a pleasant bar and sidewalk cafe, perfect for sitting and watching town life go by.

Vale and Arkadiou. www.leohotel.gr. © **28310/26197.** 8 units. 75€–100€ double. Rates include breakfast. **Amenities:** Cafe; free Wi-Fi.

Where to Eat in Rethymnon

In Koumbes, a little enclave just west of Old Town past the Venetian fortress, a string of tavernas line the shore, offering drinks, coffee, and seafood meals. Among the most popular is **Tabakario,** 93 Stamathioudaki (✆ **28310/29276**), perched just above the surf crashing onto the rocks below.

Avli ★★★ GREEK/CRETAN This veritable temple to Cretan cuisine, part of the noted hotel (p. 308), introduces you to the freshest island ingredients. Fish and lamb appear in many different guises, as do mountain greens and other fresh vegetables, all served in a romantic garden, an arched dining room, and the narrow lane in front of the hotel. Avli also operates an *enoteca* that offers a wide choice of serious Greek wines and a shop selling local foodstuffs.
Xanthoudidou 22. www.avli.gr. ✆ **28310/28310**. Main courses 15€–30€. Daily 1pm–12:30am.

Kyria Maria ★★ GREEK/CRETAN Excellent plain cooking and friendly service are the hallmarks of this old favorite, where tables are set along a narrow lane near the Rimondi Fountain, beneath a trailing grape vine. Even a simple salad, brimming with garden-fresh vegetables, is a treat, as are the generously sized appetizers and such taverna staples as *pastitsio,* lamb in lemon sauce, and octopus on a bed of orzo. A chorus of caged parakeets and canaries serenades diners.
Moshovitou. ✆ **28310/29078**. Main courses 5€–10€. Daily 9am–11:30pm.

Othonas ★★ GREEK/CRETAN It would be easy to walk by what looks like another Old Town tourist trap, but that would mean missing out on a local institution. Regulars pour in for traditional dishes based on age-old recipes: excellent lamb entrees; pork with honey, madeira, and walnuts; or chicken roasted with garlic and lemon. An attentive staff that seems to have been around for years takes the onslaught of summer visitors in gracious stride.
Plateia Pethihaki 27. ✆ **28310/55500**. Main courses 8€–15€. Daily 11am–1am.

Prima Plora ★★ GREEK/CRETAN It's a 20-minute walk or short cab ride out to this seaside spot, west of the town center, beyond Koumbes. The distance doesn't deter legions of diners from packing into the seafront terrace and lofty, whitewashed dining room, where it's a toss-up as to what is fresher, the vegetables or the seafood. All appear in simple yet wonderful creations, such as grilled shrimp on a bed of orzo or risotto with cuttlefish.
Akrotiri 4, near west entrance to national highway. www.primaplora.gr. ✆ **28310/56990**. Main courses 10€–20€. Daily 1pm–1am.

Exploring Rethymnon

Old Rethymnon is an exotic place, with Venetian palaces, wooden Ottoman houses, mosques, fountains, and a picturesque enclosed harbor. While Rethymnon was inhabited through the ages by Minoans, Mycenaeans, ancient Greeks, Romans, and Byzantines, the historic city that remains today is largely the creation of the Venetians and Turks, who were here for almost 800

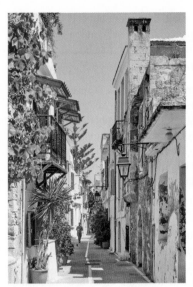

In Rethymnon's historic center, Venetian mansions and Turkish balconies bear witness to its polyglot past.

years, until the late 19th century. For Venetians, the city was an important way station on the sea route between Iraklion and Chania, and they left many landmarks, including the **Rimondi Fountain,** where streams of water gush from the mouths of three lions, symbols of the Republic, and the **loggia,** once the meeting house of Venetian nobility. The **Venetian Harbor,** at the eastern edge of the Old Town, is surrounded by a high breakwater and overlooked by a 13th-century lighthouse. Rethymnon never became a major port for Venice—its harbor was too small for large Venetian galleys—but today a jumble of cafe tables crowd the historic quayside and a fleet of colorful fishing boats are moored chockablock against one another.

Traces of the Turks, who took Rethymnon in 1646, can still be seen in the lattice-work wooden balconies on many old houses, built to ensure the privacy of Muslim women. Rising high above the tile roofs is the minaret of the **Mosque of the Nerantzes,** converted in the Turkish era from a monastery and church. Nerantzes now houses a music school, open only for concerts.

Archaeological Museum ★ MUSEUM What was once part of an ornate Venetian church dedicated to St. Francis, converted by the Turks to a poorhouse, now houses a smattering of ancient artifacts unearthed in caves and other ancient sites around Rethymnon. It lacks the Minoan frescoes and jewels that bedazzle visitors to Iraklion's Archaeological Museum (p. 291), but prehistoric stone tools, figurines, Roman oil lamps, and other finds warrant a passing glance, reminders that Crete has been inhabited for millennia.

Agiou Fragiskou 4. www.archmuseumreth.gr. ⓒ **28310/54668.** Admission 4€. Apr–Oct Wed–Mon 10am–6pm; Nov–Mar Wed–Mon 10am–3:30pm.

Fortezza ★★ HISTORIC SITE Rethymnon's most prominent landmark rises next to the sea on a high promontory at the northern end of the Old Town. Ancient Greeks built a Temple of Artemis and a Sanctuary of Artemis on the hill, and the Venetians erected a small fortress that proved useless in defending the city against pirates who attacked with 40 galleys in 1571. After that, the Venetians rebuilt the fortress with a labor force of more than 100,000 conscripted Cretans, but the thick walls, bastions, and embrasures were also unable to stop the Turks who overran Rethymnon in 1646. The vast rock-strewn space is now overgrown and barren. Inside the massive battlements are two simple churches, a mosque, and several former barracks (which in later

years became the town brothels). Every fall, the forlorn atmosphere is enlivened by musical and theatrical performances of the Rethymnon Renaissance Festival (www.rfr.gr; contact tourist office, p. 308, for details).

At the edge of Old Town. ✆ **28310/28101.** Admission 4€. Daily 8:30am–7pm.

Historical and Folk Art Museum ★ MUSEUM A restored Venetian mansion is the setting for beautiful basketry and hand-woven textiles, along with farm implements, traditional costumes, and old photographs that pay homage to Cretan traditions. These well-displayed collections are not merely a repository of the past: Many items—from lyres and other musical instruments to embroidery fashioned from techniques that date back to the Byzantines—are still a widespread part of island life.

30 Vernardou. ✆ **28310/23398.** Admission 4€. Mon–Sat 10am–4pm.

HIT THE BEACH

East of the Old Town, Rethymnon stretches along several miles of sandy beach. In recent years this asset has turned Rethymnon into a package-tour magnet, with new-built hotels and apartments lining the waterfront. This strip is not terribly attractive, but the sand and water are clean and welcoming. Much of the beach is taken up by concessionaires, from whom you can rent two beach lounges and an umbrella for about 8€ a day. You can also plop yourself down on the sand for free. West of the city, a patch of relatively undeveloped shoreline stretches for 30km (18 miles) to **Georgioupolis,** a low-key resort with miles of sandy beach and shallow waters popular with families. The national highway follows the coast much of the way, with many pullouts where you can find an isolated stretch to lay in the sun and swim.

Shopping in Rethymnon

Rethymnon's lanes are crowded with souvenir shops: Standouts include Nikolaos Papalasakis's **Palaiopoleiou,** Souliou 40, crammed with some genuine antiques, old textiles, jewelry, and curiosities; and **Avli Raw Materials,** at Xanthoudidou 22 (part of the Avli hotel and restaurant fiefdom; see p. 308), an enticing stockpile of olive oils, spices, herbs, wines, cheese, and other Cretan products. A rewarding stop on a visit to the Arkadi Monastery (see below) is the town of **Margarites,** the island's center for ceramics and pottery. One of the most venerable workshops is **Tsikalario,** at the edge of the village (tsikalario.gr; ✆ **28340/23296**), using age-old techniques in creating the many wares on display.

Day Trips from Rethymnon

Many travel agencies arrange tours to sights around Rethymnon. You can explore the countryside on foot with one of the excellent excursions from the **Happy Walker ★★★**, Tombazi 56 (www.happywalker.com; ✆ **28310/52920**), which provides in-town pickup for day hikes in the surrounding mountains and gorges, as well as multiday hikes on Crete and elsewhere in Greece.

Amari Valley ★★★ NATURAL LANDSCAPE Some of the island's most beautiful rural scenery lies in this highland valley just south of Rethymnon. As you travel the narrow roads, you'll pass through small villages, come upon Byzantine churches, and be surrounded by vineyard- and orchard-covered mountain slopes and the ever-present tinkling of goat bells. You'll need your own car to see the valley, along with a good map. You'll find tavernas and cafes in some villages, but you won't find many English speakers.

From Rethymnon, take the beach road east 2km (1 mile) to Perivolos; veer south on the Prasies road and follow it for about half an hour to Apostoli, then east to the village of Thronos. Stop into the village church, decorated with 14th-century frescoes and, on the exterior, a mosaic from a 4th-century Byzantine church that originally stood on the spot. A path from the village center leads to Sivrita, an early Greek settlement that is now being excavated; rough and unpolished, the site gives you the sense that you're stumbling upon an ancient town in its original state. The monastery of Moni Asomaton, about 5km (3 miles) southeast of Thronos, was founded in the 10th century; its present building, dating from the Venetian period, is walled and fortified, a remnant of the fierce resistance to Turkish occupation. Many objects from its 15th-century church are in the Historical Museum of Crete in Iraklion (p. 292). In Amari, about 2.5km (1½ miles) southwest of the monastery, a Venetian clock tower looms over the main square, and the Church of Agia Anna is decorated with some of Crete's oldest church frescoes, from 1225.

Arkadi Monastery ★★★ HISTORIC SITE The ornate Italianate-Renaissance facade of this monastery, built on a high plateau under Venetian rule in 1587, rises out of pretty pastureland in a high valley at the base of Mount Ida. Its serene setting belies a revolutionary past: In 1866, when rebellious zeal against the occupying Turks was at fever pitch across Crete, Arkadi and many other monasteries across the island supported the rebels, and hundreds of men, women, and children took refuge here. A Turkish force of some 15,000 men besieged the monastery, but the Cretans refused to surrender. On November 8, just as the Turks broke through the gate and swarmed the

Mount Ida: Cradle of Zeus

Among the rugged peaks defining the Amari Valley (p. 313), **Mount Ida,** at more than 2,600m (8,530 ft.), is the tallest mountain on Crete. (The mountain is also called Psiloritis, which means "highest" in Greek.) The Greek god Zeus was allegedly raised on Mount Ida in the **Idaian Cave,** where Rhea—Zeus's mother—hid him from Kronos, his father. Kronos had already eaten five of his offspring—Hades, Poseidon, Hera, Hestia, and Demeter—in an effort to outwit a prophecy that one of his sons would rob him of power. Zeus later gave Kronos an emetic that caused him to regurgitate the five siblings, and in turn, they appointed their brother the god of gods. From the village of **Fourfouras,** serious hikers can begin the ascent to Ida's summit, a strenuous climb that takes about 8 hours.

compound, the abbot ordered that the gunpowder store be ignited. The explosion killed hundreds of Cretans and Turks; the event has become synonymous with Crete's long struggle for independence. (Nov 8 is celebrated as a holiday in Crete.) Arranged around the vast rectangular inner courtyard, behind fortresslike walls, are a large church, monks' quarters, and the former refectory, now filled with vestments and other belongings of the community from over the centuries.

25km (15 miles) SE of Rethymnon; take national highway E to Platanes, then marked road to Arkadi. www.arkadimonastery.gr. *©* **28310/83135.** Admission 2€. Daily June–Aug 9am–8pm; Apr–May and Sept–Oct 9am–7pm; Nov 9am–5pm; Dec–Mar 9am–4pm. Bus service from KTEL station in Rethymnon (about every 4 hr.); trip time 1 hr., fare 4€.

Moni Preveli ★★★ HISTORIC SITE One of Crete's most beautiful and beloved monasteries is perched in isolation high above the south coast, due south of Rethymnon. The monastery is more than a thousand years old, but its fame mostly arises from the role it played in 19th- and 20th-century resistance movements—first against the Turks in 1821, when the abbot outfitted rebels to defy the Ottoman occupiers, and then against German invaders in 1941. During World War II, the monastery became a rallying point for the Allies, sheltering British, Australian, and New Zealand soldiers left behind when Germans occupied the island after the Battle of Crete. Many of these men were saved by the monks and by residents of neighboring villages, who hid them until they could be picked up by submarines from the beach below. A **memorial** on a hillside just outside the monastery commemorates the Allied soldiers, Cretan resistance fighters, and others who lost their lives in World War II. Terraces open across olive-studded hill-

The hilltop location of the Moni Preveli monastery made it a strategic refuge for resistance fighters in 1821 and again in 1941.

sides to the Libyan Sea, and **Palm Beach,** reached by a steep path from the monastery grounds, is one of the most beautiful stretches of sand on Crete, enclosed within rocky cliffs and shaded by palms that grow along the Potamas River as it flows into the sea. To get to Moni Preveli from Rethymnon, follow the Agia Galinas highway south through Armeni, veer off just past Pale, and follow signs through the Kourtaliatiko Gorge to Moni Prevelis.

35km (22 miles) S of Rethymnon. www.preveli.org. *©* **28320/31246.** Admission 2.50€. Daily Jun–Oct 9am–1:30pm and 3:30–7pm; Nov–May 9am–5pm.

CHANIA ★★★

72km (45 miles) W of Rethymnon; 150km (93 miles) W of Iraklion

One of the most beautiful cities in Greece, Chania has been settled for nearly 4,000 years. While power changed hands many times over those centuries, much of today's city is Venetian and Turkish. Minarets rise above tile roofs and bell towers, and life still centers around a remarkable harbor built to foster Venice's power here in the southern Mediterranean. Old Chania is cosmopolitan and vibrant, and it makes a handy jumping-off point for excursions into the White Mountains, the west and south coasts, and the Samaria Gorge—some of the most spectacular scenery in Greece.

ARRIVING The **Chania** airport (www.chq-airport.gr; ✆ **28210/83800**) is 15km (10 miles) out of town on the Akrotiri Peninsula. **Aegean Air** and **Sky Express** operate 7 or 8 flights a day between Athens and Chania, and the airport is also served by **Ryanair** and **EasyJet**, with flights to and from hubs around Europe. In summer many other European airlines and charters fly in and out. Public buses meet all flights except those arriving late at night; the trip to the bus station in the city center takes 30 minutes and tickets (2.50€) can be purchased from the driver. A taxi into Chania costs about 20€. The **ferry port** is at Souda, 7km (4 miles) east of the city; in season at least three boats a day arrive from Piraeus, an **Anek** ferry at about 6pm and overnight boats operated by **Minoan** and **Blue Star** at around 6am. Public buses meet the boats for the 20-minute ride into Chania, and tickets, purchased at a kiosk outside the port terminal entrance, are 1.50€. A taxi into town costs about 15€.

GETTING AROUND The main **bus station** in Chania is south of the Old Town, off Plateia 1866 at Kidonias 25 (e-ktel.com; ✆ **28210/93052**). Buses run to and from Rethymnon and Iraklion as often as every half-hour during the day, and the station is also a hub for service to Falasarna, Kissamos, Paleochora, and other towns in the west. You may want to rent a car to explore the surrounding mountains and coasts. Parking is available at several lots on the outskirts of the Old Town; follow signs as you enter town. A machine dispenses timed tickets, usually about .50€ an hour and free for overnight. Read signs carefully, especially for street parking, as many spaces are reserved for residents with permits. You can get anywhere you want to go in town on foot.

VISITOR INFORMATION The **municipal tourist office** at Milonogianni 53, in the New Town near the bus station (www.chania.gr; ✆ **28213/41600**), is open weekdays 9am to 3pm. Of the many travel agencies and tour operators in Chania, some of the most authentic experiences are offered by **Diktynna Travel,** Archontaki 6 (www.diktynna-travel.gr; ✆ **28210/41458**).

Where to Stay in & Around Chania
EXPENSIVE

Ammos Hotel ★★ A relaxed beachside mini-resort about 5 miles west of Chania, Ammos is geared to families, with playful kid-pleasing decor, fish tanks, a playroom, a shallow-ended swimming pool surrounded by lawns, and

best of all, a sandy beach out front. Well-designed rooms and suites have kitchens, breakfast bars, and cushy couches, and can be equipped with high chairs and cribs. The excellent sea-view terrace dining room caters to adult taste, and snacks are also available around the pool and on the beach.

Irakli Avgoula. www.ammoshotel.com. ⓒ **28210/33003.** 33 units. 150€–320€ double. Rates include breakfast. **Amenities:** Restaurant; bar; pool; beach; babysitting; kids' activities; free Wi-Fi. Closed Nov–Mar.

Casa Delfino ★★★ Owner Manthos Markantonakis has transformed his family's 17th-century Venetian palazzo into a remarkable inn that combines luxury with character and genuine hospitality. Many rooms are enormous and all are distinctive, filled with artwork, Cretan antiques, and specially designed contemporary pieces; many are two-level, with sleeping lofts above living areas (make it known when booking if steps are a problem). Guests enjoy a quiet haven amid the Old Town bustle in the mosaic-floored courtyard or a roof terrace overlooking the harbor.

Theofanous 9. www.casadelfino.com. ⓒ **28210/87400.** 20 units. 150€–350€ double. Rates include breakfast. **Amenities:** Cafe; bar; roof terrace; spa; Jacuzzi; room service; free Wi-Fi.

Monastery Estate Venetian Harbor ★★ A former Venetian aristocrat's home on the back lanes of the old town is now a showcase of minimalist design, with low-slung functional furnishings and high-tech lighting. The rather small and austere rooms are offset by centuries-old arches, warm stone walls, and even a section of the city's Roman walls (shown off beneath a glass floor). Hedonistic touches include a genuine Turkish hamam and a small plunge pool that can be curtained off for privacy; the excellent restaurant specializes in Cretan food. The same management operates a rustic retreat in remote Moni, just above Sougia on the southwest coast (p. 314).

40-42 4th Kallinikou Sarpaki Due. www.monasteryestate.com. ⓒ **2821/052184.** 8 units. 130€–300€ double. **Amenities:** Restaurant; bar; pool; spa; free Wi-Fi. Closed Nov–Apr.

Villa Andromeda ★★ The former seaside estate of the Turkish governor of Crete is now a luxurious enclave of eight suites surrounding a garden and swimming pool. Several units spread over two levels, and some face the sea; all are comfortably and tastefully furnished with fine carpets, original art, and excellent beds. You can dip your toes into a small pool in the garden where German general Rommel, aka the Desert Fox, supposedly cooled off when the German High Command stayed here during World War II; there's also a larger pool that's more conducive to doing laps.

Venizelou 150. www.villandromeda.gr. ⓒ **28210/28300.** 8 units. 140€–225€ double. **Amenities:** Bar; pool; free Wi-Fi. Closed mid-Nov to mid-Apr.

MODERATE

Amphora ★★ Plenty of old-world ambience enhances this beautiful 14th-century Venetian mansion just above the outer harbor. Many rooms look across the water and the Old Town to the mountains beyond; many have balconies, as well as kitchenettes. There's a sprawling rooftop terrace, and guests

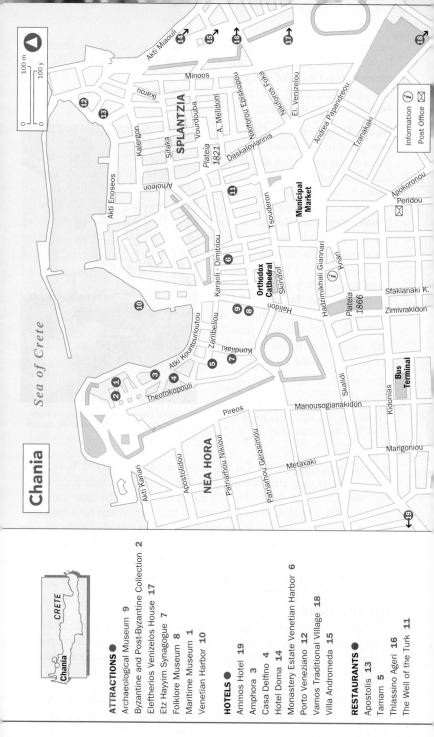

Chania

Sea of Crete

CRETE

Chania

SPLANTZIA

NEA HORA

Minoos
Ikarou
Kalergon
Sifaka
Vourdouba
A. Melidoni
Akti Miaouli
Plateia 1821
Daskaloyiannis
Nikiforos Foka
El. Venizelou
Andrea Papandreou
Tzanakaki
Apokoronou
Peridou
Nikiforou Episkopou
Tsouderon
Arholeon
Akti Enoseos
Karaoli - Dimitriou
Skridlof
Haldion
Hadzimikhali Giannari
Kriari
Plateia 1866
Sfakianaki K.
Zimivrakidon
Skalidi
Manousogianakidon
Marigoniou
Metaxaki
Patriarhou Gerasimou
Patriarhou Nikoiou
Pireos
Theotokopouli
Akti Kountourioutou
Zambeliou
Kondilaki
Apostolidou
Akti Kanari

Municipal Market

Orthodox Cathedral

Bus Terminal

0 100 m
0 100 y

Information ⓘ
Post Office ⊠

317

receive a discount at the hotel restaurant, one of the best on the waterfront. Breakfast, served in a stone-walled room down the lane from the hotel entrance, is not included in room rates.

Theotokopoulou. www.amphora.gr. ⓒ **28210/93224.** 20 units. 50€–130€ double. **Amenities:** Restaurant; bar; roof terrace; free Wi-Fi.

Hotel Doma ★★★ One of the most gracious hotels on Crete, Doma offers simple yet elegant accommodations in a seaside mansion that once served as a consulate and was the owner's childhood home. Antiques and historic photos fill the lounges and top-floor breakfast room, and a garden is accented with architectural bits and pieces. Traditional Cretan furnishings decorate the plain, handsome guest rooms; some face the sea, but the quietest overlook the garden. An airy penthouse suite, tastefully furnished with old Cretan pieces and kilims, opens to view-filled terraces.

Venizelou 124, along waterfront E of town center. www.hotel-doma.gr. ⓒ **28210/ 51772.** 25 units. 110€–140€ double; special rates for long-term stays. Rates include breakfast. **Amenities:** Bar; garden; free Wi-Fi. Closed Nov–Mar.

Traditional Cretan furnishings give the Hotel Doma the air of a private home—the owner's childhood home, in fact.

Porto Veneziano ★★ On the harbor at edge of the Old Town, these newer and extremely attractive premises may not have a historic pedigree, but old-fashioned Cretan hospitality still abounds. Most of the large and pleasantly decorated contemporary-style rooms face the sea and have balconies. Blue color palettes and sea views through large expanses of glass give the impression you're on a ship. Service is deft and personal; coffee, drinks, and snacks are served in a pleasant little garden and on a quayside terrace.

Akti Enosseos. www.portoveneziano.gr. ⓒ **28210/27100.** 57 units. 120€–225€ double. Rates include breakfast. **Amenities:** Cafe; bar; room service; free Wi-Fi.

INEXPENSIVE

Vamos Traditional Village ★★★ Restored houses scattered around Vamos and nearby hamlets in the Apokoronos district west of Chania provide a chance to experience traditional Greek village life, and make a fine base for exploring the towns, beaches, and gorges of western Crete. Houses vary considerably in size, sleeping from two to 10 people; all have been well restored but not overdone, usually with unfussy traditional furnishings, wood and tile floors, and exposed stone and beams. All have terraces and/or balconies and

some have shared or private pools. Vamos has many shops and a choice of good restaurants.

Vamos, 25km (15 miles) E of Chania, 35km (23 miles) E of Rethymnon. www.vamos village.gr. ℂ 28250/22190. 40 units. 50€–70€ double. **Amenities:** Kitchens; some pools; free Wi-Fi.

Where to Eat in Chania

Apostolis ★ SEAFOOD Chania locals have definite opinions about who serves the freshest fish in town, and this brightly lit place next to the harbor is inevitably near the top of the list (**Karnagio** on nearby Plateia Katehaki is another top choice). No need to consult the menu: The waiters will show you the fresh catch, displayed on a bed of ice, then recommend the best way for it to be prepared. *Kalitsounia* (sweet cheese pie), *dakos* (rusk topped with feta and tomato), and other Cretan specialties accompany a meal.

Akti Enoseos. ℂ **28210/43470.** Main courses 7€–20€. Daily 11am–1am.

Tamam ★★ GREEK/MEDITERRANEAN Set in a former Turkish bath (the name refers to *hamam*), this tall tiled room that once housed the cold pools now serves pan-Mediterranean offerings, many from Turkey. Peppers grilled with feta, salads made with mountain greens, vegetable croquettes, and savory kebabs are served in a lane out front in good weather.

Zambeliou 49. www.tamamrestaurant.com. ℂ **28210/96080.** Main courses 5€–14€. Daily noon–midnight.

Thalasino Ageri ★★★ GREEK/SEAFOOD A long walk along the seafront is a good start to an evening at this waterside perch in a district of old tanning factories, about a mile east of the Venetian Harbor. The sound of lapping waves accompanies a meal at one of the tables at water's edge, a perfect setting for grilled fish, cuttlefish with fennel and green olives, or any other specialties; the main dish is the stunning sunset view. Many Chaniots consider this the best spot in town for seafood and a romantic meal, so reservations are a good idea.

Vivilaki 35 Tabakaria. www.thalasino-ageri.gr. ℂ **28210/51136.** Main courses 10€–20€. Daily 7:30pm–midnight.

Well of the Turk ★★★ MIDDLE EASTERN You can find your way to this all-but-hidden restaurant at the heart of the old Turkish quarter, south of the Venetian Harbor, by keeping your eye on the minaret and asking for directions as you go. An enticing selection of Greek and Middle Eastern appetizers, juicy lamb dishes, meatballs mixed with eggplant, *laxma bi azeen* (a pita-style bread with a spicy topping), and other specialties are served on the ground floor of a Turkish house and in a lovely courtyard.

Kalinikou Sarpaki 1–3 (on small street off Daskaloyiannis). welloftheturk.gr. ℂ **28210/ 54547.** Main courses 7€–20€. Daily 6–11:30pm.

Exploring Chania

Thick fortifications once surrounded the landward side of the Old Town. These walls did not ultimately repel the Turks who invaded in 1645, but the

Venetian defenses proved so hard to topple that the invaders lost 40,000 men, an indignity for which the Turkish commander lost his head upon returning to Constantinople. The Turks subsequently fortified the walls. No amount of brick and mortar, however, could withstand the German bombs that rained down upon the city during the Battle of Crete in 1941, sparing only the western and eastern segments that still separate the Old Town from Chania's ever-sprawling newer areas. In the Old Town the Venetian **Firkas fortress** (now the Maritime Museum of Crete; p. 322) guards the narrow entrance into the harbor, protected from the open sea by long sea walls, and the palaces of the city's most prominent 15th- and 16th-century Venetian families line narrow stepped lanes. On Halidon Street is a remarkable-looking assemblage of 12 domes sitting atop a stone box. Under the Turks, this was Chania's largest *hamam* (baths) built on the site of Roman baths, fed by a fresh supply of spring water; the *hamam* in turn became part of the Venetian Monastery of Saint Clara and is now a bronze foundry. Chania's handsome covered market, om the southeastern edge of the Old Town, closed in 2022 for a complete renovation and is not expected to reopen until 2024 or later. Odos Skirdlof, outside the entrance, has dozens of jam-packed little shops selling Cretan leather goods and other wares.

Archaeological Museum ★ MUSEUM Over the ages, Chania and the surrounding lands of western Crete have passed through the hands of the Minoans, Greeks, Romans, Genoese, Venetians, and Turks. Relics of this often-tumultuous past are on display in a modern complex in the former 16th-century Church of San Francesco, in the aristocratic Chalepa district. The most engaging artifacts are utensils, burial objects, and other items that reflect

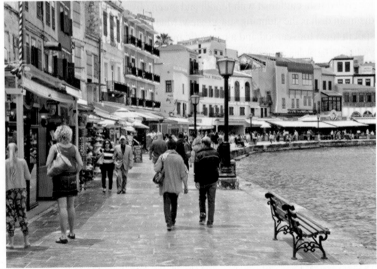

Shoppers stroll along Chania's splendid Venetian Harbor, built to bolster Venice's power in the southern Mediterranean.

CRETE | Chania

8

everyday life: a stone carved with Minoan houses standing next to the sea, a toy dog found in the tomb of a Greek boy, and several colorful mosaics that once carpeted the floor of a Roman town house.

Skra 15. www.amch.gr. ⓒ **28210/23315.** Admission 6€. Tues–Sun 8am–8pm.

Byzantine and Post-Byzantine Collection ★ MUSEUM

Christianity took root as early as the 1st century in Crete, and the Franciscan Monastery of San Salvatore, established by the Venetians next to the Firkas, houses religious works from all the centuries that followed. Many pieces—mosaics from early basilicas, fragments of wall paintings of saints, bronze lamps used during services, and icons—were fashioned when Crete was under Venetian rule, when Byzantine art continued to thrive on the island.

Theotokopoulou 82. odysseus.culture.gr. ⓒ **28210/96046.** Admission 2€. Wed–Mon 8:30am–3:30pm.

Eleftherios Venizelos House ★★ MUSEUM/HISTORIC HOME

The Chalepa district on the east end of Chania was the neighborhood of choice for wealthy and aristocratic Chaniots of the 19th and early 20th centuries. Its shaded streets are lined with mansions, among them the family home of Eleftherios Venizelos. Born here in 1864, he served two terms as prime minister of Greece and was instrumental in gaining independence for Crete; he's often called "the maker of modern Greece" for his influence during Greece's formative years as a nation. The family home reflects renovations that Venizelos and his wife, Elena, undertook when they retired here in the 1920s, filling the home with their furnishings and art. In addition to showing off these personal belongings the house also serves as a library and archive. Venizelos and his son, Sophocles, prime minister in the early 1950s, are buried on a nearby hilltop.

Pl. Elena Venizelou. www.venizelos-foundation.gr. ⓒ **28210/56008.** Admission 4€. June–Sept Mon–Fri 11am–8pm, Sat 11am–6pm; Oct–May Mon–Sat 11am–5:30pm.

Etz Hayyim Synagogue ★★ RELIGIOUS SITE

Beginning in the 17th century, Evraiki, the neighborhood of tall houses and narrow lanes just south of the Firkas, was Chania's sizable Jewish ghetto. German authorities arrested and deported the residents in May 1944, and all but a few drowned when the ship carrying them to Athens for transport to Auschwitz was torpedoed by the British. The Chania community was the last bastion of a Jewish population that had lived in Crete for more than 2,500 years—they are mentioned in the Bible—intermingling successfully over the millennia with the various cultures that occupied the island. Under Venetian rule, many emigrated to Venice and from there to other parts of Europe. This rich legacy is captured in Chania's one remaining synagogue, formerly the Venetian Church of St. Catherine, beautifully restored and reopened in 2000 for the first time since it was destroyed during World War II. During visiting hours the staff guides guests around the synagogue and discusses the surrounding neighborhood and Jewish Crete.

Parodos Kondylaki. www.etz-hayyim-hania.org. ⓒ **28210/86286.** Free admission. Mon–Thurs 10am–4pm, Fri 10am–3pm.

Folklore Museum ★ MUSEUM Crete's rich folk traditions are captured here in artifact-filled re-creations of farm and domestic scenes. You'll find more orderly presentations of folk heritage elsewhere on Crete, but the casual, overstuffed feel of this cramped space—filled to bursting with furniture, farm implements, looms, and traditional clothing—imparts a strong appreciation for a way of life quickly disappearing.

Halidon 46. ⊘ **28210/90816.** Admission 2€. Daily 10am–5pm.

Maritime Museum ★★ MUSEUM The Firkas—the waterside fortress the Venetians built to keep a watchful eye on the sea lanes and their harbor—is the setting for models of prehistoric and Minoan boats and riveting renderings of the great naval battles of the Persian and Peloponnesian wars. The museum's quirky and intriguing collection goes well beyond the long history of Cretan and Greek shipping: Attention is paid to Crete's struggle for independence and unification with Greece, celebrated here when King Constantine hoisted the Greek flag above the Firkas on December 1, 1913. Photographs and artifacts also chronicle the Battle of Crete during World War II. A scale model re-creates the 17th-century Venetian city—step outside onto the ramparts and you'll see that its palaces, sea walls, churches, and other landmarks are remarkably intact.

Akti Kountourioti. mar-mus-crete.gr. ⊘ **28210/26437.** Admission 4€. May–Oct Mon–Sat 9am–4pm; Nov–Mar Mon–Sat 9am–3:40pm.

Venetian Harbor ★★★ LANDMARK The Venetians, accustomed to the beauty of their native city, lavished considerable care when they set about rebuilding the Byzantine town of Chania—renamed *Canea*—to their needs and tastes. First and foremost, they fortified the outer and inner harbors, enclosing the natural inlet with thick **walls** that could be entered only through one well-protected, narrow slip at the foot of a sturdy **lighthouse.** Around the outer harbor rose the palaces of well-to-do officials who reaped considerable profits from the timber for shipbuilding and other raw materials the island supplied, as well as from the lucrative trade routes to which Crete provided easy access. The inner harbor, lined with wharves, was a place of business where goods were stored and ships outfitted in massive *arsenali* (warehouses). The Turks added their own picturesque element to the east side of the harbor—a **mosque** with a large central dome surrounded by 12 smaller domes. It was built as a place of worship for the Janissaries, an elite corps of 277 young Christian men conscripted from throughout the Ottoman empire; the Turks converted them to Islam and trained them as soldiers. (The mosque is open occasionally for temporary exhibitions.) **Kastelli Hill** rises above the mosque; excavations at the top of the hill (closed but observable through a fence) reveal the remains of the Minoan city that early Greeks called Kydonia. Wharves along the harbor at the northern foot of the hill are lined with Venetian *arsenali*. One has been converted to a exhibition space, and another houses a replica of a Minoan ship.

Shopping in Chania

Among Chania's endless parade of shops, two standouts are **Carmela,** 7 Anghelou (✆ **28210/90487**), where owner-artist Carmela Latropoulou shows the work of jewelers and sculptors from all over Greece. Many of the pieces are inspired by ancient works and made according to traditional techniques. Carmela is often on hand to discuss her wares and Greek craftsmanship. At **Roka,** Zambeliou 61 (✆ **28210/74736**), Mihalis and Annie Manousakis weave carpets and other textiles in rich colors on a centuries-old loom.

Day Trips from Chania

The broad Akrotiri Peninsula, just east of Chania, encloses the deep waters of Souda Bay, one of the largest and deepest natural harbors in the Mediterranean. This fact was not lost on the ancient Greek residents of Aptera (p. 324), who built a port on the shores of the bay as early as the 7th century B. C., followed over the centuries by waves of invaders and pirates, all seeking to control that prize harbor. NATO now operates a large naval base on the peninsula, and Chania's airport is here. At the base of the peninsula, the **Souda Bay War**

The Akrotiri Monasteries

At the northern tip of the Akrotiri Peninsula, which juts into the Cretan Sea east and north of Chania, stand three adjacent monasteries. Only a half-hour's drive from Chania, they preserve an aura of sanctity amid huge swaths of olive groves next to the sea. A cypress-lined drive leads to the beautiful Venetian Gate of **Agia Triada,** beyond which are flower-filled courtyards and cloisters, a church, a small museum of icons, and a spine-tingling chamber filled with the skulls and bones of monks, many killed by Turks. A shop sells the monastery's excellent olive oil, some of Crete's best. The monastery is open from 8am to sunset in summer and from 8am to 2pm and 4pm to sunset in winter; admission is 3€. The Venetian Renaissance **Moni Gouverneto** monastery at the northern tip of the peninsula is near the even more remarkable 11th-century **Monastery of Katholiko,** the oldest in Crete. The primitive complex was founded by John the Hermit, one of the island's most popular saints. Tradition has it that John, fleeing Muslim persecution in Asia Minor, sailed across the Aegean on his cloak and came ashore on these lands, where he and 98 followers lived in the caves that riddle a wild, rocky ravine. These caves, accessible via a 30-minute walk on a path from the Gouverneto courtyard, have long been associated with worship. The **Cave of the Bear,** named for the ursine shape of a stalagmite in the cavern, is believed to have been a place of ritual for the Minoans and a sanctuary of Artemis for the ancient Greeks. John spent his last days in a cave-hermitage farther along the path, near the old Katholiko monastery he founded, partially cut out of the rock face and embellished with a Venetian facade. The steep path ends at a little cove. You'll be tempted to dive in, though a monk may be keeping watch to remind you that swimming is not allowed on monastery grounds. Gouverneto and Katholiko are open on Tuesday, Thursday, and Friday 9am to noon and 5 to 7pm, and on Saturday and Sunday from 9 to 11am and 5 to 8pm; the admission fee is 2.50€.

Cemetery holds the graves of some 1,500 Commonwealth soldiers who died in the Battle of Crete and other conflicts on the island in World War II.

Ancient Polyrinia ★ ANCIENT SITE One of the most important Greek city-states of western Crete tops a remote hillside, a half-hour walk from the modern village of Polyrinia through meadows ablaze with wildflowers in spring. Legend has it that Agamemnon stopped at Polyrinia on his way back to Mycenae from Troy. He entered the city to make a sacrifice at the city's famous Temple to Artemis, but the proceedings were cut short when the king saw that his prisoners of war had set fire to his ships, anchored far below. The city still commands a view of much of the northwestern coastline; stone from the temple was used to construct the sturdy 19th-century Church of the Holy Fathers, incongruously standing amid the ruins.

Take national highway from Chania 40km (25 miles) W to Kastelli, then 5km (3 miles) S toward modern Polyrinia. Take path from village to ancient Polyrinia. Free admission. Daily dawn–dusk; site is unattended.

Aptera ★ ANCIENT SITE Founded in the foothills of the White Mountains around 1200 B.C., at the end of the Minoan civilization, Aptera became an important Cretan settlement for 7th- to 4th-century-B.C. Greeks. In that era, Aptera had some 20,000 inhabitants and sent soldiers to aid the Spartans in their war against Athens. Aptera then became an important outpost for the Romans, a trading center that minted more than 75 different denominations of coins. You can still see traces of the Romans' elaborate vaulted cisterns and the ruins of their villas and temples, as well as a small chapel left by the Byzantines who followed them. Aptera fell into permanent ruin sometime after the 15th century, while the Turks built the 19th-century fortress of Izzedin on a promontory at the far northeastern tip of the site. In recent years, the Roman theater has been restored, and once again hosts occasional performances, mostly Greek classics (check with the tourist office in Chania, p. 315, for schedules).

5km (3 miles) SE of Souda. odysseus.culture.gr. ✆ **28210/40095.** Admission 4€. Mid-Apr to Aug daily 8am–8pm; Sept 1–15 daily 8am–7:30pm; Sept 16–30 8am–7pm; Oct 1–15 8am–6:30pm; Oct 16 to mid-Apr 8am–6pm.

Stavros ★ TOWN The sandy beach at this scrappy little village on the north coast of the Akrotiri Peninsula is a pleasant place for a swim before heading back to Chania. It was the setting for an iconic scene in the film *Zorba the Greek*—on this beach, backed by a barren promontory, Zorba teaches the young intellectual, Basil, to dance.

5km (3 miles) W of Gouverneto.

Vrisses and the Gorges ★★ TOWN/NATURAL WONDER This pretty village just off the north coast 35km (21 miles) southeast of Chania rests its fame on thick, creamy yogurt, topped with local honey and savored at cafe tables beneath the shade of plane trees alongside a rushing stream. Two of Crete's most beautiful churches are in the countryside just outside of Vrisses. The 11th-century, honey-colored church at **Samonas** rests atop a

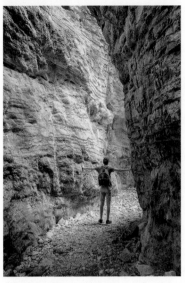

At some points the Imbros Gorge is so narrow, hikers can touch its walls with both hands on either side.

knoll in a green valley, with some well-preserved frescoes of the Virgin and Child inside; the **Church of the Panagia** in Alikambos, surrounded by orange groves, houses one of the finest fresco cycles in Crete, a vivid telling of the Bible story from Adam and Eve to the Crucifixion, painted in 1315. Both churches are usually open daily 8am to 5pm and admission is free, though donations are welcome. From Vrisses, a road heads south across the White Mountains to the south coast, following the fertile **Kare Gorge** into the rugged landscapes of the **Imbros Gorge.** The road follows the cliffs atop the gorges, providing some hair-raising views. You can hike into the narrow canyon from the village of Imbros; on even a short scramble, you can experience the drama of the gorges, flanked by steep cliffs and forested with oak and cypress. If you traverse the gorges' entire 11km (7-mile) length—a few hours of fairly easy walking—you'll emerge on the south coast near Hora Sfakion (p. 326). Many tour operators in Chania and Rethymnon organize walking excursions through the canyon.

Exploring Crete's West Coast

One of the most photographed beaches in Greece, **Balos** ★★ is a remote strip of pinkish sand skirting a turquoise lagoon along the Gramvousa Peninsula, at Crete's northwestern tip. The isolated surroundings are home to falcons, sea turtles, and other rare creatures; the colorful fish schooling along the rocky coastline are a snorkeler's delight. The only land access to Balos is on a dirt track so rugged that car rental companies will not cover damages incurred on the drive. Instead, most visitors arrive by excursion boats from **Kissamos,** 38km (23 miles) west of Chania, with a stop for a swim on **Imeri Gramvousa** islet, overlooking the lagoon and topped with the ruins of a Venetian fortress. As idyllic as Balos might seem, keep in mind that once tour boats start pulling into the lagoon, paradise can quickly become a mob scene. Excursion boats operated by **Crete Daily Cruises** (www.cretandailycruises.com) and other companies depart Kissamos in the morning with late afternoon returns; they charge about 30€. You can purchase tickets from offices along the port. Agencies in Chania sell packages that include bus transfer to Kissamos.

Farther down the west coast, about 60km (37 miles) directly west of Chania, past the end of the national highway, the long white-sand beach of **Falasarna** ★★ is washed by crystal-clear waters and interspersed with boulders. Just behind the beach are the scant remains of an ancient Greek harbor, once

protected within thick walls. Due to sea level shifts over the past 2,500 years, the old stones are now scattered across dry, rugged terrain several hundred feet from shore.

Some 35km (21 miles) south of Falasarna along the west coast road, the beautiful whitewashed monastery of **Moni Chrysoskalitissa** ★ appears like a mirage atop an outcropping above the rugged coast. The name means "golden stair," and legend has it that one of the 90 stairs ascending to the monastery is made of gold, but only those without sin can see it— which may explain why the stair has never been sighted in the 600 or so

Excursion boats run to remote Balos Beach, along a turquoise lagoon protected by a rugged islet.

years since the hermitage was established. As many as 200 monks and nuns once lived at Chrysosokalitissa, but today only two remain. Admission is 2€; it's open daily 9am to 7pm.

Another 5km (3 miles) south of Moni Chrysosokalitissa, at the southwestern corner of the island, lies **Elafonisi beach** ★★. Despite its remote location, legions of summertime beachgoers seek out this beautiful string of little inlets, lined with tamarisk-shaded sands and washed by shallow turquoise waters. Many avoid the overland journey and arrive by boat from Paleochora (p. 328). A sandbar, sometimes submerged, links the shoreline to a narrow islet, where another, less frequented, tree-shaded beach faces the open sea.

Exploring Crete's Southwest Coast

The most efficient way to hop from town to town along the southwest coast is on boats operated by **Anendyk** (anendyk.gr), running from May through October between Hora Sfakion and Loutro, Paleochora, Sougia, and other ports.

Hora Sfakion and Frangokastello ★ TOWNS A rather forlorn-looking little port and fishing village, Hora Sfakion is enlivened in summer by hikers, who emerge here from the Imbros Gorge or pass through en route to the Samaria Gorge (p. 327). The small harbor was the stage for a massive evacuation of Allied troops after Germans took the island in the Battle of Crete; a memorial commemorates the operation, in which Cretan civilians played a large part. You can watch the harbor's comings and goings from a seat in one of many cafes, where the dish to order is Sfakian cheese pie, a crêpe filled with sweet, creamy *mizithra* cheese and drizzled with mountain honey. **Frangokastello,** 10 km (6 miles) east of Hora Sfakion on the coast road, surrounds a mighty Venetian fortress, erected on the flat coastal plain in 1371 as a defense against pirate raids and the rebellious local populace. Admission is 2€ and the fortress is usually open daily 9am to 4pm (hours

HIKING THE samaria gorge

Although it's located on the remote southwestern coast, the longest gorge in Europe is one of the most traveled places in Crete. Every morning from spring through fall, eager trekkers get off the bus at the head of the gorge on the Omalos Plateau and descend the Xyloskaka, the wooden steps, to begin a 15km (9-mile) walk to the sea at Agia Roumeli. While other gorges on the southern coast offer more solitude, none can match the Samaria for spectacle—the canyon is only 3m (10 ft.) wide at the narrowest passage, the so-called Iron Gates, and the sheer walls reach as high as 600m (1,969 ft.). Copses of pine and cedar and a profusion of springtime wildflowers carpet the canyon floor, where a river courses through a rocky bed, fed by little streams and springs. Kri-kri, the shy endangered Cretan wild goat, can sometimes be sighted on the flanks of the gorge, and eagles and other raptors soar overhead. Samaria has been a national park since 1962 (www.samaria.gr), and the only sign of habitation is the now-deserted village of Samaria and a church dedicated to namesake St. Maria. You will, of course, be partaking of this natural paradise with hundreds of other enthusiasts, but the experience will be no less memorable.

Many trekkers set off on organized gorge tours from Chania and Rethymnon. Most tour operators provide a bus trip to the drop-off at the Xyloskaka

entrance; transfer by boat at the end of the hike from Agia Roumeli to **Hora Sfakion, Paleochora,** or **Sougia;** and a return trip from there by bus. Fees begin at about 30€, though at that price you'll be part of a large group.

If you decide to hike the gorge on your own, you can take the morning bus from Chania or Rethymnon to Xyloskala. At the end of the hike, from the mouth of the gorge at Agia Roumeli boats will take you to Hora Sfakion, Sougia, or Paleochora, and from there you can catch a return bus to Chania or Rethymnon.

The gorge is open from May through mid-October, depending on weather conditions; rains raise the risk of flash floods, and winds have been known to send rocks toppling down on hikers. Entry is from 7am to 4pm, and the entrance fee is 5€; you will be asked to show your ticket as you leave the gorge. (This way, park personnel can keep track of numbers and launch a search for errant hikers if necessary.) The trek takes 5 or 6 hours; boulders can make for some rough going in places. Wear sturdy hiking shoes, sunscreen, and a hat, and bring a bathing suit for a well-deserved swim in the sea after the hike. You'll want to bring a snack, but don't load yourself down with extra water—you'll pass several freshwater springs along the trail. Any tourist office on Crete can provide additional information on this phenomenal attraction.

vary). The sandy beach and shallow waters in front of the fortress are especially popular with families.

Hora Sfakion is 72km (47 miles) S of Chania on a well-marked road off the national road.

Loutro ★★ TOWN One of the most scenic villages in Crete, sitting above a perfect semicircle of a bay, remote Loutro is accessible only on foot or by boat (a 3-hr. hike or 45-min. ferry ride from Hora Sfakion). Long-ago Romans, Venetians, and 19th-century Cretan freedom fighters made use of Loutro's well-protected anchorage; today its isolation is a boon for travelers looking for a getaway. Loutro's shady taverna terraces and clear waters are the

CRETE'S rebel HERO

biggest draws, but the village is also a starting point for some rewarding hikes. A half-hour coastal walk leads east to **Sweetwater Beach,** named for the springs that bubble forth from its rocks. A more strenuous half-day hike leads from Marmara Beach, east of Loutro, into the Aradena Gorge, a deep oleander-scented cleft in the White Mountains. The walk ends at the abandoned village of **Aradena,** where half-ruined houses surround a sturdy 14th-century Byzantine chapel.

24km (15 miles) W of Hora Sfakion.

Paleochora ★★ TOWN/BEACH It's been a long time since hippies wandering through southern Europe discovered this once-isolated fishing village, but Paleochora's quiet, out-of-the-way setting is as appealing as ever—a rambling collection of whitewashed houses set on a stubby peninsula, with a

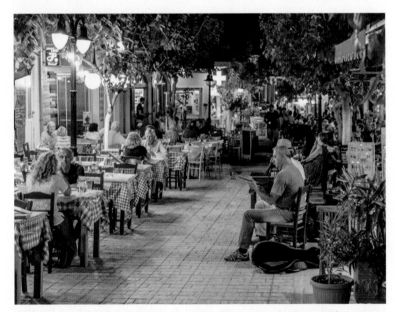

Once a simple fishing village, Paleochora is now a low-key resort town well situated for exploring Crete's unspoiled south coast.

pebbly beach on one flank, a carpet of soft sand on the other, and a pictur-esquely ruined 13th-century Venetian fortress at the end. Some of Greece's most beautiful and unspoiled coastline scenery can be easily explored from Paleochora by foot and boat. A pleasant walk of about 5km (3 miles) into the hills north of Paleochora ends at **Anidri,** where a simple little chapel is beauti-fully frescoed with images of St. George. From there, you can scramble down the steep hillside for a swim in one of several idyllic coves.

75km (47 miles) S of Chania.

Sougia ★★★ TOWN/BEACH Home to no more than a few dozen fami-lies, attractive little Sougia is known for its long, wide, and uncrowded pebbly beach backed by cave-etched cliffs. Sougia is a popular outing from Chania, especially with hikers trekking through the surrounding mountain gorges and beachgoers looking for a laidback getaway. The scant, largely unexcavated ruins of the ancient Greek city of **Elyros** are about 10m (6 miles) north of Sougia, marked off the main route through the mountains. The ancient temple at **Lissos,** a 3km (2-mile) walk west from Sougia along a seaside path (or a round-about drive of more than an hour through the mountains), was dedi-cated to Asklepios, god of healing; a spring that bubbled into a fountain was reputedly therapeutic. Romans sought cures from the waters as well, and their small settlement, of which a few ruined houses remain, catered to ill legion-naires and colonists who made the sea journey to Lissos from throughout Crete.

60km (37 miles) S of Chania.

THE SPORADES

This archipelago of 24 islands came to be when a god threw stones randomly into the sea. Like so much else in Greece, this is a legend, of course, but it's a poetical way to describe these widely scattered little outcroppings across the Aegean Sea, off the northeast coast of the mainland. While most of the islets are uninhabited, four islands have captured attention since ancient times: Skiathos, Skopelos, Alonissos, and Skyros.

Skiathos has the bounty of beaches—among them Lalaria, where sea cliffs amplify a soft incessant rumble of white marble stones rolling in the surf, and Koukounaries, where a perfect crescent is backed by sandy-floored pine groves. Skopelos has an appealing capital, Skopelos Town, and so many churches that it's said that islanders count them, not sheep, to induce sleep. Forested Alonissos, surrounded by pristine waters, is the gateway to the alluring National Marine Park of Alonissos Northern Sporades. On Skyros, hilltop Hora, clinging to a rock high above the coastal plain, is a spectacular sight that alone rewards the effort to reach this remote island; indeed, all of this rugged island seems out of this world, adrift from the other Sporades and the rest of Greece.

SKIATHOS ★

108km (65 miles) from Ayios Konstandinos on the Greek mainland

Philip of Macedonia, Persian king Xerxes, and many occupiers over the centuries probably made less of an impact on this small island than sun-seeking travelers have in the past 30 years or so. Yet Skiathos doesn't entirely lose its identity in the presence of 50,000 visitors a year. Outside Skiathos Town and the resort- and sand-lined south coast, the island retains much of its rugged, pine-clad beauty.

Essentials

ARRIVING The fastest and easiest way to reach Skiathos is by flying from Athens to Alexandros Papadiamantis Airport, 3km (2 miles) outside Skiathos Town. **Olympic Air** (www.olympicair.com) and **Aegean Airlines** (en.aegeanair.com) operate service five times daily from June to September, less frequently the rest of the year. The airport also handles many flights to and from European cities in summer including service from London on **British Airways** (www.britishairways.com). Expect to pay about 10€ for a taxi to

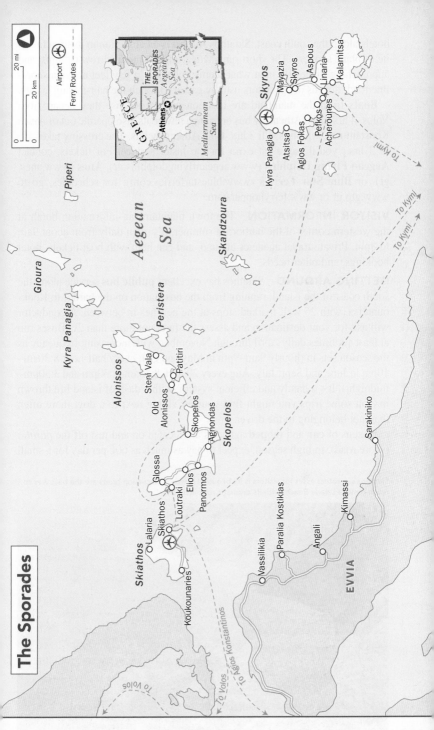

The Sporades

Airport ✈

Ferry Routes - - - -

20 mi

20 km.

GREECE

Athens ★

THE SPORADES

Aegean Sea

Mediterranean Sea

Aegean Sea

Piperi

Gioura

Kyra Panagia

Peristera

Skandzoura

To Kými

Skyros

Mayazia

Skyros

Aspous

Linaria

Kalamitsa

Pefkos

Acherounes

Agios Fokas

Atsitsa

Kyra Panagia

To Kými

To Kými

Alonissos

Stení Vala

Patitiri

Old Alonissos

Skopelos

Skopelos

Agnondas

Glossa

Elios

Panormos

Skiathos

Lalaria

Skiathos

Loutraki

Koukounaries

Sarakiniko

Vassilikia

Paralia Kostikias

Angali

Kimassi

EVVIA

To Volos

To Volos

To Agios Konstantinos

hotels along the south coast. Skiathos Airport is an attraction in itself, a favorite of plane spotters: The short runway is wedged onto a narrow isthmus, and approaching planes fly in at what seems to be only a few feet above a shoreline road; dozens of spectators usually gather to watch the hair-raising events.

Boats from the mainland are less convenient, because they depart from Volos, 4 hrs. from Athens by bus or train; a few boats also operate out of Agios Konstantinos, which is still 3 hrs. from Athens by bus. The crossing takes 1½ to 3 hrs.; you'll pay a bit extra for the faster service. For tickets, contact **Aegean Flying Dolphins** (www.aegeanflyingdolphins.gr), **Anes** (www.anes.gr), or **Blue Star Ferries** (www.bluestarferries.com); for schedules, go to www.gtp.gr or www.ferryhopper.com.

VISITOR INFORMATION The town maintains an information booth at the western corner of the harbor; in summer, it's open daily from about 9am to 8pm. Private travel agencies abound, and can help with boat tickets, hotel bookings, and other needs.

GETTING AROUND Skiathos has excellent **public bus** service along the south coast of the island, running from the bus station on the harbor to Koukounaries, with 26 well-marked stops at the beaches in between. A conductor will ask for your destination and assess the fare, not more than 2€. Buses run at least six times daily April through November, with increasing frequency as the season sets in (hourly 9am–9pm in May and Oct; every half-hour 8:30am–10pm in June and Sept; July–Aug every 20 min. 8:30am–2:30pm and 3:30pm–midnight). It's a handy and efficient system, with a dash of island life thrown in—on some trips you might find yourself sitting next to a dog, more often than not belonging to the driver.

Dozens of **car** and **moped** agencies are located on and just off the *paralia* (shore road). In high season, expect to pay as much as 60€ per day for a small

Skiathos's greatest asset for visitors is its beautiful beaches. Excursion boats are the best way to reach remote Lalaria Beach, with its dramatic rock arches.

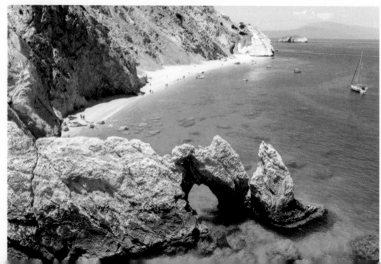

car with manual transmission; weekly and off-season rates are significantly cheaper. Mopeds start at about 35€ per day. Parking around Skiathos Town is tight, but be sure to find a space in a legal zone—police ticket readily.

A car is really not necessary to see the small island—sights on the south coast are easily accessible by bus, and the north coast beaches, adjacent islands, and historic Kastro can be reached by **caiques,** which sail frequently from the fishing harbor west of the Bourtzi fortress (look for signs posting their beach and island tour schedules). An around-the-island tour that includes stops at Lalaria Beach and the Kastro will cost about 50€.

Where to Stay on Skiathos

Most hotels on the island require a minimum stay in July and August, sometimes for as long as a week.

EXPENSIVE

Atrium Hotel ★★★ Tumbling down a pine-clad hillside above Agia Paraskevi, one of the island's nicest beaches, these beautiful and comfortable accommodations range from doubles to lavish maisonettes with endless sea views from terraces and outdoor living spaces. Wood and warm stone are accented with antiques and island-style furnishings, all carefully chosen by the architect family that built and still runs the hotel.

Agia Paraskevi. www.atriumhotel.gr. ℂ **24270/49345.** 75 units. 190€–250€ double. Rates include breakfast. **Amenities:** 2 restaurants; bar; pool; private pools in some units; nearby beach; Wi-Fi (free). Closed Oct to mid-May.

Atrium Villas ★★★ Six beautifully designed glass-and-stone houses are set amid pine forests on the rugged north coast, overlooking the sea from a hillside. It's about as far away from it all as you can be on busy Skitathos. Each of the villas has three or four bedrooms over two floors, along with airy indoor/outdoor living spaces, an excellent kitchen, and a private pool.

North Coast. www.atriumhotel.gr. ℂ **6970/440025.** 6 villas. 350€–550€ double. **Amenities:** Private pools; full kitchens; Wi-Fi (free). Closed Oct to mid-May.

MODERATE

Bourtzi ★★ Right in the center of Skiathos Town, these contemporary guest rooms all open to private balconies facing a courtyard or the streets of the old quarter. Sleek furnishings sit atop cool marble floors beneath color-rich murals. The pool will tide you over between trips to the beach, and an inviting indoor/outdoor cocktail lounge may provide all the nightlife you need.

8 Moraitou, Skiathos Town. www.hotelbourtzi.gr. ℂ **24270/21304.** 38 units. 150€–240€ double. Rates include breakfast. **Amenities:** Bar/lounge; pool; Wi-Fi (free). Closed Oct–Apr.

Skiathos Princess ★★★ This swanky resort complex climbing a hill above Agia Paraskevi beach seems quite grand at first sight but is actually casual and relaxing; the friendly service is outstanding. A long stretch of sand is the main attraction, with well-landscaped acres of green lawns, cushion-filled terraces, and two swimming pools also geared to easy leisure. Pleasantly

elegant, though somewhat generic, rooms open to terraces or ground-floor patios. Unlike many self-contained resorts, this one is easily accessible to the rest of the island, including Skiathos Town, by bus.

Coast Rd., 8km (5 miles) S of Skitathos Town. santikoscollection.com. 🕐 **24270/49731.** 155 units. 100€–350€ double. **Amenities:** 2 restaurants; 3 bars; 2 pools; beach; gym; spa; Wi-Fi (free). Closed mid-Oct–Apr.

Shops, hotels, and restaurants line the narrow streets of Skiathos Town.

INEXPENSIVE
Design Architectonika Hotel ★★
For convenience and good-value comfort, it's hard to beat this in-town spot that makes "basic" into a pleasing design statement of concrete floors and low-slung furnishings. The longer the climb up a tight staircase, the better the reward: Top-floor rooms have views over tile rooftops to the sea, and above them is a breezy roof deck. All rooms open to small terraces. Just outside, intriguing alleys lead to the nearby waterfront or into the quieter sections of the mazelike old town.

Mitropolitou Ananiou 20, Skiathos Town. hotelarchitectonika.gr. 🕐 **24270/23633.** 9 units. 55€–140€ double. **Amenities:** Roof terrace/bar; Wi-Fi (free).

Where to Eat on Skiathos

The Borzoi ★ GREEK/MEDITERRANENAN Some patrons might remember this intimate space at the end of an alley from the 1970s, when it was the island hotspot. The bar still pours excellent house cocktails, and meals are served in a huge interior garden with whitewashed walls, colorful flowers, and bright cushions. A Mediterranean menu includes seafood risottos, fresh fish, and heaping salads, served with hospitality that's a lot more down to earth than you'd expect to find in such chic surroundings.

Polytexneiou 27, Skiathos Town. borzoiskiathos.com. 🕐 **24270/23605.** Main courses 12€–20€. Daily 6pm–midnight. Closed mid-Oct to Apr.

Ergon ★★ GREEK/DELI In an attractive, brightly lit space that spills onto a terrace, this outlet of an international Greece-based chain is part grocery shop, part cafe, and part *ouzeri*. The emphasis is on organic, small-production foods from throughout Greece, with vegetables from the island, tuna from Alonissos, and fava beans from the mainland showing up in small plates and main courses. Specials allow you to mix and match from the a la carte menu—gruyere from Naxos, served in fruit syrup, or grilled chicken breast on a bed of Cretan pilaf. Excellent breakfasts are served as well.

Papadiamandis, Skiathos Town. www.ergonfoods.com. 🕐 **24270/21441.** Starters from 6€, main courses 12€–14€. Daily 9am–1am.

Taverna Alexandros ★★ GREEK This Skiathos institution serves traditional taverna fare on a tree-shaded terrace and in a stone-walled room just off the harbor. The standards shine here—lamb chops and other meats grilled over an open fire, and huge fresh salads of beets and other island-grown vegetables. Live bouzouki music adds a festive note most nights. A good choice of breakfasts also makes this a popular morning stop. In high season you'll have to wait for a table (no reservations).

Kapodistríou, behind the old port, Skiathos Town. ⓒ **24270/22431.** Main courses 8€–12€. 9am–1pm and 6pm–midnight. Closed Oct–Apr.

Taverna Sklithiri ★★★ SEAFOOD A terrace on a golden beach with a turquoise sea almost lapping up to the tables is the perfect Greek-island setting. Off the grill comes the freshest fish, and plump mussels are roasted in white wine. Friendly service befits the relaxed ambiance.

Tzaneria Beach, 8km W of Skiathos Town (btw bus stops 11 and 12). ⓒ **694/693-2869.** Main courses 9€–18€. Daily 11:45am–11:45pm. Closed Oct–Apr.

Exploring Skiathos Town

The attractive island capital is relatively new, mostly built in the 1930s then reconstructed after heavy German bombardment in World War II. Outdoor cafes, postcard stands, and souvenir shops are as profuse as the bougainvillea that climbs whitewashed houses clustered on two low hills above the harbor.

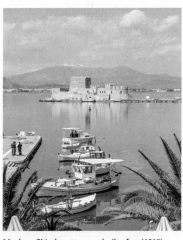

Modern Skiathos town, rebuilt after WWII bombing, looks across its harbor to its 13th-century Venetian fort, the Bourtzi, now a cultural center.

Among the picturesque remnants of old Skiathos are the 13th-century fort the Venetians erected on a pine-clad peninsula; known as **Bourtzi,** it's now a cultural center. Ferries and hydrofoils stop at the port on the east side of the fortress, while fishing boats and beach excursion caiques dock to the west. West of the port, an old quarter of cobblestone and stepped lanes surrounds the **Church of Trion Ierarchon** (Three Archbishops). Bars, clubs, and *ouzeries* line the waterfront all the way to the yacht harbor.

Around Skiathos

The island's top attractions are the famed beaches ringing the coves and bays that etch the south coast. All are sandy and protected from the northerly meltemi winds; a welcome barrier of pine trees also shields them from an almost unbroken line of resorts, shops, and restaurants.

Writer **Alexandros Papadiamandis** (1851–1911) was born and raised on Skiathos. After a career as a journalist in Athens, he returned to the island in 1908 and lived until his death in a humble dwelling now known as the **Papadiamandis House,** off an alley to the right of Papadiamandis, near the harbor ((℃ **24270/ 23-843;** admission 1€; Tues–Sun 9:30am–1pm and 5–8pm; 8:30am–3pm in winter). Simply furnished rooms, filled with the writer's personal possessions, evoke a style of island life that has all but disappeared in the past century. Papadiamandis is not widely translated or known outside of Greece, though his nearly 200 short stories and novellas, mostly about Greek island life, assured him a major reputation at home. His *Tales from a Greek Island,* set on Skiathos, is good reading before a visit. Although the tales are rife with superstition, hardship, and the insularity of island life, they are not without beauty and even sensuality (as in "The swelling flesh beneath the thin camisole hinted that here was a store of pale lilies, dewy and freshly cut, with veins the color of a white rose"). You'll find a statue of Papadiamandis standing in front of the Bourtzi fortress.

The rugged, mountainous interior is a world removed, with enough sights to make it worth renting a car for a day. You can easily see the island sights and still have time to hit the beach in the late afternoon: Moni Evangelistrias is only a 10- to 15-minute drive north of Skiathos town, Kastro another 20 minutes beyond that. There's also an easy-to-follow footpath to Moni Evangelistrias; ask at the tourist information office for directions. Another popular activity is dog walking at the Skiathos Dog Welfare Association (skiathosdogshelter.com), in the hills above Troulos Beach. The shelter houses dogs and cats abandoned by their owners (a common problem throughout Greece) and works with international groups to find them homes. Visitors are welcomed daily between 9am and 1pm to walk the dogs along paths in the surrounding woods. The shelter is about 3km (2 miles) from Troulos on the inland road.

Kastro ★★ RUIN By the 16th century, repeated pirate raids had forced Skiathos islanders to take refuge in a fortified compound on high ground. A drawbridge, moat, and high thick walls deterred invaders approaching by land, while steep cliffs dropping into the water thwarted any raid by sea. The settlement thrived for years, with a village of 300 houses and 22 churches eventually taking root within the walls. It lasted until the 1820s, when piracy ended under the newly created Greek state, making seaside settlement safe once again. Kastro was abandoned for Skiathos Town, and the elements began to take their toll on the wind-swept headland. Today, all but a few houses and churches have crumbled into the Aegean. A short but steep path leads uphill from the road into the ruins, where you can see faded frescoes in the church of Yeni Nisi tou Khristou and look across the sea to the islet of Kastronisia. Another steep path drops from the ruins to a pebbly beach beneath the headland.

8.5km (5 miles) NE of Skiathos Town. From Moni Evangelistrias, drive W then N (3km/2 miles).

It's said that the first flag of an independent Greek nation was flown above the walls of the Evangelistrias monastery in 1807, by Greek revolutionaries sheltered here by its monks.

Moni Evangelistrias ★★ RELIGIOUS SITE A setting atop a deep ravine amid pines and cypresses lends this large monastery of golden stone an especially ethereal quality. Founded by monks who left the mainland's Mount Athos after a dispute in 1794, the compound—like many monasteries around Greece—was soon sheltering revolutionaries fighting against the Turkish occupation. It's claimed that the first Greek flag was woven here and raised above the high walls in 1807. The icon-filled church has been restored, and monks' cells, a kitchen, and a refectory surround the shady courtyard.

5km (3 miles) N of Skiathos Town (take airport road). Free admission. Daily 10am–7pm. Bus from Skiathos Town.

The Best Skiathos Beaches

More than 50 beaches ring Skiathos, and 50,000 summertime visitors set their sights on them. You'll be able to rent beach chairs and umbrellas on most beaches, even the remote north coast strands that are accessible only by boat.

You'll also find plenty of ways to stay active, especially on the south coast. Activities abound on Kanapitsa Beach, where the **Moutzouris Konstantinos Water Sports Center** (☎ **694/533-4999**) will equip you to water-ski, jet-ski, or windsurf. On Tzaneria Beach, the **Dolphin Diving Center** (www.ddiving. gr; ☎ **694/499-9181**) organizes dives and offers certification. On Vassilias Beach, **Stefanos Ski School** (www.stefanosskischool.com; ☎ **694/441-9425**) rents boats and runs water-skiing and wakeboard lessons.

SOUTH COAST Some of Greece's most beautiful beaches are along this stretch of shoreline. A shuttle bus plies the south coast as often as every 20 minutes in summer, making 25 stops between Skiathos Town and Koukounaries. At the western end, the bus chugs along inland Lake Strofilias, making stops at the edge of a fragrant pine forest, beyond which lie long ribbons of

sand. **Koukounaries** ★★★, 12km (7 miles) west of Skiathos Town, is widely touted as the most beautiful strand on the island, a lovely golden crescent 1km (½ mile) long, with crystalline waters backed by fragrant pine groves (*Koukounaries* means "pine cones" in Greek). You'll be sharing this paradise with thousands of other beachgoers, however. Those in search of relative quiet can stroll from Koukounaries for about 2km (1 mile) through shady groves to **Limonki Xerxes** and **Elias,** two lovely beaches on the **Mandraki Peninsula** ★★★ at

Well-developed Koukounaries Beach is a popular crescent of sand, easily reached by shuttle bus from Skiathos Town.

the northwestern tip of the island. (Rough dirt roads lead to all these beaches.) Limonki Xerxes is named for the Persian king, who moored his fleet here before his ill-fated attempt to conquer the Greek mainland in the 5th century B.C. A few piles of stones on the peninsula are believed to be some of the world's first lighthouses, erected by the Persians to guide their triremes across the reefs at night. Nudists usually find their way to Krasa, aka **Little Banana** ★★ (a reference to the shape and color of the beach).

NORTH COAST The top contender for the island's most scenic spot is **Lalaria** ★★★, a stretch of marble pebbles nestled beneath limestone cliffs. The Tripia Petra—natural arches sculpted from the rock by wind and waves—frame the beach, and the marble seabed gives the turquoise waters a supernatural translucence. Caves are etched into the base of the cliffs, and just to the east are three spectacular sea grottoes—Spilia Skotini (Dark Cave), Spilia Galazia (Azure Cave), and Spilia Halkini (Copper Cave). Boats squeeze through the narrow channel into Spilia Skotini and shine a light to transform the 6m-high (20 ft.) cavern into a neon-blue water world. Lalaria and the grottoes can be reached only by water; excursion boats leave the port in Skiathos Town about 10am every day and usually include a stop on the beach beneath Kastro (p. 336), where a steep trail climbs the cliffs to the ruins. You could also hire a water taxi, but it's costly and you'll share the beach with boat tours anyway.

Skiathos After Dark

You can count on Skiathos Town for a lively nightclub scene, especially on the narrow lanes off **Papadiamandis** in the center of town and on the quays of the old port. **Polytechniou** is also lively, known as "Bar Street." A reliable island institution is the **Bourtzi Festival,** staged from late June through early October in the outdoor theater of the Bourtzi. Events range from classical Greek drama to modern dance and experimental music; most begin at 9:30pm and cost 15€. Movie fans might enjoy the open-air 9pm showings at **Attikon**

(on Papadiamandis, opposite Mare Nostum Holidays). A perennial favorite is *Mamma Mia!,* filmed on neighboring Skopelos.

SKOPELOS ★★

13 km (8 miles) east of Skiathos

Skopelos is larger, greener, and lower-key than its near neighbor Skiathos, carpeted by pine groves and orchards rather than by resorts. Not that Skopelos shuns visitors—a surge in popularity was inspired by the 2008 film *Mamma Mia!* and its 2018 sequel, both largely shot on the island. Yet you'll still encounter relatively undisturbed island life in the countryside, on the cove-fringed coast, and in two beautiful towns, Skopelos and Glossa. Skopelos Town is especially appealing, a dazzling display of white houses with a ruined Venetian fortress overlooking terracotta roofs, the sea, and blue church domes. Skopelos has 360 churches, many built by grateful islanders who survived the mass slaughter wreaked by Barbarossa, the Ottoman pirate. The sight of so many white churches glistening on the hillsides inspired novelist Lawrence Durrell to remark that Skopelos islanders count churches, not sheep, when they can't sleep.

Essentials

GETTING THERE Getting to Skopelos usually involves going through Skiathos (see p. 330). Skopelos has no airport, and most **boats** from the mainland port of Volos first stop at Skiathos, where you may have to change boats. Total travel time is about 4 hours by ferry, 2½ hours by hydrofoil. From Skiathos, about eight hydrofoils make the 45-minute crossing to Skopelos Town daily; most also serve Loutraki, the island's second port, below Glossa. In summer only, **Skyros Shipping Company** (www.sne.gr; ☏ **22220/91-780**)

Skopelos has some 360 churches and chapels, many built in gratitude after islanders survived pirate attacks.

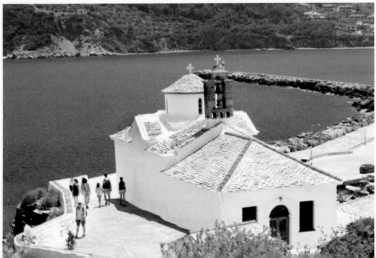

runs a boat 2 days a week from Kymi (2½ hr. from Athens) to Alonissos and Skopelos; the trip from Kymi to Skopelos takes about 3½ hours. The boat originates on Skyros, providing a direct, though long (6 hr.), connection between Skyros and Skopelos.

VISITOR INFORMATION A handy online source of information is **skope los.com**. Among many travel agencies on the waterfront promenade, **Dol-phins of Skopelos** (dolphinofskopelos.com; ✆ **24240/29191;** open all year) is a handy place to buy boat tickets, rent cars, and get info about the island.

GETTING AROUND You can get around Skopelos fairly easily by **bus,** with service every half-hour in high season. The route begins in Skopelos Town (the terminal is near the harbor entrance) and stops at Stafilos, Agnon-das, Panormos, Milia, Elios, Klima, and Glossa and its port, Loutraki. The trip from Skopelos Town to Glossa takes 55 minutes. Buy tickets on the bus. Fares vary depending on distance; the fare from Skopelos to Glossa is 4.80€. **Taxis** will take you almost anywhere on the island; the taxi stand is at the far end of the waterfront (left off the dock). Taxis are not metered—negotiate the fare before you get in. A typical fare from Skopelos to Glossa runs 40€. The easiest way to see the island is by **car** or **moped,** rented at one of many shops on the port. In season, car rentals begin at about 40€ a day, while mopeds cost about 20€ a day. Excursion boats to Glisteri, Gliphoneri, and other beaches operate from the port in peak season.

Where to Stay on Skopelos

Adrina Beach Hotel and Resort & Spa ★★ With a romantic name-sake (the female pirate Adrina), this pleasant little resort climbing above a beautiful cove on Panormos Bay is a true island getaway. Guest rooms are large and tastefully done in whites and pastels with sleek contemporary furnishings, and each has its own sea-view balcony or veranda, surrounded by greenery. Large, simply furnished two-floor maisonettes are ideal for families. More luxu-rious villa units sleep up to six and are stacked down the steep slope toward the hotel's private beach. A big saltwater pool is one of many amenities.

About 500m (¼ mile) from Panormos. www.adrina.gr. ✆ **24240/23373.** 58 units. 55€–240€ double; villas 150€–400€. Rates include breakfast. **Amenities:** 2 restaurants; bar; kids' playground; Jacuzzi; minimarket; pool; beach; spa; Wi-Fi (free). Closed Oct–Apr.

Hotel Denise ★★ A climb to the top of Skopelos Town is rewarded with top-of-the-world views from these large, bright, simply furnished rooms on a hillside above the port. All rooms open to balconies overlooking the town, sea, surrounding mountains, and a large swimming pool on the terrace. Hospitality includes free port pick-up and drop-off to spare you the climb with luggage.

Skopelos Town. www.denise.gr. ✆ **24240/22-678.** 25 units. 40€–60€ double. Rates include breakfast. **Amenities:** Restaurant; bar; pool; Wi-Fi (free). Closed Oct–May.

Kir Sotos ★ An unprepossessing entrance up some rickety wooden steps from the harbor front leads to one of the island's best-value lodgings, occupy-ing a restored traditional house that would be a distinctive place to stay at any

price. Pine-floored rooms surround a secluded garden backing onto a church. Room sizes vary from modest doubles that hold not much more than two twin beds to larger quarters, sone facing the waterfront through tall windows. Alexandra is the welcoming, on-the-scene host, and her amenities include a communal kitchen. Open year-round.

Harbor. www.skopelostravel.net/soto. © **242/402-2549.** 12 units. 25€–55€ double. **Amenities:** Garden; sun terrace; kitchen; Wi-Fi (free).

Skopelos Village ★★★
This tasteful, low-key, pleasant little resort is just a 10-minute walk from the port in Skopelos Town. Its spacious, bright-white bungalow-like accommodations are scattered amid fragrant gardens and around two inviting swimming pools. Rooms have crisp, attractive furnishings; some have fully equipped kitchens and many have one or two bedrooms. A beach lies just beyond the entrance, and there's daily transport around the island. The cast of *Mamma Mia!* stayed here, as you'll see from a photo board in the cafe.

About 1km (½ mile) SE of Skopelos Town center. www.skopelosvillage.gr. © **24240/22-517.** 36 units. 155€–225€ double. Rates include breakfast. **Amenities:** 2 restaurants; bar; babysitting; 2 pools; beach; room service; Wi-Fi (free).

Studios Filippos ★
Breezily furnished in light woods and white tile floors, these rooms and studios open to terraces that overlook a tidy garden; just outside the gate are olive groves and vegetable plots, even a little country chapel. Despite the bucolic setting, the port and town center are just a 10-minute walk away, and waterfront bars and tavernas are even closer. **Soula,** a similarly pleasant small pensione just down the lane, is owned by the same extended family; it's a good alternative when Filippos is full, which it often is.

Eastern edge of Skopelos Town. studiosfilippos.4ty.gr. © **2424024631.** 10 rooms. 50€–70€ double. **Amenities:** Bar; garden; Wi-Fi (free).

Where to Eat on Skopelos

The island's dish of note is Skopelos pie, a spiral of thin, flaky dough filled with goat cheese and often topped with honey and sesame. You'll also notice many savory dishes cooked with prunes; islanders traditionally dried plums in the outdoor brick ovens you'll still see around the island, even in Skopelos Town gardens. Though commercial production has made the labor-intensive process too expensive to pursue on a large scale, plum orchards still carpet parts of the island and the prunes often find their way into a potent *prunia* liqueur.

The place to find an inexpensive meal in Skopleos Town is **Platanos Square,** where several simple tavernas and gyro and souvlaki shops set tables out beneath huge shade trees.

Azan ★★★ GREEK/MEDITERRANEAN
A counter in the old town caters to locals with takeout meals, while a loyal following sits at the few tables out front for some of the best cooking on Skopelos. Tradition and fresh natural ingredients are the bywords—moussaka, pastitsio, meatballs, baked giant beans, stews, and all the other classics rotate daily, along with some pastas and lunchtime sandwiches and salads. The neighborhood is charming

too, with flower shops, bakers, and butchers doing business beneath balconied facades.

Manolaki St. Skopelos Town. ✆ **24240/33-076.** Main courses 6€–10€. Daily 9am–7:30pm.

Taverna Agnanti ★★ SKOPELITAN Despite considerable acclaim, and the occasional celebrity sighting, this informal Glossa landmark is simple and unfussy. A long menu ranges from herb fritters and smoked cheese in grape leaves to succulent pork roasted with prunes or chicken breast with sun-dried tomatoes. Just-caught sardines are grilled, as is herb-infused lamb. The terrace overlooking the town and bay (the name means "View") is by far the choice place to be on an evening in Glossa, all the better when musicians provide *rembetika,* the Greek version of American blues.

Glossa, near Town Hall. agnanti.com.gr. ✆ **24240/33-076.** Main courses 6€–22€. Daily 11am–midnight.

Taverna Alexander ★★ GREEK Islanders tend to call this place in the upper reaches of Skopelos Town the "Garden," because summertime dining is in a stone-walled courtyard planted with pine, jasmine, and lemon trees. A well supplies fresh spring water that, along with a palatable island wine, accompanies such standards as mushrooms with garlic, calamari stuffed with cheese, and pork baked with plums from the garden.

Manolaki St., Skopelos Town. ✆ **24240/22324.** Main courses 7€–15€. Daily 7–11pm. Closed Nov–Mar.

Exploring Skopelos Town

The island capital and the administrative center for the Sporades is one of the most appealing, unspoiled island towns in Greece. Blue-domed churches and white houses fronted with wooden balconies climb a hillside above the bay, and narrow streets look over rooftops of rough-hewn slate and tiles to the sea. Most of the many churches and chapels along the lanes are privately owned, used by families as ossuaries, where ancestors' bones are preserved in polished wooden boxes (Greek cemeteries are so overcrowded, bones are usually dug up after 4 years and placed elsewhere).

The island's showcase church is a dazzling white wedding cake set high above the harbor, dedicated to the Virgin Mary. Though you'll probably find the church closed, it's well worth climbing up for the spectacular views over the harbor and old town. Another beauty is just off Doulidou Street, near the old olive pressing works (look for the restaurant Olio); much of its golden stone was quarried from Roman sites around the island. Notice the china plates embedded in the façade: Mariners brought these back from their travels and placed them there in gratitude for their safe return.

Folklore Museum ★ MUSEUM A colorfully historic collection a couple of minutes' walk up from the waterfront focuses on domestic furnishings and the embroidery for which island women are known throughout Greece.

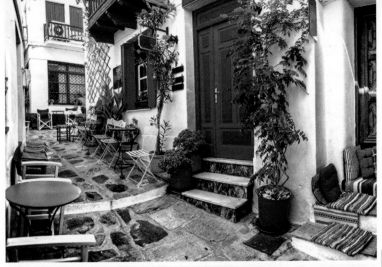

Skopelos has managed to preserve much of its traditional island atmosphere, one very good reason why the *Mamma Mia!* movies were largely shot here.

Just as interesting is the old mansion in which the costumes, ceramics, and other handiwork are displayed.

Hatzistamatis St. ℗ **24240/23494.** Admission 3€. May–Sept daily 10am–10pm.

Kastro ★ RUIN Keep walking up and up from the waterfront, and you'll eventually reach the 13th-century Kastro, erected by the Venetian lords who were awarded the Sporades after the sack of Constantinople. They built this stronghold on the foundations of an acropolis from the 5th century B.C.; amid the ancient masonry you may spot the ruined fortress walls built by Philip of Macedonia when he took the island in 340 B.C. The oldest of the town's 123 churches, 11th-century **Agios Athanasios,** rises within the Kastro walls.

Free admission. Open site.

The Mount Poulouki Monasteries ★★ MONASTERIES The slopes of Mount Poulouki, topping a peninsula to the east of Skopelos Town, cradle a clutch of the island's 40 monasteries amid olive groves and prune and almond orchards that give way to deep pine forests. **Moni Evangelismou,** about 4km (2½ miles) east of Skopelos Town, was founded in 1712 by a Skopelitan noble who imported monks from the mainland's Mount Athos to establish a center of learning. Today the all-but-deserted compound is best appreciated for its remote location and spectacular views of Skopelos Town and the sea, as well as a beautiful 11th-century icon of the Virgin Mary. **Agia Barbara,** about 6km (4 miles) east of Skopelos Town, is heavily fortified and surrounded by a high wall; its church is decorated with colorful frescoes depicting the main feasts in the Orthodox calendar. **St. John the Baptist** (also known as Prodromos, or Forerunner), only 300m (984 ft.) away, houses some especially beautiful icons. Just beyond the pair is **Metamorphosis,** the island's oldest monastery, founded in the 16th century. (Hours for the last three vary considerably.) You

PIRATES OF THE aegean

Greece has a long tradition of piracy that dates back to ancient times. Hundreds of islands, most of them uninhabited, once provided hidden anchorages from which to launch attacks on merchandise-laden ships crisscrossing the Aegean on the way to and from the Near East, North Africa, and Western Europe. The Sporades, floating in the lucrative sea routes to and from Thessaloniki, were pirate lairs well into the 19th century. An infamous female pirate, Adrina, operated out of the Sporades until islanders slaughtered her marauders; she eventually plunged to her death from a rock above the bay at Panormos, on **Skopelos**—but not, or so the story goes, before burying a horde of gold somewhere along the shore. On **Skyros,** islanders cashed in on the marauding business by alerting pirates to merchant ships that were especially ripe for plunder (receiving, of course, a cut of the profits in return). Skyrian workshops still turn out ceramics and hand-carved chests and chairs based on exotic designs that pirates brought to the island from afar.

can visit them on foot along a well-marked 6km (3½-mile path that climbs the mountain from Skopelos Town; Heather Parsons lays out a route in *Skopelos Trails;* see below). Some can also be reached by car, though the roads are rough; follow signs toward Moni Evangelismou from Skopelos Town.

Free admission (donations welcome). In season, open daily 8am–1pm and 4–7pm.

Around Skopelos

A single highway, 37km (22 miles) long, curves around the island, running south from Skopelos Town then up the west coast to Glossa and Loutraki. The island is laced with **hiking trails,** including centuries-old stone mule paths. Islander Heather Parsons heads efforts to maintain trails, and due largely to her efforts the government is now promoting Skopelos as a leading hiking destination. Parsons organizes guided walks from gentle rambles to full-day hikes, and has published a book, *Skopelos Trails,* sold in shops around town. She also leads highly informative evening walks around town, examining local architecture and customs (10€ a person). For information, go to skopelos-walks.com, or call ✆ **694/524-9328.**

Beach life on Skopelos centers on Milia, Adrina, and other stretches of the west coast's broad, sheltered **Panormos Bay ★★**, once a lair for pirates (see box, above). A few stony remnants of an 8th-century-B.C. settlement are hidden in the pine woods above the sparkling waters, about 11km (7 miles) west of Skopelos Town. Inland are the orchards where farmers grow plums and apricots, for which Skopelos is famous throughout Greece.

South of Skopelos Town, the rugged terrain drops down to seaside promontories and sparkling bays along the **Drachondoschisma Peninsula,** where in the 4th century St. Reginos reputedly slew a dragon that was devouring islanders. **Agnonda,** a small fishing port on the west side of the peninsula, is named for an island youth who sailed into the cove after his victory in the 546 B.C. Olympic games. **Stafylos,** 2 km (1 mile) east across the peninsula, is also

steeped in legend, named after the son of Ariadne—daughter of Crete's King Minos—and Dionysos, the god who rescued her when she was abandoned on Naxos (p. 188). Whatever Stafylos's parentage may have been, he is believed to have been a real Minoan who found his way north: In 1935, a 3,500-year-old tomb thought to be his was unearthed, filled with gold and weapons. Stafylos is a popular but low-key beach, while **Velania,** a short trek across a headland, is more isolated and quieter; bathing suits are optional.

Glossa/Loutraki ★★ TOWN The island's second settlement after Skiathos Town, Glossa (also known as Loutraki) is much more bucolic than the capital, rising from the sea on terraced hillsides. Steep streets wind past gardens where residents grow prunes and almonds, and most houses have sturdy balconies looking out to sea. The most popular landmark these days is about 7km (4 miles) east of town, **Agios Ioannis Kastri** church. Set on a rocky outcropping above the sea, the little chapel is so incredibly picturesque it steals the show in the film *Mamma Mia!* Beware, though, the climb to the summit, on a ladder-like stone staircase, is not the breeze it appears to be in the film.

20km (12 miles) NW of Skopelos Town.

The tiny church of Agios Ioannis Kastri, on a high crag over the sea, steals the show in the *Mamma Mia!* movies.

Klima ★ TOWN In 1965 an earthquake dislodged all the residents of Klima, one of the island's most prosperous towns. Klima is slowly being reclaimed: Some trim houses, newly whitewashed and roofed with red tiles, are taking shape amid the rubble in Ano Klima, the upper town, and Kato Klima, the lower town. Even so, the place still has the atmosphere of a ghost town. Looking through pane-less windows and open doorways, you'll catch glimpses of abandoned bakery ovens and *kalliagres,* hand-operated olive presses, remnants of life the way it was when the village came to a standstill. Residents were resettled in the far less colorful **Elios-Neo Klima,** just 3km (2 miles) south, hurriedly assembled in the wake of the 1960s earthquake. South of Neo-Klima, cliff-backed **Hovolo** is one of Skopelo's most scenic beaches and **Kastani** is one of the few sandy beaches on the island.

17km (10 miles) NW of Skopelos Town.

Skopelos After Dark

The nightlife scene on Skopelos isn't nearly as active as that on Skiathos, but there are still plenty of bars and late-night cafes, many along the waterfront.

In Skopelos Town you can often hear *rembetika,* soulful, blueslike music, at **Ouzerie Anatoli** (*©* **24240/22851**), which overlooks the sea from within the walls of the Kastro, and at **Blue Bar** (*©* **694/240-6136**), at the northwestern end of the quay. A well-known rembetika venue in Glossa is **Taverna Agnanti** (*©* **24240/33076**).

ALONISSOS ★★★

10km (6 miles) east of Skopelos

Cloaked in green and surrounded by pristine waters, little Alonissos is the only inhabited island within the boundaries of the **National Marine Park of Alonissos Northern Sporades** (p. 348). Founded in 1992, the park protects the waters and islands of the eastern Sporades and the myriad creatures who thrive there, including dolphins, Eleonora's falcons, seabirds, and the highly endangered monk seal (see box, p. 349). With its rugged landscapes of pine and cedar forests and rockbound coasts, Alonissos has an ambience even more low-key than that of Skopelos, let alone Skiathos. You can easily visit Alonissos on a day trip from those other islands, but it's a great place to settle in and relax for a few days or a week.

Essentials

GETTING THERE Alonissos is on the same **hydrofoil** and **ferry** routes that serve Skiathos and Skopelos (see p. 339). It's about 4½ hours by regular ferry and 2 hours by fast boat from the mainland port of Volos. In summer there is also twice-a-week ferryboat service (2½ hr.) from Kymi and Skyros (about 5 hr.). Boats run frequently from Alonissos to Skopelos (about ½ hr.) and Skiathos (from ½ hr. to about 1½ hr.).

VISITOR INFORMATION Any of the many agencies near the waterfront in the island's main town, Patitiri, can provide information about the island and surrounding national park. **Albedo Travel** (www.alonissosholidays.com;

C **24240/65804**) is an excellent resource for accommodations, boat tours, and other excursions.

GETTING AROUND Seasonal **bus** service is limited but handy for getting from Patitiri to Hora and some of the beaches around Steni Vala, the end of the route. Service runs only June through September, and even then, not too frequently. Fare is 1.70€, payable on the bus.

You might want to rent a **car** for a day to explore the island's hinterlands and beaches, though a day should be plenty. Many agencies in Patitiri rent cars and bikes, from about 40€ a day for a small car with manual transmission.

Where to Stay & Eat on Alonissos

Archipelagos ★ GREEK/SEAFOOD Many islanders claim that the fish and seafood at this waterfront favorite is the freshest and best prepared on Alonissos. While fish is the star of the show, a huge selection of spreads and mezes are available, as are some excellent meat standards, including lamb cooked with tomatoes and artichokes.

Patitiri. *C* **24240/65031.** Main courses 9€–18€. Daily 6pm–midnight. Closed Oct–Apr.

Atrium Hotel ★ Some of the island's most stylish and comfortable accommodations are on a pine-clad hillside behind Patitiri. The beach is a short walk away, and all the bright, contemporary-styled rooms face the sea from balconies. A large pool gleams in the garden, surrounded by a terrace and cocktail bar.

Patitiri. www.atriumalonnissos.gr. *C* **24240/65750.** 80€–160€ double. Rates include breakfast. **Amenities:** Bar; pool; Wi-Fi (free). Closed mid-Oct–Apr.

Ostria ★★★ GREEK/SEAFOOD
A standout in a line of eateries along the Patitiri waterfront, Ostria takes traditional cooking up a notch or two. Sea bream comes stuffed with mountain herbs and ouzo, and pork fillet is baked in a ginger-orange sauce, alongside standards like mussels saganaki and grilled sardines. Friendly service is on a covered terrace facing the port.

Patitiri. www.ostria-restaurant.gr. *C* **24240/ 65243.** Main courses 9€–18€. Daily 6pm– midnight. Closed Oct–Apr.

Paradise Hotel ★★ This laid-back, small-scale resort looks out to sea from one of the forested hillsides around the port. From the entrance, staircases and a path lead right into the heart of Patitiri, and gardens drop

Even more laid-back than its neighboring islands, Alonissos is a relaxing getaway for those who don't need luxury or nightlife.

through a series of terraces to a beautiful cove. Rooms are simple and fairly basic, though polished stone floors and paneled ceilings add character. Most rooms overlook the pool, gardens, and sea from sunny balconies or terraces surrounded by greenery. Owners Bessy and Kostas welcome their guests with relaxed hospitality.

Above Patitiri. www.paradise-hotel.gr. ℭ **24240/65160.** 28 units. 70€–120€ double. Rates include breakfast. **Amenities:** Bar; pool; Wi-Fi (free). Closed Oct–mid-May.

Exploring Alonissos

The long, narrow island, 23km (14 miles) from north to south and 3km (2 miles) at its widest point, is covered with pine, oak, and scrub in the north and olive groves and fruit orchards in the south. Beaches are pebbly and less spectacular than those on Skiathos and Skopelos, but the waters, protected as they are by the national park, are some of the purest in the Mediterranean.

The island's only two sizable settlements are in the south. Beautiful hilltop **Hora ★★★**, or Old Town Alonissos, was largely toppled by an earthquake in 1965. Residents were relocated to the hastily expanded port town, **Patitiri,** which takes its name from the dockside wine presses that were much in demand until the 1950s, when a phylloxera infestation laid waste to the island's vines. Now populated mostly by Northern Europeans, Hora is slowly being restored. On a clear day, views extend all the way to Mount Athos on the northern mainland. If you take the bus up to Hora, you can walk back down to Patitiri via a centuries-old stepped path; the 3km (2-mile) hike takes less than an hour.

Most beaches are on the east coast, accessible off the island's north–south road; several cluster around **Kokkinokastro,** about 3km (2 miles) north of Patitiri, where the walls of the ancient city of Ikos are visible beneath the waves.

Exploring the National Marine Park

The National Marine Park of Alonissos Northern Sporades was established in 1992 chiefly to protect the endangered Mediterranean monk seal (see box, p. 349), whose numbers in Greek seas are now estimated to be less than 200. The park covers 2,200 sq. km (849 sq. miles), making it the largest marine protected area in the Mediterranean. Within the park are eight islands (of which only Alonissos is inhabited), 22 rocky outcroppings, and the marine habitats that surround them. In addition to the shy seals, who rarely make an appearance, falcons, dolphins, and wild goats also live here, along with many species of sponges, algae, and land-lubbing flora, including the wild olive.

In summer, you can tour the park on **excursion boats** from Alonissos, including trips arranged through Albedo Travel (p. 346); you'll see signs advertising trips along the dock in Patitiri, where the park also runs an information booth (summer only, hours vary). On the day-long outings (about 45€, with lunch), tour boats chug past the scattered island refuges. Sightings of the seals and wild goats is almost as rare as a glimpse of the Cyclops, who in Homer's *Odyssey* inhabited a cave on one of the islands, cliff-ringed **Gioura.**

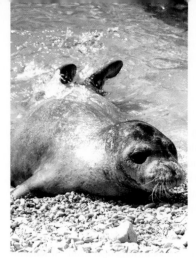

Dolphins often escort the boats, which keep a safe distance from **Piperi,** the major habitat for the monk seal and Eleonora's falcon, for whom this a major breeding ground. Stops often include **Kyra Panagia,** for swimming, snorkeling, and a walk to the all-but-abandoned **Megistis Lavras** monastery; **Psathoura,** where the tallest lighthouse in the Aegean rises above a white-sand beach and the remains of an ancient city is visible on the seabed; and **Peristera,** with its alluring remote beaches.

The National Marine Park of Alonissos Northern Sporades was established to protect the habitat of the endangered Mediterranean monk seal.

Conservationists applaud the park's preservation efforts, while many locals claim the park impinges on resort development, fishing, and other economic opportunities. Make it a point to let restaurateurs and hoteliers know that you have come to the Sporades in part to enjoy the park—that the park enhances tourism rather than hindering it.

Outdoor Sports on Alonissos

Alonissos is laced with a network of 14 **walking trails** that traverse the length of the island, crossing olive groves, pine forests, and rocky gorges and dropping down to secluded coves. Walking tours and route maps are available through Albedo Travel on the waterfront in Patitiri (www.alonissosholidays.com; ℰ **24240/65804**). If you plan to do some serious walking on Alonissos, pick up a good hiking map and a copy of *Alonissos Through the Souls of Your Feet,* available at shops along the Patitiri waterfront.

These seas also harbor a number of ancient shipwrecks as well as sunken vessels from the days of Byzantine and Venetian occupation. Diving and

THE MEDITERRANEAN monk seal

The Mediterranean monk seal is one of the world's most endangered marine mammals—only an estimated 600 exist worldwide. Hunting probably pushed the numbers close to extinction as early as Roman and medieval times; until recently fishermen routinely killed off the seals to cut down on competition—these huge creatures (on average 2.5m long, or more than 8 ft., weighing up to 300kg/661 lb.) devour 3kg (7 lb.) of fish, octopus, squid, and other sea creatures a day. As development has sullied once pristine shorelines, the seals no longer lounge and whelp on open beaches; instead they seek out sea caves with submerged entrances far from humans. Battered by waves, the caves are not ideal nurseries, and many seal pups die. For ancient Greeks, sighting a monk seal was an omen of good fortune. The creature's survival would bode equally well for the Sporades.

snorkeling tours, along with instruction and gear, are available from **Alonissos Triton Dive Center** in Patitiri (bestdivingingreece.com; ☏ **24240/65804**).

SKYROS ★★★

47km (25 nautical miles) NE from Kymi; 182km (113 miles) NE from Athens

Adrift by itself in the Aegean, far from the other major Sporades, Skyros is a land apart—less green, less visited, and maybe a little less worldly, with its own laidback, off-the-beaten track, and (in places) chic charm. You'll sense there is something different about this island as soon as you set eyes on **Skyros Town,** a cliff-hugging white mirage that seems to float above the surrounding plain, and the impression won't wane as you settle in.

Essentials

GETTING THERE Getting to Skyros can be a challenge. From Athens, the trip is easiest **by air.** In summer, **Olympic Air** (www.olympicair.com) and **Aegean Airlines** (en.aegeanair.com) usually operate three flights a week between Athens and Skyros, as well as between Thessaloniki and Skyros. A taxi from the airport to Skyros Town or the beach towns Magazia and Molos is about 20€, but expect to share.

Skyros Shipping Company (www.sne.gr; ☏ **22220/91-780**) offers the only **ferry service** to Skyros. (Stockholders are all citizens of the island.) Service runs from Kymi, which is about 3 to 4 hours from Athens's Liosion Station (aka Terminal B) by bus (www.ktelevias.gr); the trip often requires a change in Chalcis. Usually an early-morning bus from Athens will connect directly with the Skyros-bound boat; otherwise, the bus will take you to the center of Kymi, about 5km (3 miles) above the port, and you'll have to take a taxi to the port (Paralia Kimis). Unless you set off from Athens early, you may find yourself spending a night in Paralia Kimis waiting for the morning boat. Check out the company's website for current timetables for service to and from Skyros and between Skyros and the other Sporades. Schedules change frequently.

In summer, ferry service runs 3 times daily between Kymi and Skyros; the crossing takes a little under 2 hours. Off season, there's one ferry daily, leaving Skyros early in the morning and Kymi in late afternoon. Skyros Shipping and travel agencies that sell tickets for the boat service also sell bus tickets between Athens and Kymi. In summer only, the company's boats also link Skyros to Alonissos (5 hr.), Skopelos (6 hr.), and Skiathos (7½ hr.), as well as to the port of Volos on the mainland (10 hr.).

VISITOR INFORMATION The largest tourist office on the island is **Skyros Travel and Tourism** (www.skyrostravel.com; ☏ **22220/91-123**), in the main market of Skyros Town. The staff offers assistance with accommodations, tickets, car and bike rentals, and tours.

GETTING AROUND On Skyros, ferries dock at Linaria, on the opposite side of the island from Skyros town. The island's only **public bus** will meet

the boat and take you over winding, curving roads to Skyros Town and on to Magazia and Molos for 1.50€; taxis also meet the boats, and charge about 15€ for the ride to Skyros Town and the beach communities below. In high season (July–Aug), Skyros Travel (see above) offers a daily **excursion bus** to the beaches, as well as a daylong island excursion in a small bus with an English-speaking guide. For many, this may be the best way to get an overview of the island. A small **car** rents from about 40€ per day; **mopeds** and **motorcycles** cost about 25€ per day.

Where to Stay on Skyros

Skyros has a nice selection of pleasantly casual hotels. Stepping off the boat, you'll be met by room-letters hawking accommodations in private homes; these are usually well-equipped and immaculately kept. For easiest access to restaurants, shops, and other conveniences, set your sights on Skyros Town; most visitors, though, settle down in easygoing Magazia or Molos, strung out along soft sands just below town.

Adriane Studios ★ Warmly furnished studios and one-bedroom apartments, decorated with local crafts and original art and equipped with kitchens, surround a garden full of flowers and fruit trees, creating a paradise within a paradise—the soft sands of Magazia Beach are just at the end of the lane. Snacks and drinks are on offer in an appealing garden-side cafe, and some of Magazia's nicest restaurants and beach bars are just outside the door.

Magazia. www.ariadnestudios.gr. ℂ **222/209-1113.** 11 units. 65€–85€ double. Breakfast 7€–10€. **Amenities:** Bar/cafe; garden; Wi-Fi (free). Closed Nov–Apr.

Skyros Town looks almost like a mirage, with its white houses cascading down steep slopes beneath the Venetian-era fortress.

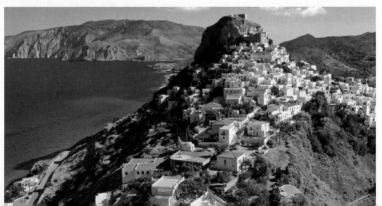

Hotel Angela ★★ Set off the back lanes of Molos behind a stand of pines, this attractive whitewashed compound run by a young family surrounds a large swimming pool amid beautiful lawns and gardens. Rooms are fairly basic but well-kept and comfortable, and the bathrooms have large, glassed-in showers, a rare luxury in modest hotels like this. All units have balconies or terraces; those on the second floor have glimpses of the sea or Skyros Town. The beach is a short walk away.

Molos. www.angelahotelskyros.com. ✆ **22220/91764.** 17 units. 70€–90€ double. **Amenities:** Pool; free parking; Wi-Fi (free). Closed Nov–Apr, but open for Carnival & Easter.

Hotel Nefeli ★★ Five buildings set in gardens at the edge of Skyros Town house some of the island's most distinctive accommodations, though you'll be trading the beach for in-town convenience. Some apartments are set up in traditional Skyrian style, spread across several levels with lots of carved wood pieces, and in some, fireplaces. Other units, many with kitchenettes, range from hotel-style rooms to apartments and are done in well-designed contemporary style. All have balconies or terraces and face a large saltwater pool, surrounded by a flower-filled terrace, with the white cluster of Skyros Town as a backdrop. The hotel is open all year, making it one of the few places to stay in winter.

Skyros town center. www.skyros-nefeli.gr. ✆ **222/209-1964.** 32 units. 75€–120€ double. Breakfast 6€. **Amenities:** Restaurant; bar; children's play area; pools; free parking; Wi-Fi (free).

Hotel Perigiali ★★ In the quiet back lanes of Magazia, this distinctive cluster of bungalows gives off an island vibe, with terraces and balconies surrounding a sparkling pool. The decor of the attractive rooms and studios, many set up for families with foldouts and kitchens, is all white and blue. Some rooms have views out to sea, others up to the heights of Skyros Town.

Magazia. www.perigiali.com ✆ **222/209-2075.** 27 units. 80€–180€ double. Rates include breakfast. **Amenities:** Bar/cafe; pool; garden; free parking; Wi-Fi (free).

Hydrousa Hotel ★ A welcoming entry court of warm stone is full of flowers and opens to a homey, drawing-room-like lobby, but the showpiece at the island's only oceanfront hotel is its beautifully tended lawn, set up with loungers and tables for drinks and light meals, just a few steps above Magazia beach. Rooms are small but have the same full-on sea views and open to breezy balconies. Wooden Skyrian furnishings add a bit of local flair.

Magazia. www.hydroussahotel.gr. ✆ **222/209-1209.** 22 units. 100€–120€. Rates include breakfast. **Amenities:** Bar/cafe; beach; free parking; Wi-Fi (free).

Where to Eat on Skyros

Skyrians make the most of the bounty of the land and sea: Simply grilled pork, chicken, and fish are staples on menus. Fava beans, cooked until they're creamy, are often served with capers and onions. A local starter is oil pie, fluffy bread that's baked and topped with creamy sour cheese.

Many of the island beaches are backed by tavernas and beach clubs that offer light meals and drinks throughout the day, often served in sun loungers

on the sand. In Molos, **Anemomulos** (⊘ **222/209-3656**) occupies a windmill next to the Pouria rock formations; tables on its terrace or the rocky, sea-washed ledges are top spots for a sunset cocktail.

Margetes ★ GREEK This simple but always crowded dining room in the center of Skyros Town, with a warm-weather terrace, is known for meats, especially grilled pork and chicken and goat roasted in lemon sauce. Baked eggplant, creamy house-made fava, Skyrian *mizithra* cheese, and other local standards are delicious accompaniments. Fried potatoes, the common taverna side dish, are especially well done here, topped with herbs.

Main St., Skyros Town. ⊘ **22220/91311.** Main courses 6€–10€. Daily 1–3pm and 6pm–midnight.

O Pappous ki Ego ★★ GREEK The name translates as "My grandfather and I," and the appealing room, a former pharmacy in Skyros Town, is now under the watchful eye of the grandson. The *dolmades* and other *meze* are delicious, as are some of the meat and fish dishes; cuttlefish in anise sauce is a specialty. Live music is sometimes performed on weekend evenings.

Main St., Skyros Town. ⊘ **22220/93200.** Main courses 6€–10€. Daily 1–3pm and 6pm–midnight.

Stefanos ★★ GREEK One of the island's oldest tavernas has a choice spot just above Magazia beach at the end of a pretty lane of traditional houses. Fish and meat from the grill are the focus, though accompanying them are nicely done *mezedes*, including delicious stuffed peppers and tomatoes. The unflappable staff caters to a crowd of regulars who return to the island yearly.

Magazia. ⊘ **222/209-1272.** Main courses 7€–14€. Daily noon–1am.

Taverna Mouries ★★★ GREEK/SKYRIAN A highlight of a trip to Skyros is a meal at this island institution that's overseen by third-generation proprietor Manolis. In all but the chilliest weather, dining is on a welcoming terrace shaded by mulberry trees. Creamy fava, from beans grown on the premises, is one of many delicious preludes to lamb or goat in lemon sauce

A pagan custom PRESERVED IN SKYROS

An age-old tradition in Skyros, the pre-Lenten **Apokriatika** festival is famous throughout Greece. On each of the four Sundays before Clean Monday (first Mon of Lent), men and a few women don goat-hair jackets and goat masks and drape themselves in goat bells. Other men, dressed in traditional wedding garb, and women and children in their Western-style Sunday best, surround them. Ensembles proceed through the streets of Skyros Town, singing, brandishing shepherds' crooks, and reciting bawdy verses. When two groups meet, they try to outdo each other with bell clanking, ribald gestures, and shouting. Scholars trace this traditional event to pagan Dionysian revels and Achilles-style cross-dressing (p. 354). If you plan to attend, book a room months in advance.

and other hearty favorites. Star guests are the Syrian horses on the family's farm across the road.

Kalamitsa, 9km, 5½ miles S of Skyros Town. ✆ **222/209-3555.** Main courses 8€–12€. Daily 1–11:30pm. Closed Nov–Apr.

Exploring Skyros Town

The island's only sizable town, home to most of the 3,000 Skyrians, inspires comparisons to a mirage or a magical kingdom. It's only fitting that this stunning collection of white, flat-roofed houses clinging to a high rocky bluff has figured in myth since ancient times. The sea nymph Thetis sent her son, Achilles, to the island disguised as a young woman to outwit the oracle's prediction that he would die in the Trojan War; the ruse worked until Odysseus unmasked the boy's true identity and sent him off to battle on a Skyrian pony. In another legendary episode, Theseus—founder-king of Athens and son of Poseidon and Aegeus—fled to Skyros when he fell out of favor; Lycomedes, king of the island, eventually pushed him over a cliff.

Founded in 962, the monastery of Agios Yeoryios (St. George) is protected within the walls of the Kastro, high atop its bluff above Skyros Town.

From the foot of the town, near the market square, it's all uphill. At the very top of a knot of steep lanes is the Venetian-era **Kastro** and, within its walls, the **monastery of Agios Yeoryios.** Founded in 962, the aerie-like monastery contains a famous black-faced icon of St. George brought from Constantinople. From one side of the citadel, the view is over the white houses of the town to the inland hills; from the other, the cliff drops precipitously to the sea (this, according to myth, is where King Lycomides pushed Theseus to his death).

Farther down the slope at the edge of a sea-facing hillside on **Plateia Rupert Brooke,** a statue memorializes the British poet, who in 1915 died on a hospital ship just off Skyros and is buried on the southern end of the island (see p. 356). The virile bronze nude caused a public outcry when it was unveiled in the 1930s; it is not a likeness of Brooke but was intended to be an idealized figure of poetry. The **Folklore Museum** (p. 355) is just off Plateia Rupert Brooke, as is the **Archaeological Museum** (odysseus.culture.gr; ✆ **22220/91327**), which displays stone vessels and other intriguing finds from Palamari (p. 356) and Greco-Roman graves around the island. The archeological museum is open daily except Tuesday, 8:30am to 2:30pm; admission is 2€.

As you wander the steep lanes, you might notice women in doorways bent over vibrantly colored embroidery with fanciful flower and bird designs. Many Skyrian homes contain museum-like collections of colorful plates, embroidery, copperware, and carved furniture—a throwback to the days of Byzantine occupation, when families made fortunes from the lucrative Near East sea lanes. The merchant ships were soon followed by pirates, with whom the Skyrian ruling families went into business, tipping them off to expected trading ships in return for a share in the plundered profits.

The Manos Faltaits Historical and Folklore Museum ★★ MUSEUM/ HISTORIC HOME The private collection of islander Manos Faltaits, lodged in his family home, contains a large and varied selection of plates, embroidery, weaving, woodworking, and clothing, as well as rare books and photographs. It's a fascinating collection, and all the more satisfying when you realize how many of these collectibles are still part of everyday island life. Attached to the museum is a workshop where young artisans make lovely objects using traditional patterns and materials. Proceeds from the sale of these items go to the museum's upkeep. The museum also has a shop, **Argo,** on the main street of town (✆ **22220/92-158**), open daily from 10am to 1pm and 6:30 to 11pm.

Plateia Rupert Brooke. www.faltaits.gr. ✆ **22220/92158.** Admission 4€. Daily 10am–2pm and 6–9pm.

Around Skyros

You can drive around the north half of this cinch-waisted island in a counterclockwise circuit from Skyros Town; the entire circuit on a well-marked road is less than 30km (19 miles).

THE NORTH

Skyros's fertile, forested north varies so much from the arid, rugged south that it has been conjectured, wrongly, that the island was at one time two separate land masses. The northwest corner of the island is especially green, with thick pine forests that drop down to coves and sandy beaches.

Two seaside villages lie side by side, just north of Skyros Town. **Magazia,** at the bottom of a stairway from Plateia Rupert Brooke, fronts a sandy beach that extends north into **Molos,** a fishing village that does double duty as a laidback beach town. **Pouria,** at the north end of Molos, is surrounded by weirdly shaped rock formations that were chiseled not by wind and

Hardy little Skyrian ponies once ran wild across the rugged island; today they are a protected species. See box p. 356.

The Fabled Ponies of Skyros

Large herds of the diminutive Skyrian pony once scampered across the rocky interior of Skyros. It's believed that these beautiful little beasts are the horses that frolic on the Parthenon frieze; Achilles allegedly rode one into battle during the Trojan War. Isolated on Skyros, their bloodlines have changed little over the millennia.

Time was, Skyros farmers put the ponies to work for the harvest, then released them to graze on upland plateaus in winter. Farm machinery, however, has replaced the ponies as beasts of burden, and they vie for grazing with sheep and goats. Today there are less than 150 ponies left. They are now protected, however, and efforts are afoot to restore the remaining herds. While you are unlikely to catch a glimpse of a Skyrian pony in the wild, at **Mouries Farm** in Kalikiri (© **694/746-5900**), you can see them up close—and, if you are under the age of 15, climb onto one. Admission is free, though donations are accepted; the center is open daily. You can combine a visit here with a meal at the excellent Mouries Taverna across the road (p. 353).

waves but by Romans, who quarried the stone; the exotic little chapel of **Agios Nikolaos** occupies one of the hollowed-out stones. **Palamari,** near the airport at the northern tip of the island, was settled around 2000 B.C. by traders and sailors who protected themselves from raiders with trenches and thick stone walls. A sandy beach skirts the harbor where the inhabitants once beached their vessels.

Atsitsa, directly west of Skyros Town on the west coast's Bay of Petros, is surrounded by several beaches along the pine- and cedar-clad northwest coast; one of the most appealing, **Kyra Panagia ★★**, is just north of Atsitsa. **Agios Fokas ★★**, a short drive south of Atsitsa, is usually touted as the island's most beautiful beach, a triplet of little bays edged with white pebbles.

THE SOUTH

From Aspous, a short drive south of Skyros Town, a road leads south and west across the island's narrow waist through a rocky landscape that is desolate, yet hauntingly beautiful. After the main island port of Linaria the rocky coast gives way to beaches at **Kalamitsa,** and just south of there, **Kolymbada.** Scrappy clusters of houses surround both, rare signs human habitation around here. A half-hour's drive south of Kolymbada, the road ends at **Tris Boukes Bay,** where British poet Rupert Brooke is buried in an olive grove, his simple gravestone inscribed with words from his poem "The Soldier": "If I should die think only this of me/ That there's some corner of a foreign field/ That is forever England." Brooke spent only a few days on Skyros in 1915, before a mosquito bite tragically led to blood poisoning. He died on a hospital ship in the bay.

In the village of Molos, a giant boulder on the beach was hollowed out to become the chapel of Agios Nikolaos.

Skyros Shopping

The island is famous for carved furniture; you'll find good hand-carved wooden chests and chairs made from beech (in the old days, it was blackberry wood) from **Lefteris Avgoklouris** (www.thesiswood.com; © **22220/91106**) on the coast road between Skyros Town and Aspous, alongside the work of his wife, **Emmanouela Toliou,** who creates beautiful sculptures and jewelry from repurposed wood. **Stamatis Ftoulis** carries on the island ceramics tradition at his workshop in Magazia (© **22220/92220**) and a shop in Skyros Town.

THE NORTHERN AEGEAN ISLANDS

Far removed from the Greek mainland, the islands of the northern Aegean share dramatic mountainous landscapes, enticing architecture, fine beaches, and plenty of ancient and medieval sites, as well as a tinge of exoticism from nearby Turkey (easy to visit on day trips). The three main islands in the archipelago—Samos, Chios, and Lesbos—each have their distinct, even quirky allure: the ruins of the greatest temple in the Greek world on Samos, the mastic villages on Chios, a petrified forest on Lesbos. Best of all, on all these islands it's also easy to experience a quintessentially Greek way of life—to wander off the beaten path into untrammeled hinterlands where stone village rise above forests, orchards, and olive groves, and to sit down to a simple meal of grilled fish with the sea glimmering just a few steps away.

10

LESBOS ★★★

348km (188 nautical miles) NE of Piraeus

Greece's third-largest island—known to most Greeks as Mytilini, also the name of the island capital—is famous as the home of the ancient female lyric poet Sappho. The island's appeal far surpasses this claim to fame, however. Separated from Turkey by the Strait of Mytilini, barely 5km (3 miles) wide, the island has long been a crossroads shifting between the Byzantine and the Ottoman Empires. Many islanders are descendants of Greeks from Asia Minor who emigrated to Lesbos during the population exchange of 1923, and a century later the island became the first stop in Europe for asylum seekers fleeing unrest in Syria, Afghanistan, Iraq, and Africa.

The island is beautiful, etched with deep bays, topped with craggy mountain peaks, and verdant with pastures, orchards, and deep forests of pines and chestnuts. Some 12 million olive trees carpet the rolling hills and mountain slopes, yielding some of Greece's finest olive oil. The island also entices visitors with attractive seaside and mountain villages, some excellent beaches, and even a sophisticated collection of 20th-century art.

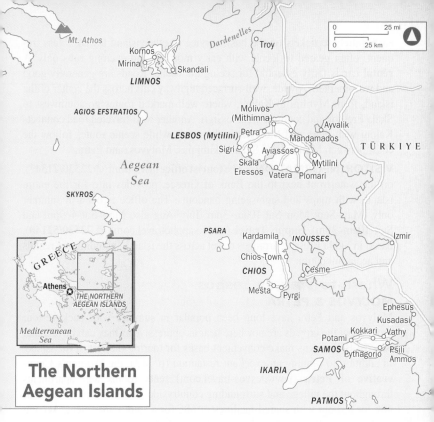

The Northern Aegean Islands

Essentials

ARRIVING **Odysseas Elytis airport** (www.mjt-airport.gr), 8km (5 miles) south of Mytilini, handles several flights to and from Athens on Olympic Air (www.olympicair.com) and Aegean Airlines (www.aegeanair.com); service is less frequent in winter. Flight time from Athens is less than an hour, a time-saver compared to a 14-hour overnight ferry trip. Seats go quickly during the summer season, so book well in advance. City buses (www.astika-mitilinis.gr) run from the airport to the center of Mytlini, usually timed to meet flights; pay the 2€ fare on the bus. Hertz, Sixt, and other car-rental agencies have outlets at the airport. **Blue Star Ferries** (www.bluestarferries.com) and **Hellenic Seaways** (hellenicseaways.gr) operate overnight ferries to and from Piraeus, calling at Chios as well. There are usually two sailings a day in summer, though in winter service dwindles to several times a week. The port is at the northern end of the Mytilini waterfront, an easy walk to the center of town. If your hotel is a distance away (quite likely on this large island), you can arrange for a rental car agency to meet the boat.

GETTING AROUND Island **buses** (www.ktel-lesvou.gr) operate from the main stop at the center of the Mytilini waterfront. Several buses a day make the 2-hour trip to and from the towns of Molyvos and Petra (fare about 3€

each, purchase tickets on the bus); service to other island towns is less frequent, often geared to locals with early morning and evening runs only. A **rental car** is fairly essential for seeing the island. Roads are generally good and well-marked. A wide, well-surfaced highway cuts across the center of the island, from Mytilini to Kaloni, where well-marked routes go southwest to Skala Eressos and continue west to Sigri. Another well-traveled road connects Kaloni with Petra and Molyvos in the north, while scenic routes follow the coast between Mytilini and Skala Sikiminias, Molyvos, and Petra.

VISITOR INFORMATION The **tourist office** in Mytilini (℘ **22530/71347**), on the waterfront next to the Bank of Greece, provides info for the entire island, with maps and sightseeing handouts. The office is open in summer only (May–Sept Mon–Sat 10am–3pm; July–Aug also Mon–Sat 4–9pm and Sun 10am–3pm). **Sapph Travel** (www.sapphotravel.com; ℘ **22530/52140**), based in Skala Eressos, arranges travel across the island, including car rentals and accommodation.

Where to Stay on Lesbos
MOLYVOS & PETRA

Molyvos and Petra have long been popular in summer with package-tour groups, but the crowds are nowhere near as oppressive as they can be on other islands. Both towns make convenient bases for touring the rest of the island. In addition to running an excellent restaurant (p. 363), the **Women's Cooperative of Petra** (www.lesvos-travel.com) rents rooms and apartments throughout the village and surrounding countryside. You might pay as little as 40€ for a room with shared facilities or 60€ for a studio apartment. Accommodation usually includes a homemade breakfast.

Niki's Studios Sea-Front ★★★ At this little haven just steps from the center of Petra, sparkling studios done in smart contemporary style have big terraces and open to a large garden surrounding a pool. The main attractions are the beach just across the road, sea views from just about anywhere on the property, and nice outdoor spaces. The very reasonable rates include a large breakfast, making this comfortable seaside spot an especially good value.

Petra. www.nikistudios-petra.com. ℘ **22530/46101.** 20 units. 45€–65€ double. Rates include breakfast. **Amenities:** Pool; garden; beach; hot tub; free Wi-Fi.

Olive Press ★ Waves lap against the stone walls of this converted oil factory on Molyvos's Delfinia Beach, where handsome contemporary-style seaview rooms surround a swimming pool and flower-filled garden. Rooms show off stone walls and other vintage embellishments, while many of their balconies hang right over the water. A jetty makes it easy to jump right in.

Molyvos. olivepresshotel.gr. ℘ **22530/72020.** 50 units. 60€–120€ double. Rates include breakfast. **Amenities:** Bar; pool; beach; free Wi-Fi. Closed Nov–Mar.

Sea Horse Hotel ★★ Luxuries are few and far between at this attractive, stone-fronted landmark on Molyvos Harbor, but the simple tile-floored rooms and their balconies hang right over the quay and provide a ringside seat for the

comings and goings below. (Double-pane windows and air-conditioning allow you to shut off the show at night.) To join the action you need only take a seat in the waterside cafe, an extension of the airy lobby.

Molyvos. www.seahorse-hotel.com. ℂ **22530/71320.** 14 units. 50€–65€ double. Rates include breakfast. **Amenities:** Cafe/bar; refrigerators; free Wi-Fi.

MYTILINI

Loriet ★★　A 19th-century estate on the coast just outside Mytilini provides an atmospheric getaway in a character-filled old mansion and a 1970s-era addition. Suites in the mansion are huge and elaborately appointed, beamed attic rooms and cottages are cozy, and the newer hotel rooms and small apartments are pleasantly contemporary. Beautiful gardens, a saltwater pool, and access to a small beach lend a resortlike vibe to this gracious old property.

Varia, 4km (2½ miles) S of Mytilini off road to airport. www.loriet-hotel.com. ℂ **22510/43111.** 30 units. 65€–90€ double. Rates include breakfast. **Amenities:** Bar; pool; nearby beach; free Wi-Fi.

Theofolis Paradise ★★　Guests looking for a casual getaway might find the stylishly neoclassic rooms here a bit fussy, but draped beds, handcrafted furniture, and polished wood floors are in keeping with historic ambiance of this 1912 mansion and two adjoining new wings. A rooftop garden includes a small pool where you can do laps. The seafront, markets, and other in-town attractions are just outside the door.

Skra 7. www.theofilosparadise.gr. ℂ **22510/43300.** 24 units. 80€–110€ double. Rates include breakfast. **Amenities:** Cafe; rooftop lounge; pool; free Wi-Fi.

Votsala Hotel ★★★　No in-room TVs, no pool, no air-conditioning, no spa—rather than resort-style luxuries, this laidback and welcoming retreat on the coast north of Mytilini offers relaxing seaside gardens and such perks as a generous breakfast, barbecues, and other family-style meals on a pine-shaded waterside terrace. Large, homey, breezy rooms are spread through Bauhaus-inspired wings; all have balconies or terraces and small kitchens. Beautifully tended grounds run down to the sea and a swimming pier, while a few shops and simple tavernas are a short walk away along a waterside path. Hosts/owners Yiannis and Daphne and their extended family share tips on enjoying the island and may even accompany guests on boat trips, country walks, and other excursions. Their hospitality brings many guests back year after year.

The imposing waterfront of Mytilini, Lesbos's capital.

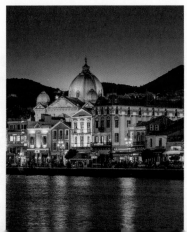

Pyrgi Thermis, 10km (6 miles) N of Mytilini. www.votsalahotel.com. ℂ **22510/71231.** 45 units. 50€–85€ double. Rates include breakfast. **Amenities:** Bar; cafe; beach; excursions; free Wi-Fi. Closed Nov–Mar.

SIGRI & SKALA ERESSOS

Heliotopos ★★ Host Elini Mantzorou shares her little patch of paradise, where guest bungalows equipped with large double studios and apartments are set amid a garden of exotic flowers and citrus and olive trees, interspersed with lawns and terrace. A bounty of fruit comes right off the trees, the beach is a short walk down the road, and a lake across the road is home to turtles and storks. The simple, comfortable lodgings are well suited to long-term stays; many guests settle in for a week or more to enjoy the laidback lifestyle.

Outskirts of Skala Eressos. www.heliotoposeressos.gr. ℂ **6948/510-527.** 8 units. 35€–55€ double. **Amenities:** Garden; kitchens; free Wi-Fi. Closed Mid-Oct to Apr.

VATERA

Aphrodite Beach ★★ Run by a large Greek-American family, these friendly premises on Vatera Beach are geared to families, with nicely outfitted rooms as well as big, airy apartments with fully equipped kitchens. A trampoline, playground, and separate kid's area of the pool with a slide and waterfall keep young travelers occupied; the main draw is the stretch of sand out front. The excellent on-premises restaurant makes the most of garden vegetables, locally raised meat, and fresh fish; lighter fare is available at the pool bar/cafe and beach taverna.

Vatera. www.aphroditehotel.gr. ℂ **22520/61288.** 30 units. 50€–80€ double. Rates include breakfast. Min stay required some periods. **Amenities:** Restaurant; bar; pool; playground; kitchens; free Wi-Fi. Closed Oct–Apr.

Where to Eat on Lesbos
MOLYVOS & PETRA

Captain's Table ★★ SEAFOOD/MEDITERRANEAN This fixture on Molyvos Harbor never disappoints. Chef/owner Melinda and husband Theo serve fresh fish and an array of dips, pies, and other mezes (including some memorable smoked fish variations), along with creative pastas and other Mediterranean favorites. A backdrop of the sea reflecting the twinkling lights of the town puts a nice spin on a meal.

Molyvos Harbor. ℂ **694/412-1297.** Entrees 8€–18€. Tues–Sun 5:30pm–midnight (no lunch late Oct to mid-Apr).

Cafes and restaurants crowd right up to the water's edge along beautiful Molyvos harbor.

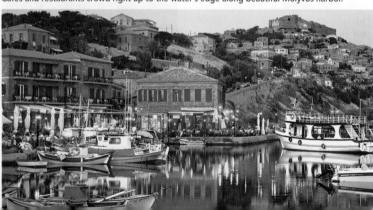

Women's Cooperative of Petra Restaurant ★★★ GREEK The idea behind this island-famous spot is to boost the income and independence of local women, and to achieve this goal the chefs focus on home-cooked traditional Greek and local dishes. Menus change frequently, but the kitchen usually turns out delicious takes on such staples as moussaka and lamb in wine sauce, served in an airy second-floor dining room and adjoining terrace. In summer you should reserve several days in advance.

In alley off main square, Petra. www.lesvos-travel.com. ℗ **22530/41238.** Entrees 7€–16€. Daily 12:30pm–midnight, shorter hours in winter.

MYTILINI

Kafeneion O Ermis ★★★ GREEK Operating since 1800, this ouzeri has been run by four generations of a family that arrived from Asia Minor in 1922. They've had the good sense to leave alone the Belle Epoque charm—big mirrors, wooden sofas, and gold-framed paintings by local artists. Most patrons come to drink and nibble on a wide variety of small plates, but the moussaka and other homey main dishes are delicious, too.

Kornarou 2. ℗ **22510/26232.** Entrees 6€–12€. Tues–Sat 10am–midnight.

To Kardasi ★★ GREEK/TURKISH The exotic Mytilene cityscape of domes and tall Ottoman houses is a suitable backdrop for this mix of Turkish and Greek favorites served at quayside tables. A long menu includes local cheese in many guises and *golzeme* (Turkish pies) and moves on to sardines from the Gulf of Kaloni and other fresh fish, along with grilled meats and moussaka and other *mayirefta* (ready-cooked meals).

Christougennon 1944. ℗ **22510/41444.** Entrees 7€–14€. Daily noon–midnight.

SIGRI & SKALA ERESSOS

Cavo d'Oro ★★★ SEAFOOD/GREEK Despite its off-the-beaten-track location at the island's far west end, this Sigri landmark is considered by many islanders to serve the best seafood on Lesbos. The signature dish here is lobster spaghetti, but any of the shellfish and fish (smoked, marinated, or grilled) is deliciously fresh, just off the boats along the dock out front. Garden fresh vegetables and many delicious mezes accompany a meal.

Dikastika 9, Sigri. ℗ **22530/54221.** Entrees 8€–25€. Sat–Thurs 10am–11pm, Fri 2–11pm.

Parasol ★★ BAR/GREEK Of the many beachfront bars in Skala Eressos, none sets the easygoing mood as well as this thatch-roofed patio built on pilings over the sand. The all-day menu offers sandwiches, salads, and other fairly nondescript light fare, but food is not really the point here. Cocktails draw a big afternoon-into-evening crowd, and many regulars come back to spend the morning over a coffee while soaking in the sea view.

Seafront, Skala Eressos. ℗ **22530/52050.** Dishes 5€–12€. Daily 9am–2am. Shorter hours in winter.

Soulatso ★★ SEAFOOD/GREEK The long stretch of sand out front creates a backdrop for a seaside feast on the terrace or in a simple room. You'll want to try such local favorites as *sardeles pastes* (fresh sardines, skinned and

seasoned); the house specialty is octopus, hung to dry on lines out front, grilled to tender perfection, and accompanied by local ouzo.

Seafront, Skala Eressos. ℂ **22530/52387.** Entrees 6€–20€. Daily noon–midnight. Shorter hours in winter.

VATERA

Akrotiri Fish Restaurant ★★★ SEAFOOD/GREEK It's worth a trip (or several) to Vatera to enjoy what many regulars consider the freshest seafood on the island. Most of what chef Dimitris serves comes right off his own fishing boat, and he accompanies grilled fish and big platters of mussels with many delicious mezes, including fresh crab and shrimp salads. The restaurant is especially busy on weekends, when a meal here is part of a day at the beach.

Agios Fokas, Vatera (inland from the beach). ℂ **22520/61465.** Entrees 8€–20€. Daily noon–midnight, shorter hours in winter.

Exploring Mytilini ★★

A walk along the long *paralia* (waterfront boulevard) of Lesbos's main town provides a refreshing look at workaday island life. Mytilini is an energetic and cosmopolitan little city, full of students from the University of the Aegean. Its multicultural local population includes recent refugees from Syria and elsewhere as well as many descendants of the refugees who settled here during the 1922–23 population exchanges, when it's estimated that more than a million ethnic Greeks were expelled from their Turkish homelands.

The old part of town, laid out by Byzantines and Ottoman Turks, sprawls across a hilly promontory between two harbors, an ancient one to the north and the modern port to the south, always busy with ferries sailing to and from Turkey and Athens. A largely Turkish Kastro (fortress) sits in fragrant pine forests on a rise at the eastern flank of the promontory. Below the fortress, a boisterous market street, Ermou, bisects the center of town, lined with stalls, little shops, coffee houses, and landmarks that include the Yeni Mosque.

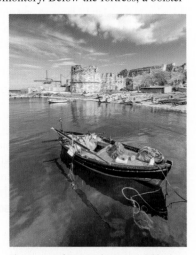

Archaeological Museum ★★

MUSEUM Many cultures have thrived on Lesbos, leaving behind them some wonderful bits and bobs, such as capitals from the columns of temples at Klopedi, an 8th-century B.C. sanctuary near the center of the island. Three rooms from a Roman villa are especially engaging, with their glittering mosaic floors. Many depict scenes from plays by Medeander, with actors wearing masks and costumes; others portray Socrates, the

The remains of Roman wharves are visible along Mytilini's ancient harbor, just north of the crenellated Kastro fortress, built under Turkish rule.

Muses, and lyric poets. These were no doubt meant to reflect the owner's literary tastes and perhaps set the stage for dramatic readings and performances.

8i Noemvriou 8. odysseus.culture.gr. (C) **22510/40223.** Admission 4€. Tues–Sun 8:30am–3:30pm.

Teriade Museum ★★★ MUSEUM Stratis Eleftheriades left Lesbos for Paris in 1915, westernized his name to Teriade, and established himself as publisher of the avant-garde art journals *Minotaur* and *Verve.* Teriade published and collected works by many great artists of the early 20th century, and these well-designed galleries in Vatera, a Mytilini suburb, are hung with drawings, lithographs, and paintings by Matisse, Picasso, Giacometti, and many, many more, as well as the Teriade publications that boosted them to the forefront of modern art. Teriade was a patron of the local folk artist Theophilos (see below), so it's fitting that their museums share the same parklike grounds.

Varia, 4km (2½ miles) S of Mytilini off road to airport. www.museumteriade.gr. (C)**22510/ 23372.** Admission 2€. Mon–Fri 10am–6pm, Sat 11am–4pm.

Theophilos Museum ★★ MUSEUM The painter Theophilos Hatziminhail was born in 1873 in Varia, an outlying neighborhood of Mytilini, and this stone house surrounded by olive groves near his birthplace shows off his primitive and colorful canvases, depicting island life as well as gods, goddesses, and saints. Theophilos was even better known as an eccentric than as a painter—he often walked through the streets of Mytilini dressed as a Greek god or Alexander the Great. In 1919 Lesbos-born art critic and publisher Teriade discovered the impoverished artist and supported him until he died from food poisoning in 1934. Unfortunately, Theophilos painted many pieces on the walls of cafes and houses, in exchange for food and lodging, and many of these were long ago destroyed. The house is on the same grounds as the Teriade Museum (see above), so it's easy to combine visits to the two.

Varia, 4km (2½ miles) S of Mytilini off road to airport. odysseus.culture.gr. (C) **22510 41644.** Admission 3€. Mon–Fri 8:30am–2:30pm.

Thermal Gera Hot Springs ★★ NATURAL ATTRACTION Lesbos is riddled with hot springs and islanders have been plunging into them since antiquity. The Ottomans were ardent soakers and built bathhouses across the island, but many of their complexes—as well as those of more recent eras—have been abandoned, except for this one on the Gulf of Yera. Recent renovations have added a cafe/restaurant, sun terraces, swimming pool, spa, and Jacuzzi to the original pool, fed by 103-degree waters that are a tonic for rheumatism and arthritis. Another timeless feature is the beach out front.

Mytilene-Kaloni Rd., 12km (7 miles) W of Mytilene. thermaspalesvos.com. (C) **22510/ 41503.** From 3€. Daily 9am–9pm.

Exploring North of Mytilini

Some of the island's prettiest towns, best beaches, and most striking coastal scenery are in the northeast corner. The Strait of Mytilini, which separates this

part of the island from Turkey, is only a little more than 4km (2½ miles) wide at its narrowest point.

Given the island's triangular shape, travel time from Mytilini to Molyvos and other places on the island's north end are about the same whether you follow the coast road or head inland, then north from Kaloni. En route to or from the north coast, you may want to stop off at Mandamados ★, a stone village on a high inland plateau, about 35km (21 miles) north of Mytilini. It's beloved by islanders for the remarkable icon of the Archangel Michael in the Church of the Taxiarchis. It's said that during a pirate raid, all but one of its monks were slaughtered; when the lone survivor emerged from hiding to find the bloody corpses of his dead companions, he responded by gathering the blood-soaked earth and fashioning it into the face of the Archangel Michael. This simple icon, its lips worn away by pilgrims' kisses, is set at the center of the iconostasis, at the back of the main chapel. Pilgrims leave behind pairs of tiny tin shoes, to be worn by the archangel as he rushes about the island nightly to ensure the well-being of the faithful. The church is usually open daily, 10am to 6pm.

The chief town on the north coast is **Molyvos ★★★**, which lies about 60km (37 miles) northwest of Mytilini, 28km (17 miles) north of Kaloni. Though officially listed by its ancient name, Mithymna, it's known to many travelers and islanders as Molyvos, from the days of Byzantine rule. (By the time you've gotten this far in Greece you've probably realized that many places have more than one name.) During the Trojan War, Achilles besieged the town but was unable to penetrate the walls—until a young woman, smitten with the handsome warrior, opened the gates for him (most unchivalrously, he then slaughtered her and took the town). These days, tourists are the invading armies, and the pretty town is fairly irresistible, with lanes full of mansions of stone and pink-pastel stucco capped by red-tile roofs. Balconies and windowsills are decorated with geraniums and roses, and the picturesque harbor is a working port, where fishing boats unload their catch next to cafes well suited to lingering over a coffee for an hour or two. The influence here is decidedly Ottoman, with marble fountains at street corners and wooden balconies *(sachnisia)* overhanging the lanes. The 19th-century **Komninaki Kralli mansion,** behind the church of Aghios Panteleimon, houses an annex of the Athens School of Fine Arts. Some weekdays between 9am and 5pm you can step into the ground floor salons to admire the paneled walls and ceilings, painted with scenes from Constantinople (admission is free).

The narrow lanes of Molyvos, shaded by a ceiling of ivy, have a bazaarlike quality, harking back to the days of Ottoman rule.

The Genoese, who were granted Lesbos in 1373, greatly expanded and reinforced the hilltop **Castle of Molyvos** (odysseus.culture.gr; ⓒ **22530/71803**), built a century earlier by the Venetians. Its sturdy stone walls, gates, and stout towers have all been well preserved, though there's little to see inside other than the views across the island and up and down the Turkish coast. From these ramparts the wife of a medieval governor saved the town when she put on her husband's uniform and led a charge against invading Turks—a short-lived victory, unfortunately, as the Ottomans soon returned with a fleet of 150 warships and brought the island under their control for 450 years, until 1912. A stage in the southwest corner of the castle courtyard is often used for theater performances in summer. Several streets in town merge into paths leading up the castle hill, though the climb is steep; by car, follow the well-marked road from the eastern edge of town to the castle parking lot. The castle is open Wednesday to Monday 8:30am–3:30pm; admission is 3€. To the east of Molyvos, **Golden Beach** is a long stretch of sand where you're likely to find a spot far from the crowds.

The most popular asset of Petra ★★, some 7km (4 miles) south, is a long stretch of sandy beach, but behind the sun umbrellas lies a traditional stone village of tile-roofed houses clustered around a massive monolith. At the top of 114 rough-hewn steps cut into the rock face, the little chapel of **Glykophilousa Panagia (Our Lady of the Sweet Kiss)** was built in the 17th century to house an icon of the Virgin Mary. One day, so the story goes, a fisherman accidentally dropped this icon from his boat. That night he saw a strange light burning atop the rock. He came ashore, climbed to the top, and found his icon, lit by a candle. He took the icon back to his boat, but the next day it went missing again, only to appear back atop the rock—obviously where the Virgin intended it to be. The church is usually open from 8am to 5pm. One of the many beautiful houses on the streets below is the **Vareltzidena Mansion,** one-time home of a wealthy Ottoman merchant, where charming murals in some rooms depict circus bears, sailing ships, and courting couples. Admission is 3€ and the house is open Tuesday through Sunday, 8am to 3pm.

A flat and well-maintained dirt road skirting the north coast heads east 20km (12½ miles) from Molyvos to the compact fishing port of Skala Sikiminias ★★, the northernmost point on the island (it's 48km/28 miles north of Mytilini). Sikiminias seems almost too picturesque to be real, with a string of cafes along a wharf with a little church at one end. The idyllic setting is immortalized in the 1955 novel *Mermaid Madonna* by Stratis Myrivilis, who was born and raised here. The novel depicts the flood of refugees from Asia Minor in 1922, events that seem especially poignant now, as Skala Sikiminias served as a gateway for thousands of refugees in the migrant crisis of 2015–16.

Exploring Southwest of Mytilini

The Gulf of Yera and the Gulf of Kaloni carve deeply into Lesbos's south coast, defining the island's lush southeast. Rising high above the rural and often wild countryside is Mount Olympus—one of 19 peaks in Greece with that name. Orchards, olive groves, and pine and chestnut forests climb the slopes toward a craggy summit that reaches 968m (3,200 ft.).

Follow the main east–west road that traverses the island, then turn south at Keramia to reach the beautiful mountain village of **Agiasos ★★★**, about 25km (15 miles) from Mytilini. Agiasos sits on the forested heights of Mount Olympus, which towers over the village's tile rooftops and winding cobblestone streets. Among the many travelers who come here are pilgrims visiting the ornate church of the **Panagia Vrefokratousa (Madonna Holding the Infant),** which contains an icon of the Virgin Mary supposedly painted by St. Luke the Evangelist and brought here from Jerusalem in 803. Allegedly the icon worked a miraculous cure for

The ornate church of the Panagia Vrefokratousa draws pilgrims to the lovely mountain town of Agiasos.

an 18th-century Turkish administrator, who, just as miraculously, showed his gratitude by excusing the village from taxation. The church is usually open 8am to 1pm and 3pm to 7pm. Villagers celebrate the miracle on August 15, the Feast of the Virgin, when they parade the icon through the streets. Workshops built into the church's exterior walls and in the surrounding bazaar sell pottery and handcrafted wooden furniture and utensils, much of which transcends the usual souvenir offerings. En route to Agiasos, you may also want to stop off at the tiny hamlet of **Karini,** off the main road 7½ km (4½ miles) north of Agiasos, where you can park in the shade near the taverna and follow a short path to the hollowed-out tree where the folk artist Theophilos (see p. 365) once made his home.

Continue for a half-hour's drive west to another remarkable landscape, the valley around **Polychnitou,** where hot springs bubble and boiling streams flow through richly colored beds of rocks and minerals. Since antiquity, these waters have been channeled into thermal pools and stone bathhouses. Sad news for the sore and weary is that all are now closed, and most stand in eerie ruin.

An 8km (5-mile) drive south from Polychnitou will take you to **Vatera ★★**, an unbroken fringe of golden sands stretching 7km (4½ miles), backed by simple bars and tavern and some low-key hotels. (You may also reach Vatera directly from Agiasos, on a winding and often unpaved but well-maintained road south through chestnut forests skirting Mount Olympus.) In **Plomari ★**, 31km (19 miles) east of Vatera, old houses line the banks of the Sedounta River. Plomari is the ouzo capital of Greece, so it would be a shame to pass through without sampling the local product at one of the cafes around the main square.

Exploring the Far West

The main cross-island road skirts the lush plain around the Gulf of Kaloni, where flamingos gather on the flats. The gulf attracts more than 250 species of birds; watchtowers just off the road are prime viewing spots. After a climb through pine-scented mountain heights the road drops down into the rugged

A modern statue in Skala Eressos commemorates the town's association with the ancient poet Sappho.

landscapes of western Lesbos. Towns out here are a bit too far removed to be convenient touring bases, but you may want to spend a night or two in **Skala Eressos** ★★★ (85km/49 miles southwest of Mytlini) to enjoy its laidback beach life. Even if its 3km (2-mile) expanse of brown sand backed by tamarisk trees wasn't among the finest on Lesbos, this friendly seaside town would have many admirers. The association with Sappho (see box, below) draws many female visitors; another Erossos native was Theophrastus, a student of Plato, successor of Aristotle at the Lyceum in Athens, and a prolific writer on botany, metaphysics, and ethics. Today's low-key modern town follows part of the beach, with a clutch of outdoor bars hanging over the sand at one end, and scrub-backed sands stretching to the west. Behind the beach are a stream and spring-fed lake, surrounded by almost tropical greenery and home to turtles and many birds, including storks.

Perched on the hillside 11km (7 miles) inland from Skala Erossos, **Medieval Erossos** was built during the Middle Ages to provide protection from pirate raids. Surrounding the town is a valley full of farms and orchards, and views extend across the fertile coastal plains below.

About an hour's drive northwest of Skala Erossos, the east-west highway meets the sea at **Sigri** ★, a windswept little town built around a massive but derelict Turkish castle and a busy fishing harbor. The bleak rocky landscape that surrounds Sigri is nowhere more desolate than it is in the **Petrified Forest of Lesbos,** a collection of fallen and still-standing tree stumps turned to stone after a volcanic eruption some 20 million years ago. A path winds through the eerie setting, littered with trunks almost 20m (66 ft.) and 3m (10 ft.) in diameter. The vistas are fascinating, but avoid visiting in the heat of the day, since petrified trees provide no shade. The park is 10km (6 miles) east of Sigri and is open daily 9am to 5pm, from 9:30am on Sunday; admission is 3€. Back in Sigri, the **Natural History Museum of the Lesbos Petrified Forest** explores this fascinating

The Poetry of Desire

Ancient Erssos, of which only scant traces remain near the harbor of Skala Erossos, was home to the poet Sappho, who was born here around 612 B.C. After her marriage, she ran what was essentially a finishing school for young women. She praised her charges in such verses as "and I yearn, and I desire," lyrics that have lent the island's name to desire between women. Today a contemporary sculpture of Sappho playing a lyre stands next to the sea near the harbor—it's lyrical indeed.

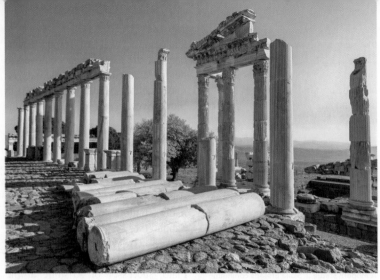

The ruins of Pergamon, one of the great ancient Greek cities, sit just across the strait from Lesbos in Turkey. Tour operators from Mytilini run frequent excursions—see "Passage to Pergamon," below.

local geology in depth; it's open the same hours as the park, admission 3€. As you walk on the beach in Sigri look for little pieces of petrified wood among the pebbles. Sigri is 88km (53 miles) west of Mytilini.

CHIOS

283km (153 nautical miles) NE of Piraeus

"Craggy Hios," as Homer dubbed the island—which he knew well, since it was said to have been his native land—is known throughout the Greek world for shipbuilding, having surrendered many of its towering trees to masts and raised generations of seafarers. Many of Greece's shipping dynasties still retreat to estates behind stone walls on jasmine-scented lanes in Kambos. The island's other traditional source of wealth is on display in a string of "mastic villages," named for the aromatic tree resin that was long Chios's chief agricultural product. These so-called *mastihohoria* are some of the finest

Passage to Pergamon

One of the most important cities of the Greek world, **Pergamon** sits atop a wooded hillside just inland from the Turkish coast. Magnificent artifacts from the site now fill the Pergamon Museum in Berlin, but what remains amid the ruins, especially on its Acropolis, is stunning: sanctuaries to Trajan and Athena, royal palaces, and a library (Marc Antony presented the 200,000 scrolls to Cleopatra as a wedding gift). Many Mytilini travel agencies offer day tours to Pergamon for about 60€, but you can easily get there on your own; take a ferry from Mytilini to Cesme, Turkey, from where you can catch a bus to the site. A visa is not required for a day visit.

medieval settlements in Greece, complete with towers and stenciled houses. Yet another kind of wealth shows up at Nea Moni, an 11th-century Byzantine monastery set amid majestic mountain scenery and carpeted with extraordinary mosaics. Chios is beautiful and largely wild; despite the shipbuilders' axes and some devastating fires in recent years, it's still generously green in many places, with forested mountain slopes and hidden valleys.

Essentials

ARRIVING Chios airport, 5km (3 miles) south of Chios Town, handles several **flights** a day to and from Athens in summer, on Olympic Air (www. olympicair.com) and Aegean Airlines (www.aegeanair.com); service is less frequent in winter. Flight time from Athens is less than an hour. Seats go quickly in the summer season, so book well in advance. A taxi to the city center costs about 10€. Blue Star Ferries (www.bluestarferries.com) and Hellenic Seaways (hellenicseaways.gr) operate overnight **ferries** to and from Piraeus, which make the trip in about 12 hours. Both lines offer two sailings a day in summer, though in winter service dwindles to several times a week.

GETTING AROUND Operating from a station on the waterfront, **Green Line** buses serve Mesta, Pyrgi, and other towns around the island. **Travelshop** (www.travel-shop.gr; ✆ 22710/81500), on the waterfront at Leoforos Egeou 56, rents cars and is convenient to the port.

VISITOR INFORMATION The **tourist office** in Chios Town, near the waterfront at Kanari 18 (www.chios.gr; ✆ 22713/51723), is open May to September, weekdays 7am to 2:30pm and 6:30pm to 9:30pm, weekends 10am to 1pm; from October to April it's only open weekdays 7am to 1pm. **Chios Tours,** Kokkali 4 (www.chiostours.gr; ✆ 22710/29-444), helps with car rentals, accommodation, tours, and other details. To learn about the island's main product, mastic, you can take mastic-harvesting tours with Mesta-based **Masticulture** (www.facebook.com/masticulture; ✆ 22713/00500), which also offers village visits and bike and sea-kayaking trips.

Where to Stay on Chios

Top choice for a place to stay is Kambos, an outlying district of Chios Town filled with citrus groves. Kambos is well positioned for exploring the rest of the island, and some of its walled estates have been converted to hotels.

CHIOS TOWN & KAMBOS

Chios Chandras ★★ One of the grandest buildings in Chios Town is also one of the island's most luxurious places to stay, commanding the southern edge of the harbor with views of town and sea from huge expanses of glass, airy balconies, and a swimming pool terrace. Large pastel-hued guest rooms are generic yet softly soothing, and offer a lot of comfort at very good value.

Evgenias Chandris 2. www.chioschandrishotel.gr. ✆ **22710/44401.** 85€–145€ double. Rates include breakfast. **Amenities:** Restaurant; bar; pool; free Wi-Fi.

Grecian Castle ★★ A castle it's not, but this handsome stone complex fashioned out of an old pasta factory is comfortable and filled with character.

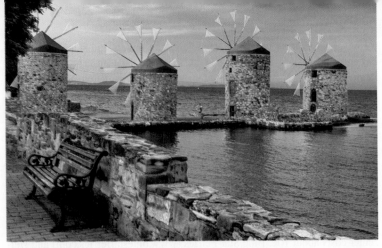

Just north of Chios's main port, a quartet of traditional windmills faces out to sea.

Traditionally furnished, marble-floored rooms occupy newer neoclassical cottages and have nice balconies for outdoor living. What's really inspiring here, though, is the large garden and swimming pool. The sea is across a busy thoroughfare; the town beach is a short walk to the south.

Leoforos Enosseos. www.greciancastle.gr. © **22710/44740.** 69 units. 65€–90€ double. Rates include breakfast. **Amenities:** Restaurant; bar; pool; free Wi-Fi.

Hotel Kyma ★ During the Turko-Greek refugee crisis of 1922, this neoclassical villa, built for a shipping magnate, was the headquarters of prime minister Nikolaos Plastiras; today it's a character-filled hotel embellished with frescoes and marble staircases, perched at water's edge. Sea views fill the large windows, and many rooms have balconies that seem to hang over the water.

Evgenias Chandri 1. www.hotelkyma.com. © **22710/44500.** 59 units. 50€–70€ double. Rates include breakfast. **Amenities:** Restaurant; bar; free Wi-Fi.

Perleas Mansion ★★★ Antiques and carefully chosen artwork fill this stone mansion and two outbuildings set amid fragrant citrus orchards in Kambos, where terraces and patios set beneath a canopy of grand trees are filled with birdsong. It all adds up to an exceptional country retreat, with the beach a short drive away. Guests are welcome to wander the grounds, still a working orchard.

Vitiadou 8. www.perleas.gr. © **22710/32217.** 8 units. 130€–150€ double. Rates include breakfast. **Amenities:** Meals on request; gardens; free Wi-Fi.

Voulamandis House ★★ This modern take on a Kambos estate is comfortably stylish, with stone-walled rooms in a large house and outlying cottages full of architectural details and a pleasant mix of traditional and contemporary furnishings. The place to be is out of doors in the lemon-scented air, and this working farm offers terraces, balconies, and patios for relaxing. Oranges, mandarins, lemons, olives, and wine from the estate are on offer.

Dimarchoy Kalvokoresi 117. www.chioshotel.gr. © **22710/31733.** 13 units. 40€–80€ double. Rates include breakfast. **Amenities:** Garden; terrace; some kitchens; free Wi-Fi. Closed mid-Oct to Apr.

AROUND THE ISLAND

Emporios Bay ★★ At the little resort that Giouli and Elias Telli have created behind the seafront in Emborios, bright, handsomely furnished studios and apartments in whitewashed tile-roofed houses surround a large pool and garden. All have kitchens and terraces with views of the sea and mountains. Emborios is a pleasant beach town, and its port, with shops and restaurants, is a short walk down the road; the greatest local asset, the black beach of Mavra Volia, is just around a bend in the road, and the mastic villages are nearby.

Emborios, 30km (19 miles) S of Chios Town. www.emporiosbay.gr. ✆ **22710/70180.** 30 units. 45€–75€ double. Rates include breakfast. **Amenities:** Bar/cafe; kitchens; pool; free Wi-Fi. Closed Oct–Apr.

Medieval Castle ★★ All the atmosphere of medieval Mesta comes to the fore in these comfortably quirky lodgings fashioned out of several old houses. Stone walls, arched ceilings, fireplaces, and many nooks and crannies offset stylish contemporary furnishings, and common spaces include a welcoming terrace in the heart of the village.

Mesta. www.mcsuites.gr. ✆ **22710/76345.** 20 units. 70€–90€ double. **Amenities:** Restaurant; bar; terrace; free Wi-Fi.

Where to Eat on Chios

The island's famous mastic is likely to appear on menus in the form of *mastiha,* a tasty and fairly easy-on-the-palate liqueur—especially compared to the raki you may have been drinking on other islands. The island has its own version of raki, too: *souma,* made from fermented figs. Chances are a restaurant will offer a glass of either.

CHIOS TOWN

Tsivaeri Ouzeri ★ GREEK You don't have to look far to find this popular ouzeri, a casual taverna right on the harbor next to the port; a seat on the terrace comes with a view of all the comings and goings. Some of the excellent standards include fried *gavros* (anchovies) and grilled sardines, served alongside tomato *keftedes,* deep-fried tomato balls that are a Chios specialty.

Neorion 13. ✆ **2710/43559.** Entrees 6€–10€. Daily noon–1am.

AROUND THE ISLAND

O Passas ★★★ SEAFOOD/GREEK Langada, a fishing village about 10km (6 miles) north of Chios Town, is where locals head for a seafood dinner. The quay is lined with excellent fish tavernas, where prices are reasonable and the fish fresh. This 50-year-old landmark with a large quayside terrace stands out for its excellent service and tasty preparations of everything from fried shrimp to grilled meat platters.

Langada. passas-chios.gr. ✆ **22710/74218.** Entrees 8€–25€; fish sold by the kilo. Daily 8am–11pm.

Psitopolio Georgios Marina Pannadi ★★ GREEK The cobblestone streets of Mesta are a lively setting for a meal. Tzatziki, fried shrimp, and other meze, served at one of the outdoor tables, are followed by grilled meat

platters—lamb chops, baby pig, chicken filets, or just souvlaki. It's a memorable experience in the center of this transporting town.

Mesta. © **22710/76458.** Entrees 6€–12€. Daily 7pm–midnight.

Taverna To Asteri ★★★ GREEK A drive 16km (10 miles) west of Chios Town through pine forests leads to the attractive stone village of Avgonyma, where this homey inn sits on a hillside overlooking the Aegean. A big terrace and hearth-warmed dining room are settings for country meals of *krasato xirino* (pork baked in wine sauce), grilled meats, and huge salads brimming with garden-fresh vegetables. Lunch here is a perfect follow-up to a visit to nearby Nea Moni monastery. You might be so taken with the ambience that you'll want to check into one of the four charming rooms.

Avgonyma. www.toasteri.gr. © **22710/20577.** Entrees 8€–15€. Daily 10:30am–10:30pm. 50€–60€ double.

Exploring Chios Town

The *paralia* (waterfront) of Chios's capital, also known as Chora, is likely to be your first glimpse of the island, and admittedly, the port town has lost a lot of its looks over the years to invasions, earthquakes, and ill-conceived building sprees. But what the little city lacks in beauty it makes up for with bustle and character, especially in the bazaar around Vounakiou, the main square. Its jumble of stalls and small shops reminds visitors how close Asia Minor is—just 9km (5½ miles) across the Strait of Chios.

Byzantine Museum ★ MUSEUM The timbered porch and courtyard of Medjitie Djami, a former mosque, are littered with Muslim and Jewish tombstones, carved marble lintels from churches around Chios, cannons that once defended the island, and other bits and pieces. The collection is scattershot but fascinating to peruse; keep an eye out for the colorful fresco of three girls sleeping, from a cycle on the miracles of St. Nicholas, and Renaissance-era Genoese door lintels depicting St. George slaying the dragon.

Plateia Vounakou. odysseus.culture.gr. © **22710/26866.** Admission 4€. Wed–Mon 8am–3:30pm.

Kastro ★★ HISTORIC DISTRICT The Byzantines built this walled seaside castle in the 10th century; Venetian traders enlarged the compound in the 14th century; and when the Turks took over in 1566, they added fountains, hamams, and mosques, creating a residential and administrative district now known in Chios as the "old quarter." Within the Portara Maggiora, the main gate, stand the wood-and-plaster houses of the Ottoman Turks, who banished Greeks to precincts outside the Kastro walls. Many of the houses are now derelict, though elaborate doorways and facades suggest their one-time importance. In better shape is the medieval **Giustiniani mansion** (admission 2€; Tues–Sun 8am–7pm), home of the powerful Genoese family that oversaw the island under Byzantine rule. Its salons are now loaded with frescoes of the prophets from the Church of Panagia Krinia, on the Kambos plain south of town. Nearby is the grim little prison where the Turks held Chiots before hanging them during the rebellion of 1822.

Exploring the ancient walled Kastro fortress in Chios Town, you'll see several derelict houses.

Koreas Library/Argenti Museum ★ MUSEUM Chian aristocrat and local historian Philip Argenti collected embroideries, folk objects, and costumes from around the island throughout much of the 20th century. Among his holdings is a copy of Eugene Delacroix's despair-filled *Scenes from the Massacre at Chios,* a painting (the original is in the Louvre in Paris) inspired by the events of 1822, when the Turks savagely squashed the Greek independence movement on Chios by murdering 20,000 men, enslaving 50,000 women and children, and exiling another 20,000. (Only 2,000 Greeks remained on Chios after the attacks.) News of the slaughter, fueled in large part by this painting, did much to muster Western European support for Greek independence. Many rare volumes from wealthy islanders are in the adjoining library, a 135,000-volume collection that's one of the largest in Greece—testimony to the fortunes made in Chios from shipping. Korais 2. www.koraeslibrary.gr. ✆ **22710/44246.** Admission 1.50€. Mon–Fri 8am–3pm.

AROUND CHIOS TOWN

Kambos ★★★ NEIGHBORHOOD The plain that stretches south along the coast from Chios Town is a patchwork of orange and lemon groves and ornate Turko-Greco style estates. The district has long been the domain of the foreign elite that ruled the island, as well as local aristocracy, many of whom made their fortunes in shipping (the island's forests provided materials for shipbuilding, and seafaring was one of the few occupations available to many Chiots). High walls of golden stone hem in the narrow lanes, but a peer through wrought-iron gates often reveals lush gardens, pebbled courtyards, splashing fountains, and arched verandas and balconies. Many estates are derelict, and have been since the Turkish massacres of 1822 and an 1888 earthquake that leveled much of the island. Others retain their splendor, however, and a few offer accommodations (see p. 371). One place to savor the architecture is at the **Citrus Museum,** Argenti 9–11 (www.citrus-chios.gr; ✆ **22710/31513;** daily 9am–9pm), an attractive old estate with a large cafe, a shop selling sweets and other citrus products, and a signposted walk around the beautiful estate buildings, arbor, windmill, and orchards, where farm animals provide

charming company. It's almost impossible to find a specific address on the maze of Kambos's wall-lined narrow lanes, but the estate is well signposted.

6km (3½ miles) S of Chios Town off the main north-south road, near the airport.

Nea Moni ★★★ MONASTERY One of the great architectural and artistic treasures of Greece, this 11th-century monastery has a spectacular setting in the mountains overlooking Chios Town. As is the case with many monasteries in Greece, the story of Nea Moni begins with the appearance of a mysterious icon. In 1066, three shepherds saw a strange light in the undergrowth and found, surrounded by flames, an icon of the Virgin Mary. The icon announced that Constantine XI would become emperor of Byzantium. When this portent came to pass, Constantine and his wife, the Empress Zoe, built this beautiful monastery to house the icon. The blackened image hangs over the altar of the octagonal *katholikon,* or principal church. Around the square nave, eight niches contain sequences of extraordinary mosaics, among the finest examples of Byzantine art, with portrayals of the saints, Christ washing the disciples' feet, and sinners being devoured by fish. The icon is believed to work mysterious cures for the faithful and in recent years was credited with stopping the flames that engulfed the surrounding forests. Sadly, no such intervention spared the monastery from an 1881 earthquake that sent the dome and many beautiful mosaics crashing to the ground. The monastery has now been designated a UNESCO World Heritage Site and the mosaics are slowly being restored to their glory. A chapel on the grounds is filled with skulls, some showing axe marks, of the 600 monks and 3,500 islanders who sought refuge here during the Turkish massacres of 1822—and were slaughtered when Ottoman troops broke through the gates. A round-trip taxi ride from Chios town to Nea Moni costs around 40€, including a half-hour at the monastery.

Nea Moni, about 12km (7½ miles) W of Chios Town. odysseus.culture.gr. ⓒ **2710/79391.** Donations welcome. Daily 8am–1pm and 4:30pm–sunset.

Extraordinary Byzantine mosaics surround the holy icon at the Nea Moni monastery, a UNESCO World Heritage Site.

Vrontados ★ NEIGHBORHOOD This seaside suburb makes two extraordinary claims. Before Christopher Columbus journeyed to the New World, he allegedly came ashore to seek advice on routes and navigational tactics from local seafarers (still a large sector of the island population) and, while here, discovered the pleasures of mastic (see box, at left). What's more, Homer is said to have lived here and taught from a boulder conveniently topped with a lecternlike outcropping. The so-called **Daskalopetra** (Teacher's Rock) was probably an ancient altar to Cybele, the nature goddess, but with the sea glistening below and birdsong coming from the lemon and olive trees, it would certainly have been a delightful place to listen to the greatest poet of all times. 5km (3 miles) N of Chios Town.

> ## What Is Mastic?
>
> The soil of Chios is especially well suited to mastic, a tree that produces an aromatic and useful resin. Hippocrates prescribed mastic for everything from snake bite to boils. Romans used it to clean their teeth, and Turkish harems chewed mastic to sweeten their breath. Mastic is still made into gum, toothpaste, mouthwash, cosmetics, and a digestion-abetting liqueur. Some medical researchers claim that mastic can also lower blood pressure and boost the immune system.

Exploring the Mastic Villages

The Genoese who governed the island from the 14th to the 16th centuries began establishing 20 or so *mastihohoria* (mastic villages) to ensure a steady supply of pleasantly smoky-tasting little pellets of mastic, the island's most valuable product (see box, above). Mastic was, in fact, so valuable that Ottoman troops spared these villages when they depopulated the island in 1822. With fortresslike outer walls, arcaded streets, and elaborately patterned exteriors, the remaining *mastihohoria,* especially Pyrgi and Mesta, are some of the most intriguing villages in Greece. They are surrounded by welcoming

Orchards of gum trees produce mastic, Chios's most valuable export.

In the mastic village of Pyrgi, elaborate geometric patterns decorate the house facades.

landscapes where, despite fires in recent years, olive groves and mastic orchards rise and fall across rolling hills. This part of the island is also ringed with beaches of black volcanic sands; the best known is **Mavra Valia** (Black Pebbles), near Embrio about 8km (5 miles) southeast of Pyrgi.

In **Mesta ★★★**, some 35km (22 miles) southwest of Chios Town, an out-ermost perimeter of houses creates a solid rampartlike wall, with no doorways or windows, presenting a forbidding aspect to the outside world. Only a few gates lead into the maze of narrow lanes that burrow between and beneath houses. These architectural hurdles were meant to deter pirates, for whom mastic-rich villages were a prime target. Mesta has two churches named for the Archangel Michael. **Megas Taxiarchis** (Great Archangel), on the main square, is aptly named—not only is this the larger of the two, but it is also one of the largest churches in Greece. The sand beach at **Apothika,** one of the best on the island, is 5km (3 miles) east of Mesta.

Another 10km (6 miles) southeast of Mesta, 25km (15 miles) southwest of Chios Town, the village of **Pyrgi ★★★** is best known for its houses elaborately decorated with *xysta*. With this technique, a layer of gray-black volcanic sand is coated with white lime, then etched with circles, stars, diamonds, and other elaborate geometric patterns and floral motifs to reveal the dark layer beneath. Another design aesthetic shows up in the main square's 12th-century church of **Agli Apostoli,** with its brick-banded exterior and an interior rich in frescoes of biblical scenes, including St. Paul's visit to Chios in the 1st century A.D.

Chios Mastic Museum ★★ MUSEUM A stunning complex tucked into a hillside above Pyrgi tells you everything you need to know about Chios's most important agricultural product. Fascinating displays show how residents of the nearby village once harvested the plant and processed the resin under the watchful eyes of their Turkish masters, usually for subsistence wages and under penalty of death for hiding even a tiny scrap of the precious

substance. Mastic orchards spread below the museum, and a posted walk guides you through the trees, explaining more about growth and cultivation.

3km (2 miles) S of Pyrgi. www.piop.gr. ℰ **22710/72212.** Admission 4€. Wed–Mon 10am–6pm (closes 5pm mid-Oct to Feb).

SAMOS

322km (174 nautical miles) NE of Piraeus

Excellent beaches are among the many natural assets of this northern island, and these have not gone unnoticed. Much of the coast becomes a holiday haven for northern Europeans in the summer, but it's easy to get away from the crowds in the verdant, cyprus- and vineyard-clad hillsides, quiet mountain villages, and the remote, rugged northwest. Polycrates, the island's 6th-century B.C. ruler, left behind a feast for travelers interested in the ancient world, with a temple and other engineering marvels in and around Pythagorio. As an added bonus, the island's famous wines are sweet and plentiful.

Essentials

ARRIVING **Samos Aristarchos International Airport** (www.smi-airport. gr) is 4km (2½ miles) west of the village of Pythagorion. **Aegean** (aegeanair. com), **Olympic** (www.olympicair.com), and **Sky Express** (www.skyexpress. gr) operate as many as 4 flights a day in summer between Samos and Athens, with curtailed service in winter. Sky Express has a few flights a week linking Samos to Chios and Lesbos, and in summer, flights sponsored by various tour operators connect Chios to cities in northern Europe. A public bus operates between the airport and Vathy, the island's capital, with departures about every hour to 1 1½ hours throughout the day; fare is 4€, buy the ticket from the driver.

 Ferries between Samos and Piraeus run twice a day in summer, several times a week in winter; the trip takes about 13 hours. A few boats a week sail between Samos and Chios and Lesbos. Ferries also connect Samos with the Cyclades islands of Naxos, Paros, Mykonos, Ios, Santorini and Syros (daily service in summer), as well as Patmos, Leros, Kalymnos, Kos, and Rhodes in the Dodecanese. Most boats are operated by **Blue Star** (www.bluestarferries.com). Good places to check out service and schedules are Ferry Hopper (www.ferryhopper. com) and the Greek Travel Pages (www.gtp.gr). Samos has three ports, at Vathy, Pythagorio, and Karlossi; most boats to Piraeus leave from Vathy, while boats to the Cyclades and Dodecanese use Karlossi and Pythagorio, though this varies.

GETTING AROUND The island has good **bus** links between villages and beaches, with as many as 13 buses a day between Vathy and Kokkari and Pythagorio. If you're staying in Pythagorio or Kokkari you could probably get by without a rental car if you are willing to confine your touring to main sights and the more popular beaches. For bus schedules, go to www.samosin.gr.

VISITOR INFORMATION The municipality of Samos offers information from its office on the Vathy waterfront (visit.samos.gr; ℰ **27340/28582**). **Samina Tours,** at Themistokli Sofouli 67 (www.travel-to-samos.com; ℰ **22730/87000**), is a good source for car rentals, accommodations, and excursions around the island.

Where to Stay on Samos

Arion Hotel ★ Samos has many bungalow-style resort hotels, but these whitewashed and pastel-hued bungalows above Lemonákia and Tsamadoú beaches break the mold with rather stunning landscaped grounds and gardens and plenty of room to relax. Guest rooms are pleasantly traditional if uninspired; all open to balconies and terraces, a few with glimpses of the sea and most with nice outlooks over palm trees and other plantings. A large pool is surrounded by sunny terraces and an outdoor bar, and a shuttle makes regular trips back and forth to nearby beaches.

Kokkari. arion-hotel.com. ✆ **22730/92020.** 108 units. 65€–130€ double. Rates include breakfast. **Amenities:** Restaurant; bar; sauna; beach shuttle; free Wi-Fi. Closed Nov to mid-Apr.

Armonia Bay ★★★ One of the most pleasant places on Samos to settle in for a few days is this villa on a pine-clad hillside above Tsamadou Beach, just west of Kokkari. While the beach is an easy downhill walk away, the lawns, gardens, and pool can easily tempt you to stay put. Rooms are soothingly done in pastel colors and contemporary decor, and many open through French doors to airy balconies. Informal yet attentive service from Telis and Alex and their family and staff extends to serving relaxed meals in the garden.

Tsamadou Beach. www.armoniahotels.com. ✆ **22730/92279.** 24 units. 90€–145€ double. Rates include breakfast. Min. stay required some periods. **Amenities:** Bar/restaurant; pool; free Wi-Fi.

Hotel Samos ★ Vathy isn't the most relaxing spot on the island, but the attractive capital is a handy base for exploring and a convenient stopover before boarding an early morning ferry. This waterfront landmark is the closest the island comes to having a big-city hotel, with a rooftop terrace, a pool, and functionally stylish rooms overlooking the harbor from balconies.

Sofouli 11, Vathy. www.samoshotel.gr. ✆ **22730/28377.** 105 units. 65€–75€ double. **Amenities:** Bar; pool; free Wi-Fi.

Sea hammocks dangle over a secluded bay on Samos, known for its excellent beaches and getaway-from-it-all resorts.

Proteas Blu Resort ★★ This gated cluster of pink bungalows spilling down a hillside outside Pythagorion is all about seclusion and high-style relaxation. It's geared to couples, with a chic pool terrace, two semi-private beaches, a spa, and gourmet dining in a choice of glamorous settings. Pastel-hued guest quarters are rather generic and not as luxurious as the setting would suggest, but they're large and most have sea-facing balconies; a few have private pools.

Pythagorio. www.proteasbluresort.gr. © **22730/62200.** 112 units. 170€–300€ double. Many rates include breakfast. **Amenities:** 3 restaurants; 2 pools; 2 bars; spa; yacht hire; free Wi-Fi. Closed Oct to mid-Apr.

Samian Mare ★★ Top choice for a stay on the eastern end of the island is this chic getaway just steps from the ferry port at Karlovasi. Its attractive rooms and suites are far more than a convenient stopover between boats— some have Jacuzzis, all have excellent rain showers, and they overlook two lavish pools or the sea. A beach is just across the road, and the Potlomi waterfalls and other attractions are near at hand. Karlovasi, about a mile down the road, is a pleasantly old-fashioned Greek town that's well worth a wander.

123 Kon/nou Kanari, Karlovasi. www.samianmare.com. © **227320/0210.** 40 units. 75€–250€. Rates include breakfast. **Amenities:** Restaurant; bar; 2 pools; spa; free Wi-Fi.

Semeli Beach ★★★ The excellent Armonia Bay (see above) has extended its flair for innkeeping to this attractive hotel just across the road, with the same hillside views over pines to Tsamadou Beach. Father and son Telis and Alex offer the trademark Armonia Bay hospitality, here housing guests in large, beautifully designed, contemporary-styled rooms with built-in furnishings, stone floors, and nicely done stone-and-tile bathrooms. A long narrow pool has been carved out of a former quarry.

Tsamadou beach, Kokkari. www.armoniahotels.com. © **22730/92111.** 14 units. 90€–135€ double. Rates include breakfast. **Amenities:** Bar; pool; free Wi-Fi.

Where to Eat on Samos

Ammos Plaz ★ SEAFOOD/GREEK The location, right on the beach in Kokkari, is a standout, and the kitchen turns out what many locals consider the best traditional Greek food on Samos. A changing menu usually includes savory stews and creamy moussaka, as well as fish reeled in by the owners' family.

West end of beach, Kokkari. © **22730/92463.** Entrees 7€–16€. Daily noon–11pm. Closed Nov–Mar.

Aphrodite Garden ★★ GREEK/SAMIAN Step off the touristic main drag and away from the busy port to appreciate what a pretty town Pythagorio is, with stone and stucco houses climbing a hillside. There's no better place to take in the scene than this restaurant in a bougainvillea-scented garden, where the focus is on such Samian classics as chicken meatballs and spicy grilled feta with peppers. Souvlaki appears in many incarnations, including a delicious preparation in a mushroom sauce.

Behind port, Pythagorio. © **22730/61672.** Entrees 8€–12€. Daily 6pm–midnight. Closed Nov–Mar.

El Greco ★ GREEK A trip out to the southwestern end of the island should include a meal at this simple family taverna on a side street off the harbor. Grilled meats, gyros, fish, traditional starters, and other fare are served in an indoor-outdoor room that's a gathering spot from morning until late evening.

Votsalakia–Marathokampo. ℂ **22730/37668.** Entrees 5€–12€. Daily 10am–11:15pm (shorter hours in winter).

Elia ★★ GREEK/MEDITERRANEAN The Pythagorio waterfront is chockablock with friendly tavernas, none more sophisticated than this waterside terrace where a Swedish chef sends out inspired pastas and other Mediterranean fare. Traditional island dishes include pork cooked in Samian wine.

Pythagorio, waterfront. ℂ **22730/61436.** Entrees 9€–22€. Daily 11am–12:30am.

Galazio Pigadi ★★★ GREEK One of the top spots for lunch during a circuit of the mountain villages above Kokkari is this simple tavern with a wisteria-covered terrace. Hearty stews and other traditional meals are accompanied by house wine from the vineyards that climb the surrounding hills.

Vouliotes. ℂ **22730/93480.** Entrees 7€–11€. Daily 9am–11pm. Closed Oct–Mar.

Exploring Vathy (Samos Town)

The island capital surrounds a fine natural harbor, much of which is skirted by a lively and colorful *paralia* (beachfront avenue). Fishing boats are tied up along the wharf, and the old town, Ano Vathi, climbs toward the hilltops in steep lanes that narrow down to paths in many places, overhung with the balconies of old, tile-roofed mansions.

Archaeological Museum ★★★ MUSEUM Just beyond Vathy's waterside municipal gardens is one of Greece's largest archaeological collections. Samos was a major power in the Aegean as early as the 7th century B.C. Early Samarians traded with Egypt and cities on the Black Sea, dug elaborate tunnels, built magnificent temples, and cultivated the wines for which Samos is still known. You will encounter much of this past as you tour the island, and many of the most treasured finds are here in Vathy. From the Heraion (p. 384), a sanctuary devoted to Hera, wife of Zeus, comes one of six monumental *kouroi,* statues of naked youths that flanked the roadway leading to the enormous temple. Towering more than 5m (16 ft.) high, the gray-and-white marble *kouros* is the largest free-standing statue from ancient Greece to survive intact. Other statuary from the Heraion includes the Genolos Group, named for the sculptor who inscribed his name on the base of the pieces. The marbles depict a family—a reclining patriarch, his seated wife, a boy playing the pipes, and three girls poised to sing. The family seems devout and eager to pay homage to Hera, but the marbles may also have been a bit of ostentation, flaunting the wealth required to commission such an elaborate offering. ***Note:*** Check to make sure the museum has reopened after recent renovations.

Gimnasiarchou Katevaini 24. odysseus.culture.gr. ℂ **22730/27469.** Admission 4€. Wed–Mon 8am–4pm.

Museum of Samian Wine ★

MUSEUM Samos is famous for its wines, produced from grapes grown mostly on terraced hillsides in the north of the island. Many are sweet, amber-colored dessert wines made from the white muscat grape, though some dry whites and roses are also produced. Very few vineyards have tasting rooms, but you can sample island wines amid the tools, barrels, pumps, and other vintage items displayed at this old winery on the outskirts of Vathy.

Vineyards on Samo's hillsides produce some of Greece's most admired wines.

Outside Vathy. samoswine.gr. ⓒ **22730/87511.** Admission 2€, tastings extra. May–Oct Mon–Fri 10am–8pm, Sun 9am–7pm.

Exploring Pythagorio

11km (6 miles) south of Vathy

This lively resort town south across the island from Vathy has some charm, with a lively seafront and cobbled back lanes, though the appeal dims when tour groups pack in during the summer. Some of the island's splashiest hotels are on the coast nearby, but for anyone interested in history, the real draw here is fascinating traces of the ancient town, surviving amid the modern-day clamor. Renamed in 1955 for Pythagoras, the Samos-born 6th-century B.C. mathematician and philosopher, the modern town is built over the ruins of Ancient Samos, famous as the capital of the ruler Polycrates (ruled 538–522 B.C.). In Ancient Samos he created one of the most famous and cultured cities in the Aegean, a magnet for poets, artists, musicians, philosophers, and mathematicians. Half a century before his rule, Aesop had been brought to the island as a slave and was soon charming the islanders with his fables; a couple of centuries later Samian Epicurus laid down the groundwork of atomic theory.

Polycrates built a circuit of massive walls—at 6km (3¾ miles) long, they enclosed the entire city—parts of which still climb the slopes of Mount Kastro. He also commissioned the engineer Eupalinos to build a massive jetty and seawall, 370m (1,214 ft.) in length, around the harbor, where he anchored 40 triremes (warships) and various other craft with which he and his marauders plundered lands across the eastern Aegean. Much of the stone structure is still visible just beneath the waves, creating a pattern that, when viewed from the hillsides above, is shaped like a *tigani*, frying pan—which explains why Tigani is the local nickname for the town.

The castle that rises above the red-tile roofs of the Old Town is of more recent vintage, erected in 1824 by local lord and revolutionary hero Lykourgou Logotheri to help the townsfolk defend themselves against the Turkish fleet. Under his leadership, Samians and other Greeks routed the Turks just offshore on August 6, 1824 (Transfiguration Day), a victory commemorated

in the **Church of the Transfiguration,** which shares the hilltop with the castle. Notice the sign reading, "CHRIST SAVED SAMOS 6 AUGUST 1824."

Archaeological Museum of Pythagorio ★★ MUSEUM Another treasure trove of the island's past sits next to the remains of Ancient Samos, and part of a visit includes a walk among the signposted ruins. The prize of the galleries is a marble statue of a seated Aiakes, father of island ruler Polycrates. There's also a life-size likeness of the Roman Emperor Trajan, a remnant from the island's prosperity as part of Asia Minor. The Byzantines left behind the 300 gold coins on display, stashed in a brass jug retrieved from a cove in the 1980s.

Pythagorio. odysseus.culture.gr. (✆) **22730/62813.** Admission 6€. Wed–Mon 8:30am–3:30pm.

The Heraion ★★★ ANCIENT SITE A temple has stood near the banks of the Imbrasos River since the 9th century B.C. The goddess Hera, elder sister and wife of Zeus, was allegedly born on the riverbanks, where she later consummated her relationship with Zeus. By the 6th century B.C. a much larger temple had risen on the site, with 168 columns surrounding an altar to the goddess. After an earthquake leveled the temple, the ruler Polycrates set out to create the largest temple ever built in Greece. Polycrates was assassinated by the Persians before the massive temple was complete, but even before his death the structure was four times larger than the Parthenon in Athens. A roadway called the Iera Odos (Holy Road) linked the temple to Ancient Samos; some of the statues that once lined the stone avenue are in the Archaeological Museum in Vathy (p. 382). Of the temple itself, only a single column and the massive foundation survive, the rest of the site having been leveled by earthquakes and scavengers carting off the marble over the centuries. Rival Ionian cities were so impressed that they rebuilt many of their ancient temples in similar style. The well-preserved Temple of Artemis in Ephesus (see box,

Only foundations remain of the ancient Heraion temple, once the largest ever built in Greece.

Crossing to Ephesus

One of the great cities of Ancient Greece is not in Greece these days but outside the Turkish port of Kusadasi, a 1½-hour hop from Vathy or Pythagorio. One of the Seven Wonders of the Ancient World, the **Temple of Artemis** at Ephesus was modeled on the Heraion in Samos (p. 384). Today the city's most famous monument is the **Library of Celsus,** completed in A.D. 135 when Ephesus was the second-largest city in the Roman Empire, with its grand façade still standing. You can easily visit Ephesus on a day trip from Samos, taking a ferry from Vathy or Pythagorio, or join one of the many organized tours that operate out of these port towns. For a 1-day visit you won't need a visa, just your passport. **Samos Travel Services** (www.samostravelservices.gr) is one of many companies offering tours of Ephesus, usually costing about 70€, boat travel, bus transfers, and admission included; a port tax of 10€ is usually extra.

above) is a direct imitation of the great Samian structure, so if you make the trip across the straits to Turkey, you can get an idea of what Polycrates's masterwork looked like.

9km (5½ miles) SW of Pythagorio, signposted off road to Ireon. odysseus.culture.gr. ℂ **22730/95277.** Admission 6€. Wed–Mon 8:30am–3:30pm.

Tunnel of Eupalinos (Efpalinio Orgyma) ★★ ANCIENT SITE One of the most impressive engineering accomplishments of the ancient world, this tunnel through Mount Kastro was commissioned by the ruler Polycrates to transport water from mountain streams to Ancient Samos. This supply was especially vital during times of siege, and unlike an aqueduct, the tunnel could not be tampered with. Without the aid of compasses, surveying equipment, or sophisticated mathematics, the great architect Eupalinos designed a channel 1,000m (3,280 ft.) long. He directed two teams made up of hundreds of slaves, wielding picks and chisels, to dig from each side along a remarkably level line, and after nearly 15 years they met within a few meters of each other. The tunnel, which supplied water for more than a thousand years, was rediscovered in 1882. Archeologists were clued into its existence by the Greek historian Herodotus, who lived on Samos in the 5th century B.C. and wrote about a passage "dug through a mountain . . . through which water is conducted and comes by pipes to the city, brought from an abundant spring." Today's visitors clamber down a staircase into a narrow, sliverlike passage that after 20m (66 ft.) or so widens into the main tunnel, through which you can walk another 100m (328 ft.) into the mountain. Notice the clear-cut water passage and, above it, a narrow walkway from which workers could clear debris and make repairs. A generator supposedly starts up in the event the tunnel lights go out, but you might want to bring your own flashlight just in case. The tunnel could induce claustrophobia in even a veteran spelunker; seeing the straight lines of the shaft and the ancient chisel marks in the stone walls is likely to bring a chill to anyone's spine.

3km (2 miles) NW of Pythagorio, signposted off main road to Vathy. www.eupalinos-tunnel.gr. ℂ **22730/61400.** Admission 8€. Tues–Sun 8:30am–3:30pm.

Exploring Samos's North Coast

The north of the island is wild and steep, with mountains rising abruptly from the water's edge. Verdant uplands are the setting for picturesque villages, and beaches around Kokkari and Karlovassi are the best on the island.

About 10km (6½ miles) northwest along the coast from Vathy, **Kokkari ★★** is one of the island's most attractive seaside towns, stretching along a sandy beach between two headlands known as the Didymi, the Twins. As popular as Kokkari is these days, the rocky summits seem to close the town off from the modern world. You'll get a few glimpses of what life here must have been like back when the quays were piled high with fishing nets rather than crowded with cafe tables. A small fleet still sets out from the docks, and fields of *kokkari,* the small onions from which the village takes its name, stretch toward the hills. To the west, the tree-lined coast road leads to pebbly beaches at Lemonakia, Tsamadou, Aviakia, and the prettiest of them all, Tsabou.

From Aviakia, about 3km (2 miles) west of Kokkari, a road heads south through orchards and the cool, shady forests that carpet the foothills of the **Platanakia ★★** region. The terrain here is the most scenic on Samos, the villages the most picturesque. **Vourliotes,** about 3km (2 miles) above Aviakia, is a little collection of tile-roofed houses with bright shutters. The vineyards that surround the village yield some of the island's best wine, which you can sample at any of the tavernas on the main square. The fortified 16th-century **monastery of Moni Vronta** is on the mountainside about 2km (1 mile) above the village by road or 7km (4 miles) by zigzagging track. The compound is still recovering from a fire that ravaged the surrounding countryside in 2000; among other damages, it toppled the double row of cypresses that once led up to the gate. A *spileo* (cave) chapel is built into the thickness of the outer wall. Knock on the gate to see if a caretaker or someone else can let you in; the monastery is usually open daylight hours and admission is free.

> ## A Seaside Hike on the Wild West Coast
>
> West of Potami is the most scenic stretch of coast on Samos, a roadless, isolated domain of clamoring goats and the shy, endangered monk seal. The coastal road peters out at the south-western end of Potami, where a seaside path crosses olive groves and meadows scented with wild herbs to reach **Mikro Seitani,** a rockbound cove with a small beach, then the pine-backed sands of **Megalo Seitani.** Allow about half an hour for the walk to Mikro Seitani and an hour to Megalo Seitani. Bring plenty of water and protect yourself from the sun; a bathing suit is optional at both beaches.

You can reach **Manolates,** another mountain village of steep cobblestone lanes, by hiking through a river canyon for about 5km (3 miles) from Vourliotes; by car, backtrack from Vourliotes to Aviakia, follow the coast west for about 2km (1 mile) to Platanakia, then head inland for another 5km (3 miles) up the slopes of Mount Ampelos to Manolates. Village houses are whitewashed and decorated with elaborate floral designs, and the surrounding hills

and valleys attract many butterflies and birds. One especially lush, birdsong-filled glen has been designated the Valley of the Nightingales. Ambitious hikers can follow a path from Manolates up the summit of **Mount Ampelos,** the second-highest peak on Samos at 1,153m (3,783 ft.). Allow at least a half day for the trek to the top and back.

By car, you can visit two more pretty villages in the foothills, **Ampelos** and **Stavrinides.** Return to the coast, then turn inland west of Agios Konstantinos for about 4km (2½ miles) to Ampelos; from there it's another 2km (1 mile) east to Stavrinides. All these villages are watered by springs that bubble up in their squares, said to be the sweetest in Greece.

Karlovassi, 25km (15 miles) west of Kokkari, is an old-fashioned town, with some nice early 20th-century architecture; another 2km (1 mile) west is the popular sand-and-pebble beach at **Potami.** Another place to cool off is the **Potami waterfall,** in a shady river gorge about a 20-minute hike inland from the beach. The path skirts the 11th-century **church of Metamorphosis,** with its faded frescoes, then reaches a string of little pools. You can reach the foot of the cascades by climbing dozens of steep, slippery steps or swimming through bone-chillingly cold, spring-fed waters for 100m (330 ft.) or so to the falls.

THE IONIAN ISLANDS

Greener and shaggier than the Aegean Islands, Corfu and its neighbors adrift in the Ionian Sea can seem as far removed from the rest of Greece in spirit as they are geographically. Corfu, especially, is a world of its own, rich in landmarks and customs of the many cultures that have set their sights on the strategically placed island, with a strong essence of Italy and France and an overlay of British formality. Kefalonia, enjoying relative isolation off the western coast of the Peloponnese, seems more caught up in everyday business than with tourism, and rugged and forested Ithaca is the legendary homeland of Odysseus, the legendary hero of Homer's *The Odyssey*.

CORFU ★★

24km (19 miles) W of mainland port of Igoumenitsa; 558km (342 miles) NW of Athens

Corfu often seems to be several islands in one (and even has a couple of names, the other being Kerkyra). Corfu Town, the capital, is attractive and cosmopolitan, showing off French arcades, English gardens, a Venetian flavor, and a hue of Mediterranean ochers and pastels. On the coast, Corfu is ringed with cliff-backed sandy shores and lively beach towns. In the interior, olive and fruit trees surround modest villages and farms. The island's sands and green mountainsides have inspired the poetry of Homer, the plays of Shakespeare, and more than a few postcards. According to myth, Hercules, Jason and the Argonauts, and Odysseus all found refuge on this hospitable island—and its islanders and their remarkable surroundings will make you feel welcome, too.

Essentials

ARRIVING From Athens, it's easiest to make the trip to and from Corfu by **air,** on one of four or five flights a day operated by Olympic (www.olympicair.com) and Aegean (en.aegeanair.com). Flying time is less than an hour. EasyJet and several other carriers also fly to Corfu from cities in western Europe. Corfu's **Ioannis Kapodistrias airport** (www.corfu-airport.com; ✆ **22610/8960**) is in Kanoni, 3km (2 miles) south of Corfu Town. Bus number 15 runs between

The Ionian Islands

Ferry Route ----

Ionian Island Hopping

For years, combining a trip to Corfu with visits to Kefalonia or Ithaca was nearly impossible—there are no inter-island flights, and there used to be no inter-island ferry service. Their ferries leave from different ports on the mainland, requiring hours of bus travel to switch from one to the other. Now, however, the *Lefkada Palace* (lefkadapalace.com) connects Corfu with Ithaca and Kefalonia (Sami) three times a week from June through September. The route takes 9 hours to get from Corfu to Ithaca and another 45 minutes to get to Kefalonia.

the city center and the airport about every hour; fare is 1.10€. A cab into Corfu town costs about 15€.

Otherwise, it's a long haul to Corfu from Athens. Three buses a day depart from Athens Bus Terminal A (100 Kifissou, Athens) for the 6½-hour trip to **Igoumenitsa,** the nearest mainland ferry port. From Igoumenitsa, almost-hourly **ferries** make the crossing to Corfu Town (about 1–1½ hr.) and Lefkimi, on the south end of the island (about 1 hr. 15 min.). For the most part, buses are timed with ferry comings and goings. There are also several boat connections from Italy: **Blue Star Ferries** (www.bluestarferries.com) and **Superfast** (www.superfast.com) operate ferries to Corfu from Brindisi, Bari, Venice, and Ancona, for overnight trips of about 8 to 14 hours; **ANEK** (www.anek.gr) sails to Corfu from Bari and Ancona, and **Minoan Lines** (www.minoan.gr) connects Corfu with Ancona and Venice. The quickest Italian connections are from Otranto, in southern Puglia, with six boats a week operated by Liberty Lines (www.ferries.gr) making the summertime-only crossing in a little under 4 hours.

GETTING AROUND Corfu has a fairly good **bus network.** Blue Bus runs (www.astikoktelkerkyras.gr; ℂ **26610/31595**) to and from suburbs and towns around Corfu Town, including Kanoni (airport and Mon Repos) and Gastouri (the Achilleion). Routes originate and end in San Rocco square, just west of the Old Town. Green Bus (greenbuses.gr; ℂ **26610/28900**) serves towns farther afield, including such popular beach towns as Pelakas and Paleokastritsa; routes originate at a terminal near the new port at Lefkimmis 13. Service is extensive and frequent—you can see quite a bit of the island without a car.

Roads on Corfu are good and well-marked, and most major rental car companies and many local ones operate here (see p. 411). Parking in and around Corfu Town, however, is next to impossible. If you're staying in a Corfu Town hotel and renting a car, arrange in advance for parking. If you drive into Corfu Town from elsewhere on the island, head for parking lots near the new and old ports and New Fortress, where you'll pay about 3€ an hour.

Eastertide customs in Corfu town include uniformed bands of musicians processing through the streets of the historic quarter.

VISITOR INFORMATION In summer, the municipality of Corfu Town often installs an information kiosk on or around the Splanada. The island's many travel agencies also provide info on what to see and do. A good all-around agency for car rentals, accommodation, and excursions is the long-standing **Corfu Tourist Services,** Nafsikas 29, Corfu Town (www.corfutouristservices. gr; ✆ **26610/24023**).

Where to Stay on Corfu
EXPENSIVE
Kontakali Bay Resort and Spa ★ Of the many large resort complexes in Corfu, this one stands out for its beautiful seaside gardens, sandy beaches, many amenities, and proximity to Corfu Town—a plus that makes it easy to eat and drink somewhere besides the expensive, though very good, on-premises outlets. The most pleasant of the large and attractive guest rooms are in bungalows scattered among pines and cedars. A host of amenities include outdoor and indoor swimming pools, two beaches, and every water sport under the sun. Shoulder-season rates are a good value.

Kontaki Bay, 6 km (4 miles) N of Corfu Town. www.kontokalibay.gr. ✆ **26610/99000.** 250 units. 130€–340€ double. Rates include breakfast; meal plans available. **Amenities:** 3 restaurants; 2 bars; 2 beaches; 3 swimming pools; kids pool; watersports; tennis courts; spa; Wi-Fi (free). Closed Nov to mid-Apr.

MODERATE
Bella Venezia ★★ You may feel as though you've been whisked westward across the Adriatic in this pleasant Venetian mansion, full of polished wood and shiny brass and set in a pretty garden. The high-ceilinged guest rooms are pleasantly done in plain contemporary style, while the lobby and bar, full of brocade and paneling, are charmingly old fashioned.

Zambelli 4, Corfu Town. www.bellaveneziahotel.com. ✆ **26610/20707.** 31 units. 90€– 190€ double. Rates include breakfast. **Amenities:** Bar; garden; free Wi-Fi.

Mayor Mon Repos Palace ★★ Though Old Town is less than a mile away on a coastal walkway, this subtly glamorous adults-only retreat has the air of a seaside resort, thanks to sea views from every attractive room, a pool and sun terrace, and Anemomylos Beach just across the road. A sophisticated bar and terrace are especially welcome after a day of seeing the island sights.

Dimokratias and Iasonos Sosipatrou, Anemomylos. www.mayormonrepospalace.com. ✆ **26610/32783.** 110 units. 80€–180€ double. Rates include breakfast. **Amenities:** Restaurant; bar; pool; spa; free Wi-Fi. Closed Nov–Apr.

Siora Vittoria ★★ The Liston and other Corfu Town landmarks are a short walk away, but you wouldn't know it when sitting beneath the magnolia tree in the garden of this magnificent 19th-century Venetian townhouse (namesake Siora Vittoria was the owner's grandmother). Furnishings throughout are homey and Italianate, and warm-hued color schemes lend the rooms a soothing vibe. It's a quietly sophisticated retreat, a rare thing on Corfu.

St. Padova 36, Corfu Town. www.sioravittoria.com. ✆ **26610/36300.** 9 units. 90€–230€. Rates include breakfast. **Amenities:** Garden; free Wi-Fi.

Villa de Loulia ★★ A 200-year-old country house full of beams, polished wood floors, and old mantelpieces creates a homey feeling that does justice to the pretty rural setting outside a small village. Popular Peroulades beach is a short walk away. The noisy tourist hub of Sidari is nearby, but high estate walls enclose this orange-scented refuge, made all the better with a large pool. The character-filled rooms are not air-conditioned, but thick walls and ceiling fans do the trick.

Peroulades, 39km (23 miles) NW of Corfu Town. villadeloulia.gr. ℂ 26630/95394. 9 units. 110€–120€ double. Rates include breakfast. **Amenities:** Restaurant; bar; pool; free Wi-Fi. Closed Oct–Apr.

INEXPENSIVE

Casa Lucia ★★★ Corfu Town and the east- and west-coast beaches are within an easy drive of this charming rural compound of cozy stone bungalows, fashioned from an olive mill and set amid rolling groves and orchards in the center of the island. Each unit has a nice terrace and kitchen, and several are well suited to families, with one or two bedrooms; they surround a hibiscus-scented garden and pool. A car is fairly essential for a stay here, and given the popularity with return guests, it's a good idea to reserve well in advance.

Sgombou, 12km (7 miles) NW of Corfu Town. www.casa-lucia-corfu.com. ℂ 26610/91419. 9 units. 60€–70€ double; long-term rates available. **Amenities:** Pool; gardens; free Wi-Fi. Closed Nov–Mar.

Levant Hotel ★ A genteel retreat on a mountaintop next to Kaiser's Throne ensures magnificent views up and down the coast. Rooms are simply and pleasantly traditional, a swimming pool is surrounded by well-maintained gardens, and the terrace of the bar-lounge is a top spot for enjoying the sunset. A car puts the hotel within easy reach of Corfu Town and some of the island's most acclaimed beaches, including Pelakas and Myrtiotissa.

Pelakas, 14km (8½ miles) SW of Corfu Town. levant-hotel.corfu.hotels-corfu.com. ℂ 26610/94240. 26 units. 50€–70€ double. Rates include breakfast. **Amenities:** Restaurant; bar; pool; free Wi-Fi. Closed mid-Oct to late Apr.

Penelope Hotel ★★★ A low-key beach hotel is a rarity in Corfu these days, but the Vlachopoulos family has the concept down pat, with attractive, airy, pastel-hued rooms that face a pool, olive groves, and the sea just beyond their balconies. The surroundings on the quieter south end of the island are idyllic, with a gentle bay, fishing harbor, and beach just down the road. Two nearby seaside villas house five self-catering apartments, and islanders often make a special trip down here for a seafood feast at the family's **Bourkari Beach Restaurant,** where hotel and apartment guests can arrange half board.

Boukari Beach, 26km (16 miles) S of Corfu Town. boukaribeach.gr. ℂ 69370/28457. 21 units. 50€–70€ double. **Amenities:** Restaurant; bar; pool; free Wi-Fi. Closed Dec–Mar.

Where to Eat on Corfu

Menus across the island tend to be international, leaning heavily toward Italian, though many kitchens serve Greek standards, along with some island specialties: *sofrito,* veal cooked in wine sauce; and *pastitsada,* beef cooked with pasta and fresh tomatoes, wine, and spices.

Aegli ★★ GREEK/CORFIOT The Liston Arcade is the atmospheric setting for this elegant old-timer, where *bacala* (salted cod) and other Corfiot specialties are on offer. Snacks and drinks are served on the terrace throughout the day—the fruit salad is an island favorite.

Liston, Corfu Town. aeglirestaurant.gr. ✆ **26610/31949.** Main courses 10€–20€. Daily noon–midnight.

Etrusco ★★ GREEK/MEDITER-RANEAN Many travelers come to Corfu just to enjoy the cuisine of chef Ettori Botrini, served on a romantic

On Corfu's west coast, the town of Agni has three excellent seafood tavernas right on the water.

terrace and in a handsome dining room that seem rather fancy for the small-village surroundings. Delicious homemade pastas and risottos make use of local fish, seafood, and game, and tasty lamb and other dishes are prepared to traditional recipes with innovative twists. Reservations are essential.

Kato Korakiano, about 15km (9 miles) N of Corfu Town. etrusco.gr. ✆ **26610/93342.** Main courses 20€–30€, set menus 50€. Daily 7:30pm–midnight.

Taverna Limeri ★ GREEK At this informal village tavern, make a meal of *meze,* small plates. Offerings often include a surprise or two, such as pork in cranberry sauce or homemade lamb sausages. Salads, brimming with village produce, are excellent, too.

Kato Korakiano, 15km (9 miles) N of Corfu Town. ✆ **694/443-7379.** Main courses 8€–16€. Daily 5pm–midnight.

Venetian Well ★★★ You'll probably have to ask your way a couple times before finding this charming spot in the depths of Old Town, where your efforts will be rewarded with a table on a romantic square ringed with old houses, or in the candlelit dining room. Creative seafood pastas and daily specials are based on the market-fresh ingredients available. The house version of *pastitsada,* a traditional Corfu ravioli-like pasta, is filled with cockerel instead of the more traditional beef.

Plateia Krematsi, Corfu Town. venetianwell.gr. ✆ **2661/550-955.** Main courses 10€–25€. Mon–Sat 7–11:30pm.

Seafood Village

A west-coast hamlet strung along a white pebble beach backed by cypress trees, **Agni** is blessed with three seafood tavernas. Corfiots have their favorites, but all serve freshly caught fish and seafood in friendly surroundings. You may want to come back a few times and try all three: **Nikolas Taverna** (agnibay.com; ✆ **6630/91243**); **Taverna Agni** (taverna-agni.com; ✆ **26630/91142**); and **Toula's** (toulasagni.com; ✆ **26630/91350**). All are open May through October and serve lunch and dinner, from about 1 to 11pm. Agni is 15km (9 miles) north of Corfu Town.

Many of the sights below can be viewed on a 15€ combined 3-day ticket that includes the Antivouniotissa Museum, Archaeological Museum, Corfu Museum of Asian Art, Museum of Palaiopolis at Mon Repos, and Paleo Frourio (Old Fortress)—a good investment if you're spending more than a few hours in Corfu Town. You can learn a lot about Corfu Town's colorful history on walking tours with **Corfu Perspectives;** aside from fact-filled tours of the sights, the company also leads various themed walks, such as one that focuses on life under Venetian rule. For details, go to corfu guidedtours.com; tours cost 23€ and up.

Exploring Corfu Town ★★★

Many cultures have claimed the island capital as their own. Ancient Greeks, Byzantines, Venetians, French, British, Austro-Hungarians—they've all held the island at one time or another and left behind churches, palaces, sea-girt fortresses, medieval lanes jammed with little shops and taverna tables, and a wealth of ancient statuary and even Asian porcelains, shown off in fine museums. The city-center Liston arcade is emblematic of this cosmopolitan island, with a Venetian name and French-inspired architecture. Patrons at the sophisticated cafes are a polyglot mix of Corfiots and international visitors. It's one of the most alluring and graceful cities in Greece.

Antivouniotissa Museum ★ MUSEUM Corfu sustained a long tradition of icon painting, and with Crete (another Venetian possession) was one of Greece's major centers for the art form. In these galleries, on an upper floor of the church of the Pangia Andivoumniotissa, you may notice the influence of Western artistic traditions on the highly stylized Byzantine forms. No doubt due to the island's close ties with Venice and proximity to the West, shades of the Renaissance creep in, with naturalistic depictions of saints and sinners, often set against distinctly Italian-looking backgrounds. A wonderful swath of mosaic flooring is from an early Christian church in the ancient city of Paleopolis, the ruins of which litter the grounds of Mon Repos (see p. 399).

Arseniou 25. www.antivouniotissa museum.gr. Ⓒ **26610/38313.** Admission 4€; included in 15€ combined ticket (see above). Wed–Mon 8:30am–4pm.

The gracious Liston arcade adds a note of Parisian elegance to Corfu Town's Esplanade, the center of its cosmopolitan social life.

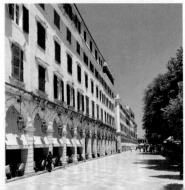

Archaeological Museum ★★★ MUSEUM Medusa, the Gorgon with hair of venomous snakes and a stare that could turn anyone to stone, is the star of this collection of artifacts from the Temple of Artemis in the ancient city of Paleopolis, on the grounds of Mon Repos (see p. 399). The Medusa relief, from about 590 B.C., adorned

the temple pediment and is the finest example of Greek archaic art to survive the millennia. Artisans took a bit of liberty with the myth: Legend has it that Medusa gave birth to her sons, Pegasus and Chrysaor, the moment Perseus beheaded her, but in this charmingly naive rendering she is shown with both her head and offspring intact. A magnificent marble of a funerary lion that crouches near the Medusa came from the tomb of Menekrtes, a 7th-century B.C. Corinthian colonizer of the island; the tomb itself is inside a necropolis just south of the museum off the seaside promenade.

Vralia 1. archaeologicalmuseums.gr. ℗ **26610/30680.** Admission 6€ Apr–Oct, 3€ Nov–Mar; included in 15€ combined ticket (p. 394). Wed–Mon Apr–Oct 8am–8pm; Nov–Mar 8:30am–3:30pm.

Corfu Museum of Asian Art ★ MUSEUM Built for the British Lord High Commissioner in 1819, the Palace of St. Michael and St. George became a residence of the Greek royal family in 1864, when the Ionian Islands were unified with Greece and British rule ended. State rooms now house one of Europe's finest collections of Asian art—an unexpected surprise on a Greek island—displaying Samurai swords, Noh masks, and Chinese porcelains collected by Corfiot diplomats and merchants in the late 19th and 20th centuries. Exotic trees bloom in the palace gardens that overlook the bay and sea lanes into the harbor; a cafe displays works by local artists. The Greek royal family, whose members included England's Prince Philip, used to slip down an iron staircase at the end of the gardens to take a dip in the waters below.

Palaia Anaktora. www.matk.gr. ℗ **26610/20193.** Admission 6€ Apr–Oct, 3€ Nov–Mar; included in 15€ combined ticket (p. 394). Daily 8am–8pm.

Neo Frourio (New Fortress) ★ HISTORIC SITE "New" is a relative term for this massive fortification that the Venetians erected when they took control of the island in the 13th century. These days the high walls, adorned here and there with the Venetian winged lion of St. Mark, still serve as a barrier, dividing the modern city and new port from the narrow lanes of the Old Town. You can explore a maze of medieval tunnels and battlements within the walls and climb to the ramparts for airy sea views. Stalls of the fish and vegetable market fill the moat every morning but Tuesday.

Off Dionisiou Solomou. Free admission. Wed–Mon 8am–4pm.

Old Town ★★★ NEIGHBORHOOD Wedged onto a squat peninsula between the Neo Frourio and the Paleo Frourio, Old Corfu is a neighborhood of narrow lanes *(kantounia),* and stepped streets that twist and turn past Venetian loggias, Greek churches, British palaces, and French arcades. It's best to stroll aimlessly through the maze; if you become disoriented, look for the campanile of Agios Spyridion, the tallest structure in town. Just off the southwest end of the Liston arcade, across from the **Splanada** (p. 396), is the Roman Catholic **Cathedral of Agios Iakavos,** better known as San Giacomo, built in 1588 to serve the Venetian and French inhabitants of the island; it was rebuilt after World War II bombing, but the bell tower is original. Heading south across Dimarchiou Square, the **Town Hall,** originally a Venetian loggia,

has served as Corfu's opera house for almost 200 years; in addition to the Italian repertoire, many Greek works were performed here for the first time. Head north on Theotoki, then Filamonikis, to the **Cathedral of Agios Spyridion,** the tallest church on the island, with a domed bell tower. It's dedicated to Corfu's patron, St. Spyridon, a 4th-century shepherd from Cyprus who over the centuries has performed several miracles in service to Corfu, including saving his church from total destruction when a Nazi bomb fell on it in 1944. The saint is entombed in a silver casket that's

The narrow streets of Corfu's Old Town are flavored with all the cultures that have ruled here: Venetian, French, British, and Greek.

paraded through the streets four times a year. Just beyond is the heart of the medieval **Campiello,** where narrow, winding lanes are darkened by the balconies of tall Venetian houses and lined with small shops. To the east, tucked against the walls of the Neo Frouio, is the **Jewish Quarter.** The thriving community here was decimated in June 1944, when Germans rounded up some 2,000 residents and shipped them off to concentration camps, where most perished. Only 200 Jews, hidden by non-Jewish Corfiots, escaped imprisonment. A 300-year-old synagogue on Velissariou has been restored and houses a collection of torah crowns (usually open Mon–Fri 10am–3pm; admission is free).

Paleo Frourio (Old Fortress) ★★ HISTORIC SITE Corfu was long defended by two fortresses, the old and the new. Byzantines started building the Old Fortress on a hilly seaside promontory in the 12th century. Corfu Town was once entirely enclosed within its walls, wedged beneath two hillocks that give their name to the island (Corfu means "peak"). Venetians dug the moat that separates the fortress from the Splanada (see below); later, the British tore down most of the Byzantine and Venetian remnants and erected, facing the sea, the Anglican church of Saint George in the style of a Greek temple, fronted by a row of six Doric columns. Views from the heights sweep across the town and sea, with glimpses of the forested hills of Albania to the north. A statue by the fortress's Splanada-side entrance commemorates Count Schulenburg, an Austrian general working for the Venetians who was the hero of the siege of 1716. With a force of 5,000 Venetians and 3,000 Corfiots, the count repelled a 22-day-long siege by 33,000 Turkish forces. The thick, unassailable walls of the Paleo Frourio were no doubt a factor in the successful outcome, as was the alleged intervention of the ghost of St. Spyridon, brandishing a torch and cross.

Eastern edge of Old Town. odysseus.culture.gr. Admission 6€; included in 15€ combined ticket (p. 396). Daily 8am–8pm.

The Splanada (Esplanade) ★★★ LANDMARK An expanse of greenery and paving stones at the eastern edge of the Old Town is one of Europe's

largest squares and the stagelike setting for much of the island's social life. Corfiots come and go here amid landmarks of the island's cosmopolitan mix of cultures. The late Prince Philip of Britain was christened in the Paleo Frourio (Old Fortress), on the seaward flanks of the square, and cricketers compete on a pitch adjacent to a round columned monument honoring Sir Thomas Maitland, British governor of the island from 1815 to 1821. (He is more favorably remembered for his romance with a Portuguese-Celanese dancer than for his autocratic rule.) The island orchestra plays from an ornate pavilion on warm summer nights. Facing onto the Splanada is **the Liston,** a beautiful arcade from 1807, when the island was part of the French First Empire of Napoleon. Modeled after the rue de Rivoli in Paris, the gracious portico is lined with sophisticated cafes. The name derives from the word "list"—a sort of social registry of the island's elite residents for whose pleasure the Liston was built. The writer Gerald Durrell, who was raised on Corfu, wrote that "you would sit a little table just under the arcades or beneath the shimmering trees and sooner or later you would see everyone on the island and hear every facet of every scandal." We visitors might miss some of the social nuances swirling around us, but it's easy to imagine that for Corfiots the observation still holds true.

CORFU TOWN SHOPPING

Many shops are clustered in and around Old Town, especially along Theotoki street. Along with standard-issue souvenirs, merchants also sell some well-crafted jewelry and items fashioned from island olive wood. One of the more common wares is kumquat liqueur, made from this exotic fruit that the British introduced to the island. Stalls of a **fish and vegetable market** fill the moat of the Neo Frourio (New Fortress) Monday through Saturday mornings.

Corfu Sandals, Filellinon 9 (www.corfusandals.com; ℂ 26610/37768), has dozens of styles, all made in Greece, along with bags, wallets, and other leather accessories. **Lazaris Distillery & Artisan Sweets Brand Store,** Agios Vasiliou 34 (lazarisartisan.com; ℂ 26610/41102), sells everything kumquat, including creamy liqueurs and candies, along with other sweets and drinks from around the island, and serves cocktails as well. **Muses,** at Theotoki 22 (www.musescorfu.com; ℂ 26610/30708), showcases Greek fashion, jewelry, and home accessories, along with folk dolls and other playful items. **Patounis Soap Factory,** Theotoki 9 (www.patounis.gr; ℂ 26610/39806), makes and sells olive oil soap, as the family concern has been doing since 1891. **Spirit of Olive Wood,** Filellinon 4 (www.solivewood.com; ℂ 266130/2257), fashions local wood into beautiful bowls and other objects. **Stella,** Kapodistriou Ioanni 62 (ℂ 22610/24012), specializes in religious icons; its appealing collection also includes hand-crafted ceramics and sculpture, most from Greek artists.

Exploring Beyond Corfu Town

The Achilleion ★★★ PALACE Few palaces are more beautifully located, on a verdant, flowery hillside above the sea, or linked with a more romantic figure, Elisabeth of Bavaria (aka Sisi), empress of the Austrian-Hungarian empire. That said, it's also a building of ostentatious and exuberant excess,

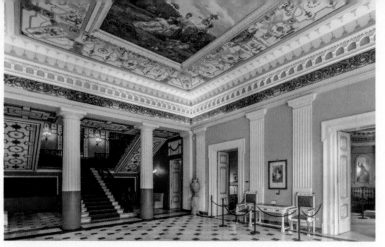

Empress Elisabeth of Bavaria's 19th-century island getaway, The Achilleion, pulls out all the stops in its pseudo-classical ostentation.

proof that money alone cannot buy taste. Sisi sailed around the Mediterranean on the royal yacht almost constantly to escape court life in Vienna. She built this palace after her only son, Crown Prince Rudolf, and his mistress died in an apparent murder-suicide. The estate's pseudo-classical staterooms and gardens are filled with statues and frescoes of gods and goddesses, with Sisi showing a distinct preference for Achilles, whose tragic death at an early age in the Trojan War she associated with her son's. The god is depicted riding a chariot across a fresco on the ceiling of the entrance hall and in several statues, one of which towers 5m high (16½ ft.). Emperor Kaiser Wilhelm of Germany bought the palace in 1907, soon after Sisi was stabbed to death by a terrorist in Geneva. The Kaiser left his own imperial imprints on the palace, including a stone overpass and stairway to the beach below the gardens, known as the Kaiser's Bridge (designed to ensure the Kaiser would not have to rub elbows with the hoi polloi en route to his daily swim). He also had the base of one of the Achilles statues immodestly inscribed, "To the greatest Greek from the greatest German." When the ostentation gets to be overwhelming, turn your back on all the statuary and take in the spectacular sea views.

Gastouri, 10km (6 miles) S of Corfu Town. www.achillion-corfu.gr. ✆ **26610/56210.** Admission 7€ adults, 5€ ages 14–18, 2€ ages 13 and under. Mon–Fri 8am–7pm, Sat–Sun 8am–2:30pm. Bus #10 from San Rocco square.

Kanoni ★ NEIGHBORHOOD The view from the verdant hillsides of this residential enclave just south of Corfu Town was once among the requisite stops on the Grand Tour. Captured on millions of postcards, the sweep of sparkling sea and verdant coastline takes in two islets floating in the bay. On **Vlaherna,** a lone cypress sways above a white-washed convent. **Pontikonisi,** or Mouse Island, is so picturesque, with its chapel set amid a grove of pines, it's easy to believe the legend that the islet is really the ship on which Odysseus sailed home to Ithaca, turned to stone by Poseidon to revenge the death of his son, Polyphemus. You can walk out to Vlaherna on a stone causeway

and from there take a small launch (2€ each way) to Pontikonisi. Thousands of Corfiots cross over to Pontikonisi on August 6 to celebrate the Feast of the Transfiguration, the only time the chapel is open. You can save yourself the effort of the trip, however—the outlook from the shoreline is much more magical than views from the islands toward the overbuilt coast and airport.

5km (3 miles) S of Corfu Town on the airport road. Bus #2 from San Rocco square.

Mon Repos ★★ HISTORIC HOME/ARCHAEOLOGICAL SITE This neo-classical villa, set amid English gardens next to the sea, was once the residence of the British high commis-

A relic of the British rule on Corfu, the neo-classical villa Mon Repos was the birthplace of the late Prince Philip of Great Britain, who was born into the Greek royal family.

sioners. Like the Palace of St. Michael and St. George in Corfu Town (p. 395), Mon Repos went to the Greek royal family when Corfu was united with Greece in 1864. The late Prince Philip, duke of Edinburgh and husband of England's Queen Elizabeth II, was born at Mon Repos in 1921, though his family was soon exiled from Greece in the aftermath of the Greco-Turkish war. The Greek government took over the estate in the early 1990s, and several of its restored state rooms now display artifacts from Paleopolis, the ancient city of Corfu that appears in scattered ruin on the grounds of the estate. A walk across the wooded grounds leads to temples of Hera and Poseidon from the 7th and 6th centuries B.C.; nearby are Roman baths, a Christian chapel from the 5th century, and a Byzantine church. A little beach is below the temple ruins. A seaside walkway leads here from Old Town.

Kanoni peninsula, 2km (1 mile) S of Old Town. odysseus.culture.gr. (C) **26610/41369.** Admission to museum 4€ Apr–Oct, 2€ Nov–Mar, gardens free; included in 15€ combined ticket (p. 394). Museum 8:30am–3:30pm; gardens open dawn–dusk. Bus #2 from San Rocco square.

Paleokastritsa ★★ TOWN/VIEWS The ancient city of Scheria, which once allegedly stood on these shores, is where the shipwrecked Odysseus supposedly washed onto shore and was rescued by Nausicäa, who escorted him to her father, Alcinous, king of the Phaeacians. Alcinous welcomed Odysseus into his palace, with its walls of bronze and gates of gold, and dispatched magical ships, steered by thought alone, to take the wanderer home to Ithaca (see p. 407). No physical evidence has ever emerged to place the story here on the west coast, but by virtue of beauty alone, this string of coves backed by cliffs and forests certainly seems like a place where a myth could unfold. In some places, civilization has encroached unattractively onto the spectacular scenery, but the farther you walk from the village, the more appealing the beaches are. **Theotokou,** a monastery atop a seaside bluff, is a tranquil retreat,

with spectacular sea views and a shady courtyard filled with cats and flowers. A small museum here houses a 12th-century icon of the Virgin (daily 8am–1pm and 3–8pm; free admission). The villages of **Lakones** and **Krini,** sitting high above Paleokastritsa on an adjacent mountainside, can be reached on a steep, cliff-hugging road; Lakones is 7km (4 miles) north of Paleokastritsa, Krini about 10km (6 miles) northwest. The views are even better from **Ange-lokastro,** a ruined medieval castle perched 300m (984 ft.) above the sea, which you can reach on a clifftop path from the southern edge of Krini.

24km (14 miles) NW of Corfu Town on well-marked cross-island road. Served by green line buses from new port in Corfu Town.

Pelakas ★★ TOWN/VIEWS This hilltop town and surroundings above the cove-etched west coast are renowned for their views over the sumptuous folds of forested mountains plunging into the sea. The most noted viewpoint is **Kaiser's Throne,** a rocky summit at the northern edge of town where Kaiser Wilhelm used to ride and take in the vistas. Just below to the east stretches the **Ropa Valley,** Corfu's agricultural heartland, a patchwork of fertile fields, vineyards, orchards, and olive groves. The coast near Pelakas is lined with some of Corfu's most beautiful beaches (see below).

14km (8½ miles) SW of Corfu Town on well-marked road. Bus #11 from San Rocco square.

Corfu Beaches & Outdoor Sports

The west coast around Paleokastritsa (see p. 399) is famously popular for beaches tucked along little bays flanked by cave-riddled cliffs and bluer-than-blue sea. While the main **Paleokastritsa Beach** ★ can be mobbed, you can get away from the crowds by renting a pedal boat from one of many beach concessions and poking along the shoreline, where you're likely to find an inlet all to yourself. The coast below Pelakas (see above) is also lined with golden sands. **Pelakas Beach** ★, a long stretch of sand backed by cliffs (and a large hotel complex) is one the most popular spots on the island, with many sun beds, food concessions, and water sports outlets. The popular resort of **Ermones** ★ is 6km (3½ miles) north of Pelakas, and two sandy beaches stretch between the two, popular **Glifyda** ★★ and, best of all the island beaches, **Myrti-otissa** ★★★, described by novelist Lawrence Durrell as "perhaps the loveliest beach in the world" (it's a favorite these days with snorkelers and nude bathers). Travelers with children like **Sidari** ★★, up on the north coast, an unattractively overbuilt beach town that does no justice to its beautiful coastal setting, where sandstone formations rim calm waters; and nearby **Ayios Georgios** ★★, a laid-back

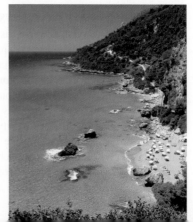

Novelist Lawrence Durrell described Myrtiotissa beach as "perhaps the loveliest beach in the world."

Hit the Back Country on the Corfu Trail

Hikers can traverse the entire island on the 220km-long (137-mile) **Corfu Trail ★★★**. Running from Cape Aspro-kovas in the south to Cape Agias Ekaterinas in the north, the trail crosses the island's most scenic landscapes, including the west coast, Ropa Valley, and **Mount Pantokrator,** Corfu's highest summit. Around the base of the mountain, centuries-old olive groves have been allowed to go wild, creating primordial-looking forests interspersed with oak and chestnut. (A curvy road also ascends Pantokrator, with access to paths along the way, so you can explore the flanks and summits without the stiff uphill hike.) If you're hiking long stretches of the trail, there's no need to bring camping gear—you'll find rooms and tavernas all along the route. For info on the route, check out www.corfu trailguide.com, where you can also download a copy of *The Companion Guide to the Corfu Trail,* by Hilary Whitton Paipeti, who created the trail some 20 years ago. Anna Apergi Travel (www.aperghitravel.gr; ✆ **26610/48713**) puts together walking tours, arranges accommodation, and takes care of luggage transfer and other details.

family-friendly resort town 33km (20 miles) northwest of Corfu Town with a long stretch of fine sand washed by shallow waters. On the northeast coast, amid cypress and olive trees, crescent-shaped **Kalami Bay ★★★**, one of many Corfu settings in Gerald Durrell's memoir *My Family and Other Animals,* is still green and tranquil.

You'll find watersports concessions at just about any beach on the island. The **Achilleion Diving Center,** in Paleokastritsa and Ermones, offers dives and instruction (www.diving-corfu.com; ✆ **6932/729011**). **Next Holidays** arranges parasailing, windsurfing, waterskiing, snorkeling, and other watersports around the island (www.corfunext.com; ✆ **6945/265048**).

Corfu is good **birdwatching** territory, hosting more than 300 species, from cormorants and egrets to migrating flamingos. The marshy shoreline of **Lake Korission,** 26km (16 miles) south of Corfu Town, is a prime viewing spot. Follow signs to Issos beach, where a path follows dunes around the lake.

The **Corfu Golf Club,** outside Ermones, 16km (10 miles) west of Corfu Town, has one of Greece's best courses, ranging across beautiful terrain in the Ropa Valley; fees for 18 holes are 45€ November–March, 55€ July–August, and 65€ April–June and September–October (corfugolfclub.com; ✆ **26610/94220**).

KEFALONIA ★★

335km (201 miles) W of Athens

The largest and greenest of the Ionians, Kefalonia is not nearly as glamorous or popular as Corfu, and that low-key charm is one of the island's great assets. Outside the pleasant bayside capital of Argostoli and a clutch of relaxing seaside towns, Kefalonia—often spelled Cephalonia—is a place to take in the scent of pine forests, keep an eye out for wild horses grazing in meadows, and find a stretch of soft sand without a beach umbrella in sight.

Essentials

ARRIVING To reach Kefalonia by **boat,** take a bus or drive to Kylini, on the west coast of the Peloponnese, about 3½ hours from Athens. From there, **Kefalonia Lines** ferries (kefalonianlines.com) make the 80-minute crossing to Poros, Kefalonia's main port, as often as 6 times a day. Buses (ktelkefalonias.gr) from Athens Bus Terminal A (100 Kifissou) make a direct boat connection several times a day; on Kefalonia, the bus continues on to Argostoli. Aegean (en.aegeanair.com) operates several **flights** a day between Athens and Kefalonia's **Anna Pollatu airport,** 10km (6 miles) north of Argostoli. In summer, many charter airlines connect the airport with London, Manchester, and other European cities. Fare for a taxi to Argostoli is about 15€, and a summertime-only airport bus (www.ktelkefalonias.gr) operates several times a day; fare is 3€, payable to the driver. For connections to Corfu, see box p. 390.

GETTING AROUND In summer **buses** (www.ktelkefalonias.gr) serve most holiday resorts and major towns with some regularity, though schedules are not set up for sightseeing, with the last bus out of Argostoli to Sami, Poros, and Skala at 2 or 2:30pm, and service is curtailed for the rest of the year. The central bus station in Argostoli is on the south end of town just off the waterfront at Tritsi 5. **Ferries** (www.ionianseaferries.gr; ✆ 26710/91280) make the 20-minute trip from Argostoli to Lixouri about every half hour; tickets, bought on board, are 2.80€ for passengers, 4€ for cars. **Car rental** on the island is relatively expensive, and cars can be scarce during the summer. Reserve well in advance with Greekstones (greekstones-rentacar.com; ✆ 26710/42201) or other reliable local companies. Companies on the island require an International Driver's Permit (IDP) from citizens of many non-EU countries, including the United States.

VISITOR INFORMATION A fairly extensive online guide to the island is at kefaloniaisland.org. The city of Argostoli operates a tourist info point next to the bus station, with limited information about the rest of the island. The office is usually open in summer Monday to Saturday, 9am to 2pm and 5pm to 8pm. **Kefalonia Excursions** (kefaloniaexcursions.com; ✆ 267110/0817) and many other companies offer full-day tours of the island, often with stops at the Sami caves and Myrtos Beach, usually about 30€. Given the limited bus service, tours are the only way to see much of the island without renting a car.

Where to Stay on Kefalonia

Hotel Galini ★★ These simple but bright, airy, and extremely good-value accommodations at the north end of town in Poros provide all the basic comforts, along with sea-view balconies. Host Efi is on hand with advice for seeing the island and may even offer to pick you up at the port.

1 block above beach road N of center, Poros. pension-galini.hotelsinkefalonia.com. ✆ **690/853-0821.** 40€–60€ double. **Amenities:** Shared kitchens; free Wi-Fi.

Ionian Plaza ★ A center-of-town location on Plateia Valianou makes this hotel convenient and, given the pedestrian-only surroundings, fairly quiet. Welcoming terraces surround the ground floor lounges, while large guest

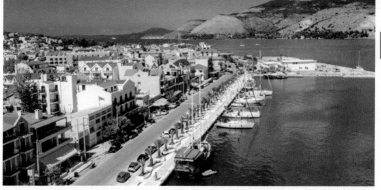

Rebuilt after a 1953 earthquake, Argostoli, Kefalonia's capital, is an appealing modern resort town.

rooms upstairs are colorful and comfortably deluxe. Their balconies overlook the square and town, with a few even catching a glimpse of the sea.

Palteia Vallianou, Argostoli. www.ionianplaza.gr. ✆ **26710/25581.** 75€–250€ double. Rates include breakfast. **Amenities:** Gym; snack bar; free Wi-Fi.

Museum Hotel George Molfetas ★★★ A historic home is a rarity in Kefalonia, which was all but leveled in the 1953 earthquake. This handsome family house in a village above Argostoli survived and has been restored by host Katerina Dima, whose efforts have been recognized by Greece's Register of Historic Buildings. She's named the hotel for a great uncle who lived here and has filled the lounges and rooms with heirlooms, hand-crafted pieces, and rich carpets; they open to a courtyard, and several have wood stoves for the winter months. Excellent meals are served outdoors in summer and in front of a glowing hearth in winter. Argostoli is only a 15-minute drive down the hillside.

Faraklata, 9km (5 miles) NE of Argostoli. www.kefaloniamuseumhotel.com. ✆ **26710/84630.** 5 units. 65€–135€. Rates include breakfast. **Amenities:** Bar; restaurant; garden.

Natalie's Hotel and Apartments ★★ Crisp, white-tiled contemporary studios and apartments, all with balconies and kitchenettes, share attractive surroundings that include a sunny terrace, outdoor bar, and saltwater pool. A back street location provides a nice escape from the waterfront; the beach is a short walk away.

Skala. natalieshotel.com. ✆ **26710/83586.** 45€–130€ double. **Amenities:** Bar; pool; free Wi-Fi.

Northpoint Rooms 1953 ★★ The best of Kefalonia comes together at this cluster of restored stone farm buildings in the beautiful countryside outside Fiskardo. Within easy reach are the lively Fiskardo harbor front, lovely beaches at Amos and Myrtos, and walks through lush forests. But it's tempting to stay put: Attractive rooms have contemporary furnishings set against warm colors and golden-hued stone walls, and the garden has a small glass-sided pool that's perfect for a plunge on a hot day.

Markandonata Village. Northpoint.gr. ✆ **690/705-5556.** 8 units. 115€–185€ double. 4-night min. stay. Rates include breakfast. **Amenities:** Garden; pool; free Wi-Fi. Closed Nov–Apr.

Where to Eat on Kefalonia

Odd for an island, maybe, but Kefalonia's most famous culinary specialties are meat-laden *kreatopita* (a hefty pie usually made with beef, rice, and a tomato sauce) and *crasato,* pork cooked in wine. The island's vineyards yield some excellent wines, including Robola whites.

Captain Nicolas ★★ GREEK/SEAFOOD What seems like a simple beach cafe on the sandy Lixouri Peninsula has in fact a expert traditional Greek kitchen. Lamb kleftiko and moussaka, along with heaping platters of fried anchovies and grilled shrimps, are served on a friendly sea-view terrace.

Vatsa, Lixouri. ☏ **26710/92722.** Main courses 7€–15€. Mon–Fri 11am–midnight, Sat–Sun 11am–1am. Closed for part of winter.

Captain's Table ★ GREEK/SEAFOOD It's easy to spot this old-time favorite on the waterfront, with a breezy cafe out front and iced displays showing off today's fresh catch, which is prepared many ways; try the fish soup, the house specialty. An all-day menu includes sandwiches and salads.

Waterfront, Argostoli. captainstable-restaurant.com ☏ **26710/27170.** Main courses 8€–20€. Daily 9am–midnight.

Irida ★★ GREEK/SEAFOOD In the long line of tavernas and cafes crowding Fiskardo's harbor, Eleni Germeni's family enterprise is a stand-out. Set in a 200-year-old salt warehouse, it serves a tasty menu including seafood pastas, innovative salads, and classic Greek starters, along with breakfasts and daylong snacks. Irida (or the Iris) also has the distinction of being just about the only Fiskardo restaurant that's open year-round.

Harborfront, Fiskardo. www.irida-restaurant.gr. ☏ **26740/41343.** Main courses 8€–14€. Thurs–Tues 8am–11:30pm, Wed 10:30am–11:30pm.

Exploring Argostoli
ARGOSTOLI ★

You won't find landmarks, monuments, ruins, or history-rich lanes and squares in Kefalonia's capital. In fact, you won't find much that predates 1953, when an earthquake leveled most of the island, killing hundreds of islanders. Survivors from ruined villages straggled into Argostoli, only to find the capital in rubble as well. An estimated 100,000 of the 120,000 islanders emigrated from Kefalonia, leaving Argostoli a ghost town. Yet today Argostoli is attractive and appealing, stretching along a thumb-shaped bay of the Gulf of Argostoli. The town's most popular residents (and major attraction) are a bale of loggerhead turtles that congregate beneath the stone-arched **De Bosset pedestrian bridge.** Inland, vast **Plateia Vallianou** square is lined with cafes on one side and government offices on the other; from here pedestrian-only, shop-lined **Lithostroto** cuts through the heart of town.

Korgialenio History and Folklore Museum ★ MUSEUM While you won't see many remnants of old Kefalonia on the island, you'll find plenty in this quirky collection of furniture, tools, and other artifacts. Fascinating

photographs chronicle island life before the quake, as well as the devastation and rebuilding.

Ilia Zervou 12, Argostoli. odysseus.culture.gr. ℂ **26710/28835.** Admission 3€. Mon–Sat 8:30am–3pm.

EXPLORING AROUND THE GULF OF ARGOSTOLI

Agios Gerasimos ★★ CHURCH Rebuilt after the 1953 earthquake, Kefalonia's holiest shrine, honoring the island patron, is awash in colorful

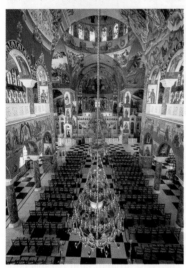

biblical scenes. The main attractions are glass cases housing relics of the saint, a cave in which he allegedly spent his days in prayer, and a gentle setting in the folds of pine-covered mountains. Many visitors also make the trip 9km (6 miles) south through Robola vineyards to climb up to the extensive ruins of **St. George's Castle** ★★, near Livathou (ℂ **26710/27546**), begun under the Byzantines in the 11th century and fortified by the Venetians. **Kastro,** the medieval town beneath the castle, was once capital of the island. The castle is open Tuesday through Sunday, 8:30am to 3:30pm, and admission is free.

Biblical scenes cover the walls of Agios Gerasimos church, which houses Kefalonia's holiest shrine.

Omala Plain, Frangata, 15km (9 miles) E of Argostoli. ℂ **26710/86385.** Free admission. Daily 8am–1pm and 3–8pm.

Lixouri Peninsula ★★ BEACHES The island's second-largest town, just across the narrow Gulf of Argostoli from the capital, Lixouri itself is fairly unremarkable, but the beaches to its south are spectacular. At **Lepeda,** just 2km (1½ miles) south, strange rock formations rise from a long stretch of red sand, creating enticing pools. Just beyond, red sands are backed by white cliffs at **Xi** and **Megas Lakkos.** At the southern tip of the peninsula, **Kounopetra** (Rocking Stone), 8km (5 miles) south of Lixouri, has lost its claim to fame: The namesake rock used to move rhythmically but ceased to do so after the 1953 earthquake. The golden sands are still enticing, though, as are those at **Agios Nikolaos,** another 2km (1½ miles) farther west. The easiest way to reach Lixouri is via ferry from Argostoli (see p. 390).

EXPLORING THE SOUTH & THE SAMI CAVES ★★

The southern reaches of the island are mountainous, with lush forests of oak and cypress and farming valleys. Rising above these soothing landscapes is **Mount Ainos** ★★, the island's tallest summit at 1,600m (5,250 ft.). A unique species of fir, *Abies cephalonica,* flourishes in the mountain's ecosystem, which has been designated a national park for the tree's protection. A road

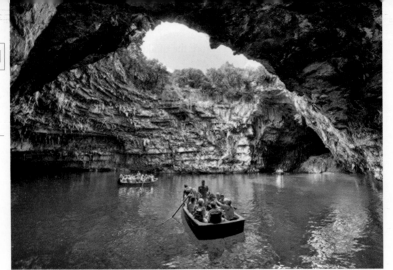

Boatmen guide visitors through the dramatic Mellisani sea cave, near Sami on Kefalonia's east coast.

rounds the mountain to the top, where there are phenomenal views over the island, other Ionians, and the Peloponnese and central mainland.

Poros ★★, near the bottom of the southeastern coast 40km (25 miles) southeast of Argostoli, is the island's main port these days. Many travelers move on to Argostoli or settle down on the east coast in nearby **Skala** ★, 36km (22 miles) southeast of Argostoli, or **Sami** ★, 26km (15½ miles) northeast of Argostoli. Both are agreeable if unremarkable resort towns, with good beaches and many seasonal hotels and tavernas. The coast around Sami is especially appealing, with a nice fishing village, **Agia Efymia** ★★, sharing the same bay, and an especially beautiful beach at **Antisamos** ★★. Poros itself makes no pretense to resort glamor, but is a pleasant, albeit rather scrappy, low-key fishing village, farm town, and summertime retreat for Kefalonians and Greeks from the mainland.

The Sami Caves ★★ NATURAL ATTRACTION On either side of Sami lie two of Kefalonia's most popular attractions. Nature endowed the **Drogarati chamber,** 4km (2½ miles) south of Sami off the Argostoli road, with a forest of fantastic stalagmites and near-perfect acoustics, so refined that concerts are sometimes held in the cave, where the great Maria Callas once performed. Eerie **Melissani Cave,** 3km (2 miles) north of Sami off the coast road, is even more dramatic, due to a weird hydrologic phenomenon—the water that sloshes inside its roofless cavern flows all the way across the island from a submerged sea cave near Argostoli. A boatman rows visitors across the lake, where sunlight from the collapsed roof casts multicolored hues on rock and water. The best effects are between noon and 2pm.

Drogarati Cave: Chaliolatta. Admission 5€. Apr 1–19 Wed and Fri–Sat 10am–3pm; Apr 20–30 daily 10am–4pm; May–Oct daily 10am–5pm. Melissani Cave: Sami. www.melissani-cave.com. ✆ **26740/22997.** Admission 7€. May–Oct daily 9am–7pm; Nov–Apr Wed and Sat–Sun 10am–4pm.

The beautiful island of Ithaca, a 20-minute crossing from Sami, is the fabled home of Odysseus, where Penelope patiently awaited the hero's return. Especially when viewed across the shimmering sea, the forested little island can evoke powerful feelings of nostalgia. The **Cave of the Myths,** where Odysseus supposedly hid gold and copper, is reached by a steep uphill climb off a well-marked road 3km (2 miles) outside **Vathy,** the island's attractive little capital. The sleeping hero was allegedly set down on the soft sands of nearby **Dexia Beach,** and another 3km (2 miles) south is the **Fountain of Arethusa,** where Odysseus, dressed as a beggar, went to meet his loyal swineherd. **Alalkomenai,** once thought to be the site of Odysseus's capital, is 8km (5 miles) west of Vathy. You'll need a car to get around the island, though Kefalonia Tours (www.kefaloniantours.com), Kefalonia Cruises (kefalonia-cruises.gr), and other operators offer full-day boat tours from Skala and Sami, with stops at Vathy and the attractive little port of Koni, along with the chance to swim in some picturesque spots. Rates are around 45€ adults, 30€ kids.

EXPLORING THE NORTH COAST ★★★

A road follows the west coast north from Argostoli to the island's two prettiest towns, Assos and Fiskardo. The drive is one of the most scenic in Greece—and if not taken very slowly can be one of the most hair-raising, full of hairpin curves along steep mountainsides, with the sea crashing onto rocks far below.

A 37km (22-mile) drive north of Argostoli, a ruined Venetian castle overlooks the postcard-picturesque fishing port of **Assos ★★★.** Mansions and pine groves surround the pretty, protected harbor, and a steep walkway ascends in switchbacks through a scented forest from water's edge up to the castle grounds. Stealing the show around here is **Myrtos Beach,** about 12km (7½ miles) south of Assos via steep roads, considered one of the most beautiful beaches in Greece (it's certainly one of the most photographed), following a turquoise inlet backed by white cliffs and forests.

From Assos, continue north up the coast another 12km (13 miles) to **Fiskardo ★★,** on the northern tip of the island, 49km (29 miles) north of Argostoli. A popular port of call for yachters, this colorful town is the only one on the island that was spared in the 1953 earthquake. Fine 18th-century Italianate houses surround a harbor backed by hillside forests of fir and cedar. The village was the backdrop for parts of the 2001 film *Captain Corelli's Mandolin,* based on the much-better novel by Louis de Bernieres; the scenery here and elsewhere around the island steals the show. Adding more allure are a recently excavated Roman burial site and adjacent theater, untouched over the past 2,000 years. In the small theater, stone backrests are still in place on the rows of seats. The site is always open; admission is free.

PLANNING YOUR TRIP TO GREECE

Greece has famously experienced economic woes in recent years, yet tourism numbers remain high—in fact, there's been a significant increase—and for a very good reason. A visit to Greece should be an occasion for sheer enjoyment. All it takes is a bit of planning to make the visit all the smoother and more pleasant.

This chapter provides planning tools and other resources to help you get around and get the most out of your time in Greece. First and foremost, it's important to keep in mind that while Athens goes full-tilt 12 months a year, the time slot for enjoying island life is relatively short, from May to mid-October. Obviously, you can visit the islands outside of those times. Crete, especially, with its big cities of Iraklion and Chania, gets some wintertime visitors. But for the most part, islands are geared to warm weather, and most hotels and restaurants close up tight from fall to late spring.

Whenever you visit, and wherever you go, you'll enjoy Greece the most if you get into Greek time. That has nothing to do with a clock or season, just a rhythm. Slow down to take notice of life swirling around you. Take a siesta in the heat of the day. Eat late, and dine outdoors under the stars. Greece may have its struggles, but in many ways the Greek way of life is as rich as ever.

GETTING THERE

By Plane

The majority of travelers reach Greece by plane, and most arrive at the Athens airport—officially **Eleftherios Venizelos International Airport** (ATH), sometimes referred to by its new location as "the Spata airport."

American, Delta, and Emirates fly nonstop from the U.S., with schedules varying by season, while nearly all the big European airlines fly to Greece from European cities; among them are Greece's own **Olympic Airlines** (www.olympicair.com) and **Aegean** (www.aegeanair.com). Many airlines these days belong to an "alliance" or code-sharing group, so you might be able to use or earn frequent-flyer

The greatest threats to your well-laid Greek vacation plans may well be the strikes that can close museums and archaeological sites, shut down the metro, keep ferries in port, and stop buses, taxis, and even flights. Strikes are commonplace and often deliberately planned to cause maximum inconvenience for commuters and tourists. The good news is, strikes are usually short-lived and announced in advance. Many websites post strike updates, among them www.ekathimerini.com. Your hotel will probably have its own sources and can check to see if buses will be running when you want to get to the airport or if ferries are operating when you're headed to the islands. One way to protect yourself is to leave time to adjust to last-minute changes—for instance, plan to arrive back in Athens the day before your outbound flight, just in case you need extra time to get to the airport.

miles with one of the other members. **Ryanair** (www.ryanair.com), **EasyJet** (www.easyjet.com), and **Air Berlin** (www.airberlin.com) are among the many low-cost carriers that fly between European hubs and Greece. Some island airports also handle a good number of flights from European countries, especially those on Rhodes and Crete (both Iraklion and Chania), and, to a lesser degree, Skiathos and Kos. Summertime flights increase considerably and expand to such smaller islands as Mykonos, Paros, and Santorini. If you're thinking of purchasing a ticket through an airfare search engine, keep in mind that researchers at Frommers.com have found that skyscanner.com consistently finds the lowest airfares.

By Car

Many Europeans drive to Greece, and some North Americans may also wish to bring in rented cars if they're traveling from another European country. (Make sure a car rented in another country is allowed to be taken to Greece, including into the countries you may have to drive through en route.) Drivers often come from Italy via ferry, usually disembarking at Patras; the drive to Athens from there is about 210km (130 miles). Others enter from the Former Yugoslavian Republic of Macedonia, or FYROM. (The road from Albania, although passable, doesn't attract many tourists.) There are no particular problems or delays at the border crossings, providing all your papers are in order. These include valid registration papers, an international third-party insurance certificate, a driver's license, and an International Driver's Permit. As GPS navigation along the route can be spotty, arm yourself with a good up-to-date map such as the ones published by Baedeker, Hallwag, Michelin, or Freytag & Berndt.

By Train

There is train service to Greece from virtually all major points in Europe, although the trains tend to be slow and uncomfortable—almost 24 hours from Venice, for example. A **Eurail pass** is valid for connections all the way to Athens or Istanbul and includes the ferry service from Italy. North Americans

must purchase their Eurail passes before arriving in Europe. For information, see www.raileurope.com and **www.eurail.com**.

By Ship

While most people traveling to Greece from foreign ports these days are on cruise ships, many others still come on ferries or other ships, often from Italy. There is also occasional service from Cyprus, Egypt, Israel, and Turkey. The most common ferry crossing is from Brindisi, Italy, to Patras, Greece—about a 10-hour voyage, with as many as seven departures a day in summer. There is also regular service, twice a day in summer, from the Italian city of Ancona, once daily from Bari, and several times a week from Venice. Another popular crossing is from Italy to Igoumenitsa, 480 km (300 miles) northwest of Athens, with service at least once a week to and from Ancona, Bari, Brindisi, Ravenna, Trieste, and Venice. Igoumenitsa Passage is often included in Eurail passes, though holders should consult **www.raileurope.com** or **www.eurail. com** to see which operators will honor their passes.

Given the number of shipping lines involved and the variations in schedules, it's best to consult a travel agent about the possibilities, or go to reliable search engines such as www.ferries.gr and www.ferryhopper.com. Book well ahead of time in summer, and reconfirm with the shipping line on the day of departure.

GETTING AROUND

By Plane

Olympic Air (www.olympicair.com)**, Aegean Airlines** (www.aegeanair. com), and **Sky Express** (www.skyexpress.gr) offer intra-Greece flights that can be a convenient alternative to boat travel, and, depending on the time of travel, not much more expensive. Among the many airports served are those in Chios; Corfu; Iraklion, Chania, and Sitia, Crete; Kefalonia; Kos; Lesbos; Milos; Mykonos; Naxos; Paros; Samos; Santorini (aka Thira); Skiathos; and Skyros. **Sky Express** (www.skyexpress.gr) also offers limited service between some Greek cities and islands.

By Car

Driving in Greece is a bit of an adventure, but there's no denying that it's the best way to see the country at your own pace. Renting a car is the most convenient way to make a circuit of the ancient sites in the Peloponnese, and you'll probably want to rent a car for at least a day or two of exploring when visiting some of the islands. The Peloponnese and other regions are now linked to Athens by modern toll roads that are extremely well maintained. The posted speed limit is 120kmph (75mph), 50kmph (31mph) in built-up areas, and 80kmph (50mph) on rural roads.

It's important to keep alert and drive defensively. Greece has an unenviable road-fatality record, and a very high accident rate. Drivers can be aggressive and erratic, often exceeding the limit, tail-gating (if they're flashing their

headlights, move to a slower lane), and using the shoulder as an extra lane. Drivers often pass on the right, crowd you onto the shoulder in order to pass, ignore stop signs and red lights, and fail to give the right of way. Police are increasingly vigilant, especially about driving under the influence of alcohol, and it is not uncommon for tourists to be arrested while driving back to their hotels after a night out. Offenses result in stiff fines (up to 2,000€), jail sentences and loss of your license. All the more sobering is the fact that in Greece the admissible blood alcohol level while driving is .05 percent, the equivalent of just two drinks, compared to .08 percent levels in the U.S. The bottom line, applicable anywhere in the world: Do not drink and drive.

Signs are in Greek and English, but some are easy to miss, obscured by branches, poorly placed, or neglected. Observe highway signs for how far away the next gas (petrol) station is if you need to fill up (full service), and note that in towns, gas stations close in the evenings and on Sundays (though one is always open on a rotation system). Fuel is quite expensive by American standards, more than $8 a gallon.

CAR RENTALS You will find no end of car-rental agencies throughout Greece, both the familiar international chains and many Greek firms. There is considerable variation in prices, although rates in high season generally begin at about 40€ a day and 240€ for a week. Prices will be lower on some islands, depending on the competition, and are definitely lower outside of high season. Shop around and don't be shy about bargaining. Most cars have a **standard shift;** if you must have an automatic, make sure in advance that one is available (and be prepared to pay quite a bit extra). Always ask if the quoted price includes insurance; many credit cards include collision-damage waivers, but you will find that most rental agencies automatically include this in their rates, usually with a deductible of 500€ to 900€. You can usually add full insurance for an extra fee, and doing so can be worth the added price for peace of mind. Most companies require that the renter be at least 21 years old (25 for some car models). You must also have a major credit card (or be prepared to leave a *very* large cash deposit).

PARKING Parking is a serious challenge in the cities and towns of Greece. Most city streets have restricted parking of one kind or another. Observe signs

Get an IDP!

Many non-E.U. drivers in Greece, including those from the U.S., are required to carry an International Driver's Permit (IDP). While in the past many car rental agencies waived this requirement, enforcement has been tightened, and now many will not rent to you if you don't have one. Consequences for driving without an IDP can be serious, and expensive. Police often issue stiff fines (in excess of 100€) if you cannot produce an IDP; should you be involved in an accident and not have one, you may discover you've been driving illegally and your insurance is invalid. Obtain a permit before leaving home from your national automobile association.

carefully, as police are quick to ticket and fines can be steep. Police often remove license plates, necessitating a visit to the police station and payment on the spot to retrieve them. Whenever you park, be sure to lock the car and remove valuables from sight. Better hotels provide parking, either on their premises or by arrangement with a nearby lot.

By Boat

Ferries are the most common, cheapest, and generally most "authentic" way to visit the islands. A wide variety of vessels sail Greek waters—many, especially those making longer trips, are huge, sleek, and new, with TV lounges, discos, and good restaurants.

Ferry service (often accommodating vehicles) is available between **Athens (Piraeus)** and other Greek ports, and the network of interisland boat service is extensive. For some of the **Cyclades** islands, crossing is shorter and less expensive from Rafina, an hour east of Athens. The **Sporades** are served by boats from Kymi, and Volos (with connecting bus service from Athens), and sometimes from Agios Konstantinos. **Kefalonia** is served by ferries to and from Killini in the western Peloponnese, with bus connections to and from Athens, and **Corfu** is linked to the mainland with service to and from Igoumenitsa, on the western mainland, also with bus connections from Athens. So-called "Flying Catamarans" and hydrofoils dubbed "Flying Dolphins" serve many of the major islands, though their schedules are often interrupted by weather conditions. Drinks and snacks are almost always sold on board ferries and hydrofoils.

For schedules maintained by the dozens of shipping companies, search online at **www.ferryhopper.com**, **www.gtp.gr**, or **www.ferries.gr**. You can usually depend on purchasing a ticket from a dockside agent or aboard the ship itself, though this is often more expensive. Different travel agencies sell tickets to different lines—this is usually the policy of the line itself—and one agent might not know or bother to find out what else is offered. However, reputable agencies will present you with all options. At the height of summer, when boats can be crowded, it's best to buy tickets well in advance of your planned day of travel, especially if you are booking accommodations.

First-class accommodations are usually in roomy air-conditioned cabins. Second-class cabins are smaller and you may share with strangers. Tourist-class fare entitles you to a seat on the deck or in a lounge. (Tourists usually head for the deck, while Greeks stay inside and watch TV.) Hold onto your ticket; crews conduct ticket-control sweeps.

BY HYDROFOIL Hydrofoils (often referred to as Flying Dolphins, or by Greeks as *flying*) are faster than ferries and their stops are much shorter. They have comfortable airline-style seats but are noisy and provide little or no view of the passing scenery. Though fares are higher than those in ferries, they can save quite a bit of time. However, hyrdofoils run notoriously late, and often not at all, so you may spend hours on a dock waiting for the boat to arrive and get to your destination later than you would have on a regular ferry.

Flying Dolphins operated by **Blue Star Ferries** (www.bluestarferries.com) sail to the Saronic Gulf islands and throughout the Sporades. There is also

hydrofoil service from Rafina, on the east coast of Attika, and from Piraeus to several of the Cyclades islands.

By Train

Greek trains are generally inexpensive and fairly pleasant, though the network is quite limited, but expanding. Trains are operated by the Hellenic Railways Organization (OSE). **Trains** leave from the Larissa station (Stathmos Larissis), off Diliyianni Street, west of Omonia Square; to get or from there, take metro line 2 (with stops at Syntagma Square, Omonia, and other stations in central Athens). A popular route operates between Athens and Corinth, handy for access to the Peloponnese; service operates about every half hour and the trip takes about an hour. An Express train connects Athens with Thessaloniki in 4 hours. Purchase your ticket and, if possible, reserve a seat ahead of time, as a 50% surcharge is added to tickets purchased on the train, and some lines are packed, especially in summer. A first-class ticket may be worth the extra cost, as seats are more comfortable and cars are less crowded. For information and tickets in Athens, visit the ticket office in Larissa Station (www.trainose.gr). You will find timetables, along with an online booking option, at www.hellenictrain.gr.

By Bus

Greece has an extensive **long-distance bus service** organized under **KTEL,** an association of regional operators with buses that leave from convenient central stations. Overall, long-distance bus travel is quite pleasant, and most coaches are equipped with Wi-Fi. For information about the long-distance-bus offices, contact the KTEL office in Athens (© **210/880-8000**). Note that KTEL does not have a unified online presence to supply timetables or sell tickets, but you'll find a KTEL website, with schedules and many with ticketing options, for each island and region (most, but not all, are in English); you'll find these in our listings.

In Athens, most buses heading to destinations within **Attica** leave from the Mavromateon terminal, north of the National Archaeological Museum. Most buses to **Central Greece** leave from 260 Liossion, often called Terminal B, 5km (3 miles) north of Omonia Square (take local bus no. 024 from Leoforos Amalias in front of the entrance to the National Garden and tell the driver your destination). Most buses to the **Peloponnese,** and to **western** and **northern Greece,** leave from the long-distance bus terminal at 100 Kifissou, often called Terminal A, 4km (2½ miles) northeast of Omonia Square (to get to Terminal A, take local bus no. 051 from a stop 2 blocks west of Omonia, near the big church of Ayios Konstandinos, at Zinonos and Menandrou). Bus travel will be made easier in the mid-2020s, when a new central bus depot, with Metro connections, is slated to open in outlying Eleonas.

Express buses between major cities, usually air-conditioned, can be booked through travel agencies. Even express buses make stops every 2½ hours for food and toilet breaks.

Organized and guided **bus tours** are widely available from Athens. Some of them will pick you up at your hotel; ask the hotel staff or any travel agent

in Athens. **CHAT Tours** is the oldest and probably most experienced provider of a wide selection of bus tours led by highly articulate guides. Almost any travel agent can book a CHAT tour, but if you want to deal with the company directly, contact them through their website, www.chat-tours.com.

By Taxi

Taxis are usually available in small towns and on the islands, and can be a good alternative to renting a car in places where public transportation is spotty. Though they are equipped with meters, in many cases you can negotiate a price with a driver for a sightseeing tour, a day trip, a dropoff and pickup at a rural restaurant or beach, or others rides outside of getting from one point to another. Hotels can often refer you to a reliable driver. For taxis in Athens, see p. 70.

TIPS ON ACCOMMODATIONS

Greece offers a full spectrum of accommodations, ranging from the extravagant to the basic, from massive, all-inclusive hotel complexes at beach resorts to a room in a private home. Government-issued ratings are indicated by a star system, from 1 to 5, but these are based more on facilities such as public areas, pools, and in-room amenities than on charm or service.

Many major chains operate in Greece, alongside some Greek-owned groups, but most Greek hotels are independent lodgings run by hands-on owners. Greece has some of the most luxurious lodgings in the world, setting the gold standard with such amenities as private in-suite pools and gyms. At the other end of the scale are perfectly acceptable but modest lodgings. Especially in the countryside and on the islands, you will often encounter bathrooms that, while decently equipped, lack enclosed showers (a hose and a drain suffice). Whatever the level of luxury, however, standards of cleanliness are generally very high. Most rooms, even modest ones, offer air-conditioning in the hot season and heating in the colder months, as well as TVs and, often, small refrigerators. Private bathrooms are the norm, although these are sometimes accessed from a hallway or courtyard outside the room.

Note that a **double room** in Greece does not always mean a room with a double bed but *might* be a room with twin beds. Double beds in Greece are called "matrimonial beds," and rooms with such beds are often designated "honeymoon rooms." A **passport** or other form of identification is usually required when registering in a hotel.

Hotels in Athens and especially on Santorini and Mykonos tend to be expensive, but in the countryside and on many islands, hotel rates in general are a relative bargain when compared to those elsewhere in Europe. Don't be shy about bargaining, especially with expensive properties, whether it's in an email, on the phone, or in person. Many hotels offer discounted rates for longer stays, for Internet bookings, advance payment, or payment in cash.

ACCOMMODATION SOURCES You probably won't get too far off an arriving ferry or bus before encountering someone offering a "room to let." This might be in a private home, a full-blown hotel dredging up clients, or in

a purpose-built or refitted "room to rent" structure. The price is almost always on the low side. Accommodations are rarely luxurious, but they are often extremely comfortable and full of character and usually have private bathrooms and other amenities. The tout often comes equipped with photos or a printed pamphlet; aside from price, you should ask up front about location before following a stranger through the back streets. Inquire about terms of payment (usually cash only) and any amenities you require—terrace, view, inclusive breakfast, pool, whatever. Soliciting clients is honorable in Greece, and not a sign of desperation; in fact, finding a room in this way can ensure a nice bond with the proprietor. On some islands tourist offices and travel agencies have lists of rooms to let.

Apartment and house rentals are common in Greece, with a wide-range of offerings from such sources as **Airbnb** (www.airbnb.com) and **VRBO** (www.vrbo.com). **Yades Historic Hotels** (www.yadeshotels.gr) represents stylish and distinctive hotels throughout Greece, with many excellent properties in the Peloponnese and on Santorini and Crete. **True Trips** (www.truetrips.com) also represents some especially distinctive hotels in Athens and on the islands.

MINDING YOUR LOCAL MANNERS

DRESS CODES Most Greeks wear bathing suits only on the beach and do not go into restaurants, cafes, or shops without putting something over their skimpy garments. Also, many Greeks consider bare feet off the beach seriously odd and quite rude. Almost no Greek man would go into a church in shorts, and Greek women do not enter churches in sleeveless tops or shorts. Slacks for women are now acceptable almost everywhere, however, except in the most traditional churches and monasteries.

SAYING HELLO & GOODBYE Few Greeks go into a bakery and say "Loaf of bread, please," and then pay and leave. Almost all encounters begin with a greeting: *"Kali mera"* (Good day) is always acceptable, but on Monday, you'll hear *"Kali ebdomada"* (Good week) and on the first of the month *"Kalo mena"* (Good month). Sprinkle your requests on how to find the Acropolis or where to buy a bus ticket with *"Sas para kalo"* (Excuse me, please) and *"Eucharisto"* (Thanks), and you'll help make Greeks reconsider all those things they've come to believe about rude tourists. And on that topic, although most Greeks don't mind having their photo taken, always ask first.

TOURS/SPECIAL-INTEREST TRIPS

You can find a wide variety of tours, special-interest trips, classes, and workshops available when you travel to Greece, focusing on everything from antiquities to wine tasting. In addition, there are a number of organized possibilities for volunteerism, whether on excavations or on farms. Here are some suggestions.

The **Cultural Experience** (archaeology-travel.com; ✆ **877/209-5620** in the U.S., 0345/475-185 in the U.K.) offers tours led by expert guides; typical trips might be to ancient sites in Athens and the Peloponnese. The **Aegean Center for the Fine Arts** (www.aegeancenter.org), based on the island of Paros, offers courses in painting, photography, music, creative writing, and modern Greek. Most of the students are college-age Americans. The American-run **Island Center for the Arts** conducts classes in painting, photography, and Greek culture on the island of Skopelos between June and September (www.island center.org; ✆ **24240/24036**). As the school is affiliated with the Massachusetts College of Art, some educational institutions grant credits for its courses.

The popular **Road Scholar** program (formerly Elderhostel; www.road scholar.org; ✆ **800/454-5768**) is a learning experience for adults (with some intergenerational programs) that offers a couple dozen trips to Greece and the surrounding area each year, ranging from cruises on smaller ships that explore the history and culture of the Aegean Islands, to overland road trips where participants explore the art, architecture, and archeology of the region.

Adventure & Wellness Trips

Trekking Hellas (www.trekking.gr) offers white-water rafting excursions in the Peloponnese and northern Greece. Although plenty of beginners go on these trips, most foreign participants have had some rafting experience. Trekking Hellas also organizes hiking tours (see "Walking Tours," p. 417). **Back-roads** (www.backroads.com; ✆ **800/462-2848**) leads multi-adventure tours in Santorini, Crete, and the Peloponnese. **SwimTrek** (www.swimtrek.com; ✆ **877/ 455-7946**) offers holidays that focus on coastal swims around Crete, the Sporades, the Cyclades, and the Ionians.

Eumelia (www.eumelia.com) hosts up 25 guests on its organic farm outside the hamlet of Gouves, in the Peloponnese south of Sparta, for workshops and seminars focusing on wine, gastronomy, and mind/body experiences. **Limnisa** (www.limnisa.com) offers silent retreats, writing retreats, and workshops by the sea near Methana, in the east Peloponnese, near the island of Poros. **Skyros Center** (www.skyros.com; ✆ **22220/92842** in Greece) offers

Learning the Language

The **Dartmouth College Rassias Center** (rassias.dartmouth.edu) language program in modern Greek is a very popular 10-day total-immersion session that should have you arriving ready to amaze and delight Greeks with your command of their glorious and tricky language. This is the same method used to train Peace Corps volunteers. Classes are held in totally un-Greek surroundings, on the Dartmouth campus in Hanover, New Hampshire. In Greece, the **Athens Centre**, 48 Archimidou, Athens (athens centre.gr), which has been around since 1969, offers modern Greek classes year-round, with 3-week language immersion courses. During the summer, the center also hosts 2-week workshops in painting, photography, poetry, and theater.

yoga and holistic holidays (as well as writing holidays and singles holidays) on the island of Skyros.

Food & Wine Trips

If you're heading for Santorini and want to learn about Greek cuisine, the island's best restaurant, **Selene** (www.selene.gr), offers cooking classes with the most varied and fresh local ingredients each summer. **Diane Kochilas** (www.dianekochilas.com), a Greek-American expert on Greek foods, offers a variety of activities, including cooking classes in Athens and culinary tours in Athens and throughout Greece. **Nikki Rose** (www.cookingincrete.com), a Cretan-American professional chef, operates seminars on Crete that combine some travel with cooking lessons and investigations of Crete's diet. Susanna Spiliopoulou of the excellent **Hotel Pelops** (www.hotelpelops.gr) in Olympia offers cooking workshops based on traditional recipes.

Guided Tours

Organized and guided **bus tours** focusing on the glories of ancient Greece are widely available. Escorted tours are structured group tours, with a group leader. The price usually includes hotels, meals, tours, admission costs, and local transportation. Single travelers are usually hit with a "single supplement" to the base price for package vacations and cruises, while the price of a single room is almost always well over half that for a double.

CHAT Tours (www.chat-tours.gr), founded in 1953, is the oldest and most experienced provider of a wide selection of bus tours led by highly articulate guides. Be sure to ask how many will be on your tour, as a large group usually results in a more regimented and much less personal experience. **Greece Tour Hub** (www.greecetourhub.com) is notable for its variety of interesting itineraries, from food tours of Athens to multiday tours of the classical sights to day sails on the islands.

Fantasy Travel, 19 Filelinon (www.fantasytravel.gr; © 210/331-0530), is another solid travel agency in Athens that offers tours. Another long-standing Greek tour organizer is **Homeric Tours** (www.homerictours.com; © 800/223-5570). Such tours fall into the "moderate" category in pricing and accommodations; they're especially handy for quick visits to the top sights.

TrueTrips (www.truetrips.com; © 800/817-7098 in North America or 210/612-0656 in Greece) plans highly customized tours to selected destinations, taking into account your interests, level of accommodation, and other details.

If you'd like to take a day tour of Athens, or a week-long tour of Greece, that focuses on Greece's **Jewish heritage,** check out www.jewishtours.gr.

Walking Tours

Trekking Hellas, based in Athens at 10 Rethimnou (www.trekkinghellas.gr; © 210/331-0323), is a well-known outfit offering guided hiking tours of the Greek mainland, Crete, and several Cycladic islands. If you don't want to be with a group, but do want some pointers, Trekking Hellas will help you plan an itinerary and book you places to stay along the way. The Crete-based

Happy Walker in Rethymnon (www.happywalker.com; © 28310/52920) leads day hikes into the mountains and gorges of Western Crete, as well as multiday hikes on Crete and elsewhere in Greece.

[FastFACTS] GREECE

Area Codes Area codes in Greece range from three digits in Athens **(210, 211, etc.)** to as many as five digits in less populated locales. All numbers provided in the text start with the proper area code.

ATMs In commercial centers, airports, all cities and larger towns, and most tourist centers, you will find at least a couple of machines accepting a wide range of cards. Smaller towns will often have only one ATM.

But for all the prevalence of ATMs, you should keep at least some actual cash on you for those occasions when all the ATMs you can locate are out of order or out of cash. You can usually get by with a credit card, even in rural areas, but many establishments much prefer cash.

Note: Greek ATMs accept only a four-digit PIN—you must change yours before you go. And since Greek ATMs use only numeric PINs (personal identification numbers), before you set off for Greece be sure you know how to convert letters to numerals as the alphabet will be in Greek.

Business Hours Almost all stores and services are **closed on Sunday**—except the many tourist-oriented shops and services. **Supermarkets, department stores,** and **chain stores** are usually open 9am to 9pm,

Monday through Saturday. On Monday, Wednesday, and Saturday, smaller **retail shops'** hours are usually 9am to 3pm; Tuesday, Thursday, and Friday, it's 9am to 2pm and 5 to 7pm. The **afternoon siesta** is generally observed from 3 to 5pm, though many tourist-oriented businesses have a minimal crew on duty during this time, and they may keep extended hours, often from 8am to 10pm. Call ahead to check the hours of businesses you must deal with, and try not to disturb Greek friends during siesta hours.

Most **government offices** are open Monday through Friday only, from 8am to 3pm. **Banks** are open to the public Monday through Thursday from 8am to 2:30pm, Friday from 8am to 2pm. Banks at a few locations may be open for some services such as foreign currency exchange into the evening and on Saturday. All banks are closed on the long list of Greek holidays (see p. 38).

Final advice: Anything you really need to accomplish in a government office should be done on weekdays between about 9am and 1pm.

Credit Cards In Greece, Visa and MasterCard are the most widely accepted cards. Diners Club is less widely accepted; American Express

is even less frequently accepted, because it charges a higher commission and is more protective of the cardholder in disagreements. Credit cards are accepted throughout Greece in hotels, restaurants, and at most shops, even small ones, where they are increasingly being used, even for small purchases. Contactless cards (with the little Wi-Fi symbol) are the norm, and you will be asked to tap your card against a monitor. Apple Pay, Google Pay, and other payment apps are also widely accepted, in which case you will simply hover your phone over the monitor. Some hotels require a credit card number when you make advance reservations but will demand payment in cash; inquire beforehand if this will be the case. Many establishments, even better hotels, will offer you a discount if you pay in cash.

Customs **What you can bring into Greece:** Passengers from North America arriving in Athens aboard international flights are generally not searched, and if you have nothing to declare, continue through the green lane. Citizens of the United States, Canada, Australia, New Zealand, and other non-E.U. countries do face a few commonsensical restrictions. Clearly, no narcotics: Greece is *very* tough on

THREE warnings ABOUT DEBIT & CREDIT CARDS

Amid increasing concerns about fraud, some banks and credit-card companies are apt to deny your cards if you try to use them overseas. Check with your bank to see if it's necessary to let them know you will be using your cards out of the country. You can usually post a travel notification online.

Beware of **hidden credit card fees** while traveling. Check with your credit or debit card issuer to see what fees, if any,

will be charged for overseas transactions. Recent reform legislation in the U.S., for example, has curbed some exploitative lending practices. But many banks have responded by increasing fees in other areas, including fees for customers who use their cards while out of the country. Fees can amount to 3% or more of the purchase price. Check with your bank to avoid any surprise charges on your statement.

drug users. No explosives or weapons—although upon application, a sportsman might be able to bring in a legitimate hunting weapon. Only medications for amounts properly prescribed for your own use are allowed. Plants with soil are not. Dogs and cats can be brought in, but they must have proof of recent rabies and other health shots.

What You Can Take Out of Greece (All Nationalities): Exportation of Greek antiquities is strictly protected by law. No antiquities may be taken out of Greece without prior special permission from the **Archaeological Service,** 3 Polignotou, Athens, which you can arrange with a dealer, who must also provide you with an export certificate for any object dating from before 1830. For more information, consult the Hellenic Society for Law and Archaeology at www.law-archaeology.gr. In general, **keep all receipts** for major purchases in order to clear Customs on your return home.

For further information on what you're allowed to bring into your country of residence, contact one of the following agencies:

U.S. Citizens: U.S. Customs & Border Protection (www.cbp.gov; © **877/227-5511**).

Canadian Citizens: Canada Border Services Agency (www.cbsa-asfc.gc.ca; © **800/461-9999** in Canada).

U.K. Citizens: HM Revenue & Customs (www.hmce.gov.uk; © **0845/010-9000,** or from outside the U.K., 020/8929-0152).

Australian Citizens: Australian Customs Service (www.customs.gov.au; © **1300/363-263**).

New Zealand Citizens: New Zealand Customs (www.customs.govt.nz; © **0800/428-786**).

Doctors Any foreign embassy or consulate can provide a list of area doctors who speak English. If in a town without these offices, ask your hotel management to recommend a local doctor—even his or her own.

Drinking Laws The minimum age for being served alcohol in public is 18. Wine and beer are generally available in eating places, but not in all coffeehouses or dessert cafes. Alcoholic beverages are sold in food stores as well as liquor stores. Although a certain amount of high spirits is appreciated, Greeks do not appreciate public drunkenness. The resort centers where mobs of young foreigners party every night are tolerated as necessary for the tourist trade, but such behavior wins no respect for foreigners. Do not carry open containers of alcohol in your car and don't even think about driving while intoxicated—offenders are often jailed and almost always fined heavily.

Electricity Electric current in Greece is 220 volts AC, alternating at 50 cycles. (Some larger hotels have 110-volt low-wattage outlets for electric shavers, but they aren't good for hair dryers and most other appliances.) Electrical outlets require Continental-type plugs with

two round prongs. U.S. travelers will need an adapter plug. Laptop computer users will want to check their requirements; a transformer may be necessary, though many laptops function at 220 volts.

Embassies & Consulates Foreign embassies in Athens include **Australia,** Level 2, 5 Hatiyianni Mexi St. (www.greece.embassy. gov.au; ☎ **210/870-4000**); **Canada,** 48 Ethnikis Antistaseos St. (www.greece.gc.ca; ☎ **210/727-3480**); **Ireland,** 7 Vas. Konstantinou (www. dfa.ie/irish-embassy/greece; ☎ **210/723-2771**); **New Zealand,** 76 Kifissias Ave, Ambelokipi (www.mfat.govt. nz; ☎ **210/692-4136**); **South Africa,** 60 Kifissias, Maroussi (www.gov.za; ☎ **210/ 6178020**); **United Kingdom,** 1 Ploutarchou (www.ukin greece.fco.gov.uk; ☎ **210/ 727-2600**); **United States,** 91 Leoforos Vas. Sofias (gr. usembassy.gov; ☎ **210/ 721-2951**). Be sure to phone ahead before you go to any embassy; most keep limited hours and are usually closed on their own holidays as well as Greek ones.

Emergencies The national emergency number is ☎ **112.** Contact the local police at ☎ **100.** For fire, call ☎ **199.** For medical emergencies and/or first aid and/or an ambulance, call ☎ **166.** For hospitals, call ☎ **106.** For automobile emergencies, put out a triangular danger sign and call ☎ **10400** for road assistance and/or the number your rental-car agency provides. Embassies, consulates, and many hotels can recommend an English-speaking doctor.

Health If you suffer from a chronic illness, consult your doctor about your travel plans before your departure. If you have special concerns, before heading abroad you might check out the United States **Centers for Disease Control and Prevention** (www.cdc. gov/travel; ☎ **800/232-4636**). While Greece does not require proof of Covid vaccination for entry, the CDC recommends that you do not travel abroad if you are not fully vaccinated.

Travelers should check their health plans to see if they provide appropriate coverage; you may want to buy **travel medical insurance.** Bring your insurance ID card with you when you travel.

Drugstores/Chemists: These are called *pharmikon* in Greek; they are identified by a green cross. For minor medical problems, go first to the nearest pharmacy. Pharmacists usually speak English, and can offer advice on many minor conditions. Many medications that require a prescription in the U.S. and U.K. can be dispensed without prescription in Greece. In the larger cities, a sign in the window of a closed pharmacy will direct you to the nearest open one.

Common Ailments: Diarrhea is no more of a problem in Greece than it might be anytime you change diet and water supplies, but occasionally visitors do experience it. Common over-the-counter preventatives and cures are available in Greek pharmacies, but if you are concerned, bring your own. If you expect to be taking sea trips and are inclined to get **seasick,** bring a preventative. **Allergy sufferers** should carry antihistamines, especially in the spring.

Sun Exposure: Between mid-June and September, too much exposure to the sun during midday could well lead to sunstroke or heatstroke. High-SPF **sunscreen** and a hat are strongly advised. Stock up on sunscreen before setting out to the islands, where these products tend to be more expensive and choices are limited.

Hospitals In Greece, modern hospitals, clinics, and pharmacies are found everywhere, and personnel, equipment, and supplies ensure excellent treatment. Dental care is also widely available. Most doctors in Greece speak English, and many have trained in the U.S. and U.K.

Emergency treatment is usually given free in state hospitals, but the care in outpatient clinics, which are usually open mornings (8am–noon), is often somewhat better. You can find them next to most major hospitals, on some islands, and occasionally in rural areas, usually indicated by prominent signs.

Internet & Wi-Fi Internet connection with Wi-Fi is now available virtually anywhere a visitor is apt to be. Most bars have Wi-Fi, as do hotels and many public places.

Language Language is usually not a problem for English speakers in Greece, as so many Greeks have studied English in school and find it necessary to use in their work worlds—most particularly, in the tourist realm that visitors encounter. Many Greeks have also lived abroad in places where English is the primary language. For better or worse, Greeks also learn English from Anglo American–dominated pop culture. Several television programs are broadcast in their original languages, and American prime-time soaps are very popular, nearly inescapable. Even advertisements have an increasingly high English content. Don't let all this keep you from trying to pick up at least a few words of Greek; your efforts will be rewarded by your hosts, who realize how difficult their language is for foreigners and will patiently help you improve your pronunciation and usage. Meanwhile, see the "Useful Words & Phrases" at the end of this chapter.

Legal Aid If you need legal assistance, contact your embassy or consulate. If these institutions cannot themselves be of help, they can direct you to local lawyers who speak English and are willing to assist you.

LGBT Travelers
Greece—or at least parts of it—has a long tradition of being tolerant of gay men, and in recent years these locales have extended this tolerance to lesbians. However, although Greeks in

Athens, and perhaps a few other major cities, may not care one way or the other, Greeks in small towns and villages—indeed, most Greeks—do not appreciate flagrant displays of dress or behavior.

Among the best-known hangouts for gays and lesbians are Mykonos and Chania, Crete, but gays and lesbians travel all over Greece without any particular issues. The age of consent for sexual relations with homosexuals is 17, and this can be strictly enforced against foreigners.

Mail The mail service of Greece is reliable—but slow. (Postcards usually arrive after you have returned.) You can receive mail addressed to you c/o Poste *Restante*, General Post Office, City (or Town), Island (or Province), Greece. You will need your passport to collect this mail. Many hotels will accept, hold, and even forward mail for you; ask first. For the fastest service, try FedEx or one of the other major private carriers; travel agencies can direct you to these.

Postage rates have been going up in Greece, as they are elsewhere. At press time, a postcard or a letter up to an ounce to foreign countries costs .85€; up to 2 oz. 1.70€; up to 3 oz. 2.55€. Rates for packages depend on size as well as weight, but are reasonable. **Note:** Do not wrap or seal any package—you must be prepared to show the contents to a postal clerk. If you are concerned about some particular item, you might

consider using one of the well-known international commercial delivery services. Your hotel or any travel agency can direct you to the nearest local office.

Medical Requirements There are no immunization requirements for getting into Greece. Proof of a Covid vaccination is no longer required for entry, though the C.D.C. highly recommends that you do not travel abroad if you are not fully vaccinated. It's always a good idea to have polio, tetanus, and typhoid covered when traveling anywhere. See "Health," p. 420.

Mobile Phones Before you spend too much time navigating the ins and outs of using your cell phone in Greece, note that Verizon offers what's called **Wi-Fi calling.** As long as you have an Internet connection, you may usually call any U.S. number at no extra charge, making this an inexpensive option for keeping in touch with the folks back home (Canadian, U.K, and Australian providers offer similar plans for their customers). The drawbacks, however, are that you may not make calls if you do not have an internet connection, and you will be billed at international rates for any calls you make within Greece.

T-Mobile provides free international data and charges $.25 a minute for calls. The free data is a bonus when using map navigation. Another option are the so-called **travel passes** available from most carriers that allow you to use data

and make unlimited calls for one set daily fee, usually about $10 a day. The pass is activated for 24 hours as soon as you take your phone out of airplane mode and use it. Check with your carrier to learn about the options available for international use.

WhatsApp has long been popular in Europe and is catching on among American travelers, too. This app allows you to call anyone in your contact list for free, provided you have an internet connection or are using data.

An alternative if you intend to make many phone calls in Greece is to bring your unlocked cellphone to Greece and **buy a SIM card** in the national telephone office (OTE) center in major cities or a commercial phone store. These cards—actually a tiny chip inserted into your phone—cost about 20€ and include a Greek phone number and a number of prepaid minutes; when you have used up these minutes, you can purchase a phone card at a kiosk that gives you more minutes. Any calls you make outside of Greece with this system will be very expensive.

Renting a phone in Greece may also be a good idea. You can rent a phone from any number of places in Greece—including kiosks at major airports, OTE

offices, and cellphone stores.

If you expect to be abroad for more than a brief time, however, and/or will be visiting more than one country, **buying a phone** can make economic sense. Numerous companies now sell phones with a SIM card included and with a U.S. or U.K. phone number assigned to it—so-called global roaming services that offer relatively cheap per-minute rates for both outgoing and incoming calls. You may buy a phone in Greece in either the national telephone office (OTE) in any decent-size city or a retail electronics store. Another option for renting or buying a Greece-compatible cell phone is **www. cellularabroad.com**. Also see "Telephones" below.

Money The currency in Greece is the **euro** (pronounced *evro* in Greek), abbreviated "eu" and symbolized by €. (If you still own the old drachmas, it is no longer possible to exchange them.) The euro comes in seven paper notes and eight coins. The **notes** are in different sizes and colors, and come in the following denominations: 5, 10, 20, 50, 100, 200, and 500. (Considering that each euro is worth more than $1, those last bills are quite pricey!) Six of the **coins** are officially

denominated in "cents"— e.g., one-hundredths of a euro—but in Greece the name for this is *lepta*, the old Greek name for sums smaller than the drachma. These smaller coins, which come in different sizes, are valued at 1, 2, 5, 10, 20, or 50 *lepta*. There are also 1€ and 2€ coins. Although one side of the coins differs in each of the member E.U. nations, all coins and bills are legal tender in all countries using the euro.

Warning: The 1€ and 2€ coins look similar to a 1-lira Turkish coin—worth less than half the 1€, so count your change carefully.

You may easily obtain euros at airport ATMs upon arrival, and should an ATM not be available, you'll probably be able to get by with a credit card. If you want to arrive with some euros in your pocket, you can obtain some before you leave home at an American Express office or at some banks (note, though, that you'll pay fees and a higher exchange rate than you will with an ATM in Greece).

Frommer's lists exact prices in the local currency (the euro). The conversion rate provided was correct at press time. However, rates fluctuate, so before you leave, check a website like **www.xe.com** online for the latest rates.

THE VALUE OF THE EURO VS. OTHER POPULAR CURRENCIES

Euro€	Aus$	Can$	NZ$	UK£	US$
1	A$1.47	C$1.31	NZ$1.62	£.84	$1.02

WHAT THINGS COST IN ATHENS

	€
Taxi from the airport to downtown Athens	35–50.00
Double room, moderate	101–150.00
Double room, inexpensive	70–100.00
Three-course dinner for one without wine, moderate	12–20.00
Bottle of beer	2.50–4.00
Cup of coffee	1.50–3.50
1 gallon/1 liter of gas	9.30/2.45
Admission to museums and archaeological sites	3–12.00

Costs Greece is no longer the bargain it once was, though even Athens is still not in the category of London or New York or Paris or Tokyo. Even so, in Athens and on Santorini and Mykonos, prices at many hotels and upscale restaurants are comparable to those in most other developed countries. Admission to major museums and archaeological sites is comparable to fees in major European cities. But it is still possible to have a reasonably modest holiday in Greece. You can start by visiting outside the high season—July and August. Pick mid-price hotels and restaurants—and make sure breakfast is included in your hotel price. Look for deals on car rentals. Fly at off-peak times, and avoid expensive services such as spas or purchases such as jewelry.

Newspapers & Magazines All cities, large towns, and major tourist centers have at least one shop or kiosk that carries a selection of foreign-language publications; most of these are flown or shipped in on the very day of publication.

English-language readers have a wide selection, including most of the British papers (*Daily Telegraph, Financial Times, Guardian,* and *Independent*). The *New York Times International Edition* (with an English-language insert of the well-known Athens newspaper *Kathimerini*) and *USA Today* are also available. *Kathimerini* has an online English edition that is quite adequate for keeping up with Greek news (**www.ekathimerini.com**).

Packing As most visitors to Greece tend to be there between the first of May and the end of September, light jackets and sweaters should suffice for any overcast days or cool evenings—unless you are planning to spend time in the mountains. Except for some high-end hotels and resorts, casual dress is accepted in almost all restaurants and facilities. Greeks remain uncomfortable with beachwear or too-casual garb in villages and cities. Females are expected—indeed, often required—to cover their arms and upper legs before entering monasteries

and churches. Some priests and monks are stricter than others and may flatly bar men as well as women if they feel that they are not dressed suitably.

Passports For entry into Greece, citizens of non-E.U. countries are required to have a **valid passport,** which should be stamped upon entry and exit, for stays up to 90 days. Keep in mind that authorities can detain you upon departure for being in violation of this 90-day requirement if they do not find an entry stamp in your passport. As of late 2023, Americans and other non-EU citizens (including British subjects) are also required to have an electronic ETIAS (European Travel Information and Authorization System) visa waiver, obtained by filling out an online application and paying a small fee with a credit or debit card (7€ for applicants 18 and older). The ETIAS waiver is linked electronically to your passport. For more information, go to www.etiasvisa.com.

Citizens of European Union countries are required to present a valid ID (driving

licenses do not qualify) for entry into Greece; you may stay an unlimited period, although you should inquire about this at a Greek consulate or at your embassy in Greece. Children under 16 from E.U. countries may travel without an ID if accompanied by either parent. All E.U. citizens are reminded that they should check the requirements for non-E.U. countries through which you might travel to get to Greece.

For stays longer than 90 days, all non-E.U. citizens will require visas from the Greek embassies or consuls in their home countries. If already in Greece, arrangements must be made at least 2 weeks before the required departure date with the **Bureau of Aliens,** 24 Petri Ralli, Tavros (© **210/340-5806**).

Police To report a crime or medical emergency, or for information or other assistance, first contact the tourist police (© **171**), where an English-speaking officer is more likely to be found. If there is no tourist police officer available, contact the local police at © **100** or call the national emergency number, © **112** (many operators speak English).

Note: The Greek authorities and laws are extremely tough when it comes to foreigners with drugs—starting with marijuana. Do *not* attempt to bring any illicit drug into or out of Greece.

Safety Crime directed at tourists was traditionally unheard of in Greece, but in more recent years there are occasional reports of cars

broken into, pickpockets, purse snatchers, and the like. Normal precautions are called for. For instance, keep an eye on hand luggage containing expensive items, whether jewelry or cameras. Lock the car and don't leave cameras or other such gear visible. Don't leave your luggage unattended, and it is probably safer not to leave valuables unattended at beaches. Young women should observe the obvious precautions in dealing with men in isolated locales.

High among potential dangers are automobile accidents: Greece has one of the worst vehicle accident rates in Europe. You should exercise great caution when driving over unfamiliar, often winding, and often poorly maintained roads. This holds true especially when you're driving at night. As for those who insist on renting motorbikes or similar vehicles, at the very least wear a helmet.

Senior Travel Greece does not offer too many discounts for seniors. Some museums and archaeological sites offer discounts for those 60 and over, but the practice is unpredictable, and in state-financed museums the discount is restricted to citizens of an E.U. nation.

Many reliable agencies and organizations target the 50-plus market. **Road Scholar** (formerly Elderhostel; www.roadscholar.org; © **800/454-5768**) arranges study programs for those ages 55 and over (and a spouse or companion of any

age). In Greece, groups typically settle in one area for a week or two, with excursions that focus on getting to know the history and culture. Canada-based **Elder-Treks** (www.eldertreks.com; © **800/741-7956**) offers small-group tours to off-the-beaten-path or adventure-travel locations, restricted to travelers 50 and older. Britain-based **Saga Holidays** (Saga Building, Folkestone, Kent CT20 1AZ; saga.co.uk; © **0800/504-555** in the U.K.), offers all-inclusive tours in Greece for those ages 50 and older.

Single Travelers Single travelers are usually hit with a "single supplement" to the base price for package vacations and cruises, while the price of a single room is usually close to half of that for a double. Many reputable tour companies offer singles-only trips, however. **Singles Travel International** (www.singlestravelintl.com; © **877/765-6874**) offers escorted tours for travelers over 50 to places like the Greek Islands. **Backroads** (www.backroads.com; © **800/462-2848**) offers "Couples, Friends & Solos" active-travel trips to destinations worldwide.

Smoking In recent years the Greeks have imposed no-smoking regulations on airplanes, on areas of ships, and all public locations (banks, post offices, and so on). Small restaurants, tavernas, and cafes must declare whether they allow smoking or not; larger establishments are supposed to set aside smoking areas. But Greeks

continue to be among the world's most persistent smokers and, except on airplanes, many Greeks—and some foreigners—feel free to puff away at will. Hotels are only beginning to claim that they have set aside rooms or even floors for nonsmokers, so ask about them, if it matters to you. If you are really bothered by smoke while eating, about all you can do is position yourself as best as possible—and then be prepared to leave if it gets really bad.

Student Travel In Greece, students with proper identification are given reduced entrance fees to archaeological sites and museums, as well as discounts on admission to most artistic events, theatrical performances, and festivals. A student ID often suffices, or you can arm yourself with an **International Student Identity Card (ISIC),** which offers substantial savings on rail passes, plane tickets, and entrance fees. It also provides you with basic health and life insurance and a 24-hour help line. The card is available for $20 from the ISIC Association (www. isicassociation.org). If you're no longer a student but are still under 31, you can get an **International Youth Travel Card (IYTC)** from the ISIC Association for $20.

The **World Youth Student and Educational (WYSE) Travel Confederation** (www.wysetc.org) has a history going back to 1949 to make travel around the world more affordable for students. Check out its

website for comprehensive travel services information for students. Irish students may prefer to turn to **USIT** (www.usit.ie; ℂ **01/436-2420**), an Ireland-based specialist in student, youth, and independent travel.

A **Hostelling International** membership (www. hihostels.com) can save students and older travelers as well money in some 5,000 HI hostels in 70 countries (including Greece), where sex-segregated, dormitory-style sleeping quarters cost about $15 to $35 per night. Some Greek hostels, including some in Athens, are quite upscale and also offer double rooms and apartments.

Taxes & Service Charges The **Value Added Tax** (VAT) is 24% for many purchases and services, including restaurants and car rentals; food and medicine and certain other "vital goods" tend to have a VAT of 13% while books and newspapers have 6%. You may sometimes be given a printed receipt that shows these percentages, but the taxes have already been included in the price quoted and charged. In addition to 13% VAT, hotel prices usually include a charge of .50€ to 4€ a night, depending on the category of the accommodation. Many restaurants add a "cover charge" in addition to the VAT that may be .50€–2€ per place setting and some include a service charge of 15% or so, though this is rare.

If you have purchased an item that costs 120€ or more and are a citizen of a

non–European Union nation, you may be able to get most of the VAT refunded (provided you export it within 90 days of purchase). Usually, only stores that display the sign **"Tax-Free for Tourists" participate in the program,** so be sure to ask before making a large purchase. Many stores participate in VAT-refund program Global Blue (www.global blue.com); you'll see the logo in the window.

The store provides you with a completed Tax-Free Check Form, along with your receipt. If you use your charge card, the receipt will list the VAT separately from the cost of the item. As long as the single receipt is for 120€ or more it may include multiple items.

As you are leaving the country, present a copy of this form at the Customs desk, where it will be stamped. Be prepared to show both the goods and the receipt as proof of purchase. Once you have cleared passport control, go to a refund counter; in the Athens airport, go the OneXchange desk in the non-Schengen area. The amount will be credited to your charge card or a check will be mailed to you in the envelope provided with the Tax-Free Check Form; Global Blue charges a processing fee on refunds, which can also be issued in cash.

Telephones Public phones are increasingly rare in Greece, but those you can find take prepaid phone cards, available at OTE

offices or at most kiosks. The cards come in various denominations, from 3€ to 25€.

To Call Greece from the United States, Canada, U.K., Australia, or New Zealand:

1. Dial the international access code: 011 from the U.S or Canada; 00 from the U.K., Ireland, or New Zealand; or 0011 from Australia
2. Dial the country code: 30
3. Dial the 10-digit number, which, includes the city code city code (three to five digits).

To Make International Calls from Within Greece:

1. Dial the 00 international access code,
2. Dial the country code.
3. Dial the area code (omitting zeroes, if any).
4. Dial the number.

Some country codes are: Australia, 0061; Canada, 001; Ireland, 00353; New Zealand, 0064; United Kingdom, 0044; and United States, 001. If you wanted to call the British Embassy in Washington, D.C., you would dial 00-1-202-588-7800.

Time The European 24-hour clock is used to measure time, so on schedules you'll see noon as 1200, 3:30pm as 1530, and 11pm as 2300. In informal conversation, however, Greeks express time much as we do—though noon may mean anywhere from noon to 3pm, afternoon is 3 to 7pm, and evening is 7pm to midnight.

Greece is 2 hours ahead of Greenwich Mean Time. In reference to North American time zones, it's 7 hours ahead of Eastern Standard Time, 8 hours ahead of Central Standard Time, 9 hours ahead of Mountain Standard Time, and 10 hours ahead of Pacific Standard Time. Greece observes daylight saving time, although it may not start and stop on the same days as it does in North America.

Tipping In restaurants, good service merits a tip of 5% to 15%, or round up, so 17€, say, becomes 20€. Some restaurants Greeks rarely tip taxi drivers, but tourists are expected to, at least by rounding cents up to a full euro figure. Hotel chambermaids should be left about 2€ per night. Bellhops should be tipped 1€ per bag.

Toilets Most Greek establishments—hotels, restaurants, museums, and so on—provide clean and well-equipped facilities, but often in Athens and almost always on the islands, you may be asked to deposit toilet paper in a container beside the toilet. In cheaper and more remote restaurants, you may find that there is no water at the hand bowl or a shortage of toilet paper; you might consider carrying some tissues with you. Many toilets do not have seats.

Public restrooms are generally available in any good-size Greek town, though they are sometimes rather crude. (Old-fashioned stand-up/squat facilities are still found.) If there is an attendant, you are expected to leave a small tip, or you may be asked to pay a fee, often .50€. In an emergency, you may ask to use the facilities of a restaurant or shop; if you do so, it's respectful to buy something.

Travelers with Disabilities Few concessions exist for travelers with disabilities in Greece. Though some provisions are slowly appearing, impediments abound: steep steps, uneven pavements, almost no cuts at curbstones, few ramps, narrow walks, slick stone, and traffic congestion create obstacles. The stepped streets of Santorini and other islands are especially difficult to navigate, as are archaeological sites, by their very nature. An elevator takes individuals in wheelchairs to the top of the Acropolis; but even this requires that the wheelchair be pushed up a lengthy path.

The Athens airport and metro system are wheelchair accessible, however, and more modern and private facilities are beginning to provide ramps. Increasingly, hotels are setting aside rooms that they advertise as "disability-friendly" or "handicap accessible," although that may mean nothing more than handrails in the bathtub. Nonetheless, foreigners in wheelchairs—accompanied by companions—are becoming a more common sight in Greece. Sage Traveling (www.sagetraveling.com) arranges accessible tours of Athens, Corfu, Rhodes, and other destinations in Greece.

Visitor Information The **Greek National Tourism Organization** (**GNTO** or **EOT** in Greece—and increasingly

referred to as the Hellenic Tourism Organization) has offices throughout the world that can provide you with information concerning all aspects of travel to and in Greece. Look for them at **www.gnto.gr**.

Among the sites we've used for broad-based searches on Greece are:

○ **www.mfa.gr** (official Greek matters)

○ **www.gtp.gr** (ship and air travel in Greece)

○ **www.ferryhopper. com** (ship travel in Greece)

○ **www.greecetravel. com** (tips from ex-pat Matt Barrett)

○ **www.perseus.tufts. edu** (classical Greek texts)

Water The public drinking water in Greece is safe to drink, although it can be slightly brackish in some locales near the sea. For that reason, many people prefer the bottled water available at restaurants, hotels, cafes, food stores, and kiosks. If you do order bottled water, you will have to choose between natural or carbonated (*metalliko*), and domestic or imported.

Women Travelers
Young women—especially singles or small groups—may well find Greek males coming on to them, particularly at beaches, clubs, and other tourist locales, in a rather forward manner. But our informants tell us that, in general, Greek males (a)

do not attempt any physical contact; and (b) sooner or later respect "No." One tactic said to work for women is to say, "I'm a Greek-American." The other advice is never to leave well-attended locales with someone you don't really know. Women should also be aware that some cafes and even restaurants are effectively male-only haunts; men will not appreciate attempts by foreign women to enter these places.

Many single European women travel on their own in Greece, and in general are quite comfortable doing so. Hotel and restaurant owners are often solicitous and protective of these travelers.

USEFUL WORDS & PHRASES

When you're asking for or about something and have to rely on single words or short phrases, it's an excellent idea to use *"sas parakaló,"* meaning "please" or "you're welcome" to introduce or conclude almost anything you say.

Airport	Aerothrómio
Automobile	Aftokínito
Avenue	Leofóros
Bad	Kakós, -kí, -kó*
Bank	Trápeza
Breakfast	Proinó
Bus	Leoforío
Can you tell me?	Boríte ná moú píte?
Cheap	Ft(h)inó
Church	Ekklissía
Closed	Klistós, stí, stó*
Coffeehouse	Kafenío
Cold	Kríos, -a, -o*
Dinner	Vrathinó
Do you speak English?	Miláte Angliká?
Excuse me.	Signómi(n).

Expensive	Akrivós, -í, -ó*
Farewell!	Stóka-ló! *(to person leaving)*
Glad to meet you.	Chéro polí.**
Good	Kalós, lí, ló*
Goodbye.	Adío *or* chérete.**
Good evening.	Kalispéra.
Good health (cheers)!	Stín (i)yá sas *or* Yá-mas!
Good morning *or* Good day.	Kaliméra.
Good night.	Kaliníchta.**
Hello!	Yássas *or* chérete!**
Here	Ethó
Hot	Zestós, -stí, -stó*
Hotel	Xenothochío**
How are you?	Tí kánete *or* Pós íst(h)e?
How far?	Pósso makriá?
How long?	Póssi óra *or* Pósso(n) keró?
How much does it cost?	Póso káni?
I am a vegetarian.	Íme hortophágos.
I am from New York.	Íme apótí(n) Néa(n) Iórki.
I am lost *or* I have lost the way.	Écho chathí *or* Écho chási tón drómo(n).**
I'm sorry.	Singnómi.
I'm sorry, but I don't speak Greek (well).	Lipoúme, allá thén miláo elliniká (kalá).
I don't understand.	Thén katalavéno.
I don't understand, please repeat it.	Thén katalavéno, péste to páli, sás parakaló.
It's (not) all right.	(Dén) íne en dáxi.
I want a glass of beer.	Thélo éna potíri bíra.
I want to go to the airport.	Thélo ná páo stóaerothrómio.
I would like a room.	Tha íthela ena thomátio.
Left (direction)	Aristerá
Lunch	Messimerianó
Map	Chártis**
Market (place)	Agorá
Mr.	Kírios
Mrs.	Kiría
My name is . . .	Onomázome . . .
New	Kenoúryos, -ya, -yo*
No	Óchi**
Old	Paleós, -leá, -leó* *(pronounce palyós, -lyá, -lyó)*
Open	Anichtós, -chtí, -chtó*
Patisserie	Zacharoplastío**
Pharmacy	Pharmakío
Please *or* You're welcome.	Parakaló.
Please call a taxi (for me).	Parakaló, fonáxte éna taxi (yá ména).
Point out to me, please . . .	Thíkste mou, sas parakaló . . .

Post office	Tachidromío**
Restaurant	Estiatório
Restroom	Tóméros *or* I toualétta
Right (direction)	Dexiá
Saint	Áyios, ayía, *(plural)* áyi-i *(abbreviated* ay*)*
Show me on the map.	Díxte mou stó(n) chárti.**
Square	Plateia
Station (bus, train)	Stathmos (leoforíou, trénou)
Stop (bus)	Stási(s) (leoforíou)
Street	Odós
Thank you (very much).	Efcharistó(polí).**
Today	Símera
Tomorrow	Ávrio
Very nice	Polí oréos, -a, -o*
Very well	Polí kalá *or* En dáxi
What?	Tí?
What's your name?	Pós onomázest(h)e?
What time is it?	Tí ôra íne?
Where am I?	Pou íme?
Where is . . . ?	Poú íne . . . ?
Why?	Yatí?

*Masculine ending -*os,* feminine ending -*a* or -*i,* neuter ending -*o.*

**Remember, *ch* should be pronounced as in Scottish *loch* or German *ich,* not as in the word *church.*

Numbers

0	Midén
1	Éna
2	Dío
3	Tría
4	Téssera
5	Pénde
6	Éxi
7	Eftá
8	Októ
9	Enyá
10	Déka
11	Éndeka
12	Dódeka
13	Dekatría
14	Dekatéssera
15	Dekapénde
16	Dekaéxi
17	Dekaeftá

18	Dekaoktó
19	Dekaenyá
20	Íkossi
21	Íkossi éna
22	Íkossi dío
30	Triánda
40	Saránda
50	Penínda
60	Exínda
70	Evdomínda
80	Ogdónda
90	Enenínda
100	Ekató(n)
101	Ekatón éna
102	Ekatón dío
150	Ekatón penínda
151	Ekatón penínda éna
152	Ekatón penínda dío
200	Diakóssya
300	Triakóssya
400	Tetrakóssya
500	Pendakóssya
600	Exakóssya
700	Eftakóssya
800	Oktakóssya
900	Enyakóssya
1,000	Chílya*
2,000	Dío chilyádes*
3,000	Trís chilyádes*
4,000	Tésseris chilyádes*
5,000	Pénde chilyádes*

*Remember, *ch* should be pronounced as in Scottish *loch* or German *ich,* not as in the word *church.*

Days of the Week

Monday	Deftéra
Tuesday	Tríti
Wednesday	Tetárti
Thursday	Pémpti
Friday	Paraskeví
Saturday	Sávvato
Sunday	Kiriakí

Index

Restaurants

Photo Credits

front cover: © Yiannis Papadimitriou/Shutterstock; p. i: © Lightlook/Shutterstock; p. 2: © Heracles Kritikos/ Shutterstock; p. 3: © Mapics; p. 4: © Leonardohyo/Shutterstock; p. 5: © Panos Karas/Shutterstock; p. 6: © Vladimir Zhoga/Shutterstock; p. 7: © Dziewul/Shutterstock.com; p. 9: © balipadma/Shutterstock; p. 10: © Georgios Tsichlis/Shutterstock; p. 11: © simonjenkins' photos; p. 12: Courtesy of Aqua Blu; p. 13: Courtesy of Villa Marandi/GEORGE SFIROERAS; p. 14: Courtesy of Fresh Hotel Athens; p. 15: Courtesy of S. Nikolis Hotel; p. 16, top: Courtesy of Avil; p. 16, bottom: Courtesy of Lithos; p. 19: © Markara/ Shutterstock; p. 22: © Rostislav Ageev/Shutterstock; p. 23: © Fotokon/Shutterstock; p. 24: © Andrey Lobachev/Shutterstock; p. 26: © Lefteris Papaulakis/Shutterstock; p. 29: © Jekatarinka/Shutterstock; p. 30, top: © Yiannisscheidt/Shutterstock; p. 30, bottom: © Karl Allen Lugmayer/Shutterstock.com; p. 33: © Aybige Mert/Shutterstock; p. 35: © Nadir Keklik/Shutterstock; p. 37: © Ali Efe Yilmaz/Shutterstock; p. 44: © apanikolakis Photography/Shutterstock; p. 45: © Heracles Kritikos/Shutterstock; p. 48: © Kartouchken/Shutterstock.com; p. 50: © Milan Gonda/Shutterstock.com; p. 54: © Aerial-motion/ Shutterstock; p. 55: © Antonio Gravante/Shutterstock; p. 57: © Iremt/Shutterstock; p. 59: © © Freesurf69 | Dreamstime.com; p. 60: © Georgios Tsichlis/Shutterstock; p. 62: © Dasha Petrenko/Shutterstock; p. 65: © Nick Pavlakis/Shutterstock.com; p. 68: © Milan Gonda/Shutterstock.com; p. 76: Courtesy of The Foundry; p. 77: Courtesy of Grande Bretagne; p. 78: Courtesy of Hotel Attalos/imagIN visual promotions; p. 82: Courtesy of Marble House/PANOS DEMIROPOULOS PHOTOGRAPHY; p. 83: Courtesy of Aleria/Kleanthis Mitsioulis; p. 84: Courtesy of Café Avissinia; p. 86: Courtesy of Dio Dekares I Oka; p. 89: Courtesy of

ur use of a Frommer's
vant to consult

FROMMERS.COM

FROMMERS.COM IS KEPT UP-TO-DATE, WITH:

NEWS
The latest events (and deals) to affect your next vacation

BLOGS
Opinionated comments by our outspoken staff

SLIDESHOWS
On weekly-changing, practical but inspiring topics of travel

CONTESTS
Enabling you to win free trips

PODC
Featuring experts fro

DESTINA
Hundreds of cities, their hot

TRIP I
Valuable, offbeat suggestio